COSMOS

COSMOS

• From Romanticism to the Avant-garde •

Edited by Jean Clair

THE MONTREAL MUSEUM
OF FINE ARTS

Jean-Noël Desmarais Pavilion

Prestel
Munich – London – New York

The Montreal Museum of Fine Arts

Cosmos
From Romanticism to the Avant-garde

The Montreal Museum of Fine Arts
Jean-Noël Desmarais Pavilion
June 17 to October 17, 1999

Guy Cogeval, Director
Paul Lavallée, Director of Administration
Danielle Sauvage, Director of Communications
Hilliard Goldfarb, Associate Chief Curator

Presentation in Montreal
Co-ordination: Rosalind Pepall
Design: Paul Hunter

Centre de Cultura Contemporània de Barcelona
November 23, 1999, to February 20, 2000

Josep Ramoneda, Director
Jordi Balló, Head of Exhibitions and Research Department

The Montreal Museum of Fine Arts would like to thank
the following organizations for their ongoing support:

Ministère de la Culture et des Communications du Québec
Department of Canadian Heritage (Museums Assistance Program)
Montreal Urban Community Arts Council

ISBN The Montreal Museum of Fine Arts: 2-89192-231- X
Legal deposit – 2nd quarter 1999
Bibliothèque nationale du Québec
National Library of Canada

English edition distributed by
Prestel Verlag
French edition distributed by
Gallimard, Paris

© 1999 Prestel Verlag
Mandlstrasse 26, D-80802 Munich Tel.: (89) 38.17.09.0 – Fax: (89) 38.17.09.35
4 Bloomsbury Place, London WC1A 2QA Tel.: (171) 323 5004 – Fax: (171) 636 8004
16 West 22nd Street, New York 10010 Tel.: (212) 627-8199 – Fax: (212) 627-9866

Library of Congress Cataloging-in-Publication Data is available for this title.

Prestel books are available worldwide. Information concerning local distributors
may be obtained from any of the above addresses, or contact your bookseller.

ISBN Prestel Verlag: 3-7913-2089-0

Printed in France

Lenders to the Exhibition

*We gratefully acknowledge
the generosity of the institutions
and individuals whose loans have
made this exhibition possible.*

AUSTRALIA
Epping
David Malin

AUSTRIA
Vienna
Museum moderner Kunst
Stiftung Ludwig

BELGIUM
Brussels
Galerie Patrick Derom

CANADA
Calgary
The Arctic Institute of North
America, University of Calgary
Glenbow Museum
Kleinburg
McMichael Canadian Art
Collection
London
London Regional Art Gallery and
Historical Museums
Montreal
Bibliothèque nationale du Québec
Canadian Centre for Architecture
Michel Daras collection
McCord Museum of Canadian
History
McGill University Libraries, Rare
Books and Special Collections
Division
The Montreal Museum of Fine Arts
Montreal Museum of Decorative
Arts/The Montreal Museum of
Fine Arts
Osler Library of the History of
Medicine, McGill University
Redpath Museum, McGill
University
Stewart Museum at the Fort, Île
Sainte-Hélène
Université de Montréal, Service
des bibliothèques, livres rares et
collections spéciales
Orillia, Ontario
Sir Sam Steele Art Gallery

Ottawa
Geological Survey of Canada
National Archives of Canada
National Gallery of Canada
Quebec City
Musée du Québec
Toronto
Art Gallery of Ontario
Royal Ontario Museum
Vancouver
Vancouver Art Gallery

CZECH REPUBLIC
Prague
Národní Galerie

FRANCE
Agen
Musée des beaux-arts d'Agen
Paris
Bibliothèque du film (BIFI),
Cinémathèque française collection
Bibliothèque nationale de France
Jean Charles de Castelbajac
collection
Liliane and Michel Durand-Dessert
collection
Fondation Cartier pour l'art
contemporain
Galerie Maeght
Galerie Nelson
Galerie Yvon Lambert
Sara Holt collection
Institut Français d'Architecture/
Archives nationales
Musée de la Mode de la Ville
de Paris, Musée Galliera
Musée des arts et métiers du CNAM
Musée du Petit Palais
Musée national d'art moderne/
Centre de création industrielle,
Centre Georges Pompidou
Musée Picasso
Observatoire de Paris
Céleste Plantureux collection
Société astronomique de France
Société française de photographie
Strasbourg
Musée d'art moderne et
contemporain de Strasbourg

GERMANY
Berlin
Staatliche Museen zu Berlin,
Nationalgalerie

Cologne
Galerie Gmurzynska
Museum Ludwig
Dresden
Staatliche Kunstsammlungen,
Gemäldegalerie Neue Meister
Duisburg
Wilhelm Lehmbruck Museum
Düsseldorf
Kunstsammlung Nordrhein-
Westfalen
Hamburg
Museum für Kunst und Gewerbe
Hamburg
Itzehoe
Wenzel-Hablik-Museum
Stuttgart
Galerie Valentien
Ulm
Ulmer Museum

ISRAEL
Tel Aviv
Tel Aviv Museum of Art

ITALY
Florence
Istituto Museo di Storia della
Scienza
Milan
Pierpaolo Cimatti collection
Marinetti collection
Rome
Mr. and Mrs. Luciano Berni
Canani collection
Fondazione Giorgio e Isa de Chirico
Galleria Nazionale d'Arte Moderna

LITHUANIA
Kaunas
M.K. Čiurlionis National Museum
of Art

MONACO
Musée océanographique de
Monaco

THE NETHERLANDS
Otterlo
Kröller-Müller Museum

NORWAY
Oslo
Nasjonalgalleriet

RUSSIA
Moscow
A.V. Shchusev State Research
Museum of Architecture
Saint Petersburg
State Russian Museum

SPAIN
Madrid
Fundación Colección Thyssen-
Bornemisza

SWEDEN
Stockholm
Kungliga Biblioteket

SWITZERLAND
Basel
Öffentliche Kunstsammlung
Basel, Kunstmuseum
Zurich
Kunsthaus Zürich
Angela Thomas Schmid collection

UNITED KINGDOM
Bradford
The National Museum of
Photography, Film and Television
Glasgow
Glasgow Museums: The People's
Palace Museum
Greenwich
National Maritime Museum
London
Guildhall Library, Corporation of
London
Christopher Mendez collection
Tate Gallery
Warner Fabrics Plc
Newcastle upon Tyne
Laing Art Gallery (Tyne and
Wear Museums)

THE UNITED STATES
Baltimore
The Baltimore Museum of Art
Bloomfield Hills, Michigan
Cranbrook Art Museum
Boston
Museum of Fine Arts, Boston
Buffalo
Albright-Knox Art Gallery
Cambridge
Harvard University Museums,
Fogg Art Museum

Chicago
The Art Institute of Chicago
Cincinnati
Carl Solway Gallery
Dallas
Dallas Museum of Art
Fort Worth
Kimbell Art Museum
Indianapolis
Indianapolis Museum of Art
Lincoln
Sheldon Memorial Art Gallery
and Sculpture Garden, University
of Nebraska
Los Angeles
Los Angeles County Museum of Art
The Museum of Contemporary Art
Steve Tisch
Milwaukee
The American Geographical
Society Collection of the
University of Wisconsin-
Milwaukee Library
New Bedford, Massachusetts
Old Dartmouth Historical Society,
New Bedford Whaling Museum
New Haven
Yale University Art Gallery
New York
American Museum of Natural
History
Brooklyn Museum of Art
Cooper-Hewitt, National Design
Museum, Smithsonian Institution
Leonard Hutton Galleries
David and Renee McKee collection
The Metropolitan Museum of Art
The New York Public Library
Paine Webber Group Inc. Collection
Solomon R. Guggenheim Museum
Whitney Museum of American Art
Newport Beach, California
Orange County Museum of Art
Philadelphia
Philadelphia Museum of Art
Reading, Pennsylvania
Reading Public Museum
Richmond
Virginia Museum of Fine Arts
Saint Louis
The Saint Louis Art Museum
Simsbury, Connecticut
The Town of Simsbury
Toledo
The Toledo Museum of Art

Tucson
Center for Creative Photography,
University of Arizona
Tulsa, Oklahoma
The Gilcrease Museum
Washington
Gary Edwards Gallery
Hirshhorn Museum and Sculpture
Garden, Smithsonian Institution
National Air and Space Museum,
Smithsonian Institution
National Gallery of Art
National Museum of American
History
Williamstown, Massachusetts
Sterling and Francine Clark Art
Institute

*We are also grateful to the following
galleries and organizations for
their co-operation:*

Anthony d'Offay Gallery, London
Calder Foundation, New York
Capricorn Trust, Cavaliero Fine
Arts, New York
Gemini G.E.L., Los Angeles
Howard Schickler Fine Arts,
New York
Julie Saul Gallery, New York
Michael Werner Gallery, New York
Sidney Janis Gallery, New York

as well as

Art Co. Ltd., George Costakis
collection
Collezione "Campiani"
Charles Isaacs Photographs
Phyllis and Graeme Ferguson
collection
Noelle C. Giddings and Norman
Brosterman collection
Gilman Paper Company Collection
Susan and Michael Hort collection
NASA
Germaine Richier family collection

*and those lenders who prefer to
remain anonymous.*

Acknowledgements

The curators of the exhibition would like to thank the following people for their kind co-operation:

Jane Adlin
Nijolé Adomavièiené
Patricia Ainslie
Maxwell L. Anderson
Jean-Pierre Angremy
Colin Bailey
Judith Barter
Felix A. Baumann
Geneviève Bazin
Graham W.J. Beal
Ingrid Birker
Ulrich Bischoff
Lise Bissonnette
Alf Bogusky
Doreen Bolger
Bruce Bolton
Frederick R. Brandt
Marta Braun
James D. Burke
May Castleberry
Diane Charbonneau
Jean-Louis Cohen
Marjorie B. Cohn
Michael Conforti
Aliki Costakis
James Cuno
Nandou Daliès
Malcolm Daniel
Osvalda Daugelis
Stéphane Deligeorges
James T. Demetrion
Lisa Dennison
Patrick Derom
Stephen Deuchar
Victoria Dickenson
François Doumenge
Wolf-Dieter Dube
Volkmar Essers
Maurizio Fagiolo
Kurt Forster
Lea Freid
Sharon Frost
Elisabeth Fuchs-Belhamri
Jean-François Gauvin
Claudia Gian Ferrari
Tom Giles
Krystyna Gmurzynska
Valérie Guillaume
Françoise Guitère and the family
of Germaine Richer
André Gunthert
Gay Guthrie

Rosemary Haddad
Maria Morris Hambourg
David Hanks
Anne d'Harnoncourt
Eleanor Jones Harvey
Neil Harvey
Robert Headland
Richard Herd
Charles Hill
Erica Hirshler
Mrs. Leonard Hutton
Luc d'Iberville-Moreau
Ahuva Israel
Sona Johnston
Rüdiger Joppien
Brooks Joyner
Peter Kaellgren
Igor A. Kazus
Laurel Kendall
Ashley Kistler
Lilly Koltun
Ch. Kotrouzinis
Phyllis Lambert
Yvon Lambert
Arnold Lehman
Michael Light
Yannick Lintz
Kenneth Lister
Tomàs Llorens
Eva Major-Marothy
Constance Martin
Catharine Mastin
Moira McCaffrey
Julia McCarthy
Patricia Mears
Eileen Meillon
Pam Miller
Philippe de Montebello
Daniel Moquay
Anne Morand
Douglas Nickel
Isabelle Nolin
Caroline Ohrt
Nicholas Olsberg
Richard Ormond
Jacques Pernet
Evgenia Petrova
David Peyceré
Sandra Phillips
Sandra Pinto
Michel Poivert
John Porter

Earl A. Powell III
Roger Quarm
Mélanie Racette
Rodolphe Rapetti
Jock Reynolds
Vladimir Rezvin
Jovanka Ristic
Malcolm Rogers
Alexander Rower
Julie Saul
Paul Schimmel
Katharina Schmidt
Daniel Schulman
Douglas G. Schultz
Peter Klaus Schuster
Joan Schwarz
Nicholas Serota
Lindsay Sharp
Deborah Shinn
Philippe Siauve
Kim Sichel
Kiki Smith
Lydia Sokoloff
Me Lucien Solanet
Werner Spies
Kevin Stayton
David Steadman
Carlene E. Stephens
Mrs. David M. Stewart
Evert J. van Straaten
Marilyn Symmes
Matthew Teitelbaum
Guy Tessier
Ian Thom
Ann Thomas
Shirley L. Thomson
Carol Troyen
Eric Turner
Steven Turner
Barbara Tyler
Huguette Vachon
Guy Vadeboncoeur
Freerk C. Valentien
Julia Van Haaften
Charles Venable
Marc Vernet
Bret Waller
Sylvia Wolf
James Wood
Ann Wright-Parsons
Amanda Young
James Zender

The exhibition

**Cosmos
From Romanticism to the Avant-garde**

was organized by

Pierre Théberge, C.Q.
National Gallery of Canada
Ottawa

•

Chief Curator
Jean Clair
Musée Picasso
Paris

•

Curatorial Committee
Mayo Graham
National Gallery of Canada
Ottawa

Constance Naubert-Riser
Université de Montréal

Didier Ottinger
Centre Georges Pompidou
Paris

Rosalind Pepall
The Montreal Museum of Fine Arts

Christopher Phillips
Art in America
New York

4• BEYOND THE EARTH: THE MOON

5• IMAGINARY COSMOLOGIES

6• TO INFINITY AND BACK

Vaghe stelle dell'Orsa, io non credeva
Tornar ancor per uso a contemplarvi...
Giacomo Leopardi, *Ricordanze*

Seen from an earthly vantage point, the starry universe has always appeared endless, and the logic of its exploration has seemed a daunting task. When artists raised their eyes to the heavens and tried to represent that immensity, they sketched a response to the anxieties that grip us when we face the measureless. This exhibition is not concerned merely with *portrayals* of the cosmos; its purpose is not fulfilled simply by arranging a series of views of the planets. It would be more accurate to say that it deals with the *imaginary depiction of the infinite* – interstellar space being as close as we can come to an approximation of its unattainable limits. The plan proposed by Jean Clair and his team offers a thread to lead viewers through the labyrinth connecting the Romantic contemplation of the moon of Caspar David Friedrich's generation with NASA's most recent images of space, passing through the stretching of human vision in nineteenth-century panoramas of great cities, stopping at Church's and Bierstadt's monumental images of the natural landscape of America, with their metaphors of a frontier to be conquered, going on to the floating cities that took form from the fantasies of the Russian Constructivists, and continuing through Miró's constellations and a host of other images. This exhibition is much more than an attempt to show the conquests of science and the exploration of the universe. Centred on the production of artists belonging to different schools (I am not in much danger of contradiction in claiming that this is the first time Van Gogh, Méliès and Calder have been compared), it presents all the metaphors of a visual frontier that, through the visionary invention of the artists represented, has continually receded before us. At the dawn of the new millennium, museum-goers in Montreal are invited to ponder two centuries of our modern artistic tradition, as seen in part, but only in part, through the telescope.

I would like to express my pride in being at the helm of a museum with the courage to suggest a thematic exhibition of this scope, and to find the means to carry it out; over the years it has become almost impossible to bring this type of lateral, intellectual project to fruition. We owe the audacious policy that made it possible to the tenacity of Pierre Théberge, my predecessor, who richly deserves to be the first person to be thanked. My total admiration also goes to Jean Clair, one of the greatest art historians of our age, who has already been in charge of other projects of similar scope in Montreal. My admiration extends to his team, whose varied areas of specialization and curatorial prowess have allowed the scientific content of the exhibition to flower in unexpected and hitherto unexplored directions. I will let Pierre Théberge finish expressing the thanks owed in these circumstances, in particular to the entire staff of the Montreal Museum of Fine Arts, who have always enthusiastically supported this type of original project, and to all those who have lent works to this exhibition.

I reserve my final words for my colleague Josep Ramoneda, director of the Centre de Cultura Contemporània in Barcelona, and to his team, in particular Jordi Balló. Their willingness to remount the exhibition *Cosmos* in one of Spain's great cities after it closes in Montreal will make it possible for a major show from the Montreal Museum of Fine Arts to be presented to a European audience for the first time, and at the start of a new millennium at that; they deserve our heartfelt gratitude for their generous support. With them, we will, as Leopardi invites us to do, go back and gaze once more upon the "wandering stars of the Bear".

Guy Cogeval
Director
The Montreal Museum of Fine Arts

*... finding the sources of life some
elsewhere akin to the Garden of Eden.*
Jean Clair[1]

Since the first Sputnik was launched in 1957, there have been an astonishing number of discoveries in cosmology. Subsequent lunar exploration and space probes have sent back dazzling images of the earth and the other planets of the solar system, including Mars, which is to be explored actively in the next decades. The Hubble telescope is currently transmitting a constant stream of data, continually driving back the spatial and temporal frontiers of the known universe and approaching the very beginnings of the cosmos.

This exhibition, which I first conceived of several years ago as a celebration of our entering the third millennium, provides striking proof that artists of the past two centuries have been as fascinated by the cosmos as today's astronomers and astrophysicists, and have paid tribute to it in a fashion no less extraordinary.

We owe the realization of this exhibition to Jean Clair, who rigorously defined its parameters, "from Romanticism to the avant-garde", and to the curatorial team he set up to explore its major themes. For Mr. Clair and some members of the team, this has been the third collaboration on a major project, since they previously worked together on two notable theme-based shows at the Montreal Museum of Fine Arts: *The 1920s: Age of the Metropolis* in 1991 and *Lost Paradise: Symbolist Europe* in 1995.

I would like to extend my sincere thanks to all the members of the curatorial committee for their enthusiasm in accepting this new challenge, and to Guy Cogeval, the Montreal Museum of Fine Arts' new director, himself a member of the curatorial committee for the exhibition *Lost Paradise*, for his vigorous support in making the original idea a reality.

I also wish to express my gratitude to the authors of the essays in this catalogue, who collaborated with the curators in defining the exhibition's historical, scientific and artistic context, and to Paul Hunter, who assumed with intelligence and sensitivity the formidable task of designing and implementing the installation of the show within the Museum's walls.

Finally, I would like to convey my appreciation to the lenders for their generous support of our project and to thank all museum personnel, near and far, for their invaluable co-operation in bringing this considerable undertaking to fruition.

Pierre Théberge, C.Q.
Director
National Gallery of Canada

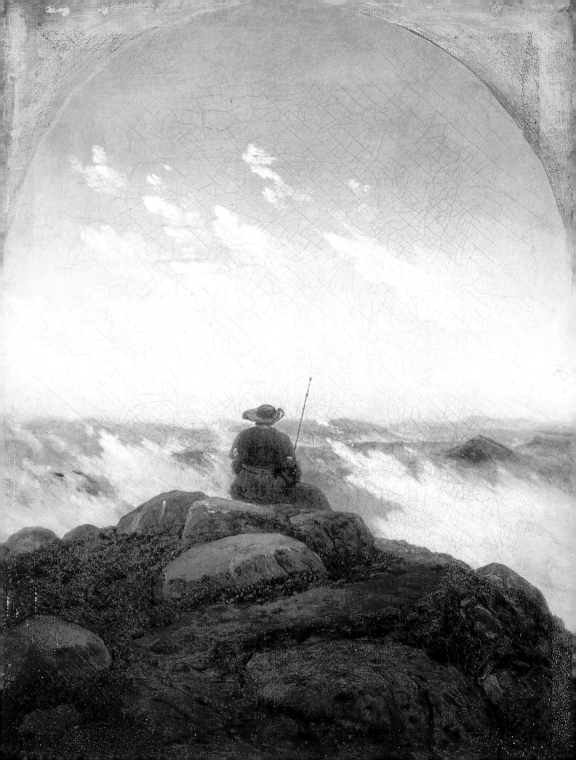

- 1 -
NATURE AND THE COSMOS

O care fiubi, o cielo, o terra, o piante...
Leopardi

The Dream Promontory

A few hours later the astronomer bid his guest
ascend the winding staircase of the observatory,
and at last step out upon the completely open plat-
form of a lofty round tower. A most brilliant
night, sparkling and glowing with all the stars of
heaven, surrounded the observer, who seemed for
the first time to behold the lofty firmament in all
its glory...

Humboldt to Hubble

Jean Clair

Rapt and astonished, he shut his eyes. The immense
[*das Ungeheure*] ceases to be sublime; it surpasses
our faculty of comprehension, it threatens to
annihilate us.[1]

Thus, Wilhelm Meister, paying a visit to Makarie,
is led by an elderly astronomer into his observatory,

At this point, he wrote, "You see the moon, and this
figure of the unexpected emerges before you; and
you find yourself face to face in the shadows with
this atlas of the Unknown. The effect is terrifying ...
You grow dizzy at the sight of a world suspended in
emptiness ... The perception of the phenomenon
becomes increasingly clear; this presence wrings
your heart. The effect is like that produced by powerful
spectres. The silence heightens the horror – the sacred
horror."[3]

Thus, the effect produced by the heavenly vault is,
once again, one not of admiration but of terror. Once
again the sublime has given way to dread, to a horror
very much like the *Ungeheure* that Goethe experienced.
Confronted with the feeling of the loss of limits,
faced with this plunge into the infinite, what classical
aesthetics knew as the *stupendum* or *mirum* is
transformed into *mysterium tremendum et fascinans*
– in other words, "sacred horror".

This marked the first appearance in modern literature
of the singular category that Rudolf Otto, in his
essay on the Holy, called "the numinous"[4] – the
uncanny and disturbing that eludes our grasp,
infinitely outstrips our capacity for spatial perception

1804, Alexander von Humboldt explored the last horizons of the globe and, through his voyages, helped to close it in upon itself. He was the last to make an inventory of the world, the last universal figure to cast his gaze on this world finally turned inward. Humboldt the geographer, cartographer, geologist, volcanologist, botanist and sociologist was also the inventor of climatology, statistics and political economy. He was perhaps the last who could realistically lay claim to the title of *homo universalis* – the last of the encyclopedists, in any case, mastering all branches of knowledge at a time when the world was closing in around him.

But when the wheel – this "cycle" of knowledge, this cyclorama completed by Humboldt's trip to the Andes – came full circle, human curiosity discovered another equally dizzying panorama. I am referring to the one discovered when the eye first managed to leave the earth behind, to rise up, like a bird, into the air. With the earth finally closed in upon itself, the sky suddenly presented another (and apparently unlimited) horizon for its delectation.

Not by chance did Mario Praz, in the vast collection adorning the walls of the Primoli Palace, grant pride of place to paintings, decorations, drawings and carved mirrors that, in the early years of the century, recalled the first experimental aerostats, the silhouette of the first hot air balloons, the delicate ribbing of the first parachutes. Thrust into the heart of Neoclassical, Empire and Biedermeier iconography, these strange and unaccustomed forms presaged the threats that, in the troubled sensitivity of his erudition, he saw gathering on the horizon.

We no longer have the ordeal of the observatory as experienced by Goethe and Victor Hugo; in its place is what we might call the experience of the balloon. It is no longer through the lens, but through this other technical instrument, this gas-filled envelope, that the feeling of infinity and its attendant horror are passed on to us. But also, at a more secret level, there is the belligerent threat concealed within this panoptical machine that may lift off with us one day and swoop down on us the next.

Thus, when Goya painted the first hot air balloon (cat. 117), he showed a terror-stricken crowd scurrying away across the field beneath the gracefully rounded envelope.

A secret dread is also the subject of Méryon's 1844 print of the Pont au Change. The first state shows an empty sky over the Conciergerie. In the second state, we see a balloon bearing the name *Speranza* – Hope – carried on the wind. The same balloon reappears in the next four proofs of state as well. In the seventh state, however, it has been effaced; in its place, a flock of crows seems to swoop down in close formation over the city. In the final proofs, the birds have disappeared, to be replaced by a flotilla of tiny balloons that seem to

FIGS. 1-2 - CHARLES MÉRYON
THE PONT AU CHANGE, 1854
5TH AND 9TH STATES

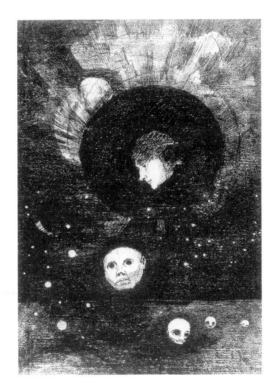

FIG. 3 - ODILON REDON
GERMINATION, 1879

preserve the undercurrent of threat introduced by the crows (figs. 1-2). Referring to Méryon's engravings in a letter to Poulet-Malassis, Baudelaire would talk of "birds of prey", "eagles" and "omens".

In a fin de siècle haunted by the idea of the world's demise – an idea sanctioned by the new theories of entropy – Odilon Redon, with his ocellated balloons, would be heir to these grim and disturbing premonitions. In 1879, he made *Germination* (fig. 3), in which celestial bodies are swallowed up in the expanse of space.

• The Disenchantment of the World

In these years of Romanticism, we are far from the light-hearted and hopeful atmosphere that surrounded the previous century's first aerostatic experiments – when, for example, Louis Watteau executed several delightful paintings to celebrate the flights of Blanchard and Lépinard from Lille in 1784.

Here again, literature supplies us with precious evidence. In 1841, at the height of the Biedermeier period, Adalbert Stifter, the greatest stylist of the German language, published "Der Condor".

This short story, divided into four tableaux, is thematically very complex. On the one hand, we have a painter intent on capturing the essence of the world in his paintings; on the other, a bold young woman named Cornelia, who is anxious to become an equal of men. She takes part in the flight of the *Condor*, a type of airship, over the Alps. But the great altitude is too much for her, and the break with her known horizons becomes unbearable: "But lo!, everything was strange. The comfortably familiar had disappeared, and with it the threads that bind us to the little spot we call home." [6]

Home – perhaps the German word *Heimat* is stronger, for it also refers to our native soil, our origins, the country of our childhood; to customs and odours, to the colours of a cherished horizon and the familiar homeland where our parents brought us into the world.

But her shock is even greater when, having lost her footing and left the soil where her feet were wont to make their mark day after day, Cornelia looks to the sky for a refuge: "But the sky, the beautiful blue dome of our earth, had become a black abyss of immeasurable and limitless depth." Thus, the loss of her native land is accompanied by the loss of the guideposts that have always been available to human beings in the constellations named for the fabulous creatures of the zodiac.

The young woman is utterly changed. Once back on earth, she finds herself a stranger to everything and everybody and no longer has the strength to declare her love to the young painter. Meanwhile, alone and abandoned, he continues to paint, to trace on canvas those indissoluble links that connect our gaze to its native soil.

*

These few luminous and tranquil pages are unparalleled as an expression of the extent to which the closing in of our tiny planet and the conquest of outer space (a development akin to closing the family door behind oneself and setting out on the world's roads) marked the beginning, in the previous century, of what Max Weber was soon to call the "disenchantment of the world". By leaving the verdant paradise of childish loves for the blackness of infinite spaces, modern man, man in the adult phase, has also left what Stefan Zweig described at the turn of the century as "the world of security".[7] From that point on, everything would appear alien and disturbing, perhaps even hostile.

*

In Leopardi's poem "The Infinite", we encounter a sensibility akin to Stifter's:
> This lonely hill has always been so dear
> To me, and dear the hedge which hides away
> The reaches of the sky. But sitting here
> And wondering, I fashion in my mind
> The endless space far beyond, the more
> Than human silences, and deepest peace;
> So that the heart is on the edge of fear.[8]

The hedge that cordons off the gaze, with all its nesting birds, is also a place of birth, the enclosure and the clearing where human hands first derived their sense of work and purpose. Is it possible to imagine a place without a place? The mind is gripped by vertigo when one looks through the openings in the surrounding foliage to the immense void that lies beyond it. Leopardi smiles the smile of the desperate man who denies himself all illusions and any hope of transcendence. The heavens are empty, and there is nothing to be gained from mastery over a Nature indifferent to human purpose.

• Fantastic Voyages

Nothing to be gained? The century echoes with the call of the sea, and many other examples could be adduced to counter the sidereal pessimism exhibited by these authors. The passion of the century is also the passion for science, and its optimism the same as that which drives the conquest of the heavens. Indeed, a voyage by balloon inaugurates the work of Jules Verne,[9] who is, with his passionate interest in distant countries and his confidence in the power of science, at the opposite pole from the sceptical and grim visions we have been discussing. And it also happens that the balloon that Nadar, Verne's model and hero, succeeded in setting aloft was named *The Giant*, which fueled Parisians' imagination.

At yet another level, Poe, in his "Unparalleled Adventure of One Hans Pfaall" – an account of a trip to the moon on a paper aircraft – takes up a genre of philosophical tale made popular by Voltaire and even more so by Swift, namely, stories dealing with the multiplicity of inhabited worlds.

The search for the sources of the Nile undertaken in Jules Verne's balloon, and Nadar's trip "from the earth to the moon" [10] – which had to wait, meanwhile, for its hypothetical rocket – are but two examples of an initiatory journey. Although, in the cases at hand, this journey ranges from the confines of Egypt to the conquest of the pale planet, it would also take many other forms. The quest for what Michel Butor calls the "supreme point" would assume numerous other guises, including the conquest of the ocean floor and the earth's centre. The Unknown, the Forbidden, stretched another twenty thousand leagues under the sea;[11] it lay beneath the crater of Mount Sneffels.[12]

Among these supreme points, one in particular will long retain the full force of its magnetic attraction. I am referring, of course, to the true North. Let us read again the lines with which the adventures of Captain Hatteras come to a close:

> Captain Hatteras, followed by his faithful dog, who gazed sadly and tenderly upon him, walked for many hours each day. His excursion, however, invariably took him in a specific direction ... under the influence, so to speak, of a magnetic force.
> Invariably, Captain John Hatteras walked North.[13]

The voyage of the *Forward* in search of the Northwest Passage is, therefore, a hallucinatory quest for a central point that, once reached, would be not only the last point on earth to be discovered, but also a unique one, "the only fixed point on the globe, whereas all the others were hurriedly spinning".

<center>*</center>

In addition to placing Humboldt's exploratory genius within the reach of popular imagination, Jules Verne deftly revealed the most secret dreams of the century that was then drawing to a close. The North that subjected John Hatteras – *bonhomme d'Ampère*, a magnetized compass needle – to a sort of ambulatory automatism (to use a phrase invented by Janet and widely used in the psychiatry of the period) by making him turn "invincibly" and "invariably" towards the Arctic pole, by afflicting him with what Verne termed "polar madness", is the same North that led him to discover, amid the great ice wastes atop our small planet, a volcano "rising up like a beacon at the boreal pole of this world". And so the North, the precise point of the pole, is located at the heart of a yawning and inaccessible crater of fire (fig. 4).

How could one ignore, in these fanciful imaginings, the vitiated yet still vital traces of the finest mystical cosmogonies known to the West? And how could one fail to recognize in Riou's and Dumont's admirable illustrations of icebergs and ice floes for Verne's chronicle (figs. 5-6), the popular equivalent of the

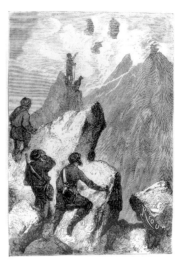

FIG. 4

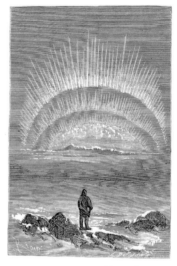

FIG. 5

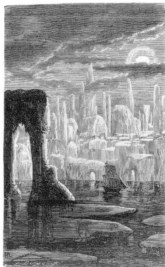

FIG. 6

FIGS. 4-6 - JULES VERNE
VOYAGES ET AVENTURES
DU CAPITAINE HATTERAS
ILLUSTRATIONS BY RIOU AND L. DUMONT.

prints Flaxman and Gustave Doré executed for Dante's Hell of Ice, and of Blake's illustrations of the ice field for Milton's *Paradise Lost*?

*

Verne is undoubtedly the last herald, accessible to children and ordinary people, of a line of writers who celebrated the North as Ultima Thule, as the first and last point to be conquered, as that point which, once reached, would deliver up the secret of existence.

In the last quarter of the century, these reveries of the North – this "polar madness" – replace what the dream of the West was for the first American settlers with their ideal of a new Garden of Eden to be conquered by a regenerated humanity cleansed of the sins that had brought down the Old Continent.[14] The volcano, this immobile pivot of the world spitting out its fire amid the great ice fields, this beacon set atop the earthly globe, here becomes the metaphysical equivalent of Yosemite's two-thousand-year-old giant sequoias (whose age can be determined by counting the concentric rings of a section of the trunk), which have been growing since the time of Christ (see "The World-Tree", pp. 33-37).

It was not the adventures of Karl May (or rather, Buffalo Bill) that enchanted the young Arthur Rimbaud in the small French town of Charleville. Rather, it was Norway, the north road, which he spelled *Norwège*, in the old fashion (as he also wrote *wasserfall*). In his drafts of *A Season in Hell* (like Dante's *Inferno* illustrated by Blake?), he wrote, "I travelled a little. I headed North."

Is not the North also that mythical place, pure and desolate, where nothing decays and everything is preserved for eternity, the place the accursed choose for their last refuge, so they can escape the murderous fury of men? Captain Nemo, Victor Frankenstein's creation (the "new man" conceived by Mary Shelley) – we would still have to wait for the "new man" of the socialist utopias and the National Socialists – it is these who seek their ultimate asylum in the northern ice.

In the twentieth century, it is the heroes of interplanetary voyages, figures like Flash Gordon (of the 1930s comic books of the same name) and Doug Quaid (in the 1990 movie *Total Recall*) – new men, too, in their way – who have fleshed out the myth.

• **From the Moon to Eternity**
Let us affirm, however, that in spite of the hold exerted by this optimistic and stimulating phantasmagoria, the Romantic enterprise is first of all an acknowledgement of the disenchantment of the world brought about by technical progress. The moon of Leopardi and Cornelia, the moon that Goethe and Victor Hugo gazed at through a telescope, was still to some extent the same moon that captivated Homer.

Yet, it is already the moon of Galileo and Newton: none of these poets was unaware of the conquests achieved by scientific thought. Remember that Leopardi's first significant book was *A History of Astronomy*, penned when he was fifteen, and the importance of Goethe's scientific writings is well known. Regardless of how blurred it became, the ancient image of our satellite would endure – up to the advent of Symbolism.[15] It was still the moon of Méryon and Redon. The moon, as a satellite of the earth and a dead, uninhabited celestial body, seems to be of decidedly little use to the imagination.

When, in the first or second decade of the coming century, it finally becomes the focus of technical conquest and is no longer considered a fitting subject for reverie, will it shed the image the nineteenth century continued to cherish of it, shelve it along with the old moons of the past? Just as the discovery of X rays excluded once and for all the Baroque motif of the *calvarium* – the skull and crossbones – from the realm of iconography, the increasingly dry and precise photographs of our satellite will render our old representations useless.

This conflict between the artist's and writer's wild imagination and the precision of the data provided by scientists crops up again in Poe's "Eureka: An Essay on the Material and Spiritual Universe". It is no coincidence that Poe dedicated this work to Humboldt, whose *Cosmos* he had read. "Eureka" is a fantastic compendium, containing a treatment not only of cosmogonic theories of time borrowed from Laplace, but also of theories of magnetism and electricity drawn from the work of Faraday, Oersted, Cavendish and Benjamin Franklin. Poe's whole effort here is directed towards the construction, via an often striking meditation on the theological usefulness of science, of a vast modern theodicy capable of taking the place of ancient beliefs. Valéry did not err in characterizing Poe as a poet of knowledge and his metaphysical essay as an epic account of science.

*

Ought Blanqui's essay "L'Éternité par les astres" be classed with this type of theodicy or cosmogonic poem? "Our earth, as well as the other celestial bodies, is the repetition of a primordial combination that is always reproduced in the same way and that exists simultaneously in thousands of identical copies … In this vast expanse, each man possesses an infinite number of doubles who live his life exactly as he lives it. He is infinite and eternal in the person of his other selves, and not only at his present age, but at all ages. Each second, millions of doubles of himself are simultaneously born and die, while a host of others duplicate every second of his life from birth to death."[16]

On the basis of this fantastic conjecture, this Commune revolutionary imagines the wildest of revolutions from his prison cell, a revolution that will transform the universe, once again, into an eternal cycle of the same events in which the necessarily finite combinations of its constituent elements are endlessly repeated. "I have already written, and will continue to write throughout eternity, the words I am writing at this very moment in a dungeon of the Taureau garrison. My table, my quill, the clothes I am wearing and the circumstances in which I am writing will remain identical." He adds, "Everything that one could have been on this earth, one has already accomplished in some other place ... All the fine things of this earth have already been seen by our future descendants, who are moreover seeing them at this very moment and will see them always."

The confusion, the sacred horror that the infinite produced in Goethe and Stifter, gives way a hundred years later to a fanciful astronomy not unlike a nightmare – or, one might say, to a supreme ataraxy which posits that there is no longer, in the universe or any of its phenomena, any beginning, becoming or end, but merely eternal repetition.

We have here the striking figure of a gloomy modernity, a modernity that views progress as pointless. At the same time, its strains can be heard in Jules Laforgue's melancholy poems on "eternullity", as well as in Nietzsche's elucidation of eternal recurrence. And the same tone reappears again in more recent times in the *ficciones* of Jorge Luis Borges and the parallel universes of science fiction. Finally, we find it in the disabused philosophy of Walter Benjamin, that disenchanted theorist of Marxist messianism and of History as an indeterminate catastrophe.

• White Square on White

The curious syncretism of mysticism and scientism found in Poe and Blanqui reappears – this time stoked to a white heat – among the Russian visionaries both before and after the Revolution of 1917.

The most curious of all these was undoubtedly Nikolai Fedorov, a modest Moscow library employee who, in the 1880s, published a series of articles distributed privately under the title *The Future of Astronomy and the Necessity of the Resurrection*.[17] In one of these articles he writes,

> The worlds of Space will accommodate the houses of the ancestors of the people of earth, and these worlds will be available to those who have been, or are yet to be, resurrected. The exploration of interstellar space will consist, then, of a search for these inhabitable worlds and in the preparation of these houses.

> Above towns and villages, we can now observe the flight of numerous dirigibles, which may be taken as invitations for us to consider the ways in which we might blaze the trail to the Heavens.

> This conquest of the path to Space is an absolute imperative, imposed on us as a duty in preparation for the Resurrection. We must take possession of new regions of Space because there is not enough space on Earth to allow the co-existence of all the resurrected generations ...

> The possibility of travelling from one world to another seems to belong to the fantastic, but it only has the appearance of a fiction. The need for such travel is obvious for those who have contemplated the problems associated with the birth of an ideal society in which social vices would be abolished. To refuse the conquest of Space would be to refuse to solve the economic problems of the Future, predicted by Malthus, to say no to an ideal existence for humanity.[18]

*

Such lunacy is hardly rare in parascientific and pseudoscientific writings at the end of the century. The transmigration of souls from one planet to another, and even across interstellar space, became one of the most prevalent themes of this literature.

In his dialogue-novel *Lumen*, published in 1872, Camille Flammarion, an astronomer and writer known mainly as a great popularizer of science, gives us an intergalactic hero who tells us about his existences on other planets and the fascinating beings he encountered there. Flammarion's *Uranie*, published in 1889, deals again with psychic voyages throughout various universes and worlds, complete with reincarnations and resurrections of the dead.

An avid devotee of spiritism and metempsychosis, Flammarion is the last in a line of cosmic dreamers that began with Swedenborg, who described angels and spirits wandering throughout the planets of the solar system,[19] and Blake, with his *Marriage of Heaven and Hell*.

*

On the other hand, reveries about resurrection and regeneration are an integral feature of the thought of a long succession of mystical reformers who can be found in every corner of Russian history (although Tolstoy was one opponent of this mode). We will cite here, as one of the most curious examples, the case of Josef Hoene-Wroński, a mathematician known mainly as a great literary and scientific eccentric who proclaimed himself both Messiah and Newton of the New Age and who, in mid-century, published *An Epistle to His Majesty the Emperor of Russia to Complete the Decisive Hundred Pages and to Bring about the Reform of Celestial Mechanics*.[20]

Fedorov's text is particularly seminal if we hold to the central idea he keeps coming back to: man's colonization of space has become a necessity, given the depletion of Mother Earth's natural resources and human overpopulation. In fact, Fedorov's ideas launched a cosmic messianism that can be found in the works of all the great Russian and Soviet thinkers. Thus, it should come as no surprise that on December 28, 1928, for the centenary of his birth, *Izvestia* paid this prophet a major tribute, declaring that if he was a "reactionary theologian", he was also "the one who paved the way for a great technological revolution that would profoundly alter human relationships and render territorial boundaries useless".

One could say in effect that Fedorov's reveries, which date from the final years of the nineteenth century, were as influential in shaping the utopias of the writers and painters of the young Soviet state as they were in promoting actual scientific and intellectual progress. In the realm of art and poetry, this visionary's flashes of brilliance can be detected in the programme of Suprematism, in the spaces inhabited by the planits and architectons of Malevich and his followers, and in the floating cities of Krutikov (cat. 162) – just as, in the real world of science and technology, we might look for them in the ideas of Konstantin Tsiolkovsky, the father of Russian rocket science, who, in 1896, devised a programme using interplanetary vessels to populate distant worlds.[21] In this case, the wildest dreams are anchored in the highest degree of rationality and in a reality that has eventually become our everyday world.

The fantasy of a floating city, an idea that Fedorov toyed with when he saw dirigibles floating above towns and villages, would warrant long and careful study on its own. We recall, in Part Three of *Gulliver's Travels*, the flying island of Laputa (fig. 7), a striking prefiguration – in the engravings of Grandville – of Krutikov's floating cities. Yet, contemporary with the Russian visionaries, American comic book imagery, in the hands of Alex Raymond, presented a flying city where Flash Gordon and Dale Arden were held prisoner (fig. 8).

And within the very heart of Romanticism, the ideal country for Shelley was nothing other than an island floating

> ... twixt heaven, air, earth, and sea,
> Cradled, and hung in clear tranquillity.[22]

• **Arrival and Departure**

From being the locus of a "sacred horror" in the previous century, space at the end of the twentieth century has become a fundamental dimension of our imaginative life. *The Principle of Hope*, written by philosopher Ernst Bloch between 1938 and 1947 when he was a refugee in the United States, traces the legendary itinerary of geographical utopias and

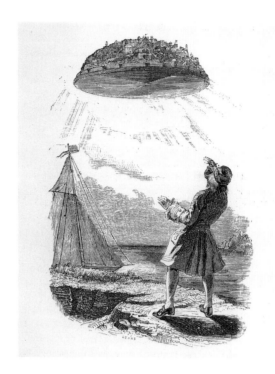

FIG. 7 - JONATHAN SWIFT
VOYAGES DE GULLIVER
ILLUSTRATION BY GRANDVILLE, 1838

FIG. 8 - ALEX RAYMOND
FLASH GORDON, 1936

notes how the notion of an Elsewhere gradually retreated with the discovery of new countries.

Let us be clear on this point: from Pytheas of Massalia (the first to pass through the Pillars of Hercules) to Lucian of Samosata, from Humboldt crossing the Andes to Darwin discovering the key to the origin of species in the Galápagos Islands – an entire legendary topography pushed back the borders of the unknown, without, however, changing the utopic mission of finding the sources of life in some *elsewhere* akin to the Garden of Eden. This is the myth underlying Stanley Kubrick's movie *2001: A Space Odyssey* (1968).

For the symbolic transgression of space is, in the final analysis, a symbolic transgression of time. To conquer space is to seek to triumph over time and death. To reach the limits of space would be to arrive at our own origins, at that place where Life began.

The Promised Land of Canaan is a hope flowing with milk and honey that lies beyond the desert, in the mythic assurance of luxuriant and fertile splendour. The belief in a distant earthly Paradise is what drove the great maritime explorers of the Late Middle Ages. The dream of El Dorado and the search for a lost paradise accompanied Christopher Columbus and his emulators on their voyages. The first colonists in the New World saw its shores as those of a New Earth where they could found a more just, beautiful and pure society. The conquest of the West would rejuvenate this myth; in untouched desert landscapes, each new animal and plant would be approached as if it were the bearer of secrets from the original world. "The horizon of the earth was immeasurably broadened by the voyages of discovery, but it was also supposed to be raised closer to heaven, with the approach to the eastern or solar point of Creation, to be discovered closer to it."[23]

If, as we have seen, the Far North, or Ultima Thule, once played the ultimate role in our search for the "supreme point", today it is intergalactic space, the cosmos, that assumes this meaning. Meanwhile, the very concept of a frontier is disappearing, once again leaving to the imagination the quest to solve the enigma.

On December 4, 1996, the United States launched the Pathfinder space probe, which landed on Mars the following year on the American national holiday. The probe, launched from Cape Canaveral, was programmed to touch down, not on a *promontorium somnii*, but in Ares Vallis, a rocky area in the northern region of Mars formerly covered by water. The challenge was clear. In preparing the missions to follow – the Mars Surveyor, Planet B and sample return programmes (this last for 2005) – the search for water on the red planet is intended as a first step towards finding life, be it only in the form of fossils. By making the search for the sources of life in intergalactic space the utopic aim of space conquest, cosmological discourse is renewing the oldest and most insistent myth of human history – that of the quest for our own origins.

• Notes

1. Johann Wolfgang von Goethe, *Wilhelm Meisters Wanderjahre*, Book 1, Chapter 10. Quoted in English from *Wilhelm Meister's Travels* (London: G. Bell and Sons, 1885), pp. 116-117.

2. Victor Hugo, *Le Promontoire du songe* (Paris: Les Belles Lettres, 1993), p. 6.

3. *Ibid.*, pp. 12-13.

4. Rudolf Otto, *The Idea of the Holy: An Inquiry into the Non-rational Factor in the Idea of the Divine and Its Relation to the Rational*, trans. John W. Harvey (London: Oxford University Press, 1958), Chapter 2, "'Numen' and the 'Numinous'".

5. Goethe, *Faust*, Part II, Act I, lines 6272-6274:
"Das Schaudern ist der Menschheit bestes Teil; / Wie auch die Welt ihm das Gefühl verteure, / Ergriffen, fühlt er tief das Ungeheure."
Quoted in English from the translation by Bayard Taylor (London: Ward, Lock and Co., 1890), p. 331.

6. Adalbert Stifter, "Der Condor", in *Werke und Briefe*, ed. Alfred Doppler and Wolfgang Frühwald, vol. 1.1 (Stuttgart: W. Kohlhammer, 1978), p. 19 (p. 21 for the following excerpt).

7. In the title of Chapter 1 of his autobiography, *Die Welt von Gestern*. Published in English as *The World of Yesterday* (Lincoln and London: University of Nebraska Press, 1964).

8. "L'Infinito" (*Canti*, XII):
"Sempre caro mi fu quest'ermo colle, / E questa stepe, che da tanta parte / Dell'ultimo orrizonte il guardo esclude. / Ma sedendo e mirando, interminati / Spazi di là da quella, e sovrumani / Silenzi, e profondissima quiete / Io nel pensier mi fingo; ove per poco / Il cor non si spaura."
Quoted in English from *A Leopardi Reader*, ed. and trans. Ottavio M. Casale (Urbana, Illinois: University of Illinois Press, 1981), p. 41.

9. Jules Verne, *Cinq semaines en ballon* (*Five Weeks in a Balloon: A Voyage of Exploration and Discovery in Central Africa*), 1863.

10. Jules Verne, *De la Terre à la Lune* (*From the Earth to the Moon*), 1865.

11. Jules Verne, *Vingt mille lieues sous les mers* (*Twenty Thousand Leagues under the Sea*), 1870.

12. Jules Verne, *Voyage au centre de la Terre* (*A Journey to the Centre of the Earth*), 1864. See Chapter 4.

13. Jules Verne, *Voyages et aventures du capitaine Hatteras* (*The Voyages and Adventures of Captain Hatteras*), 1866.

14. See Simon Schama, *Landscape and Memory* (New York: Knopf, 1995).

15. On Symbolism as an attempt to restore our lost connection to the sacred, see *Lost Paradise: Symbolist Europe*, exhib. cat. (Montreal: Montreal Museum of Fine Arts, 1994).

16. Louis Auguste Blanqui, "L'Éternité par les astres. Une hypothèse astronomique" (1872), reprinted in *Pleine marge. Cahiers de Littérature, d'Arts plastiques et de Critique*, no. 22 (December 1995), pp. 33ff.

17. I am grateful to Serge Plantureux for having drawn my attention to this astonishing visionary.

18. Nikolai Fedorov, *Works*, vol. 2, p. 253, vol. 1, pp. 216 and 283 (written about 1880).

19. See Emanuel Swedenborg, *The Earths in the Universe and Their Inhabitants, Also Their Spirits and Angels from What Has Been Heard and Seen* (London: Swedenborg Society, 1860), and *The Earths in Our Solar System, Which Are Called Planets* (London: Swedenborg Society, 1894).

20. Josef Hoené-Wroński, *Épître à sa Majesté l'Empereur de Russie* (Metz: Alcan, 1851).

21. Konstantin Tsiolkovsky, *Investigating Space with Reaction Devices* (Kaluga: self-published, 1914).

22. Percy Bysshe Shelley, "Epipsychidion", in *The Complete Poetical Works*, vol. 2 (London: John Slark, 1885), p. 362.

23. Ernst Bloch, *The Principle of Hope*, vol. 2, *Outlines of a Better World*, trans. Neville Plaice, Stephen Plaice and Paul Knight (Cambridge, Massachusetts: MIT Press, 1986), p. 774.

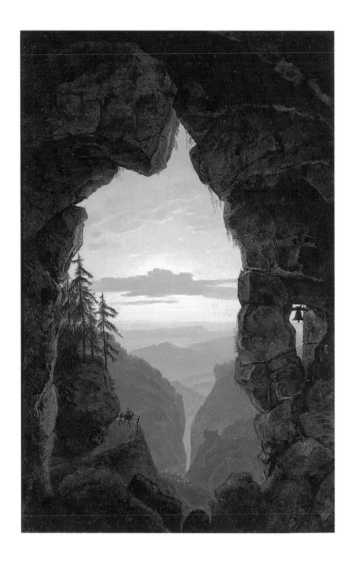

269• KARL FRIEDRICH SCHINKEL, **THE GATE OF ROCK**, 1818
BERLIN, NATIONALGALERIE

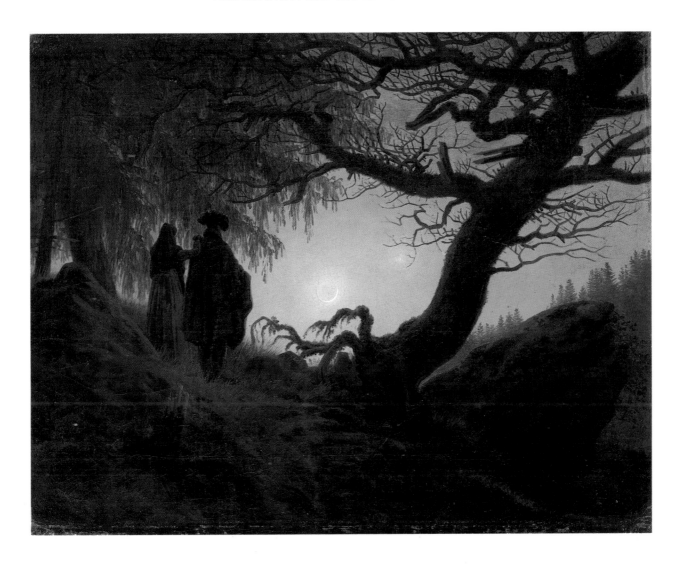

110· CASPAR DAVID FRIEDRICH, **MAN AND WOMAN CONTEMPLATING THE MOON**, ABOUT 1824
BERLIN, NATIONALGALERIE

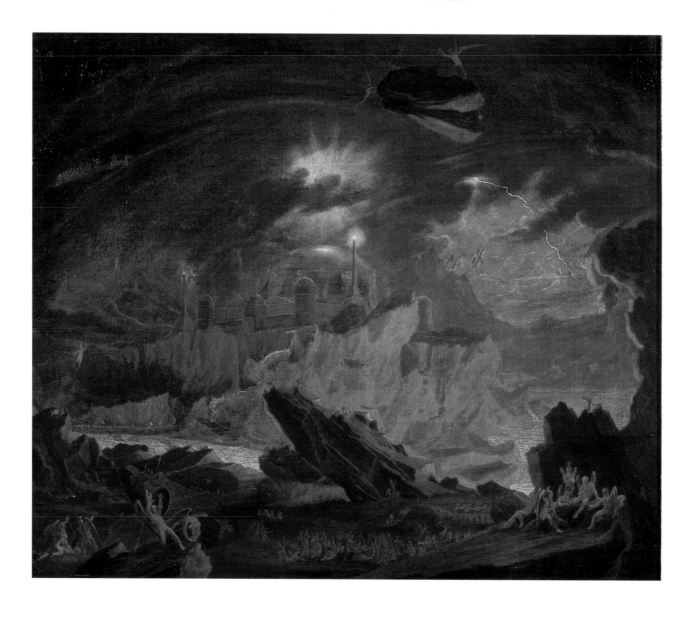

188· JOHN MARTIN, **FALLEN ANGELS ENTERING PANDEMONIUM**, 1829-1832
LONDON, TATE GALLERY

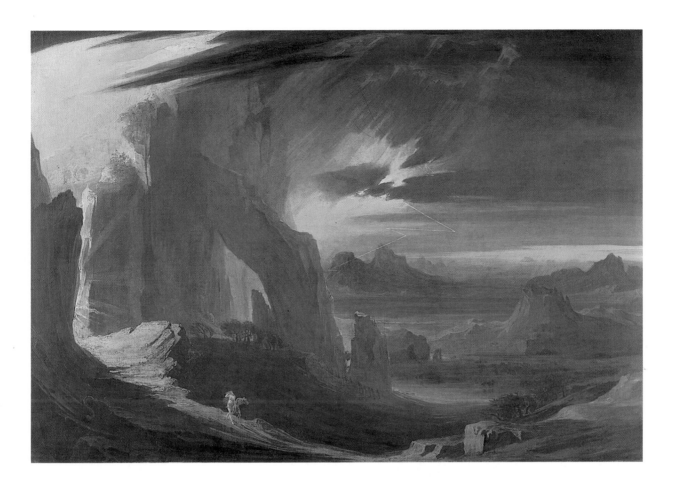

187· JOHN MARTIN, **THE EXPULSION OF ADAM AND EVE**, 1824-1827
NEWCASTLE UPON TYNE, LAING ART GALLERY

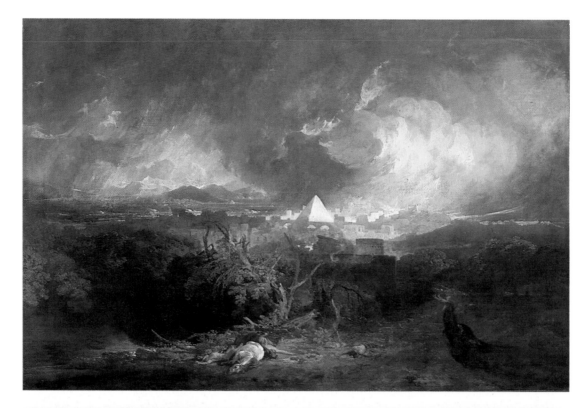

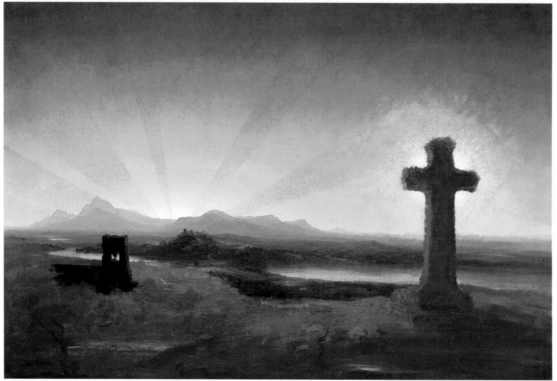

309• J.M.W. TURNER, **THE FIFTH PLAGUE OF EGYPT**, 1800
INDIANAPOLIS MUSEUM OF ART

74• THOMAS COLE, **CROSS AT SUNSET**, ABOUT 1848
MADRID, FUNDACIÓN COLECCIÓN THYSSEN-BORNEMISZA

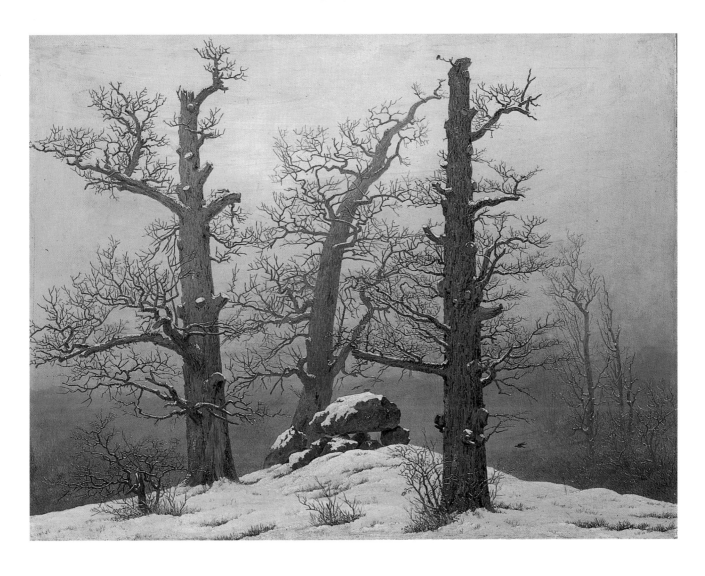

109· CASPAR DAVID FRIEDRICH, **CROMLECH IN THE SNOW**, 1807
DRESDEN, GEMÄLDEGALERIE NEUE MEISTER

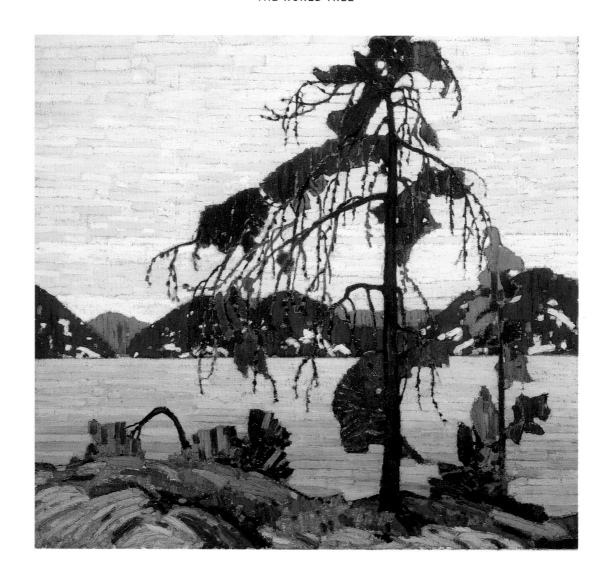

304• TOM THOMSON, **THE JACK PINE**, 1917
OTTAWA, NATIONAL GALLERY OF CANADA

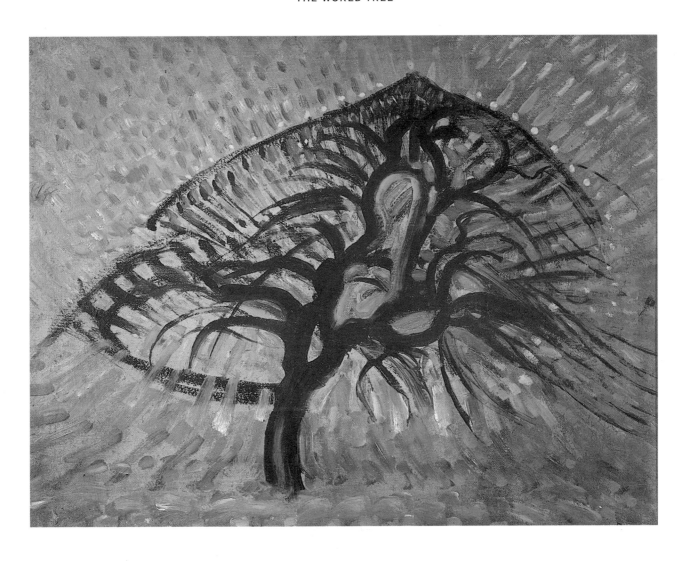

209• PIET MONDRIAN, **BLUE TREE**, ABOUT 1909-1910
DALLAS MUSEUM OF ART

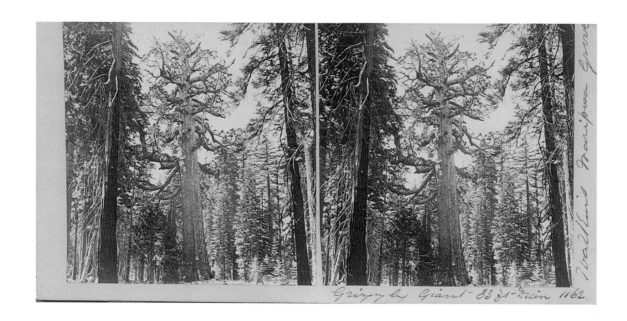

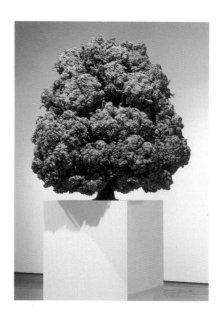

314• CARLETON WATKINS, **GRIZZLY GIANT, 33 FOOT DIAMETER, MARIPOSA GROVE**, 1860s
THE NEW YORK PUBLIC LIBRARY

136• MARTIN HONERT, **LINDEN**, 1990
THE MONTREAL MUSEUM OF FINE ARTS

 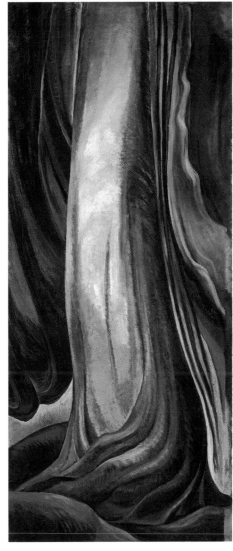

46• EMILY CARR
SCORNED AS TIMBER, BELOVED OF THE SKY, 1935
VANCOUVER ART GALLERY

45• EMILY CARR
TREE TRUNK, 1930
VANCOUVER ART GALLERY

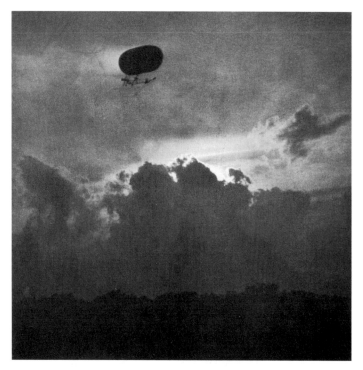

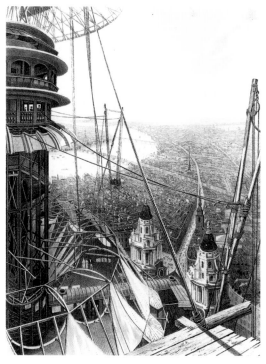

284• ALFRED STIEGLITZ, **A DIRIGIBLE**, 1910-1911
OTTAWA, NATIONAL GALLERY OF CANADA

327• ARTIST UNKNOWN, **A BIRD'S-EYE VIEW
FROM THE STAIRCASE AND UPPER PART
OF THE PAVILION IN THE COLOSSEUM,
REGENT'S PARK**, 1829
LONDON, GUILDHALL LIBRARY

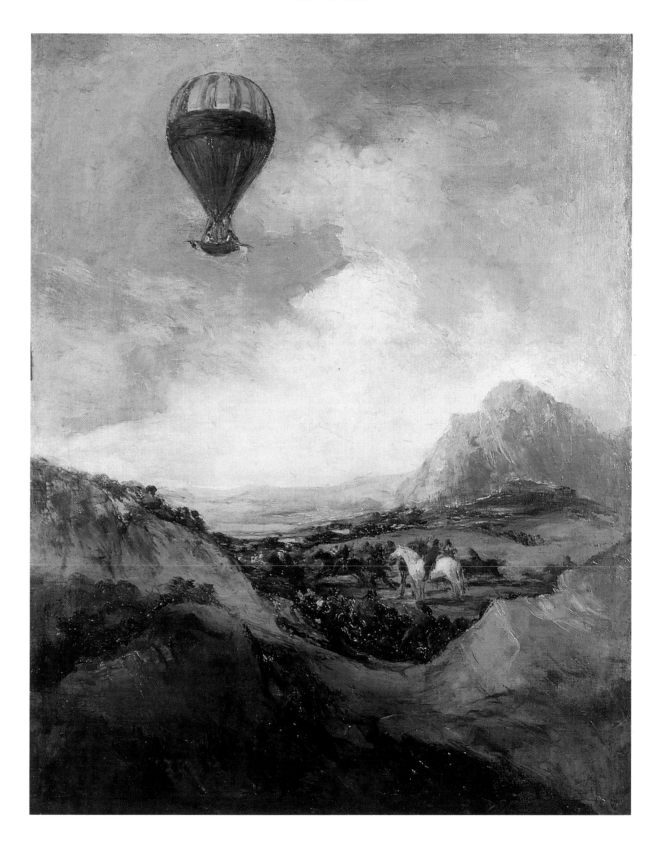

117• FRANCISCO DE GOYA, **THE BALLOON**, 1813-1816
MUSÉE DES BEAUX-ARTS D'AGEN

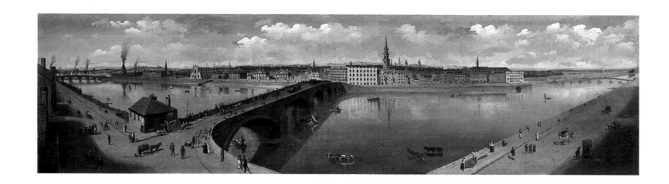

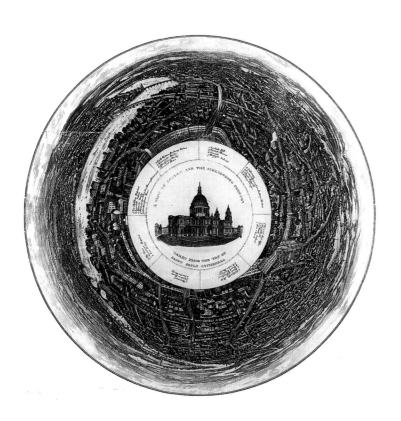

160· JOHN KNOX, **GLASGOW PANORAMA**, 1809
GLASGOW, THE PEOPLE'S PALACE MUSEUM

328· ARTIST UNKNOWN, **A VIEW OF LONDON AND THE SURROUNDING COUNTRY
TAKEN FROM THE TOP OF SAINT PAUL'S CATHEDRAL**, ABOUT 1845
LONDON, GUILDHALL LIBRARY

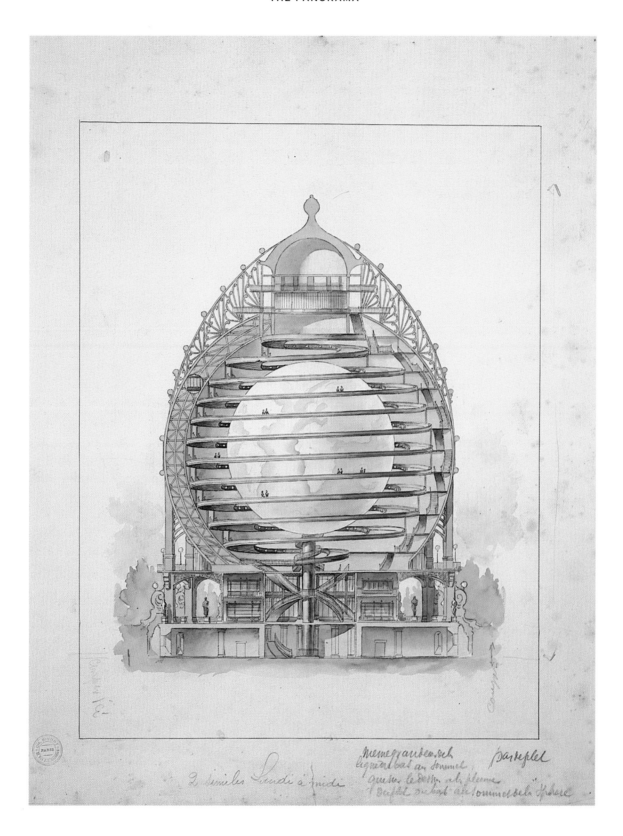

25· LOUIS BONNIER, ÉLISÉE RECLUS GLOBE FOR THE 1900 PARIS WORLD'S FAIR.
SECTIONAL VIEW SHOWING THE SYSTEM OF THE SPIRAL, ELEVATORS AND STAIRS, 1897-1898
PARIS, INSTITUT FRANÇAIS D'ARCHITECTURE/ARCHIVES NATIONALES

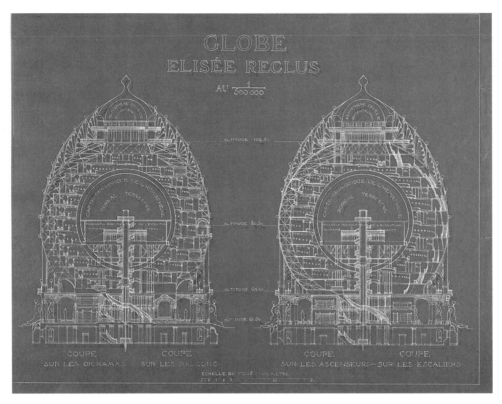

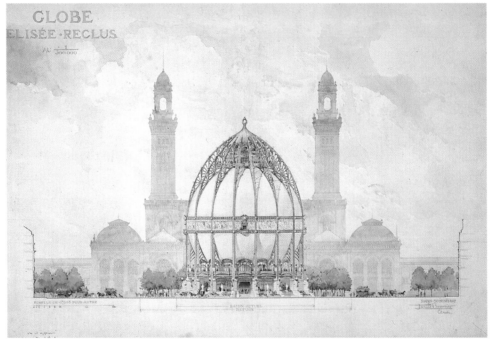

LOUIS BONNIER

24· ÉLISÉE RECLUS GLOBE FOR THE 1900 PARIS WORLD'S FAIR.
EAST-WEST SECTION AND NORTH-SOUTH SECTION, 1897-1898

22· ÉLISÉE RECLUS GLOBE FOR THE 1900 PARIS WORLD'S FAIR.
ELEVATION AND SILHOUETTE OF THE OLD TROCADÉRO, 1897-1898

PARIS, INSTITUT FRANÇAIS D'ARCHITECTURE/ARCHIVES NATIONALES

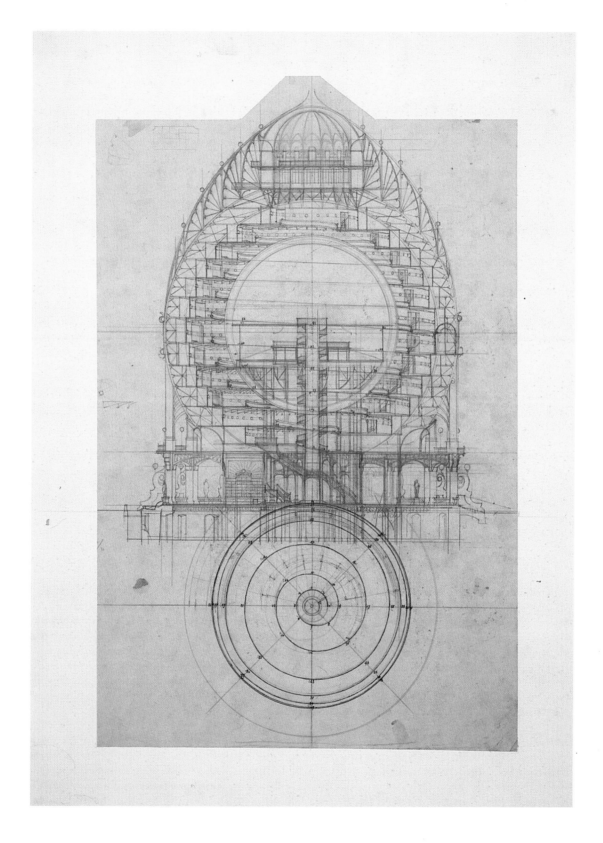

23· LOUIS BONNIER, ÉLISÉE RECLUS GLOBE FOR THE 1900 PARIS WORLD'S FAIR.
SECTION STUDY AND PLAN OF THE SPIRAL, 1897-1898
PARIS, INSTITUT FRANÇAIS D'ARCHITECTURE/ARCHIVES NATIONALES

Of all the concepts that can be manipulated in the mind, the Idea of the Universe is, like that of our own mortality, one of the most baffling. This Idea (capitalized here in keeping with Kant) involves something both infinitely beyond, yet still enclosing, the local diversity of all the beings it contains. The Universe, the subject of Cosmology, is thus one of the most astonishing subjects any discipline can tackle. It is the Unique, since it is all-encompassing, the supreme container that determines all of time and space, the space-time continuum. My purpose here is to review, with a narrower and more modest focus,

The Scales of the Universe

From the Finite to the Infinite

by Stéphane Deligeorges

the decisive episodes and the stages completed in mankind's attempt to measure the All. These important moments are few, although the history preceding and producing them is tortuous, varied, difficult and often confused. To achieve our goal, we must retrace the path that brought mankind to grasp some idea of the *measurements* and *proportions* of our Cosmos. First, however, the guidelines must be drawn.

Traditionally, Cosmology is concerned with all the disciplines that study, each by its own methods, the whole Universe as a Totality. In its scope and complexity, this is one of the most overwhelming tasks human reason can set itself, presenting as it does something immeasurable in the face of the extreme fragility of the human condition. And yet, "Far from yielding to a kind of intellectual hubris, the question of the cosmos is undoubtedly the field of research that has done more to free human consciousness by dragging it out of its intellectual myopia. The history of cosmology shows that the more man becomes aware of his pathetic smallness in regard to the immensity of the universe, the more he gains in dignity, attempting, in so far as he can, to rid himself of deep-rooted anthropomorphic and anthropocentric illusions. Knowledge of the Universe is not without its effect on self-awareness."[1]

It is a universal characteristic of human cultures to have felt and expressed, orally or in writing, their wonder at and conceptions of the cosmos. Every group of human beings, whatever its size and geographical and environmental setting, seems to have had in its own way an idea of the All. Each of these groups has constructed, if not a complete theory of cosmology, at least a summary cosmogony, a story of how the World came to be.

In Western culture, when philosophy emerged with the Greeks, the notion of a primeval chaos was not long in developing – a chaos from which the Cosmos

would be born, that is, a universe structured by an actual, perceptible order. Pythagoras is said to have been the first to give it the name Cosmos, a word that means container of all realities and refers to the world's essential order. The first thinker to construct a cosmology free of myth, though many residual traces remained, was Plato. In the *Timaeus*, although the dialogue seems to be about the origin of the universe (What is the world's history? How did it come about?), as a whole it gives a fixed, precise and coherent picture of the physical world, an image of the eternal living entity, designed by a creator, a unique, mobile, spherical, circular, eternal universe.

Later, Aristotle in turn constructed an image, a cosmological model that was to be of incomparable historical significance. His Cosmos, as developed in the *Metaphysics*, the *Physics* and *On the Heavens*, would hold for two millennia. In Aristotle's universe, the motionless globe of the earth, of small dimensions, is suspended at the geometrical centre of another much vaster rotating sphere, called the sphere of fixed stars, which carries all the stars. The circular motion of the sphere of fixed stars symbolizes divine perfection through its spherical shape, which makes it the most all-encompassing container.[2]

Within this system, the order of the cosmos has the perfection of a circular trajectory, which comes from the farthest limit of the universe, the sphere of the *primum mobile*, or prime mover. Time is also thought of as circular, endlessly unfolding and repeating itself. The question of the world's infinity is of great import here. As Jean-Pierre Verdet notes,[3] in answer to those who countered the notion of a finite universe with the enigma of Archytas's arrow (which flies to the end of the world, hitting and piercing the last barrier), Aristotle, basing his argument on the earth's immobility, retorted that the "body of the world", subject to circular revolution, is necessarily limited in its total extent. Otherwise, the fixed stars would have to travel an infinite distance in the finite twenty-four hours of the daily rotation. And to those who persisted, demanding to know the arrow's fate, the sage of Stagira replied that the question was meaningless, since "beyond the last sphere, there was neither void nor place". Finally, for him, it was "evident that there is only one heaven".[4]

Opposed to this concept of a closed, finite, unique and geocentric universe were the partisans of an open, infinite universe, an All composed of multiple worlds, who were to push cosmology towards promising ideas, encouraging speculation on the new dimensions of the Universe. The proponents of an infinity of worlds were to open up vistas of new distances.

Epicurus was the first post-Aristotelian thinker to define the world as infinite. He was followed by Lucretius:

Does it have finite limits or does it reach
Unmeasurable in deep wide boundlessness?

The universe is limitless, unbounded
In any of its areas; otherwise
It would have to have an end somewhere, but no –
Nothing, it seems, can possibly have an end
Without there being something out beyond it,
Beyond perception's range. We must admit
There can be nothing beyond the sum of things,
Therefore that sum is infinite, limitless.
It makes no difference where you stand, your center
Permits of no circumference around it.[5]

The new idea of an infinite universe is expressed in two books by Giordano Bruno published in 1584, *The Ash Wednesday Supper* and *On the Infinite Universe and Worlds*. Bruno, good Copernican that he was, rejects all notion of a hierarchy in the universe. In his vision, the earth is no longer the "trash of all bodily substances",[6] but a star like any other. Not only does he assert that the universe is infinite, but he sees it as homogeneous, having the same structure throughout. Within this system, the group formed by a sun and its planets constitutes the basic unit. The universe consists of an infinite repetition of such solar systems. Bruno's term is *synodi ex mundis*, "assemblies of worlds". This stage of development hypothesizes a universe of mind-boggling dimensions.

It is to the eighteenth-century scholar Emmanuel Kant that we owe one of the most fertile, and strangest, hypotheses about the universe, a concept that much later was to be remarkably well confirmed by observation. In working out his hypotheses on the nature of the universe, Kant held to a rational cosmology, detached from all theological considerations. He relied strictly on ideas, theoretical concepts, and within this framework extended to infinity all the mechanical considerations recognized as valid for the earth-moon-sun system. Kant moved from the local to the global scale. It was a pioneering stroke.

He then came out with the hypothesis that, at the dawn of time, there took place a universe-wide scattering of the primordial substance of all the bodies in the cosmos. This was the simplest natural state that could follow nothingness. Kant's extrapolation was audacious in that it summoned up the integrality and the immensity of the heavens. In his *Universal Natural History and Theory of the Heavens* (1755), he wrote, "I accept the matter of the whole world at the beginning as in a state of general dispersion, and make of it a complete chaos. I see matter forming itself in accordance with the established laws of attraction, and modifying its movement by repulsion. I enjoy the pleasure, without having recourse to arbitrary hypotheses, of seeing a well-ordered whole produced under the regulation of the established laws of motion, and this whole looks so much like the system of the world which we have before our eyes, that I cannot refuse to identify it with it."[7]

Kant was the first to describe, purely speculatively, the Milky Way's precise nature as stellar, that is, composed of infinitely many stars. In particular, he developed, in theoretical terms, an idea that posterity would call "island universes", which are comparable to galaxies. This idea was not fully confirmed until almost two centuries later, in 1929. According to Kant, some of the nebulas seen faintly in telescopes are in fact Milky Ways, or galaxies, like the one containing our solar system. These galaxies are something like enormous solar systems. Thus, the universe would be made up of galaxies linked together by the force of attraction, as are the stars in each galaxy and the planets with their satellites in relation to their sun.

The second surveyor of worlds in classical science, motivated mainly, however, by observation and empirical enquiry, was William Herschel. At the age of nineteen, this great astronomer was an oboe player in the band of the Hanoverian Guards. In the 1750s, the fortunes of war took him to England, where he became interested in astronomy and made considerable advances in the technique of telescope building. Herschel embarked on the first of his great systematic astronomical "enquiries" in 1778.

Three years later, on March 13, 1781, he discovered Uranus, which he named Georgium Sidus, and earned immediate fame. For forty-five years, Herschel was to explore the far reaches of the heavens with a telescope 18.7 inches (47.5 cm) in diameter and having a focal length of twenty feet (6.1 m). His results were impressive. In 1786, he published his first catalogue of nebulas and star clusters, logging a thousand new phenomena; he repeated this achievement in his catalogue of 1789. In 1802, he recorded five hundred more new objects. When on June 11, 1818, Herschel presented his last cosmological report, he was eighty years old. "He found in the sky more things than mankind had discovered in several millennia," as Jacques Merleau-Ponty sums up his achievement, adding, "His eyes were his guide and witness."[8] In his observations, Herschel went back to Kant's notion of island universes, which until then had only been a hypothesis. Nebulas, the term used at the time for all the diffuse objects telescopes could then glimpse, were in fact very distant Milky Ways, galaxies like ours. He thus took astronomical research beyond the realm of this galaxy. Herschel was, according to Merleau-Ponty, the first to make cosmology a positive science, open to the entire universe. His masterstroke, made possible by the power of his telescopes, was the sorting out of the Milky Way, our galaxy, into stars. Where previously only diffuse phenomena could be seen, Herschel demonstrated that these were indeed individual stars, actual suns exactly like our own. This was, then, truly an island universe. It was, he thought, disk-shaped, with the sun at its centre.

Through Herschel, without going into statistics, the universe grew considerably in size.

The last of our celestial surveyors is the American Edwin Hubble, whose observational equipment was outstanding for its time. It was now the first half of the twentieth century, and Hubble's work would solve a century of questions and controversies. His instrument was the Hooker telescope on Mount Wilson, with its 100-inch (2.54 m) mirror.

We have seen that one of the unresolved questions of cosmology is that of the scale of distances. Are the phenomena that instruments captured island universes, comparable in size to the Milky Way, or are they only satellites of our galaxy? In 1771, the astronomer Charles Messier had observed faintly luminous objects, like the Andromeda Nebula, which he inscribed in his numbered list as M31. In 1924, Hubble discovered in this nebula Cepheid-type variable stars that emit series of pulses of light. The variations in brilliance of these stars correspond to their luminosity, and this correspondence gives us their distance from earth. Hubble thus calculated that this nebula was two million light-years away from us, an enormous distance when the farthest known star at the time was a hundred thousand light-years away. So Andromeda was, as Kant had predicted, not part of our universe, but constituted a universe distinct from ours. Finally, Hubble demonstrated, in the law that bears his name, how all galaxies are continually moving away from each other with a motion thought to be the expansion of the Universe.

This brief summary shows that we are living through a reappraisal of the Universe that in terms of scale transcends by far anything mankind has been able to conceive of in more than two millennia. Looking at these orders of magnitude brings home to us how relatively tiny we are. We know from reliable scientific calculations that the Universe is between fifteen and twenty billion years old. It sprang from a primal explosion that left behind a cosmological relic, a 3-degree Kelvin radiation, an echo of this combustion.

Yearly, new observations are recorded, continually pushing back the boundary of the observable Universe. The most distant candidate is a galaxy with a red-shift of 4.92, a figure representing almost twenty billion light-years. Beyond it is total darkness.

There remains the basic enigma, both infuriating and welcome to those who are not among the "moonstruck by distant worlds", in Nietzsche's phrase. Is the Universe finite? If so, it will recondense upon itself to a single point under the effect of its own mass. Is it in infinite expansion, endlessly extending the dimensions of time-space? Or is it, in the end, according to a strange mathematical figure, an indeterminate Universe that does not resolve either question?

• Notes

1. Jean Seidengart, "Cosmo-logique", in *Encyclopédie Philosophique Universelle*, vol. 1 (Paris: PUF, 1989), p. 353.

2. This was, of course, a smaller universe than the one we know today. Our solar system is gigantic. The most distant objects in it are a billion kilometres from the centre of the sun. It thus takes light three hours (at a speed of 300,000 kilometres per second) to cross the entire system. The diameter of our galaxy is something like a billion billion kilometres, or 100,000 light-years. If the diameter of the solar system were represented as one millimetre, that of the galaxy would be a thousand kilometres.

3. Jean-Pierre Verdet, *Penser l'univers* (Paris: Gallimard, 1998), p. 9.

4. *Aristotle's Metaphysics*, trans. Hippocrates G. Apostle (Bloomington and London: Indiana University Press, 1966), Book Lambda (12), Chapter 8, 1074a (p. 208, line 33).

5. *The Way Things Are: The "De Rerum Natura" of Titus Lucretius Carus*, trans. Rolfe Humphries (Bloomington and London: Indiana University Press, 1968), p. 47, lines 955-969.

6. Giordano Bruno, *La cena de le ceneri*, quoted in English from *The Ash Wednesday Supper*, trans. Stanley L. Jaki (The Hague and Paris: Mouton, 1975), p. 61.

7. Immanuel Kant, *Allgemeine Naturgeschichte und Theorie des Himmels,* quoted in English from *Universal Natural History and Theory of the Heavens*, trans. W. Hastie (Ann Arbor: University of Michigan Press, 1969), p. 23.

8. Jacques Merleau-Ponty, *La science de l'univers à l'âge du positivisme* (Paris: Vrin, 1983), p. 98.

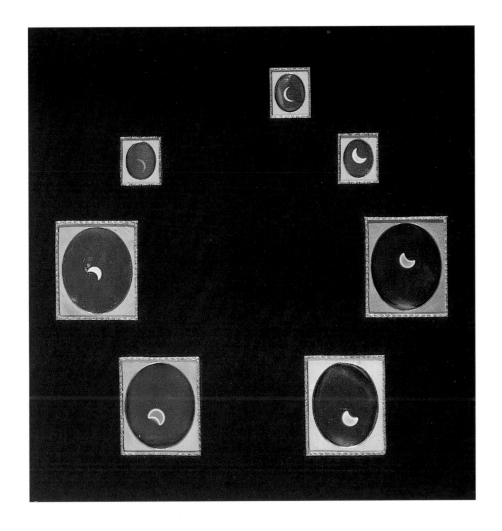

167· WILLIAM AND FREDERICK LANGENHEIM, **ECLIPSE OF THE SUN**, 1854 (MAY 26)
GILMAN PAPER COMPANY COLLECTION

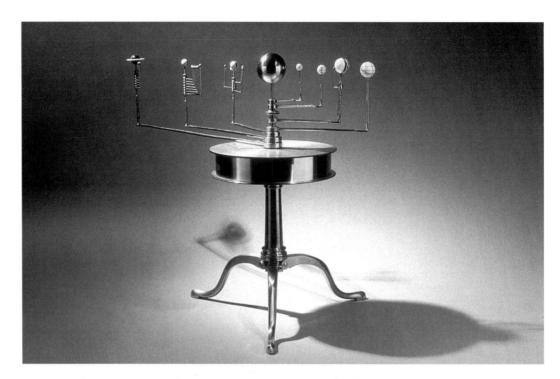

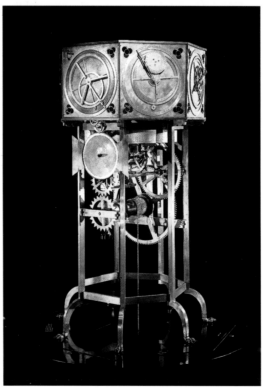

338• ROBERT BRETTELL BATE, **ORRERY**, FIRST HALF OF 19TH C.
MONTREAL, STEWART MUSEUM AT THE FORT, ÎLE SAINTE-HÉLÈNE

339• GIOVANNI DONDI, **ASTRARIUM (ASTRONOMICAL CLOCK)**, ABOUT 1364
(RECONSTRUCTION 1962, THWAITES AND REED, LTD., LONDON)
WASHINGTON, NATIONAL MUSEUM OF AMERICAN HISTORY

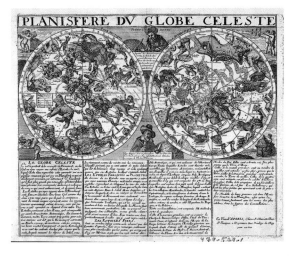
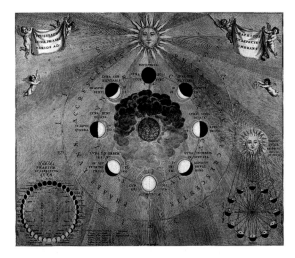
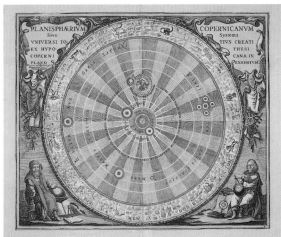
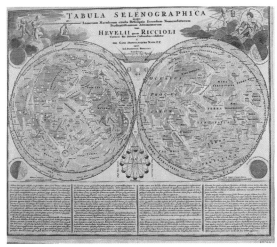

264• NICOLAS SANSON
PLANISPHERE OF THE HEAVENS, 1658

49• ANDREAS CELLARIUS
TYPUS SELENOGRAPHICUS, 1660

265• PIETER SCHENK AND GERARD VALK
PLANISPHAERIUM COPERNICANUM, 1706

93• JOHANN GABRIEL DOPPELMAYR
TABULA SELENOGRAPHICA, ABOUT 1742

MONTREAL, STEWART MUSEUM AT THE FORT, ÎLE SAINTE-HÉLÈNE

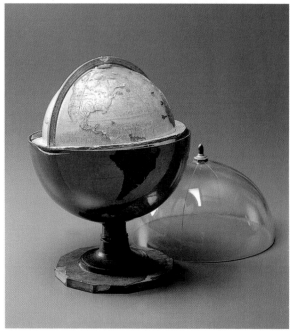

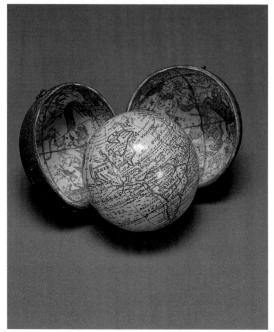

302• KARL FRIEDRICH THIELE, AFTER KARL FRIEDRICH SCHINKEL
SET DESIGN FOR "THE MAGIC FLUTE": THE ENTRANCE OF THE QUEEN OF THE NIGHT, 1819
NEW YORK, THE METROPOLITAN MUSEUM OF ART

337• URSIN BARBAY, **TERRESTRIAL GLOBE**, YEAR VII,
FRENCH REVOLUTIONARY CALENDAR (1799)
MONTREAL, STEWART MUSEUM
AT THE FORT, ÎLE SAINTE-HÉLÈNE

341• NATHANIEL HILL
TRAVELLER'S POCKET-SIZE GLOBE AND CASE, 1754
MONTREAL, STEWART MUSEUM
AT THE FORT, ÎLE SAINTE-HÉLÈNE

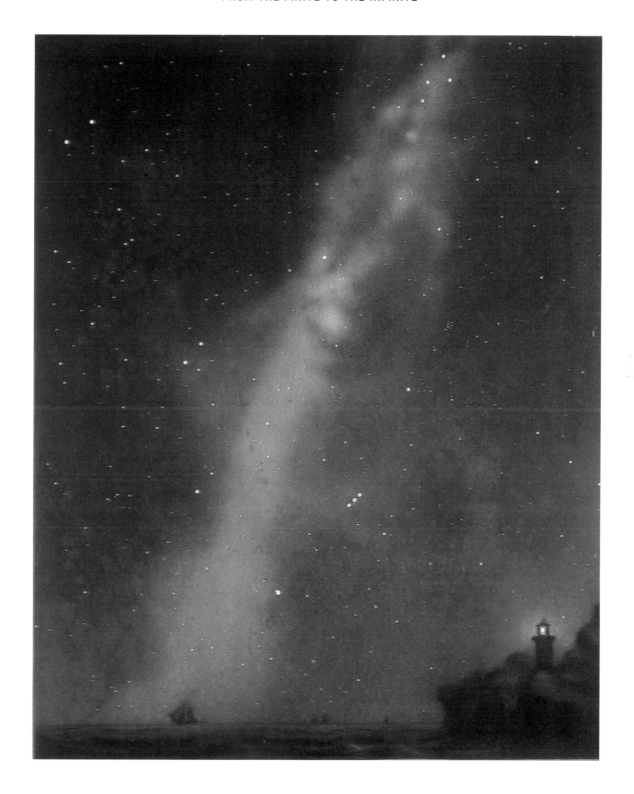

308· ÉTIENNE LÉOPOLD TROUVELOT,
PART OF THE MILKY WAY VISIBLE IN WINTER, OBSERVED IN 1874-1875
OBSERVATOIRE DE PARIS

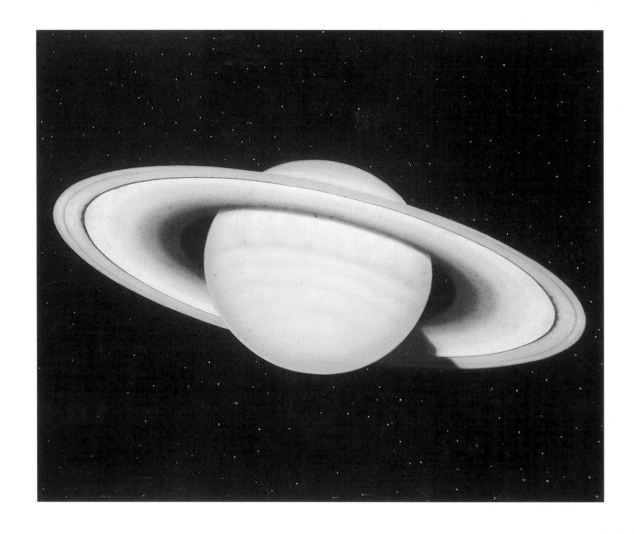

305· ÉTIENNE LÉOPOLD TROUVELOT, **THE PLANET SATURN**, 1874 (DECEMBER)
OBSERVATOIRE DE PARIS

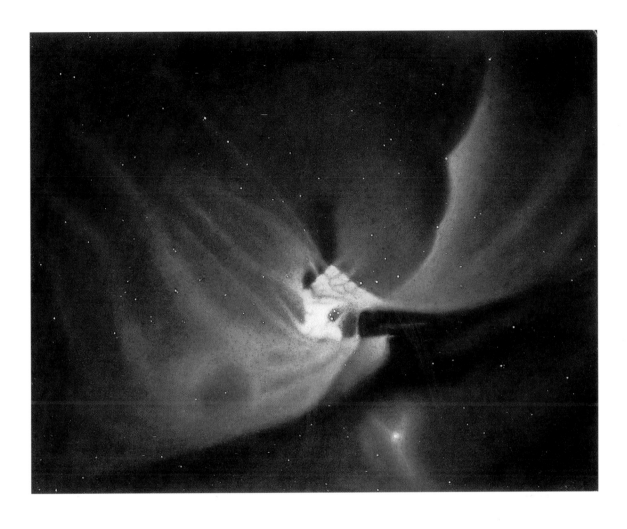

307· ÉTIENNE LÉOPOLD TROUVELOT, **GREAT ORION NEBULA**, ABOUT 1874-1875
OBSERVATOIRE DE PARIS

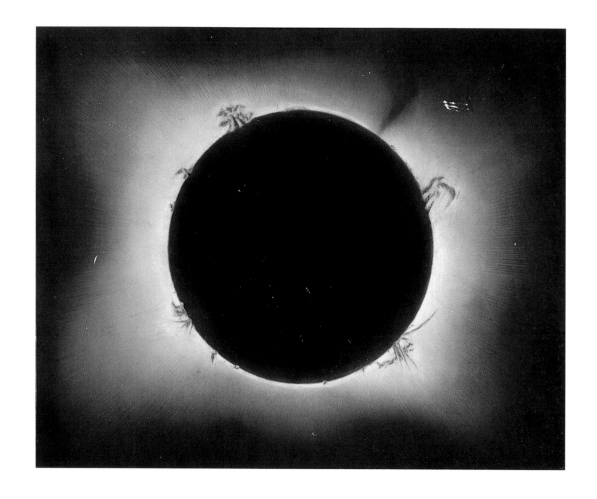

306· ÉTIENNE LÉOPOLD TROUVELOT, **TOTAL ECLIPSE OF THE SUN**, ABOUT 1874-1875
OBSERVATOIRE DE PARIS

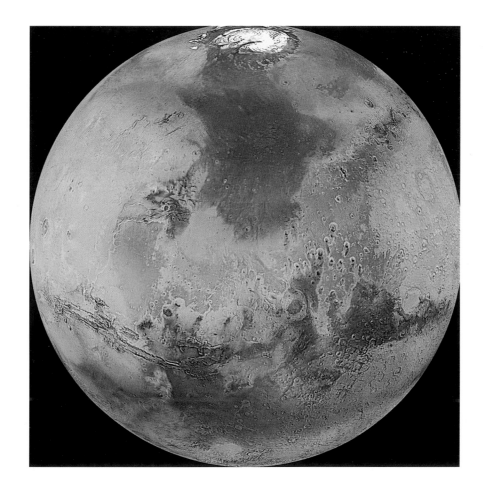

226· NASA, JET PROPULSION LABORATORY, VIKING ORBITER, **THE RED PLANET MARS**, 1976-1980
TUCSON, CENTER FOR CREATIVE PHOTOGRAPHY, UNIVERSITY OF ARIZONA

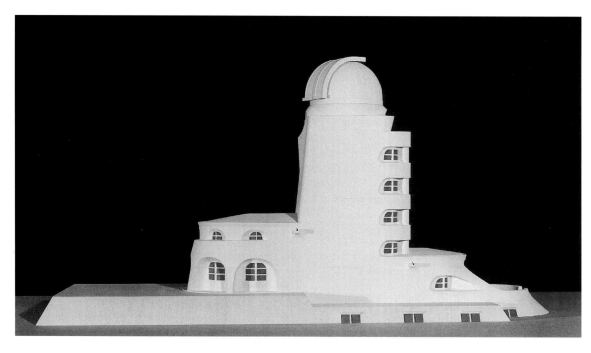

195• ERICH MENDELSOHN, **MODEL OF THE "EINSTEIN TOWER"**, 1919-1921
(RECONSTRUCTION BY ÉTIENNE FOLLEFANT, 1978)
PARIS, MUSÉE NATIONAL D'ART MODERNE/CENTRE DE CRÉATION INDUSTRIELLE, CENTRE GEORGES POMPIDOU

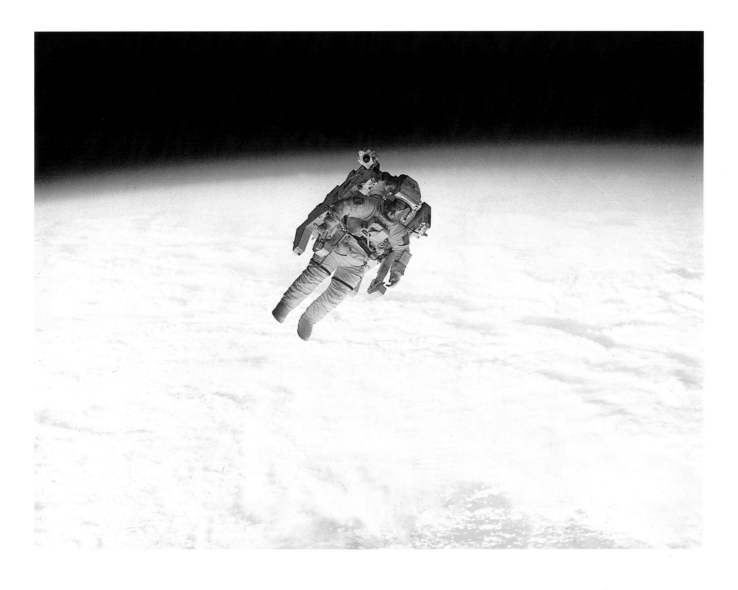

227• NASA, SPACE SHUTTLE MISSION STS 41-B,
VIEW OF EXTRAVEHICULAR ACTIVITY DURING STS 41-B, 1984
COURTESY OF NASA

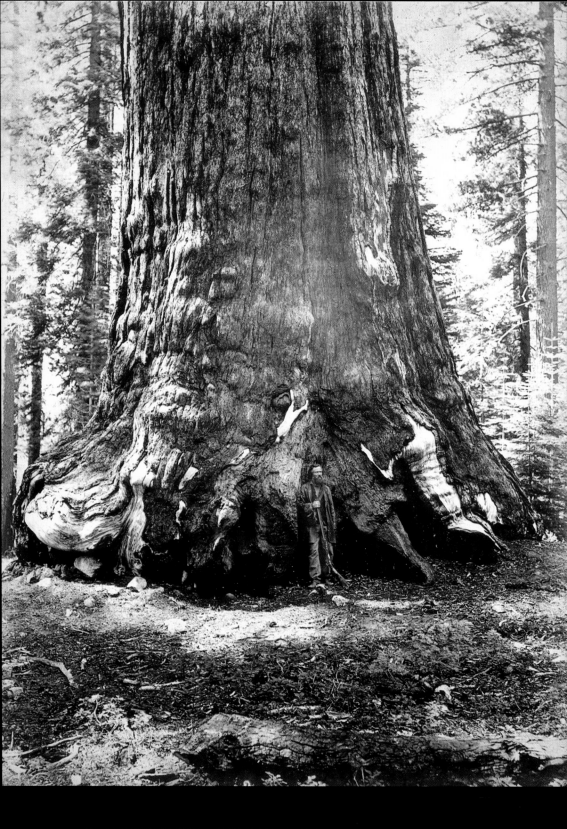

- 2 -
THE PROMISED LAND

Among the works by Max Ernst hanging in the Beyeler Foundation in Basel is a small oil painting entitled *Humboldt Current* (1951-1952; fig. 1).[1] Against sombre colours, it shows a luminous disk above an undulating band. According to the cosmological model developed by Ernst in the series of rubbings he called "Histoire naturelle", this composition may be interpreted as representing one of his favourite subjects: the sun and the sea.

What interests us in this instance is the sea, which Ernst, then living in Arizona, identifies as the Humboldt Current, the cold Pacific current that flows

Heart of the Andes

Humboldt's *Cosmos*

and Frederic Edwin Church

by Günter Metken

off the coast of Peru. It is one of many topographical features in the New World named after explorer-naturalist Alexander von Humboldt. When Humboldt

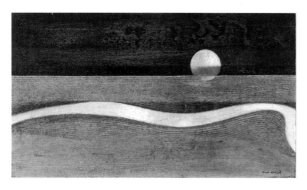

FIG. 1 - MAX ERNST
HUMBOLDT CURRENT, 1951-1952

set out on his famous expedition precisely two hundred years ago – in 1799 – to the largely remote lands then under Spanish rule (and therefore called Latin America), he left from Madrid.

Which brings us to a "second movement" of this "sea prelude". Humboldt's name also figures in the title of a work shown in February 1998 in the Project Rooms of the international contemporary art fair ARCO 98 in Madrid.[2] *Humboldt's Crocodile Is Not Hegel's Crocodile*, by Colombian artist José Alejandro Restrepo, makes a critical statement about the collective term "Latin American art", under which Europeans and North Americans, with their hegemonic point of view, typically lump the entire aesthetic production of a quarter of the globe while ignoring the individual expression of its individual countries.

Restrepo's ironically named work consisted of two video monitors set up some distance apart. The larger of them showed the lazily winking eye of the reptile in question; the other, its swaying tail. Painted on the white wall between the two screens was a 25-foot-long ruler, above which hung two frames containing the following texts:

America has shown itself, and even today shows itself, to be physically and spiritually impotent. Its lions, tigers and crocodiles, although they look like their counterparts in the Old World, are in every regard smaller, weaker and less powerful.

Hegel, *Lessons on the Philosophy of History*

I would renounce voluntarily the European belief that Hegel in his ignorance believes so superior to American belief, and I would like to live near his delicate and weak crocodiles, which unfortunately are 25 feet long.

Humboldt, *American Letters*

Both quotations are quite fictitious: the philosopher made no such claim; the explorer, no such response. They do, however, represent two opposing positions: one, a quasicolonial attitude that subjugates anything alien to its own Eurocentric standards; the other, a more open-minded encounter with South American culture in quest of knowledge. Humboldt, whose five-year scientific expedition marked for his friend Simón Bolívar the true discovery of America, represents the latter.

Alexander von Humboldt (1769-1859)[3] was certainly the most important scientific explorer of the modern age before Darwin. His immediate model was Georg Forster, who had gone as a boy on James Cook's second trip around the world. Forster's account of the journey, *A Voyage round the World*, already contains the mixture of observations of scenery and economic and socio-cultural details found in Humboldt's writings, which are, however, more strongly scientifically oriented and broaden to include the entire world.

Humboldt was born in Berlin, the son of a Prussian chamberlain. He studied natural sciences in the spirit of the Enlightenment and specialized in mining. Within four years, he advanced to the position of deputy minister in the Prussian Ministry of Mining. At the end of 1796, he left the administration to devote himself to his life's dream: the exploration of Central and South America. He was able to finance his travels himself, due to an inheritance from his mother. This assured him an independence no explorer before him had ever known. Nor had anyone else been so well prepared scientifically as Humboldt. He acted as a private citizen, not in the service of a government with its economic and colonial ulterior motives. And in contrast to the previous sea voyages, his was a purely land-based expedition.

After abandoning a civil service career, Humboldt began a careful study of the natural history and archeology of America. He also maintained contact with Goethe, whose concept of a unified morphology he shared. He tested the geodetic, magnetic and astronomical devices, the barometers, thermometers and hygrometers he would need for taking measurements and mapping. The latest models of these instruments were acquired partly in London but mostly in Paris. Humboldt, the liberal-minded, democratic, freedom-loving German who believed in the ideal of progress, had moved there in 1798 to join the scientists at the newly founded Muséum d'histoire naturelle. He worked in the Jardin des plantes and the Observatory. He made a name for himself through lectures at the Institut. He met the leading scientists and mathematicians Cuvier, Jussieu, Lamarck and Monge as well as the world traveller Bougainville, whom he greatly admired. He also found an ideal travelling companion in Aimé Bonpland, an army surgeon by profession and a botanist by vocation (fig. 2).

The Spanish government in Madrid granted the travellers broad privileges for the colonies, guaranteeing them the necessary freedom, support and access to archives, libraries and institutions. Humboldt met the top-ranking officials in the colonial administrations as well as dominant figures among the *independentistas*, through whom he gained an impression of the historical and cultural development of the countries he visited. Thus, a *corpus scientificum americanum* was created that formed the basis for the further exploration of the continent and the geography of these young countries.

FIG. 2 - EDUARD ENDER
**ALEXANDER VON HUMBOLDT
AND AIMÉ BONPLAND IN A JUNGLE HUT**
MID-19TH C.

The great journey lasted five years. It began in the Canary Islands and ended with a visit to the United States, where President Jefferson met the now-famous explorer. The trip may be broken into three parts: the stay in Venezuela and exploration of the valleys of the Orinoco and Amazon Rivers, 1799-1800; the journey through the Andes via Colombia and Ecuador to Peru, 1800-1802; and a one-year stay in Mexico and the return to Europe by way of Cuba and the United States, 1803-1804.

Humboldt spent the next twenty years, mostly in Paris, publishing his monumental travel log. He reacquainted himself with his colleagues and befriended François Arago and especially the physicist Gay-Lussac. He attended Cuvier's famous evenings, and also the salon of Mme Récamier, where Chateaubriand and the painter Gérard became confidants. Humboldt and Bonpland donated the fifty-eight hundred plants they had collected to the Muséum, including thirty-six hundred unknown species.

Voyage aux régions equinoxiales du Nouveau Continent was published in French from 1807 to 1834. It was illustrated and edited by a team of talented painters, engravers and cartographers. Of the thirty-odd quarto and folio volumes, sixteen are devoted to botany, two deal with anatomical and zoological subjects, six are devoted to geography, three to measurements and data, and three contain the *Relation historique*, the actual travel log, which ends with the arrival in Colombia.

Humboldt was concerned with the description of the physical world as a whole, including the creation and formation of the earth's crust as well as vegetation and respective life forms. Mountains are particularly well suited for this purpose.[4] One can gage the morphology of the earth from them. As in old Books of Nature, the layers are laid open; and in the case of volcanos, often still active, one can see the "common elements of the volcanic form". Identical rock formations are formed under identical conditions. What may be inexplicable on one continent can be explained through analogous occurrences on another. Thus, the necessity of global description: "One formation appears to create the same result in both the Andes and in the Alps. Concentrations of the same name turn themselves into similar formations."

The development of vegetation in the mountains can also be studied according to climate and elevation. The determination of these zones and communities of plants was one of Humboldt's main achievements. He systematized his observations by means of samples, measurements and statistics, and recorded the precise data in cross sections of the mountains. The results of these records for the entire continent are shown in the famous *Tableau physique des Andes et pays voisins* (fig. 3), which Humboldt laid out in 1803 in Guayaquil after crossing the Andes and finished later in Paris. Louis Bouquet's coloured copperplate engraving is a landscape of the globe, which combines the general with the specific. The totality of South America's mountain range as Humboldt explored it during

his travels is shown in an idealized profile of the 6,310-metre-high Mount Chimborazo, pictorially to the left, with labels in a cross section to the right. All the plants encountered between 10 degrees north and 10 degrees south of the equator are listed at their proper elevation, which makes the state of research at the time spatially appreciable. Landscape painting and text, aesthetics and analysis complement each other in a conception that is at once science and art.

This combination is not a coincidence. Humboldt insisted upon the "aesthetic treatment of objects of natural history", the difficulty of which he did not deny in the preface to *Views of Nature* (*Ansichten der Natur*) in 1807: "The riches of nature lead to a piling

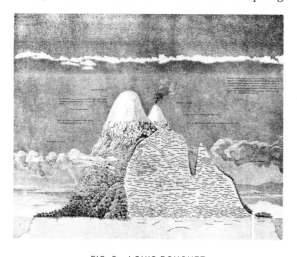

FIG. 3 - LOUIS BOUQUET
AFTER A SKETCH BY HUMBOLDT
TABLEAU PHYSIQUE DES ANDES ET PAYS VOISINS
1803

up of individual images and this piling up disturbs the calm and complete impression of the painting". More than forty years later, in 1849, he reiterated the correctness of his concept in another preface.

What is most notable about such passages is the recurring use of the expression "painting", that is, the iconographic approach to the research. This is related to the earlier meaning of "tableau" – painting as general perspective. But in light of the wealth of facts and the necessarily incomplete nature of Humboldt's undertaking, it has also to do with the concentration of the painted image as an artfully constructed composition. Humboldt's *Relation historique* is made up of a loose series of such tableaux. The first volume of the travel log, *Ideas for a Geography of Plants* (*Ideen zu einer Geographie der Pflanzen*), carries the subtitle "with a landscape painting of the tropics". According to Humboldt, it is the task of the landscape painter to organize the abundance of individual objects so that the characteristics of a region of the earth emerge: "Are we not justified in hoping

that landscape painting will flourish with a new and hitherto unknown brilliancy when artists of merit shall more frequently pass the narrow limits of the Mediterranean, and when they shall be enabled, far in the interior of continents, in the humid mountain valleys of the tropical world, to seize, with the genuine freshness of a pure and youthful spirit, on the true image of the varied forms of nature?" (*Cosmos*, vol. 2, p. 452.)[5]

The artist who proved himself equal to the task, as was noted by contemporaries in regard to Humboldt, was the American Frederic Edwin Church (1826-1900).[6] In the middle of the nineteenth century, Church was America's leading landscape painter. His paintings were considered spectacular, technical tours de force and attracted thousands of usually paying visitors. They were consciously conceived as masterpieces[7] through painstaking attention to detail and displayed by the artist in various places for money. The work in the studio was preceded by long journeys from which Church brought back detailed drawings and oil sketches; he then worked these into grandiose landscapes divorced from specific places and events. No other artist displayed the microscopic observation of the positivist in such close connection with the overlapping worldview of the idealist.

The presentation of the paintings was correspondingly ceremonial. Church himself embodied ability and complete devotion to work combined with self-promotion and business sense. His central work *Heart of the Andes* was displayed in 1859 as a "one-picture, paid admission special exhibition" in a gallery rented by the artist (fig. 4).[8] The room had benches and was darkened; the three-metre-wide canvas was brightly lit. It was set in an altarlike wooden frame recalling Caspar David Friedrich's *Tetschen Altar*. The frame was pompously draped and surmounted by portraits of American presidents, so that the work of art was elevated to the status of American icon, emanating a quasi-religious consecration. There were binoculars so that the visitors could examine the details more easily, and extensive descriptions of parts of the painting. Within three weeks, over $3,000 in ticket sales and over $6,000 in orders for the engraved reproduction were collected.

Since Church presented dignified subjects as entertainment, the enthusiasm of the public and the press knew no bounds. And soon, this enthusiasm moved to Europe, where the painting was sent after being sold for the then-enormous sum of $10,000. The artist wrote a friend on May 9, 1859, "The *Andes* will probably be on its way to Europe before your return to the City ... The principal motive in taking the picture to Berlin is to have the satisfaction of placing before Humboldt a transcript of the scenery which delighted his eyes sixty years ago – which he had pronounced to be the finest in the world."[9] But the ninety-year-old scholar

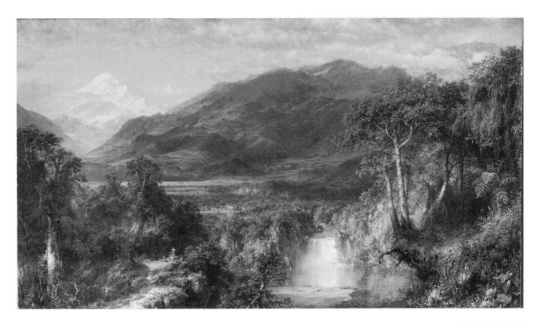

died before he could see this probable fulfilment of his dream of "nature painting", and the European tour of *Heart of the Andes* was limited to the British Isles.

Great Britain had provided Church with a number of important influences. John Ruskin, the first part of whose *Modern Painters* Church possessed as early as 1848, had taught him "the truth of nature". In William Turner, he found the visions of light that suited him, the change from clarity to ominous haze, the graduation from brightness to darkness he mastered with such virtuosity that contemporaries enthused in biblical terms of "celestial fire" and "sublime psalm of light". In regard to the dramatic culmination of images and their sublimely sensational character, Church gained strong impressions from John Martin and Fuseli.

However, Church knew these models only through reproductions; he received the most decisive stimulus from the American painter Thomas Cole, whose student he had been for two years, from 1844 to 1846. Cole's symbolically loaded landscapes, especially his cycle *Voyage of Life*, moved Church's work towards a renewal of the heroic landscape à la Claude, combining the breadth of the American continent with its messianic promise as a new paradise. The *Making of America* proved to be a second, this time successful, creation showing America as a new Adam upon whose pioneering diligence God's blessing appeared to rest and who was chosen to lord over the entire continent.[10] Church created emblems in which the history of the earth and of mankind merged into one. Inspiration came from William Wordsworth's nature lyric and from the pantheism of the transcendental poet Ralph Waldo Emerson as well as from the nature

philosophy of German Romanticism, in particular that of Friedrich Wilhelm Schelling. Pictures like *New England Scenery* (1851) confirm the young American nation in its sense of mission.

By this time, Church had already read the writings of Alexander von Humboldt that would determine his future works.[11] The first two volumes of *Cosmos* appeared in 1845 and 1847 and were immediately translated into the principal languages of the period. The broad effect of this "sketch of a physical description of the universe", which Stephen Jay Gould considers perhaps "the most important work of popular science ever published",[12] was due to more than the classical polish of the style and the well-presented wealth of knowledge. It also corresponded to a need of an uncertain era. Humboldt summarized the state of knowledge at the time into a system in which detailed rational analysis went hand in hand with the belief in a divinely ordered structure of the universe. This was an attack against the modern scepticism that, over time, had been fed by observation and empirical sampling. True to the principles of the Enlightenment, and building upon mankind's growing powers of reason, Humboldt believed firmly in the ultimate harmony of nature. This was achieved at the cost of biological dynamics, which for Humboldt came second to a rather static geography – or topography – of the universe in which everything had its own place. Humboldt's fundamental concern was the agreement of nature and knowledge, the unity of science and art: "The principle impulse by which I was directed, was the earnest endeavour to comprehend the phenomena of physical objects in their general connection,

and to represent nature as one great whole, moved and animated by internal forces." (*Cosmos*, vol. 1, p. IX.)

In the first volume of *Cosmos*, Humboldt employs powerful language to construct a synthesis of the physical universe. In the second volume, he describes how mankind reacts to it. As he stated in his Introduction to volume three, "I have [in the preceding volumes of *Cosmos*] … considered Nature in a twofold point of view. In the first place, I have endeavoured to present her in the pure objectiveness of external phenomena; and, secondly, as the reflection of the image impressed by the senses upon the inner man, that is, upon his ideas and feelings." (*Cosmos*, vol. 3, p. 1.) Its highest form of expression is landscape painting as a balance between emotion and reason, between detailed observations and poetic flights of fancy. It combines the results of conscientious, detailed observation into "nature paintings" that show the cosmos as a structured whole.

Frederic Edwin Church's library contained several editions of *Cosmos*, which he constantly reread and consulted (as he did the description of Humboldt's South American travels). The Bible-quoting New Englander could completely identify with this inspiring worldview. It gave his technical bravura the desired depth. Humboldt, whom Gould considers "probably the world's most famous and influential intellectual" in the first half of the nineteenth century,[13] had precisely formulated his aesthetics to allow emotion and reason to flow together "as an upwardly spiraling system, moving progressively toward deep understanding".[14] In addition, Church's work habits corresponded to the scholar's concept whereby a good landscape painter also had to be an accurate scientific observer. Humbly approaching nature, following the tenets of Ruskin, Church employed his wide knowledge of meteorology, geography, rocks and plants in his preliminary sketches.[15]

From that point onwards, Humboldt became the artist's guiding star. Instead of undertaking a grand tour of Europe and its cultural centres for education like his colleagues, Church twice travelled to South America, in 1853 and 1857, in the footsteps of the Prussian explorer.[16] He visited the same sites and haciendas, followed the same rivers and admired the volcanos Humboldt had explored – Cotopaxi, Pichincha and Sangay. In Quito, he moved into the house where Humboldt had lived. Like his illustrious predecessor, he also climbed Chimborazo, from which he made numerous drawings and watercolours, as always with the striking sights he encountered along his way.

Like Humboldt's own "nature paintings", Church's panoramas are composites that do not represent any particular view. Some are named after the mountains central to the piece; others bear the generic term "Andes" in the title. This brings us to another affinity Church had with Humboldt. Like Humboldt, Church sought unity in multitude, and multitude in unity. At the beginning of *Cosmos*, the author explains why he chose the Andes as the goal of his explorations:

But the countries bordering on the equator possess another advantage, to which sufficient attention has not hitherto been directed. This portion of the surface of the globe affords in the smallest space the greatest possible variety of impressions from the contemplation of nature. Among the colossal mountains of Cundinamarca, of Quito, and of Peru, furrowed by deep ravines, man is enabled to contemplate alike all the families of plants, and all the stars of the firmament. There, at a single glance, the eye surveys majestic palms, humid forests of bambusa, and the varied species of musaceae, while above these forms of tropical vegetation appear oaks, medlars, the sweetbrier, and umbelliferous plants, as in our European homes. There, as the traveller turns his eyes to the vault of heaven, a single glance embraces the constellation of the Southern Cross, the Magellanic clouds, and the guiding stars of the constellation of the Bear, as they circle round the arctic pole. There the depths of the earth and the vaults of heaven display all the richness of their forms and the variety of their phenomena. There the different climates are ranged the one above the other, stage by stage, like the vegetable zones, whose succession they limit; and there the observer may readily trace the laws that regulate the diminution of heat, as they stand indelibly inscribed on the rocky walls and abrupt declivities of the Cordilleras. (*Cosmos*, vol. 1, pp. 10-12.)

Church also composed his pictures of the Andes so that the view of the observer comprised at once all the climatic-botanical zones, from rocky, snow-capped summits to the temperate vegetation of the midrange and finally the lush tropical vegetation of the plains. Each picture recapitulates the story of Creation. Each one contains small, yet clearly drawn crosses as symbols of salvation in light of so much seductive sensuality.[17] And in each one, the tensions of the earth's crust – between the fiery volcanos and eternal ice, arid regions and paradise-like clear waters that mirror the temptations of the human soul and its longing for purity – are played out. The fact that Church, the painter of Niagara Falls, sought extremes is well known. The *Aurora Borealis* (1865) stands as the northern pendant to his *Rainy Season in the Tropics* (1866). Even his fascination with polar regions, which culminated in his immense *Icebergs* (1861; cat. 67), is connected to Humboldt and his stay in Siberia in 1827.

Upon his return from his second journey to South America, Church painted a panorama of Cayambe. It was commissioned by the rich sugar magnate and

amateur botanist Robert L. Stuart. As a diligent reader of Humboldt, Stuart knew he considered Cayambe perhaps the most beautiful volcano in South America. In the foreground of the painting, which is arranged in horizontal layers, an Inca stele appears as a symbol of this pre-Columbian culture, much admired by Humboldt. In the plateaux of the middle ground, one sees a reflecting lake and, at the top, in pure white and unattainable, the summit of the mountain, as if the painter wanted to re-create the world and the hereafter in one picture. Many of Church's paintings are fraught with symbolic references. The rainbow in *Rainy Season in the Tropics* is drawn as a sign of national reconciliation after the American Civil War. Finally, Church planned to combine three of his most important pictures of South America – *Cotopaxi*, *Heart of the Andes* and *Chimborazo* – into the noble form of a triptych that at the same time would be a precursor to Giovanni Segantini's equally important *Trittico degli Alpi*, painted for the 1900 Universal Exposition in Paris.

During the preparations for his momentous journey on the *Beagle*, Darwin wrote to his sister Caroline on April 28, 1831, "My head is running about the tropics; in the morning I go and gaze at Palm trees in the hothouse and come home and read Humboldt; my enthusiasm is so great that I can hardly sit still on my chair." Having reached Brazil ten months later, he wrote in his journal,

> Humboldt's glorious descriptions are and will for ever be unparalleled; but even he with his dark blue skies and the rare union of poetry with science

which he so strongly displays when writing on tropical scenery, with all this falls far short of the truth. The delight one experiences in such times bewilders the mind; if the eye attempts to follow the flight of a gaudy butterfly, it is arrested by some strange tree or fruit; if watching an insect one forgets it in the stranger flower it is crawling over; if turning to admire the splendour of the scenery, the individual character of the foreground fixes the attention. The mind is a chaos of delight, out of which a world of future and more quiet pleasure will arise. I am at present fit only to read Humboldt; he like another sun illuminates everything I behold.[18]

In 1859, the year Humboldt died and Church, at the pinnacle of his career, sent *Heart of the Andes* to London, Darwin's *On the Origin of Species* was published there – the book that would strike down the harmonious, balanced worldview of the Humboldt he admired and replace it with a struggle of antagonistic forces that attack and destroy each other.[19] And Church? His last important nature paintings were created in the 1860s. At the end of 1869, he undertook a two-year journey through Egypt, the Middle East and almost all of Europe. The results are seen in pictures of Rome, Greece and above all the Middle East – that Middle East which influenced the architecture of his country house Olana, overlooking the Hudson River, the main preoccupation of his later years. His time as a nature painter was over; now, realism and objectified understanding of the world reigned.

• Notes

1. See Werner Spies, Sigrid Metken and Günter Metken, *Max Ernst, Oeuvre-Katalog: Werke 1939-1953* (Cologne, 1978), no. 2669.

2. See Carlos Basualdo, "Crocodiles, or Latin America Project Rooms Installations at ARCO", *Arconoticias* (Madrid), no. 11 (May 1998), pp. 11-12.

3. See Helmut de Terra, *Alexander von Humboldt und seine Zeit* (Wiesbaden, 1956); Hanno Beck, *Alexander von Humboldt*, 2 vols. (Wiesbaden, 1959-1961); Douglas Botting, *Humboldt and the Cosmos* (London, 1973); and Jean Paul Duviols and Charles Monguet, *Humboldt, savant-citoyen du monde* (Paris, 1994).

4. See Günter Metken, "Tableau physique de la montagne. Humboldt et les volcans de l'Amérique latine", in *Le sentiment de la montagne*, exhib. cat. (Musée de Grenoble, 1998).

5. All quotations from Humboldt's *Kosmos* are from the translation by E. C. Otté, *Cosmos: A Sketch of a Physical Description of the Universe*, 4 vols. (London: Henry G. Bohn, 1849-1852). This translation, with a different pagination, was also published in New York in 1852.

6. See David C. Huntington, *The Landscapes of Frederic Edwin Church: Vision of an American Era* (New York, 1966), and Franklin Kelly, ed., *Frederic Edwin Church*, exhib. cat. (Washington: National Gallery of Art, 1989), which includes a Bibliography.

7. See Hans Belting, *Das unsichtbare Meisterwerk. Die modernen Mythen der Kunst* (Munich, 1998).

8. Franklin Kelly, "A Passion for Landscape: The Paintings of Frederic Edwin Church", in Kelly 1989, p. 57, which also gives further details of the painting's first presentation (see pp. 55-58).

9. Quoted in Stephen Jay Gould, "Church, Humboldt, and Darwin: The Tension and Harmony of Art and Science", in Kelly 1989, p. 94.

10. See David C. Huntington, "Frederic Edwin Church, 1826-1900: Painter of the Adamic New World Myth", thesis, Yale University, 1960.

11. Gould 1989 provides an illuminating treatment of the influence of the explorer-naturalist Humboldt on the painter Church, as well as listing articles and exhibition catalogues that deal with the relationship between the work of the two men (p. 107, note 4).

12. *Ibid.*, p. 97.

13. *Ibid.*, p. 96.

14. *Ibid.*, p. 99.

15. See David C. Huntington, "Landscape and Diaries: The South American Trips of F. E. Church", *Brooklyn Museum Annual*, vol. 5 (1963-1964).

16. See Katherine Emma Manthorne, *Tropical Renaissance: North American Artists Exploring Latin America, 1839-1879* (Washington and London, 1989).

17. See *Un nouveau monde. Chefs-d'œuvre de la peinture américaine 1760-1910*, exhib. cat. (Paris: Grand Palais, 1984), p. 252.

18. The passages from Darwin are quoted in Gould 1989, p. 102.

19. See *ibid.* for a fuller development of the interrelation of these three events of 1859.

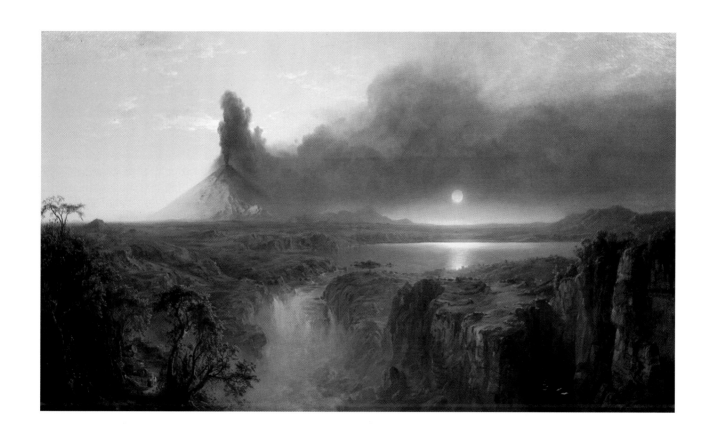

68· FREDERIC EDWIN CHURCH, **COTOPAXI, ECUADOR**, 1863
READING, PENNSYLVANIA, READING PUBLIC MUSEUM

Not yet a century since Columbus had set foot in America – and more than two hundred years before the nineteenth century's great outpouring of depictions of the North American wilderness – Jacques Le Moyne de Morgues and John White recorded images of indigenous Americans that fascinated a European public.[1] These provocative glimpses of exotic new frontiers and peoples prompted further explorations, both topographical and artistic.[2]

In the intervening years up to the nineteenth century, a number of artistic developments contributed to the dawn of a new era and the flourishing of landscape

Nineteenth-century America

The New Frontiers

by Mayo Graham

painting in the United States. From the French and Italians came the influence of Claude Lorrain and Salvator Rosa, whose historicist and moralistic content lent credence to this new direction. And from the Germans and English – Friedrich, Turner and John Martin – came symbolic content and Romantic idealism. Martin, who was particularly influential in the development of nineteenth-century landscape painting in America, broke the rules of history painting by emphasizing the landscape. Through the combination of narrative and symbolic seminaturalistic elements, he elevated mere landscape, then considered an inferior form of art, to loftier heights.

In the United States, the Hudson River, the Catskills and the Adirondacks became a focus for the flowering of landscape painting in the early nineteenth century. However, a vast range of New World scenic wonders – Niagara Falls, the volcanos and forests of South America, the Arctic, the Rocky Mountains and Yosemite – attracted the attention of many of the painters of the Hudson River School and others in search of the sublime view of this paradise that was America. These dramatic vistas, more than the gentler, romantic representations of the Hudson River Valley, provided quintessential visions of the new Eden, a concept shared by artists and writers alike for almost a hundred years.

The artist who epitomized the link between the Old and New Worlds, who grew from European Neoclassical and Romantic landscape traditions and who reinterpreted them for the New World, was Thomas Cole (1801-1848). Recognized as the founding father of the Hudson River School, Cole nevertheless became better known for his epic landscape cycles such as *The Course of Empire* (1834-1836), an allegory in five panels. Cole's *Wild Scene* (1831-1832; cat. 72), a preliminary version of the *Empire* cycle's opening panel (*The Savage State*), was painted after the

artist's first trip to Niagara Falls in the spring of 1829 and after he had met John Martin in London. Niagara Falls seems to be the source of inspiration for the tumultuous falls in *A Wild Scene*, where against a symbolic backdrop of untouched mountain wilderness and dramatically brightening sky, hide-clad primitives greet the dawn.

In 1830, Cole had depicted Niagara Falls directly (fig. 1); here, the landscape is equally untamed, with two tiny Amerindian figures on a rocky ledge in the near middle-ground giving a sense of the majestic scale of the scene. By inventing the figures he included in his paintings – when this panel was painted, for example, Niagara Falls was already surrounded by a population of some two thousand residents – Cole captured what was for him the deistic essence of the natural world. He "was convinced that the face of nature reflected God's presence. But he believed that only in America's virgin wilderness could one experience the actuality of redemption."[3] At the same time, the artist presents an idealized and fictitious reality.

An icon and symbol of the United States as the paradisiac garden, Niagara Falls was a destination for many besides Cole.[4] An earlier portrayal of the great falls dates to the beginning of the century. At various times attributed to John Vanderlyn (1775-1852) and to Samuel F.B. Morse (1791-1872), *Niagara Falls from Table Rock* (cat. 216) was painted between 1801 and 1815.[5] If it is by Vanderlyn, it would seem to be the original from which an engraving was produced in England, by means of which the artist hoped to earn money through the mass distribution of an image with popular appeal.

In this view of the cataract, we see both indigenous people (three figures in Native costume) and visitors in European dress, with top hat and tailcoat. Adding to the natural spectacle, one figure has crawled to the

FIG. 1 - THOMAS COLE
DISTANT VIEW OF NIAGARA FALLS, 1830

edge of the precipice and is peering over. The element of terror experienced vicariously by the viewer of the painting underlines the sublimity. So too, the rainbow and clearing sky reflect divine presence in the grandeur of nature.

John F. Kensett (1816-1872) first visited the falls in August 1851; he returned the following year and again in 1857. His *Niagara Falls* (1855; cat. 146) centres on a towering side chute of the great cataract, which nearly fills the painting's vertical axis. As in Cole's 1830 view, we see tiny Amerindian figures, here in the right foreground, set against immense pinkish boulders. The worm's-eye perspective can be compared to the 1847 watercolour by British army officer Henry S. Davis (cat. 80), who was stationed in Canada between 1831 and 1847. Kensett's replacement of the crowds at the site[6] with fictitious Amerindians recalls Cole's use of figures. Symbolically, they function as identifiers of both America and its wilderness.

Later views, such as those by Frederic E. Church (1826-1900), include glimpses of civilization while maintaining the sense of the grandeur and power of nature. Like Morse (or Vanderlyn) and any number of other artists who portrayed the falls, from Thomas Davies to George Inness, Church incorporates a sensational rainbow in his panoramic *Niagara Falls* (1857; fig. 2) painted after his first visit to the site. The rainbow arcs through almost half of Church's painting. In the context of the American landscape as the new Eden or Promised Land, "the rainbow could be an emblem of Manifest Destiny or of God's new covenant with the United States".[7]

Another grand New World frontier was South America, and it was Frederic E. Church who summarized on canvas an artistic interpretation of its geography.

In 1853 and again in 1857, following the trail blazed by the great German naturalist Alexander von Humboldt, Church explored Colombia and Ecuador in search of unspoiled nature, which he recorded and translated into bold panoramas.[8] Church's quest was for sublime landscapes to portray, and these were increasingly difficult to find. His *Cotopaxi* (1863), with its smoking volcano, tremendous cliffs and falls, and reflection of an orange sunset veiled in smoke, has all the hallmarks of Church at his most eloquent, combining science and religion. "Steeped in the New England Calvinistic traditions inherited from a long line of Puritan ancestors, Church, who in keeping with his heritage always refused to discuss the meaning of his works, arrived at a way of representing natural features that incited – even demanded – the pondering of the cosmic truths of which his painted scenes are obviously emblematic."[9]

An equally awesome new frontier of the nineteenth century was the Arctic. Some of the earliest and most compelling views by American artists in the Far North were produced in the latter decades of the century by William Bradford (cats. 30-32), as well as Frederic E. Church (cats. 60-67). Previously, British lieutenant F. W. Beechey had provided drawings in 1819 for Admiral W. E. Parry's *Journal of a Voyage for the Discovery of a North-West Passage*, published in 1821, and Elisha Kent Kane had made watercolours during his voyage with the first American Arctic expedition, in 1850-1851, in search of Franklin and his crew, and of an open polar sea. Kane's influential account of a second search expedition, *Arctic Explorations*, was published in 1856.[10]

Another source of new vistas and avenues of artistic interpretation of the natural wilderness of America

lay in the Rocky Mountains and beyond. Albert Bierstadt (1830-1902) and Thomas Moran (1837-1926) are the two artists most closely associated with the discovery of the splendours of the western United States, although a number of photographers, such as Carleton E. Watkins (1829-1916), were equally instrumental in presenting this new frontier to the public.[11]

Even before the completion of the transcontinental railroad in 1869, Bierstadt had twice journeyed west. He was part of Colonel Frederick Lander's expedition in the spring of 1859, the purpose of which was to map a wagon route through the Rocky Mountains. Painted outdoors, Bierstadt's oil-on-paper sketches are remarkably detailed yet fresh, and they provided him with a great deal of material for his studio production on his return east, when he relocated to New York. Bierstadt's second overland journey, with writer Fitz Hugh Ludlow in 1863 via the Oregon Trail, took him as far as the Pacific Northwest. The highlight of the trip was the Yosemite Valley. In a letter to a friend, Bierstadt wrote, "We are now here in the garden of Eden I call it. The most magnificent place I was ever in, and I employ every moment painting from nature."[12] Thanks largely to the work of Bierstadt and Watkins in capturing the beauty of Yosemite, President Abraham Lincoln had the valley designated as state land in 1864.

Yosemite Valley (cat. 19), which followed his third trip to the area, exemplifies the spectacular views of the valley that Bierstadt produced in his studios in San Francisco and New York. More than two metres wide, this dramatic panorama was painted at the height of his career.[13] Hovering above and gazing down into the valley, the viewer, embraced by the mountains on either side, is led along the winding Merced River to distant regions of light, emblematic of eternal divinity. One senses having reached a new paradise. At the same time, one is aware of the horseback figures travelling along the trail at the lower left of the painting, evidence that this sublime wilderness is being tamed.

Thomas Moran, a rival of Bierstadt, was the first landscape painter to travel to Yellowstone. Joining Ferdinand Hayden's U.S. Geological and Geographical Survey as guest artist, Moran arrived in Yellowstone in July 1871 with the official party that was to map the region. The watercolours and drawings of the hot springs, geysers and waterfalls that Moran brought back East, along with the photographs of William Henry Jackson, helped convince the U.S. Congress to preserve Yellowstone as a national park. Moran's 1872 panorama *Grand Canyon of the Yellowstone* was purchased by Congress that same year, and his career was launched.

The field drawings and sparkling watercolours Moran made during the Hayden survey are remarkable for their colour and clarity. The four watercolours from the Gilcrease Museum (cats. 211-214) are among the series that formed the basis of a portfolio of chromo-lithographs published by Louis Prang in 1876, bringing the extraordinary colours of Yellowstone to a wide audience for the first time. *Hot Springs of the Yellowstone* (1872; cat. 210), a small but powerful oil, exemplifies the strange landscape that Moran encountered and meticulously rendered. Rather glacial or even lunar in feeling, these geological formations and their intense hues – oranges, yellows, iridescent blues – were unknown in the East. The soft rosy clouds, misty sky and rainbow reminiscent of Turner also recall the spiritual presence in nature that was a focus of artists earlier in the century.

Twenty years later, Moran returned to the subject, making a second journey to Yellowstone in 1892 (as well as to the Grand Canyon of the Colorado, which he had visited in 1873 with the Powell survey). Late in life, Moran could still evoke the grandeur of the American West, as evinced by *Lower Falls, Yellowstone Park* (1893; cat. 215), although by this time Yellowstone was gradually becoming a nostalgic symbol of the edenic American wilderness the West had been.

The close of the nineteenth century brought an end to interest in grandiloquent landscape views like those by Bierstadt and Moran; more intimate Luminist works were now held in esteem. But it is understandable how these magnificent untamed American frontiers had led to epic visual interpretations. It has been remarked about Thomas Cole that "it is not difficult to imagine that if [he] were alive today he might be making motion pictures, especially ones with 'celestial' or even intergalactic endings",[14] an observation that finds resonance in many other of these nineteenth-century artist-explorers.

• Notes

1. Le Moyne made sketches of Timucua Indians in northern Florida during the French expeditions in 1562 and 1564-1565. White travelled on Martin Frobisher's 1576 and 1577 voyages to Baffin Island, where he made drawings and watercolours of Inuit. A woodcut based on White's original depicts the sea and icy landscape, Frobisher's men in a skirmish with Inuit, and a man in a kayak in the foreground. (See Sturtevant, "First Visual Images of Native America", in Fredi Chiapelli, ed., *First Images of America* [Berkeley and Los Angeles: University of California Press, 1976], pp. 438-441.) Then, in 1585, White was sent by Sir Walter Raleigh to set down his impressions of America and its Native people.

2. Niagara Falls was first depicted in 1697 in an engraved illustration in Father Louis Hennepin's book *Nouvelle découverte d'un très grand pays situé dans l'Amérique*. Hennepin had been a member of LaSalle's expedition of 1678-1682.

3. Earl A. Powell III, "Thomas Cole and the American Landscape Tradition: The Picturesque", *Arts Magazine*, vol. 52, no. 7 (March 1978), p. 116.

4. See Elizabeth McKinsey, *Niagara Falls: Icon of the American Sublime* (Cambridge: Cambridge University Press, 1985), and Jeremy Elwell Adamson, *Niagara: Two Centuries of Changing Attitudes, 1697-1901*, exhib. cat. (Washington: Corcoran Gallery of Art, 1985).

5. The attribution to Morse has been based on his inscription, with the year 1835, on the back of the canvas. Paul Staiti, in a letter of July 1995 to Carol Troyen (Museum of Fine Arts, Boston, curatorial file), suggests the possibility of either attribution but that if the painting is by Morse, it dates from 1811 or 1815, not 1835. See Kenneth C. Lindsay, "John Vanderlyn in Retrospective", *The American Art Journal*, vol. 7, no. 2 (November 1975), pp. 79-90, for a discussion of the attribution to Vanderlyn.

6. While sketching the falls, Kensett was at first irritated by the crowd: it "is a slight obstacle to one's studying – indeed the first annoyance seemed beyond my patience – but I am now getting hardened and don't mind an audience of fifty" (letter from the artist to Frederick Kensett, August 24, 1851. John F. Kensett Papers, Archives of American Art, Smithsonian Institution, Washington; quoted in Adamson 1985, p. 51).

7. George P. Landow, "The Rainbow: A Problematic Image", in U. C. Knoepflmacher and G. B. Tennyson, eds., *Nature and the Victorian Imagination* (Berkeley: University of California Press, 1977), pp. 365-366.

8. See Günter Metken's essay "*Heart of the Andes*: Humboldt's *Cosmos* and Frederic Edwin Church" in this catalogue for further discussion of Humboldt and his influence.

9. Oswaldo Rodriguez Roque, "The Exultation of American Landscape Painting", in *American Paradise: The World of the Hudson River School*, exhib. cat. (New York: Metropolitan Museum of Art, 1987), p. 42.

10. In their essays in this catalogue, Eleanor Jones Harvey and Rosalind Pepall more fully describe the artistic activity in the Arctic frontier.

11. See also Mary Warner Marien's essay "First Images of Yosemite, First Icons of the American West" in this catalogue.

12. Albert Bierstadt, letter of August 22, 1863, to John Hay (John Hay Collection, John Hay Library, Brown University, Providence; quoted in Nancy K. Anderson and Linda S. Ferber, *Albert Bierstadt: Art and Enterprise*, exhib. cat. [New York: Brooklyn Museum, 1990], p. 178).

13. This painting and other similar oils became the inspiration for Bierstadt's enormous *Domes of the Yosemite* (1867), now in the Saint Johnsbury Athenaeum, Saint Johnsbury, Vermont. Bierstadt continued to paint views of Yosemite until very late in life, although by then, theatrical canvases had fallen out of fashion.

14. Ellwood C. Parry III, *The Art of Thomas Cole: Ambition and Imagination* (Newark, Delaware: University of Delaware Press, 1988), p. 367.

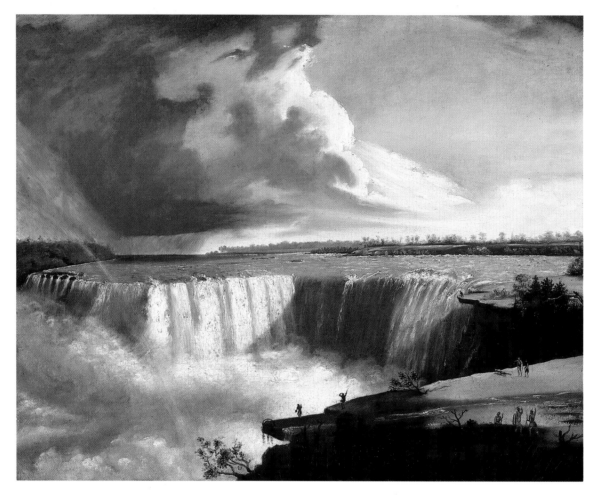

6· GEORGE BACK,
PORTAGE LA LOCHE (METHYE)
BETWEEN LAC LA LOCHE AND
THE CLEARWATER RIVER, 1825-1826
OTTAWA, NATIONAL ARCHIVES OF CANADA

5· GEORGE BACK, **WILBERFORCE FALLS
ON THE HOOD RIVER,** 1821 (AUGUST)
OTTAWA, NATIONAL ARCHIVES OF CANADA

216· SAMUEL F.B. MORSE, **NIAGARA FALLS FROM TABLE ROCK,** 1835
MUSEUM OF FINE ARTS, BOSTON

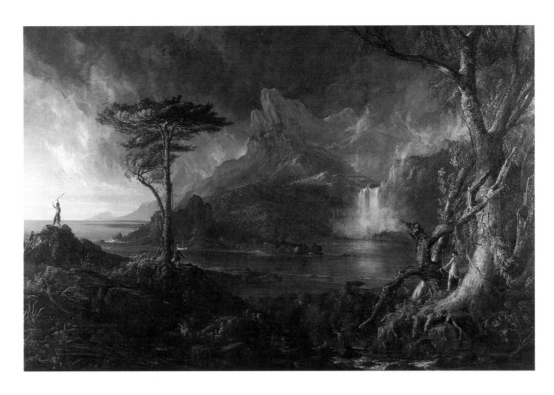

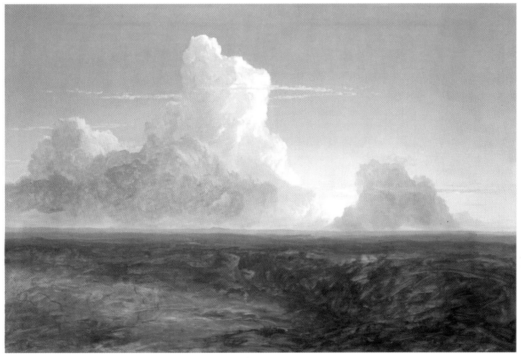

72· THOMAS COLE, **A WILD SCENE**, 1831-1832
THE BALTIMORE MUSEUM OF ART

73· THOMAS COLE, **STUDY OF CLOUDS**, 1846-1847
PRIVATE COLLECTION

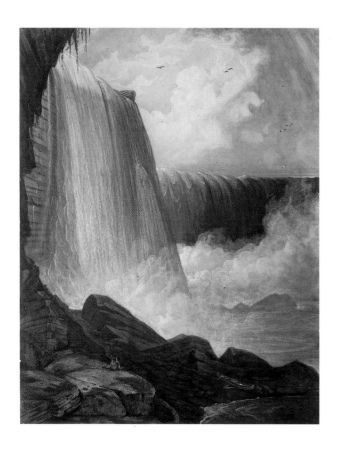 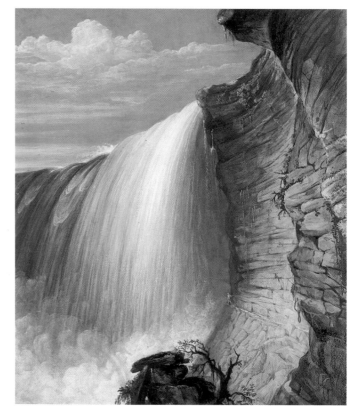

HENRY SAMUEL DAVIS

80· **HORSESHOE FALLS**
FROM GOAT ISLAND, 1847

79· **HORSESHOE FALLS**
AND TABLE ROCK, 1847

TORONTO, ROYAL ONTARIO MUSEUM

210• THOMAS MORAN, **HOT SPRINGS OF THE YELLOWSTONE**, 1872
LOS ANGELES COUNTY MUSEUM OF ART

215• THOMAS MORAN, **LOWER FALLS, YELLOWSTONE PARK**, 1893
TULSA, OKLAHOMA, THE GILCREASE MUSEUM

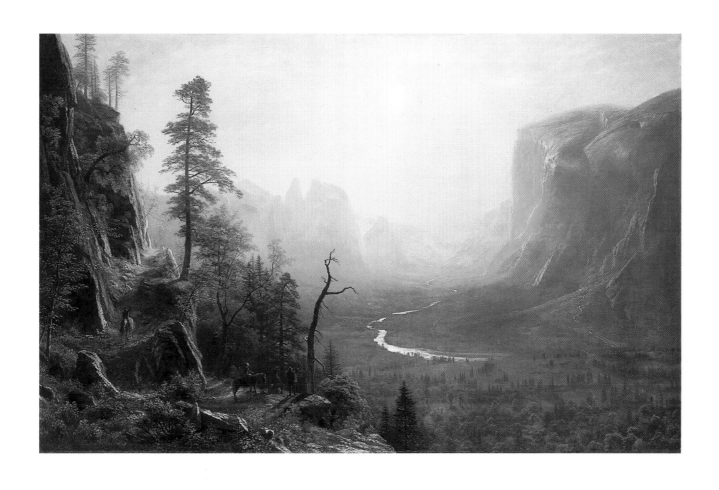

19• ALBERT BIERSTADT, **YOSEMITE VALLEY**, ABOUT 1875-1880
NEW HAVEN, YALE UNIVERSITY ART GALLERY

THOMAS MORAN

213· TOWER FALLS, 1872 212· WYOMING FALLS,
 YELLOWSTONE RIVER, 1872

211· THE GRAND CANYON 214· THE UPPER FALLS
OF THE YELLOWSTONE, 1872 OF THE YELLOWSTONE, 1872

TULSA, OKLAHOMA, THE GILCREASE MUSEUM

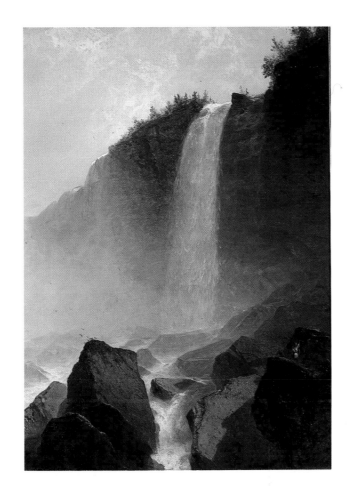

146· JOHN FREDERICK KENSETT, **NIAGARA FALLS**, 1855
THE TOWN OF SIMSBURY, CONNECTICUT

175· JOHN MACWHIRTER, **THE VALLEY OF SLAUGHTER, SKYE**, BY 1876
THE MONTREAL MUSEUM OF FINE ARTS

In Wildness is the preservation of the World.
Thoreau

When Carleton Watkins left rural upstate New York for California in the spring of 1851, he set out for a region that was at once old and new, known and unknown. The area had been a pawn in European politics beginning in the sixteenth century, and it saw renewed Spanish-American friction during the early eighteen hundreds. Nevertheless, California did not emphatically penetrate American cultural consciousness until 1848, when, almost simultaneously,

First Images of Yosemite,

First Icons of the American West

by Mary Warner Marien

the territory was ceded to the United States after the war with Mexico and gold was discovered at Sutter's Mill, on the American River.

The Gold Rush made final the Far West's connection to the rest of the country, while deepening the association of California with American notions of unsullied nature. Americans long believed that the New World surpassed the Old World in natural riches, if not artistic and cultural attainment. In the 1840s, California and the American West were mythologized as an inviolable wilderness, that is, a natural paradise or pure space where nature's monuments and majesty bettered anything Europe had to offer.

Westward expansion and development in the United States were driven by political, economic and spiritual yearnings for unity and wholeness, which seemed to compromise the contrary cultural notion of the western wilderness's inviolability. Consequently, while fulfilling one part of America's sense of continental destiny, the Gold Rush and subsequent closing of the frontier threatened to do away with a central psychic dynamic in American life – the awareness that in a pinch, one could head out to a place beyond the taint of human society and live simply. American enterprise appeared to endanger the unique American landscape, just as the wilderness seemed to hamper economic development.

Presumably these heady ideas were not on the mind of Carleton Watkins, who, like so many of the young and luckless 49ers, found not fortune but a profusion of odd jobs in the boom town of San Francisco. Chance, not artistic interest, directed him to eventual employment in a commercial photography studio in 1854. How Watkins perfected his trade is easy to answer: he learned photography in the course of routine studio work. But how he invented an aesthetic that cast the deep valley and towering cliffs known

as Yosemite as a symbol of American enterprise and national identity that eventually eclipsed Niagara Falls will probably never be fully understood. Nothing in Watkins's early life hints at so broad a future accomplishment.[1]

Watkins's letters disclose him to be a person with little fondness for the felicities of language. He had no art training beyond what he randomly picked up in the photography studios and collections of San Francisco. He would, as his reputation increased, meet artists, writers, scientists and thinkers who expanded his intellectual scope. But during his first years in California, it is doubtful that he thought carefully about the philosophy of nature called transcendentalism, which found moral law and spiritual fulfilment in nature, or that he knew the implications of recent developments in the field of geology, which was stretching prehistory to the millions and millions of years that would ultimately accommodate Darwin's theory of evolution.

Watkins's early solo career brought him near Yosemite, to the vast Mariposa Estate, where he was commissioned to make photographs of the property's mining activities. The photographs were used to entice foreign investment in the estate's gold and mineral potential. These early commercial photographs reveal the visual symbols developing in Watkins's photographic practice. In *Josephine and Pine Tree* (fig. 1), for example, mountain ridges recede to remote and misty peaks, suggesting a pristine spot where the earth reaches for the heavens. But in the same image, the steep hillsides of the foreground are traced by access roads leading to the Mariposa mines. Watkins was one of the first American artists in any medium to construct an image of nature's grandeur attended by supple accommodation to economic enterprise, that is, a "commercial sublime".

In his mining, lumbering and railroad pictures, Watkins often transformed nature into a natural re-source, while preserving undefiled vistas. Wilderness was not destroyed in Watkins's cosmology, but brought within human scope. It is likely that Watkins made his initial 1861 trip to Yosemite in the company of one of the Mariposa Estate's entrepreneurs. Watkins returned to Yosemite in 1865 and 1866, under the informal auspices of the California State Geological Survey, whose members studied the geology, biology and mining possibilities of the region, as well as the places best suited for building roads.

Watkins – acutely aware that the Yosemite Valley's scenic beauty was attracting both a growing curiosity back East and even a few intrepid tourists – began a series of photographs aimed at this promising market.

Yet, Watkins was not the first photographer to work in Yosemite. Another San Francisco photographer, Charles Leander Weed, visited Yosemite in 1859, producing images that were exhibited in August of

FIG. 1 - CARLETON E. WATKINS
JOSEPHINE AND PINE TREE, 1860

that year.[2] Weed's images, in mammoth plate and stereographic formats, were advertised as "not simply pictures, but fac-similies of the spots themselves".[3] What they may have lacked in visual impact and innovation they made up for in being first. Weed's later *Yosemite Valley from the Mariposa Trail* (cat. 321) is uncommon among Yosemite pictures in that it includes tourists taking in the view. David Robertson has discerningly observed that Weed's photograph is at cross purposes.[4] The large expanse of foreground brush, together with the position of the camera and the casual poses of the man leaning on the tree and the woman reposing on the rocks, anchor the image in physical comfort and security, and lessen the wallop of Yosemite's staggering immensity. Watkins likely saw Weed's photographs, and perhaps they served him as think pieces for his own work. The interpretative devices Watkins used in his Yosemite photographs become apparent when compared with Weed's technically skilled, yet formally and symbolically uninventive, designs.

Watkins's images of the Grizzly Giant, a three-thousand-year-old sequoia in the Mariposa Grove at Yosemite, reveal how willing he was to narrate a progression of visual themes and symbols rather than foster quiet contemplation of a scene. In one photograph, Galen Clark, the Yosemite pioneer and caretaker of the great trees, is posed before the tree's huge, bulbous base (cat. 317). Fallen branches and twisted dead patches along the trunk attest the tree's antiquity. In a period when the vastness of prehistoric time was just being countenanced, the hoary appearance of the Grizzly Giant made it seem like a token from a distant past, perhaps even a relic of Paradise. Other Watkins views were distinctly without human

occupants. The absence of people accentuated Yosemite as a prime site in which to witness the eons-long processes of nature.

Watkins's 1861 Yosemite photographs were among the first sent back East to influential intellectuals and politicians. Mammoth plate prints were exhibited in New York at Goupil's Gallery. President Abraham Lincoln saw some of Watkins's work, and it helped convince him to sign the Yosemite Bill in 1864, which began the process of preserving the valley and the Mariposa grove of big trees.[5] At the end of the carnage and divisive politics of the American Civil War, far-off California, largely untouched by battle, seemed even more pure and edenic. It was an inviting stage on which to re-enact the American drama of social and individual regeneration through contact with nature.

The primeval aspect of Yosemite was a continuing theme in the photographs Watkins made during the 1860s. His stereograph *From the Best General View, Mariposa Trail* (cat. 313) typifies the "soaring sublime" he contrived in order to convey the expansiveness of the valley and the height of its crags. Although more tourists were arriving in Yosemite by the mid-1860s, Watkins took this photograph from a vantage point that eliminated all traces of human presence. In effect, the view cannot be located in the contemporary world, but seems to have existed intact from the beginning of time. The viewer, not situated in a particular spot, is implicitly flung out over the edge of the chasm to soar above the valley. The resulting vertiginous feeling is increased by the deeply recessed planes of the picture, which three-dimensional stereographic format makes all the more intense.

Watkins's San Francisco workplace and makeshift exhibition area, the Yosemite Gallery, was succeeded in 1871 by the larger Yosemite Art Gallery. Though other photographers made images of the magnificent valley, it was Watkins who was most closely associated with it. His gallery became a San Francisco tourist attraction. Hence, when financial overreaching caused him to lose his inventory of Yosemite views, he proceeded to make fresh ones, called the "New Series". Although Watkins never abandoned the soaring sublime, there is an altered sensibility of nature in the late Yosemite images. Many of them circular or oval, these photographs do not amplify the power and processes of nature. In *View on the Merced* (cat. 315), the river flows through Yosemite with a glassy stillness. Where before, water thundered over falls and etched rock, now it shimmers in the afternoon light. Where mountains reached into the sky, now tree branches reach down to restrain them. Yosemite has been transformed from a turbulent wilderness into a civilized park. In Watkins's later work, apocalypticism fades into lyricism, even as the

dream of California as a pastoral paradise was replaced by a sense of its urbane modernity.

As the years passed, Carleton Watkins faced growing competition. National and international interest in Yosemite, an increase in tourism, California's expanding population and the smooth merger of California with American cultural symbols guaranteed a steady market. Perhaps the most popular of Watkins's competitors was Albert Bierstadt, a painter who also produced photographs, engravings and chromolithographs.

Bierstadt was born in Solingen, Germany, in 1830 but arrived in the United States at the age of two. He returned to Germany from 1853 to 1857 to advance his art studies. Like many of his generation, Bierstadt was intrigued by the American West, and he determined to see it for himself. He first travelled to Yosemite in 1863, but it was not his first "westering". In 1859, he had joined the Frederick W. Lander survey expedition bound for the Rocky Mountains, where they hoped to find an alternative route to California.

Bierstadt's famous letter of July 10, 1859, published in *The Crayon* for September of that year, underscored how the American West was seen as a greener, wilder, better version of Europe. As did many Americans, Bierstadt compared the Rockies favourably with the Alps. Looking out at the mountains, he declared, "We have here the Italy of America in a primitive condition."[6] Bierstadt returned home with sketches, photographs, stereographic views and Native American artifacts. Among the large paintings he produced from his first Western experience is *Rocky Mountains, "Lander's Peak"* (1863; fig. 2), a memorial piece for Lander, who had died from a lingering wound received in a Civil War skirmish.[7]

Rocky Mountains, "Lander's Peak" offers considerable contrast to the photographic work of Carleton Watkins. Bierstadt took advantage of painting's ability to render atmosphere and colour, and thereby to concoct more sensuously compelling fictions of the real. The golden tonality of the foreground and middle ground set off an icy alpine upland and lucent blue sky. The daily labours of the Native Americans in the tranquil riverine area are opposed to an idealization of nature in the dramatically lit high falls and distant ethereal mountain. Like Watkins before him, Bierstadt imbricated the image with symbols the American public readily comprehended. Whether they liked the painting or not, reviewers understood that *Rocky Mountains, "Lander's Peak"* was not a simple representation of the West. One approving commentator considered that the painting's power lay in its ability to express the idea of Manifest Destiny: "This is a glimpse into the heart of the continent toward which civilization is struggling," he wrote. "I know the nation's future greatness is

somehow dimly seen in the great West," he continued. "This picture is a view into the *penetralia* of destiny as well as nature."[8] In other words, the act of subduing the continent coast to coast was an enterprise as epic and noble as the West itself.

Bierstadt, who saw Watkins's photographs of Yosemite in both New York and San Francisco and purchased quite a few in addition, acknowledged them as models for his paintings. But unlike Watkins, Bierstadt exuberantly dramatized his images. His *Great Trees, Mariposa Grove, California* (1876), prepared for the United States' Centennial Exposition in Philadelphia, offers an imposing vertical image of the Grizzly Giant. Reaching from forest gloom to dappled sky, the tree looks as if it has erupted from the earth moments before. By contrast, Watkins's versions of the tree are impressive for their grounded massiveness.

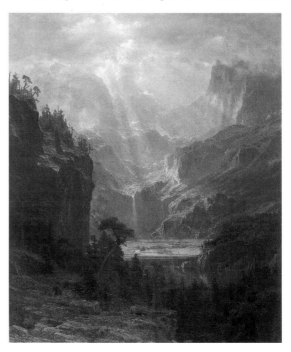

FIG. 2 - ALBERT BIERDSTADT
ROCKY MOUNTAINS,
"LANDER'S PEAK", 1863

Despite his contact with Watkins's prints and his repeated trips to Yosemite, Bierstadt seldom employed Watkins's soaring sublime. He usually pictured Yosemite from a vantage point low on the valley floor, which comfortably secured the viewer, while distancing and intensifying the otherworldly peaks against a shimmering cloud-spangled sky. In *Yosemite Valley* (about 1875-1880; cat. 19), the presence of people along the pathway somewhat moderates the scenic wonders.

Looking down Yosemite Valley (1865), one of Bierstadt's most publicly debated showpieces, is a

backlit panorama of primal existence, a vision of the land before time that diverges from many of his large works in that it does not contain humans or animals. On seeing this painting, one critic deemed Bierstadt an American genius, but Bierstadt's extravagant effects did not please everyone.[9] Another commentator called it an "acre-and-a-half of slovenly and monstrous stage-scenery".[10] The fact that the painting was exhibited in New York nearly two weeks later than scheduled, due to the assassination of Lincoln, must have accentuated the conflation of Yosemite, America and Eden. In the midst of the intense national emotion after the assassination, the painting's golden haze could easily be read as a light radiating from heaven. While admiring some of Bierstadt's mountain views, Mark Twain unerringly characterized the lily-gilding that many found in the painter's Yosemite works. "We do not want this glorified atmosphere smuggled into a portrait of Yosemite, where it surely does not belong," Twain remarked.[11]

It has long been debated whether Bierstadt's heightened visual effects were influenced by the sensation of spatial depth achieved in stereographic photography, or whether they owe to his training in European painting. Certainly Bierstadt was familiar with the surviving Baroque convention of alternating sharp contrasts of dark and light areas on the picture plane, and placing objects in the immediate foreground to give the appearance of extreme recessive space. One need not choose between these influences. The rhetoric of the old and new mediums blended efficiently. Surely the conventions of European painting lent validity to the New World's Alps; photographic effects confirmed the truth of the artist's impressions. The presence of what is either a surveying instrument or a camera in the foreground of *Rocky Mountains, "Lander's Peak"*, bears witness to the scientific accuracy of the scene.

The sensationalism of Bierstadt's paintings was frequently matched by the photographs of Eadweard Muybridge, who had visited Yosemite with the painter. The English-born Muybridge, best known for his studies of human and animal locomotion, settled in San Francisco and, like Watkins, earned a reputation as a photographer of Yosemite. He also had other careers before becoming a photographer. Following on the success of Watkins's views of the valley, Muybridge made his first trip to Yosemite in 1867. During his second trip, in 1872, he produced an important series of mammoth plate prints that competed with those on display at Watkins's Yosemite Art Gallery.

Muybridge, however, seldom quoted Watkins's soaring sublime. When Muybridge chose to dangle the viewer over a precipice, he did not amplify the effect with the hypnotic detail and eerie, airless clarity that mark Watkins's first series of Yosemite images.

Instead, he preferred to render atmospheric effects. On the other hand, Muybridge's mammoth plate *Tenaya Canyon, Valley of the Yosemite* (cat. 217) shows how he may have benefited instead from Bierstadt's techniques. Like the painter, Muybridge chose a scene with masses of dark trees in the foreground, while the distant mountains are nearly invisible in the mist.

Where Watkins adopted points of view that minimized the bleached, blank skies resulting from shortcomings in photographic technology, Muybridge – again like Bierstadt – worked to fill the sky with dramatic atmospheric effects. Although Watkins rarely put clouds in his pictures, Muybridge's devotion to impressive skies led him to invent a device that minimized overexposure of areas receiving light from the sky and thus allowed clouds to appear over the valley. Muybridge even printed separate cloud studies in the top register of his Yosemite scenes.

In fact, he treated his subject matter with some freedom. Besides the addition of clouds, he is said to have cut down many trees to achieve a view and dodged out branches on his negatives. He also created moonlight effects by underexposing prints. In one photograph, *Spirit of Tutohannula* (1867), he went so far as to have an individual portray the ghostly presence of the Native American chief said to have inhabited the summit of El Capitan. Muybridge's adjustments to the scene indicate an attitude towards photography. Where Watkins made potent symbols of the landscape, Muybridge was willing to alter the landscape itself for symbolic ends.

Muybridge was an overt interpreter of Yosemite, using strategies that audiences recognized as interventions. He relied on symbols of change, like rainbows, reflections, clouds and heavy shadows. He presented Yosemite less as a timeless Eden than as a place of personal astonishment. In the nineteenth century, storm damage and debris from floods were not routinely removed from scenic vistas in Yosemite. Watkins tended to occlude these tangles of fallen trees, but Muybridge regularly included jumbled snares, both as testament to the power of nature and as foreground devices to create greater depth in stereoscopic photographs. Yet, Muybridge was not inflexibly sensationalistic. Likely enough, his view of *Mirror Lake, Valley of the Yosemite* (cat. 218) is true to its name. The reflections on the lake are enhanced by a peaceful yet powerful horizontal design verging on abstraction.

The soaring sublime contrived by Carleton Watkins and the spectacular imagery produced by Muybridge and Bierstadt were tamer than the views of the American West rendered by artists for American and European illustrated weekly magazines. Dime novels and popular journals portrayed derring-do as a daily feature of life in a landscape

that could do no less than be breathtakingly heroic. Stylistically, Watkins, Bierstadt and Muybridge were notably different. But the contrasts in their approaches should not obscure the overarching similarity they share. Aesthetically and commercially, these artists constructed the enduring visual rhetoric with which the nation and the world viewed, and continue to view, Yosemite and the American West.

• Notes

1. For a fine review of Watkins's work, see Peter E. Palmquist, *Carleton E. Watkins, Photographer of the American West,* exhib. cat. (Albuquerque: University of New Mexico Press, 1983).

2. For a discussion of Weed, see David Robertson, *West of Eden: A History of the Art and Literature of Yosemite* (Yosemite Natural History Association; Wilderness Press, 1984), pp. 12-16.

3. *Daily Times* [San Francisco], September 15, 1859, quoted *ibid.*, p. 14.

4. Robertson 1984, p. 16.

5. Yosemite did not officially become a national park until 1890.

6. Quoted in Gordon Hendricks, *Albert Bierstadt: Painter of the American West* (New York: Harry N. Abrams, 1974), p. 73.

7. *New York Leader*, April 2, 1864, quoted in Nancy K. Anderson, "'Wondrously Full of Invention': The Western Landscapes of Albert Bierstadt," in Nancy K. Anderson and Linda S. Ferber, *Albert Bierstadt: Art and Enterprise*, exhib. cat. (New York: Brooklyn Museum, 1990), p. 78.

8. The painting was shown at the 1864 Sanitary Fair in New York to raise money for medical aid for the troops.

9. See Anderson 1990, p. 89.

10. *New York Leader*, May 20, 1865, excerpted in Anderson and Ferber 1990, p. 200.

11. Quoted in William H. Goetzmann and William N. Goetzmann, *The West of the Imagination* (New York: Norton, 1986), p. 166.

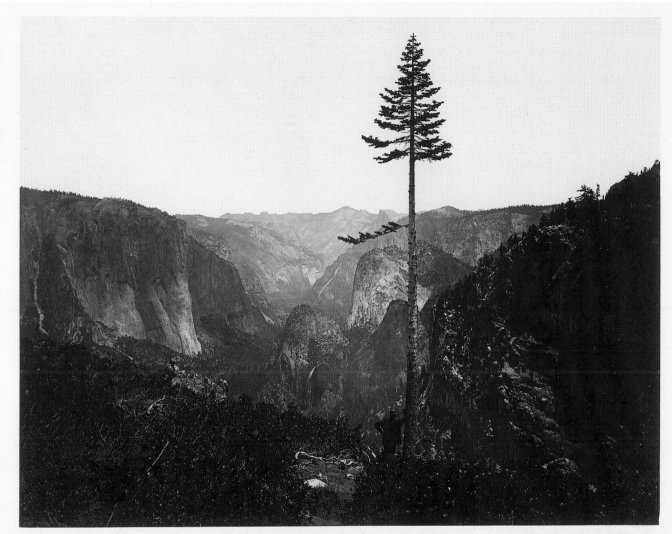

Thomas Houseworth & Co., Publishers,

Yo-Semite Valley, from the Mariposa Trail.

317-319 Montgomery St., San Francisco.

Mariposa County, Cal.

No. 1.

321• CHARLES LEANDER WEED, **YOSEMITE VALLEY FROM THE MARIPOSA TRAIL,**
MARIPOSA COUNTY, CALIFORNIA, NO. 1, 1865 ?
OTTAWA, NATIONAL GALLERY OF CANADA

Speaking in 1841 of his desire to reveal the character of America, Emerson invoked the image of the "Daguerreotype professor" who, "with camera-obscura and silver plate, begins now to traverse the land".[1] This linking of an invention synonymous with positivity to an enterprising science seems an appropriate symbol of American culture in the mid-nineteenth century, and especially of the impulse to explore that made the name of Humboldt a familiar one. However, photography became part of the exploration of the West only fairly late – scarcely earlier than 1865. Before discussing the venture, this American paradox should be explained.

Geological Views as Social Art
Explorers and Photographers
in the American West, 1859-1879

by François Brunet

Between 1840 and 1860, when daguerreotype was king, very little photography was carried out in the context of federal exploration. Pioneering attempts such as those by John C. Frémont, who tried to create his own daguerreotypes from 1842 before hiring a professional in 1853, and by Albert Bierstadt, who in 1859 accompanied a military expedition with daguerreotype equipment, have often been described.[2] Despite these attempts, there was a long period of inertia that is striking for at least three reasons: exploration and its graphic illustration began again in full spate after the war against Mexico; after 1850, if not even earlier, the West was full of photographers, some of whom experimented with capturing landscapes; and lastly, because in Canada and in colonial empires, photography was early on integrated into major missions of exploration and surveys of various kinds, in accordance with an agenda that was set up in 1839.

This remarkable delay in American exploration has been explained by the long monopoly of the daguerreotype in the United States. It was a complex process, and as Frémont had realized, only professionals could use it successfully. Furthermore, the production of a positive on metal meant that additional prints could not be made, nor could the process be used for purposes of illustration. These technical limitations, however, did not greatly change thereafter: the difficulties of the wet collodion on glass process restricted its use to experts, and although a large number of prints were possible, it could only produce printable illustrations in the form of engravings and lithographs.[3]

A more cultural explanation is suggested by the remarks of Captain James H. Simpson, an engineering officer who in 1859 experimented with daguerreotypes.

Simpson deemed photography unsuitable for the main subjects of topographical illustration, that is, "distant scenery", "extensive mountain chains and other notable objects having considerable extent", which the daguerreotype reproduced only with "a blurred effect" and "distortion of parts". Hence his conclusion, surprising as late as 1859, that "the camera is not adapted to explorations in the field, and a good artist, who can sketch readily and accurately, is much to be preferred".[4]

Distant scenery and other sizable natural features fed into the panoramic vision typical of "Humboldtian" exploration, as can be seen in hundreds of plates.[5] If, however, photography was rarely a part of surveys before 1860, it was mainly for organizational reasons. Exploration at the time was the prerogative of the military engineer corps, which championed a strategic and topographical approach to terrain, with little concern for illustration, especially of geology. In topography, mapmaking, panoramas and line drawing views, this approach was linked to the techniques and practice of draftsmanship, which attained a finesse unequalled since. It is significant that in 1859 Captain Simpson was still thinking of drawing and photography as mutually exclusive. It would seem that engineering officers had not yet considered the uses of photography and were reluctant to abandon tried and true skills and habits for an ideologically prestigious invention that nonetheless was tainted with charlatanism.[6]

The rapid development that made photographers indispensable to exploration after the Civil War was largely the result of the experience of the war, during which the army had discovered that photography was a profession and not an abstract entity. Above all, however, this development was due to changes in the process of exploration itself, and to new challenges – railroads and western settlement. After the war, the former topographical logic gave way – even among the military – to a viewpoint influenced by geology, economic considerations and society's expectations.[7] Thus, between 1867 and 1879, four large-scale undertakings, the great surveys, were inaugurated and continued; these, by incorporating photography and photographers into exploration, demonstrated the new concern for illustration and visual communication.

The first of these missions, the Geological Survey of the Fortieth Parallel, was led by the gifted geologist and adventurer Clarence King, who had earned his laurels and discovered an interest in photography as a member of the California Geological Survey.[8] His innovative personnel roster included a salaried photographer, Timothy H. O'Sullivan, a former employee of the Army of the Potomac.[9] This addition of a *salaried* official photographer, which guaranteed the survey his constant availability and the full use

of his negatives, became one of the characteristics of the great surveys. The King, Wheeler, Hayden and Powell surveys regularly employed photographers, the best known of them being O'Sullivan, William H. Jackson, William Bell and John K. Hillers.[10] These ventures thus amassed large archives – at least several thousand negatives – at the cost of an equally large investment, which increased in proportion to the rivalry between them until they were wound up in 1879.

As a result of this outpouring of energy, which was scarcely if at all controlled by Congress, by 1873 the federal government had become a major producer and distributor of photographs. Indeed, the images were not confined to the internal use of the surveys. The outstanding ones were reproduced in the reports, but three of the four ventures concerned distributed a great number of proofs among scientific, economic and political circles, selling some also to the general public. Thus, it is hard to define in strictly scientific terms the significance of this one-of-a-kind body of work, the production of which seems to have been largely motivated by the logic of public demand.

<center>*</center>

The photographers, who were experts at picture making, albeit without expertise or academic standing, played a new role in the exploration process. In many ways, they were outsiders to its structure and methods: even the time required for their activities was incompatible with that of triangulations or specimen collecting. Although they took part in and illustrated the human adventure of the surveys, they often operated quite separately from the explorers, who in general could not or would not oversee their work. The reports are mainly laconic on the subject, or confined to tallies of "views" together with very general essays on "the value of photography"; this reflects the legal and budgetary need to justify a practice that was in fact scarcely regulated at all and that the geographers and geologists were reluctant to codify. The total and persistent indifference of American explorers to the advances made from about 1860 on in techniques of photography-based topographical surveying, known as photogrammetry, and used in Europe and Canada, is striking; this indifference shows that the methodological research that could have made photographers real scientific assistants was not attempted, or even considered.[11] The one important exception to this rule – the huge ethnographic survey initiated by Hayden's and particularly Powell's ventures, and continued after 1880 by the Powell-Hillers team[12] – is not relevant here.

If there were nevertheless true working relationships between explorers and photographers, they are hard to define. The fascinating diaries of the members of the Powell survey in 1871-1872 show that the explorers quite often asked for specific images from the photographers, who were interested in geological phenomena and wished to depict them in an "effective" manner.[13] This kind of synergy was most common in geology. The diaries of the geologist Grove K. Gilbert, who worked successively with the Wheeler and Powell expeditions, indicate that he kept in close touch with the photographers' work.[14] In the series produced by O'Sullivan and Bell – the two photographers who worked with Gilbert – there are several close-up photographs of rocky masses and silhouettes, probably inspired by Gilbert (cat. 17). Some photographers working alone, however, also chose to use the same "geological" motif, if only in a symbolic or humorous way: examples are Andrew J. Russell and William H. Jackson, even before his collaboration with the Hayden survey (fig. 1). These fantasies of rock were very much to public taste.

In contrast, it has been suggested that the harsh shapes of volcanic formations photographed by O'Sullivan in Nevada in 1868-1869 may have been inspired by the theory of catastrophism attributed to Clarence King.[15] This geological theory privileged sudden convulsions and fractures over slow and continuous movements; its recurrent popularity in the United States was connected with powerful and definite theological and political themes to which King responded despite his rather syncretic epistemology. It should be noted, however, that the catastrophist theory concentrated on telluric occurrences of such magnitude that no sort of photograph could illustrate

FIG. 1 – WILLIAM HENRY JACKSON
TEAPOT ROCK,
NEAR GREEN RIVER STATION, WYOMING, 1869

them except anecdotally. Moreover, despite the rugged and contorted look of O'Sullivan's landscapes, his main shots were reproduced in a popular magazine (figs. 2a-c) with a half-serious, half-humorous commentary

<center>87</center>

that is less about geological theory than about the photographer's impressions as a sort of tourist: "It was a pretty location to work in, and *viewing* there was as pleasant work as could be desired."[16] King no doubt encouraged and appreciated these images, some of which are precisely echoed in sketches in his notebooks, but his interest in photography was less that of a theoretician than of an aesthete.[17]

Ironically, the clearest example of a didactic discussion of geological photography came from Grove K. Gilbert, whose interpretation of the formation of the Utah Basin was resolutely evolutionist, that is to say, anti-catastrophist. In a report of 1872, as commentary on the reproduction of a photograph by William Bell showing an escarpment of sandy conglomerates fluted by runoff (fig. 3), the great geologist explained,

> It is in the presentation of such subjects as these that the camera affords the greatest aid to the geologist; only with infinite pains could the draughtsman give expression to the systematic heterogeneity of the material, and, at the same time, embody in his sketch the wonderfully convoluted surface, so suggestive of the folds of heavy drapery.[18]

This very atypical analysis reflects a genuine epistemology of geological imaging. Gilbert admired the way photography could present both the beauty of the visual ("the wonderfully convoluted surface") and the logic of the structure ("the systematic heterogeneity of the material"), as well as attest through what he later calls its "guarantee of accuracy" to the continuity between surface and structure, without the imposition of figuration inherent in drawing. This continuity between surface and structure was particularly important to Gilbert's geomorphology; he was like Darwin in his phenomenalist rejection of secret depths and his faith in the exegesis of surface networks.[19] Though only poorly reproduced in the 1872 report, Bell's photograph allowed the geologist to "publish [the] lesson" of runoff. This example nevertheless represents the borderline case of a practice that frequently went beyond the bounds of its scientific rationalization.

*

"Everyone can understand a picture," trumpeted an editorial of 1875 in the *New York Times* that asked the federal government to disseminate photographs of explorations more widely. Unlike the geological and botanic studies published in the reports, destined for "the select few", the pictures could show everyone the appearance of the land explored and the work of the explorers.[20] During the 1870s, such demands for popularization often appeared in the press, not in support of the refined theories of someone like Gilbert, but rather in testimony to public curiosity

2A

2B

2C

FIGS. 2A-C - ILLUSTRATIONS FROM
HARPER'S NEW MONTHLY MAGAZINE (1869)
AFTER PHOTOGRAPHS BY TIMOTHY H. O'SULLIVAN
A. **PYRAMID LAKE**
B. **STRANGE TUFA**
C. **THE CARSON SINK**

FIG. 3 - WILLIAM BELL
RAIN SCULPTURE,
SALT CREEK CAÑON, UTAH, 1872

cataloguing and distributing views, providing the geographical discourse with the visual expression called for by the *New York Times*. The success of this system more or less transformed the Hayden Survey into a photographic agency.[22]

The same concern for making publication and distribution easier led the other expeditions to adopt similar filing systems, evident in the labelling and serializing procedures, and in the numbering of the negatives, visible on some prints.

As well as recording the scientific exploration of the terrain, these views constituted an inventory of a visual continent, an objective and instantly apparent visual domain: what Jack Hillers called "all the best scenery". This landscape heritage, institutionalized in the National Park System, was the more readily accepted by popular culture because it put a face on the promise of the West, and photographic images of it gave the illusion of taking part in the exploration. Photographers identified with this illusion, sometimes giving it an unexpected twist.

Let us consider the picture *Chocolate Butte, near Mouth of the Paria* (cat. 16), taken about 1872 in the area around the Grand Canyon by William H. Bell, who briefly took part in the Wheeler Survey. The first thing one notices is the rocky peak named in the title: a "chocolate butte" (so called from its brownish colour) projecting over the Arizona desert a denying and tempting symbol of sweet abundance. The regularly veined bedrock is reminiscent (if we extend the pastry shop metaphor) of a layer cake, the icing being the scree visible on the right. This sort of musing is not out of place in the context of an exploration project that helped to consolidate the myth of the West as the Garden of the World, but it is nevertheless interrupted by the sense of the sublime, the titanic scale of the scene and, above all, the presence of two men standing at the foot of the butte. The prominence of their position in the picture, in the centre foreground, indicates that they are its subject just as much as Chocolate Butte itself.

Clearly, these two observers are not there simply to indicate scale: they are also symbolic spectators. As in other photographs of the Grand Canyon, Bell goes back here to a classic picturesque convention, widely seen in the photographic output of exploration. Their position at centre stage, their ordinary clothes and their attitude, which is both casual and awestruck, make the two seem to represent, within the context of exploration, ordinary curiosity, the gaze of "real people": these are average citizens, those the *New York Times* was speaking in behalf of, who could appreciate the humour of a chocolate mountain in the middle of a desert. At the same time, and more specifically, they represent the very act of looking. Jackson regularly had the painter Moran pose in his photographs of Yellowstone. O'Sullivan went much

about the exploration of the West, a curiosity comparable in intensity to the excitement surrounding lunar exploration in the 1960s. The role of photography in relaying this undertaking to the people was indeed not unlike that of television at the time of Apollo 9. In 1870, photography was considered primarily as a means of "armchair travel", a stock phrase at the time for stereoscopy, which, together with prints in the press, was the most widespread disseminator of "views" of the West.[21] Even when displayed in large format in such high-profile settings as Philadelphia's 1876 Centennial Exposition, these views had no epistemological or aesthetic connotations for the public at large. As a continuation of the tradition of the picturesque, they were part of what could be called an order of visual evidentiality aimed at revealing, identifying and illustrating what were then called "the wonders of the West".

In 1875, the prime example of the marvellous in landscape was the Yellowstone region, made popular by Thomas Moran's paintings and William H. Jackson's photographs (cat. 137). Jackson, who excelled at creating edifying images, seems to have been particularly in tune with the imagination of his era. In co-operation with his employer Ferdinand V. Hayden, he established an elaborate system of filing,

further by giving the spectator a distinctly mirrorlike and often enigmatic posture (cat. 232), sometimes including an interplay of mirrors or explicit traces of himself, his body and his equipment.

Bell, perhaps less daring, nevertheless made an unusual choice in placing two spectators in the same view. One of the men, in the exact centre, has his back turned and is looking at Chocolate Butte; the second, to his right, is turned towards the left and seems to be looking beyond the frame. This juncture opening out off-camera evokes scientific observation: the searching, comparing gaze of the geologists who were then attempting to establish the overall structure of the Grand Canyon basin.[23] This sort of miming was also justified by the public's curiosity, which was as keen in regard to geology, its methods and personalities, as to landscapes. This photograph was reproduced in heliotype as the frontispiece of the main geological publication of the Wheeler Survey.[24]

This duplication of viewpoints is, finally, reminiscent of the serial status of the views, which in almost all cases were conceived, produced and distributed as sets, particularly narrative ones.[25] The body of work produced by exploration includes many examples of groups and sequences of images linked to one another in order to reconstitute the movement of travel through visual narration, as in albums and series of stereoscopic views; to compose panoramas (something Jackson often did); to study variations in lighting; or to outline sites according to the quasi-photogrammetric principle of the shot-reverse shot.[26] Although this serial presentation involved didactic and narrative purposes of an academic sort, photographers were quite willing to adopt it, as though they had found in it an opportunity to demonstrate a form of virtuosity. The undisputed master of these games was O'Sullivan, who favoured circular coverage; an example is his remarkable series of Snake River Falls views,[27] two of which were reproduced as lithographs in King's final report. But Bell too had recourse to this method (figs. 4a-b); as he himself explained, the difficulties of collodion photography in the Grand Canyon obliged the cameraman "on the lookout for views" to concentrate on places "whence three or four can be had".[28]

＊

Thus, it was his own experience as a prospector for views that Bell staged in the Chocolate Butte photograph, while O'Sullivan pushed the rhetoric of the gaze to the verge of self-portraiture. The emphasis on this mirror motif may seem surprising. The photographic work of American exploration was certainly not just a narcissistic exercise aimed at the media – although, as Tocqueville noted, the conquest of

FIG. 4A - WILLIAM BELL
CAÑON OF KANAB WASH, COLORADO RIVER,
LOOKING NORTH, 1872

the West was not without an element of collective narcissism.[29] But this narcissism itself was above all the expression of a national passion for exploration, and photographers were its natural intermediaries. That is why, even when the images act as self-representation, they always relate back to a social or cultural order – a collective viewpoint – rather than to the academic or psychological categories sometimes applied to them ("science" or "art", "document" or "landscape").[30] In the views, individual intentions and specific content are less important than the complex and collective system of production and representation by which they are ordered. In the same way, methods of exploration were governed less by the logic of genres and disciplines than by that of organizations and networks: institutions and professions, political, economic and social links. Explorers and photographers, subject to excessively standardized budgetary and institutional reasoning, could scarcely formulate officially the reality of their practice, which was often more playful than has been thought. That is the reason why we have today the opportunity and the duty to turn again to these unforgettable views, to seek in the brilliance of albumen paper the subtle art of those W. H. Jackson called "government photographers".[31]

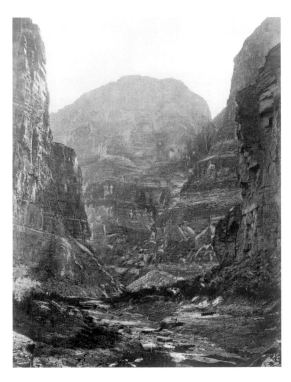

FIG. 4B - WILLIAM BELL
CAÑON OF KANAB WASH, COLORADO RIVER,
LOOKING SOUTH, 1872

• Notes

1. *The Collected Works of Ralph Waldo Emerson*, ed. Alfred R. Ferguson, vol. 1 (Cambridge, Massachusetts: Belknap Press, 1971), p. 170 ("Lectures on the Times").

2. See Robert Taft, *Photography and the American Scene: A Social History, 1839-1889* (New York: Dover, 1964), pp. 261-268; and Eugene Ostroff, *Western Views and Eastern Visions*, exhib. cat. (Washington: Smithsonian Institution Traveling Exhibition Service, 1981), pp. 10-18.

3. A large number of which can be found in Ostroff 1981.

4. Quoted by Taft 1964, pp. 266-267; and Ron Tyler, "Prints vs. Photographs, 1840-1860", in May Castleberry, ed., *Perpetual Mirage: Photographic Narratives of the Desert West*, exhib. cat. (New York: Whitney Museum of American Art, 1996), pp. 45-46.

5. Notably in the reports of the Pacific Railroad Surveys and the Mexican Boundary Survey: see William H. Goetzmann and William N. Goetzmann, *The West of the Imagination* (New York: Norton, 1986), pp. 100-111; Herman J. Viola, *Exploring the West* (Washington: Smithsonian Books, 1987), pp. 86-119; and Tyler 1996, pp. 41-47.

6. On the tribulations in the profession in the 1850s, see William Welling, *Photography in America: The Formative Years, 1839-1900* (Albuquerque: University of New Mexico Press, 1987), pp. 81-137.

7. William H. Goetzmann, *Exploration and Empire: The Explorer and the Scientist in the Winning of the American West* (New York: Knopf, 1978), pp. 355 and following, p. 430. See Patricia Hills, "Picturing Progress in the Era of Westward Expansion", in William H. Truettner, ed., *The West as America: Reinterpreting Images of the Frontier, 1820-1920*, exhib. cat. (Washington: Smithsonian Institution Press, 1991), pp. 97-147.

8. W. H. Goetzmann 1978, pp. 374-385, 430-433; and Peter E. Palmquist, *Carleton E. Watkins, Photographer of the American West*, exhib. cat. (Albuquerque: University of New Mexico Press, 1983), pp. 23-25.

9. Recent reference works are Joel Snyder, *American Frontiers: The Photographs of Timothy H. O'Sullivan, 1867-1874*, exhib. cat. (Millerton, New York: Aperture, 1981); and Rick Dingus, *The Photographic Artifacts of Timothy O'Sullivan* (Albuquerque: University of New Mexico Press, 1982).

10. See primarily Weston J. Naef and James N. Wood, *Era of Exploration: The Rise of Landscape Photography in the American West, 1860-1885* (Buffalo: Albright-Knox Art Gallery; New York: Metropolitan Museum, 1975).

11. As indicated *a contrario* by the self-conscious statements of programme of Lieutenant George M. Wheeler, *Progress-report upon Geographical and Geological Explorations and Surveys West of the One Hundredth Meridian in 1872* (Washington: Government Printing Office, 1874), pp. 11-12. On the history of photogrammetry and its spread, see Aimé Laussedat, *Recherches sur les instruments, les méthodes et le dessin topographiques* (Paris: Gauthier-Villars, 1899-1903), especially Tome 2, Part 2, p. 14.

12. At the Bureau of American Ethnology. See Paula Richardson Fleming and Judith Luskey, *The North American Indians in Early Photographs* (New York: Dorset, 1988), pp. 102-178, and Don D. Fowler, *The Western Photographs of John K. Hillers: "Myself in the Water"* (Washington: Smithsonian Institution Press, 1989).

13. See William C. Darrah *et al.*, eds., "The Exploration of the Colorado River and the High Plateaus of Utah in 1871-1872", *Utah Historical Quarterly*, vols. 16-17 (1948-1949), in particular "Journal of Walter Clement Powell", pp. 257-478; and *"Photographed All the Best Scenery": Jack Hillers's Diary of the Powell Expeditions, 1871-1875*, ed. Don D. Fowler (Salt Lake City: University of Utah Press, 1972). Corroborating memories can be found in W. H. Jackson, *Time Exposure* [1940] (Albuquerque: University of New Mexico Press, 1986).

14. See Stephen J. Pyne, *Grove Karl Gilbert, a Great Engine of Research* (Austin: University of Texas Press, 1980), pp. 42-45; and Dingus 1982, p. 59.

15. Snyder 1981, pp. 48-49; see the recent summary of the debate in William H. Goetzmann, "Desolation, Thy Name Is the Great Basin: Clarence King's 40th Parallel Explorations" in Castleberry 1996, pp. 57-61.

16. Quoted in [John Sampson], "Photographs from the High Rockies", *Harper's New Monthly Magazine*, vol. 39, no. 232 (1869), p. 471.

17. See Alan Trachtenberg, *Reading American Photographs: Images as History, Matthew Brady to Walker Evans* (New York: Hill and Wang, 1989), pp. 119-121.

18. G. K. Gilbert, in Wheeler 1874, p. 11.

19. Pyne 1980, pp. 51-57; François Dagognet, *Une épisté-mologie de l'espace concret : Néogéographie* (Paris: Vrin, 1977), pp. 76-94.

20. "The Hayden Survey", *New York Times*, April 27, 1875, p. 1.

21. On the concept of the view and its application in the exploration of the West, see Rosalind Krauss, "Photography's Discursive Spaces: Landscape/View", *The Art Journal*, vol. 42

(1982), pp. 312-319; and Alan Trachtenberg, "Naming the View", in Trachtenberg 1989, pp. 119-163.

22. See François Brunet, "Picture Maker of the Old West: W. H. Jackson and the Birth of Photographic Archives in the United States", *Prospects: An Annual of American Cultural Studies*, vol. 19 (1994), pp. 161-187.

23. On this subject, see the impressive and superbly illustrated overview by John W. Powell, *The Exploration of the Colorado River and Its Canyons* [1895] (New York: Dover, 1961), pp. 379-397.

24. George M. Wheeler, *Report upon Geographical and Geological Explorations and Surveys West of the One Hundredth Meridian*, vol. 3, *Geology* (Washington: Government Printing Office, 1875), frontispiece.

25. See Castleberry 1996, pp. 7-29.

26. As has been demonstrated clearly and decisively, especially in reference to O'Sullivan, in the rephotographic research of Mark Klett *et al.*, *Second View: The Rephotographic Survey Project* (Albuquerque: University of New Mexico Press, 1984). See also the very detailed analyses of Dingus 1982, pp. 33-64.

27. On these series and their aesthetic significance for King and O'Sullivan, see the analyses in Synder 1981, pp. 49-51, and especially Dingus 1982, pp. 87-90.

28. William Bell, "Photography in the Grand Gulch of the Colorado River", *The Philadelphia Photographer*, vol. 10, no. 109 (1873), p. 10. Comparable remarks can be found in Jackson's autobiography (cited in note 13 above) and in the illustrated account by John Sampson (cited note 16).

29. "The American people sees itself striding across these deserts ... This magnificent image of themselves ... follows each of them in their least as in their principal actions." (Alexis de Tocqueville, *De la démocratie en Amérique*, Tome 2, Part 1, Chapter 17.)

30. See among others Naef and Wood 1975, pp. 70-71.

31. Quoted in Taft 1964, p. 288.

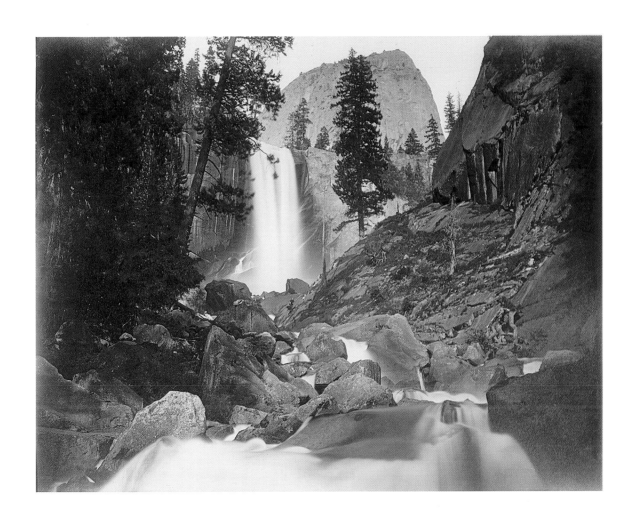

316· CARLETON WATKINS, **VERNAL FALLS, 300 FEET, YOSEMITE, NO. 87**, 1861
THE NEW YORK PUBLIC LIBRARY

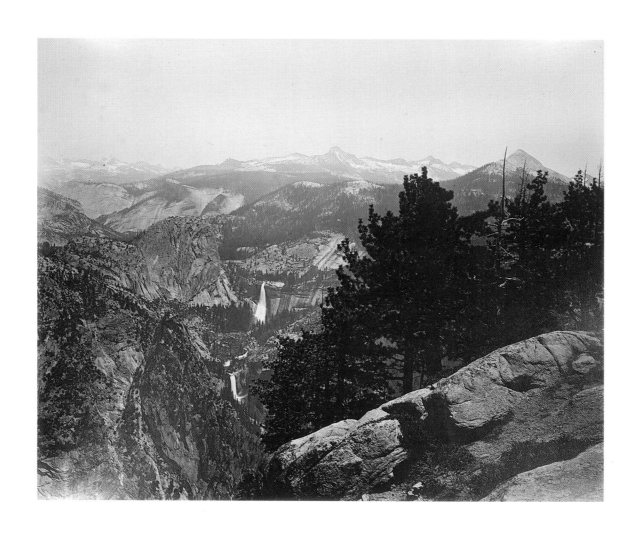

319· CARLETON WATKINS, **VERNAL AND NEVADA FALLS FROM GLACIER POINT, YOSEMITE**, ABOUT 1866
THE NEW YORK PUBLIC LIBRARY

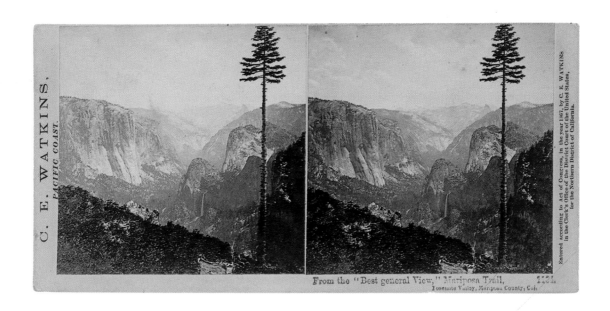

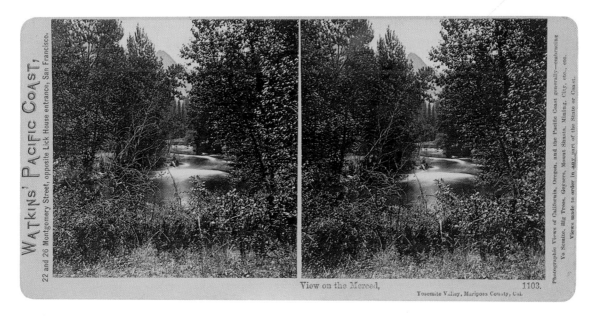

CARLETON WATKINS

313· FROM THE BEST GENERAL VIEW, MARIPOSA TRAIL, 1860s

315· VIEW ON THE MERCED, 1860s

THE NEW YORK PUBLIC LIBRARY

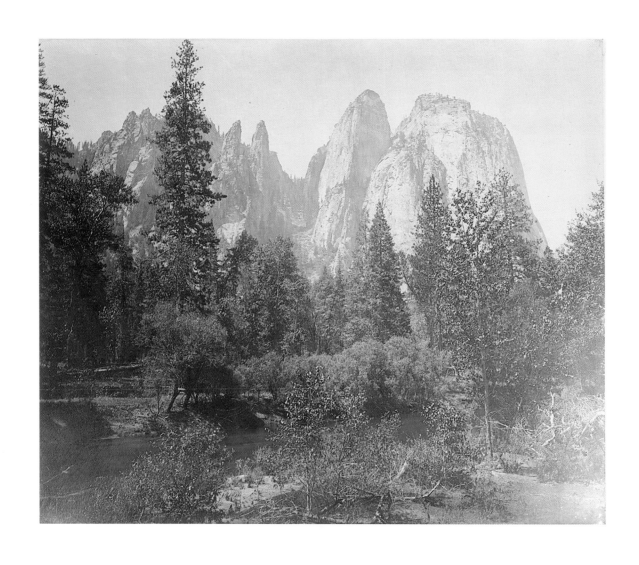

320• CHARLES LEANDER WEED, **CATHEDRAL ROCKS**, ABOUT 1864-1865
THE NEW YORK PUBLIC LIBRARY

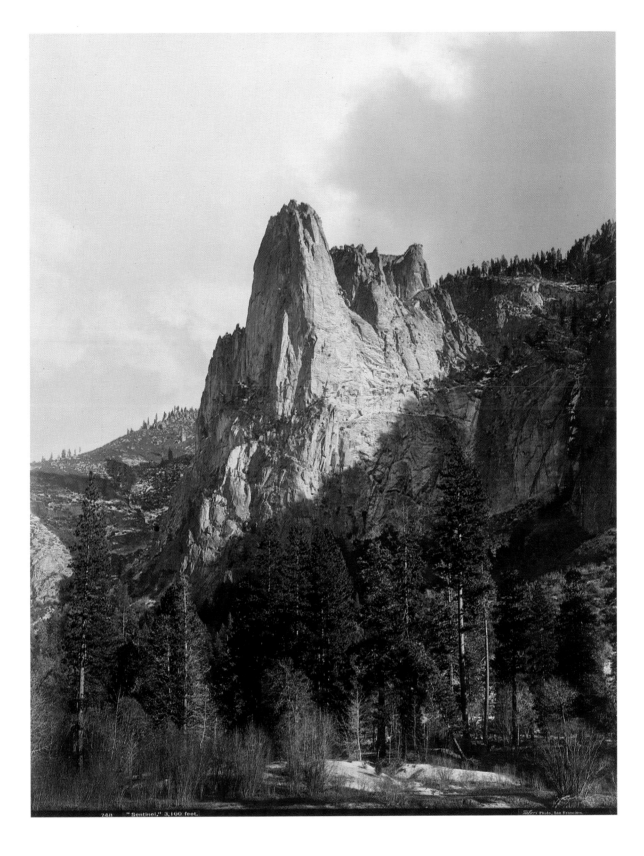

318• CARLETON WATKINS, **THE SENTINEL, 3100 FEET**, 1865-1866
NEW YORK, THE METROPOLITAN MUSEUM OF ART

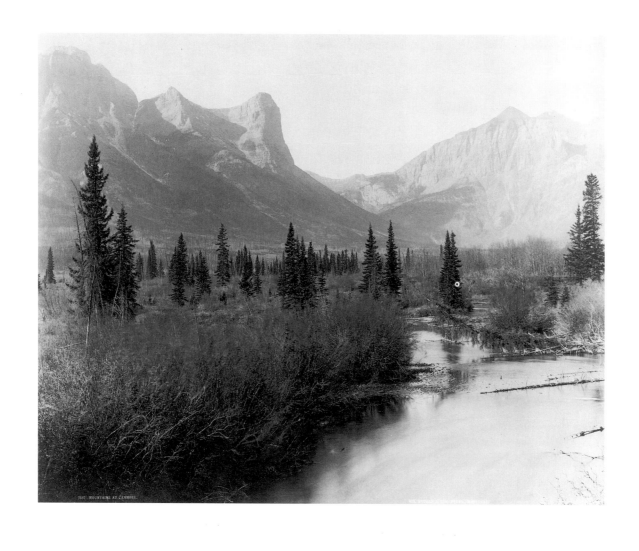

230• WILLIAM McFARLANE NOTMAN, **MOUNTAINS AT CANMORE**, 1889
OTTAWA, NATIONAL GALLERY OF CANADA

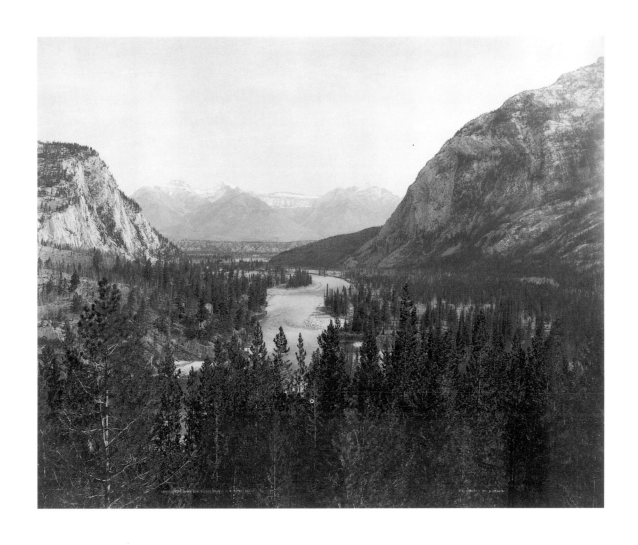

229• WILLIAM McFARLANE NOTMAN, **LOOKING DOWN BOW VALLEY FROM CPR HOTEL, BANFF**, 1887
OTTAWA, NATIONAL GALLERY OF CANADA

TIMOTHY O'SULLIVAN

231· ROCK FORMATIONS (TUFA DOMES), PYRAMID LAKE, NEVADA, 1867

232· STEAMBOAT SPRINGS, RUBY VALLEY, NEVADA, 1867

UNIVERSITY OF WISCONSIN-MILWAUKEE LIBRARY, THE AMERICAN GEOGRAPHICAL SOCIETY COLLECTION

233• TIMOTHY O'SULLIVAN, **TUFA: PYRAMID LAKE**, 1867
UNIVERSITY OF WISCONSIN-MILWAUKEE LIBRARY, THE AMERICAN GEOGRAPHICAL SOCIETY COLLECTION

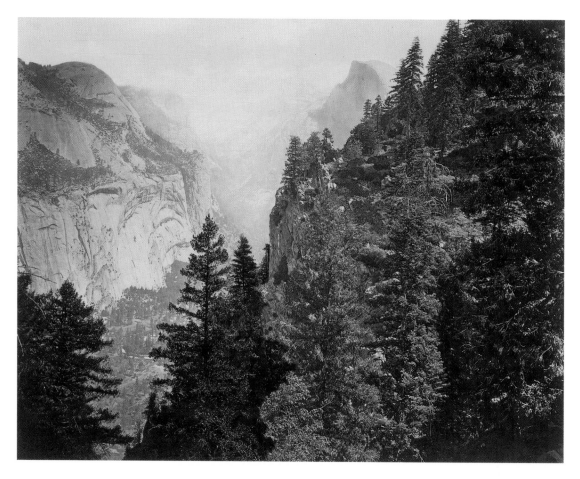

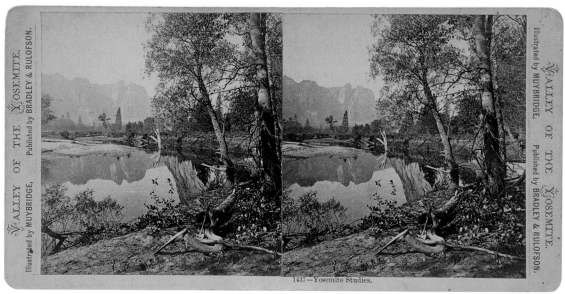

217• EADWEARD MUYBRIDGE, **TENAYA CANYON, VALLEY OF THE YOSEMITE FROM UNION POINT**, 1872
NEW YORK, THE METROPOLITAN MUSEUM OF ART

219• EADWEARD MUYBRIDGE, **YOSEMITE STUDIES**, 1872
THE NEW YORK PUBLIC LIBRARY

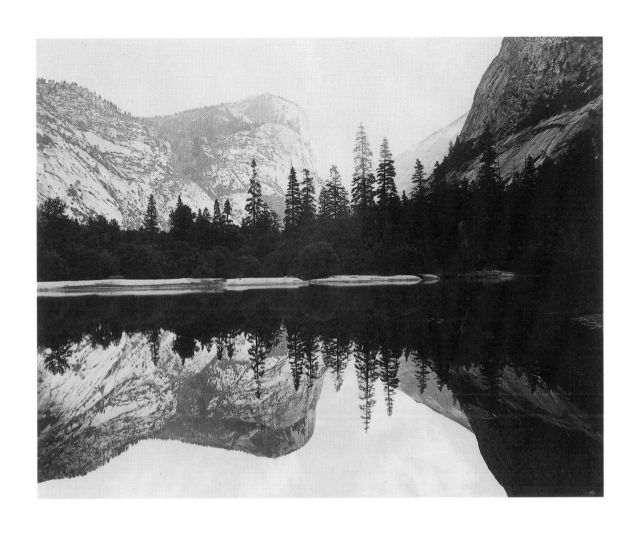

218· EADWEARD MUYBRIDGE, **MIRROR LAKE, VALLEY OF THE YOSEMITE**, 1872
NEW YORK, THE METROPOLITAN MUSEUM OF ART

PERCHED ROCK, ROCKER CREEK, ARIZONA.

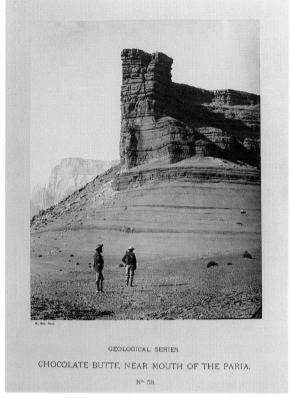

GEOLOGICAL SERIES.

CHOCOLATE BUTTE, NEAR MOUTH OF THE PARIA.

Nᵒ. 58.

17· WILLIAM BELL, **PERCHED ROCK, ROCKER CREEK, ARIZONA**, 1874 ? OTTAWA, MUSÉE DES BEAUX-ARTS DU CANADA

16· WILLIAM BELL, **CHOCOLATE BUTTE, NEAR MOUTH OF THE PARIA**, ABOUT 1872 THE NEW YORK PUBLIC LIBRARY

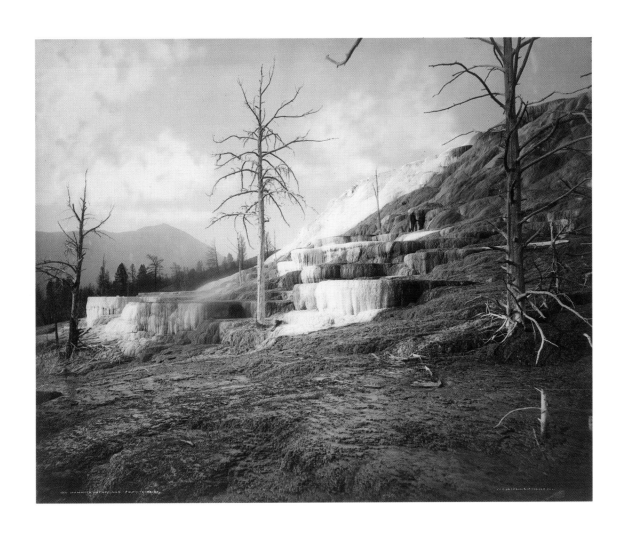

137· WILLIAM HENRY JACKSON, **MAMMOTH HOT SPRINGS, PULPIT TERRACES, YELLOWSTONE**, ABOUT 1883
NEW YORK, THE METROPOLITAN MUSEUM OF ART

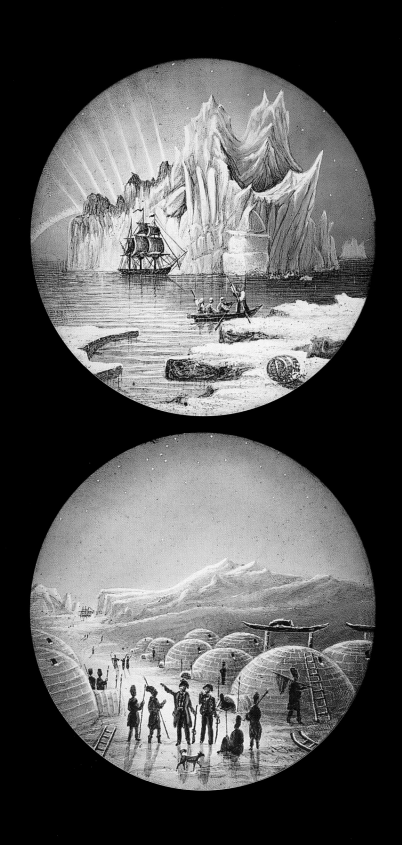

329• ARTIST UNKNOWN, **TWO LANTERN SLIDES OF ARCTIC SUBJECTS**
ICEBERG AND IGLOOS, MID-19TH C.
TORONTO, ROYAL ONTARIO MUSEUM

- 3 -
THE VOYAGE
TO THE POLES

For centuries, man has been fascinated with the remote and little-known polar regions. Unlike the continental landmass, the Arctic is a glacial archipelago of islands and moving pack ice that alters the contours of the terrain with each passing season. For explorers, charting a return course was thus not the same as retracing one's steps overland; it required an equally difficult and original journey to come home. As a literal, metaphorical and spiritual landscape, the Far North has served as a proving ground for those who would test their strength in a beautiful yet forbidding environment. As explorers plied the northern

Artistic Conquest of the Far North

Eleanor Jones Harvey

waters, painters and writers alike created visions of the Far North, presenting them to an audience as receptive to their works as to the published accounts of each explorer's voyage. The alien nature of the Arctic landscape posed a particular challenge for painters, accustomed as they were to painting landscapes whose features were fixed and far more

seemed to represent the very essence of the potentially fatal lure of the unknown.[1] In fact, the greater number of far northern landscapes and seascapes painted by nineteenth- and early twentieth-century artists focussed on the region's powerful spiritual pull, apparent in works as diverse as Peder Balke's *Seascape* (cat. 9) and Gustave Doré's illustrations for Coleridge's *Rime of the Ancient Mariner* (cats. 94, 360). The symbolic qualities of this alien region presented a paradigm for the hero-explorer (or nation) who set out to test himself against God and nature, on a quest for spiritual regeneration that would forever change the protagonist who did survive.

The Arctic might seem an unlikely locus for spiritual epiphany were it not for the centuries-old belief in a mythic open polar sea. Proponents of the myth, including respected scientists and explorers, held that a warm-water tropical paradise existed at the top of the world, ringed by icebergs and glaciers. The search for this elusive Arctic Eden resembles the world-myth of the hero who, embarking on a quest for enlightenment, must travel beyond the known limits of the world to achieve his goal. Such a quest took concrete form in the attempt to discover

from Franklin's expedition in 1859, ships still plied the Arctic waters. As Tennyson wrote, in affirmation of the region's grip on the imagination, "There is nothing worth living for but to have one's name inscribed on the Arctic chart."[2] This sentiment also informed explorers' narratives, notably those of Elisha Kent Kane,[3] who combined scientific observation with literary invention in an attempt to convey the Arctic's mutable nature. In 1860, Isaac Hayes, an American doctor and renowned polar explorer, organized an expedition to the Arctic to prove the existence of the open polar sea;[4] he published his theories seven years later to wide acclaim.[5] His enthusiasm, coupled with his professional credentials, extended the life of the myth late into the nineteenth century.

What drove explorers also inspired artists to look north for a new artistic frontier. Between 1850 and 1880, artists from the United States paid particular attention to the Canadian Arctic, finding in the frozen landscape an opportunity to craft a distinctive statement about personal heroism, spiritual growth and cultural identity. In the United States, fascination with the Arctic provided a welcome distraction from the war with Mexico and the growing turmoil that would lead to the Civil War. The search for Franklin was made less abstract for Americans thanks to the presence of Lady Jane Franklin, who toured the United States first in 1850 and again in 1860 under the auspices of Henry Grinnell, a New York philanthropist and shipping magnate who sent two expeditions of his own to search for her husband.[6] She did more than raise money to outfit ships: her personalized mission satisfied the need for diversion from the domestic rumblings preceding the outbreak of the internal conflict. Conceived as a romantic rescue mission, the search for Franklin soon gave way to more individual goals, as explorers, responding to the challenge of travelling farther north and west than the last explorer, vied to establish records for fortitude and endurance and to name Arctic landmarks. Expansionist tendencies in the United States, a hallmark of the settlement of the American West, found in the Arctic a new kind of frontier.

Frederic Edwin Church is best known of the American artists who turned their eyes northward. Accompanying him to Labrador in 1859 was the Reverend Louis Legrand Noble, who chronicled their adventures. Two years later, Noble published *After Icebergs with a Painter*, describing the hazards of seasickness and calving icebergs the artist experienced while sketching on the ship's deck. Church captured the otherworldly quality of the floating icebergs in his vibrant, rapidly painted plein-air oil sketches (cats. 60, 65-66) that also provided the raw material for his monumental painting *The Icebergs* (cat. 67), completed in 1861 as the Civil War began.

Church's *Icebergs*, first painted as a straight-forward Arctic "landscape", dedicated to the "North" (in this case, the Union Patriotic Fund), was transformed with his addition in 1863 of the broken mast in the foreground. Church's Arctic is only nominally that of Franklin. If the shattered mast, often interpreted as a symbolic marker for all explorers who perished in the Arctic, was a marketing ploy aimed (successfully) at his British audience, it was equally a literal and figurative cross in the wilderness. That spiritual component was integral to the American landscape tradition, derived from Enlightenment thinking. During the mid-nineteenth century, it evolved into a form of Protestant deism acknowledging the appreciation of nature as a form of artistic religion, to be preached by the artist and worshipped by the masses, each participant deriving grace from the encounter.

The search for Franklin was frequently described in terms borrowed from religion; popular were analogies to the Crusades, in which the would-be rescuers pursued a kind of grail – if not Franklin, then the Northwest Passage or even the North Pole. In fact, the lure of the Arctic outlasted the search for Franklin precisely because the region offered something badly needed in war-torn America: a quest that provided opportunities for individual acts of fortitude and heroism, coupled with national prerogatives of expansion and conquest. The impulse to map and name (or rename) distinctive features was an attempt to fix an identity to an alien landscape. It was an honour bestowed on artists as well as explorers, notably Church, for whom Hayes named "Church's Peak", the pyramidal mountain that appears in the centre of *Aurora Borealis* (fig. 3), unveiled in 1865.[7] The artist's second large-scale Arctic drama portrays Hayes's icebound ship, the crew waiting out the six-month Arctic winter, gambling that the spring thaw will release the ship undamaged. As a dogsled skims the surface, the northern lights flicker in the sky, bathing the landscape in an eerie greenish red glow, the unearthly tones a reminder of the uncertainty of the expedition's fate.

A devotee of Humboldt's writings, Church perceived the Arctic to be a region of geological antiquity in which time appeared to be frozen. In this regard, it was an obvious counterpoint to the volcanic activity he witnessed in South America, where the earth itself was being born in violent, sulfurous eruptions. *Cotopaxi* presents the newly formed landscape as a sea of fire and brimstone, its heat reflected in the lurid palette saturating the surrounding countryside. For Church, the twin themes of fire and ice carried deeper meaning; the artist shared Humboldt's interest in making the mysteries of the universe manifest through science and religion. The cross of light implicit in the transverse

FIG. 3 - FREDERIC EDWIN CHURCH
AURORA BOREALIS, 1865

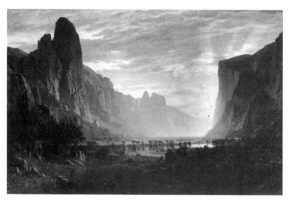

FIG. 4 - ALBERT BIERSTADT
LOOKING DOWN YOSEMITE VALLEY
1865

rays of *Cotopaxi*'s setting sun mirrors the broken mast added to *The Icebergs*.

The need to find another frontier was an intrinsic part of American culture. Yet, the Arctic evolved into a realm concerned less with conquest and more with individual and national soul-searching, as though by its very alien and deadly qualities, the Arctic could help Americans come to grips with domestic strife and emerge whole again, in possession of a new frontier ethos carved from the ice. Artists in the United States depicted the Arctic as a counterpoint to the confident promise of the western frontier, alternately presenting the Far North as an icy version of the West, ripe for exploration, and an inhospitable setting for disaster. This dichotomy reflected the mood in the United States during and after the Civil War. The American vision of the Arctic was essentially a psychological frontier for a nation adrift. Indeed, the region served as an alternative frontier for a generation in search of the answers to the same questions faced by polar explorers: can you go beyond the known limits of the world and come back again from a journey through a landscape that will kill you if given the chance?

The rigours of Arctic exploration made the opening of the American West seem like a stroll through Paradise. Albert Bierstadt's *Looking down Yosemite Valley* (fig. 4), exhibited in 1865 at the end of the war, presents a landscape of awe-inspiring scenery awash in light, epitomizing the region's golden promise. Bierstadt's companion on his trip to Yosemite, the writer Fitz Hugh Ludlow, described the artist's goal as that of reaching "the original site of the Garden of Eden".[8] In doing so, Ludlow answered the characterization of Frederic Church as a hero-explorer of South America and the Arctic with his own fashioning of Bierstadt as the artist-priest of Yosemite. Ludlow's imagery derived from the writings of the popular preacher Thomas Starr King.[9] The

vesting of the landscape with spiritual values further held out a hope of redemption for a nation at war with itself.[10] Bierstadt's Yosemite and Church's Labrador presented two different ways of dealing with the emotional turmoil of the war. California offered a redemptive landscape far from actual bloodshed, whereas Church soberly contemplated the Darwinian drama played out on the ice.

The American artist William Bradford centred his career on Arctic imagery, and his inaugural trip to Labrador in 1861 was undoubtedly inspired by Church, Hayes and Kane.[11] In 1869, Bradford outfitted the *Panther* with his camera equipment as well as his sketchbox. He published a folio of his photographs in 1873 (cats. 27-29).[12] Bradford painted Arctic scenes for close to three decades, often focussing on the dramatic elements of survival in the frozen land. In *Whalers Trapped in Arctic Ice* (fig. 5), which is among his most successful compositions, the crew struggles to off-load the crippled ship and make camp on the frozen surface. As the men move with singleness of purpose, one ceases his labours, staring off at the setting sun, the weakening light an augur of the uncertain nocturnal existence that lies ahead.

In Polar Seas (cat. 32) remains the artist's most unusual and effective icescape. In it, Bradford has removed all traces of human existence. The two principal icebergs loom like Scylla and Charybdis, mythological monsters that stood between seafarers and their destination. The horizon is obscured by sea fog, illuminated with the same queasy yellow-green light permeating the scene. Placed next to Bierstadt's views of Yosemite, Bradford's destabilized world of floating ice stands in stark contrast to the luminous California landscape. Bradford's vision is both disturbing and compelling, made all the more so by the complete absence of any human activity. Bradford's silent icebergs challenge the viewer to

look beyond the world of exploration into the realm of metaphor.

Canadian artistic exploration of the northern landscape mainly stopped short of the actual Arctic region, instead playing out a variation on the theme of national and cultural identity in the remote wilderness of northern Ontario. Shortly after the turn of the century, Canadian artists and writers actively sought a definition of their nation that emerged from within, in direct response to the Canadian experience. They found a vision of the link between Canada's past and its future in the powerful yet often bleak features of the Canadian Shield, a Precambrian formation extending from the Great Lakes northward to the Arctic Ocean. Prominent among the artists who espoused landscape painting as a genre well suited to this mission was Tom Thomson, who explored the wilderness landscape of Ontario around Georgian Bay and in the Algoma district, and encouraged the development of a landscape genre validated by the northern wilderness, equivalent in power and imagination to the West.[13]

Thomson's forays into the Canadian wilderness inspired many of his colleagues to make extended sketching trips into the field, fostering a camaraderie that would culminate in the founding of the Group of Seven in 1920.[14] Linked by their desire to foster a new art movement in Canada, these artists viewed the Ontario wilderness as a symbol of Canada's "nativist" self. As Lawren Harris wrote, "Our art is founded on a long and growing love of and understanding of the North in an ever clearer experience of oneness with the informing spirit of the whole land and a strange brooding sense of Mother Nature fostering a new race and a new age."[15] In Harris's view, the "True North" became a means of identifying what it meant to be Canadian.

The developing wilderness aesthetic in Canada endowed the components of the landscape with nationalistic sentiment: jack pines, waterfalls, lakes

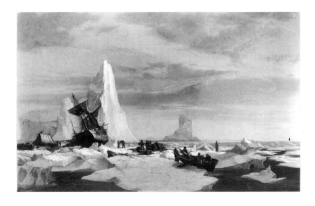

FIG. 5 - WILLIAM BRADFORD
WHALERS TRAPPED IN ARCTIC ICE
ABOUT 1870-1880

and hills all played seminal roles in the modernist landscape tradition. The Arctic, by contrast, was less relevant to the Group's stated goals of fostering appreciation of Canadian culture. A. Y. Jackson and Lawren Harris were the only members of the Group to venture as far north as the Arctic, Jackson in 1927 and Harris in 1930.[16] Jackson's sketches and diary describe icebergs in lyric tones,[17] but it was Harris who would make a group of Arctic-inflected paintings among his strongest works. His interest in theosophy and transcendentalism added symbolic weight to the abstract qualities in his paintings. *Icebergs, Davis Strait* (cat. 130) conveys an ethereal, mystical feeling linked to the philosophical tenets he espoused during his lifetime.

Harris's interest in the northern landscape had been inspired in no small measure by his visit to Buffalo in 1913 to view a travelling exhibition of contemporary Scandinavian art. His travelling companion, J.E.H. MacDonald, described the works as "true souvenirs of that mystic north around which we all revolve".[18] For both Harris and MacDonald, the subarctic region was a landscape mythic in character, in which mood, form and colour took precedence over strict topographic concerns.[19] In MacDonald's *Aurora, Georgian Bay* (cat. 173), the light rippling from the sky seems to call forth a response from the wind-shaped trees along the shore, the entire landscape animated by the northern lights. Similarly, Harris's evocatively titled *Winter Comes from the Arctic to the Temperate Zone* (fig. 6) uses a series of overlapping forms to create the sense of inexorable forces at play in a landscape infused with the concepts of spiritual and cultural metaphor.

Canadian modernist artists mined the northern scenery of their country for the same visual and symbolic messages contained in American paintings of the West. Criticism levelled at both traditions often derides their regionalism and eschewing of European modernist vocabulary, yet the lasting aesthetic appeal of both countries' landscape traditions is precisely in these indigenous stylistic conventions. The Group of Seven and their colleagues found higher purpose in the native landscape and chose the North for their touchstone. In the United States, landscape in general and Arctic landscapes in particular were painted to achieve similar goals. In each case, it was the more austere, challenging features in nature that provided the model for two very different approaches to nationalism in the visual arts.

Lawren Harris's American pupil Rockwell Kent joined his mentor in his appreciation of the potential for visual power invested in the northern region. Reflecting on his years spent in Greenland, Kent summed up centuries of fascination with the Far North, asking himself, "What is Paradise to you ... have you the inner fortitude, the spiritual resourcefulness,

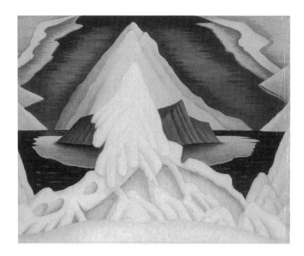

FIG. 6 – LAWREN S. HARRIS
WINTER COMES FROM THE ARCTIC
TO THE TEMPERATE ZONE
(SEMI-ABSTRACT NO. 3), ABOUT 1935

to endure eternally the vast and heartless grandeur of the scene confronting you?"[20] Kent's words underscore man's quest to find his place in the cosmos. The northern paintings by American and Canadian artists embody this quest, framed by man's restless search for personal and national goals.

• Notes

1. See especially Chauncey C. Loomis, "The Arctic Sublime", in U. C. Knoepflmacher and G. B. Tennyson, eds., *Nature and the Victorian Imagination* (Berkeley: University of California Press, 1977).

2. Quoted in Pierre Berton, *The Arctic Grail: The Quest for the North West Passage and the North Pole, 1818-1909* (New York: Penguin Books, 1988), p. 236.

3. Kane's two-volume *Arctic Explorations* (Philadelphia, 1856) was illustrated with engravings based on watercolours by James Hamilton.

4. Hayes's 1860 trip was funded by the American Geographic Society, the Smithsonian Institution and Henry Grinnell, who had underwritten two expeditions bearing his own name, in 1850 and 1853-1855.

5. Isaac Israel Hayes, *The Open Polar Sea: A Narrative of a Voyage of Discovery towards the North Pole* (New York: Hurd and Houghton, 1867).

6. Lady Franklin returned a final time in 1870 in a failed attempt to convince explorer Charles Francis Hall to resume her search for her husband's remains. See Chauncey C. Loomis, *Weird and Tragic Shores: The Story of Charles Francis Hall, Explorer* (Lincoln: University of Nebraska Press, 1991), pp. 244-245.

7. Church provided Hayes with drawing lessons and based several compositional elements in *Aurora Borealis* on sketches Hayes made during his 1860 voyage, including Church's Peak and the explorer's dogsled. See Gerald L. Carr, *Frederic Edwin Church: The Icebergs* (Dallas: Dallas Museum of Fine Arts, 1980), p. 39.

8. Fitz Hugh Ludlow, "Seven Weeks in the Great Yo-Semite", *Atlantic Monthly*, vol. 13 (June 1864), p. 740.

9. See Thomas Starr King, "Selections from a Lecture-Sermon after Visiting Yosemite Valley", in *The California Scrap-book*, compiled by Oscar T. Shuck (San Francisco: H.H. Bancroft, 1869). King's letters from California were published in several New York newspapers and the *Boston Daily Evening Transcript* between May and October 1863. See also Thomas Starr King, *The White Hills: Their Legends, Landscapes, and Poetry* (1859), and, for a discussion of Bierstadt's relationship with King, Nancy K. Anderson, *Albert Bierstadt: "Cho-looke, the Yosemite Fall"*, exhib. cat. (San Diego: Timken Art Gallery, 1986), unpaginated.

10. See Eleanor Jones Harvey, *The Painted Sketch: American Impressions from Nature, 1830-1880* (New York: Harry N. Abrams, 1998), especially pp. 256-257.

11. Circumstantial evidence suggests Bradford may have travelled along the coast of Labrador during the late 1850s; however, further research is needed to substantiate this claim. See John Wilmerding, *William Bradford, 1823-1892*, exhib. cat. (Lincoln, Massachusetts: DeCordova Museum, 1969), p. 12.

12. William Bradford, *The Arctic Regions* (London, 1873).

13. "The North, like the West, creates types. It is an indication of ourselves. The North, like the West, to be expressed in paint, demands ... a suitable soul-equipment and great powers of creative expression." Frederick Housser, *A Canadian Art Movement: The Story of the Group of Seven* (Toronto: Macmillan Company of Canada, 1926), p. 14; quoted in Christopher Jackson, *North by West: The Arctic and Rocky Mountain Paintings of Lawren Harris, 1924-1931*, exhib. cat. (Calgary: Glenbow Museum, 1991), p. 15.

14. The Group of Seven included Frank Carmichael, Lawren Harris, A. Y. Jackson, Franz Johnston, Arthur Lismer, J.E.H. MacDonald and Fred Varley. For a thorough analysis of the Group's history and significance in championing Canadian art, see Charles C. Hill, *The Group of Seven: Art for a Nation*, exhib. cat. (Ottawa: National Gallery of Canada; Toronto: McClelland and Stewart, 1995).

15. Lawren Harris, "Creative Art and Canada", in *Yearbook of the Arts in Canada* (1928-1929), Bertram Brooker, ed.;

quoted in Ann Davis, *The Logic of Ecstasy: Canadian Mystical Painting, 1920-1940* (Toronto: University of Toronto Press, 1992), pp. 65-68.

16. Franz Johnston, a Group of Seven member briefly at its founding in 1920, visited the Arctic in 1939, by which time the group had disbanded.

17. See *A. Y. Jackson: The Arctic, 1927* (Toronto: Penumbra Press, 1982).

18. J.E.H. MacDonald, quoted in Dennis Reid, *A Concise History of Canadian Painting*, 2nd edition (Toronto: Oxford University Press, 1988), p. 141.

19. "The North ... is a single, simple vision of high things and can, through its transmuting agency, shape our souls into its own spiritual expressiveness." *Ibid.*

20. Rockwell Kent, *It's Me, O Lord* (New York, 1955), p. 330; quoted in Lewis Shepard, *American Artists in the Arctic* (Amherst, Massachusetts: Mead Art Gallery, 1975), unpaginated.

In the nineteenth century, the Arctic landscape was portrayed not only by professional artists in dramatic canvases of towering glaciers and walls of ice, but also by naval officers who sketched on-the-spot records of this unexplored terrain. Their depictions of the northern frontier were created in the expedient mediums of watercolour and pencil and limited to the size of a sketchbook that could easily be carried through the rigours of a long expedition. With time on their hands as they passed endless months of waiting for their ships to be freed from the ice's grip, these amateur artists went beyond topographical

Icebergs, Polars Bears

and the Aurora Borealis

by Rosalind Pepall

documentation and expressed in small works on paper their emotional response to the grandeur of the landscape and their wonder at the beauty and terror of this inhospitable, uncharted frontier.

Over the centuries, interest in the Arctic had drawn international explorers to the northern reaches of Canada; the names of Frobisher Bay, Davis Strait and Baffin Island are reminders of early British expeditions.[1] With the end of the Napoleonic wars, men and ships were available for England to turn her attention once again to the blank parts on the map above the sixtieth parallel. The nineteenth century saw an unprecedented number of Arctic expeditions, spurred on by the British Admiralty's interest in finding a Northwest Passage to the Pacific, not so much for commercial reasons as for national prestige. In their wish to chart the unexplored polar regions of the world, the British navy sent ships in the direction of the North Pole and the Antarctic as well. Accounts of polar voyages were published from the journals of their commanders or members of the crew and were illustrated with engravings after in situ sketches.

Fortunately, some of these original watercolour sketches and drawings have found their way into museums and archives. It is a wonder these artists were able to safeguard their sketches despite the life-threatening dangers they often encountered. George Back, for example, managed to save his pocket-size sketchbooks even though he was too weak and disoriented to draw and his companions, half of whom died of cold and starvation, scattered their possessions to lighten their load as they trudged through the northern wilderness.[2]

On the expedition in 1818 that reinitiated British Arctic exploration in the nineteenth century, the commander himself, John Ross, provided the visual record that accompanied the published account of his trip, entitled *A Voyage of Discovery Made under*

the Orders of the Admiralty in His Majesty's Ships "Isabella" and "Alexander", for the purpose of Exploring Baffin's Bay, and Inquiring into the Probability of a North-West Passage.[3] Two rare watercolours by Ross show his ships off the west coast of Greenland, where they met whaling vessels (cats. 252-253). He has depicted the boats under sail, wending their way through fantastic pinnacled icebergs that hover threateningly – scenes that were to be repeated by many Arctic artists after him. John Ross was a self-taught artist, but these amateur sketches, executed in a limited colour range, appeal because of the immediacy of the rendering. Although they were meant to document his trip (each is captioned with handwritten date and latitude), these watercolours nevertheless convey the drama of sailing through a land of half-day, half-night, amid the eerie stillness of mighty monoliths of ice. Ross also captures in words his wonder at the sight of the icebergs: "It is hardly possible to imagine anything more exquisite than the variety of tints which these icebergs display; by night as well as by day they glitter with a vividness of colour beyond the power of art to represent."[4] This was a landscape rarely seen by the English eye more familiar with the pastoral countryside and picturesque mountain vistas. Ross's ships, bobbing like toys, were at the edge of the world in a barren, forbidding polar sea.

Sir John Ross was one of England's great Arctic explorers. His portrait by James Green in the National Portrait Gallery in London shows him draped in furs, leaning his right arm on the prow of a small boat and holding an Inuit hunting spear in his left hand.[5] A glistening glacier fills the background of the painting executed in 1833, just after Ross returned from a second voyage to the Arctic that lasted a gruelling four years, from 1829-1833, during which family and friends had given him up for lost.[6] Hailed and congratulated upon his return, he remained a central figure in Arctic exploration.

The English naval officer George Back was another explorer-artist who kept returning to the North with enthusiasm. His on-the-spot sketches were also published as engravings in the accounts of his expeditions. He joined the Royal Navy in 1808, just short of his twelfth birthday, but was not introduced to the Arctic until 1818, when he served under Lieutenant John Franklin on a British naval expedition to the North Pole by way of Spitsbergen.[7] Back's association with Franklin continued the next year, when he joined the senior officer's 1819 overland expedition down the Coppermine River to the Arctic Ocean. Back was valued for his skill in mapping the coast and drawing the features of the landscape. On this trip, he went beyond the call of duty in saving the life of his commander in the face of fatigue and starvation. For his bravery, Back was eventually elevated to the rank of captain,

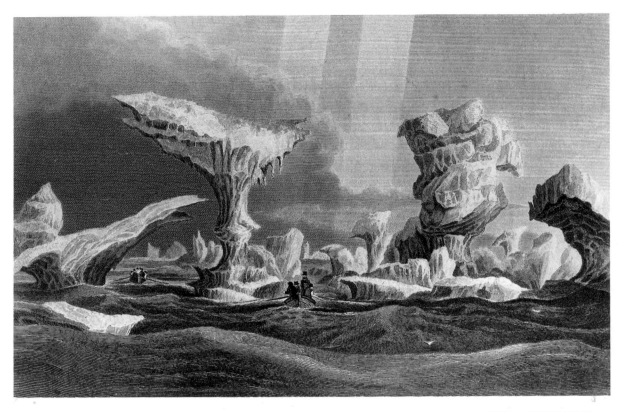

FIG. 1 – GEORGE BACK
BOATS IN A SWELL AMONGST ICE, 1826
(ENGRAVED BY EDWARD FINDEN, 1828)

and in 1833, he commanded his own expedition along the shores of the Arctic Ocean, charting the Great Fish River, which was renamed in his honour.[8]

On his three expeditions to the Canadian North, George Back spent much of his time inland, mapping great lakes and the rivers that flow into the Beaufort Sea. His sketchbooks are filled with views of the waterways and forests he crossed and the mountains and cliffs along his route, such as Wilberforce Falls (1821; cat. 5), which, Back wrote, "was by far the grandest scene of the kind in the country".[9] Another grand scene compressed into a tiny sketch is a view from Portage La Loche (1825; cat. 6), showing a valley stretching as far as the eye can see. Back, who had not been to military school, learned watercolour technique from his senior officers. He had a natural talent for composition and colour tonalities, and his picturesque renderings and sublime landscapes suited the current artistic trends in Britain. As Ian MacLaren noted in his study of Back's early sketch-books, the artist expressed "the naval officer's concern for accurate depiction and the picturesque traveller's interest in mood".[10] In another series of watercolours, entitled *Panoramic View Eight Miles from Fort Franklin – Great Bear Lake* (1826), Back responds to the overwhelming sense of the northern

wilderness by depicting an unending forest that carries over four pages of his sketchbook. The trees are painted in horizontal band after band as they recede into limitless space.

In addition to land features, Back was also drawn to the infinite space of the sky and to the splendour of the aurora borealis. On his 1833-1835 expedition to the Arctic coast, he tells how he studied the aurora borealis for six months in 1833-1834 and five months in 1834-1835, noting its position in the sky, its times of occurrence, its forms and colours. A notebook (cat. 7) devoted exclusively to these obser-vations includes small watercolour or ink sketches of the aurora's dazzling effects.[11] He wrote in the appendix of his published narrative of the trip, "I went out to watch the motion of the aurora, when it under-went transitions of form, from streaming arches to spirals, zig-zag'd, convoluted, and indescribable bands of rays, and beams altogether so eccentric and beautiful, as to exceed the visions of the most exuberant imagination."[12]

Back also sketched the icebergs in seas along Canada's most northerly coast. A drawing of boats among fantastically shaped icebergs, which he created while mapping the coastline west of the Mackenzie River with Franklin in 1826, became a

popular image of polar adventures when it was published in Franklin's *Narrative of a Second Expedition to the Shores of the Polar Sea in the Years 1825, 1826, and 1827* (fig. 1). A later watercolour of an iceberg was probably worked up from sketches after his return. In this romanticized view of the Arctic sea, complete with three frolicking walruses in the foreground (cat. 8), the vaulted hollows and passages in the iceberg's mass suggest the structure of a Gothic cathedral or some fairytale ice palace. George Back is known to have given his watercolours as gifts, and this one is inscribed on the back *My dear Lady Louisa*.[13]

Stories and illustrations of Arctic adventure intrigued the British public, and the polar expeditions were widely covered in the newspapers and reviews of the day, in addition to the explorers' published narratives. The saga of the 1845 Franklin expedition that never returned heightened the mystery and romance of these terrifying and awe-inspiring regions of the North American continent. The lure of the Arctic seemed irresistible to explorers, who were always eager to return even if it cost them their lives. Ross went on his last expedition in 1850 at the age of seventy-two to search for his old friend Franklin, and in his house in Stranraer, Scotland, one room was an exact copy of his cabin on the *Victory,* complete with a panorama of his sketches on movable screens.[14]

Another panorama, based on Ross's voyage of 1829-1833, was on display to the general public in Leicester Square, London, in 1834. *A View of the Continent of Boothia, Discovered by Captain Ross, in His Late Expedition to the Polar Regions* was produced by Robert Burford, who painted the scenes after Ross's sketches. A booklet promoting the panorama in hyperbolic tones refers to "towering icebergs of gigantic size and singularly fantastic form ... the prominent surfaces tinged with the most vivid emerald and violet tints, and the most intense blue shades lurking in the recesses, presenting a splendid exhibition of icy grandeur". It went on to say, "Spectators are placed in the actual tent in which the gallant Captain passed the nights during his long and dreary journey of nearly 500 miles."[15]

The 1848-1849 expedition of John Ross's nephew James Clark Ross was similarly rendered as a panorama in 1850 by the enterprising Burford. It represented summer and winter views of the polar regions with the usual icebergs, polar bears, stranded ships and aurora borealis all numbered and identified.

Arctic explorers were greeted as heroes upon their return from expeditions – like astronauts today – and were in demand as guest lecturers. Two glass lantern slides with hand-painted images taken from contemporary published engravings are examples of

the desire for visual representation of the northern frontier (cat. 329).[16] One British firm even decorated dishes with blue transfer-printed views of Arctic scenery.[17]

Glaciers, icebergs, the harshness of the climate and the nature of the light were the main focus of narratives and visual depictions of the Arctic throughout the nineteenth century. One of the most readable and popular accounts, by American naval doctor Elisha Kent Kane, was published in 1856 under the title *Arctic Explorations*.[18] Kane, who had travelled the seas all over the world, first went to the Arctic in 1850 on an American expedition in search of Franklin, financed by the shipping merchant Henry Grinnell. After this experience, Kane took command of Grinnell's second expedition to continue the search for Franklin and to try and find the open polar sea that many believed was navigable around the North Pole. He sailed between Ellesmere Island and the west coast of Greenland, where he discovered the "Great Glacier" he named after Alexander von Humboldt;[19] six pages in his book are devoted to an eloquent description of its mass and signs of movement. Not nearly as well fitted out as the British naval expeditions, Kane ran into almost insurmountable difficulties in three years of being held hostage by the North. In the account of his trials, Kane vividly describes the colours, sounds and physical features of the Arctic landscape for his readers, as well as the misery and terror of his crew's battle with the elements in a land where "an Arctic night and an Arctic day age a man more rapidly and harshly than a year anywhere else in all this weary world".[20] The book was wildly popular, as were his frequent lectures. A decade later, Jules Verne modelled elements of his adventure stories set in the North after Kane's accounts.[21]

Besides writing well, Elisha Kent Kane had an amateur's talent for drawing and painting in watercolour. *Arctic Explorations* was illustrated with over three hundred engravings after Kane's sketches of his Arctic journeys. Even though he did not have professional training, Kane wrote with an artist's eye when he described the landscape of Hakluyt Island as affording "studies of color that would have rewarded an artist. The red snow was diversified with large surfaces of beautifully-green mosses and alopecurus, and where the sandstone was bare, it threw in a rich shade of brown."[22] In the introduction to his book, Kane acknowledges the help of American artist James Hamilton, who reworked Kane's on-the-spot sketches into romantic, picturesque renderings of the Arctic sea and landscape.[23]

Like other travellers before him, Kane gazed in wonder at the Arctic sky: "The intense beauty of the Arctic firmament can hardly be imagined. It looked close above our heads, with its stars magnified in glory and the very planets twinkling so much as to baffle

the observations of our astronomer."[24] A feature of every explorer's description of the Arctic was the light effects in the sky, whether the absence of daylight during the long winters, the presence of the midnight sun or the spectacular display of the aurora borealis.

On the last of the British Navy's expeditions in quest of the North Pole in 1875-1876, led by George Nares, the assistant paymaster, Thomas Mitchell, recorded his impression of the aurora borealis from his vantage point on Ellesmere Island and inscribed on the watercolour that it "was like a luminous hanging curtain waving in the wind".[25] The reappearance of the sun after endless weeks of darkness, an event ranking with the aurora borealis in impressiveness, is the subject of one of Mitchell's finest watercolours, *Return of the Sun to Discovery Harbour, Ellesmere Island* (cat. 206). Mitchell dramatizes this joyous moment by depicting a spectacular sky in tones of orange, red, pink and yellow, as the sun steals up over the distant hills, bringing light and warmth to this desolate region. The sun casts long shadows on blocks of ice scattered across the broad expanse of land, which, in its barrenness, could be a moonscape.

Mitchell achieves the same sense of mystery and awe before nature in other works such as *Arctic Terrain with Cairn* (cat. 204), in which he looks out over mountains beyond to a further range of peaks as if he were at the very edge of the frontier. The remains of a fire with a bottle and can in front of a cairn are the only signs of human habitation at this spot on top of the world.

While Mitchell was capable of painting watercolours in the grand English sublime tradition, he was also in the forefront of photographic recording. He and George White, the junior engineer on the trip, were responsible for photographs taken during the Nares expedition that were reproduced as Woodburytypes (a photomechanical process) in the published account of the voyage.[26] Photographs were eventually preferred to engravings and lithographs to illustrate reports of northern expeditions.

The Nares expedition closed the chapter on the British Admiralty's programme of Arctic exploration in the nineteenth century. By the late decades, the public had become familiar with views of ice-strewn landscapes. Franklin's fate was known, the "open polar sea" had proved a myth, and Nares confirmed that it was impractical, if not impossible, to reach the North Pole by ship or sledge in the region north of Ellesmere Island. The hard realities of the Arctic quest diffused the romance of polar exploration, and the northern frontier lost its attraction. As Chauncey Loomis stated in his essay "The Arctic Sublime",

> By the end of the century, although the North Pole had not yet been reached, the Arctic had been

thoroughly explored, studied, and mapped, and its geographical features had been domesticated with names – Victoria Island, Prince Regent Inlet, Coronation Gulf, Thackeray Point. The mystery was gone in fact if not in fiction. The Sublime cannot be mapped.[27]

By the time Roald Amundsen navigated the Northwest Passage for the first time in 1906 and Robert Peary believed he had reached the North Pole in 1909, the photographer had replaced the young naval officer setting up his sketchboard before the limitless expanse of the northern wilderness. The new century had begun to set its sights on another frontier, which, in its earliest recorded images, would appear as bleak, lifeless and eerie as those that confronted the nineteenth-century Arctic explorers.

• Notes

1. Martin Frobisher discovered the bay named after him while searching for the Northwest Passage in 1576; John Davis charted Davis Strait on an expedition in 1585-1587; and William Baffin explored Canada's largest Arctic island in 1616.

2. This occurred on the Franklin expedition to the Arctic seacoast by way of the Coppermine River. See John Franklin, *Narrative of a Journey to the Shores of the Polar Sea in the Years 1819, 1820, 1821 and 1822* (1823; reprinted Edmonton: Hurtig, 1969). The commander, John Franklin, lost all his papers and books on the journey while crossing a river. Two of Back's sketchbooks from this trip have been preserved in the National Archives of Canada, Ottawa, which also has four others: one from Back's 1818 trip to the North, two from 1825-1826 and one from 1834-1835.

3. John Ross, *A Voyage of Discovery...* (London: John Murray, 1819).

4. *Ibid.*, p. 22.

5. Green's portrait of Ross is reproduced as the frontispiece of Maurice James Ross, *Polar Pioneers: A Biography of John Ross and James Clark Ross* (Montreal and Kingston: McGill-Queen's University Press, 1994).

6. Over twenty watercolours and drawings by Ross from this trip are in the collection of the Scott Polar Research Institute, Cambridge, England.

7. Captain David Buchan was the commander of this expedition sent out at the same time as John Ross to explore an alternative route to the North.

8. George Back, *Narrative of the Arctic Land Expedition to the Mouth of the Great Fish River and along the Shores of the Arctic Ocean in the Years 1833, 1834, and 1835* (London: John Murray, 1836; reprinted Edmonton: Hurtig, 1970).

9. George Back, *Arctic Artist: The Journal and Paintings of George Back, Midshipman with Franklin, 1819-1822*, ed. C. Stuart Houston (Montreal and Kingston: McGill-Queen's University Press, 1994), p. 165.

10. Ian S. MacLaren, "The Aesthetics of Back's Writing and Painting from the First Overland Expedition", in *ibid.*, p. 295.

11. Back's notebook "Observations on the Aurora Borealis

by Captain Back" is in the archives of the McCord Museum of Canadian History, Montreal.

12. Back 1836/1970, p. 622.

13. The inscription on the back of the watercolour continues, "I am too unwell to call on you but I send you a little sketch of an iceberg with a Ship and some Walrus – seen generally in great numbers about the entrance of Hudson's Straits." C. Stuart Houston refers to Back's habit of giving watercolour sketches to friends (see Back 1994, pp. 371-372, footnote 45).

14. See M. J. Ross 1994, p. 255.

15. Robert Burford, *Description of "A View of the Continent of Boothia, Discovered by Captain Ross, in His Late Expedition to the Polar Regions", Now Exhibiting at the Panorama, Leicester Square* (London: J. and G. Nichols, 1834), pp. 4-5. On this trip, Ross had to abandon ship and trudge overland with small boats and sledges. This panorama was shown as a double feature with *A View of the Falls of Niagara*, another wonder of the New World, exhibited in the Upper Circle of the building.

16. The Scott Polar Research Institute has a set of fifty lantern slides with lithograph views of the George Nares expedition of 1875-1876. Constance Martin has discussed the popularization of Arctic imagery in Chapter 3 of her thesis, "Perceptions of Arctic Landscapes in the Art of the British Explorers, 1818-1859", University of Calgary, 1981.

17. Elizabeth Collard, *The Potters' View of Canada: Canadian Scenes on Nineteenth-century Earthenware* (Montreal and Kingston: McGill-Queen's University Press, 1983), Chapter 6, "Arctic Scenery", pp. 39-43. The images on the plates were taken from the engravings published in William Edward Parry's accounts of his two voyages to the North in 1819-1820 and 1821-1823.

18. Elisha Kent Kane, *Arctic Explorations: The Second Grinnell Expedition in Search of Sir John Franklin, 1853, '54, '55*, 2 vols. (Philadelphia: Childs and Peterson, 1856).

19. Before his trip, Kane had corresponded with the famous explorer to ask him to recommend a German naturalist to accompany the expedition. See George W. Corner, *Doctor Kane of the Arctic Seas* (Philadelphia: Temple University Press, 1972), p. 115.

20. Kane 1856, vol. 1, p. 173.

21. Corner 1972, p. 270, compares scenes from Verne's *Les Anglais au pôle Nord* and *Le Désert de glace* (serialized in 1864-1865) with Kane's accounts and notes that Verne's characters refer to the real Kane in the stories.

22. Kane 1856, vol. 1, pp. 45-46.

23. Constance Martin, *James Hamilton: Arctic Watercolours*, exhib. cat. (Calgary: Glenbow Museum, 1983). The Glenbow Museum in Calgary has over a hundred and fifty sketches and watercolours by Elisha Kent Kane and James Hamilton.

24. Kane 1856, vol. 1, p. 425.

25. George Nares, *Narrative of a Voyage to the Polar Sea during 1875-1876 in H.M. Ships "Alert" and "Discovery"* (London: Sampson, Low, Marston, Searle and Rivington, 1878).

26. See Douglas Wamsley and William Barr, "Early Photographers of the Arctic", *Polar Record,* vol. 32, no. 183 (October 1996), pp. 312-314. See also Michael Bell, "Thomas Mitchell, Photographer and Artist in the High Arctic, 1875-76", *Image,* vol. 15, no. 3 (September 1972), pp. 12-21.

27. Chauncey C. Loomis, "The Arctic Sublime", in U. C. Knoepflmacher and G. B. Tennyson, eds., *Nature and the Victorian Imagination* (Berkeley: University of California Press, 1977), p. 112.

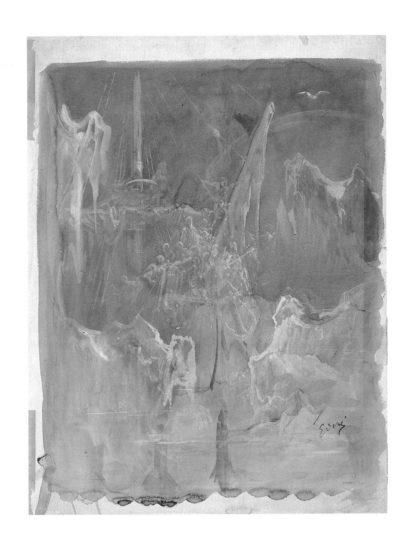

94· GUSTAVE DORÉ, **THE ICEBOUND SHIP**, ABOUT 1875
MUSÉE D'ART MODERNE ET CONTEMPORAIN DE STRASBOURG

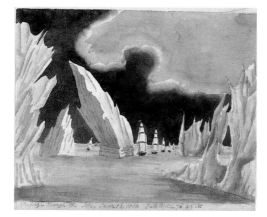

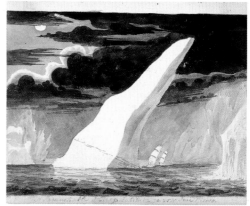

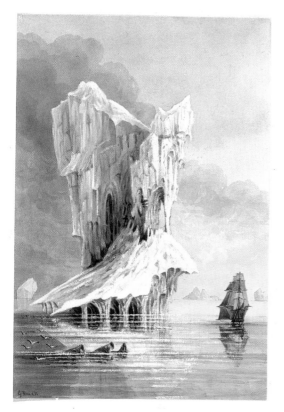

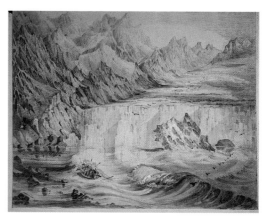

253• JOHN ROSS, **A REMARKABLE ICEBERG,
LATITUDE 70°, 45' N., JUNE 19, 1818**, 1818
OTTAWA, NATIONAL ARCHIVES OF CANADA

15• FREDERICK WILLIAM BEECHEY
**WRECK OF THE "TRENT"'S BOAT FROM A PIECE
OF ICE BREAKING OFF THE GLACIER**, ABOUT 1818
CALGARY, THE ARCTIC INSTITUTE OF NORTH AMERICA

128• JAMES HAMILTON
GLACIER FROM NEAR UPPER NAVIK, ABOUT 1852
CALGARY, GLENBOW MUSEUM

252• JOHN ROSS, **PASSAGE THROUGH THE ICE,
JUNE 16, 1818, LATITUDE 70°, 44' N.**, 1818
OTTAWA, NATIONAL ARCHIVES OF CANADA

8• GEORGE BACK, **AN ICEBERG, A SHIP
AND SOME WALRUS NEAR
THE ENTRANCE OF HUDSON STRAIT**, ABOUT 1840
OTTAWA, NATIONAL ARCHIVES OF CANADA

ELISHA KENT KANE

145· TWO STUDIES OF ICEBERGS, 1850-1855

143· BOAT AND 144· FOUR STUDIES
ICEBERG, 1850-1855 OF THE ICE BREAK-UP, 1850-1855

CALGARY, GLENBOW MUSEUM

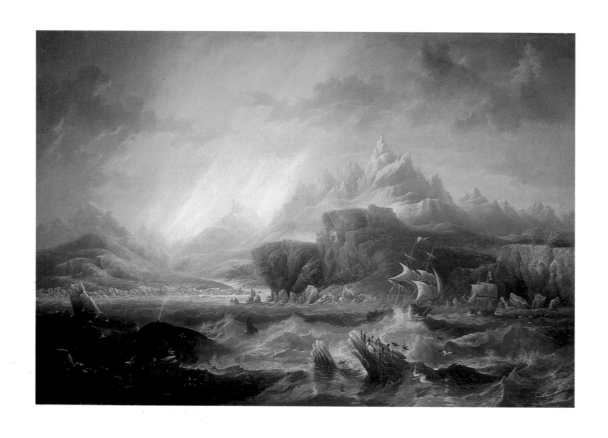

44· JOHN WILSON CARMICHAEL, **HMS "EREBUS" AND "TERROR" IN THE ANTARCTIC,** 1847
GREENWICH, NATIONAL MARITIME MUSEUM

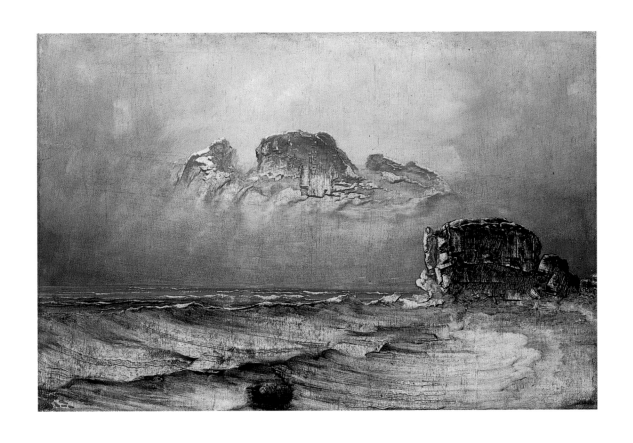

9· PEDER BALKE, **SEASCAPE**, ABOUT 1860
OSLO, NASJONALGALLERIET

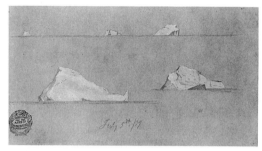

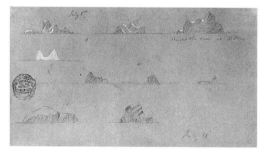

FREDERIC EDWIN CHURCH

61· **FLOATING ICEBERGS**, 1859 (JULY 4 AND 5)

62· **FLOATING ICEBERGS**, 1859 (JULY 5)

63· **SEASCAPE, NEWFOUNDLAND**, 1859 (JULY 6)

64· **FLOATING ICEBERGS**, 1859 (JULY 6 AND 16)

NEW YORK, COOPER-HEWITT, NATIONAL DESIGN MUSEUM, SMITHSONIAN INSTITUTION

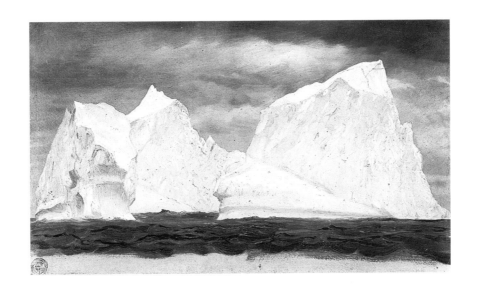

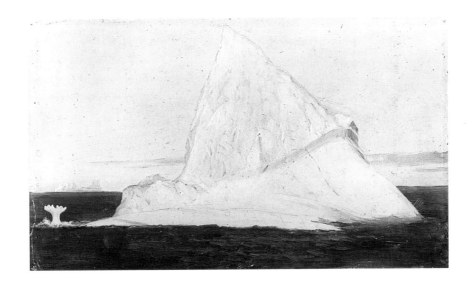

FREDERIC EDWIN CHURCH

65· **FLOATING ICEBERG UNDER CLOUDY SKIES**, 1859

66· **ICEBERG AND ICE FLOWER**, 1859

NEW YORK, COOPER-HEWITT, NATIONAL DESIGN MUSEUM, SMITHSONIAN INSTITUTION

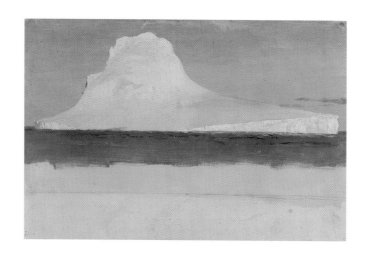

60· FREDERIC EDWIN CHURCH, **FLOATING ICEBERG, LABRADOR**, 1859 (JUNE-JULY)
NEW YORK, COOPER-HEWITT, NATIONAL DESIGN MUSEUM, SMITHSONIAN INSTITUTION

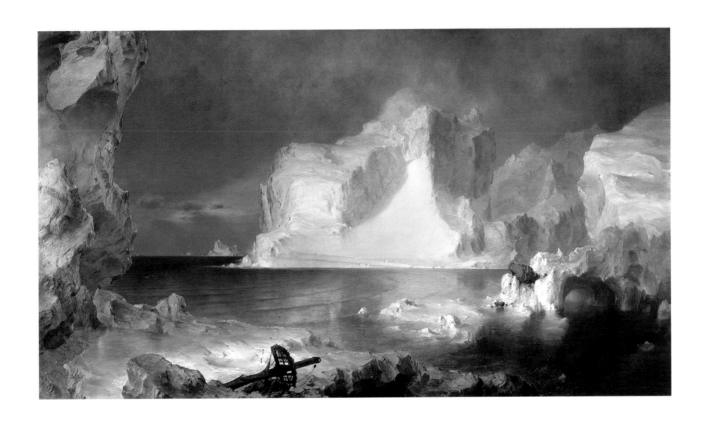

67• FREDERIC EDWIN CHURCH, **THE ICEBERGS**, 1861
DALLAS MUSEUM OF ART

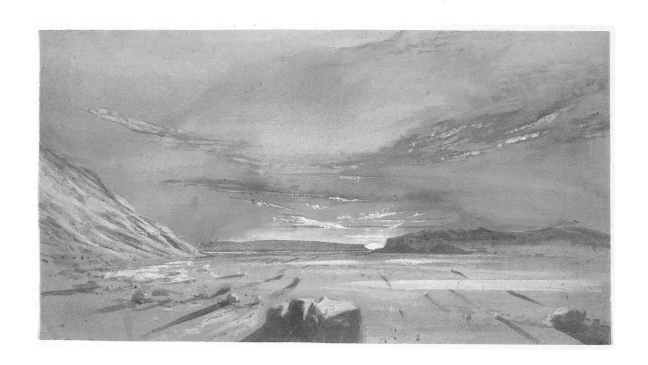

THOMAS MITCHELL

206· RETURN OF THE SUN TO DISCOVERY HARBOUR, ELLESMERE ISLAND, 1876 (MARCH 1)

203· VIEW FROM BESSELS FIORD, GREENLAND, LOOKING NORTHWEST, 1875 (AUGUST 23-24)

OTTAWA, NATIONAL ARCHIVES OF CANADA

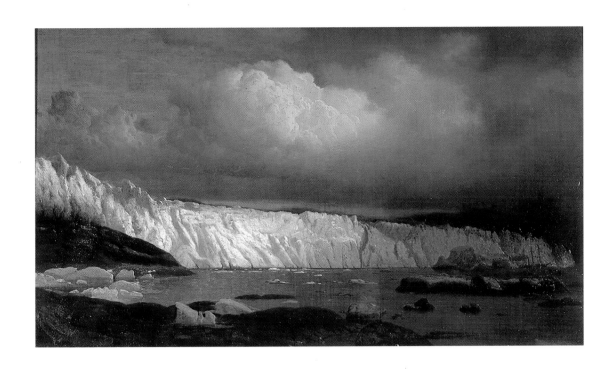

30• WILLIAM BRADFORD, **SERMITSIALIK GLACIER**, ABOUT 1870
OLD DARTMOUTH HISTORICAL SOCIETY, NEW BEDFORD WHALING MUSEUM (MASSACHUSETTS)

THOMAS MITCHELL

204· **ARCTIC TERRAIN WITH CAIRN**, ABOUT 1875-1876

208· **FROM CAPE FRAZER, ELLESMERE ISLAND, LOOKING NORTH**, 1876 (AUGUST 22-24)

207· **WESTWARD HO! VALLEY, ELLESMERE ISLAND**, 1876 (MAY 16)

OTTAWA, NATIONAL ARCHIVES OF CANADA

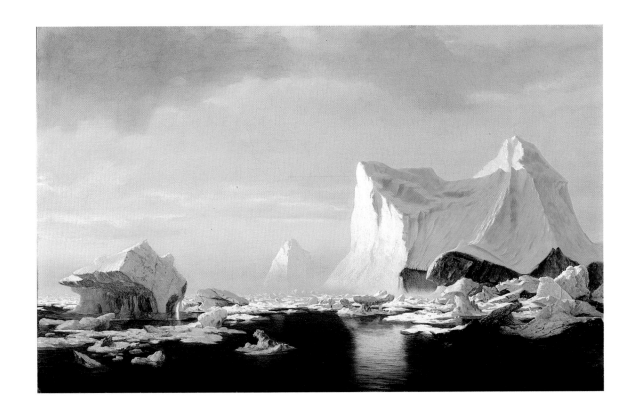

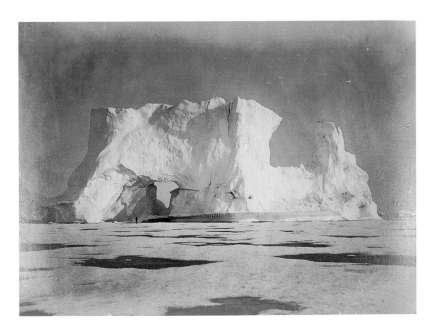

32• WILLIAM BRADFORD, **IN POLAR SEAS**, 1882
PRIVATE COLLECTION

27• WILLIAM BRADFORD, **THE "CASTLE" ICEBERG AS SEEN IN MELVILLE BAY IN AUGUST 1869**
THE NEW YORK PUBLIC LIBRARY

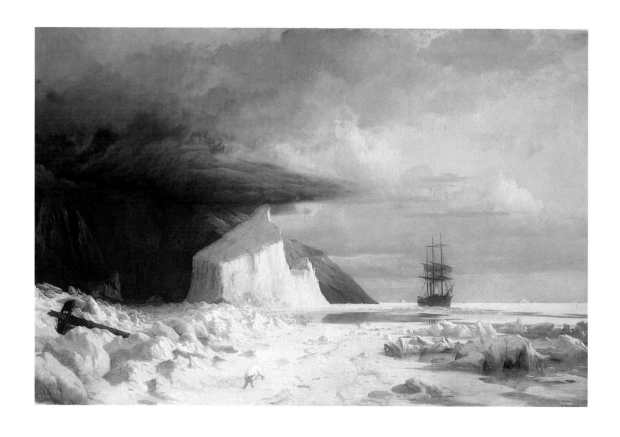

31• WILLIAM BRADFORD, **AN ARCTIC SUMMER, BORING THROUGH THE PACK ICE IN MELVILLE BAY**, 1871
NEW YORK, THE METROPOLITAN MUSEUM OF ART

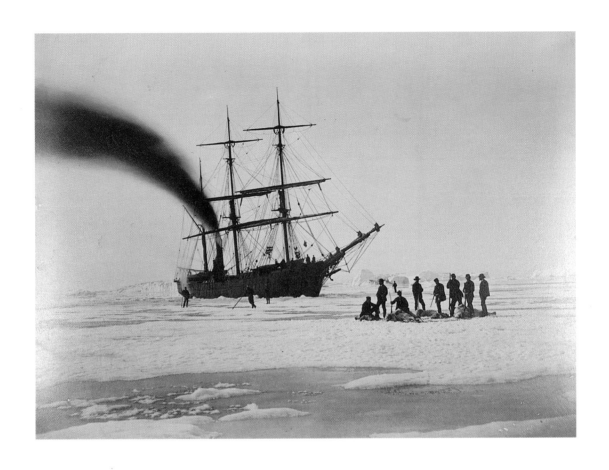

28· WILLIAM BRADFORD, **HUNTING BY STEAM IN MELVILLE BAY IN AUGUST.**
KILLING SIX POLAR BEARS IN ONE DAY, 1869
THE NEW YORK PUBLIC LIBRARY

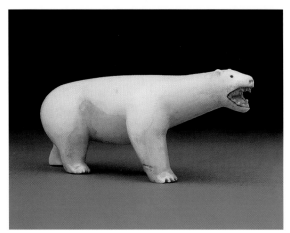
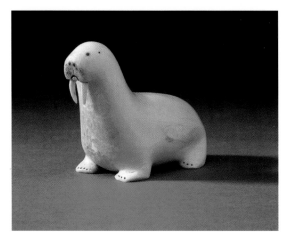

BAFFIN ISLAND, PANGNIRTUNG AREA

332• **NARWHAL**, 1933-1942 330• **WHITE WHALE**, 1928

333• **POLAR BEAR**, 1933-1942 331• **WALRUS**, 1933-1942

TORONTO, ROYAL ONTARIO MUSEUM

334• NORTHEASTERN SIBERIA, CHUKOTKA REGION, **KORYAK COAT**, BEFORE 1901
NEW YORK, AMERICAN MUSEUM OF NATURAL HISTORY

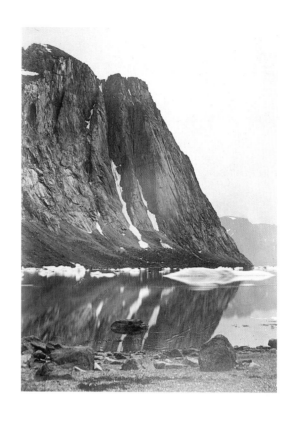

29· WILLIAM BRADFORD, **CLIFFS IN ARSUT FIORD 3000 FEET HIGH, NORTH GREENLAND**, 1869
THE NEW YORK PUBLIC LIBRARY

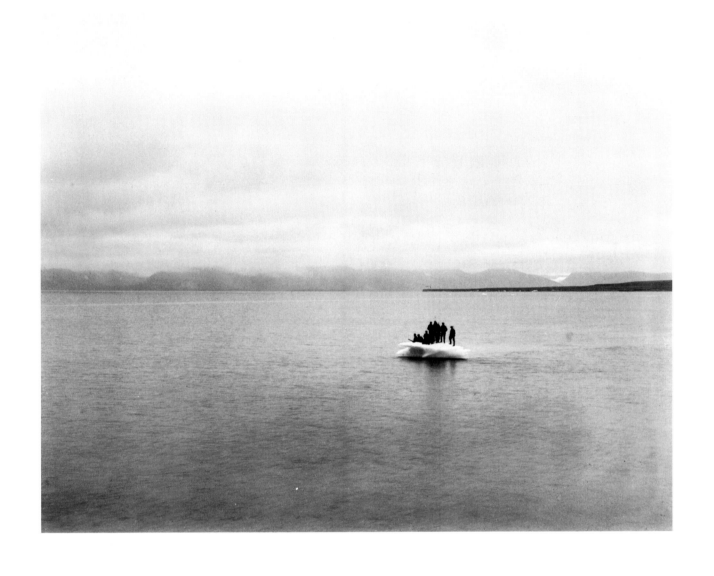

2• HIS MOST SERENE HIGHNESS, PRINCE ALBERT I OF MONACO, **THE STAFF OF THE "PRINCESSE-ALICE II"**
ON A FRAGMENT OF PACK ICE FLOATING IN RECHERCHE BAY, 1899 (AUGUST 25)
MUSÉE OCÉANOGRAPHIQUE DE MONACO

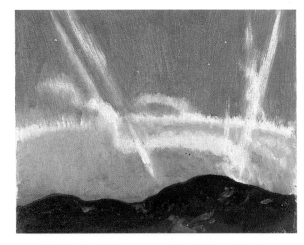
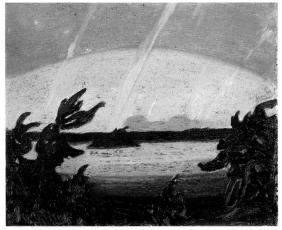
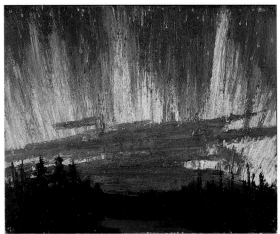
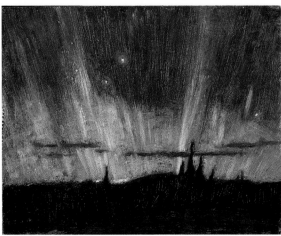

173• J.E.H. MACDONALD, **AURORA,
GEORGIAN BAY, POINTE AU BARIL**, 1931
KLEINBURG, ONTARIO
McMICHAEL CANADIAN ART COLLECTION

139• FRANZ JOHNSTON, **NORTHERN NIGHT**, 1946
ORILLIA, ONTARIO, SIR SAM STEELE ART GALLERY

172• J.E.H. MACDONALD, **NORTHERN LIGHTS**
ABOUT 1915-1916
KLEINBURG, ONTARIO

303• TOM THOMSON, **NORTHERN LIGHTS**, ABOUT 1916
THE MONTREAL MUSEUM OF FINE ARTS

McMICHAEL CANADIAN ART COLLECTION

26• PAUL-ÉMILE BORDUAS, **THE BLACK STAR**, 1957
THE MONTREAL MUSEUM OF FINE ARTS

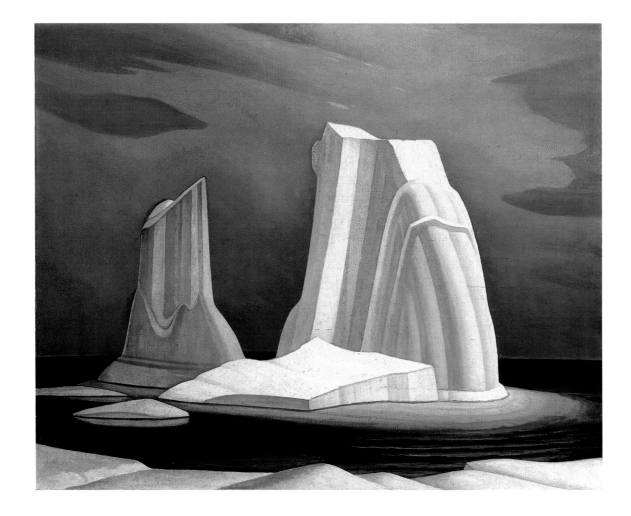

248• JEAN-PAUL RIOPELLE, **PANGNIRTUNG**, 1977
QUEBEC CITY, MUSÉE DU QUÉBEC

130• LAWREN S. HARRIS, **ICEBERGS, DAVIS STRAIT**, 1930
KLEINBURG, ONTARIO, McMICHAEL CANADIAN ART COLLECTION

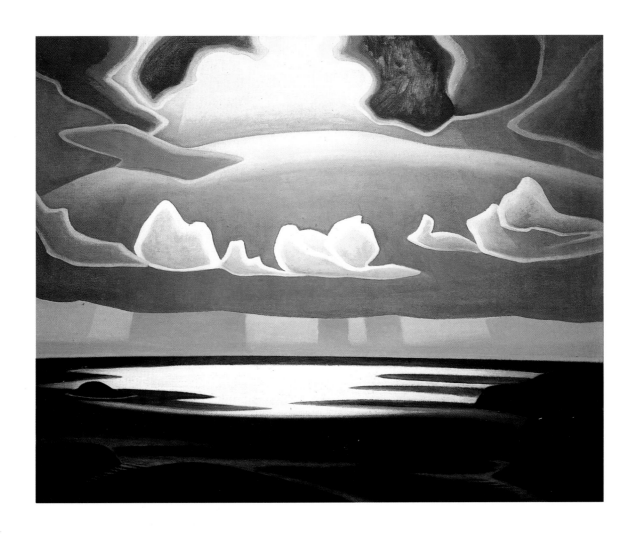

129· LAWREN S. HARRIS, **FROM THE NORTH SHORE, LAKE SUPERIOR**, ABOUT 1927
LONDON, ONTARIO, LONDON REGIONAL ART AND HISTORICAL MUSEUMS

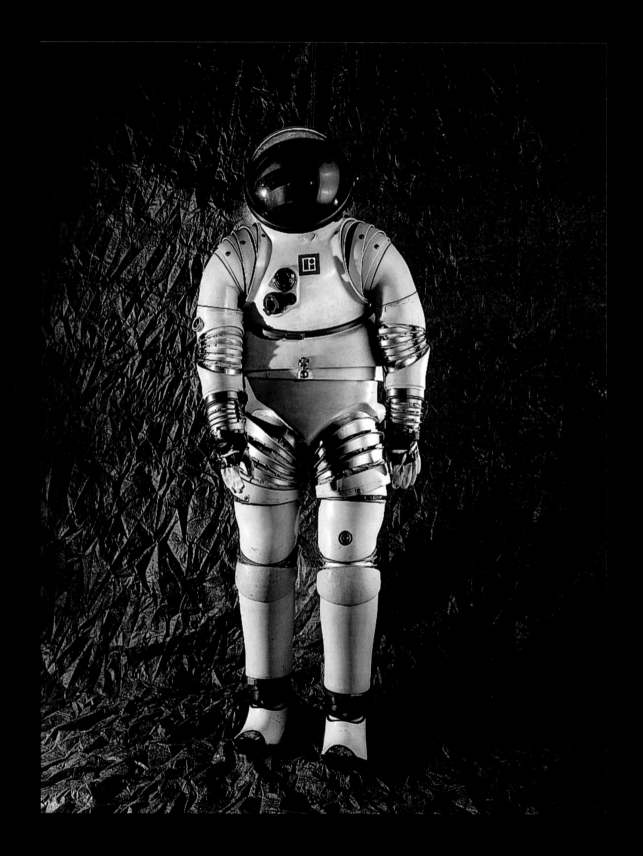

342• LITTON INDUSTRIES, **ASTRONAUT'S HARDSUIT:**
LITTON EXPERIMENTAL IN CONSTANT VOLUME, LATE 1960s
WASHINGTON, NATIONAL AIR AND SPACE MUSEUM, SMITHSONIAN INSTITUTION

- 4 -
BEYOND
THE EARTH:
THE MOON

• Hoax!

In early November 1835, François Arago of the Paris Observatory rose before the Académie des sciences to denounce what he called an "odious abuse" of the reputation of an eminent astronomer. He was agitated by articles circulating in the international press that attributed to the celebrated British scientist Sir John Herschel sensational sightings of life-forms on the moon. It was widely known that Herschel had gone to the Cape of Good Hope the previous year and established an observatory equipped with one of the world's most powerful telescopes. Hence the public interest when,

"Magnificent Desolation"

The Moon Photographed

by Christopher Phillips

on August 25, 1835, the *New York Sun* breathlessly announced that "great astronomical discoveries" had been made at Cape Town, which the newspaper proceeded to relay in a series of reports supposedly provided by Herschel's assistant.

The story began slowly, with a meticulous description of Herschel's great telescope. Outfitted with a glass lens measuring twelve feet (3.6 m) in diameter and weighing seven tons (6.3 t), it was said to possess a magnifying power that permitted the resolution of objects as small as eighteen inches (28 cm) in diameter on the lunar surface. But the pace of the account quickened when the *Sun* stated that Herschel's first observations of the moon with this instrument unexpectedly revealed the existence of a lunar atmosphere not unlike that of earth. The moon proved, in fact, a "gorgeous land of enchantment", covered with vast forests, majestic oceans, live volcanos and tall, slender pyramids of wine-coloured amethyst. Still more astonishing was the plant and animal life, so abundant that Herschel was described as sitting at his telescope busily classifying thirty-eight species of trees and nine species of mammals. Among the fauna were diminutive bison, unicorn-like goats, horned bears, blue and gold pheasants, and a beaver that walked upright. Finally, sighted in a region of particular fertility was a race of batlike humanoids, more than a metre tall, with copper-coloured hair and membrane-like wings. The *Sun*'s series of articles ended with tantalizing hints of the discovery of a second, superior race of bat-men, "of infinitely greater personal beauty". But here, the narrative broke off, with assurances that full details would soon appear in Herschel's "authentificated natural history of this planet".

Needless to say, the report created a furor in New York, and the tale quickly made its way across the Atlantic, where it was translated into every major European language. The truth, however, soon came out: the real author of the story was an enterprising journalist named Richard Adams Locke, who had apparently set out to satirize a Christian sect which believed in the habitation of other worlds. However, Locke's masterful mimicry of Humboldtian scientific language persuaded even learned readers to accept his sober (albeit wholly fictive) portrayal of lunar geology, botany and zoology. Edgar Allan Poe, who followed the unfolding of the "moon hoax" with fascination, confided to a friend, "Not one person in ten discredited it, and (strangest point of all!) the doubters were chiefly those who doubted without being able to say why." Herschel himself, who wrote from the Cape to thank Arago for seeking to quell the hoax, expressed keen amusement at this evidence of modern gullibility.[1]

• **The Dawn of Lunar Photography**
The gradual extinction of such lunar fantasies in the decades that followed owed much to the advent of astronomical photographs that delineated the moon's true, barren face for all to see. Arago may well have recalled Locke's moon hoax when he announced Daguerre's invention before the Chamber of Deputies in 1839, for he took pains to prophesy with remarkable accuracy the advantages that astronomers would obtain from the new medium. With the aid of photography, he predicted, "We may hope to be able to make photographic maps of our satellite. In other words, it will be possible to accomplish within a few minutes one of the most protracted, difficult, and delicate tasks in astronomy."[2] Although he evidently encouraged Daguerre to attempt to capture the moon's image, it proved impossible to register more than a vague, feeble record on the daguerreotype's silvered plate. Arago could award Daguerre only the distinction of having obtained "the first chemical impressions of the moon's light".

The earliest years of astronomical photography were marked by continually frustrated efforts to harness primitive photographic processes to the optics and mechanics of telescopes. Although John William Draper is credited with attaining the first modestly successful daguerreotype of the moon, in 1840 in New York City, physical evidence of his experiment has not survived. A subsequent, and far more consequential, attempt took place at the Harvard College Observatory in Cambridge, Massachusetts. In 1847, the observatory acquired a new thirty-eight-centimetre telescope, the "Great Refractor", at the time one of the two largest such instruments in the world. The observatory's director, William Cranch Bond, and his son, George Phillips Bond, were determined to make astronomical daguerreotypes, and to this end they entered into collaboration with the noted Boston photographer John Adams Whipple.

The Bonds and Whipple promptly encountered two obstacles that would long plague lunar photographers. The first was the lack of a reliable driving mechanism to turn the telescope during the long exposure, so as to track the movement of the moon across the sky and hold its image stationary on the daguerreotype plate. The second was atmospheric. Whipple complained of the sea breeze from nearby Boston harbour and described the harmful visual result of the commingling of hot and cold air: "When the moon was viewed through the telescope it had the same appearance as objects when seen through the heated air from a chimney, in a constant tremor, precluding the possibility of successful daguerreotypy." Such conditions could persist for weeks, he added, "so that an evening of perfect quiet was hailed with the greatest delight".[3]

After initial failures, by November 1850 Whipple and G. P. Bond appear to have made reasonably successful lunar daguerreotypes as well as the first stellar photographs, of the star Vega. In March 1851, however, Bond and Whipple executed a series of lunar views that went far beyond their previous efforts, and with a thirteen-second exposure they obtained a sharply defined image of the moon approximately 7.5 centimetres in diameter. A copy of one of these daguerreotypes was dispatched to the Crystal Palace exhibition in London, where it was displayed to great acclaim. Bond himself soon embarked on a European tour, armed with a supply of daguerreotype copies of his lunar views, to receive the plaudits of Europe's leading scientists. In Paris, he presented one lunar daguerreotype to the Académie des sciences; in Berlin, he bestowed another on the celebrated naturalist Alexander von Humboldt.

While undoubtedly a remarkable technical accomplishment, early lunar daguerreotypy spurred no real astronomical discoveries. Striking advances on both fronts came only after 1850, first with the advent of wet-collodion negatives, which were far more sensitive than the daguerreotype, and then with the introduction of special achromatic optics for telescopes. A key figure in this latter development was Lewis Morris Rutherfurd, one of a series of wealthy amateur astronomers who made important contributions during this era. In 1856, Rutherfurd built a small observatory in the garden of his house in lower Manhattan. His first successful photographs of the moon were made the following year, although he, too, had to contend with the deleterious effects of the city's tremors and atmospheric disturbances.[4] Seven years later, seeking to improve the clarity of his lunar photographs, Rutherfurd began to devise a method of focussing not the rays of the spectrum to which the eye is most sensitive, but those which most strongly affect the photographic negative. As a result, by 1865 he was able to produce large-format photographs of the moon which surpassed all previous examples in sharpness and detail. These spectacular images, praised by scientists in North America and Europe, won him greater fame than his ultimately more important discoveries in spectroscopic astronomy.

In London, the paper manufacturer and amateur astronomer Warren De la Rue had been producing excellent lunar photographs with the wet-plate process since 1852. At about the same time as Rutherfurd, De la Rue arrived at an optical technique similar to Rutherfurd's and achieved equally impressive results. He carried out a remarkable series of lunar photographs which followed the satellite through its monthly phases, and he was the first to invent a method for making stereoscopic photographs of the moon.[5] By such means, De la Rue and his colleagues hoped to determine conclusively whether geological changes were still occurring on the moon's surface – a topic hotly debated at a time when some astronomers were claiming (fancifully, it proved) to have evidence of the sudden disappearance of previously identified craters.

• Mapping the Moon from Paris

To determine if the moon was truly a living or dead sphere would require a far more extensive and systematic effort. However, the latter decades of the nineteenth century saw a dramatic falling-off of interest in lunar observation, as astronomers turned from the study of our nearest celestial neighbour to ponder the immense vistas opened by the rise of astrophysics – then called the "new astronomy" – and its extraordinary revelation of the chemical composition of distant stars and galaxies. In these developments, to be sure, astronomical photography played a crucial role. By the 1860s, the analysis of the photographed spectra of stars enabled astronomers to begin to catalogue the chemical elements composing individual stellar objects. The early 1880s witnessed the first photographs of far-off nebulas and galaxies. During the same decade, a number of photographic star-mapping projects were launched, the most important of which was the celebrated Carte du Ciel, initiated in 1887 at the Paris Observatory and directed by Paul and Prosper Henry (see p. 176). Through the co-ordinated efforts of eighteen observatories around the world, it was hoped to draw up a comprehensive star chart against which subsequent celestial movements could be measured.

By the time that fast, standardized dry-plate negatives arrived in the 1880s, the photographic telescope had moved from peripheral to central status among the instruments employed by astronomers. Its importance was emphasized by influential figures like Jules Janssen, director of the Meudon Observatory, who staked his career on the belief that further advances

would come not from the visual observations of the individual astronomer at the telescope's eyepiece but from the impersonally recorded revelations of astronomical photography. By 1883, Janssen could confidently assert, "I do not hesitate to say that the photographic plate will soon be the scientist's true retina."[6]

Addressing a scientific congress in Toulouse in 1887, Janssen showed projections of the lunar photographs of Rutherfurd and De la Rue and commented extensively on the geology of the moon – a celestial body that Janssen, then the foremost practitioner of solar astronomy, likened to a modestly interesting cadaver.[7] He insisted, however, that the time had come to push to completion the tasks of lunar photography. Returning to this theme two years later, he recommended that a photographic atlas of the moon be undertaken, one which would present "an uninterrupted series of images in large format … in such a manner as to follow, on the surface of our satellite, the progress of light and shadow, and to deduce from them the exact detailed forms of the accidents of the surface".[8]

Janssen's call undoubtedly helped spur the greatest achievement of nineteenth-century lunar photography, the *Atlas photographique de la Lune*. Work on it was begun in 1894 at the Paris Observatory by Maurice Lœwy, who in 1896 became that institution's director, and by his younger colleague Pierre Puiseux, a specialist in lunar geology. Declaring their intention to assemble a visual representation of our satellite "as truthful and precise as possible", Lœwy and Puiseux set out to compile a general map of all the moon's regions as illuminated by sunlight emanating from various directions. They were convinced that photography, because of its rapidity, precision and fidelity, afforded the most suitable means of fulfilling these aims. "In this regard," they argued, "the superiority of photography to all the procedures of drawing no longer requires demonstration. While the sensitive plate [of the negative] cannot succeed in collecting some tiny details that are visible in the telescope's eyepiece, it stamps its images with a character of indisputable authenticity, which all the draftsman's dexterity cannot supply."[9]

Lœwy and Puiseux's technique was the culmination of the preceding six decades of astronomical photography. They began by obtaining negatives of the moon roughly sixteen to eighteen centimetres in diameter. During the exposure, which lasted from one-half to four seconds, the glass-plate negative (not the telescope) was moved by a clockwork mechanism which could be adjusted to thirty-six hundred different speeds – a necessity for accurately tracking the moon's variable movements. In addition, the shutter could be manually operated so that the brightest areas of the moon's surface received relatively less exposure. Owing to the disadvantageous atmospheric conditions of central Paris, where the observatory was located, no more than one in ten negatives was deemed satisfactory. Enlarged glass-plate negatives were then prepared, from which pictorially stunning photogravures were produced. These spectacular prints made up the *Atlas*, published from 1896 to 1909 in a series of fascicules that were accompanied by a volume of commentary. The Harvard astronomer William H. Pickering, one of the era's leading lunar specialists, echoed a widely shared sentiment when he called the images in the *Atlas photographique de la Lune* "the very best results of the 19th century".[10]

There was less agreement as to the lessons that could safely be drawn from this momentous exercise in descriptive astronomy. Lœwy and Puiseux, engaged participants in the debate over the nature of the geological forces that had pocked the moon's surface, were convinced that their images lent credence to the theory that the moon's cratered topography resulted mainly from internal volcanic action. On this point, they found themselves in sharp disagreement with arguments such as those advanced by the chief geologist of the U.S. Geological Survey, Grove Karl Gilbert. Based on his investigations of meteor craters in Arizona, Gilbert maintained that meteor impact was the chief cause of the moon's pitted aspect. Only by the mid-twentieth century did the dispute subside, with the gradual abandonment of the theory of lunar vulcanism set forth by Lœwy and Puiseux.

• Cameras to the Moon

After the telescopic virtuosity of Lœwy and Puiseux, lunar photography reached a technical impasse that lasted half a century. Already with the *Atlas*, the limiting factor of lunar observation was no longer telescope optics but the inevitable degradation of the image by atmospheric turbulence. Even when situated on remote mountain peaks – as new observatories generally were in the twentieth century – the most powerful earth-based telescopes could seldom detect objects on the moon's surface measuring less than a kilometre. Only two paths promised substantial increases in observational power: the placement of large telescopes in orbit beyond the earth's stratosphere and the dispatching of smaller packages of optical instruments to the moon itself.

If the latter course was taken first, this owed not to scientific calculation but to political circumstances. Stung by the Soviet Union's early triumphs in space exploration, in 1961 the U.S. inaugurated a top-priority programme to land American astronauts on the moon by the end of the decade. As part of the preparation for manned flights, three unmanned lunar missions equipped with different kinds of video or photographic systems were launched during the mid-1960s to relay

back to earth detailed visual information about potential landing sites. The earliest and most primitive was the Ranger programme, in which rockets outfitted with a television camera were sent hurtling towards targets on the moon's surface. During the last quarter hour of the flight, a video camera was turned on and a series of pictures was beamed back to earth. Lunar features as small as one metre in diameter were revealed in the final moments, before the rocket's crash landing brought the transmission to an abrupt end.

Far more sophisticated were the five Surveyor spacecraft that made successful soft landings on the moon between June 1966 and January 1968. (The Soviets' Luna 9 carried out the first soft landing in early 1966, but the Soviet military chose not to give the resulting images wide publicity.) The primary aim of the Surveyor programme was to obtain close-up photographs, taken over an extended period, of prospective sites for manned landings. Each Surveyor craft was equipped with a video camera that could resolve objects of a size as small as one millimetre. The camera's zoom lens, controlled from earth by radio signal, was mounted in a periscope-like construction that could rotate to scan a 360-degree horizon. (The tilting of the camera during such panoramic sequences often imparted the look of a sinusoidal wave to the lunar horizon, a bizarre effect that prompted artists to experiment with similarly distorted photographic landscapes.) Transmitted back to earth, the individual Surveyor video frames were printed onto small "chips" of photographic paper and combined into mosaic-like images; all together, around three hundred distinct Surveyor mosaics were produced.[11]

The final preparatory mission before the Apollo landings, the Lunar Orbiter flights of 1966-1967, was meant to provide a highly detailed photographic map of twenty selected landing sites. Circling in orbits that dipped as low as forty-five kilometres from the moon's surface, the Orbiters accomplished this task and went on to map over 99 percent of the moon. Because the most detailed visual information possible was sought, the Orbiters employed not direct video camera transmissions, as had the Ranger and Surveyor missions, but an unusual film-based system. Housed in a heated pressurized compartment, the Orbiter imaging system included a camera with a wide-angle and a telephoto lens, a film processor, a video scanner and a transmitter. Once the special high-resolution film was exposed, it was chemically processed on board and automatically passed before the scanner; these images were transmitted back to earth and recorded on magnetic tape, from which photographic negatives were made.

The engineering sophistication of the Lunar Orbiter was remarkable: to compensate for the movement of the spacecraft while exposures were being made, the camera was linked to an optical sensor which guided constant microadjustments. Over sixteen hundred photographs resulted, whose pictorial and scientific interest was immediately recognized. The Orbiters captured stunning oblique vistas of the lunar terrain as well as dizzying views plunging straight down into craters and valleys. Lunar Orbiter 1, in addition, furnished the first picture of the earth as it appeared from beyond the moon, seen from a spacecraft looking back almost a half million kilometres.[12]

Given the enthusiastic popular response to these images, it seems curious that the NASA space programme at first included no plans for U.S. astronauts to carry photographic equipment. There was apparently ingrained resistance, on the part of the no-nonsense engineers who designed the programme, to the idea that astronauts' valuable time should be spent making what was disparagingly called "touristy snapshots". It was only when John Glenn took his own camera into orbit in 1962 and made photographs that were immediately reproduced around the world that photography began to expand into a serious component of the U.S. manned space programme. Still, as Brian Duff, NASA's director of public affairs at the time of the first moon landing, has recalled, "It may surprise you to know that it was necessary to demand that color film be carried to the moon for Apollo 11. It was not considered 'scientifically accurate'."[13]

Thorough photographic training eventually became part of the Apollo astronauts' prelaunch preparations. Astronauts were equipped with extensively redesigned Hasselblad 70mm square-format cameras. The cameras intended for use during space walks and on the lunar surface were fitted with plates that superimposed a subtle grid of crossmarks on the resulting images to aid in later analysis of them. Astronauts had to master unaccustomed movements in order to manoeuvre the camera, which was bracketed solidly to the chest area of the space suit. With the camera mounted in this position and the viewfinder thus visually inaccessible, it was necessary to learn how to estimate the framing of any given image. Each astronaut practised, too, turning his body in increments so as to make multiple-exposure panoramic series that captured the vast sweep of the lunar landscape.

While on the moon, the Apollo astronauts were guided by a detailed operations plan, or "timeline", that prescribed exactly when and where photographs were to be made. The purpose of such photography was to provide full visual documentation of each phase of activity, particularly when exploring the lunar terrain. Astronauts were instructed to periodically make "locator" photographs that included bits of recognizable terrain or objects as markers for NASA's photo analysts.[14] The astronauts were also taught to

photograph rock samples in situ before collecting them – the members of the final lunar mission, Apollo 17, did this in the Taurus-Littrow Valley when they investigated boulders, some billions of years old, that had tumbled down from the mountains ringing the valley floor.

In their laconic directness, the photographs made on the moon by the Apollo astronauts recall nothing so much as the images of the American West made a century earlier by the photographers of the U.S. Geological Survey. In both cases, the terrain pictured is typically of a bleak yet awe-inspiring majesty. Buzz Aldrin, one of the first pair of astronauts to walk on the moon, radioed back to earth his initial impression of "magnificent desolation". The barrenness of this airless, waterless, rocky terrain, stunningly conveyed in the Apollo astronauts' photographs, doubtless instilled in these first moon explorers a sudden appreciation for the brilliant blue disk of their home planet, hovering in the black lunar sky.

Of the dozen men who have landed on the moon, none has more eloquently evoked the new vision of earth it affords than astronaut Eugene Cernan. Reflecting afterward on his experiences during the Apollo 17 mission, he admitted that the earth had no doubt seemed larger to him, gazing up from the moon's surface, than it actually was. "Yet," he went on, "because the Earth's beauty was so predominant, there was also a feeling that it was the most precious possession a man could stow in his memory. There was the beauty of the colors of the oceans and the clouds: multiple shades of blue, from the azure of the Caribbean to the deep dark blues of the Pacific; the shades of white of the clouds and the snow; and the black of space around it. There you were, standing on the surface of the moon in full sunlight, looking at the Earth … It's an overpowering figure of life in the sky."[15]

• Notes

1. On the "moon hoax", see Michael J. Crowe, *The Extraterrestrial Life Debate, 1750-1900: The Idea of a Plurality of Worlds from Kant to Lowell* (Cambridge and New York: Cambridge University Press, 1986), pp. 210-215; the reaction of Edgar Allan Poe is detailed on p. 211. For the repercussions in France, see Michel Nathan, *Le Ciel des fouriéristes : habitants des étoiles et réincarnations de l'âme* (Lyons: Presses universitaires de Lyon, 1981), pp. 73-85. The text of the *New York Sun* articles appears in Richard Adams Locke, *The Celebrated "Moon Story": Its Origins and Incidents* (New York: Bunnell and Price, 1852). For Herschel's letter to Arago, see "Astronomie – Prétendues découvertes dans la Lune", Institut de France, Académie des sciences, *Comptes rendus*, October 31, 1835, p. 505. For an account of Arago's intervention before the Académie des sciences, see the *Journal des débats*, November 19, 1835, pp. 2-3.

2. Dominique François Arago, "Report of the Commission of the Chamber of Deputies", July 3, 1839, in Alan Trachtenberg, ed., *Classic Essays on Photography* (New Haven: Leete's Island Books, 1989), pp. 20-21. A good early history of the development of lunar photography can be found in Georges Rayet, *Notes sur l'histoire de la photographie astronomique* (Paris: Gauthier-Villars, 1887).

3. John Adams Whipple, letter to the editor, *Photographic Art Journal* (New York), vol. 6, no. 1 (1853), p. 66. See George Phillips Bond's similar complaints about the atmospheric obstacles encountered in Cambridge in an 1864 letter cited in Bessie Zaban Jones and Lyle Gifford Boyd, *The Harvard College Observatory: The First Four Directorships, 1839-1919* (Cambridge, Massachusetts: Harvard University Press, 1971), p. 85.

4. Lewis Morris Rutherfurd, "Astronomical Photography", *American Journal of Science*, vol. 39 (May 1865), p. 6.

5. See Warren De la Rue, "Report on the Present State of Celestial Photography in England", in *Report of the 29th Meeting of the British Association*, 1859, pp. 130-153.

6. Jules Janssen, "Le progrès de l'astronomie physique" (1883), in Janssen, *Œuvres scientifiques*, vol. 1 (Paris: Société d'Éditions géographiques, maritimes et coloniales, 1929), p. 483.

7. Jules Janssen, "La photographie céleste" (1887), *ibid.*, vol. 2, pp. 33-38, 47.

8. Jules Janssen, "Discours prononcé à la séance d'ouverture du Congrès de photographie céleste" (1889), *ibid.*, vol. 2, p. 179.

9. Maurice Lœwy and Pierre Puiseux, *Atlas photographique de la Lune. Études fondées sur les photographies de la Lune obtenues au Grand Équatorial Coudés* (Paris: Observatoire de Paris, 1896), p. 2.

10. William Henry Pickering, *The Moon: A Summary of the Existing Knowledge of Our Satellite, with a Complete Photographic Atlas* (New York: Doubleday, 1903), p. 87.

11. See National Space Science Data Center, *Catalog of Surveyor 1 Television Pictures* (Washington: NASA, 1968).

12. See David E. Bowker and J. Kenrick Hughes, *Lunar Orbiter Photographic Atlas of the Moon* (Washington: NASA, 1971).

13. Brian Duff, quoted in H.J.P. Arnold, "Lunar Surface Photography: A Study of Apollo 11", in *Proceedings of the Twentieth and Twenty-first History Symposia of the International Academy of Astronautics; History of Rocketry and Aeronautics*, vol. 15 (1993), p. 278. For an excellent overview of U.S. astronaut photography, see Ron Schick and Julia Van Haaften, *The View from Space: American Astronaut Photography, 1962-1972* (New York: Clarkson N. Potter, 1988).

14. A transcript of all radio conversations between moon-walking astronauts and their earth-based colleagues can be found at the NASA Web site "Apollo Lunar Surface Journal" (http://www.hq.nasa.gov/alsj). These transcripts are accompanied by the complete series of photographs made by the astronauts at each stage of their moon exploration and contain valuable commentary on the images added subsequently by the astronauts.

15. Eugene Cernan, commentary on transcript of Apollo 17 radio conversations, mission timetable 143.20.14, archived at the Apollo Lunar Surface Journal Web site (http://www.hq.nasa.gov/alsj/a17/a17j.html).

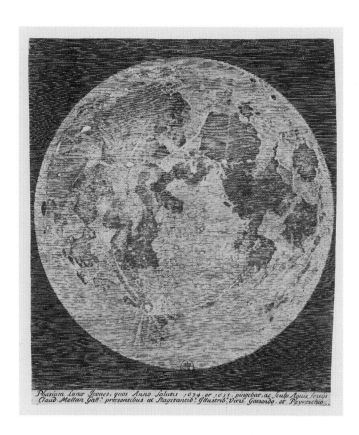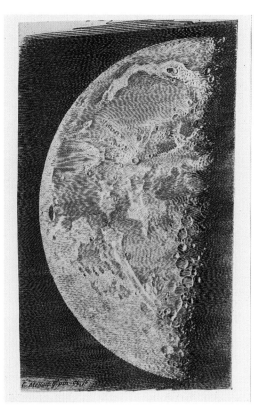

CLAUDE MELLAN

194· **FULL MOON**, 1636 193· **THE MOON, LAST QUARTER**, 1636

PARIS, BIBLIOTHÈQUE NATIONALE DE FRANCE

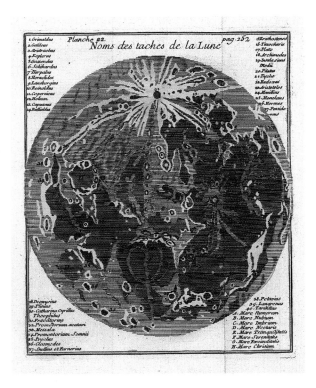

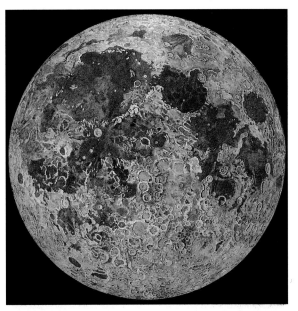

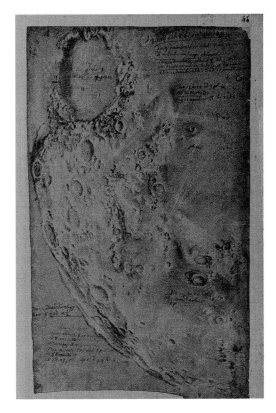

20• NICOLAS BION, **NAMES OF THE MOON'S SPOTS**, 1744
MONTREAL, STEWART MUSEUM AT THE FORT, ÎLE SAINTE-HÉLÈNE

258• JOHN RUSSELL, **LUNAR PLANISPHERE**, 1805-1806
LONDON, CHRISTOPHER MENDEZ COLLECTION

48• JEAN-DOMINIQUE CASSINI, **THE MOON'S SPOTS**, 1673-1679
OBSERVATOIRE DE PARIS

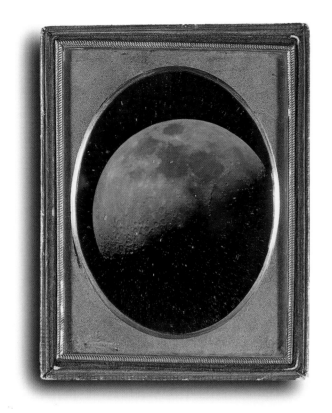

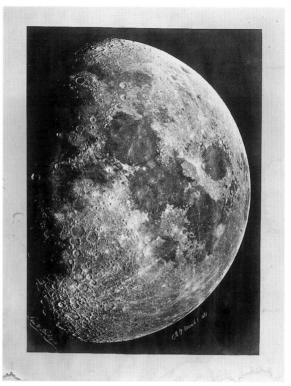

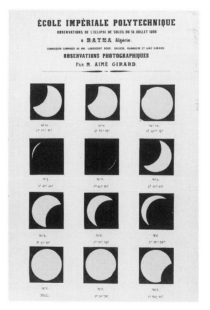

322• JOHN ADAMS WHIPPLE, **MOON**, 1851
BRADFORD, ENGLAND, THE NATIONAL MUSEUM
OF PHOTOGRAPHY, FILM AND TELEVISION

262• LEWIS MORRIS RUTHERFURD
THE MOON, NEW YORK, 1865 (MARCH 6)
PRIVATE COLLECTION

113• AIMÉ GIRARD, **OBSERVATIONS OF THE ECLIPSE OF THE SUN, JULY 18, 1860, AT BATNA, ALGERIA**
PARIS, SOCIÉTÉ FRANÇAISE DE PHOTOGRAPHIE

50• VIJA CELMINS, **MOON SURFACE #2 (LUNA 9)**, 1969
NEWPORT BEACH, CALIFORNIA, ORANGE COUNTY MUSEUM OF ART

THE MOON.

PHOTOGRAPHED BY SMITH, BECK & BECK,
from an Original Negative by
WARREN DE LA RUE, Esq. F.R.S

THE MOON.

PHOTOGRAPHED BY SMITH, BECK & BECK,
from an Original Negative by
WARREN DE LA RUE, Esq. F.R.S.

THE MOON.

PHOTOGRAPHED BY SMITH, BECK & BECK,
from an Original Negative by
WARREN DE LA RUE, Esq. F.R.S.

THE MOON.

PHOTOGRAPHED BY SMITH, BECK & BECK,
from an Original Negative by
WARREN DE LA RUE, Esq. F.R.S.

THE MOON.

PHOTOGRAPHED BY SMITH, BECK & BECK,
from an Original Negative by
WARREN DE LA RUE, Esq. F.R.S.

THE MOON.

PHOTOGRAPHED BY SMITH, BECK & BECK,
from an Original Negative by
WARREN DE LA RUE, Esq. F.R.S.

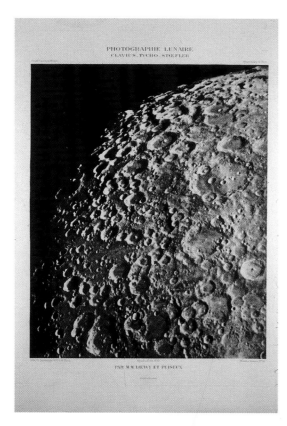

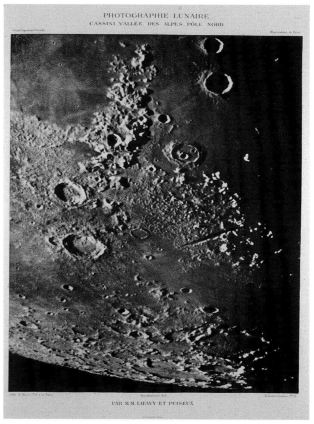

MAURICE LŒWY AND PIERRE PUISEUX

171• CLAVIUS, TYCHO, STOEFLER,
PLATE 17 FROM
THE **ATLAS PHOTOGRAPHIQUE DE LA LUNE**, 1894-1908

170• CASSINI - VALLEY OF THE ALPS -
NORTH POLE, PLATE 13 FROM
THE **ATLAS PHOTOGRAPHIQUE DE LA LUNE**, 1894-1908

COURTESY OF JULIE SAUL GALLERY, NEW YORK

NASA, LUNAR ORBITER

225· VIEW OF THE MOON 224· VIEW OF THE MOON
BY ORBITER MISSION SATELLITE, ABOUT 1967 BY ORBITER MISSION SATELLITE, 1967

WASHINGTON, GARY EDWARDS GALLERY

NASA, LUNAR SURVEYOR

222• DAY 328, SURVEY EE, SECTORS 9 AND 10, 1966-1968 220• DAY 010, SURVEY A, SECTORS 13 AND 14, 1966-1968

NOELLE C. GIDDINGS AND NORMAN BROSTERMAN COLLECTION

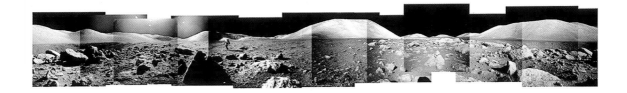

221• NASA, LUNAR SURVEYOR, **DAY 262, SURVEY W-N**, 1966-1968
NOELLE C. GIDDINGS AND NORMAN BROSTERMAN COLLECTION

59• EUGENE CERNAN, **ASTRONAUT HARRISON SCHMITT IN THE TAURUS-LITTROW VALLEY, APOLLO 17**, 1972
PRIVATE COLLECTION

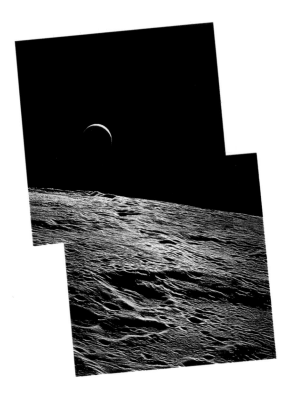

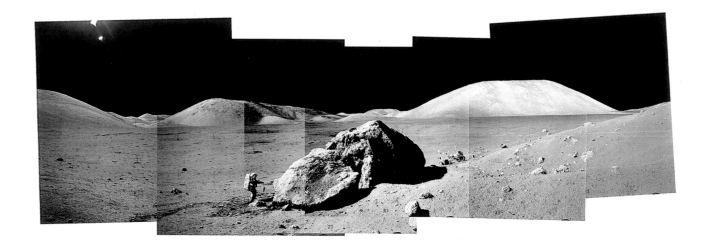

325• ALFRED WORDEN, **CRESCENT EARTH OVER THE LUNAR HIGHLANDS, APOLLO 15,** 1971
PRIVATE COLLECTION

58• EUGENE CERNAN, **ASTRONAUT HARRISON SCHMITT, BOULDER, LUNAR ROVER, APOLLO 17,** 1972
PRIVATE COLLECTION

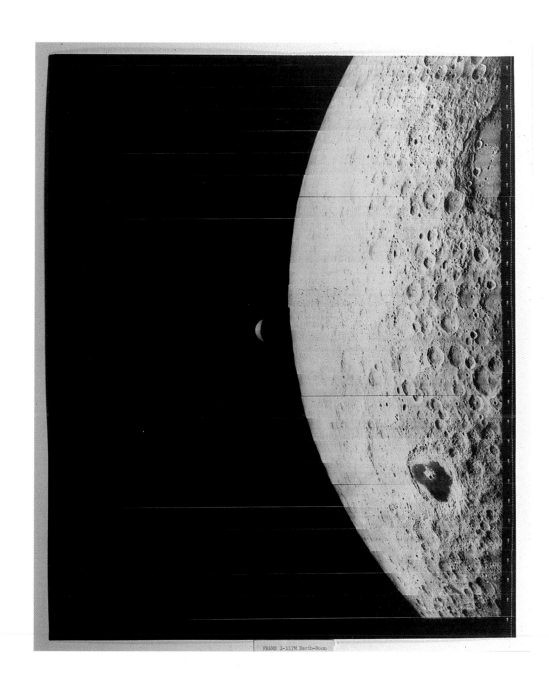

FRAME I-117M Earth-Moon

223· NASA, LUNAR ORBITER, **VIEW OF THE EARTH AND THE MOON BY ORBITER MISSION SATELLITE**, 1967
COURTESY OF CHARLES ISAACS PHOTOGRAPHS

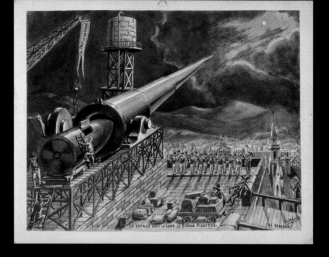

THE GIANT CANNON

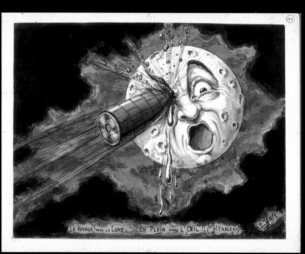

UARE IN THE EYE!!

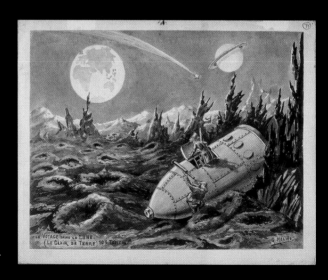

EARTHLIGHT

192• GEORGES MÉLIÈS, **SIX DRAWINGS FROM THE FILM "A TRIP TO THE MOON"** (19
PARIS, BIBLIOTHÈQUE DU FILM (BIFI), COLLECTION CINÉMATHÈQUE FRANÇAISE

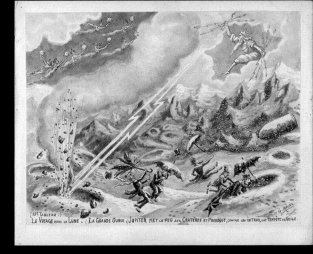

(URSA MAJOR.)
JUPITER SETS FIRE
TO THE CRATERS
AND RAISES A SNOW
STORM AGAINST
THE INTRUDERS

THE GROTTO
OF GIANT MUSHROOMS.
THE FIRST SELENITE

THE SELENITES

242· PABLO PICASSO, **HORSE LYING DOWN**, 1930 (JUAN-LES-PINS, SEPTEMBER 5)
PARIS, MUSÉE PICASSO

104· PATERSON EWEN, **GIBBOUS MOON**, 1980
OTTAWA, NATIONAL GALLERY OF CANADA

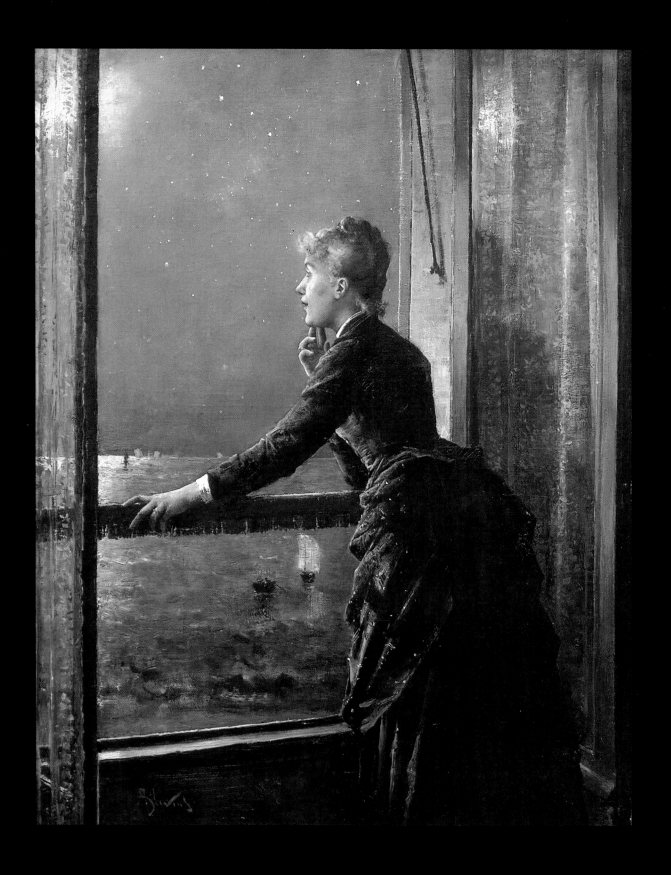

283· ALFRED STEVENS, **THE MILKY WAY**, ABOUT 1885-1886
BRUSSELS, GALERIE PATRICK DEROM

- 5 -
IMAGINARY COSMOLOGIES

The revolution in astronomy that occurred in the last four decades of the nineteenth century reverberated in the development of French modernism. Impressionism's concern for the natural properties of light and changes in colour effected by weather and the hour of day evolved at a time when the emerging science of solar physics was bringing the investigation of energy and light to bear upon solar-terrestrial relationships, and meteorology, armed with recent inventions, was progressing in the understanding of atmospheric conditions in the context of cosmic dynamics. At the turn of the century, Symbolists with

The New Astronomy and the Expanding Cosmos: The View from France at the End of the Nineteenth Century

by Barbara Larson

mystic tendencies speculated about the possibility of spiritual life on other planets, following the lead of imaginative astronomers who used scientific advances to support the claim of infinite possibilities for an afterlife on other orbs. Whether attention was focussed on the earth or the stars, on this life or the hereafter, it seemed that lasting truths dissolved and the earth shrank before the immaterial forces of the cosmos.

Until the mid-nineteenth century, Newtonian principles of a clockwork universe had guided French astronomers, who devoted themselves largely to observing the position and motion of heavenly bodies – charting their orbits, masses and distances. Laplace's work in the late eighteenth and early nineteenth centuries, including his widely read *Exposition du système du monde* (1796) and the authoritative *Mécanique céleste* (1799-1825), provided a convincing model of a stable, self-regulating solar system where even unique events like comets could be predicted accurately. Celestial mechanics upheld the idea of order in the universe and the notion that cosmic beginnings happened only once: following some mysterious original moment, planets and their satellites were set in motion in a timeless, unchangeable pattern; planets revolved in a given course for all eternity, and stars were set immobile in their place. The revolutionary "new astronomy" that revealed an infinitely vast, dynamic and sometimes unpredictable universe began to coalesce around 1860 and eventually replaced positional cosmology.

Several new interpretive tools were necessary to transform the way man would see the cosmos at the end of the nineteenth century. One was the "big telescope". With improvements to the telescope, celestial phenomena could be examined in greater

detail, and many new heavenly bodies were identified. The most powerful telescope in France in 1876 was that made by Martin and Gautier for the Paris Observatory. The observer reached the eyepiece at the top by way of a spiral staircase mounted on a circular track (fig. 1). By 1880, the telescope of the Nice Observatory had surpassed it with the largest refractor lens then in existence.

As the nineteenth century drew to a close, stars seemed to multiply by the dozen. New minor planets were also discovered in rapid succession. In 1845, only four had been observed. By 1870, this number had grown to a hundred and ten; in 1885, two hundred and fifty, and by 1891, three hundred and twenty were documented. Beginning in 1873, Paul and Prosper Henry charted new stellar maps at the Paris Observatory. Their work was revolutionized in the eighties by applying the newly invented process of gelatin silver dry emulsion photography in their work. They discovered that besides aiding in documenting stars, this type of photographic plate revealed celestial objects not previously observed by astronomers. The Henry brothers then headed an international photography project to produce a definitive Carte du Ciel, or Map of the Heavens (cat. 134).[1]

Perhaps the most important new tool in the study of the solar system was spectral analysis, first used in 1859. Spectroscopy breaks down the light from a celestial body into a series of coloured bands that reveal the elements it is composed of. Information thus gathered regarding physical structure and chemical substance may also be used to deduce

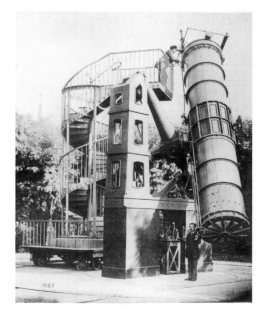

FIG. 1 - **TELESCOPE OF THE PARIS OBSERVATORY** ILLUSTRATED IN THE MAGAZINE **LA NATURE**, 1876

temperature and age. By 1866, the astronomer Pietro Secchi had begun to classify stars according to spectra. The real possibility of analyzing the evolution of a star over time was introduced into the new field of astrophysics. The heavens were no longer thought of as eternal but as constituted of celestial bodies that were born, grew older and died in the ongoing drama of the cosmos.

Spectroscopy also revolutionized the study of the sun and led to the birth of solar physics, one of the most important subfields within the new astronomy. Eclipse studies, which facilitated the observation of solar activity, gave additional impetus to identifying the nature of the sun's energy sources, surface and corona. The sun was now understood to be an ever-transforming ball surrounded by a boiling atmosphere of hydrogen. Red prominences that projected from this surface were recognized as occasional extensions, akin to huge flames, from a lower layer around the sun called the chromosphere.

New models of the sun made use not only of spectroscopy but of thermodynamics, a branch of science concerned with the conservation of energy and its loss, or entropy. In 1865, the French astronomer Faye proposed the model of a sun made up of many stars. Matter in space had collapsed and given rise – through the conservation of energy – to hot, rotating stellar masses. With contraction and cooling, molecules and particles coalesced on the surface to form a photosphere. Over a period of many years, hot gaseous masses would rise to the sun's surface from deep within. Faye's central ideas – that the sun was an ordinary star; that it originated in the gravitational collapse of matter; that the heat so engendered put it into a gaseous state; that the photosphere was a condensation surface – were all to remain central to twentieth-century theorizing. Secchi summarized his ideas on the sun several years later in the trailblazing treatise *The Sun, Exposé of the Principal Modern Discoveries about the Structure of This Star, Its Influence in the Universe and Its Relation with Other Celestial Bodies* (1870). This book, which contained new information on the surface movement of the sun, its radiation and the gases that rise from the surface, was widely consulted in France. One of the early offshoots of solar physics was the exploration of solar-terrestrial relationships. First, terrestrial magnetic variations were correlated with sunspots, which led to a detailed examination of the links between solar changes and the earth's weather.

Astronomers in search of better perspectives on celestial phenomena frequently relied on balloon ascensions. These scientists often doubled as meteorologists, using new equipment to learn more about the earth's atmosphere and pondering from aloft the effects of the sun and other celestial bodies on the surface of the planet. Hot air balloons also functioned as public spectacles, drawing attention to the scientific investigations associated with them.

It is perhaps no coincidence that the style of the sun-loving French Impressionists, which evolved in the 1860s, is characterized by vibrant, dematerialized surfaces and a fascination with atmospheric conditions. The first Impressionist exhibition was held in 1874 in the studio of the photographer Nadar, who was also known as a balloonist and amateur meteorologist. The Post-Impressionist Seurat advanced Impressionist interests with his "colour-light" formula, and Van Gogh found one of his most powerful symbols in the radiating solar disk of his *Sower* (1888; fig. 2).

Awareness of the advances in astrophysics from the 1860s on would also have been available through scientific popularizers like Amédée Guillemin. By the time the fifth edition of his *Ciel* (1864) was published in 1877, it had undergone considerable revision, due to "changes in the subject matter [of astronomy] itself ... the knowledge bestowed upon it by science, which had expanded and been in some respects transformed by ten years of new observations".[2] This revised and amplified edition and the many new publications on astronomy to follow, such as Zurcher's *Monde sidéral. Description des phénomènes célestes* (1878), Camille Flammarion's *Astronomie sidéral* (1878) and his widely read *Astronomie populaire* (1879), reflect not only the accumulating results of the ongoing revolution in the new astronomy, but the financial support given by the newly established anticlerical, pro-science Third Republic after 1874.

France's defeat in the Franco-Prussian War in 1871 had brought science's role in the life and survival of the nation to centre stage. While France had enjoyed a period of growth in the sciences in the 1860s, there were many who felt that the nation's hope of

FIG. 2 - VINCENT VAN GOGH, **THE SOWER**, 1888

regeneration lay in increased funding and support for the sciences, and "the integration of science into culture".[3] Astronomy was one of the fields that benefited from this commitment, and France assumed a leading role.

In 1876, the French government established a new observatory at Meudon, headed by Jules Janssen, who would devote the greater part of his work to solar physics. One of the most famous projects at Meudon was his atlas of solar photographs. Composed of exposures made between 1876 and 1903, it summarized the history of the sun's surface during these years (cat. 138). Also in 1876, the astronomer Rayet was appointed to oversee the newly constructed observatory in Bordeaux. Astronomical reports were gathered from all corners of the world during the last quarter of the century. Meteorological curiosities, comets, spiral nebulas and the passage of planets were observed, and upcoming cosmological events reported to the public. Observation points were set up in a number of French towns beginning in 1878. Following the complaints of Flammarion, a public observatory was instituted in Paris. Directed by Léon Jaubert, it offered telescopes, a library and series of lectures.

The Universal Expositions provided showcases for advances in astronomy under the Third Republic. An enormous telescope was one of the featured attractions in 1878. Telescopes, lunar and solar maps, and models of the solar system were on view in 1889. At the spectacular show at the Optical Palace in 1900, breathtakingly detailed photographic plates at the end of a long telescopic lens gave the viewer the illusion of being only four kilometres from the moon. A diorama re-created a voyage to a star. A series of images depicted the birth of the earth. From the basket of a balloon, one could watch a progression of images that simulated a balloon trip, with the earth receding from view. In postwar France, the new perspective of a "shrinking world" in an expanding cosmos and the growing interest in celestial phenomena can be tied to national sentiments about diminished position and power in the world, the claustrophobia of urban dwellers and escapist fantasy.

Ever since Nadar first photographed the lilliputian earth from a hot air balloon in 1856, a fascination with the minuteness of the planet when seen from far above had gripped the French imagination. Until the end of the century, the balloon remained the utopian symbol of the future, of the great space voyage and man's potential conquest of the air.

Invented in France by the Montgolfier brothers in 1783, the hot air balloon was strongly associated with French nationalism. Goya's Balloon (1813-1816; cat. 117), painted at the end of devastating Napoleonic invasions of Spain, may allude to political oppression by France. Rather than suggesting freedom from the terrestrial realm, it hovers, an ominous and dominating presence, as crowds below flee in panic from the terrifying apparition. The balloon played a significant role during the Franco-Prussian War: under Nadar's direction, more than sixty of them were used to fly mail and military personnel out of Paris when the city was under siege in 1870. Then, used in memorabilia and monuments to the war dead, the balloon became a renewed symbol of nationalism and a reminder of recent tragedy.

The balloons of 1870 encouraged additional experiments in construction.[4] An enormous balloon tethered to the ground and capable of transporting fifty people at a time was one of the attractions at the Paris Universal Exposition in 1878. Flying at heights of upwards of nine hundred metres over exotic structures like the Chinese pagoda and Algerian mosque, the balloon ride was billed as a "voyage around the world". The Symbolist Odilon Redon's fantastic conflation of an eye and a balloon in 1878 drew its inspiration from the Exposition's balloon and is the basis for the lithograph The Eye, like a Strange Balloon, Moves towards Infinity (1882; cat. 246). The image, with its mournful upwardly gazing eye, suggests not the fulfilment of collective celestial fantasy, the "voyage around the world", but a failed attempt at humanity's release from the material world. The severed head the balloon transports may be an allusion to the martyrs of the Franco-Prussian War.

However, postwar escapist meditations were generally less gloomy. Many speculated that, whether or not one could ever be entirely free of earth, life might exist elsewhere.[5] The new astronomy had given rise to a renewal of the extraterrestrial life debate. The spectral bands found in the heavens were believed to correspond with terrestrial elements and thus seemed to confirm similar operating principles and shared elements throughout the universe. Stars resembled the sun structurally and were constituted of similar elements, such as hydrogen, sodium and magnesium, which led to the belief that they too might be surrounded by planets much like our own. The discovery of new nebulas suggested the possibility of whole new planetary systems in the process of creation.

The concept of extraterrestrial life was supported by a surprising number of astronomers.[6] Janssen reported what he thought to be water vapour on Mars, asserting the possibility of life there. Flammarion, the most influential of those who believed in life on other planets, wrote more than seventy books on the subject. His first, La Pluralité des mondes habités (1862), was an immediate success.[7] Flammarion's work gained increased visibility after the Martian canal debates began in 1877. New telescopes made it possible to detect on Mars what some saw as canals

that could only have been built by intelligent beings.[8] When this sighting was "confirmed" in 1886 with the aid of the powerful new telescope at the Nice Observatory, the extraterrestrial life debate gained even greater popularity in France.

Some of Redon's imaginative cosmological lithographs from the late nineteenth century suggest an engagement with this debate. *On the Horizon the Angel of Certitude, and in the Sombre Heaven a Questioning Eye* (1882; fig. 3), with its planet-eye conflation, scattered stars and angelic presence, may respond to Flammarion's Introduction to the 1864 edition of *La Pluralité,* which the artist owned. On the search for intelligence elsewhere and its divine

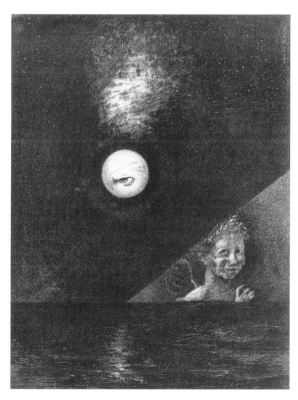

FIG. 3 - ODILON REDON
ON THE HORIZON
THE ANGEL OF CERTITUDE,
AND IN THE SOMBRE HEAVEN
A QUESTIONING EYE, 1882

affirmation, Flammarion wrote, "The curious stared inquiringly at the horizon, seeking to guess what possible races of beings could have pitched their tents up there ... Soon it became evident that the doctrine [of the plurality of worlds] is a direct confirmation of astronomical science ... and that the greatness of Creation and the majesty of its Author shone nowhere else so brightly as in this interpretation of the work of

nature."[9] On the idea of existential solitude in a universe of many humanities, a mood that is close to Redon's work, Flammarion wrote, "But the admiration aroused in us by this most moving scene of nature soon turns to an indefinable sadness, because we believe ourselves to be strangers to these worlds where solitude appears to reign ... In these deserted and silent shores, we seek a gaze in answer to our own."[10]

Redon's lithograph may contain other allusions as well, for in late nineteenth-century France, ideas on the habitability of other planets were often joined with speculations that after death the soul might find a better existence on some celestial orb. Such ideas were not new. In *Another World* (1844), Grandville satirized the contemporary utopian socialist Fourier's ideas on the voyage of the soul. According to Fourier, after death, human souls exist in the ether of the earth until the planet dies; then, they pass to other worlds. Flammarion, influenced by Reynaud's *Terres et ciel* (1854), which espoused spiritual transmigration, was among the pluralist writers who lumped rebirth together with extraterrestrial life. After the loss of the war, this spiritual escape from a doomed and lowly planet had renewed appeal. Victor Hugo and Van Gogh were among those who ruminated on the soul's journey to rebirth on other planets.[11]

The powerful forces of the invisible, immaterial world being revealed by astronomy and the popularization of the idea of legions of souls passing from this world to others informed the growing current of spiritism and interest in Oriental philosophies like Buddhism in the late eighties and nineties. The emerging occultist movement would draw upon the idea of spiritism and the stars, wherein beings from other planets might act as spiritual advisors on earth or the human spirit might travel to other realms.

French Symbolist and Rosicrucian Joseph Péladan heralded this new trend as early as 1884 with his novel *Le Vice suprême.* In it, the initiate Princess d'Este follows a doctrine that espouses a theory of astral light. Astral life was a fundamental tenet of theosophy, which influenced Sâr Péladan and many other Symbolists after the mid-eighties. According to theosophical belief, an astral self surrounds and permeates the physical body. At death, the cord between them is severed and the astral body begins its life of progressive improvement in other realms. Lévy-Dhurmer, who often exhibited at Péladan's salons, suggests the mysterious connection between the spirit and the stars in *Silence* (1895; fig. 4).

Although one of the assumptions in the examination of the late nineteenth-century revival of mysticism has been that it involved a reaction to science for having depoeticized the world, astronomy in France

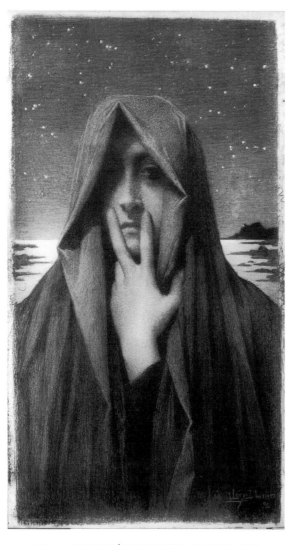

FIG. 4 - LUCIEN LÉVY-DHURMER, **SILENCE**, 1895

from the 1860s on actually fostered a sense of wonder and the imaginative possibilities inherent in the idea of limitless space. Progressive astronomers were those who were willing to admit that our "tiny earth" was the least of all worlds in the universal scheme of things. For many Symbolist artists and other late nineteenth-century celestial dreamers, natural and supernatural forces might well coexist throughout space's endless expanse. Outer space suggested fantastic possibilities and habitations for the human soul never imagined in quite the same way before the dawn of the new astronomy. While science was bringing new information to bear upon the earth's place in the universe, scientific knowledge was also being applied to forms of religious faith beyond rigid Catholic dogma, and as perspectives shifted, the modern soul found fertile terrain in this romantic vision of an active, expanding cosmos.

• Notes

1. Among the discoveries on the Henrys' negatives was the cluster of the Pleiades, invisible to the eye. Enthusiastic over these discoveries, Admiral Mouchez, director of the Paris Observatory, sponsored an international conference on astrophotography in Paris in 1887 that initiated the Carte du Ciel project.

2. Amédée Guillemin, *Le Ciel*, 5th edition (Paris 1877), Introduction.

3. The dissemination of science to the general public was high on the Republican agenda. Guillemin's *Instruction républicaine* (1871) emphasized the importance of scientific education, and science officially became part of school curricula under laws instituted by Paul Bert in 1881. This led to an explosion in the vulgarization of science, and many new books on astronomy, both didactic and fictional, were published in the last decades of the century. The popular dissemination of science, regarded as key to regeneration of the country, ensured a broad-based knowledge about astronomy.

4. The balloon's strategic potential, on the minds of many after the defeat, gave birth to a new era with the invention of powered balloons. Dirigibles could be used not only for escape, but also to protect France's borders. A workable airship had actually been ordered during the Franco-Prussian War but was not used until 1872. It was designed by naval architect Stanislas Dupuy de Lôme, who replaced the basket with what can only be described as a boat – down to a four-pronged anchor. It was powered not by an engine, but by eight sailors. What seemed more promising, however, was the application of electricity to balloon flight. This was achieved by the Tissandier brothers in 1881, and the model exhibited in Paris the same year. But the supreme, if not the sublime (it looked like a giant sausage pinched at both ends), masterpiece of the period was Charles Renard and Arthur Krebs's *La France* (1884), a battery-powered dirigible intended for military reconnaissance. It measured fifty metres in length by eight metres in diameter and held close to two thousand cubic metres of hydrogen.

5. Early science fiction writers like Jules Verne suggested that balloons and other inventions would make it possible to travel beyond the earth's atmosphere. Space flight also appealed to other novelists and poets. See for example Laforgue's *Imitation de Notre-Dame la Lune* (1885), Maupassant's "Homme de Mars", Huysmans's *En Rade*, with its dream visit to a lunar landscape, and Gide's later *Voyage d'Urien*.

6. On the scientific backing given to this discourse, see especially Michael J. Crowe, *The Extraterrestrial Life Debate, 1750-1900: The Idea of a Plurality of Worlds from Kant to Lowell* (Cambridge and New York: Cambridge University Press, 1986), pp. 402ff.

7. Flammarion even believed there was life on the moon and sun. Because of atmospheric conditions on the sun, its inhabitants would be 426,000 times the size of earthlings. Beings on Mars, where Flammarion thought the force of gravity was weak, would necessarily "fly". Flammarion repeatedly evoked the vast power and grandeur of God and the humbleness of man. Thus, he was able to gain the attention and respect of many members of the clerical community. Extraterrestrials and man formed one gigantic celestial family.

8. In 1877, Mars was in unusually close opposition to earth, and astronomers, armed with their new telescopes, eagerly awaited its passage. From Milan, Giovanni Schiaparelli reported he had observed *canali*. Some of his colleagues interpreted this as "canals", suggesting artificially created waterways, but the word *canali* may also refer to naturally occurring channels. The debate peaked twenty years later with Flammarion's *Planète Mars et ses conditions d'habitabilité* and H. G. Wells's *War of the Worlds*.

9. Camille Flammarion, *La Pluralité des mondes habités*, 2nd edition (Paris 1864), pp. xv-xvi. On Redon's cosmological works of the late nineteenth century, see Barbara Larson, "Odilon Redon: Science and Fantasy in the *Noirs*", Ph.D. dissertation, Institute of Fine Arts, New York University, 1996.

10. Flammarion 1864, p. 7.

11. On Van Gogh, astronomy and spiritual rebirth, see Albert Boime, "Van Gogh's *Starry Night*: A History of Matter and a Matter of History," *Arts Magazine*, vol. 59, no. 4 (December 1984), pp. 86-103.

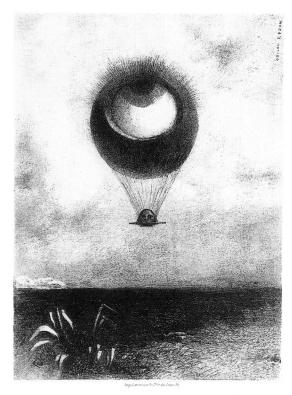

L'œil, comme un ballon bizarre se dirige vers L'INFINI.

246• ODILON REDON, **THE EYE, LIKE A STRANGE BALLOON, MOVES TOWARDS INFINITY**
PLATE 1 FROM THE SERIES **"TO EDGAR ALLAN POE"**, 1882
CAMBRIDGE, HARVARD UNIVERSITY MUSEUMS

245• ODILON REDON, **STANDING NUDE WOMAN SURROUNDED WITH CIRCLES**, ABOUT 1870
PARIS, MUSÉE DU PETIT PALAIS

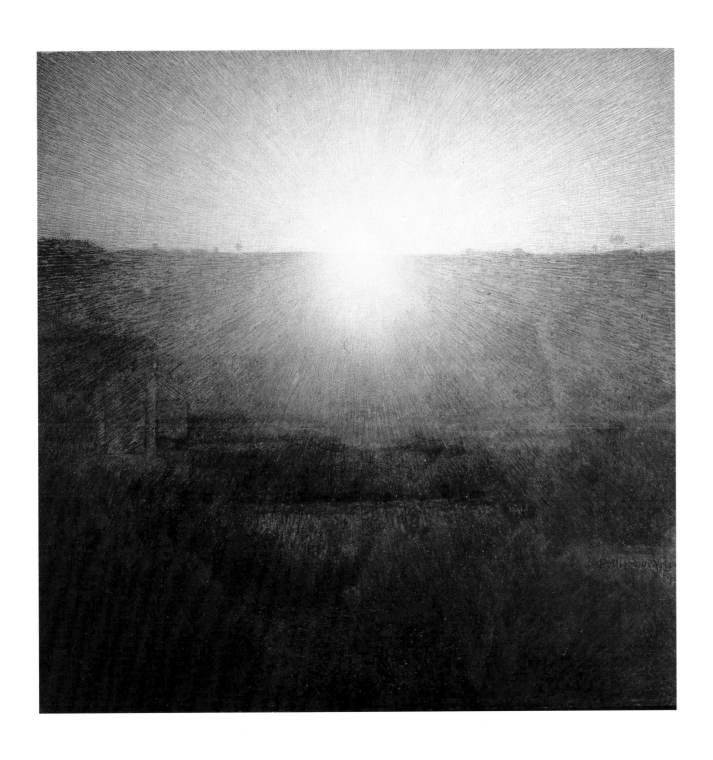

239• GIUSEPPE PELLIZZA DA VOLPEDO, **THE RISING SUN**, 1904
ROME, GALLERIA NAZIONALE D'ARTE MODERNA

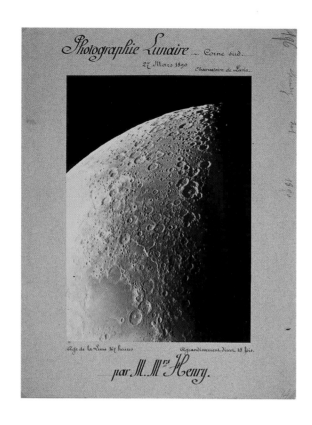

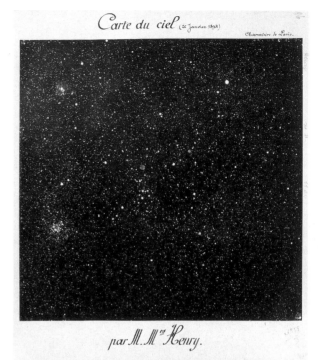

133• PAUL AND PROSPER HENRY
LUNAR PHOTOGRAPH, 1890
PARIS, SOCIÉTÉ FRANÇAISE DE PHOTOGRAPHIE

134• PAUL AND PROSPER HENRY
MAP OF THE HEAVENS (JANUARY 26, 1894)
PARIS, SOCIÉTÉ FRANÇAISE DE PHOTOGRAPHIE

105• HIPPOLYTE FIZEAU AND LÉON FOUCAULT, **THE SUN**, 1845
PARIS, MUSÉE DES ARTS ET MÉTIERS DU CNAM

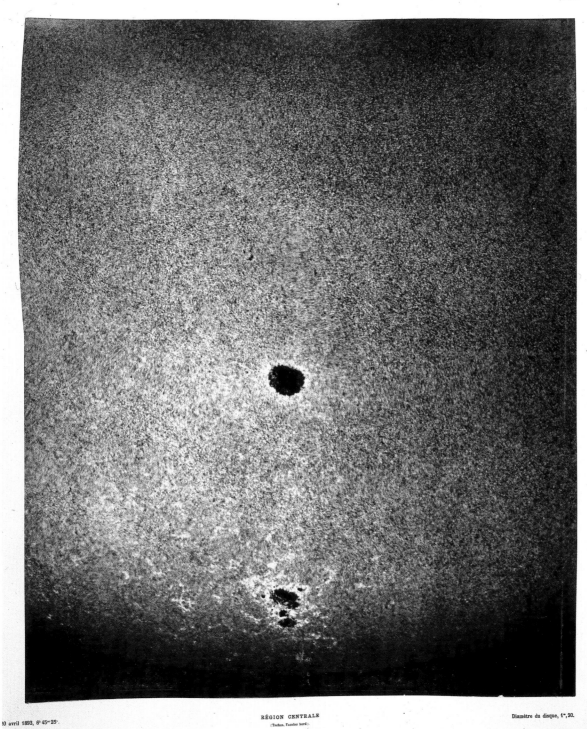

10 avril 1893, 6ʰ45ᵐ25ˢ.

RÉGION CENTRALE
(Taches, Facules bord).

Diamètre du disque, 1ᵐ,20.

138· JULES JANSSEN, **PLATE 29 FROM THE "ATLAS DE PHOTOGRAPHIES SOLAIRES"**, 1903
PARIS, SOCIÉTÉ FRANÇAISE DE PHOTOGRAPHIE

285· AUGUST STRINDBERG, **CELESTOGRAPHS**, 1894
(PRINT BY OLOF WALLGREEN, 1995)
STOCKHOLM, KUNGLIGA BIBLIOTEKET, COURTESY OF STRINDBERGSMUSEET

Futurist painting adopted the cosmos as its theme only in reference to the "universal dynamism" that underlies the movement of all things within the continuum of space. This theme also surfaced in a concept of simultaneity that recurred constantly in Futurist art, representing a utopian transcendence of all opposites. The programme set forth in the 1910 *Futurist Painting: Technical Manifesto* included the declaration that "universal dynamism must be rendered in painting as a dynamic sensation". This idea was embodied in different ways in Futurist art of the prewar period, depending on the temperament

The Cosmos as Finitude

From Boccioni's Chromogony

to Fontana's Spatial Art

by Giovanni Lista

of the individual painter. Carrà made a connection between the city and celestial dynamism in his painting *Movement of the Moonlight* (1911). Russolo was heavily influenced by Symbolism, and his work was full of ghostly, troubling allusions. In paintings like *The Solidity of Fog* (1913) and *Interpenetration of Houses + Lights + Sky* (1913), he evoked the forces that penetrate the universe by giving natural phenomena a fantastic appearance. In contrast, Severini used "dynamic analogies" to encompass the universal. In paintings like *Dancer = Sea + Vase of Flowers* (1913), he created a fusion of formal correspondences to construct a dual dimension for the image: concrete and cosmic.

Balla, in his *Iridescent Interpenetrations* (1912), appropriated the colours of the rainbow to explore the cosmic microrhythms of light propagating in space. He began a new stage in his exploration in 1913, when Marinetti assigned to Futurist art the task of expressing "the speed of the stars and clouds" and "of molecules and atoms" in order to render "the infinitely small nature of matter" and "the infinitely large nature of the universe". Balla subsequently produced paintings and drawings of the motions of the heavenly bodies: *Densities of Atmosphere + Telescope*, *Celestial Orbits*, *Everything Moves*, and *Interpenetration of the Self with the Universe*. He wove an imaginary network of curved and sinusoidal lines to render heavenly bodies' rotation and speed, the forces of attraction binding the sun and planets in the solar system, even the swirling atmospheric dust seen during astronomical observation. His analytic approach led him to place smoked glass over his telescope[1] during the November 7, 1914, transit of Mercury in order to paint his *Mercury Passing before the Sun, Seen through a Telescope* (1914),

which represents the motions of the observer, the planet and the sun simultaneously.[2] In 1915, Balla considered the possibility of moving beyond the traditional painting format[3] so as to render fully his Heraclitean view of the world in harmony with the universe. But after his formalized scenery designs for Paisiello's *Proserpine* and Stravinsky's *Feu d'artifice*,[4] he turned more towards spiritualistic pantheism. This was the source of his postwar works on the themes of spring and rebirth and of "spirit forms". It also underlay his assertion that an awareness of the life permeating the universe, just as it made the spot of blue representing the sky in old-fashioned, conventional paintings seem ridiculous, at the same time led modern man to consider the sky a sphere that "begins under our feet and surrounds us".[5]

For Boccioni, painting was interference between the self and the world, since it was the constant and simultaneous interpenetration of their forces that created the dynamic unity of reality within a universe in a continual state of becoming. In contrast to the static fragmentation of Cubism, which seemed to Boccioni a denial of the vital work of matter-energy, he sought "the unique form that renders the continuity of space". In his works, the spiral became a structural principle through which to depict the simultaneity and indivisibility of space as well as the unceasing transformation of forms. At a conference in Rome in 1911, Boccioni used the term "physical transcendentalism" to express the Futurists' rejection of the notion of bodies as opaque, fixed, material and bounded, such a notion being incompatible with the continuous flux of the universal energy. The need to transcend the painting led him to a visionary intuition of an art of dynamism in space: "A day will come when the painting will no longer suffice. Its immobility will seem archaic in comparison with the dizzying movement of human life. The human eye will perceive colours as sensations in themselves. The multiplicity of colours will not require form in order to be comprehended, and pictorial works will be swirling musical compositions of vast expanses of coloured gases, seen against the backdrop of an indefinite horizon, which agitate and electrify the complex soul of a crowd which we as yet cannot imagine."[6] The satirical press talked of "Futurist chromogony"[7] when Marinetti espoused the hypothesis of an art in space in a lecture he gave in Paris in 1912.[8] Boccioni never succeeded in carrying the notion any further, however; disagreements with Apollinaire, Delaunay and Léger placed his paintings at the centre of a tense confrontation with Parisian Cubism and led him to abandon his visionary intuition.[9]

Through his idea of an art of colour and light in space, Boccioni hoped to free himself from all forms of conventional or material determinism to attain an abstract expression of "universal dynamism". He in

fact anticipated the movement of laser beams and the immateriality of virtual space. His idea became a mythical postulate that was taken up again by the Futurists in their *Manifesto of Aero-painting* (1929), and well into the 1940s in numerous other theoretical texts. In France, Apollinaire echoed Boccioni's intuitionist vision,[10] and it was found in plans for a "cosmic, non-Euclidian art" in Charles Sirato's manifesto "Dimensionnisme" (1937).[11] Fontana's *Manifesto Blanco* (1946) and *Spatialistes* (1948), the first theoretical texts on spatial art, again put forward the concept.

Aero-painting, inaugurated in 1929, had numerous antecedents among the European avant-garde, from the Futurists Delmarle and Garçia to the English Vorticists Nevinson and Wyndham Lewis. Italian aero-painting had two main branches, representing two visions of the aerial, one physical, the other mental. The physical vision took the form of looking downward from above and was concerned with direct illustration of the dematerializing effect of the aerial view. The mental vision was based on looking upward from below and represented an attempt to put into images the psychic experience of the conquest of space and its spiritual and symbolic mythology.

After the initial intuitive approaches of Baldessari, Lega, Bucci and Azari, those aero-painters who tended towards a concrete rendering of the aerial view, including Tato, Delle Site, Angelucci-Cominazzini, Crali, Ambrosi and Di Bosso, began exploring the kinetic abstractions and metamorphoses of the image that occur with a change of vantage point.[12] The accelerated perspective, compression, bird's-eye views and distorted, transformed, disaggregated spaces in paintings like Dottori's *Flight over the Ocean* (1932) and Crali's *Looping* (1938) revealed an innovative phenomenology of perception that broke with the long iconographic tradition based on the catoptic perspective of the Renaissance.[13] Representing an effort to impose order on the world through an aerial view, catoptic perspective demonstrated man's attempt to perceive as though through the eye of God. Modern man discovered that seeing from a greater height did not make the visible world clearer but instead more complex. In aero-painting, the world viewed from above no longer manifested a superior order, but rather was dependent on or in harmony with what was passing over it: man as Icarus. Aero-painting made speeding man the axis of the universe, and its sole scale of measurement.[14]

A pantheistic approach to the works of nature, particularly on the part of Dottori,[15] prefigured the other type of Futurist aero-painting, based on "cosmic idealism". A turning point came in 1930, when Fillia proclaimed that artists would now have to paint "the mysteries of a new spirituality".[16] Prampolini wrote about the "transcending of the earth", which not only created new plastic sensations but imbued mankind with new feelings.[17] Liberation from the ordinary conditions of vision established an imaginary framework for the cosmos, founded on a mental approach to aerial space. Aero-painters of this stripe, including Diulgheroff, Oriani, Fillia, Benedetta and Prampolini, attempted to construct a new symbolic

FIG. 1 – FILLIA
HEAVIER THAN AIR
1933-1934

image of the universe. Fillia revived the rarefaction of space and sense of mystery found in metaphysical art. His paintings, for example *Aerial Spirituality* (1930), *Terrestrial Transcendence* (1931) and *Heavier than Air* (fig. 1), with their red or black spheres, created a veritable mirror image of the earth. Influenced by mysticism, Benedetta, in *The Large X* (1930), gathered together the four cardinal points in a single aerial view, the sweep of the horizon as seen by aviators. Signs were used to organize the simultaneous opposites within the cosmic order: day and night, heaven and earth. In paintings like *Deification of Space* (1931) and *Sidereal Conquest* (1931), Oriani created dreamlike images in which dark blue spheres were combined with anthropomorphic mineral fragments. A mother with a round, hollow belly, representing both transition and baptism, dominates his *Birth of Simultaneity* (fig. 2). Prampolini, who was even closer to Surrealism, made aero-painting an instrument for comprehending the "occult

FIG. 2 - PIPPO ORIANI
THE BIRTH OF SIMULTANEITY, 1931

forces of the universe". In *The Cloud Diver* (1930), he introduced the emblematic image of a blue-tinted sphere, symbol of cosmic reality. Through a repertory of biomorphic forms, cosmic metaphors and organic elements, his paintings constructed a new mythology inherent in the conquest of the universe.

In *Cosmic Motherhood*, Prampolini seems to crystallize an idea of interplanetary travel as a return to the primordial unity of nature: in the starry reaches of space, a female silhouette bears the earth in her bosom. Using an archetypal image, the painting makes explicit something that appears fleetingly in many other Futurist aero-paintings: in any fantasy of Icarus, flight is, in effect, "as though motivated by a desire to return to the mother".[18] Prampolini was probably familiar with the iconography used in ancient times for the Egyptian sky goddess Nut, personification of the celestial vault, who was represented as encircling the great disk of earth with her body.[19] In Italian culture, Cicero's *Somnium Scipionis*, the favourite text of Dante and Petrarch, is the source of a similar imagined view of the cosmos. Using the ideas of Plato and the Pythagoreans, Cicero developed a spiritual vision of the universe, emphasizing the smallness of the earth. His description of space as the true home of mankind was based on a view of the earth from the stars. As the soul's place of origin and eternal destination, cosmic space was imbued with a maternal sense.[20] Such, finally, was the imaginary nature of space and the cosmos used by the Futurist aero-painters: the universe as both eternal and finite.

For Fontana, Futurism and in particular aero-painting served as the point of departure for theoretical reflection on an art of space. Before the War, Fontana was associated with the "cosmic abstractions" of Futurist aero-ceramics.[21] By 1947, he had appropriated the title *Spatial Concept*, used by Fillia in 1932 for one of his abstract aero-paintings;[22] this term came to characterize all of Fontana's work. His position was based on Marinetti's principal ideas, for example evolutionism in the language of art, ephemerization of the work of art and the necessity of renewal in response to the anthropological changes that technology imposes on man. Fontana showed his first *Spatial Environment* in 1949, in a Milan gallery. The room had walls covered with black curtains and was left in darkness. Black light revealed the phosphorescent luminosity of a larval abstract form suspended from the ceiling. In this installation, which blurred the boundaries of the physical space, Fontana attempted to realize Boccioni's dream of the immaterialization of art. He continued his experiments using neon light; working with existing spaces, he undercut their materiality through the use of ectoplasmic arabesques that formed trajectories of energy, like the Futurists' force lines.

Yet, in the same year, 1949, Fontana undertook another experiment that carried his work in exactly the opposite direction from the immaterialization advocated by Boccioni. He created his first *buchi*, making perforations in the canvas, which, arranged in the cosmic shapes of circle and spiral, evoked starry worlds and galaxies. The canvas became a mediation between terrestrial and sidereal space; its very materiality provided the opening towards the cosmic dimension of space. Using a variety of supports, including clay and sheet metal, Fontana manipulated the material with lumps, holes, incisions, perforations, gouges and indentations, which he at times emphasized by a raking lighting that made the texture of the object resemble the surface of a meteorite. Through the material, he hoped to restore the physical sense of the work as a concrete object. This experimentation culminated in his *tagli*, begun in 1958, in which he cut the canvas to reveal the underlying space. He stated, "I don't want to make a painting, I want to open up space, to create a new dimension for art, connect it to the cosmos as it extends, infinite, above the flat surface of the image."[23] These *Spatial Concepts* (cats. 106-107) remain the most significant works in a line of experimentation that overturned the very principle of "physical transcendentalism" advocated by Boccioni.

Fontana's contribution to the Futurist heritage was as a transition between representational art and an art of pure perception in which the work is an integral part of reality. His *Spatial Concepts* opened up

a dialectic in which the painting became, *qua* object, a springboard towards the immateriality of the greater cosmic whole. Instead of continuing in the same direction to achieve total transcendence of the painting, in accordance with Futurist theory, Fontana retained the painting's formal frame and overdefined its nature as object in order to allow the imagination to come into contact with space and the cosmos. In other words, he acted exactly in accordance with Leopardi's idea that only a physical, factual, limited definition of space can allow the human spirit access to the imaginary world of the cosmos.[24]

This cosmological dimension was clearly shown in subsequent years, for example in Fontana's *Balls*, which he altered by means of holes and gouges until they resembled asteroids that had fallen to earth. Starting in 1963, a symbolic component appeared in paintings with the Nietzschean title *The End of God* and subtitle *Astral Eggs*. These were large monochromatic oval canvases studded with holes and dusted with spangles like luminous points of light in a starry sky. Their title probably refers to a poem written by Salvatore Quasimodo the night Sputnik 1 was sent into orbit, in which he glorified the lay intelligence of mankind, who, God-like, had placed a new moon in the sky.[25] But the subtitle,

Astral Eggs, also suggests a vision of cosmic space as womblike, once more evoking the Oedipal character of the dream of Icarus.

When an explorer claims a terra incognita, the farthest boundary he has reached becomes a new vantage point for observing the world.[26] Thus, Christopher Columbus's discoveries, rendering obsolete any vision of Europe as the centre of the earth, inaugurated the modern era. In the 1960s, manned flight to the moon, by creating a new vantage point, opened the era of postmodernism, globalization and the end of History. Fontana's "end of God" paintings seem to embody the idea of a finite world, of which Space is only the revealed duplicate, for the death of God is in fact an idea of finitude. This is probably what Giulio C. Argan meant when he wrote, "The value of art, its capacity to represent itself as quality without quantity, resides precisely in the fact that it is and has always been a shining metaphor for death. Art makes us aware of what thought cannot think without nullifying itself. When Fontana erased the boundary between the here and the beyond by making cuts in the canvas, he surely knew that this awareness intensifies the vital sense of the act of living."[27] The universe without God is no longer a metaphor for infinity, but simply the mirror image of another finitude.

• Notes

1. See Elica Balla, *Con Balla* (Milan: Multhipla Edizioni, 1984), p. 347.

2. See L. Marino Perez, "Astronomia e arte moderna", *Coelum* (Bologna), July-August 1959, pp. 39-44.

3. In the manifesto *Futurist Reconstruction of the Universe*, which he published with Depero, he advocated the creation of abstract assemblages that incorporated movement and sound.

4. See Giovanni Lista, *La scène futuriste* (Paris: Éditions du CNRS, 1989), pp. 315-325.

5. Reported by Louis Corpechot, *Lettre sur la jeune Italie* (Nancy, Paris and Strasbourg: Berger-Levrault, 1919), p. 84.

6. Umberto Boccioni, *Altri inediti ed apparati critici*, ed. Zeno Birolli (Milan: Feltrinelli, 1972), pp. 11-29.

7. See Lucien Métivet, "Fragments de la chromogonie des futuristes", *Fantasio* (Paris), no. 140 (May 15, 1912), pp. 734-736. The journalist responded to Boccioni's idea by speaking of an "iridist school" in ancient Greece that had already established "the laws governing a rational use of the seven colours of the rainbow".

8. Filippo Tommaso Marinetti, "La Peinture futuriste", in *Excelsior* (Paris), February 15, 1912. The complete manuscript of the lecture, which Marinetti prepared by translating Boccioni's text into French, is in the Filippo Tommaso Marinetti Papers, Beinecke Rare Book Collection, Yale University Library.

9. Boccioni included it in the guise of a utopia in the final pages of his book *Dynamisme plastique : peinture et sculpture futuristes* [1914], ed. Giovanni Lista (Lausanne: L'Âge d'homme, 1975), p. 106.

10. In his preface to the catalogue of the exhibition *Survage* in 1917 at the Galerie Bongard in Paris. See Guillaume Apollinaire, *Œuvres poétiques* (Paris: Gallimard, 1965), p. 1150.

11. Charles Sirato, "Dimensionnisme", *Plastique* (Paris-New York), no. 1 (Spring 1937), pp. 1-2.

12. See Giovanni Lista, "Visions aéropicturales," in *La Ville, art et architecture en Europe, 1870-1993*, exhib. cat. (Paris: Musée national d'art moderne, 1994), pp. 206-211.

13. On the representation of the city in catoptic perspective, i.e., viewed from above, see Jean-Marc Besse, "Représenter la ville ou la simuler?" *Ligeia. Dossiers sur l'art* (Paris), no. 19-20 (October 1996-June 1997), pp. 43-55.

14. As early as 1914, in his *Zang Tumb Tumb*, Marinetti published a work of typographical composition that made the aviator the new *axis mundi*.

15. Between 1916 and 1925, Dottori developed spiritual transfigurations of landscape art, with long views from above and allusions to the circularity of the universe in the curve of the horizon line. He also painted "astral rhythms", a theme he shared with Giannattasio.

16. Fillia, "Spiritualità aerea", *Oggi e Domani* (Rome), November 4, 1930, p. 5.

17. Enrico Prampolini, "L'aeropittura – Superamento terrestre", in *Mostra futurista di aeropittura e di scenografia*, exhib. cat. (Milan: Galleria Pesaro, 1931).

18. Michel Mathieu, "Rêve de vol et fantasme de vol", *Critique* (Paris), no. 277 (June 1970), pp. 556-563.

19. See Georges Posener, *Dictionnaire de la civilisation égyptienne* (Paris: Hazan, 1980), p. 192.

20. For Plato, the souls of the just reached heaven only to return ceaselessly to earthly life through reincarnation. For Cicero, however, Man had to work on earth to open the path of return to the heavenly spheres. See Cicero, *Laelius, on Friendship, and The Dream of Scipio*, ed. and trans. J.G.F. Powell (Warminster, England: Aris and Phillips, 1990), especially pp. 139 and 147.
When Cicero was thus extolling the spirituality inherent in the "contemplation of celestial matters", the emperor Augustus had the first inventory of the world set in a portico of the Campus Martius: an immense map showing to the people of Rome the entire extent of the empire attached to *Roma caput mundi*. See Jean-Pierre Néraudeau, *Augustus* (Paris: Les Belles Lettres, 1996), p. 333.

21. See Tullio D'Albisola, *La ceramica futurista* (Savona: Officina d'Arte, 1939), p. 29.

22. A reproduction of Fillia's abstract painting entitled *Spatial Concept* appeared in *Les Cahiers jaunes* (Paris), no. 1 (September 1932), a special issue devoted to "the Italian Futurist painters and sculptors". Boccioni used the expression "plastic concept" as early as 1913.

23. Quoted from *Lucio Fontana*, exhib. cat. (Paris: Musée d'Art Moderne de la Ville de Paris, 1970), p. 9.

24. A work like Piero Manzoni's *Base of the World* does not operate any differently. In the *Zibaldone* (1817-1832), Leopardi set forth this theory, which inspired the famous lines of "The Infinite", where the poet gives himself over to reverie on the cosmos as he contemplates a "hedgerow that hides so large a part / Of the far sky-line" from his view. See Giacomo Leopardi, *Selected Prose and Poetry*, ed. and trans. Iris Origo and John Heath-Stubbs (London: Oxford University Press, 1990), p. 213.

25. Quasimodo's poem, "Alla nuova luna", was published for the first time in the Rome daily newspaper *Paese Sera* on October 5, 1957, the day after the event. It is reprinted in Salvatore Quasimodo, *Poesia e discorsi sulla poesia* (Milan: Mondadori, 1971), p. 87.

26. See Alberto Boatto, *Lo sguardo dal di fuori* (Bologna: Cappelli Editore, 1981), p. 9.

27. Giulio C. Argan, "Questi non sono i morti", *L'Espresso* (Rome), no. 48 (December 2, 1984), p. 169.

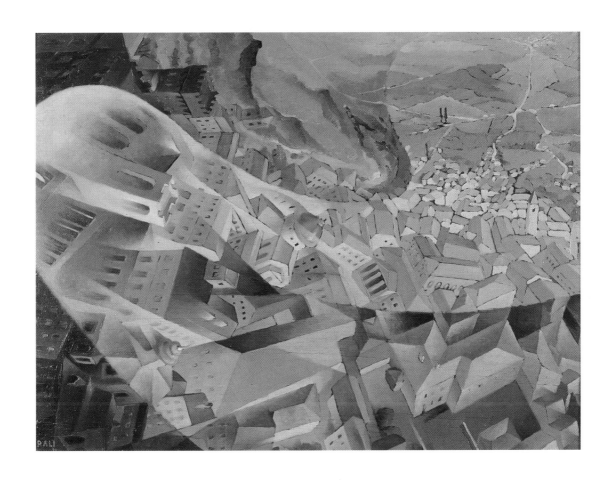

78· TULLIO CRALI, **SPIRAL GLIDE**, 1938
MILAN, MARINETTI COLLECTION

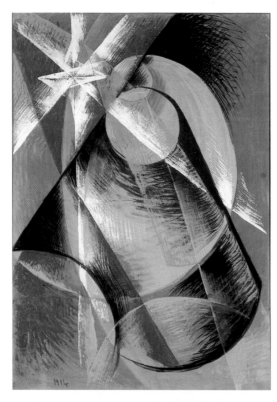

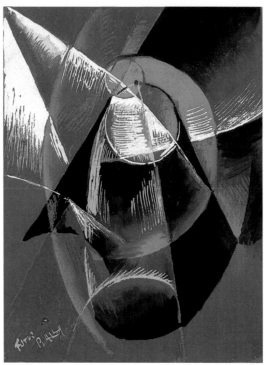

12• GIACOMO BALLA, **MERCURY PASSING BEFORE THE SUN, SEEN THROUGH A TELESCOPE**, 1914
VIENNA, MUSEUM MODERNER KUNST STIFTUNG LUDWIG

11• GIACOMO BALLA, **MERCURY PASSING BEFORE THE SUN, SEEN THROUGH A TELESCOPE**, 1914
PRIVATE COLLECTION

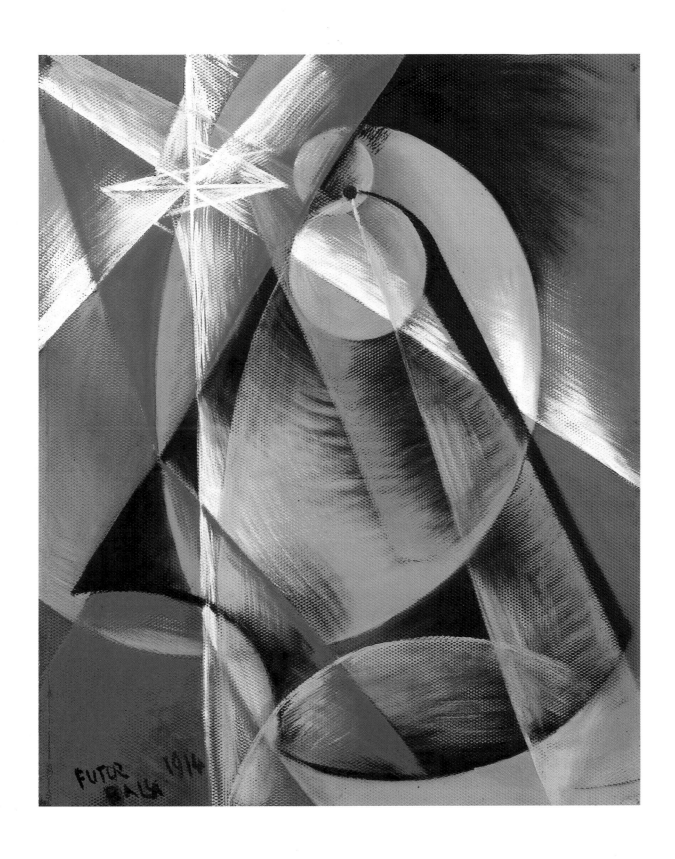

10· GIACOMO BALLA, **MERCURY PASSING BEFORE THE SUN**, 1914
PARIS, MUSÉE NATIONAL D'ART MODERNE/CENTRE DE CRÉATION INDUSTRIELLE,
CENTRE GEORGES POMPIDOU

GIACOMO BALLA

13· FORMS - SPIRITS TRANSFORMATION, 1918

14· SCIENCE VERSUS OBSCURANTISM, 1920

ROME, GALLERIA NAZIONALE D'ARTE MODERNA

261• LUIGI RUSSOLO, **AURORA BOREALIS**, 1938
PRIVATE COLLECTION

260• LUIGI RUSSOLO, **HOUSES + LIGHTS + SKY**, 1912-1913
KUNSTMUSEUM BASEL

87• MINO DELLE SITE, **INTERPLANETARY VOYAGES**, 1937
ROME, MR. AND MRS. LUCIANO BERNI CANANI COLLECTION

86• MINO DELLE SITE, **DEIFICATION OF THE EARTH**, ABOUT 1932
ROME, MR. AND MRS. LUCIANO BERNI CANANI COLLECTION

107• LUCIO FONTANA, **SPATIAL CONCEPT**, 1959
ROME, GALLERIA NAZIONALE D'ARTE MODERNA

106• LUCIO FONTANA, **SPATIAL CONCEPT – EXPECTATIONS**, 1959
ROME, GALLERIA NAZIONALE D'ARTE MODERNA

When, in the wake of Kazimir Malevich, Russian artists turned to nonobjectivity in the 1910s, they crossed a line that Western Cubists and Futurists had not yet managed to bring themselves to cross. Almost simultaneously, Malevich, Mikhail Matiushin, Vladimir Tatlin, Vassily Kandinsky, Mikhail Larionov and Pavel Filonov created different forms of nonobjective art dealing with problems of visual expression that had never been raised before. By 1913, "art's centre of gravity," Filonov wrote, "had shifted to Russia".[1]

The theme of space, the cosmos, is reflected in all Russian avant-garde trends, but particularly in the

The Idea of Cosmic Architecture and the Russian Avant-garde of the Early Twentieth Century

by Igor A. Kazus

Suprematist movement founded by Malevich. This theme had been suggested in Russia not only by Henri Bergson's ideas of "cosmic dynamism"[2] and the well-known neoromantic projects for space settlement widespread in European Futurism: the Russian philosopher Nikolai Fedorov (1828-1903) had expounded the prophetic concept of the actual cosmic transformation of the world. And Malevich, evidently the first Russian artist to take note of this, placed it at the base of Suprematism. In many ways, it was through Malevich's work that Fedorov's ideas influenced the dramatic inquiries within Russia, directing them towards the use of a system of artistic composition as a basis for a new period in art and leading to the virtually simultaneous formation of several interrelated stylistic concepts: Suprematism (Malevich), Constructivism (Tatlin, Alexandr Rodchenko, Alexandr Vesnin), and Rationalism (Nikolai Ladovsky).

The influence of Fedorov, as the founder of the cosmic movement in Russian philosophy, on the processes of style generation in early twentieth-century Russian art has yet to be thoroughly appreciated. In *The Philosophy of the Common Task* (Filosofiia obshchego dela),[3] which Fedorov worked on from the 1870s to the 1890s, he provided an argument for the inevitability of mankind's entry into the cosmos, the conquest of new habitats, and the transformation of the solar system and outer space. For Fedorov, art received its highest methodological meaning through the creation of ideas, models and artistic images of what man would actually be creating. He proposed rejecting the passive perception of the world and abstract metaphysics, and shifting to a definition of the values of the "proper" order of things, to an elaboration of a plan for mankind's

efforts at transformation – "the regulation of nature" – with philosophy having been replaced by the "project of the task". According to Fedorov, only a reality created by mankind can be known absolutely. One must reach a point, he said, where, alongside immortal mankind, there exists his creation – a world he can fully fathom. Fedorov looked on his project not as a theoretical utopia, but as a radical hypothesis of what the world ought to be. This hypothesis, he believed, required verification by universal experimentation, which would at the same time serve as a practical test.

It may have been due not simply to the natural development of knowledge but also to Fedorov's influence that science and technology's most pressing task in Russia in the last three decades of the nineteenth century was the achieving of manned flight in the atmosphere and outer space. Russia saw any number of world's firsts in this realm: in 1875, chemist Dmitri Mendeleyev put forward the idea of a stratosphere balloon to reach the upper atmosphere; in 1881, officer Alexandr Mozhaisky obtained a patent for a heavier-than-air flying machine (that is, an airplane), which he built in 1883; inventor Nikolai Kibalchich worked out a plan for a jet-propelled flying machine (1881); and mathematician Konstantin Tsiolkovsky, whose self-education was guided by Fedorov himself, proved the principle of jet propulsion in outer space (1883).

In contrast to the European idea of the synthesis of the arts in the music-drama (Schopenhauer, Nietzsche, Wagner), Fedorov proposed architecture as a vivid symbolic image of the transformed matter of the Universe, an architecture in which the earth and the entire world edifice become the arena for universal cosmic creativity. Fedorov was inspired to predict that in the future, everyone would become the Demiurges of a real and infinite Universe, which art would "mould" according to the highest laws of morality, beauty and harmony. Fedorov did not conceive of natural matter as possessing any "fateful" will of blind force; rather, man had to learn to guide this force in order to master its spontaneous laws. It was architecture that could logically organize the inert, heavy, material masses of the cosmos. In this context, seeking a solution in architecture became one of the main trends in the conscious development of Malevich's Suprematism.

The artists around Malevich, especially Matiushin and Ivan Kliun, with whom he was friendly, followed Western and Russian scientific thought closely and put scientists' achievements to good use in their work. Matiushin (whose worldview was inspired by the ideas of Nikolai Lobachevsky, Bernhard Riemann, Hermann Minkowski, Carl Friedrich Gauss, Charles Hinton and the philosopher Petr Uspensky) was the first artist to introduce the fourth

dimension – time – into Russian art (1911). Ivan Kudriashev was personally acquainted with Tsiolkovsky,[4] who in his philosophical essays developed a "cosmic philosophy" that included the concept of settling mankind throughout our solar system and beyond. Malevich never directly mentioned the influence on him of any philosophical ideas, including Fedorov's views on the future restructuring of the world and the role of architecture. Nonetheless, even the terminology Malevich used for the art movement he founded, and the meaning he invested in it, were not accidental, but closely related to the definition of Fedorov's supramoralism, for example, which demands "the transformation of outwardly earthly activity, a transformation affecting all heavenly worlds".[5] Indirect evidence of the influence of Fedorov on Malevich's inquiries lies in the fact that, although his first Suprematist compositions are dated 1915, Malevich himself stressed many times that he dated Suprematism to 1913. This was not only the year he designed a backdrop consisting of a square for the opera *Victory over the Sun* (Pobeda nad solntsem) by Matiushin, whom scholars usually credit for the germ of the idea of Suprematism, but also the year the second volume of Fedorov's book was published in Moscow.

In his easel compositions, Malevich was not depicting something but, in accordance with Fedorov's conception, "projecting" a new, Suprematist world, while planning eventually to take Suprematism into the sphere of architecture and create a "unified system of world architecture for the earth". Originally, Suprematism was conceived as a stylistic system for transforming the objective-spatial environment of the world as a whole. Malevich's early "supremes" were orthogonal projections of volumetric elements[6] hovering in infinite space, their scale emphasized by the spatial depth of the background.

Malevich greeted the October 1917 Revolution with open arms. Its idea of a humanistic life-building utopia coincided with the universal utopia of Suprematism, and the Revolution provided the impulse for Suprematism to move on into architecture. Lissitzky wrote at the time, "We are going through the exceptional period of a new birth in the cosmos entering into our consciousness,"[7] and "Our lives are now being built on a new communist foundation, solid as reinforced concrete, and this is for all the nations on earth."[8] In Vitebsk (1919), a group formed around Malevich consisting of the most active members of Unovis (Affirmers of the New Art), his main pupils and assistants: the young artists Lazar Khidekel, Ilia Chashnik, Nikolai Suetin and others. Their programme was reflected in one of their manifestos from those years: "We need a studio where we can create a new architecture. There, we painters must do what the architects cannot ... We need plans, drawings, projects,

experiments."[9] Malevich attempted in his writings from that period (1918-1920) to put into words his concept of the form of the Suprematist "machine" – an object of utterly new architecture, a kind of cosmic structure. "'The Suprematist machine', if one may call it so," he wrote,

> will be integrated and without any joins whatsoever. A metal bar is a fusion of all elements, like the earth, and carries within itself a life of perfections, so that every Suprematist body constructed will be incorporated into a natural organization and form a new satellite: all that is necessary is to discover the inter-relationship between two bodies soaring in space. The earth and the moon. Between them, a new Suprematist satellite can be constructed, equipped with every component, which will move along an orbit shaping its new track. Study of the Suprematist formula of movement leads us to conclude that rectilinear motion towards any planet can only be achieved by the circling of intermediary satellites, which would provide a straight line of circles from one satellite to another.[10]

In late 1920, Malevich announced the launching of the architectural stage of Suprematism: "Having established definite plans for the Suprematist system, I am entrusting the further development of what is now architectural Suprematism to young architects in the broadest sense of the word, because I see it as the only possible system in an era of new architecture."[11]

Under the guidance of artist-architect Lissitzky, who headed the school of architecture at the Vitebsk Svomas (Free State Art Studios), the members of Unovis learned to perceive planar Suprematist works as a projection of a volumetric composition and executed axonometric Suprematist constructions; planar Suprematism became graphic-volumetric and then spatial-volumetric. The word "project" was used at Unovis, whose elite understood and shared the views of their ideologue, Malevich, as a principal definition for "the product of creative tension". Thus, Chashnik saw in Suprematist compositions (which he called "sketches" or "plans") the projects and instruments of the manifestation of the new world edifice, the new system of the Universe. Under Malevich's influence, Khidekel and Chashnik published an article in the first issue of the Unovis journal *Aero* (1920) about an aero-city hovering over the earth. Malevich spoke many times of the cosmos and cities in the cosmos to his students in Vitebsk and, after 1922, at Ginkhuk (State Institute of Painterly Culture, Petrograd). This assumed a priori that in the future, science and technology would make it possible to create hovering city-satellites that would move freely above the earth.

Among Malevich's followers, Lissitzky was the first, in the creative dialogue with him, to adequately understand the scale of Suprematist stylistics, to foresee the onset of the space age and to find a way to translate Suprematism from the plane to the objective-spatial world (immediately, on an urban scale). Lissitzky hastened the formation of volumetric Suprematism and then Suprematism's shift to architecture. His Prouns (projects for the affirmation of the new; cats. 168-169) evidently stemmed from Malevich's cosmic "supremes" flying in space (without bottom or top) and actually became, as Lissitzky defined it in 1920, an "interchange station between painting and architecture".[12] Prouns were "within the confines of the picture-frame ... cosmic space, in which floating geometric forms were held counterpoised by tremendous tensile forces". These forms, straining ahead, were like "rockets shot from earth in the infinite space of Lissitzky's pictures" – as Sophie Küppers, who became Lissitzky's wife soon after, expressed her first impression of the Prouns.[13] Having given volume to planar Suprematist elements, Lissitzky oriented them with respect to the earth, and although the volumes in the Prouns were still hovering on a white background, he frequently expressed in them a bottom and top. These were his preparations for implementing his idea of building "monolithic communist towns ... in which the inhabitants of the world will live".[14]

Lissitzky propounded Malevich's theory of the "surplus element" concretely, architecturally, at times almost quoting Fedorov:

suprematism itself has followed the true path which defines the creative process [the composing of the new nature] consequently our picture has become a creative symbol and the realization of this will be our task in life.

when we have absorbed the total wealth of experience of painting when we have left behind the uninhibited curves of cubism when we have grasped the aim and system of suprematism – then we shall give a new face to this globe. we shall reshape it so thoroughly that the sun will no longer recognize its satellite ...

we have set ourselves the task of creating the town. The centre of collective effort is the radio transmitting mast which sends out bursts of creative energy into the world. By means of it we are able to throw off the shackles that bind us to the earth and rise above it. therein lies the answer to all questions concerning movement.

this dynamic architecture provides us with the new theatre of life and because we are capable of grasping the idea of a whole town at any moment with any plan the task of architecture – the rhythmic arrangement of space and time – is perfectly and simply fulfilled for the new town

will not be as chaotically laid out as the modern towns of north and south america but clearly and logically like a beehive.[15]

Following his pupils and Lissitzky, Malevich created a series of sketches of "aero-cities", with colonies made up of planit-houses (the homes of the future), including an Airman's Planit (1924) in the shape of an airplane. Working along these same lines were Chashnik (Architectons, 1925-1926 [cats. 299-301], Supremoplane [Suprematist Planit], 1927-1928) and Khidekel (projects for a floating city, 1925; for a spatial structure above a landscape, 1925-1930). Later, Malevich experimented a great deal with architectons (Suprematist architectural models) and exhibited them at the second Ginkhuk exhibition (1926). This experimental design by Malevich was aimed at creating a new architectonic system for the "Suprematist order".

Lissitzky applied the image of this system to the pages of his book A Suprematist Tale of Two Squares (Suprematicheskii skaz pro dva kvadrata), in which Suprematistically ordered structures fly in from the cosmos and stop on earth, introducing there a new order: "Here are two squares / They fly to the Earth from afar / And see black. Alarming / Crash. Everything scatters / And on the black is established red. Clearly."[16]

Lissitzky's next step was a project for a "horizontal skyscraper" he proposed building above existing structures in Moscow, which, although they did not meet modern requirements, could not be "shaved off" today and built "correctly" all over again for tomorrow. He approached the solution of his task in a practical manner: "Until we achieve utterly free hovering, it will be characteristic of us to move horizontally rather than vertically."[17] Lissitzky's "Wolkenbügel" (1923-1925), although visually it "hovers" in the space of the city, nonetheless rests on an access tower set upon the ground. Placed at key points in Moscow directly above the fabric of the city, Lissitzky's horizontal skyscrapers are a new "artificial nature", a structure parallel to the city but functioning and utilized in concert with it.

During the period when he was creating his skyscraper project, Lissitzky was already more involved with the association of rationalist architects known as ASNOVA than with Malevich. According to its programme, ASNOVA, which was closely linked with Vkhutemas (Higher State Art-Technical Studios, later called Vkhutein, Higher State Art-Technical Institute), considered the "earthly installation of aerial paths of communication", or "avia-construction", one of the most interesting and relevant themes for a design project.[18] As early as 1921, Ladovsky, who was the leader of ASNOVA, in discussing a sketch by Anton Lavinsky, City on Springs (Gorod na ressorakh),

expressed the notion that it was technically possible not only to lift buildings above the earth, without supports, but also to construct "flying" buildings. Vkhutein student Georgy Krutikov, who made a thorough study of the problems of forming moving elements and questions of aero- and astronautics, devoted his graduation project (1928; cat. 162), to the practical resolution of this task. In the transport section of ASNOVA, he also participated, along with Lissitzky and the engineer Vinogradov, in an architectural formulation of a plan for Tsiolkovsky's dirigible (1926). Krutikov's basic thesis in designing his "flying city" was that, with the development of civilization, mankind would necessarily acquire an irrepressible urge to free the planet from most of its structures, which could be done, he felt, by providing for buildings to hover above the earth, utilizing nuclear energy at a certain point. Moreover, he summarized "the crisis of the skyscraper (while occupying a great deal of space on the earth with its foundation, it has an insignificant section on top). In order to avoid this, the skyscraper needs to be broken up into parts, which could then be hung separately up high."[19] Krutikov considered his project for a "flying city" the first stage in man's entry into the space surrounding the earth. There is no doubt that the prototypes for Krutikov's graduation project (whose supervisor was Ladovsky) were Lissitzky's *Proun 5A* and "horizontal skyscraper".

Krutikov's proposed "City of the Future", which was oriented primarily around aerial paths of communication, included an industrial zone, arranged horizontally in a coplanar spiral on the surface of the earth, and a vertical residential section, floating freely above it. The residential section was a bowl-like paraboloid whose narrow end pointed towards the earth, its axis coinciding with the centre of the industrial zone. Stepwise housing complexes on the outer surface of the paraboloid had honeycomb slots of several structural types for "parking" mobile cells. These cells, which according to the project were to serve as a link between the aerial housing and the earth, were a sort of capsule that, being an autonomous unit, could quickly disengage from and dock at the hovering building-city. In addition, these capsules were to function both as housing for short-term stays and as a universal means of individual transportation – through the air, over land, and on and under the water.

Several of the graduation projects done in Ladovsky's studio at Vkhutein in 1928 and 1929 implemented the principle of a city hovering above the earth. Student Viktor Kalmykov proposed creating at the equator a city-ring, which he called "Saturn" and which would "hover" in the air with the aid of rigid constructions. The ring would remain in a fixed position with respect to the earth by revolving at the same speed as the earth. Isaak Yusefovich (1929) developed the theme of a floating USSR Hall of Congresses that could be moved and attached like a dirigible to docking towers set up in the cities where the congresses were being held. These towers were given the function of vertical access, but they were also both residential and public structures.

In the projects of the Soviet architects of those years, the dirigible became a symbol for the global connection of world civilization. A unique sketch-proposal by architect Sergei Gruzenberg, *The Columbus Aero-model* (late 1920s) shows a system of several rigid dirigibles and a guidance gondola hanging from a construction that had a large port facing the earth and landing platforms for airplanes on its upper level – a kind of airborne aircraft carrier. Further developing the spatial ideas of structuring installations and breaking them up at a height, Ivan Leonidov, in a project he entered in a competition to design a beacon in honour of Christopher Columbus in Santo Domingo (1929), put his "Columbus Airport" at the highest point of a circle; around the perimeter were a terminal and boarding areas, and below, in the ground, the hangars. Airplanes took off using a moving platform. Here, too, there were moorings for dirigibles. For regular Columbian routes between Europe and America, a floating air base was set in the Atlantic Ocean with all the necessary buildings, hangars, hotels, power station and radio. There was even an Institute of Interplanetary Communications.[20]

In the early 1930s, all avant-garde trends suffered a crisis that was artificially provoked by new occurrences in Soviet society. Stalin's state apparatus had proposed a change in the nature of the utopia presented to the mass consciousness, subjecting all lines of development in art and architecture to state control and making it impossible to develop any further avant-garde stylistic concepts.

• Notes

1. Evgeny Kovtun, introductory essay, in *Avangard, ostanovlennyi na begu* [The avant-garde, stopped in its tracks] (Leningrad: Aurora, 1989), p. 5.

2. See Charlotte Douglas, "On the Philosophical Sources of Nonobjective Art", in *Malevich: Artist and Theoretician* (Malevich. Khudozhnik i teoretik) (Moscow: Sovetskii khudozhnik, 1990), pp. 56-60.

3. Nikolai Fedorov, *Filosofiia obshchego dela* [The philosophy of the common task], vol. 1 (Verny, 1906), vol. 2 (Moscow, 1913).

4. See Margit Rowell and Angelica Zander Rudenstine, *Art of the Avant-garde in Russia: Selections from the George Costakis Collection*, exhib. cat. (New York: Solomon R. Guggenheim Museum, 1981), p. 305.

5. Nikolai Fedorov, *Sochineniia* [Works] (Moscow: Mysl, 1982), p. 500.

6. S. O. Khan-Magomedov, *Pionery sovetskogo dizaina* [Pioneers of Soviet design] (Moscow: Galart, 1995), p. 68.

7. N. Khardzhiev, "El Lisitskii – konstruktor knigi", in *Iskusstvo knigi* [The art of the book]), 1958-1960 (Moscow: Iskusstvo, 1962), p. 148. An abridged English translation of this article, "El Lissitzky, Book Designer", may be found in Sophie Lissitzky-Küppers, *El Lissitzky: Life, Letters, Texts*, trans. from the German by Helen Aldwinckle and Mary Whittall (London: Thames and Hudson, 1968, reprinted with revisions 1980), where the quoted passage occurs p. 388.

8. Quoted in Lissitzky-Küppers 1968/1980, from a letter of 1919 to Malevich, p. 21.

9. V. Rakitin, "Ot zhivopisi k arkhitekture" [From painting to architecture], in *Arkhitekturnaja kompozitsija* [Architectural composition] (Moscow, 1970), p. 184.

10. Kazimir Malevich, "Suprematizm. 34 risunka" (Vitebsk: Unovis, 1920). Quoted in English from "Suprematism. 34 Drawings", in Larissa A. Zhadova, *Malevich: Suprematism and Revolution in Russian Art, 1910-1930* (London: Thames and Hudson, 1982), p. 284.

11. *Ibid.*, p. 287.

12. Quoted in Lissitzky-Küppers 1968/1980, p. 21.

13. *Ibid.*, pp. 11, 20.

14. Quoted in *ibid.* from a letter of 1919 to Malevich, p. 21.

15. El Lissitzky, typescript of 1920, State Tretiakov Gallery, Moscow, Manuscript Department, Fond 76, Unovis Collection. Published in English as "Suprematism in World Reconstruction", in Lissitzky-Küppers 1968/1980, where the passage quoted appears on p. 332.

16. See Victor Margolin, *The Struggle for Utopia: Rodchenko, Lissitzky, Moholy-Nagy, 1917-1946* (Chicago: University of Chicago Press, 1997), ills. 1.15-1.19, pp. 39-41. Also reproduced in Lissitzky-Küppers 1968/1980, ills. 84-88, and Zhadova 1982, ills. 187-192.

17. El Lissitzky, "Seriia neboskrebov dlia Moskvy" [A series of skyscrapers for Moscow] (*Izvestiia ASNOVA*, 1926).

18. Letter from ASNOVA to Lissitzky, June 9, 1924, Russian State Archives of Literature and Art, Moscow, 2361/1/59/7.

19. G. T. Krutikov, "Predposylki k rabote *Gorod budushchego*" [The premises of "City of the Future"], A.V. Shchusev State Research Museum of Architecture, Moscow, R1a 11200/12.

20. I. Leonidov, "Konkursnyi proekt pamiatnika Kolumbu" [Competition project for a monument to Columbus], *Sovremennaia arkhitektura*, no. 4 (1929), p. 148.

249· ALEXANDR RODCHENKO, **POINTS: COMPOSITION NO. 119**, 1920
COLOGNE, GALERIE GMURZYNSKA

179· KAZIMIR MALEVICH

MAGNETIC SUPREMATISM, 1917 MAGNETIC SUPREMATISM, 1917

SUPREMATIST ELEMENTS, ABOUT 1917 MAGNETIC SUPREMATISM, 1917

NEW YORK, LEONARD HUTTON GALLERIES

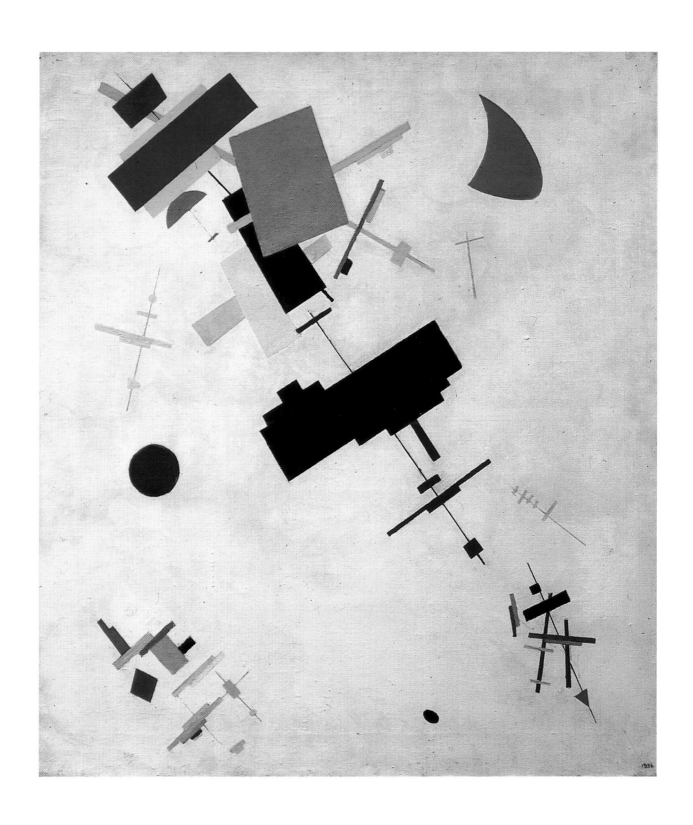

177· KAZIMIR MALEVICH, **SUPREMATISM**, 1916
SAINT PETERSBURG, STATE RUSSIAN MUSEUM

FROM THE COSMOS, ABOUT 1917-1918 COSMOS I, 1916-1917

DROP (COSMOS), 1917 COSMOS, 1916-1917

SUPREMATIST COMPOSITION, 1916-1917

CONTRAST OF FORMS, 1916-1917

CONTRAST OF FORMS, 1916

178· KAZIMIR MALEVICH, **SUPREMATIST COSMOS**
NEW YORK, LEONARD HUTTON GALLERIES

301• ILIA CHASHNIK
ARCHITECTON, 1925-1926
COLOGNE, GALERIE GMURZYNSKA

300• ILIA CHASHNIK, **ARCHITECTON**, 1925-1926
COLOGNE, GALERIE GMURZYNSKA

299• ILIA CHASHNIK, **ARCHITECTON**, 1925-1926
COLOGNE, GALERIE GMURZYNSKA

296• ILIA CHASHNIK, **SUPREMATIST RELIEF**, 1922
PRIVATE COLLECTION
COURTESY OF GALERIE GMURZYNSKA, COLOGNE

298· ILIA CHASHNIK, **COSMOS – RED CIRCLE ON BLACK**, 1925
PRIVATE COLLECTION

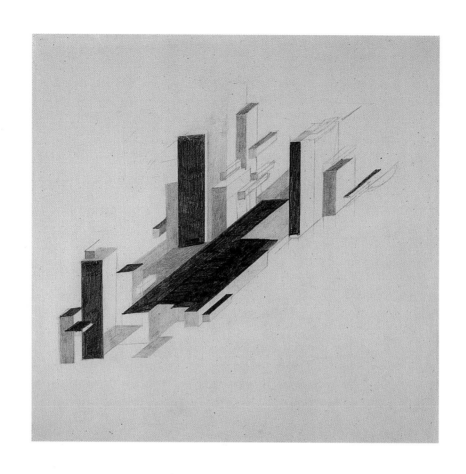

280• NIKOLAI SUETIN, **SUPREMATIST CITY**, 1931
COLOGNE, GALERIE GMURZYNSKA

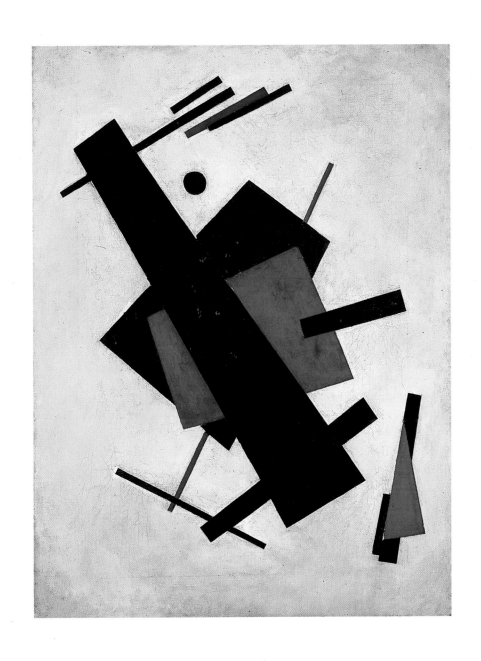

277• NIKOLAI SUETIN, **SUPREMATISM,** 1920-1921
MADRID, FUNDACIÓN COLECCIÓN THYSSEN-BORNEMISZA

158• IVAN KLIUN, **BLUE LIGHT**, 1923
COLOGNE, GALERIE GMURZYNSKA

159• IVAN KLIUN, **RED LIGHT**,
SPHERICAL COMPOSITION, ABOUT 1923
ART CO. LTD., GEORGE COSTAKIS COLLECTION

157· IVAN KLIUN, **SPHERICAL COMPOSITION**, 1923
COLOGNE, MUSEUM LUDWIG

ALEXANDR RODCHENKO

250· **SPATIAL CONSTRUCTION NO. 9**
(THE CIRCLE IN THE CIRCLE), 1920-1921
(RECONSTRUCTION BY ALEXANDER LAWRETIEW, 1993)

251· **SPATIAL CONSTRUCTION NO. 10**
(THE HEXAGON IN THE HEXAGON), 1920-1921
(RECONSTRUCTION 1979)

COLOGNE, GALERIE GMURZYNSKA

282· VLADIMIR STENBERG, **SPATIAL APPARATUS KPS 43 N VI**, 1919 (RECONSTRUCTION 1973)
COLOGNE, GALERIE GMURZYNSKA

169• EL LISSITZKY, **PROUN G7,** 1923
DÜSSELDORF, KUNSTSAMMLUNG NORDRHEIN-WESTFALEN

168• EL LISSITZKY, **PROUN 4B,** 1919-1920
MADRID, FUNDACIÓN COLECCIÓN THYSSEN-BORNEMISZA

243• MIKHAIL PLAKSIN, **PLANETARY**, 1922
ART CO. LTD., GEORGE COSTAKIS COLLECTION

240• ANTOINE PEVSNER, **SPATIAL CONSTRUCTION IN THE THIRD AND FOURTH DIMENSIONS**, 1961
DUISBURG, GERMANY, WILHELM LEHMBRUCK MUSEUM

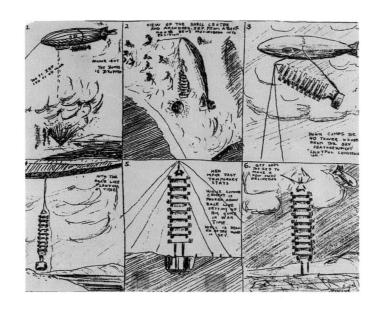

111· RICHARD BUCKMINSTER FULLER
**PROJECTED DELIVERY BY ZEPPELIN OF THE PLANNED 10-DECK, WIRE-WHEEL,
4D TOWER APARTMENT HOUSE**, 1927
CINCINNATI, CARL SOLWAY GALLERY

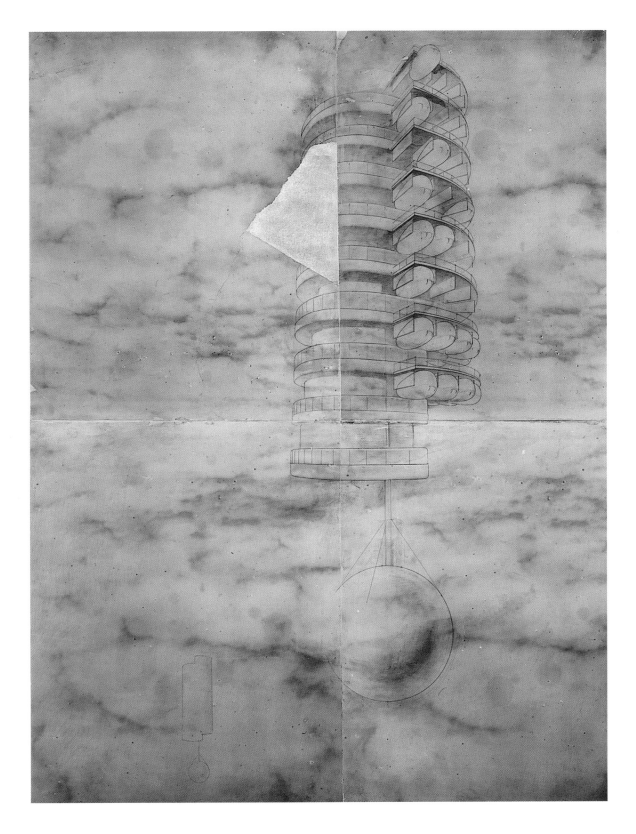

162· GEORGY KRUTIKOV, **CITY OF THE FUTURE**, 1928

COMMUNAL HOUSE. PERSPECTIVE
MOSCOW, A.V. SHCHUSEV STATE RESEARCH MUSEUM OF ARCHITECTURE

TABLE 1: A FLYING HOUSING UNIT
TABLE 2: ORGANIZATION OF THE DWELLINGS
TABLE 3: ORGANIZATION OF THE DWELLINGS
TABLE 4: ORGANIZATION OF THE CITY ON AERIAL PATHS OF COMMUNICATION

TABLE 1: VISUAL DISTORTION OF A MOVING FORM
TABLE 2: COMPOSITION OF MOBILE CONSTRUCTIONS

162• GEORGY KRUTIKOV
CITY OF THE FUTURE, 1928
MOSCOW, A.V. SHCHUSEV STATE RESEARCH MUSEUM OF ARCHITECTURE

July 1969: for the first time in history, a man, imprisoned in a space suit, set foot on the moon. A feat of technology had enabled him to fulfil the great cosmic dream of the journey "from the earth to the moon". In ancient Greece, it was believed that only souls stripped of their bodily integument could wander among the stars. Over the centuries, myths about the "celestial crossing" of souls proliferated, supported through to the Renaissance by the idea of a safe, spherical universe, handed down from Plato, Aristotle and Ptolemy. But the publication of Galileo's *Sidereus nuncius* (The Starry Messenger) in

Cosmic Imaginings,

from Symbolism to Abstract Art

by Constance Naubert-Riser

March 1610 changed this way of thinking and gave fresh impetus to the desire to "go and see". Galileo was in fact offering to the world the results of observations carried out with a simple telescope of his own devising, together with an engraving showing the surface of the moon in hitherto unseen detail.[1] And to the amazement of all, it proved to be not smooth, but broken by mountains and valleys, resembling the earth's surface in more ways than one. This discovery exerted a powerful fascination: from the seventeenth century on, the idea developed that mankind might be able to colonize the moon, to find at last a place where "the imagination was free".[2] The possibility of sending a human being into space was consequently first envisaged.

Thus, we find the literary invention of "flying machines". From the notion of harnessing giant birds or flying in a winged chariot,[3] the human imagination moved swiftly to posit the extravagant ascent of a democratic, egalitarian freethinker. The traveller in Cyrano de Bergerac's little tale demonstrates an audacity as remarkable as it is impracticable: "I fastened all about me a number of little bottles of dew, and the heat of the Sun drawing them up carried me so high that at last I found myself above the loftiest clouds."[4]

Gradually, thinkers came to terms with the idea of an infinite universe no longer fearsome and dizzying, but rather, reassuring and liberating. The early eighteenth century saw a succession of fictional characters embark upon cosmic travel that was often the pretext for satirical attacks on the shortcomings of society on earth, as in Defoe's *Consolidator* (1705), Swift's *Gulliver's Travels* (1726) and Voltaire's *Micromégas* (1752). These were followed in the nineteenth century by Poe's astonishing philosophical essay "Eureka" and Verne's famed imaginary adventures.

• **Images of the Cosmos**

Between 1872 and 1876, Étienne Léopold Trouvelot, a relatively unknown draftsman, produced an important series of works for Harvard College Observatory meticulously depicting nebulas and planets as seen through the telescopes of the period.[5] He left to posterity a number of pastels now held by the Paris Observatory, including *Part of the Milky Way Visible in Winter, Observed in 1874-1875* (cat. 308). Previously an entomologist, Trouvelot pursued his new work at the Meudon Observatory with the astronomer Jules Janssen. His change of career is an indication of the enormous interest aroused at the time by the possibilities of ever-improving telescopes for sky-gazing. Enthusiasm for heavenly bodies soon went beyond the boundaries of scientific publications. Camille Flammarion, a scholarly astronomer, wanted to popularize the new vision of the world his observations had brought him. His profusely illustrated books gave avid readers a "sense of the cosmos" based on a new science that from then on would offer a true-to-life model capable of supplanting philosophies and religions. Flammarion's importance cannot be denied; fin-de-siècle Symbolist circles were fascinated not only by his *Astronomie populaire* (1880), but also by his *Récits de l'infini* (1872) and *Uranie* (1889). The reveries induced by the contemplation of starry skies soon gave way, in the poetic universe of Jules Laforgue and Gustave Kahn, to a sort of "pathos of magnitude". Heavenly bodies moved, and invisible forces ruled their movement.

The widely disseminated discoveries of astronomy were often the unrecognized inspiration of paintings of the period,[6] like Belgian artist Alfred Stevens's charming and unusual painting *The Milky Way* (1885-1886; cat. 283), in which a young woman lost in thought gazes from her window.[7] The composition echoes the frontispieces of Flammarion's books, with an observer looking at a starry sky from a window or balcony. In a Symbolist vein, Stevens's painting invites all who see it to speculate on mankind's place in a universe that ongoing discoveries were revealing as infinite.

Van Gogh, a reader of Jules Verne,[8] was not unaffected by the ideas that arose from a new way of thinking influenced by astronomy. The unexpectedly cosmic dimension of *Road with Cypress and Star* (1889-1890; cat. 310) is more apparent when one compares it to the earlier *Starry Night* (fig. 1), in which the decentralized composition is constructed around the image of a spiral nebula. As Albert Boime has shown, Van Gogh was indeed interested in celestial phenomena.[9] Perhaps, like Flammarion, he saw in them a source of spiritual renewal completely in accord with his deep religious feelings. He may have subscribed to the idea that the discovery of a plurality of worlds through interplanetary

FIG. 1 - VINCENT VAN GOGH
STARRY NIGHT
1889

fascination with interstellar space (*Rex*, 1909; cat. 71). In *Lightning*, seven frozen, twisting lightning bolts, perhaps representing the seven days of Creation, erupt together out of an oval cloud and fall into a sea of oil. The presence of this broad, flattened oval is a direct reference to the universal symbol of the cosmic egg, which transforms the scene into a Symbolist image linked to the birth of the world.

Rex, a much more complex painting, goes back to an important element in Flammarion's thinking: that the plurality of worlds allows souls to make a kind of journey of initiation across the immensity of the universe. Each stage of this journey brings them to a higher level of spiritual achievement. The viewer of this painting can, like Lumen,[14] contemplate the universe and retrace this process of ascension through the superimposition of four spheres interlinked by "the force that governs the universe", represented here by two transparent thrones. We see the four elements – earth, water, fire and air – plants, comets and myriad angels, all drawn from the pages of Flammarion.

• Paris – Milan: Cosmos and Abstraction
Until just before World War I, artists' imaginings of cosmic space remained rooted in Symbolist imagery. It was not until about 1910 that they began to cross over into abstraction. Within the huge movement that questioned artistic conventions – from Italy's Futurists to the followers of Orphism in Paris – the first half of the twentieth century was to see scarcely hidden references to heavenly bodies. One of the first to follow this path was František Kupka.

Kupka's sources for his theories were highly eclectic, running from physiology to theosophy, and incorporating the philosophy of Bergson and the anarchist thinking of geographer Élisée Reclus, whose *L'Homme et la terre* he illustrated between 1904 and 1908. One might be inclined to see in this array of theories only the inconsistency of Kupka's thinking, but we should not forget his enormous curiosity about the scientific discoveries of his time. He was as interested in X rays as in chronophotography, the natural sciences, crystallography and theories of the fourth dimension. Deeply influenced by occultism and himself a medium, Kupka was inevitably drawn to the mysteries of the cosmos, as can be seen in an astonishing work he dated 1909, *The First Step* (fig. 2), composed of haloed disks against a black ground.[15] This painting, inspired by a monumental reconstruction of the moon he saw in Ukkel, Belgium, is evidence of his great interest in astronomy.[16] Kupka kept up with the latest discoveries published in scientific journals, which were lavishly illustrated with macrophotographs of the moon, planets and eclipses taken through a telescope. He was also a regular visitor at the Paris Observatory and later

travel could lead to a cosmic brotherhood capable of regenerating humanity.[10]

At the dawn of the twentieth century, the desire to reformulate the close bonds uniting man and the cosmos by means of Symbolist imagery is seen in the work of artists of diverse origins – George Frederick Watts, Albert Trachsel, Edvard Munch, Jens Willumsen, Eugène Jansson and Paul Sérusier.[11] This intention is also apparent in the 1904 masterpiece *The Rising Sun* (cat. 239) by Pelliza da Volpedo, a leading representative of Italian Divisionism. Pelliza clearly shows us the sun as the centre of the universe. The handling of its rays, painted as a sort of luminous magnetic cloud blending into a field of shadow in which a few details of a landscape can just be glimpsed, reveals its cosmic significance: the sun not only manifests things and makes them perceptible, it also "orders" space from an absolute centre, imposing its own gravity.

Any interpretation of the cosmos expressed in art springs from an imagination engaged in varying degrees of reverie, but nonetheless informed by a vision of the world based on a very personal assimilation of new ideas about the order of the universe. Such was the case with the painter, musician and poet Mikalojus Čiurlionis, Lithuania's most famous Symbolist. Brought up as a Catholic, he encountered the theories of Kant and Laplace and the planetary visions of Flammarion[12] while studying at the Warsaw School of Fine Arts in 1904 and embarked on a series of highly unusual images of cosmic space.[13] Although the cycle *The Creation of the World* (1905-1906) is his best-known work, in later paintings Čiurlionis turned to images both stronger, to express his passion for origins (*Lightning*, 1909; cat. 70), and more mysterious, to express his

at the Palais de la Découverte, where photographs of heavenly bodies were exhibited.

Kupka pulled together all these elements in a larger painting of 1911 entitled *Cosmic Spring II* (cat. 166), where his tendency to mysticism creates a sort of abstract personal cosmogony, bringing together shapes taken from the microcosm and the macrocosm. A whitish sphere (in the upper left), surmounted by a crater from which rays or furrows flow, is discreetly reminiscent of photographs of the moon taken at the Meudon Observatory in 1881.[17] This moon shape is seen through superimposed heteromorphic grids of cloud- and crystal-like forms. The spatial complexity of this powerfully structured painting places the viewer "in orbit", anticipating the viewpoint of an interplanetary traveller.

FIG. 2 - FRANTIŠEK KUPKA
THE FIRST STEP, 1910-1913 ?

This vision of the infinite depth of space was also at the heart of Robert Delaunay's inspiration for a remarkable series of "Circular Forms", painted in 1912 in Paris; *Circular Forms: Sun and Moon* (cat. 85) is an excellent example of the series. It would seem that the artist rejected imitating nature in order to draw the viewer's eye into an endless circular movement based on the dynamic properties of colour. The use of titles referring to celestial bodies allows us to attribute a cosmic meaning to these compositions. Their remote source, like that of Kupka's *Disks of Newton* (see cat. 163), is probably the chromatic circles found in treatises on colour. But the transformation of their "illustrated plates" through the articulation of a space that "revolves" in a sort of cosmic void and develops according to the dynamic circular rhythm of colour brings the series closer to the images in astronomy books. This work is important in two ways: not only did it spring from an "aerial symbolism" dear to Delaunay, but also, as Michel Hoog has pointed out, it "re-establishes ... the circle in a brusque, brilliant and definitive way". In fact, "the circle, the perfect shape, had been banished from painting ever since the haloes and cosmic symbols of the Middle Ages".[18] This interest in circles

and in light splintered by a prism can be found in the work of two Americans then resident in Paris, Morgan Russell and Stanton Macdonald-Wright, who exhibited their "synchromies" at the Galerie Bernheim-Jeune in October 1913.[19]

That same year, a certain Léopold Stürzwage (or Survage) invented the principle of the abstract animated film by creating an impressive group of *Coloured Rhythms* (cats. 286-289) with a view to setting them in motion by means of the cinematograph. This project, which had the support of Blaise Cendrars and Apollinaire, unfortunately never came to fruition. But the intention was a prophetic one: to go beyond painting, which is unavoidably static, by a sort of transposition into film of Delaunay's cosmic rhythms.[20]

In February of the previous year, 1912, Bernheim-Jeune had presented the first Paris exhibition of the Italian Futurists. To be truly contemporary, these young artists had decided to depict movement and time. All the stimuli of the modern city served them for themes: the flow of light from a street lamp, the dynamic action of a football player and the speed of an automobile. The boldness of their renewal of painting had a decisive impact on all of Europe's avant-garde movements. As Giovanni Lista stresses,[21] they sought to make visible the "universal dynamism", and thus they shared Delaunay's and Kupka's cosmic propensities. Fascinated by X rays and light analysis, the Futurists called into question the opacity of the body (Severini in particular). They tried to translate graphically the cosmic forces responsible for universal communication, made possible by the transparency of matter, as in Luigi Russolo's *Houses + Lights + Sky* (1912-1913; cat. 260). Giacomo Balla's many preparatory sketches for *Mercury Passing before the Sun, Seen through a Telescope* (1914; cats. 10-12), executed just after a partial eclipse he observed with his telescope in November 1914, show his pronounced interest in astronomy, which was shared by his contemporaries.[22]

• Cosmos and Utopia in Germany

Artists who are not creators in the cosmic sense have nothing in common with creativity.[23]

Images associating dreams of the cosmos with the "regeneration" of humanity also appeared in Germany before the 1914-1918 war. *Firmament*, from 1913 (cat. 122), is a remarkable painting made by visionary artist Wenzel Hablik[24] when he was living in Itzehoe, north of Hamburg. It represents the concrete result of his dream of cosmic travel, which he had made notes on in a notebook dating from his student days at the Staatliche Kunstgewerbeschule in Vienna in 1902. Excited by reading the popular novel *Two Planets (Auf zweite*

Planeten, 1897) by Kurd Lasswitz (considered the father of German science fiction), and probably familiar with Wilhelm Meyer's popular science books,[25] Hablik produced not only this enormous picture of the solar system, but also a series of smaller drawings of his inventions of inhabitable flying machines. These machines are among the earliest works of imagination to depict the achieving of a better world through technology. In their combination of Utopian vision and technical invention, *The Construction of the Air Colony* (1908; cat. 120) and *Flying Building, Large Flying Settlement* (1907-1914; cat. 119)[26] anticipated by several years the planits and architectons of Malevich and Chashnik (cats. 299-301), Krutikov's *City of the Future* (cat. 162), and the axonometric creations Lissitzky dreamed up during the 1920s (cats. 168-169).[27]

Hablik's diary contains a detailed description of one of these "colonies", which were meant to enable men not only to travel in space but to stay there for a long time. Everything was foreseen down to the smallest detail:

Today I dreamed a dream that extended over twelve years. I had a flying colony built! A framework made from a wonderful steel was covered with a strong layer of silver that had, by means of a singular method, extracted itself from the iron. This layer of silver did not oxidize or shine, instead it was a lustreless black. Rooms for fifty couples were built into this framework, which was strong enough to resist the highest temperatures one could produce. These rooms could be vacuum-sealed and contained everything necessary to sustain life for four hundred years. Through experimentation, I succeeded in producing a second metal whose resistance to all manner of destructive influences such as oxidation, fire, etc., was as great as its solidity, exceeding anything knowing to man today ...

All the machines needed to make this structure lighter than air were built of this metal. Propellers constructed from thin plates driven by automatic motors turned at 2,000 revolutions per second. For these tests, the air was first made very thin and then normal ...

It took two years to complete the frame, six and a half years to complete the living quarters and machines, the production of the foodstuffs three years. These were nothing less than cells with a limitless viability: their production was the latest chemical success, achieved by extracting the self-sustaining plasma of life and making it immediately available to the human organism. Water was produced from air in a special room. The first attempt at launching the entire building was made on the morning of August 4, 1920, and was such a complete success that an ever-greater

quantity of items could be taken along, for as yet unseen needs. Metals, precious stones, etc. Animals.

At first, the flight was to be limited to one complete trip around the globe in order to pick up representatives of various races whose procreative energy and strength had not declined and whose spirit suited the stated purpose ...[28]

Along with these drawings, in 1909 Hablik made a cycle of etchings entitled "Schaffende Kräfte" (Creative Forces),[29] a kind of reverie showing his fascination with the structure of crystals, whose regularity constituted for him a sort of metaphor for the forces of creation ruled by their own laws, not just in earthly natural phenomena but throughout the cosmos. The second plate of the series (cat. 121), with its crystalline planets, ringed like Saturn, floating in an indeterminate space, is a variation on his dream of flying, associating the transparency of quartz with cosmic travel.

After Germany's defeat in 1918, all the conditions were present for an increase in images of Utopia: the general collapse of the country, unemployment, poverty. Architecture represented the primary field of choice for "rehumanizing" man by bringing him into harmony with his surroundings. But all new ventures were paralyzed by the economic slump. Only imagination remained intact: nothing could stop it, above all when spurred on by a great desire for renewal. In January 1919, Bruno Taut and Walter Gropius, leading the A.F.K. (Arbeitsrat für Kunst, or Workers' Council for Art), launched an appeal to all young unknown architects to submit Utopian projects for exhibition, without worrying about technical difficulties in carrying them out.[30] A frequently recurring motif in the submissions was crystal, whose transparency provided a widely used metaphor for the unity of matter and spirit. Indeed, all the projects involved buildings of glass inspired by quartz crystal (*Bergkristall*), buildings within which human beings could communicate with their environment and the whole cosmos.[31]

Bruno Taut, a prolific writer, published his Utopian projects mainly in three books, in limited editions that are today very rare: *Alpine Architektur* (Alpine Architecture; cat. 293) of 1919, followed in 1920 by *Die Auflösung der Städte* (The Dissolution of the Cities; cat. 295) and *Der Weltbaumeister* (The Universal Master Builder; cat. 294), dedicated to the memory of Paul Scheerbart. His illustrations eloquently demonstrate the importance of the cosmic dimension of his proposals, which he had pondered on during the War. They represent a continuation of a sort of romantic socialism that dreamed of breaking down the barriers between town and country.[32] But the most innovative feature – very apparent in these

illustrations – was the idea of leaving the earth in order to reject materialism, to ascend to the stars. In *Alpine Architektur*, having commented at length on his images in a handwritten accompanying text, Taut chose, for the fifth and last section, entitled "Astral Building", to give only brief captions, as if once the images reached interstellar space, they required no commentary, as if these visions left him speechless: *Globes! Circles! Wheels!* (fig. 3) and *Systems within Systems – Worlds – Nebulas* (fig. 4). And these few words suffice, for the visual impact of the later, more abstract images echoes the structure of the atom and depictions of the solar system.

This visionary's cosmic imaginings reached unparalleled heights in his illustrations for *Die Weltbaumeister* (figs. 5a-f), conceived as an artist's book. The text that accompanies the pictures tells the story of the dissolution of a Gothic cathedral, a fetish image that is the starting point for his thinking about glass architecture. The broken shapes of the shattered cathedral "become atoms and are dispersed through the universe" (5a). Through a truly cosmic scenario, Taut – in this respect close to Scheerbart and Hablik – draws us into the heart of a planetary drama during which the "cathedral-star" collides with a meteor (5b-f):

It becomes dark blue and stars twinkle - - -

From afar come two turning stars - - - - one of them disappears - - -

The cathedral-star approaches - turns upon itself - - dances - -

- dances - - - changes in shape and brilliance - - - - - - -

and flies off - - a meteor - - - - - and again the dark blue space - starless - - - a long time -

MUSIC IN THE AIRY DISTANCE[33]

After the collision, the scattered debris will reinseminate the earth, ensuring its total regeneration.

During the twenties and thirties, there was a proliferation of artworks inspired by a more or less dreamlike approach to the cosmos. The fascination with spirals and spheres in the earliest abstract art shows artists' obvious interest in some of the oldest questions mankind has asked and their response to them. Into the forties and fifties, the grandeur of the skies and the poetry of deep, starlit nights continued to be admired. The absolute blues of Yves Klein, and Rothko's and Newman's monochromes overlooking the void echo cosmic order as much as do the atomized profusion of shapes in Miró's *Constellations* and those of Calder. In every age, sensitivity, like science, opens up new ways of communicating with the creative energy powering the order of the universe. Transcending all styles and all periods, the cosmos remains the touchstone of the imagination.

FIG. 3 - BRUNO TAUT
GLOBES! CIRCLES WHEELS!
FROM **ALPINE ARCHITEKTUR**, 1919

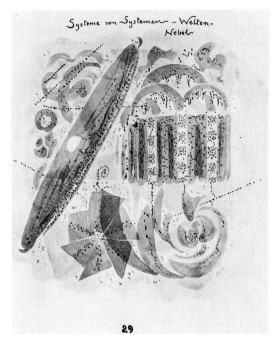

FIG. 4 - BRUNO TAUT
SYSTEMS WITHIN SYSTEMS - WORLDS - NEBULAS
FROM ALPINE ARCHITEKTUR, 1919

5A - BECOME ATOMS AND ARE DISPERSED THROUGH THE UNIVERSE - - -

FIGS. 5A-F - BRUNO TAUT
WELTBAUMEISTER, 1920

5B - IT BECOMES DARK BLUE
AND STARS TWINKLE - - -

5C - FROM AFAR COME TWO TURNING STARS - - - -
ONE OF THEM DISAPPEARS - - -

5D - THE CATHEDRAL-STAR APPROACHES -
TURNS UPON ITSELF - - DANCES - -

5E - DANCES - - - CHANGES IN SHAPE
AND BRILLIANCE - - - - - - -

5F - AND FLIES OFF - - A METEOR - - - - - AND AGAIN
THE DARK BLUE SPACE - STARLESS - - - A LONG TIME -
MUSIC IN THE AIRY DISTANCE

• Notes

1. The truly astonishing drawings this print was made from were probably by Galileo himself. They are reproduced in Samuel Y. Edgerton, Jr., "Galileo, Florentine 'Disegno' and the 'Strange Spottedness' of the Moon", *Art Journal*, vol. 44, no. 3 (Fall 1984), p. 228, figs. 10-11.

2. Savinien de Cyrano de Bergerac, *L'Autre Monde ou les États et Empires de la Lune* (1657). Quoted in English from *Voyages to the Moon and the Sun*, trans. Richard Aldington (London: George Routledge and Sons; New York: E.P. Dutton, 1923), p. 97.

3. John Wilkins, *Discourse Concerning a New World*, 1628.

4. Cyrano 1657/1923, p. 53. A colourful detail: This intrepid traveller, from fear of having gone off course, returns to earth, falling "by an almost perpendicular line in Canada", where he is "brought before the Viceroy, Monsieur de Montmagnie". To recommence his journey to the moon, he builds a new machine that, equipped with rockets, takes off from "the middle of the market-place of Quebec". (The Canadian episode occurs pp. 54-64.)

5. See Jan K. Herman and Brenda G. Corbin, "Trouvelot: From Moths to Mars", *Sky and Telescope*, December 1986, pp. 566-568.

6. On this subject, see Barbara Larson, "The New Astronomy and the Expanding Cosmos: The View from France at the End of the Nineteenth Century", in this catalogue.

7. Stevens's favourite subject was the Parisian *grande dame*, portrayed ceaselessly by him from the late 1850s on. After 1880, his health obliged him to take regular holidays by the sea in Normandy, so he would quit the salons for the balconies of Honfleur and the ocean which, seen from his window, was the inspiration for the many seascapes he painted at that time. See William A. Coles, *Alfred Stevens*, exhib. cat. (Ann Arbor, Michigan: University of Michigan Museum of Art, 1977).

8. See *The Complete Letters of Vincent van Gogh*, vol. 2 (Greenwich, Connecticut: New York Graphic Society, 1959 [2nd edition]), no. 299, p. 76.

9. Albert Boime, *Van Gogh, la Nuit étoilée* (Paris: Adam Biro, 1990). In a remarkable study of *Starry Night* (1889), Boime stresses that the theme of this famous painting was perfectly in tune with the new appreciation of astronomy's progress after the Universal Exposition in 1889. Citing a letter of 1883 that clearly proves Van Gogh had known Jules Verne's stories for many years, he concludes that the artist could not have been indifferent to the subjects popularized by Flammarion. (Some of the original material of Boime's study was published as "Van Gogh's *Starry Night*: A History of Matter and a Matter of History", *Arts Magazine*, vol. 59, no. 4 [December 1984], pp. 86-103.)

10. See Camille Flammarion, *Les Terres du ciel. Voyage astronomique sur les autres mondes* (Paris, 1884).

11. See Constance Naubert-Riser, "Towards Regeneration", in *Lost Paradise: Symbolist Europe*, exhib. cat. (Montreal: Montreal Museum of Fine Arts, 1995), pp. 457-506.

12. See Krescencijus Stoskus, "Ciurlionis and Philosophy", in Stasys Gostautas, ed., *Ciurlionis, Painter and Composer: Collected Essays and Notes, 1906-1989* (Chicago: Institute of Lithuanian Studies, 1994), pp. 415-427. Stoskus maintains that Flammarion's influence on Ciurlionis was greater than is usually thought, because of the French astronomer's poetic style and profoundly humanist attitude to the universe as astronomy presents it. His rejection of a geocentric worldview in favour of a vision of the cosmos both scientific and romantic was admirably suited to Symbolist imaginings. Furthermore, Flammarion was interested not only in astronomy but also in meteorological phenomena. Given

Ciurlionis's interest in Flammarion, he might well, during his travels in Germany, Austria and Eastern Europe in 1905-1906, have come across one of his books that could not have failed to attract him: *Les Caprices de la foudre* (E. Flammarion, 1905).

13. Ciurlionis went to Warsaw in 1894 to study music at the Conservatory (1894-1899). His first known painting dates from 1903. It is probable that he had been painting as an amateur for some years. His career in art was short but intense. Continually juggling painting and musical composition, he collapsed with exhaustion in 1909 and died in 1911 at the age of thirty-six from pneumonia contracted in the sanatorium where he was staying. See the excellent biography by Nijolé Adomovicien, "Der Lebensweg", in *Die Welt als grosse Sinfonie. Mikalojus Konstantinas Ciurlionis (1875-1911)* (Cologne: Wallraf-Richartz-Museum; Oktagon, 1998), pp. 11-27.

14. See Camille Flammarion, "Lumen", in *Récits de l'infini* (Paris: C. Marpon et E. Flammarion, 1885 [1st edition 1872]). "Lumen" has been published in English in various editions, one (London: W. Heinemann, 1897) with new material in the last chapter.

15. As Margit Rowell has shown, careful examination of this painting, later reworked, reveals black veinlets under the white surface of the central disk, which is very similar to the representation of the surface of the moon. See Margit Rowell, *Frantisek Kupka, 1871-1957: A Retrospective*, exhib. cat. (New York: Solomon R. Guggenheim Museum, 1975), pp. 118-119

16. Kupka went to Ukkel to visit Onésime Reclus, Élisée's brother. See *ibid.*, p. 119.

17. *Ibid.*, pp. 174-175.

18. Michel Hoog, in *Robert Delaunay (1885-1941)* (Paris: Orangerie des Tuileries, 1976), p. 75.

19. See Marilyn S. Kushner, *Morgan Russell* (Montclair, New Jersey: Montclair Art Museum, 1990), pp. 188-189.

20. Survage's 1913 *Coloured Rhythms* herald the abstract films made by Viking Eggeling and Hans Richter in 1920. They also represent the first attempt at creating kinetic art.

21. For a fuller discussion of Futurism, see Giovanni Lista, "The Cosmos as Finitude: From Boccioni's Chromogony to Fontana's Spatial Art", in this catalogue.

22. On this subject, see Sigmar Holsten in *Kosmische Bilder in der Kunst des 20. Jahrhunderts*, exhib. cat. (Baden-Baden: Staatliche Kunsthalle Baden-Baden, 1983), pp. 59-63.

23. Letter from Hablik to Liane Haarbrüker, in the possession of M. Grabosky, Arlesheim, Switzerland; quoted by Anthony Tischhauser in "Wenzel Hablik: Crystal Utopias", *Architectural Association Quarterly*, vol. 12, no. 3 (1980), p. 18.

24. The pictorial output of this complete artist, although large, has been neglected by art historians until quite recently. His works can be seen at the Wenzel Hablik Stiftung, Itzehoe, and the Schleswig-Holsteinische Landesmuseum, Schleswig. After studying in Vienna, he attended the Prague Fine Arts Academy. Hablik was a painter, printmaker and metalworker (see cat. 127); he also made furniture, designed his own wallpaper and made jewellery. On occasion, he created interior designs. As can be seen in photographs of the period, *Firmament* had been conceived as interior decoration for his own house. See the exhibition catalogues *Wenzel Hablik. Architekturvisionen, 1903-1920* (Itzehoe: Wenzel Hablik Stiftung, 1995); and *Hablik: Designer, Utopian Architect, Expressionist Artist, 1881-1934* (London: Architectural Association, 1980), p. 46.

25. See Bettina-Martine Wolter, " 'Die Kunst ist eine Aufführung des kosmischen Dramas'. Architekturvision

und Bühnenreform 1900-1915", in *Okkultismus und Avantgarde, von Munch bis Mondrian, 1900-1915* (Frankfurt: Schirn Kunsthalle, 1995), p. 655.

26. These works are part of a series of studies done between 1906 and 1914, "Entwürfe für Flugobjekte und fliegende Siedlungen" (Sketches for Flying Objects and Settlements), showing a wide variety of flying machines with shapes not unlike those of an airplane, a dirigible or a flying saucer. See exhib. cat. Itzehoe 1995, pp. 62-64.

27. On cosmic imagery in Russia, see Igor A. Kazus, "The Idea of Cosmic Architecture and the Russian Avant-garde of the Early Twentieth Century", in this catalogue.

28. Hablik's Diary, December 29, 1908, quoted in exhib. cat. Itzehoe 1995, p. 99, accompanying the drawing on p. 65.

29. It was shown in Berlin in 1908 and again, at Der Sturm's third annual exhibition, in 1912.

30. This *Ausstellung für unbekannte Architekten* (Exhibition for Unknown Architects) was held in the Graphisches Kabinett of the famous Berlin art dealer J. B. Neumann. The group was made up of Cesar Klein, Moriz Melzer, Wenzel Hablik, Gerhard Marks, the Molzhan brothers, Hermann Finsterlin, Jefim Golyscheff and the Dadaist Raoul Hausmann. See Iain Boyd Whyte, *Bruno Taut and the Architecture of Activism* (Cambridge and New York: Cambridge University Press, 1982), pp. 131-141. Erich Mendelsohn was not represented in the exhibition, but his *Einstein Tower* (cat. 195) dates from the same period.

31. One of the main sources for these projects is the founding text by poet Paul Scheerbart, *Glasarchitektur*, published by Der Sturm in Berlin in 1914 and dedicated to his friend Bruno Taut, whom he met at Der Sturm in 1912. The voluminous correspondence between the two until Scheerbart's death in 1915 attests to their great unanimity of thought. See the excellent article by Rosemarie Haag Bletter, "Paul Scheerbart's Architectural Fantasies", *Journal of the Society of Architectural Historians*, vol. 34 (May 1975), pp. 83-97.

32. For a history of the symbolic tradition Expressionist artists subscribed to, see Rosemarie Haag Bletter, "The Interpretation of the Glass Dream – Expressionist Architecture and the History of the Crystal Metaphor", *Journal of the Society of Architectural Historians*, vol. 40 (March 1981), pp. 20-43. Bletter emphasizes the socialist aspect of this attempt to reconstruct the Alps and Taut's personal contribution in pushing the metaphor of glass or crystal from an initial egocentrism towards a socialist attitude. "Glass is here no longer the carrier of spiritual or personal transformation, but of political metamorphosis", as Bletter (pp. 36-37) describes Taut's most advanced thinking on this issue, which he put forth in *Die Auflösung der Städte* (1920).

33. Bruno Taut, *Der Weltbaumeister. Architektur-Schauspiel für symphonische Musik* (Hagen, Westphalia: Folklang-Verlag, 1920). On these images, see also Regine Prange, *Das Kristalline als Kunstsymbol. Bruno Taut und Paul Klee* (Hildesheim, Zurich and New York: George Olms Verlag, 1991), pp. 127-140. I am grateful to the Canadian Centre for Architecture for kindly putting Taut's books at my disposal.

310· VINCENT VAN GOGH, **ROAD WITH CYPRESS AND STAR**, 1889-1890
OTTERLO, THE NETHERLANDS, KRÖLLER-MÜLLER MUSEUM

MIKALOJUS K. ČIURLIONIS

69 · **FAIRY TALE (CASTLE FAIRY TALE)**, 1909

70 · **LIGHTNING**, 1909

KAUNAS, LITHUANIA, M.K. ČIURLIONIS NATIONAL MUSEUM OF ART

71· MIKALOJUS K. ČIURLIONIS, **REX**, 1909
KAUNAS, LITHUANIA, M.K. ČIURLIONIS NATIONAL MUSEUM OF ART

LÉOPOLD SURVAGE

289· **COLOURED RHYTHM**, 1913

287· **COLOURED RHYTHM**, 1913

PARIS, MUSÉE NATIONAL D'ART MODERNE/CENTRE DE CRÉATION INDUSTRIELLE, CENTRE GEORGES POMPIDOU

LÉOPOLD SURVAGE

286· **COLOURED RHYTHM**, 1912

288· **COLOURED RHYTHM**, 1913

PARIS, MUSÉE NATIONAL D'ART MODERNE/CENTRE DE CRÉATION INDUSTRIELLE, CENTRE GEORGES POMPIDOU

85· ROBERT DELAUNAY, **CIRCULAR FORMS: SUN AND MOON**, 1912/1931
KUNSTHAUS ZÜRICH

89· OTTO DIX, **PREGNANT WOMAN**, 1919
STUTTGART, GALERIE VALENTIEN

163• FRANTIŠEK KUPKA, **STUDY FOR "DISKS OF NEWTON"**, 1911-1912
COLOGNE, GALERIE GMURZYNSKA

164• FRANTIŠEK KUPKA, **ANIMATED LINES**, 1911-1920
COLOGNE, GALERIE GMURZYNSKA

165• FRANTIŠEK KUPKA
STUDY FOR "COSMIC SPRING I", 1911-1920
COLOGNE, GALERIE GMURZYNSKA

271• GINO SEVERINI, **EXPANDING FORMS**, ABOUT 1914
PRIVATE COLLECTION

166• FRANTIŠEK KUPKA, **COSMIC SPRING II**, 1911-1923
PRAGUE, NÁRODNÍ GALERIE

174· STANTON MACDONALD-WRIGHT, **CONCEPTION SYNCHROMY,** 1915
NEW YORK, WHITNEY MUSEUM OF AMERICAN ART

259· MORGAN RUSSELL, **SYNCHROMY NO. 6,** ABOUT 1922-1923
NEW YORK, WHITNEY MUSEUM OF AMERICAN ART

131· MARSDEN HARTLEY, **PAINTING NUMBER ONE, 1913**
LINCOLN, SHELDON MEMORIAL ART GALLERY AND SCULPTURE GARDEN, UNIVERSITY OF NEBRASKA

292• BRUNO TAUT (DESIGNER), BLANCHE MAHLBERG (INVENTOR), **DANDANAH, THE FAIRY PALACE**, 1919
PRIVATE COLLECTION, ON PERMANENT LOAN TO THE CANADIAN CENTRE FOR ARCHITECTURE, MONTREAL

149· PAUL KLEE, **COSMOS-SUFFUSED LANDSCAPE**, 1917
ULM, GERMANY, ULMER MUSEUM

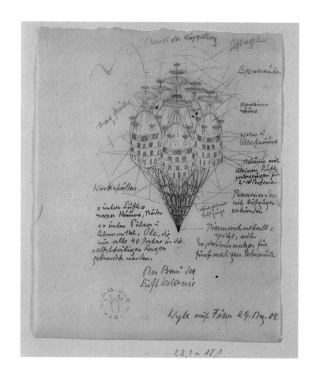

WENZEL HABLIK

120· THE CONSTRUCTION OF THE AIR COLONY, 1908 126· CATHEDRAL IN THE OPEN SEA, 1922

119· FLYING BUILDING, LARGE FLYING SETTLEMENT, 1907-1914

ITZEHOE, GERMANY, WENZEL-HABLIK-MUSEUM

WENZEL HABLIK

123· **SELF-SUPPORTING, SELF-BRACING DOMED BUILDING**, 1920

121· **UNTITLED**, PLATE 2 FROM THE SERIES **"SCHAFFENDE KRÄFTE"**, 1909

ITZEHOE, GERMANY, WENZEL-HABLIK-MUSEUM

WENZEL HABLIK

124· **SKETCH FOR A DOMED BUILDING**, 1920

125· **SKETCH FOR A SPHERICAL BUILDING**, 1920

ITZEHOE, GERMANY, WENZEL-HABLIK-MUSEUM

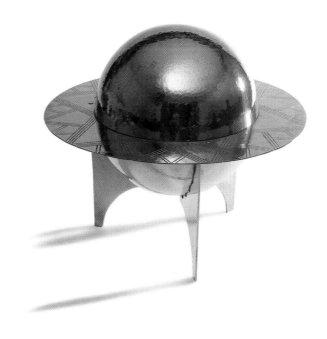

127• WENZEL HABLIK, **SATURN BOX**, 1922
ITZEHOE, GERMANY, WENZEL-HABLIK-MUSEUM

141• VASSILY KANDINSKY, **CIRCLES WITHIN A CIRCLE**, 1923
PHILADELPHIA MUSEUM OF ART

142· VASSILY KANDINSKY, **SEVERAL CIRCLES**, 1926
NEW YORK, SOLOMON R. GUGGENHEIM MUSEUM

40• ALEXANDER CALDER, **UNTITLED (THE CONSTELLATION MOBILE)**, 1941
WASHINGTON, NATIONAL GALLERY OF ART

42· ALEXANDER CALDER, **CONSTELLATION**, 1943
NEW YORK, SOLOMON R. GUGGENHEIM MUSEUM

41· ALEXANDER CALDER, **BLACK SPOT ON GIMBALS**, 1942
COURTESY OF CALDER FOUNDATION, NEW YORK

36• ALEXANDER CALDER, **UP, OVER THE HORIZON**, 1931
WASHINGTON, HIRSHHORN MUSEUM AND SCULPTURE GARDEN, SMITHSONIAN INSTITUTION

38• ALEXANDER CALDER, **SPACE TUNNEL**, 1932
COURTESY OF CALDER FOUNDATION, NEW YORK

39· ALEXANDER CALDER, **THE PLANET**, 1933
COURTESY OF CALDER FOUNDATION, NEW YORK

37· ALEXANDER CALDER, **MOVEMENT IN SPACE**, 1932
WASHINGTON, NATIONAL GALLERY OF ART

189· ANDRÉ MASSON, **THE CONSTELLATIONS**, 1925
PARIS, PRIVATE COLLECTION

198· JOAN MIRÓ, **SUNRISE**, 1940 (VARENGEVILLE, JANUARY 21)
FROM THE **"CONSTELLATION"** SERIES
THE TOLEDO MUSEUM OF ART

253

200• JOAN MIRÓ, **THE PASSAGE OF THE DIVINE BIRD**, 1941 (MONTROIG, SEPTEMBER 12)
FROM THE **"CONSTELLATION"** SERIES
THE TOLEDO MUSEUM OF ART

241• PABLO PICASSO, **TWO PAGES FROM A SKETCHBOOK**, 1924 (JUAN-LES-PINS, SUMMER)
PARIS, MUSÉE PICASSO

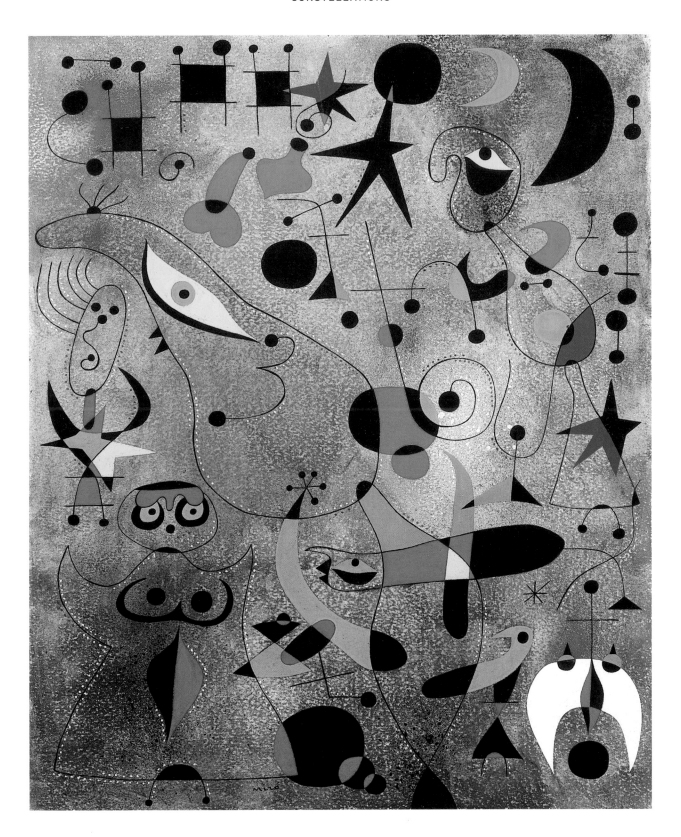

199• JOAN MIRÓ, **AWAKENING IN THE EARLY MORNING**, 1941 (PALMA DE MALLORCA, JANUARY 27)
FROM THE **"CONSTELLATION"** SERIES
FORT WORTH, TEXAS, KIMBELL ART MUSEUM

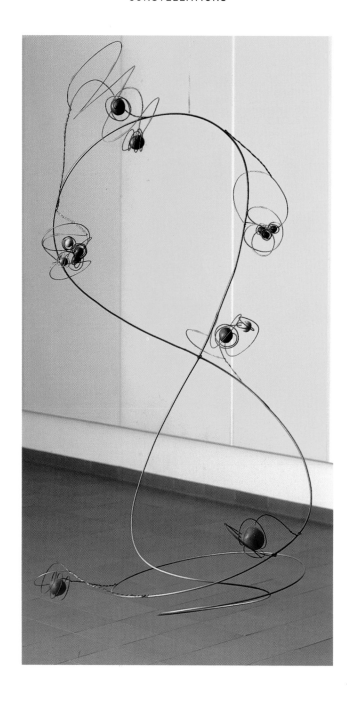

311· GEORGES VANTONGERLOO, **MASSES IN THE UNIVERSE**, 1946
ANGELA THOMAS SCHMID COLLECTION

3• HANS (JEAN) ARP, **CONSTELLATION OF WHITE FORMS ON GREY**, 1929
DUISBURG, GERMANY, WILHELM LEHMBRUCK MUSEUM

197• JOAN MIRÓ, **BLUE**,
1925 (MONTROIG, JULY-SEPTEMBER)
PARIS, GALERIE MAEGHT

4• HANS (JEAN) ARP, **STAR**, 1956
BUFFALO, ALBRIGHT-KNOX ART GALLERY

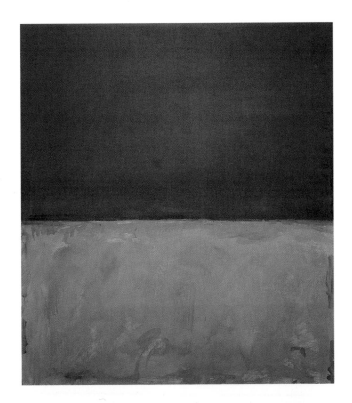

254· MARK ROTHKO, **UNTITLED (BLACK AND GREY)**, 1969
WASHINGTON, NATIONAL GALLERY OF ART

228· BARNETT NEWMAN, **YELLOW EDGE**, ABOUT 1968
OTTAWA, NATIONAL GALLERY OF CANADA

190• ANDRÉ MASSON, **CELESTIAL SIGNS**, 1938
PARIS, PRIVATE COLLECTION

326• AFTER A PROJECT BY FRANK LLOYD WRIGHT, **HYPOTHETICAL STUDY MODEL OF**
"GORDON STRONG AUTOMOBILE OBJECTIVE", SUGARLOAF MOUNTAIN, MARYLAND, 1995 (PROJECT, 1925)
MONTREAL, CANADIAN CENTRE FOR ARCHITECTURE

122• WENZEL HABLIK, **FIRMAMENT**, 1913
ITZEHOE, GERMANY, WENZEL-HABLIK-MUSEUM

247• GERMAINE RICHIER, **THE TENDRIL**, 1956
GERMAINE RICHIER FAMILY COLLECTION

98· MAX ERNST, **FOREST AND SUN**, 1926
ROME, GALLERIA NAZIONALE D'ARTE MODERNA

176· RENÉ MAGRITTE, **THE BURNING LANDSCAPE**, 1928
ROME, GALLERIA NAZIONALE D'ARTE MODERNA

101· MAX ERNST, **ETERNITY**, ABOUT 1973
MILAN, PIERPAOLO CIMATTI COLLECTION

76· JOSEPH CORNELL, **UNTITLED**
(HÔTEL DE L'ÉTOILE), 1951
RICHMOND, VIRGINIA MUSEUM OF FINE ARTS

75· JOSEPH CORNELL, **SOAP BUBBLE SET**, 1940, REMODELLED 1953
THE ART INSTITUTE OF CHICAGO

100· MAX ERNST, **SEVERAL ANIMALS,**
ONE OF THEM UNCULTURED, 1973
CAPRICORN TRUST,
COURTESY OF CAVALIERO FINE ARTS, NEW YORK

102· MAX ERNST
CONFIGURATION, 1974
CAPRICORN TRUST,
COURTESY OF CAVALIERO FINE ARTS, NEW YORK

99· MAX ERNST, **THE BEWILDERED PLANET**, 1942
TEL AVIV MUSEUM OF ART

GIORGIO DE CHIRICO

83· **SUN ON THE EASEL**, 1972

81· **OFFERING TO THE SUN. SUN AND MOON**, 1968

ROME, FONDAZIONE GIORGIO E ISA DE CHIRICO

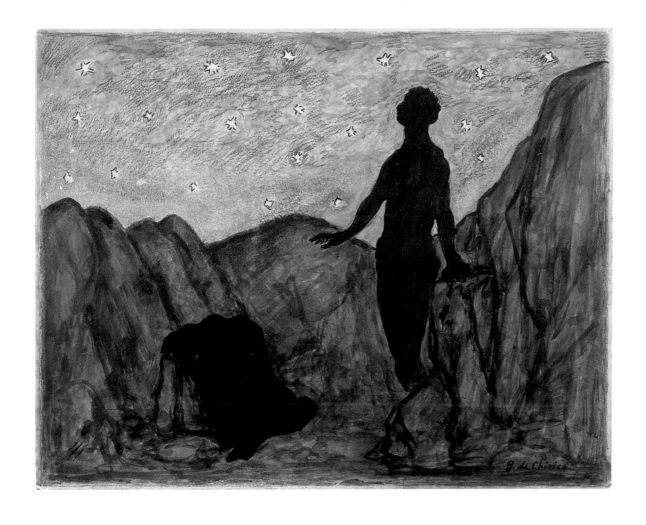

82· GIORGIO DE CHIRICO, **ECSTASY**, ABOUT 1968
SAN POLO DI REGGIO NELL'EMILIA, ITALY, PRIVATE COLLECTION

THE DECORATIVE ARTS

97· REBECCA EMES AND EDWARD BARNARD I, **TANKARD WITH THE COMET OF 1811**, 1811-1812
WILLIAMSTOWN, MASSACHUSETTS, STERLING AND FRANCINE CLARK ART INSTITUTE

116· GORHAM MANUFACTURING COMPANY, PROVIDENCE, RHODE ISLAND
"ICEBERG" BOWL WITH SPOON, ABOUT 1871
DALLAS MUSEUM OF ART

279• NIKOLAI SUETIN, **CUP AND SAUCER
WITH SUPREMATIST DESIGN**, 1923
NEW YORK, LEONARD HUTTON GALLERIES

278• NIKOLAI SUETIN, **CUP AND SAUCER
WITH SUPREMATIST DESIGN**, 1923
NEW YORK, LEONARD HUTTON GALLERIES

180• KAZIMIR MALEVICH (MODEL)
ILIA CHASHNIK (DECORATION)
HALF CUP, 1923
NEW YORK, COOPER-HEWITT, NATIONAL DESIGN
MUSEUM, SMITHSONIAN INSTITUTION

297• ILIA CHASHNIK, **PLATE**, 1922-1923
NEW YORK, LEONARD HUTTON GALLERIES

275• NAUM SLUTZKY, **PENDANT**, ABOUT 1927
MUSEUM FÜR KUNST UND GEWERBE HAMBURG

274• NAUM SLUTZKY, **PENDANT**, ABOUT 1927
MUSEUM FÜR KUNST UND GEWERBE HAMBURG

263• ELIEL SAARINEN, **COFFEE URN AND TRAY**, DESIGNED ABOUT 1933-1934
BLOOMFIELD HILLS, MICHIGAN, CRANBROOK ART MUSEUM

266· ELSA SCHIAPARELLI, **CAPE FROM THE "COSMIQUE" COLLECTION**, 1938-1939
MUSÉE DE LA MODE DE LA VILLE DE PARIS, MUSÉE GALLIERA

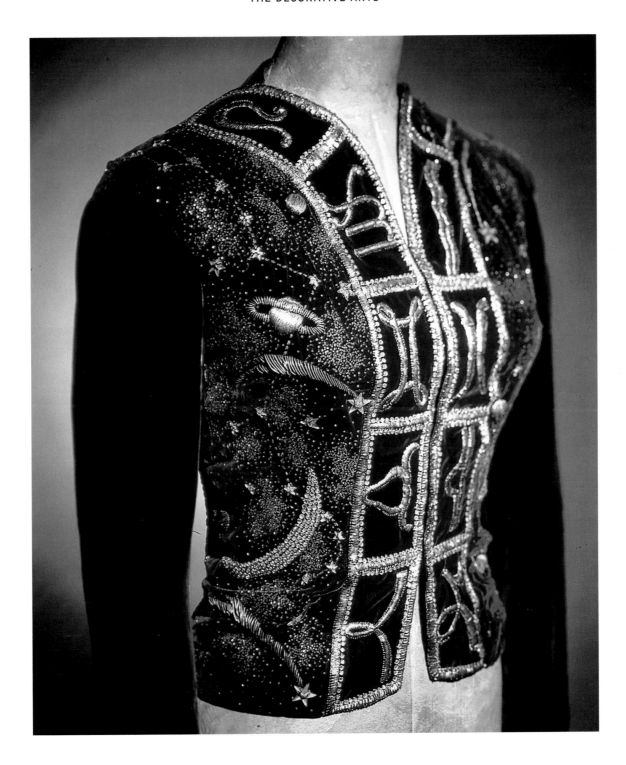

267• ELSA SCHIAPARELLI, **DINNER JACKET FROM THE "COSMIQUE" COLLECTION**, 1938-1939
BROOKLYN MUSEUM OF ART

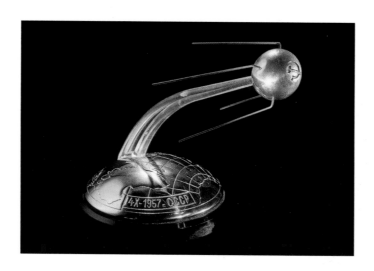

114• GLADDING Mc BEAN & COMPANY, GLENDALE AND LOS ANGELES, CALIFORNIA
"STARRY NIGHT" PLATE, CUP AND SAUCER, 1952
DALLAS MUSEUM OF ART

335• SOVIET UNION, **SPUTNIK MODEL MUSIC BOX**, 1957
WASHINGTON, NATIONAL AIR AND SPACE MUSEUM, SMITHSONIAN INSTITUTION

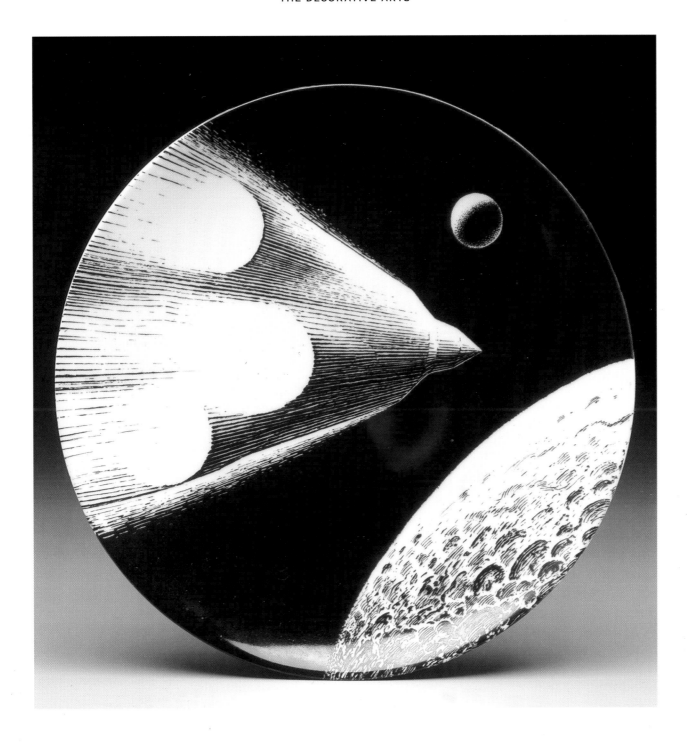

108· PIERO FORNASETTI, **THE RETURN**, PLATE FROM THE SERIES **"MAN IN SPACE"**, 1966
DALLAS MUSEUM OF ART

312• VICTOR COMPANY OF JAPAN (YOKOHAMA)
"JVC VIDEOSPHERE" TELEVISION SET, DESIGNED 1972
DALLAS MUSEUM OF ART

118• GZHEL PORCELAIN FACTORY
SOVIET UNION
COSMONAUTS AND ROCKET, 1960s
NEW YORK, COOPER-HEWITT
NATIONAL DESIGN MUSEUM
SMITHSONIAN INSTITUTION

1• EERO AARNIO, **"GLOBE" OR "SPHERE" CHAIR**,
DESIGNED 1963-1965
MONTREAL MUSEUM OF DECORATIVE ARTS/
THE MONTREAL MUSEUM OF FINE ARTS

88• MICHELE DE LUCCHI, **"FIRST" CHAIR**, 1983
DALLAS MUSEUM OF ART

18• HARRY BERTOIA, **COFFEE SERVICE**, 1937-1943
MONTREAL MUSEUM OF DECORATIVE ARTS/THE MONTREAL MUSEUM OF FINE ARTS

- 6 -
TO INFINITY
AND BACK

Contemporary art, its head in the stars, has initiated a new stage in the dialogue between art and science. Recent works of art inspired by the cosmos fall into three groups, three constellations, so to speak, that

Contemporary Cosmologies

by Didier Ottinger

call to mind three periods in art's association with astronomy – the Renaissance, the age of Romanticism and modern times – and their three corresponding tutelary figures: Leonardo da Vinci, Caspar David Friedrich and Marcel Duchamp.

Works in the first group create nostalgia for a time when the artist was not yet distinct from the scholar. Works in the second evoke the time of the schism between intuition and objective knowledge. Those in the last demonstrate the irony generated by a scientism reduced to "technologism", to the cult of the machine. The history of the relation between art and science is also the history of the conflict between empirical and abstract knowledge, between eye and mind. And contemporary art is reviving this debate.

• Harmonious Spheres

At the dawn of the modern age, there was harmony. The Italian Quattrocento bequeathed us the archetype of the scholar-artist. No one better embodies this ideal than Leonardo da Vinci, an ideal of knowledge capable of reconciling mastery of the beauties of art with expertise in anatomy and hydraulics. Humanistic culture alone could tie together the separate threads of art and science, insisting as it did on the harmony of all created things, the correspondence of the large and the small, the secret affinities between heaven and earth. Pythagoras, the first to give the name "cosmos" to the universe around us, was the source of this singular idea, which poets would one day claim as their heritage. He invented the notion of the "music of the spheres",[2] irrefutable proof of a harmony between musical intervals and the positions of the celestial bodies, with the planets in their orbits like notes on the staff. Leonardo provided a "modern" definition of this harmony: "Man has been called by the ancients a lesser world and the term is well applied. Seeing that if a man is composed of earth, water, air, and fire, this body of earth is similar. While man has within himself bones as a stay and

framework for the flesh, the world has stones which are the supports of earth. While man has within him a pool of blood wherein the lungs as he breathes expand and contract, so the body of the earth has its ocean, which also rises and falls every six hours with the breathing of the world."[3] This correspondence of microcosm and macrocosm was the cornerstone of "science" as it was conceived of at the dawn of the modern age.

During its scientific revolution, astronomy was still dependent on a system of thought according to which the world was penetrated through and through by correspondences and analogies. When Nicolaus Copernicus formulated his new theories on the order of the universe, he used humanistic metaphors: the experience of the astronomers of antiquity "was just like someone taking from various places hands, feet, a head and other pieces, very well depicted, it may be, but not for the representation of a single person; since these fragments would not belong to one another at all, a monster rather than a man would be put together from them".[4] Copernicus was expressing a concept of aesthetics based on mathematical regularity, an idea common to both scholars and artists of the Renaissance. This is reflected in his cosmology, which manifests an "admirable accord" consisting of regular motions, circular orbits and harmonious proportions. Copernicus shared with the Neoplatonists an attachment to the ontological prestige of the "perfect" shapes of the circle and the sphere. Like Leonardo, who described the growth of tree branches as an expansion in concentric circles, Copernicus believed that the planets moved in perfectly circular orbits around the sun. Like Marsilio Ficino, who imagined that "the earth gives birth, thanks to varieties of seeds, to a multitude of trees and animals",[5] Copernicus thought that it "has intercourse with the sun, and is impregnated for its yearly parturition".[6]

Tycho Brahe, one of the greatest astronomical observers of all time, discovered a nova in 1572 and watched it fade, and studied a number of comets.[7] On the strength of these observations, he became the first to question the immutability of the heavens beyond the sphere of the moon, thereby undermining one of the cardinal dogmas of Aristotelian astronomy. Tycho Brahe firmly believed in the existence of occult links uniting the cosmos. The most telling evidence of this belief was the alchemist's laboratory he set up in the cellars of the observatory he built in Uraniborg in 1576.

The founder of modern astronomy, Johannes Kepler, has been described by the epistemologist Koyré as a "Janus bifrons" because of the mixture of archaism and modernity characterizing the theses of this German scholar. Kepler's first work of cosmology was entitled *Mysterium cosmographicum* (The Secret of the

Universe). In his Preface, which sets forth the method and objectives of the work, he stated, "It is my intention, reader, to show in this little book that the most great and good Creator, in the creation of this moving universe and the arrangement of the heavens, looked to those five regular solids, which have been so celebrated from the time of Pythagoras and Plato down to our own, and that he fitted to the nature of those solids, the number of the heavens, their proportions, and the law of their motions."[8]

Plutarch attributed to the Pythagoreans the invention of the five regular solids Kepler refers to. The Platonists associated an element with each regular polyhedron.[9] The system of the "five bodies" and their symbolic nesting of one within another link Kepler's episteme to that of the ancient astrologers and alchemists. In 1599, when Tycho Brahe transmitted his precious notes on the motions of the heavenly bodies to Kepler, Kepler immediately attempted to make them conform to the laws of harmony of a God who worked according to Pythagorean principles. Kepler also tried to modernize the ancient principles of the music of the spheres. For the apparent diurnal movement of each planet, he indicated a corresponding musical interval. "We see that in this domain men have only aped God the Creator, and in a manner performed the music played by the order of the celestial motions."[10] Reinterpreting Ptolemy's *Harmonica*, Kepler attempted to rediscover the laws describing the continuity and homogeneity in the fabric of the world. In his *Epitome*, he established a relation between the density of the planets and familiar terrestrial materials.[11]

Like other astronomers of his day who held an official position, Kepler performed the duties of an astrologer. His innovation was to exercise these duties in a scientific way. "To this art of the charlatan, he opposed science resulting from a mathematical understanding of harmonies and the effect of celestial configurations on earthly faculties and human souls, in their immediate actions as in their later development."[12]

Kepler's astronomy evokes a world imbued with magic and as yet untouched by scientific rationalism. The artist Tony Cragg makes reference to this world of temporal and genetic continuity, this universe of analogies, when he grafts the feet of cows, lizards and dinosaurs onto modern telescopes and theodolites (*Terra novalis*, 1992). Cragg claims that science is not purely rational; it is also organic, animal, sensual and irrational.[13]

In his large portfolios, Anselm Kiefer recalls Kepler's magical, symbolic world when he evokes Robert Fludd (1574-1673), that Don Quixote of the hermeneutic-cabalistic tradition astray in an age of budding rationalism.

For Claudio Parmiggiani, the cosmos of Fludd and Ficino is the world of the artist. *Theatrum orbis* (1975) transposes to the letter Fludd's indications in his

Ars memoriae (1619). *La casa del poeta (II)* (1982) has the poet moving out of an open book into a starry night. Elsewhere, in *Particolare della tavola*, the music of the spheres of the Pythagoreans and Kepler, that immemorial dream of a harmonious universe, is indicated by a sheet of music in which the infinity of stars against the darkness of the page has taken the place of the notes on a musical score. Parmiggiani states that he sees "no gap between alchemy and art". "Everything – object, stone, tree, stars – has eyes and a human voice," he explains.[14]

Vladimir Skoda's artistic journey resembles the motion of the pendulums he has created in tribute to the physicist Léon Foucault. From his native Prague, he went to Paris, where he began art studies. His movement from East to West was a voyage towards a modernity merged with positivity. The works Skoda exhibited in the mid-1970s (*Volume = 3.14 cm³*, *Geometric Progression*, 1976-1977) showed that he had thoroughly assimilated the lessons of international formalism. Only at the end of that decade did he achieve – paradoxically – a modernism in which "less is more". His first works in wrought iron prefigured the spheres that would become the emblematic motif of his work (see cat. 273). The sphere, while a minimalist form, is also the form the occult tradition held to be the richest in meaning. Working in wrought iron also inspired Skoda to ponder the alchemy practised in former times. His spheres, enriched by the symbolism of their form and method of creation, brought him back to Prague. In 1995, he organized a retrospective of his work around an installation in tribute to Kepler, once the city's official astronomer. In the drawings and engravings he exhibited, starlike dots were connected with one other, allowing constellations to emerge at random – figures like the Cygnus, Libra and Capricorn that for Kepler symbolized the harmony of the universe.

Artists cultivate the memory of an enchanted world of similarities and signs to be deciphered. Their effort perpetuates that of Michel Foucault's Don Quixote. The Spanish knight, "hero of the Same", wanders through a time in which "resemblances and signs have dissolved their former alliance".[15] Like Quixote, these artists assume poetry's modern-day mission: to listen to "that 'other language', the language, without words or discourse, of resemblances", to bring "similitude to the signs that speak it".[16]

• The Sublime Today
Newton's discovery that the planets were subject to the laws of universal gravitation marked the end of a world. "Whatever is not deduced from the phenomena is to be called an hypothesis, and hypotheses, whether metaphysical or physical, whether of occult qualities or mechanical, have no place in experimental philosophy,"

he professed.[17] Farewell to the music of the spheres and the concept of the earth's "parturition".

In poets' eyes, Newton became the very incarnation of classical science; Goethe's and Blake's aversion to him is a reflection of this. Blake's 1795 portrayal of the physicist (*Newton*, monotype, London, Tate Gallery) is telling: Newton, seated beneath the waters of materialism, armed with his compasses, is striving to reduce the world to its finite appearances.[18] The treatise on colour Goethe published in 1810 was also anti-Newtonian in inspiration. For an analysis of light as broken down by the prism of reason, Goethe substituted a Symbolist theory of colour based on "philosophical" associations and endowed colours with powers that partook of both the physical and the psychic. The issue in these polemic works was poets' and artists' refusal to adhere to an idea of the world fragmented by the advance of rationalism. "Nothing occurs in living nature that is not in relation with the whole," Goethe asserted.[19]

Romanticism was the banner eventually adopted by this insurrection. Long after the advent of Kepler's ellipses and Newton's conic sections, the perfect spheres of the Neoplatonists were revived in the paintings of Runge. Turner preferred to parry Newton's compasses with the vague and elusive as his weapons. His paintings essentially dissolve the perspectivist cube.[20] Space became literally limitless. A similar temptation to escape from a world drawn with compasses and T-square was demonstrated in the hundreds of studies of the sky Constable painted in 1821 and 1822.[21]

The Romantic *Kunstchaos* of Turner's (cat. 309) and Friedrich's (cats. 109-110) works brought into question the integrity of the subject as the Enlightenment conceived of it. Instead of quantifiable knowledge, it proposed a different kind: an ecstatic understanding. "Sublime" was the term forged by the aesthetic of the era to describe these new "unframable" pictorial motifs, as well as a new relation to works in which the upheaval of panic and terror replaced the comfort of a world clearly defined by reason. And sublime is indeed the proper term for Romantic painting, in its obsession with grandiose, terrifying spectacles: nature in the grip of raging storms, unscalable mountains, fathomless seas and infinite skies.

In 1764, Immanuel Kant made an enumeration of sublime subjects. "Night is sublime,"[22] "a long duration is sublime."[23] Later, in his *Critique of Judgment*, he added another characteristic to these sublime motifs: "Hence nature is sublime in those of its appearances whose intuition carries with it the idea of their infinity."[24] A nocturnal subject that was truly infinite and suggested "long duration" would be triply sublime – a starry sky, for example. And by this token, the cosmos would be ultrasublime for modern observers, who, since Einstein, have known that looking at space is also travelling in time. Thus, the "constellations"

of Thomas Ruff (cat. 257), Vija Celmins (cats. 50-57), Imi Knobel and Paterson Ewen (cat. 103) are unarguably sublime.

Such visions of the cosmos can be thought of as providing a "functional" sublime for contemporary art. According to Kant, the sublime is accessible only if "the mind is induced to abandon sensibility and occupy itself with ideas containing a higher purposiveness".[25] In modern times, the cosmic sublime would come to meet the expectations of a conceptual art concerned with ideas alone.

Modern-day images of the sublime can also be thought of as a late twentieth-century revival of an anti-scientific tendency that developed during the Romantic era. The artists in question are good enough art historians to be aware of the wealth of meaning associated with the subjects they choose. What Kant had to say about contemplation of the starry sky can be interpreted in present-day terms: "When we call the sight of the starry sky *sublime*, we must not base our judgment upon any concepts of worlds that are inhabited by rational beings, and then conceive of the bright dots that we see occupying the space above us as being these worlds' suns, moved in orbits prescribed for them with great purposiveness; but we may base our judgment regarding it merely on how we see it, as a vast vault encompassing everything."[26] In the end, the sublime cannot be reduced to the geometer's compasses.

The work of Yves Klein, whose ultimate ambition was to write his name in the sky above Nice, fully belongs in the category of the modern sublime (cats. 152-153). Klein's pronouncements revive an attempt at cosmic fusion that goes back to the age of Romanticism: in a lecture at the Sorbonne, he stated, "'Where technique fails, science begins,' said Herschel, and I think I can reasonably say this evening that when man conquers space, it will not be with rockets, sputniks or spaceships, for in that case, we will remain tourists in space. Instead it will be by inhabiting it with sensitivity, that is, not merely by being in it but by imbuing ourselves with it through our solidarity with life itself, as represented by that space where the tranquil and formidable force of pure imagination reigns."[27] The harmony Klein aspired to was to become accessible to man in the "architecture of the air" he planned to create with architect Werner Ruhnau, which would make it possible "to live naked in immense regions that we will have regulated and transformed into a veritable paradise on earth".[28] In 1960, this exalted plan was given form in a series of cosmogonic works, initially entitled "Naturemetries". Coming after his "Anthropometries", they transposed cosmic fusion to meteors and the plant kingdom. Like the works of the Romantics, Klein's entire opus seems to be directed against Newton without explicitly naming him. Klein's obsession with flight, his leaps

into the void were all gestures of rebellion against the law of gravity. Further along in the lecture quoted above, he declared prophetically, "We will become airborne men, we will experience a force of attraction upward, towards space, which is both nowhere and everywhere; and once the force of gravity has been mastered, we will literally levitate in total physical and spiritual freedom."[29]

Artists of the modern sublime often use scientific materials. Thomas Ruff's technical mastery of photography should make him well able to take a perfect picture of the starry sky. The appropriation by Knobel, Ewen, Ruff and, even more cunningly, Malin (cats. 181-186)[30] of scientific photographs has nothing to do with laziness. Instead, it belongs to the history of the ready-made in modern art. But this is the ready-made understood in a completely different way from how it usually is: not the iconoclastic gesture, but a means of revealing the effect of moving an object from an environment based on use and consumption to one characterized by duration and Kantian "disinterest". Such a revelation occurs, for example, when an object transferred to a museum raises issues and evokes symbolic values. By displacing images from the observatory to the museum, the artists of the modern sublime identify the cosmos as a place that cannot be reduced to a useful function or a rational definition. In contrast to technical or political utilitarianism, there is space, as beautiful and useless as a work of art.

The use of these cosmic images implies another parallel with Romantic art. Photography of the starry reaches of space inevitably brings to mind paintings of clouds. Both generate a hiatus. Painting an immaterial, protean subject is as paradoxical as framing infinite space. Historians of Romanticism have compared this type of contradictory image with a figure of speech: the oxymoron. In his paintings, Caspar David Friedrich provided many examples of such a visual oxymoron, playing on the confrontation between limited and limitless, finite and infinite, precise and imprecise. Photography of the cosmos, a subject triply sublime and thus "unframable", is the modern avatar of such images.

Thomas Ruff, who vacillated for a time between astronomy and art as a career, uses photographs from the archives of the European Southern Observatory that, through his special knowledge of them, evoke more esoteric connections. The photographic image is the direct descendant of the camera obscura. As early as the sixteenth century, treatises on painting recommended the use of the camera obscura, which can be considered both a paradigm for the perspectivist view and a model of the retinal image.[31] The fact that the camera obscura was also a scientific tool is less well known.

Kepler, who learned its use from his teacher Mästlin, employed it extensively[32] to observe eclipses of the sun and moon,[33] and devoted the second chapter of his *Paralipomena* to it.

A new chapter was added to the history of the relationship linking the camera obscura, photography and astronomy when observers of the sky began making systematic use of photography to reveal the light of distant stars that were invisible to the naked eye. Historically, photography and observation of the universe are "genetically" linked.

Thomas Ruff's exhibitions of photographs of the cosmos remind us of the scientific origin of this type of photography. By transforming these images into "sublime" works, he distances his work from the initial scientific character of the medium. In establishing this distance, Ruff asserts that he has definitively chosen which camp he belongs to: art, not science.

• **The Milky Way Stripped Bare by Her Bachelors**
A final group of artists see the conquest of space as the ultimate manifestation of enthusiasm for technology. For them, space seems merely a new field for political struggle, the last refuge of science viewed as an epic. They feel it their responsibility to slide the banana peel of scepticism and irony under the feet of the dreamers and manipulators who, for the benefit of the eternally imbecilic, point a finger towards the waxing or waning moon.

In a series of sarcastic engravings, Daumier took delight in juxtaposing the popular imagination – sensible or farcical – with a scientifically programmed event: the passage of the great comet of 1857. In one plate, a pickpocket pointing to the sky with one hand advises a passer-by hoping to observe the celestial event, "Keep your eye on my finger," meanwhile relieving him of his purse with his other hand. Another plate presents "the German Astronomer" (doubtless the source of the announcement of the passage of the comet), clad like Merlin the magician. From a wooden cage, he releases a star with little feet, described by Daumier as a "fameux canard".

Today's Daumiers are named Kabakov, Fontcuberta, Colson, Haidar and Garnier. In 1988, Ilya Kabakov exhibited *The Man Who Flew into Space from His Apartment* in New York (cat. 140). A year before the collapse of the communist system, this installation ironically subverted the communist utopia. In a miserable room, its walls papered with slogans vaunting the glories of the Party, its leaders and its technological prowess, some poor fellow has turned the Soviet ethos into reality: cobbling together a makeshift catapult, he breaks through the ceiling of his hovel and disappears into space. Here, Kabakov struck at the very heart of the Soviet utopia. The historic slogan of the Communist Revolution might as well have been the promise of Soviets and Space, so indissociable from the political project did the cosmic vision

seem.[34] Few "revolutionary" artists escaped the attraction of space: Malevich, Tatlin, Rodchenko, Chashnick and later Goncharova all succumbed to it. It is possible that the cosmic imagination bears sole responsibility for the fall of the Soviet empire, which was incapable of the clearsightedness required to avoid getting entangled in the artificially initiated "Star Wars".

Artists constantly use irony to reduce the vastness of the cosmic utopia to an intimate scale. In 1998, Joan Fontcuberta showed a series of superb constellations that closer study reveals to be photographs of his car windshield spotted with crushed insects.[35] In 1994, Greg Colson, faithful to Copernicus's heliocentrism and perfect orbits, created *Solar Systems* in which he placed in orbit balls of different sizes, proportional to the planets they represented. Haidar published in *Vogue* and *Cosmopolitan* a series of so-called photographs of the universe, which he created in his studio by setting alcohol-soaked cotton on fire. Jacques L. Garnier photographed his garbage can, making it look like images transmitted from Mars by Pathfinder or sent back to earth by space probes. Is this cynicism or wisdom? In its way, this hijacking of spatial supertechnology goes back to a long tradition of contemplating the relation between microcosm and macrocosm.

By creating antidotes to the enthusiasm for science, these heirs of Picabia and Duchamp remind us that the scholars, the Dr. Nimbuses of this century, are too often replaced by Dr. Strangelove.

• Eye and Hand

Vija Celmins, Paterson Ewen and Jacques Monory paint and draw as faithfully as possible from scientific photographs of the cosmos. Are they compensating for being dispossessed?

The history of astronomy has traditionally been intertwined with the history of painter-opticians. The new respect for the eye affirmed by Leonardo da Vinci and the Italian painters of the Quattrocento rapidly brought about a revolution in which traditional established truths were suddenly superseded by knowledge based on observation. There is a good reason that the first generation of celestial observers and perspectivist painters coincided. And it is not simply by chance that Galileo is the father of astronomy and modern science. Carl Havelange has wondered whether the Florentine astronomer was not in the direct lineage of the Italian Renaissance scholar-artists who, starting with Brunelleschi and Alberti, revived the status of representation and gave it a completely new rational basis.[36] In 1589, Galileo applied for a position as professor of Euclidian geometry and perspective at the Accademia del disegno in Florence. And almost alone, he believed in the existence of the moons of Jupiter he observed with his telescope. In his optical certitude lies the origin of a new cosmology.

The use of the telescope for astronomical observation, while it marked the triumph of a rational vision, also signalled the decline of the gaze. One could even say that with Galileo's invention, not only astronomy but science as a whole entered a new phase of development, an "instrumental" phase, to use Koyré's term.[37] New instruments constantly came along to interpose themselves between the eye and the universe. In the early eighteenth century, telescopes with a primary and secondary mirror, which allowed for greater focal lengths, supplanted Galileo's model. Photography, with its almost unlimited exposure time, took the place of the astronomer looking through an eyepiece. Before World War II, André Lallemand invented the electronic camera, making it possible to record light at its theoretical limit. The CDD (Charge Coupled Device) camera, which replaced the electronic camera, not only records but amplifies the finest detail. All of these devices, however, are still based on visible light. As early as 1800, William Herschel recorded invisible solar radiation. The 1950s saw the development of radioastronomy, which analyzes radio emissions from space. Today, the Hubble telescope, in orbit around the earth, transmits complex data to astronomers that is decoded by computer. Such "progress" in the science of observation, while it brings the farthest reaches of the universe closer, also represents a perceptible distancing of man from the cosmos.

NASA understood the tactical necessity of humans' walking on the moon, having the lunar dust actually under their feet (a necessity that was totally symbolic, since a machine could have performed the task at much lower expense). Artists in their wisdom still believe that space must be made material in works that evoke the visible and the palpable. Vija Celmins piles up layers of coloured dust (pastel) to make images of the moon and distant galaxies *sensitive*. NASA, doubtless hoping to win favour with the taxpayers, recently commissioned Celmins to give a human, in other words artistic, form to the Hubble images.

Those who still believe in progress that involves only scientific advances should remember that the first man was sent into space in November 1960 at a happening organized at the Galerie Iris Clert by the experimental sculptor Takis. This event took place six months before the Soviet Union propelled Yuri Gagarin into orbit around the earth. Interviewed twenty years later, Takis declared, "It was a symbol of liberation from gravity through magnetic fields."

Can this be seen as Goethe's belated revenge on Newton, a triumph of poetic inspiration over scientific materialism?

• Notes

1. Leonardo da Vinci, *Treatise on Painting*, trans. A. Philip McMahon (Princeton: Princeton University Press, 1956), p. 11.

2. More precisely, the music of the heavenly bodies.

3. *The Notebooks of Leonardo da Vinci*, ed. Irma A. Richter (Oxford and New York: Oxford University Press, 1980), p. 45.

4. Nicolaus Copernicus, *On the Revolutions*, ed. J. Dobrzycki, trans. E. Rosen (Baltimore: Johns Hopkins Press, 1978), p. 4, quoted in Fernand Hallyn, *The Poetic Structure of the World: Copernicus and Kepler*, trans. Donald M. Leslie (New York: Zone Books, 1990), p. 73.

5. Marsilio Ficino, *Theologica platonica*, quoted in Hallyn 1990, p. 113.

6. Copernicus, *On the Revolutions*, p. 22, quoted in Hallyn 1990, p. 113.

7. This occurred thirty years before Galileo first trained his telescope on the stars.

8. Johannes Kepler, *Mysterium cosmographicum/The Secret of the Universe*, facsimile of the 2nd edition (Frankfurt 1621), with facing page translation by A. M. Duncan (New York: Arbaris Books, 1981), p. 63.

9. Earth and cube, fire and tetrahedron (pyramid), air and octahedron, water and icosahedron, ether and dodecahedron.

10. Johannes Kepler, *Harmonice mundi*, Chapter 5 (*Gesammelte Werke*, vol. 6 [Munich: Beck, 1938-], p. 320), quoted in G. Simon, *Kepler : astronome, astrologue* (Paris: Gallimard, 1979), p. 417.

11. Saturn and the hardest gems, Mars and iron, Venus and lead, and so forth. See Hallyn 1990, p. 242.

12. Simon 1979, p. 442.

13. Tony Cragg, interview with Heinz-Norbert Jocks, in *Tony Cragg*, exhib. cat. (Paris: Centre Georges Pompidou, 1995), p. 61.

14. Claudio Parmiggiani, *Stella Sangue Spirito* (Parma: Pratiche Editrice, 1995), pp. 120, 144.

15. Michel Foucault, *Les mots et les choses* (Paris: Gallimard), p. 61. Quoted in English from *The Order of Things: An Archaeology of the Human Sciences* (London: Tavistock Publications, 1970), p. 47.

16. *Ibid.*, p. 63 (translation, p. 50).

17. Sir Isaac Newton, *The Mathematical Principles of Natural Philosophy*, vol. 2, trans. Motte (London, 1803), p. 314, quoted in E. A. Burtt, *The Metaphysical Foundations of Modern Physical Science*, revised edition (Garden City, New York: Doubleday, 1954), p. 218.

18. Pierre Wat's diagnosis is that portraying Newton as the physical embodiment of error allowed Blake to assert, through an image, the superiority of spiritual intuition over rational analysis and proof. See Pierre Wat, *Naissance de l'art romantique* (Paris: Flammarion, 1998), p. 21.

19. Johann Wolfgang von Goethe, quoted *ibid.*, p. 25.

20. Hubert Damisch, *Théorie du nuage* (Paris: Seuil, 1972),

p. 266, note 2, quoted in Wat 1998, p. 132, note 144.

21. Damisch, in his *Théorie du nuage*, showed how closely the cloud motif was linked, in the pictorial imagination of the Western world, to resistance to the perspectivists' tendency towards excessive reliance on the skills of the surveyor.

22. Immanuel Kant, *Beobachtungen über das Gefühl des Schönen und Erhabenen* (Königsberg, 1764), quoted in English from *Observations on the Feeling of the Beautiful and Sublime* (Berkeley, Los Angeles and Oxford: University of California Press, 1960), p. 47.

23. *Ibid.*, p. 49.

24. Immanuel Kant, *Critik der Urteilskraft* (Berlin,1790), quoted in English from *Critique of Judgment*, trans. Werner S. Pluhar (Indianapolis: Hackett Publishing, 1987), p. 112.

25. *Ibid.*, p. 99.

26. *Ibid.*, p. 130.

27. Yves Klein, *Conférence de la Sorbonne, 3 juin 1959* (Galerie Montaigne, 1992), unpaginated.

28. Yves Klein, "Truth Becomes Reality", in *Zero* (Cambridge, Massachusetts: MIT Press, 1973), p. 93.

29. Klein 1959/1992.

30. David Malin, an Australian astronomer, currently exhibits his "colourized" photographs of space in SoHo galleries; see Margarett Loke, "The Universe Catches Up as Art", *The New York Times*, April 29, 1998, p. E-1.

31. In his writings on painting, Leonardo da Vinci explicitly indicated the similarity between painting and the image produced by the camera obscura: "An experiment, showing how objects transmit their images or pictures, intersecting within the eye in the crystalline humour. This is shown when the images of illuminated objects penetrate into a very dark chamber by some small round hole. Then you will receive these images on white paper placed within this dark room rather near to the hole; and you will see all the objects on the paper in their proper forms and colours, but much smaller; and they will be upside down by reason of that very intersection." *The Notebooks of Leonardo da Vinci*, p. 115. On the use of the camera obscura, see also Svetlana Alpers, *The Art of Describing: Dutch Art in the Seventeenth Century* (Chicago: University of Chicago Press, 1983), p. 31.

32. In Tübingen, Kepler set up a church loft as a camera obscura by removing a roof tile.

33. See Carl Havelange, *De l'œil et du monde. Une histoire du regard au seuil de la modernité* (Paris: Fayard, 1998), Chapter 9, "Ruptures : le télescope et la chambre obscure".

34. In 1958, a few months after the Soviets put the first artificial satellite in orbit, Kabakov painted a score of canvases entitled *Cosmic Composition*.

35. At the Zabriskie Gallery in New York.

36. Havelange 1998, p. 296.

37. Alexandre Koyré, *Du monde clos à l'univers infini* (Paris: Gallimard, 1973), p. 119.

153• YVES KLEIN, **COS 12**
UNTITLED COSMOGONY, 1961
PRIVATE COLLECTION

156• YVES KLEIN
PNEUMATIC ROCKET, 1962
PRIVATE COLLECTION

154• YVES KLEIN, **RP 1**, "MARS" PLANETARY RELIEF, 1961
PRIVATE COLLECTION

150• YVES KLEIN, **MG 10**
"SILENCE IS GOLDEN" MONOGOLD, 1960
PRIVATE COLLECTION

155• YVES KLEIN, **RP 12**
UNTITLED PLANETARY RELIEF, ABOUT 1961
PRIVATE COLLECTION

152· YVES KLEIN, **COS 11**, UNTITLED COSMOGONY, 1961
COLOGNE, GALERIE GMURZYNSKA

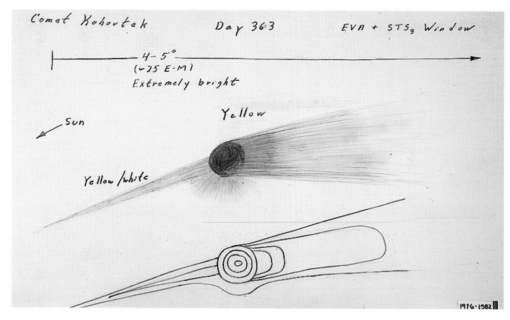

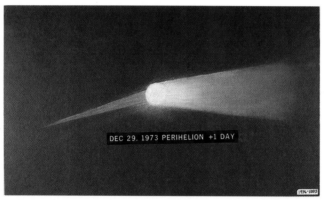

DEC 29. 1973 PERIHELION +1 DAY

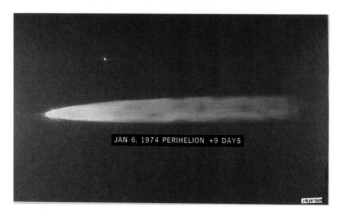

JAN 6. 1974 PERIHELION +9 DAYS

112· EDWARD G. GIBSON, **THREE DRAWINGS OF THE COMET KOHOUTEK**

DAY 363, 1973

DECEMBER 29, 1973, PERIHELION + 1 DAY, 1974

JANUARY 6, 1974, PERIHELION + 9 DAYS, 1974

WASHINGTON, NATIONAL AIR AND SPACE MUSEUM, SMITHSONIAN INSTITUTION

234 • CLAUDIO PARMIGGIANI, **THE ELEMENTS**, 1968
PRIVATE COLLECTION

196• DUANE MICHALS, **THE HUMAN CONDITION**, 1969
COURTESY OF SIDNEY JANIS GALLERY, NEW YORK

244• ROBERT RAUSCHENBERG, **SKY GARDEN**
FROM THE SERIES **"STONED MOON"**, 1969
COURTESY OF GEMINI G.E.L., LOS ANGELES

281• EDDIE SQUIRES, **"LUNAR ROCKET"** FABRIC, 1969
LONDON, WARNER FABRICS PLC

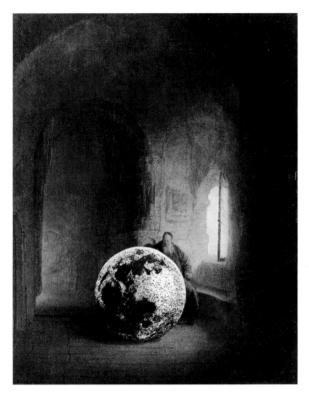

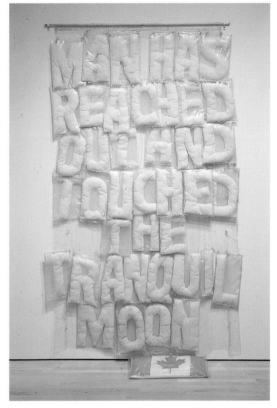

235· CLAUDIO PARMIGGIANI
SCHOLAR READING, 1969
PARIS, LILIANE AND MICHEL DURAND-DESSERT COLLECTION

323· JOYCE WIELAND, **MAN HAS REACHED OUT AND TOUCHED THE TRANQUIL MOON**, 1970
OTTAWA, NATIONAL GALLERY OF CANADA

103· PATERSON EWEN, **GALAXY NGC-253**, 1973
OTTAWA, NATIONAL GALLERY OF CANADA

256· ROTRAUT, **MOTHER EARTH AROUND THE WORLD**, 1993
PRIVATE COLLECTION

255· ROTRAUT, **BLACK HOLE**, 1974
PRIVATE COLLECTION

VIJA CELMINS, **COMA BERENICES**

51· **GALAXY #1**, 1973

53· **GALAXY #2**, 1974-1975

52· **GALAXY #4**, 1974

NEW YORK, PAINE WEBBER GROUP INC. COLLECTION

236• CLAUDIO PARMIGGIANI, **PHISIOGNOMONIAE COELESTIS, FOR ADALGISA**, 1975
PARIS, JEAN CHARLES DE CASTELBAJAC COLLECTION

135• SARA HOLT, **"WHY" (THE MOON FROM A ROCKING SAILBOAT, SAN MIGUEL ISLAND, CALIFORNIA)**, 1981
SARA HOLT COLLECTION

34· JAMES LEE BYARS, **PLANET SIGN**, 1981
COURTESY OF MICHAEL WERNER GALLERY, NEW YORK AND COLOGNE

238• CLAUDIO PARMIGGIANI, **UNTITLED (HAND WITH MOON, HAND WITH BUTTERFLY, HAND WITH EARTH)**, 1983
PARIS, FONDATION CARTIER POUR L'ART CONTEMPORAIN

270• GEORGE SEGAL, **JACOB'S DREAM**, 1984-1985
COURTESY OF SIDNEY JANIS GALLERY, NEW YORK

140· ILYA KABAKOV, **THE MAN WHO FLEW INTO SPACE FROM HIS APARTMENT**, 1981-1988
PARIS, MUSÉE NATIONAL D'ART MODERNE/CENTRE DE CRÉATION INDUSTRIELLE, CENTRE GEORGES POMPIDOU

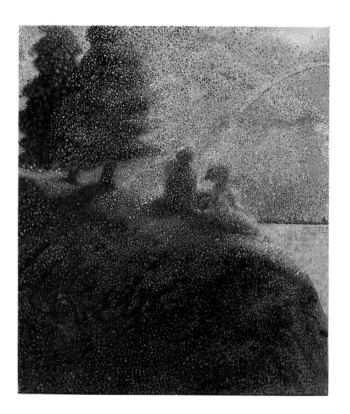

272· VLADIMIR SKODA, **UNTITLED**, 1988
PRIVATE COLLECTION

324· JOYCE WIELAND, **CREPUSCULE FOR TWO**, 1985
PHYLLIS AND GRAEME FERGUSON COLLECTION

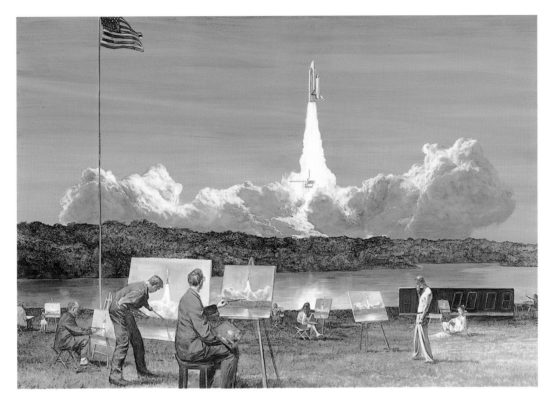

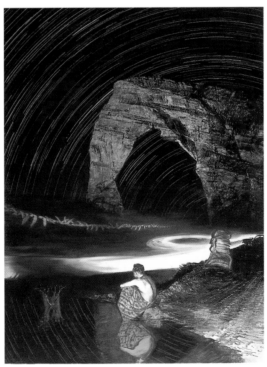

290• MARK TANSEY, **ACTION PAINTING II**, 1984
THE MONTREAL MUSEUM OF FINE ARTS

291• MARK TANSEY, **CLOCKWORK**, 1993
LOS ANGELES, STEVE TISCH

4.30 P.M. / -55°, 1989 8.52 A.M. / -45°, 1991

8 P.M. / -50°, 1989 4.40 A.M. / -45°, 1992

1.55 A.M. / -30˚, 1989

257• THOMAS RUFF, **STARS,** 1989-1992
PARIS, GALERIE NELSON

55· VIJA CELMINS, **NIGHT SKY #4**, 1992
LOS ANGELES, THE MUSEUM OF CONTEMPORARY ART

57• VIJA CELMINS, **NIGHT SKY #10**, 1994-1996
PRIVATE COLLECTION

VIJA CELMINS

56• **UNTITLED #10**, 1994-1995

54• **HOLDING ONTO THE SURFACE**, 1983

NEW YORK, DAVID AND RENEE McKEE COLLECTION

21· ROSS BLECKNER, **ARCHITECTURE OF THE SKY** V, 1989
BERLIN, NATIONALGALERIE

268• KATY SCHIMERT, **THE MOON**, 1995
SUSAN AND MICHAEL HORT COLLECTION

273· VLADIMIR SKODA, **BADRIA**, 1996
COLLECTION OF THE ARTIST

276· KIKI SMITH, **STARS AND SCAT**, 1996
COURTESY OF ANTHONY D'OFFAY GALLERY, LONDON

132• MONA HATOUM, **SOCLE DU MONDE** (PEDESTAL OF THE WORLD), 1992-1993 (RECONSTRUCTED 1996)
TORONTO, ART GALLERY OF ONTARIO

RICHARD MISRACH

201· CLOUDS, FOOL'S POND, 6.30.96, 11:41-11:56 P.M., 1996

202· CASSIOPEIA OVER UNNAMED PLAYA, 7.4.96, 11:29-11:58 P.M., 1996

THE MONTREAL MUSEUM OF FINE ARTS

148• ANSELM KIEFER, **STARFALL**, 1998
PARIS, GALERIE YVON LAMBERT

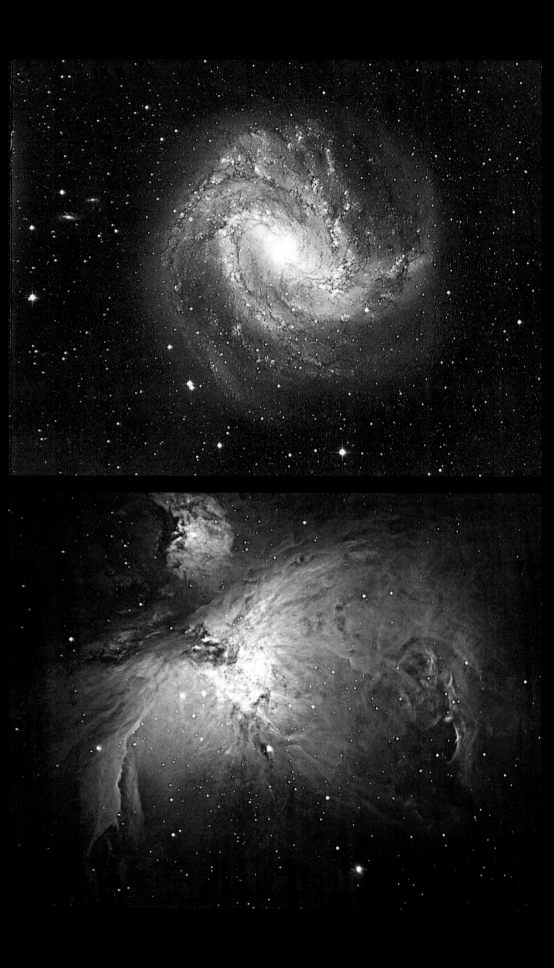

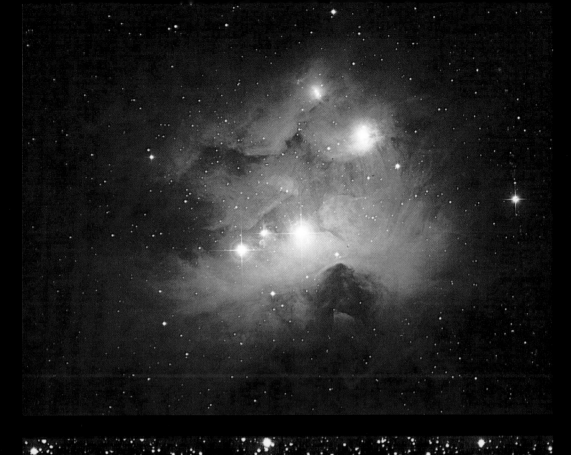

DAVID MALIN

184· A SPIRAL GALAXY (M83, NGC 5236), 1985 (MAY)

181· THE ORION NEBULA (M42 AND M43), 1979 (FEBRUARY)

183· A REFLECTION NEBULA IN ORION (NGC 1977), 1983 (JANUARY)

185· COLOUR PICTURE OF CG4, A COMETARY GLOBULE, 1990 (DECEMBER)

182· THE GLOBULAR CLUSTER TUCANAE (NGC 104), 1980 (DECEMBER)

186· THE SOMBRERO GALAXY (M104, NGC 4594), 1993 (MARCH)

EPPING, AUSTRALIA, COLLECTION OF THE ARTIST

Catalogue entries were written by:

Valérie Chaussonnet

Jean Clair

Bernadette Driscoll-Engelstad

Eleanor Jones Harvey

Constance Naubert-Riser

Didier Ottinger

Rosalind Pepall

Christopher Phillips

List of Exhibited Works

EERO AARNIO

1 [ill. p. 279]
"Globe" or "Sphere" Chair
Designed 1963-1965
Produced by Asko Finnternational,
Helsinki, 1966-1980 and about
1983-1987
Fibreglass, aluminum, synthetic
foam, wool upholstery
119.5 x 103.5 x 85 cm
Montreal Museum of Decorative
Arts/The Montreal Museum of Fine
Arts, gift of Nanette and Eric Brill,
D87.254.1

HIS MOST SERENE HIGHNESS, PRINCE ALBERT I OF MONACO

2 [ill. p. 137]
*The Staff of the "Princesse-Alice II"
on a Fragment of Pack Ice Floating
in Recherche Bay*
1899 (August 25)
Gelatin silver print
31 x 25 cm
Musée océanographique de Monaco

HANS (JEAN) ARP

3 [ill. p. 257]
Constellation of White Forms on Grey
1929
Painted wood
72 x 87 x 3.5 cm
Duisburg, Germany, Wilhelm
Lehmbruck Museum

4 [ill. p. 258]
Star
1956
Bronze
65 x 44 x 6.5 cm (with base)
Buffalo, Albright-Knox Art Gallery,
Charles Clifton Fund, 1958

GEORGE BACK

5 [ill. p. 72]
Sketchbook
1821-1822
Open to *Wilberforce Falls on the Hood
River* (August 1821)
Watercolour on paper
11.1 x 18.3 cm
Ottawa, National Archives of Canada,
acquired with the assistance of Hoechst
and Celanese Canada and with a grant
from the Department of Canadian
Heritage under the Cultural Property
Export and Import Act, 1994-254-2

6 [ill. p. 72]
*Sketchbook: Views from Upper Canada
along the McKenzie River to Great
Bear Lake*
1825-1826
Open to *Portage La Loche (Methye)
between Lac La Loche and the
Clearwater River*
Watercolour and pencil on paper
13.8 x 21.6 cm
Ottawa, National Archives of Canada,
1955-102

7
*Observations on the Aurora Borealis
by Captain Back*
1833-1835
Notebook
32 x 20.5 cm
Montreal, McCord Museum of
Canadian History, M-2634

8 [ill. p. 120]
*An Iceberg, a Ship and Some Walrus
near the Entrance of Hudson Strait*
About 1840
Watercolour and gouache over pencil
with scraping-out on paper
28.3 x 23 cm
Ottawa, National Archives of Canada,
1979-49-1

PEDER BALKE

9 [ill. p. 123]
Seascape
About 1860
Oil on paper mounted on panel
34 x 52 cm
Oslo, Nasjonalgalleriet

GIACOMO BALLA

10 [ill. p. 187]
Mercury Passing before the Sun
1914
Oil on embossed paper
61 x 50.5 cm
Paris, Musée national d'art moderne/
Centre de création industrielle,
Centre Georges Pompidou

11 [ill. p. 186]
*Mercury Passing before the Sun,
Seen through a Telescope*
1914
Tempera on paper
24 x 18 cm
Private collection

12 [ill. p. 186]
*Mercury Passing before the Sun,
Seen through a Telescope*
1914
Tempera on paper mounted on canvas
138 x 99 cm
Vienna, Museum moderner Kunst
Stiftung Ludwig

After the publication of the *Futurist Manifesto* in 1909, the emerging generation of Italian painters sought to renew their themes and pictorial vocabulary by concentrating on the study of movement and dynamic effects. Balla is one of the principal representatives of early Futurism. After settling in Rome, he focussed on the ambitions of the young Milan artists he had once welcomed into his studio. Influenced by chronophotography and seeking to shed the yoke of academicism, he undertook to represent movement and velocity by breaking them down in successive phases and by "materializing" light.

It was at this time that a celestial event provided Balla with the opportunity to extend his research to a study of planetary movements. On November 7, 1914, using a telescope with a filtered lens, he observed a partial eclipse of the sun. This spawned a series of studies in which a variety of forms are intertwined: tubes, a cone suggesting the telescope's prism, partially superimposed circles (the eclipse), a spiral suggesting motion and white radiating lines that express the dazzling brilliance of the partially hidden sun.

C.N.-R.

13 [ill. p. 188]
Forms – Spirits Transformation
1918
Oil on canvas
51 x 65 cm
Rome, Galleria Nazionale d'Arte
Moderna

14 [ill. p. 188]
Science versus Obscurantism
1920
Oil on canvas
24.3 x 35 cm
Rome, Galleria Nazionale d'Arte
Moderna

EDWARD BARNARD I
See cat. 97.

FREDERICK WILLIAM BEECHEY
15 [ill. p. 120]
Wreck of the "Trent"'s Boat from a
Piece of Ice Breaking off the Glacier
About 1818
Pencil and white highlights on paper
23 x 30.5 cm
The Arctic Institute of North America,
University of Calgary

WILLIAM BELL
16 [ill. p. 104]
Chocolate Butte, near Mouth
of the Paria
About 1872
Albumen silver print
24.1 x 21 cm
Miriam and Ira D. Wallach Division
of Art, Prints and Photographs.
The New York Public Library. Astor,
Lenox and Tilden Foundations

17 [ill. p. 104]
Perched Rock, Rocker Creek, Arizona
1874 ?
Albumen silver print
27.6 x 20.3 cm
Ottawa, National Gallery of Canada

HARRY BERTOIA
18 [ill. p. 279]
Coffee Service
1937-1943
Pewter, stained wood
Coffee pot: 17.8 x 19 x 14.3 cm;
cream pitcher: 10.2 x 11.1 x 8.9 cm;
sugar bowl: 13 x 11.4 x 8.6 cm
Montreal Museum of Decorative Arts/
The Montreal Museum of Fine Arts,
anonymous gift

ALBERT BIERSTADT
19 [ill. p. 77]
Yosemite Valley
About 1875-1880
Oil on canvas
137.2 x 215.3 cm
New Haven, Yale University Art
Gallery, gift of Mrs. Vincenzo Ardenghi

NICOLAS BION
20 [ill. p. 151]
Names of the Moon's Spots
1744
Hand-coloured copper engraving
21.6 x 18.9 cm
Montreal, Stewart Museum at the Fort,
Île Sainte-Hélène, 1979.535.1

ROSS BLECKNER
21 [ill. p. 311]
Architecture of the Sky V
1989
Oil on canvas
270 x 234 cm
Staatliche Museen zu Berlin,
Nationalgalerie, Sammlung Marx

LOUIS BONNIER
22 [ill. p. 42]
Élisée Reclus Globe for the 1900 Paris
World's Fair. Elevation and Silhouette
of the Old Trocadéro
1897-1898
Watercolour on paper
62 x 91 cm
Paris, Institut Français d'Architecture/
Archives nationales,
fonds Louis Bonnier (1856-1946)

23 [ill. p. 43]
Élisée Reclus Globe for the 1900
Paris World's Fair. Section Study
and Plan of the Spiral
1897-1898
Ink and pencil on tracing paper
mounted on paper
63.5 x 44.5 cm
Paris, Institut Français d'Architecture/
Archives nationales,
fonds Louis Bonnier (1856-1946)

24 [ill. p. 42]
Élisée Reclus Globe for the 1900 Paris
World's Fair. East-West Section and
North-South Section
1897-1898
Blueprint on paper
50.5 x 66 cm
Paris, Institut Français d'Architecture/
Archives nationales,
fonds Louis Bonnier (1856-1946)

25 [ill. p. 41]
Élisée Reclus Globe for the 1900 Paris
World's Fair. Sectional View Showing
the System of the Spiral, Elevators
and Stairs
1897-1898
Ink and watercolour on paper
59 x 45 cm
Paris, Institut Français d'Architecture/
Archives nationales,
fonds Louis Bonnier (1856-1946)

To provide the Paris Universal Exposi-
tion of 1900 with an attraction compa-
rable to the Eiffel Tower at the 1889
Exposition, geographer Élisée Reclus hit
upon the idea of erecting in the Place du
Trocadéro a gigantic terrestrial globe,
big enough to bring in the crowds but
also of educational value.
In December 1897, Reclus asked Louis
Bonnier, city architect of Paris and a
great proponent of Art nouveau, to build
the project. A 500,000th-scale globe
(1 cm = 5 km) was finally chosen to
represent the earth. It was to measure
twenty-six metres in diameter and be
housed in a frame forty-six metres in
diameter and sixty metres high. A spi-
ral ramp surrounding the globe would
enable visitors "to visit every degree of
longitude and latitude", while stairways
and elevators inside the sphere would
provide faster access.
For lack of a promoter, however, the
project went unrealized.
It was one of the last manifestations
of the fashion for dioramas, panoramas
and cycloramas that had sprung up a
century before.

J.C.

PAUL-ÉMILE BORDUAS
26 [ill. p. 139]
The Black Star
1957
Oil on canvas
162.5 x 129.5 cm
The Montreal Museum of Fine Arts,
gift of Mr. and Mrs. Gérard Lortie

WILLIAM BRADFORD
Assisted by John L. Dunmore and
George Critcherson for cats. 27-29
27 [ill. p. 131]
The "Castle" Iceberg as Seen in
Melville Bay in August 1869
1869
Albumen silver print
29.2 x 40.7 cm
Rare Books Division. The New York
Public Library. Astor, Lenox and
Tilden Foundations

28 [ill. p. 133]
*Hunting by Steam in Melville Bay
in August. Killing Six Polar Bears in
One Day*
1869
Albumen silver print
28.7 x 39.4 cm
Rare Books Division. The New York
Public Library. Astor, Lenox and
Tilden Foundations

29 [ill. p. 136]
*Cliffs in Arsut Fiord 3000 Feet High,
North Greenland*
1869
Albumen silver print
40.2 x 29.4 cm
Rare Books Division. The New York
Public Library. Astor, Lenox and
Tilden Foundations

30 [ill. p. 129]
Sermitsialik Glacier
About 1870
Oil on canvas
43.2 x 74.9 cm
Old Dartmouth Historical Society,
New Bedford Whaling Museum,
Massachusetts

31 [ill. p. 132]
*An Arctic Summer, Boring through
the Pack Ice in Melville Bay*
1871
Oil on canvas
131.5 x 198.2 cm
New York, The Metropolitan Museum
of Art, gift of Erving and Joyce Wolf,
1982

32 [ill. p. 131]
In Polar Seas
1882
Oil on canvas
71.1 x 111.8 cm
Private collection

CONSTANTIN BRANCUSI
33 [ill. p. 246]
The Beginning of the World
About 1924
Polished bronze and steel
Bronze: 19 x 28.5 x 17.5 cm;
steel disk: 45 cm (diam.)
Exceptional loan from the Musée
national d'art moderne/Centre de
création industrielle, Centre Georges
Pompidou, Paris

JAMES LEE BYARS
34 [ill. p. 301]
Planet Sign
1981
Gold fabric, wood base
500 cm (diam.)
Courtesy of Michael Werner Gallery,
New York and Cologne

ALEXANDER CALDER
The "A" numbers given for Calder's
works are from the Calder catalogue
raisonné project.

35
Croisière
1931
Wire, wood, paint
91 x 58 x 58 cm
Courtesy of Calder Foundation,
New York
A00272

36 [ill. p. 249]
Up, over the Horizon
1931
Ink on paper
50 x 65.2 cm
Washington, Hirshhorn Museum
and Sculpture Garden, Smithsonian
Institution, Joseph H. Hirshhorn
Bequest, 1981
A00073

37 [ill. p. 251]
Movement in Space
1932
Gouache and ink on paper
57.7 x 78.1 cm
Washington, National Gallery of Art,
gift of Mr. and Mrs. Klaus G. Perls
A12240

38 [ill. p. 249]
Space Tunnel
1932
Watercolour and ink on paper
57.8 x 77.5 cm
Courtesy of Calder Foundation,
New York
A01104

39 [ill. p. 250]
The Planet
1933
Ink on paper
54.9 x 74.9 cm
Courtesy of Calder Foundation,
New York
A16015

40 [ill. p. 247]
Untitled (The Constellation Mobile)
1941
Wire, wood, paint
86.4 x 106.7 cm
Washington, National Gallery of Art,
gift of Mr. and Mrs. Klaus G. Perls
A13246

41 [ill. p. 248]
Black Spot on Gimbals
1942
Wire, wood, paint
40.6 x 48.3 x 21.6 cm
Courtesy of Calder Foundation,
New York
A00555

42 [ill. p. 248]
Constellation
1943
Wood, wire, paint
55.9 x 113 x 35.6 cm
New York, Solomon R. Guggenheim
Museum, Mary Reynolds Collection,
gift of her brother, 1954
A00551

43
Constellation
1943
Wood, wire, paint
39.4 x 43.8 cm
Courtesy of Calder Foundation,
New York
A01130

JOHN WILSON CARMICHAEL
44 [ill. p. 122]
*HMS "Erebus" and "Terror"
in the Antarctic*
1847
Oil on canvas
123.2 x 184.2 cm
Greenwich, England, National
Maritime Museum

EMILY CARR
45 [ill. p. 37]
Tree Trunk
1930
Oil on canvas
129.1 x 56.3 cm
Vancouver Art Gallery,
Emily Carr Trust

46 [ill. p. 37]
Scorned as Timber, Beloved of the Sky
1935
Oil on canvas
112 x 68.9 cm
Vancouver Art Gallery,
Emily Carr Trust

CARL GUSTAV CARUS
47 [ill. p. 18]
Wanderer on the Mountaintop
1818
Oil on canvas
43.2 x 33 cm
The Saint Louis Art Museum,
Museum Shop Fund

JEAN-DOMINIQUE CASSINI
48 [ill. p. 151]
The Moon's Spots
1673-1679
Album of drawings
64 x 48 cm
Observatoire de Paris

ANDREAS CELLARIUS
49 [ill. p. 49]
Typus selenographicus lunae phases et aspectus varios adumbrans
(A Selenographic Chart Showing the Moon's Various Phases and Aspects)
1660
Hand-coloured copper engraving
43 x 51 cm
Montreal, Stewart Museum at the Fort, Île Sainte-Hélène, 1985.35.1

VIJA CELMINS
50 [ill. p. 153]
Moon Surface #2 (Luna 9)
1969
Graphite on acrylic ground on paper
35.6 x 46.7 cm
Newport Beach, California, Orange County Museum of Art, museum purchase

51 [ill. p. 299]
Galaxy #1 (Coma Berenices)
1973
Graphite on acrylic ground on paper
31.1 x 38.7 cm
New York, Paine Webber Group Inc. Collection

52 [ill. p. 299]
Galaxy #4 (Coma Berenices)
1974
Graphite on acrylic ground on paper
31.1 x 38.7 cm
New York, Paine Webber Group Inc. Collection

53 [ill. p. 299]
Galaxy #2 (Coma Berenices)
1974-1975
Graphite on acrylic ground on paper
31.1 x 38.7 cm
New York, Paine Webber Group Inc. Collection

54 [ill. p. 310]
Holding onto the Surface
1983
Graphite on acrylic ground on paper
43.2 x 38.1 cm
New York, David and Renee McKee collection

55 [ill. p. 308]
Night Sky #4
1992
Oil on canvas mounted on panel
78.1 x 95.9 cm
Los Angeles, The Museum of Contemporary Art, gift of Lannan Foundation

56 [ill. p. 310]
Untitled #10
1994-1995
Charcoal on paper
43.5 x 56.2 cm
New York, David and Renee McKee collection

57 [ill. p. 309]
Night Sky #10
1994-1996
Oil on canvas
78.7 x 95.3 cm
Private collection

EUGENE CERNAN
58 [ill. p. 160]
Astronaut Harrison Schmitt, Boulder, Lunar Rover, Apollo 17
1972
Colour coupler print
40.6 x 50.8 cm
Private collection

This photograph, one of the most memorable images made during the lunar voyages of the twentieth century, shows astronaut-geologist Harrison Schmitt in terrain that had remained virtually unchanged for three billion years. He is confronting a dramatic reminder of the moon's volatile past.
The site, the Taurus-Littrow Valley, was selected for exploration based on information supplied by earlier Apollo missions, whose orbiting command modules carried sensing equipment that could register not only visible light but also X rays, gamma rays and infrared radiation. Such geochemical mapping directed attention to the Taurus-Littrow region, which contains some of the moon's oldest basaltic "seas", formed 3.8 billion years ago during an epoch of violent eruptions.
During the Apollo 17 mission of December 1972, astronauts Schmitt and Eugene Cernan, travelling in the battery-powered "rover" that is parked beyond the boulder, collected samples of lunar soil and rocks, and took photographs of geological formations. This image, made by Cernan from a nearby slope, shows Schmitt examining a boulder measuring approximately 6 by 10 by 18 metres. In the distant past, the boulder had been propelled

to the valley floor from the side of a massif roughly 1.6 kilometres away. On the sunlit section of the rock at left can be seen the marks left by Schmitt's sampling tool. And just to the right of the boulder's tip, visible as a tiny dot in the light horizontal strip, is the landing vehicle that served as the astronauts' temporary home during this final manned lunar mission of the twentieth century.

C.P

59 [ill. p. 159]
Astronaut Harrison Schmitt in the Taurus-Littrow Valley, Apollo 17
1972
Colour coupler print
40.6 x 50.8 cm
Private collection

ILIA CHASHNIK
See cats. 180, 296-301.

FREDERIC EDWIN CHURCH
60 [ill. p. 126]
Floating Iceberg, Labrador
1859 (June-July)
Oil and slight traces of graphite on wove paper
30.5 x 46 cm
New York, Cooper-Hewitt, National Design Museum, Smithsonian Institution, gift of Louis P. Church, 1917-4-289A

61 [ill. p. 124]
Floating Icebergs
1859 (July 4 and 5)
Graphite and white gouache on paper
11.4 x 21 cm
New York, Cooper-Hewitt, National Design Museum, Smithsonian Institution, gift of Louis P. Church, 1917-4-273C

62 [ill. p. 124]
Floating Icebergs
1859 (July 5)
Graphite and white gouache on paper
11.4 x 21 cm
New York, Cooper-Hewitt, National Design Museum, Smithsonian Institution, gift of Louis P. Church, 1917-4-277A

63 [ill. p. 124]
Seascapes, Newfoundland
1859 (July 6)
Graphite and white gouache on paper
11.4 x 20.6 cm
New York, Cooper-Hewitt, National
Design Museum, Smithsonian
Institution, gift of Louis P. Church,
1917-4-274B

64 [ill. p. 124]
Floating Icebergs
1859 (July 6 and 16)
Graphite and white gouache on paper
11.4 x 20.6 cm
New York, Cooper-Hewitt, National
Design Museum, Smithsonian
Institution, gift of Louis P. Church,
1917-4-284C

65 [ill. p. 125]
Floating Iceberg under Cloudy Skies
1859
Oil and graphite on cardboard
30.5 x 50.8 cm
New York, Cooper-Hewitt, National
Design Museum, Smithsonian
Institution, gift of Louis P. Church,
1917-4-305A

66 [ill. p. 125]
Iceberg and Ice Flower
1859
Oil and graphite on board
30.6 x 51 cm
New York, Cooper-Hewitt, National
Design Museum, Smithsonian
Institution, gift of Louis P. Church,
1917-4-296B

67 [ill. p. 127]
The Icebergs
1861
Oil on canvas
163.5 x 285.8 cm
Dallas Museum of Art,
anonymous gift

In the summer of 1859, Frederic Church
chartered a schooner and embarked on
a month-long sketching trip to explore
coastal Newfoundland and Labrador.
His interest in the Arctic region piqued
by the disappearance of the Franklin
expedition, Church took the opportunity
to study the nature of ice as part of his
lifelong fascination with man's place
in the natural world. He completed this
painting during the first months of
the Civil War, exhibiting it in New York
in April 1861 to benefit the Union's Pa-
triotic Fund. A Union supporter, Church
initially entitled the painting *The North
– Church's Picture of Icebergs*.

Critics described the work as evidence
of "northern prowess under duress",
borrowing the motif of the hardy ex-
plorer, willing to risk his life, to allude
to the bravery of U.S. soldiers.
Although *The Icebergs* was much
admired in New York, it failed to sell.
In 1863, Church shipped the painting
to England for exhibition. Just prior to
that, he added the broken mast in the
foreground, most likely as a memorial
to the lost Franklin expedition. Two
chromolithographs made from the
painting, one in New York, the other
in London, bear witness to the artist's
alterations. Church also retitled the
work *The Icebergs*, perhaps in deference
to England's Confederate sympathies.
Enormously popular in England,
Church's painting was purchased by
Sir Edward William Watkin, a railroad
baron and Member of Parliament. It
remained in the family home, which was
sold to the city of Manchester in 1901
and is currently a boys' school called
Rose Hill. With the decline of Church's
reputation following his death in 1900,
The Icebergs hung unrecognized on a
staircase landing until 1979, when it
was rediscovered and sold for a record
price at Sotheby's.

 E.J.H

68 [ill. p. 67]
Cotopaxi, Ecuador
1863
Oil on canvas
87 x 150 cm
Reading, Pennsylvania, Reading
Public Museum

MIKALOJUS K. ČIURLIONIS

69 [ill. p. 228]
Fairy Tale (Castle Fairy Tale)
1909
Tempera on cardboard
49.6 x 67.1 cm
Kaunas, Lithuania, M.K. Čiurlionis
National Museum of Art

70 [ill. p. 228]
Lightning
1909
Tempera on cardboard
59.8 x 76.6 cm
Kaunas, Lithuania, M.K. Čiurlionis
National Museum of Art

71 [ill. p. 229]
Rex
1909
Tempera on canvas
147.1 x 133.7 cm
Kaunas, Lithuania, M.K. Čiurlionis
National Museum of Art

THOMAS COLE

72 [ill. p. 73]
A Wild Scene
1831-1832
Oil on canvas
128.9 x 193.7 cm
The Baltimore Museum of Art, Leonce
Rabillon Bequest Fund, by exchange,
and Purchase Fund, BMA 1958.15

73 [ill. p. 73]
Study of Clouds
1846-1847
Oil on canvas
121.9 x 182.9 cm
Private collection

74 [ill. p. 32]
Cross at Sunset
About 1848
Oil on canvas
81.3 x 123.2 cm
Madrid, Fundación Colección
Thyssen-Bornemisza

Cole, born in England, was to become
the first great American landscape
painter and the founder of the Hudson
River School, whose programme he laid
down in his "Essay on American
Scenery" of 1835. Strongly influenced
by fellow Englishman John Martin –
particularly his illustrations for Milton's
Paradise Lost – Cole created a landscape
style designed to raise the genre to
the level of history painting by imbuing
it with an intensely spiritual quality.
Hence, most of his works devoted to
the American landscape were like
odes to a new Promised Land, in which
natural phenomena are seen as prom-
ises of salvation and which embody a
symbolism where the cross (as in the
work of the German Romantic painters,
especially Caspar David Friedrich) plays
a vital part.
Between 1846 and 1848, Cole, who had
been received into the Episcopalian
Church in 1844, worked on a series
entitled *The Cross and the World*, to
which this painting, one of his last,
would have belonged. The light coming
from behind the mountains, like a halo
surrounding the cross, and the ruins
on the hill beside the river combine to
make a work of strongly symbolic
connotations based on a meticulous
observation of nature.

 J.C.

JOSEPH CORNELL
75 [ill. p. 263]
Soap Bubble Set
1940, remodelled 1953
Wood, glass, paper, metal, shell
34.3 x 48.3 x 7.6 cm
The Art Institute of Chicago,
Simeon B. Williams Fund

76 [ill. p. 263]
Untitled (Hôtel de l'Étoile)
1951
Mixed media
48.2 x 33 x 10.2 cm
Richmond, Virginia Museum of Fine
Arts, gift of Joseph and Robert
Cornell Memorial Foundation

TULLIO CRALI
77
At Take-off
1934
Private collection

78 [ill. p. 185]
Spiral Glide
1938
Oil on canvas
60 x 80 cm
Milan, Marinetti collection

HENRY SAMUEL DAVIS
79 [ill. p. 74]
Horseshoe Falls and Table Rock
1847
Watercolour, gouache and gum
arabic on paper
59 x 52.2 cm
Toronto, Royal Ontario Museum,
gift of Sigmund Samuel

80 [ill. p. 74]
Horseshoe Falls from Goat Island
1847
Watercolour, gouache and gum
arabic on paper
58.2 x 45.4 cm
Toronto, Royal Ontario Museum,
gift of Sigmund Samuel

GIORGIO DE CHIRICO
81 [ill. p. 266]
Offering to the Sun. Sun and Moon
1968
Oil on canvas
59.5 x 50 cm
Rome, Fondazione Giorgio e
Isa de Chirico

82 [ill. p. 267]
Ecstasy
About 1968
Gouache, painted cardboard
35 x 45 cm
San Polo di Reggio nell'Emilia,
Italy, private collection

83 [ill. p. 266]
Sun on the Easel
1972
Oil on canvas
64.5 x 81 cm
Rome, Fondazione Giorgio e
Isa de Chirico

WARREN DE LA RUE
84 [ill. p. 154]
The Moon in Twelve Phases
1862
12 albumen silver prints
6 x 5.4 cm each (14 x 116 cm overall)
Courtesy of Howard Schickler Fine
Arts, New York

ROBERT DELAUNAY
85 [ill. p. 232]
Circular Forms: Sun and Moon
1912/1931
Oil on canvas
200 x 197 cm
Kunsthaus Zürich

MINO DELLE SITE
86 [ill. p. 191]
Deification of the Earth
About 1932
Oil on canvas
100 x 69.5 cm
Rome, Mr. and Mrs. Luciano Berni
Canani collection

87 [ill. p. 190]
Interplanetary Voyages
1937
Oil on canvas
40 x 50 cm
Rome, Mr. and Mrs. Luciano Berni
Canani collection

MICHELE DE LUCCHI
88 [ill. p. 279]
"First" Chair
1983
Produced by Memphis, Milan
Metal, painted wood
90.2 x 64.8 x 44.5 cm
Dallas Museum of Art, gift of
Ken Darity and Ed Murchison

OTTO DIX
89 [ill. p. 233]
Pregnant Woman
1919
Oil on canvas
133 x 72 cm
Stuttgart, Galerie Valentien

Otto Dix executed two paintings linking
the theme of pregnancy to the cosmic
phenomenon of galaxies in gestation;
the curves of the former are combined
with the spirals of the latter. We see here
an echo of Dix's assiduous reading of
Nietzsche's *Zarathustra*, where woman
is shown as the enigma of the universe,
which may be solved through the birth
of the Superman.
The Expressionist poet Theodor Däubler
must have been mindful of the image
of *Natura naturans* when writing about
this work: "The pregnant woman,
standing, personifies either nature in
a permanently gravid state or the preg-
nant woman as a type and not as an
individual."

J.C.

DMITROV PORCELAIN FACTORY
Verbilki (near Moscow)
90
Plate with Scene of Outer Space
About 1957
Porcelain, enamelled and gilt decoration
19.8 cm (diam.)
New York, Cooper-Hewitt, National
Design Museum, Smithsonian
Institution

91
The Dogs Strelka and Belka
1960s
Porcelain, enamelled decoration
6 x 6 x 8 cm
New York, Cooper-Hewitt, National
Design Museum, Smithsonian
Institution

92
"April 12, 1961" Commemorative Cup
1961
Porcelain, enamelled and gilt decortion
8.4 cm (h.); 7.4 cm (diam.)
New York, Cooper-Hewitt, National
Design Museum, Smithsonian
Institution

JOHANN GABRIEL DOPPELMAYR
93 [ill. p. 49]
Tabula selenographica in qua lunarium
macularium exacta descriptio secundum
nomenclaturam praestantissimorum
astronomorum tam Hevelii quam
Riccioli curiosis rei sidereae cultoribus
exhibetur
(A selenographic chart in which the
exact description of the moon's spots
according to the nomenclature of the
most eminent astronomers Hevelius
and Riccioli is displayed for those
interested in matters concerning
the stars)
About 1742
Hand-coloured copper engraving
53.5 x 64 cm
Montreal, Stewart Museum at the Fort,
Île Sainte-Hélène, 1979.257.1

GUSTAVE DORÉ
See also cat. 360.
94 [ill. p. 119]
The Icebound Ship
About 1875
Brown wash and white gouache
on paper
51.9 x 39.9 cm
Musée d'art moderne et contemporain
de Strasbourg, Cabinet d'art graphique

DOVBUSHSKY PORCELAIN FACTORY
Soviet Union
95
"USSR / September / 1959"
Commemorative Box
1959
Porcelain, enamelled and gilt decoration
7.3 cm (h.)
New York, Cooper-Hewitt, National
Design Museum, Smithsonian
Institution

GEORG CHRISTOPHE EIMMART
96
Planisphaerium caeleste secundum
restitutionem Hevelianam et Hallejanam
(Planisphere of the heavens as
established by Hevelius and Halley)
1690
Hand-coloured copper engraving
47.5 x 56.6 cm
Montreal, Stewart Museum at the
Fort, Île Sainte-Hélène, 1979.530.1

REBECCA EMES
AND EDWARD BARNARD I
97 [ill. p. 270]
Tankard with the Comet of 1811
1811-1812
Silver, gilt interior
14.9 cm (h.); 8.4 cm (diam.)
Williamstown, Massachusetts,
Sterling and Francine Clark Art
Institute

MAX ERNST
98 [ill. p. 262]
Forest and Sun
1926
Oil on cardboard
18 x 24 cm
Rome, Galleria Nazionale d'Arte
Moderna, gift of the artist, 1955

99 [ill. p. 265]
The Bewildered Planet
1942
Oil on canvas
110 x 140 cm
Tel Aviv Museum of Art, gift of
the artist

In 1941, Max Ernst was able to flee occu-
pied France and settle in the United
States, where he continued to explore
his theme of the "great deluge" as an
image of war. In his two-panel visionary
landscape *The Bewildered Planet*, he
transforms an event in human history
into an event with cosmic relevance, a
reflection of his melancholic musings.
On either side of an immense column
spotted with blood – a well-known
reference to his earlier works (*Europe*
after the Rain and *Day and Night*,
1940-1942) – two petrified landscapes
represent Europe in ruins, devastated
by a cosmic storm.
The "paintings within the painting"
recall the automatist procedure of
decalcomania, used here to obtain the
effects of hallucinatory devastation. At
the right edge, the vertical column-like
shapes standing out against the sky
bear a strange resemblance to the sta-
lagmites at Orgnac, in Ardèche, which
appear in several of his works. However,
they are also decals of the column on the
red canvas lying flat in the foreground.
Arranging the blue and red canvasses
edge to edge discloses the secret behind
the procedure.
On the left, the well-regulated orbital
movement of a planet is set against a
blue sky. On the right, against an ochre
background, the disorderly movement
of the same planet gives the work a cos-
mic significance, leading us from the
destruction of war to the destruction
of the universe. Here, the orbits' path is
arbitrary, having been achieved by

oscillation, a method in which a perfo-
rated container full of paint is dangled
above the canvas and made to swing in
a pendular motion.
Bringing all these elements together
onto a single canvas, Ernst raises a
philosophical question about the plane-
tary scope of the consequences of the
triumph of folly.

C.N.-R.

100 [ill. p. 264]
Several Animals, One of Them
Uncultured
1973
Oil on canvas
116 x 89 cm
Capricorn Trust, courtesy of Cavaliero
Fine Arts, New York

101 [ill. p. 263]
Eternity
About 1973
Oil on canvas
21.2 x 14.5 cm
Milan, Pierpaolo Cimatti collection

102 [ill. p. 264]
Configuration
1974
Oil on panel mounted on painted
wood
33.1 x 23.9 cm; mount: 40.6 x 31.1 cm
Capricorn Trust, courtesy of Cavaliero
Fine Arts, New York

PATERSON EWEN
103 [ill. p. 298]
Galaxy NGC-253
1973
Acrylic, galvanized sheet metal
and string on plywood
228.7 x 243.2 cm
Ottawa, National Gallery of Canada

104 [ill. p. 165]
Gibbous Moon
1980
Acrylic on gouged plywood
228.5 x 244 cm
Ottawa, National Gallery of Canada

HIPPOLYTE FIZEAU
AND LÉON FOUCAULT
105 [ill. p. 176]
The Sun
1845
Daguerreotype
20.5 x 15 cm
Paris, Musée des arts et métiers
du CNAM

LUCIO FONTANA
106 [ill. p. 193]
Spatial Concept – Expectations
1959
Painted and varnished canvas
200 x 200 cm
Rome, Galleria Nazionale d'Arte
Moderna

107 [ill. p. 192]
Spatial Concept
1959
Acrylic on canvas
101 x 125 cm
Rome, Galleria Nazionale d'Arte
Moderna

PIERO FORNASETTI
108 [ill. p. 277]
*"Man in Space", Series of Five Plates:
The Departure, The Orbit, The Flight,
The Return, The History*
1966
Transfer-printed porcelain
24.1 cm (diam.)
Dallas Museum of Art, gift of
Michael L. Rosenberg

LÉON FOUCAULT
See cat. 105.

CASPAR DAVID FRIEDRICH
109 [ill. p. 33]
Cromlech in the Snow
1807
Oil on canvas
61 x 80 cm
Dresden, Staatliche
Kunstsammlungen, Gemäldegalerie
Neue Meister, Gal. Nr. 2196

110 [ill. p. 29]
*Man and Woman Contemplating
the Moon*
About 1824
Oil on canvas
34 x 44 cm
Staatliche Museen zu Berlin,
Nationalgalerie

In a reference to his friend Humboldt,
and Humboldt's *Voyage aux régions
équinoxiales du Nouveau Continent*,
Carus wrote in one of his *Nine Letters
on Landscape Painting* that the explorer,
"painting with words for our souls' eyes
the portrait of the American plains
and the great waterfalls", invented the
terms *Erdlebenbild* and *Erdlebenerlebnis*
– representation of life on earth, expe-
rience of life on earth – which, better
than the term "landscape", express the

idea of a kind of painting that com-
bines the Romantic sentiment of flowing
into and merging with Nature and the
search for knowledge – *Erlebnis* – of
natural phenomena.
This term could equally apply to the
work of Carus's teacher Caspar David
Friedrich, which, rather than present-
ing a passive view of nature, seeks to
know its essence: the nature of Nature.
"Painting," Carus wrote of him, "was a
kind of divine service. When he was
painting the sky, no one could enter his
studio."
Friedrich's paintings often show observ-
ers, always seen from behind, faces
watching nature enter them, marking
the place where we ourselves are as
viewers of the work, so that we can
enter directly into the experience of
these observers, of these faces contem-
plating a natural phenomenon: here,
the rising of the moon, which is lower
on the horizon than the human gaze
upon it.
In this way, a scientific desire to under-
stand the *Weltseele*, the world-soul, is
always combined with a feeling for the
sublime, for communing with it.
While the twenty-eight-day lunar cycle
is seen here at the beginning of the new
moon, linked to myths about female
fecundity, the half-uprooted oak tree
evokes the transience of man's life, the
short span of human existence in com-
parison with the rhythms of the eternal
cosmos.

J.C.

RICHARD BUCKMINSTER FULLER
111 [ill. p. 214]
*Projected Delivery by Zeppelin of the
Planned 10-Deck, Wire-wheel, 4D
Tower Apartment House*
1927
Mimeograph on paper
21.6 x 27.9 cm
Cincinnati, Carl Solway Gallery

EDWARD G. GIBSON
112 [ill. p. 292]
*Three Drawings of the Comet
Kohoutek*
22.9 x 38.1 cm each
Washington, National Air and Space
Museum, Smithsonian Institution

Day 363
1973
Pencil on paper

*December 29, 1973, Perihelion + 1
Day*
1974
Coloured pencil on board

January 6, 1974, Perihelion + 9 days
1974
Coloured pencil on board

AIMÉ GIRARD
113 [ill. p. 152]
*Observations of the Eclipse of the
Sun, July 18, 1860, at Batna, Algeria*
1860
12 albumen silver prints
46 x 30 cm (overall)
Paris, Société française de photographie

GLADDING McBEAN & COMPANY
Glendale and Los Angeles, California

114 [ill. p. 276]
"Starry Night" Plate, Cup and Saucer
1952
Franciscan ware: bone china,
enamelled decoration, platinum
Plate: 26.7 cm (diam.); cup: 4.5 cm (h.),
10.2 cm (diam.); saucer: 15.2 cm (diam.)
Dallas Museum of Art, 20th Century
Design Fund

BETTY GOODWIN
115
Chaos Below
1999
Oil stick, Cronoflex, Herculean paper,
neon
246.4 x 121.9 cm
Private collection

**GORHAM MANUFACTURING
COMPANY**
Providence, Rhode Island
116 [ill. p. 271]
"Iceberg" Bowl with Spoon and Tongs
About 1871
Silver
Bowl: 17.8 x 27.3 cm;
spoon: 29.2 cm (l.); tongs: 33 x 8.3 cm
Bowl and spoon: Dallas Museum
of Art, The Eugene and Margaret
McDermott Art Fund, Inc.
Tongs: Private collection

FRANCISCO DE GOYA
117 [ill. p. 39]
The Balloon
1813-1816
Oil on canvas
103 x 83 cm
Musée des beaux-arts d'Agen

GZHEL PORCELAIN FACTORY
Soviet Union
118 [ill. p. 278]
Cosmonauts and Rocket
1960s
Porcelain, enamelled and gilt decoration
15.8 cm (h.)
New York, Cooper-Hewitt, National
Design Museum, Smithsonian
Institution

WENZEL HABLIK
119 [ill. p. 240]
*Flying Building, Large Flying
Settlement*
From the "Entwürfe für Flugobjekte
und fliegende Siedlungen" (1906-1914)
1907-1914
Black ink and coloured pencil
on tracing paper
35.5 x 37.4 cm
Itzehoe, Germany,
Wenzel-Hablik-Museum

120 [ill. p. 240]
The Construction of the Air Colony
From the "Entwürfe für Flugobjekte
und fliegende Siedlungen" (1906-1914)
1908
Pencil on paper
22.5 x 18.1 cm
Itzehoe, Germany,
Wenzel-Hablik-Museum

121 [ill. p. 241]
Untitled
Plate 2 from the series "Schaffende
Kräfte"
Accompanying text plate: *Furchtbar
ist es über den Sternen – deine Seele
findet nicht eher ihren Gott – bis dass
sie zwiefach nicht ihren Leib
vernichtet*
(It is terrible beyond the stars – your
soul does not find its God until it has
doubly annihilated its body.)
1909
Etching
19.4 x 19.4 cm (image);
9.3 x 9.3 cm (text)
Itzehoe, Germany,
Wenzel-Hablik-Museum

122 [ill. p. 261]
Firmament
1913
Oil on canvas
201 x 301 cm
Itzehoe, Germany,
Wenzel-Hablik-Museum

123 [ill. p. 241]
*Self-supporting, Self-bracing
Domed Building*
From the "Architekturen" (1914-1922)
1920
Black ink on cardboard
10.6 x 14.9 cm
Itzehoe, Germany,
Wenzel-Hablik-Museum

124 [ill. p. 242]
Sketch for a Domed Building
From the "Architekturen" (1914-1922)
1920
Indelible pencil and ink on paper
12.2 x 21 cm
Itzehoe, Germany,
Wenzel-Hablik-Museum

125 [ill. p. 242]
Sketch for a Spherical Building
From the "Architekturen" (1914-1922)
1920
Pencil on paper
12.5 x 21 cm
Itzehoe, Germany,
Wenzel-Hablik-Museum

126 [ill. p. 240]
Cathedral in the Open Sea
From the "Architekturen" (1914-1922)
1922
Black ink, watercolour and pencil
on cardboard
63 x 47.1 cm
Itzehoe, Germany,
Wenzel-Hablik-Museum

127 [ill. p. 243]
Saturn Box
1922
Brass
31 cm (h.); ring: 35.7 cm (diam.)
Itzehoe, Germany,
Wenzel-Hablik-Museum

JAMES HAMILTON
128 [ill. p. 120]
Glacier from near Upper Navik
About 1852
Watercolour on paper
14.7 x 21.8 cm
Calgary, Glenbow Museum

LAWREN S. HARRIS
129 [ill. p. 141]
From the North Shore, Lake Superior
About 1927
Oil on canvas
121.9 x 152.4 cm
London, Ontario, London Regional
Art and Historical Museums, gift of
H. S. Southam, Esq., Ottawa, 1940

130 [ill. p. 140]
Icebergs, Davis Strait
1930
Oil on canvas
121.9 x 152.4 cm
Kleinburg, Ontario, McMichael
Canadian Art Collection, gift of
Mr. and Mrs. H. Spencer Clark

MARSDEN HARTLEY
131 [ill. p. 237]
Painting Number One, 1913
1913
Oil on canvas
101 x 81 cm
Sheldon Memorial Art Gallery
and Sculpture Garden, University
of Nebraska-Lincoln, F.M. Hall
Collection, 1971.H-39

MONA HATOUM
132 [ill. p. 315]
Socle du monde
(Pedestal of the World)
1992-1993 (reconstructed 1996)
Steel, magnets, iron filings
163.6 x 199.5 x 199.5 cm
Toronto, Art Gallery of Ontario,
gift from the Volunteer Committee
Fund, 1997

PAUL AND PROSPER HENRY
133 [ill. p. 176]
Lunar Photograph
1890
Albumen silver print
26 x 20 cm
Paris, Société française de photographie

134 [ill. p. 176]
Map of the Heavens (January 26, 1894)
Begun 1887
Albumen silver print
30 x 30 cm
Paris, Société française de photographie

SARA HOLT
135 [ill. p. 300]
*"Why" (The Moon from a Rocking
Sailboat, San Miguel Island,
California)*
1981
Colour photograph
120 x 80 cm
Sara Holt collection

MARTIN HONERT
136 [ill. p. 36]
Linden
1990
Wire, insulating cardboard,
polyurethane, polyester, silk paper,
enamel paint
145 x 140 x 140 cm
The Montreal Museum of Fine Arts,
purchase, Camil Tremblay Estate and
Horsley and Annie Townsend Bequest

WILLIAM HENRY JACKSON
137 [ill. p. 105]
*Mammoth Hot Springs, Pulpit
Terraces, Yellowstone*
About 1883
Albumen silver print
43 x 53.1 cm
New York, The Metropolitan Museum
of Art, Rogers Fund, 1974

JULES JANSSEN
138 [ill. p. 177]
*Plate 29 from the "Atlas
de photographies solaires"*
1903
Carbon print
66 x 46 cm
Paris, Société française de photographie

In 1903, Jules Janssen, director of the
Meudon Observatory, published his *Atlas
de photographies solaires*. This mag-
nificent large-format volume was the
culmination of the eminent astronomer's
twenty-eight years of photographic
observations of the sun.
Following his appointment as director
of the new Meudon Observatory in 1875,
Janssen had constructed a special pho-
tographic telescope of his own design,
whose optical system was sensitized
to a part of the solar spectrum barely
visible to the human eye.
The images produced with this "achro-
matized" telescope not only enabled
Janssen to study sunspots but also
revealed for the first time the millions of
granulations that cover the sun's sur-
face. These granulations, each measur-
ing roughly one thousand kilometres
across, are formed by jets of hot gases
streaming from the sun's hotter interior
to its photosphere – the outlying region
that emits most of the sun's visible
light. Exhibiting a turbulent swirling
motion, the granulations take shape,
vanish and re-form in cycles lasting
only a few minutes. Such photographs

provide sobering evidence, Janssen
wrote, that the sun's surface "is ani-
mated by movements of a violence of
which our terrestrial phenomena can
conveyonly a feeble idea".

C.P.

FRANZ JOHNSTON
139 [ill. p. 138]
Northern Night
1946
Oil on board
17.5 x 22.3 cm
Orillia, Ontario, Sir Sam Steele
Art Gallery

ILYA KABAKOV
140 [ill. p. 303]
*The Man Who Flew into Space
from His Apartment*
1981-1988
Installation: bed, springs, rubber,
wood, string, printed matter,
ballpoint pen on paper, dishes,
lamp, model, rubble and plaster dust
280 x 610 x 244 cm
Paris, Musée national d'art moderne/
Centre de création industrielle, Centre
Georges Pompidou

Ilya Kabakov, who graduated as an
illustrator in 1957, created more than a
hundred books for children over a pe-
riod of twenty years. Between 1970 and
1978, he executed *55 Albums,* each
devoted to a character brought to life
by text and images. His first installa-
tions, in the early 1980s, can be read as
transpositions of his *Albufutu. The Man
Who Flew into Space from His Apart-
ment* is a fragment of a ten-chapter
work, *Ten Characters,* created by the
artist between 1981 and 1988. On its
first showing, at Ronald Feldman Fine
Arts, New York, *The Man Who Flew
into Space* was exhibited alongside
The Little Man, The Collector and *The
Composer.*
Ten Characters constitutes a type-list
of *homo sovieticus,* caught between
material poverty and idealistic dreams.
More than any other character in
Kabakov's ten-part work, *The Man Who
Flew into Space* is a bitter and ironic
comment on the gap between Soviet
fantasies of utopia in the 1920s and the
sad existential reality of Soviet citizens
during the Cold War years. The instal-
lation piece shows the bedroom of a
poet or Professor Nimbus who has just
propelled himself into space. The walls
are plastered with promises of political
stability and a glorious future under

the auspices of scientific progress and
communism. In one corner, a model of
the city serves to determine the angle
and trajectory of the flight.
As in the *Albums,* the scene is accom-
panied by dossiers that establish the
context. The first of these flatly recounts
events as they appear in documents left
by the "cosmonaut" and in the reports
of witnesses: accounts by Nicolaev,
Startseva and Golosov, who share the
communal apartment of the man "who
flew into space".
The first story informs us that the
cosmonaut had surmised the existence
of streams of energy leading upwards:
"petals" that intersect cosmic space.
These exert an attraction from an
altitude of forty to fifty metres and can
be reached via the energy fields of the
moon, Sirius and Pluto. The planetary
conjunction favourable to the cosmo-
naut's flight took place on April 14,
1982.
The Man Who Flew into Space is a
metaphor for the flight from Soviet
Russia. As in traditional Russian
folktales and Gogol's novellas, it delib-
erately mingles the symbolic and the
political with the real and the imaginary.
The posters plastered over the cosmo-
naut's bedroom walls (they are easier to
obtain than wallpaper) make the room
a "sanctuary". They are arranged in
three tiers, corresponding to the mytho-
logical levels of existence: the gods, the
everyday and the nether regions.
The Man Who Flew into Space sets up a
dialogue with the age-old Russian dream
of soaring into the sky and inhabiting
space. It falls in line with the projects
of the philosopher Fedorov and the engi-
neer Tsiolkovsky, who envisaged a "spa-
tial migration" destined to halt earth's
overpopulation.Gagarin, the first human
being inspace, completed a project of
which the *Letatlin,* Kibalchich's heli-
copter, and Tsiolkovsky's and Korolev's
rockets represented stages.
Kabakov's installation opposes the sor-
did reality of Soviet communal lodging,
with its human relationships based
on indifference or betrayal, and that
otherwhere of a celestial, cosmic or
paradise world dreamed of in all tra-
ditions. It is not by chance that the
bedroom of *The Man Who Flew into
Space* is bathed in a vivid light that, fall-
ing from the smashed ceiling, recalls
the miraculous lighting effects in
Rembrandt's paintings and Baroque
compositions. Miracles and dream-
worlds are always "up there".

D.O.

VASSILY KANDINSKY
141 [ill. p. 244]
Circles within a Circle
1923
Oil on canvas
97.8 x 95.3 cm
Philadelphia Museum of Art, Louise
and Walter Arensberg Collection

142 [ill. p. 245]
Several Circles
1926
Oil on canvas
140.3 x 140.7 cm
New York, Solomon R. Guggenheim
Museum, gift of Solomon R.
Guggenheim, 1941

ELISHA KENT KANE
143 [ill. p. 121]
Boat and Iceberg
1850-1855
Watercolour on paper
22.2 x 28.9 cm
Calgary, Glenbow Museum

144 [ill. p. 121]
Four Studies of the Ice Break-up
1850-1855
Pencil on paper
23.1 x 30.3 cm
Calgary, Glenbow Museum

145 [ill. p. 121]
Two Studies of Icebergs
1850-1855
Pencil and white pencil on paper
7.6 x 12.7 cm; 7.4 x 10.8 cm
Calgary, Glenbow Museum

JOHN FREDERICK KENSETT
146 [ill. p. 79]
Niagara Falls
1855
Oil on canvas
145.5 x 121.5 cm
The Town of Simsbury, Connecticut,
gift of Antoinette Eno

ANSELM KIEFER
147
Germany in the Night
1981
Album
60 x 31 cm
Private collection

148 [ill. p. 317]
Starfall
1998
Mixed media
465 x 530 cm
Paris, Galerie Yvon Lambert

PAUL KLEE
149 [ill. p. 239]
Cosmos-suffused Landscape
1917
Pen and watercolour on paper,
mounted on gold paper glued
to cardboard
21.1 x 26.4 cm
Ulm, Germany, Ulmer Museum,
property of the state of Baden-
Würtemberg, BW 1971.61

YVES KLEIN
150 [ill. p. 290]
MG 10 ("Silence Is Golden" Monogold)
1960
Gold leaf on wood
148.5 x 114 x 1.5 cm
Private collection

151
COS 34 (Cosmogony of the Storm)
1960
Pure pigment on paper mounted
on cardboard
50 x 65 cm
Private collection

152 [ill. p. 291]
COS 11 (Untitled Cosmogony)
1961
Pure pigment on paper mounted
on cardboard
76 x 105 cm
Cologne, Galerie Gmurzynska

153 [ill. p. 288]
COS 12 (Untitled Cosmogony)
1961
Pure pigment and binder on paper
mounted on wood
105 x 76 cm
Private collection

154 [ill. p. 289]
RP 1 ("Mars" Planetary Relief)
1961
Pure pigment and synthetic resin
on plaster
42.5 x 31 cm
Private collection

155 [ill. p. 290]
RP 12 (Untitled Planetary Relief)
About 1961
Pure pigment and synthetic resin
96 x 69 cm
Private collection

156 [ill. p. 288]
Pneumatic Rocket
1962
Model by Tallon-Technès, painted
and chromed metal, painted rubber
82 x 65 x 77 cm
Private collection

IVAN KLIUN
157 [ill. p. 209]
Spherical Composition
1923
Oil on canvas
64.5 x 64.5 cm
Cologne, Museum Ludwig

158 [ill. p. 208]
Blue Light
1923
Oil on canvas
54.8 x 47.5 cm
Cologne, Galerie Gmurzynska

159 [ill. p. 208]
Red Light, Spherical Composition
About 1923
Oil on canvas
69.1 x 68.9 cm
Art Co. Ltd., George Costakis
collection

JOHN KNOX
160 [ill. p. 40]
Glasgow Panorama
1809
Oil on canvas
31 x 120 cm
Glasgow Museums, The People's
Palace Museum

KRASNODARSK
PORCELAIN FACTORY
Soviet Union

161
Commemorative Cup
1955-1960
Porcelain, enamelled and gilt decoration
8.4 cm (h.); 7.2 cm (diam.)
New York, Cooper-Hewitt, National
Design Museum, Smithsonian
Institution

GEORGY KRUTIKOV
162 [ill. pp. 215-217]
City of the Future
Diploma project: "Development of
urbanistic architectural principles
and organization of the space"
1928
Moscow, A.V. Shchusev State
Research Museum of Architecture

a.
Communal House. Perspective
India ink and pencil on photographic
paper
114.5 x 88 cm

b.
Table 1: *A Flying Housing Unit*
Table 2: *Organization of the Dwellings*
Table 3: *Organization of the Dwellings*
Table 4: *Organization of the City on
Aerial Paths of Communication*
1928
Collage, paper, India ink and
photographs on cardboard
47.8 x 143 cm (overall)

c.
Table 1: *Visual Distortion of a
Moving Form*
Table 2: *Composition of Mobile
Constructions (how it differs from the
composition of immobile constructions)*
Collage, paper, India ink and photo-
graphs on cardboard
47.8 x 71.5 cm

FRANTIŠEK KUPKA

163 [ill. p. 234]
Study for "Disks of Newton"
1911-1912
Watercolour
22.3 x 21.5 cm
Cologne, Galerie Gmurzynska

164 [ill. p. 234]
Animated Lines
1911-1920
Oil on canvas
27.2 x 41.1 cm
Cologne, Galerie Gmurzynska

165 [ill. p. 234]
Study for "Cosmic Spring I"
1911-1920
Gouache, pastel
23.5 x 24.6 cm
Cologne, Galerie Gmurzynska

166 [ill. p. 235]
Cosmic Spring II
1911-1923
Oil on canvas
115 x 125 cm
Prague, Národní Galerie

WILLIAM AND FREDERICK LANGENHEIM

167 [ill. p. 47]
Eclipse of the Sun
1854 (May 26)
7 daguerreotypes
7.2 x 5.9 cm (four 1/6 plate daguerre-
otypes); 3.2 x 2.5 cm (three 1/16 plate
daguerreotypes)
Gilman Paper Company Collection

EL LISSITZKY

168 [ill. p. 212]
Proun 4B
1919-1920
Oil on canvas
70 x 55.5 cm
Madrid, Fundación Colección
Thyssen-Bornemisza

169 [ill. p. 212]
Proun G7
1923
Poster paint, tempera, varnish
and pencil on canvas
77 x 62 cm
Düsseldorf, Kunstsammlung
Nordrhein-Westfalen

MAURICE LŒWY AND PIERRE PUISEUX

170 [ill. p. 156]
*Cassini – Valley of the Alps –
North Pole*
Plate 13 from the *Atlas photographique
de la Lune*
1894-1908
Photogravure
79 x 59 cm
Courtesy of Julie Saul Gallery,
New York

171 [ill. p. 156]
Clavius, Tycho, Stoefler
Plate 17 from the *Atlas photographique
de la Lune*
1894-1908
Photogravure
79 x 59 cm
Courtesy of Julie Saul Gallery,
New York

J.E.H. MACDONALD

172 [ill. p. 138]
Northern Lights
About 1915-1916
Oil on panel
17.5 x 22.3 cm
Kleinburg, Ontario, McMichael
Canadian Art Collection, gift of the
founders, Robert and Signe McMichael

173 [ill. p. 138]
Aurora, Georgian Bay, Pointe au Baril
1931
Oil on panel
21.5 x 26.6 cm
Kleinburg, Ontario, McMichael
Canadian Art Collection, gift of
Mr. R. A. Laidlaw

STANTON MACDONALD-WRIGHT

174 [ill. p. 236]
Conception Synchromy
1915
Oil on canvas
76.2 x 61 cm
New York, Whitney Museum of
American Art, gift of George F. Of

JOHN MACWHIRTER

175 [ill. p. 79]
The Valley of Slaughter, Skye
By 1876
Oil on canvas
88.3 x 134.6 cm
The Montreal Museum of Fine Arts,
gift of Lord Strathcona and his family

RENÉ MAGRITTE

176 [ill. p. 262]
The Burning Landscape
1928
Oil on canvas
54.7 x 73.2 cm
Rome, Galleria Nazionale d'Arte
Moderna

KAZIMIR MALEVICH

177 [ill. p. 201]
Suprematism
1916
Oil on canvas
80.5 x 71 cm
Saint Petersburg, State Russian
Museum

178 [ill. pp. 202-203]
Suprematist Cosmos
7 drawings
Pencil on paper
New York, Leonard Hutton Galleries

Contrast of Forms
1916
21.5 x 17.2 cm

Cosmos I
1916-1917
17.8 x 11.1 cm

Cosmos
1916-1917
17.8 x 13 cm

Suprematist Composition
1916-1917
17.8 x 11.1 cm

Contrast of Forms
1916-1917
19.2 x 14.3 cm

Drop (Cosmos)
1917
14.9 x 11.1 cm

From the Cosmos
About 1917-1918
21 x 12.4 cm

179 [ill. p. 200]
Magnetic Suprematism
4 drawings
Pencil on paper
New York, Leonard Hutton Galleries

Magnetic Suprematism
1917
20.6 x 17.2 cm

Magnetic Suprematism
1917
18 x 17.7 cm

Magnetic Suprematism
1917
20 x 13 cm

Suprematist Elements
About 1917
19.1 x 13 cm

180 [ill. p. 272]
Kazimir Malevich (designer of model)
Ilia Chashnik (designer of painted decoration)
Half Cup
1923
Produced by State Porcelain Factory, Petrograd
Porcelain, enamelled decoration
6 cm (h.)
New York, Cooper-Hewitt, National Design Museum, Smithsonian Institution/Art Resource

DAVID MALIN
The images by David Malin exhibited as slide projections; the "AAT" numbers are Anglo-Australian Observatory reference numbers.

181 [ill. p. 318]
The Orion Nebula (M42 and M43)
1979 (February)
Three-colour print
Epping, Australia,
collection of the artist
AAT 19

182 [ill. p. 320]
The Globular Cluster Tucanae (NGC 104)
1980 (December)
Three-colour print
Epping, Australia,
collection of the artist
AAT 76

183 [ill. p. 319]
A Reflection Nebula in Orion (NGC 1977)
1983 (January)
Three-colour print
Epping, Australia,
collection of the artist
AAT 34

184 [ill. p. 318]
A Spiral Galaxy (M83, NGC 5236)
1985 (May)
Three-colour print
Epping, Australia,
collection of the artist
AAT 8

185 [ill. p. 319]
Colour Picture of CG4, a Cometary Globule
1990 (December)
Three-colour print
Epping, Australia,
collection of the artist
AAT 71

186 [ill. p. 320]
The Sombrero Galaxy (M104, NGC 4594)
Three-colour print
1993 (March)
Epping, Australia,
collection of
the artist
AAT 100

JOHN MARTIN
187 [ill. p. 31]
The Expulsion of Adam and Eve
1824-1827
Oil on canvas
78.7 x 110.5 cm
Newcastle upon Tyne, Laing Art Gallery (Tyne and Wear Museums)

188 [ill. p. 30]
Fallen Angels Entering Pandemonium
1829-1832
Oil on canvas
62.2 x 76.5 cm
London, Tate Gallery, purchased 1943

The Bible was John Martin's favourite source of inspiration, in that the holy book contains the finest apocalyptic scenes. Deeply imbued with the Prot-
estant ethic, he portrayed humanity living and dying between heaven and hell, tempted, inspired, cursed and redeemed. Earthly powers assert their splendour only to be destroyed, in the fullness of time, by fire and flood, by God and by Satan, by God and Nature. This devotee of a cyclical notion of history was also the painter of an England then transforming itself into an industrial power where foundries, mines and railroads show Pandemonium become reality, the true forge of Evil.
The painting, astounding in its hellish monochrome red, shows the huge cave where the rebellious fallen angels wait to attend on Satan. It is one of Martin's most impressive canvases inspired by Milton's epic and finds its proper place among the fine series of mezzotints he was to execute for *Paradise Lost*.

J.C.

ANDRÉ MASSON
189 [ill. p. 252]
The Constellations
1925
Oil on canvas
Paris, private collection

190 [ill. p. 260]
Celestial Signs
1938
Ink on paper
50 x 66 cm
Paris, private collection

191 *The Constellation Lupus*
1942
Oil on canvas
24 x 29
Paris, private collection

GEORGES MÉLIÈS
192 [ill. pp. 162-163]
Six Drawings from the Film "A Trip to the Moon" (1902)
Paris, Bibliothèque du film (BIFI), Cinémathèque française collection

The Giant Cannon
Date unknown
Ink, ink wash
28 x 35 cm

Square in the Eye!!
Date unknown
Ink, ink wash
27 x 35 cm

Earthlight
1932
Ink wash
28 x 35 cm

(Ursa Major.) Jupiter Sets Fire to
the Craters and Raises a Snow Storm
against the Intruders
Date unknown
Ink wash, gouache
28 x 35 cm

The Grotto of Giant Mushrooms.
The First Selenite
1932
Ink wash
28 x 35 cm

The Selenites
1932
Ink wash
21 x 15 cm

CLAUDE MELLAN
193 [ill. p. 150]
The Moon, Last Quarter
1636
Engraving
23 x 13.5 cm
Paris, Bibliothèque nationale de
France, Département des estampes
et de la photographie

194 [ill. p. 150]
Full Moon
1636
Engraving
24.5 x 21.3 cm
Paris, Bibliothèque nationale de
France, Département des estampes
et de la photographie

ERICH MENDELSOHN
195 [ill. p. 56]
Model of the "Einstein Tower"
1919-1921 (reconstruction by
Étienne Follefant, 1978)
Painted wood
35.5 x 71.5 x 24.5 cm
Paris, Musée national d'art moderne/
Centre de création industrielle,
Centre Georges Pompidou

DUANE MICHALS
196 [ill. pp. 294-295]
The Human Condition
1969
6-photograph sequence of gelatin
silver prints
10.2 x 12.7 cm each
Courtesy of Sidney Janis Gallery,
New York

JOAN MIRÓ
197 [ill. p. 258]
Blue
1925 (Montroig, July-September)
Oil on canvas
62 x 92 cm
Paris, Galerie Maeght

198 [ill. p. 253]
Sunrise
From the "Constellation" series
1940 (Varengeville, January 21)
Gouache and oil wash on paper
37.8 x 45.6 cm
The Toledo Museum of Art,
gift of Thomas T. Solley

199 [ill. p. 255]
Awakening in the Early Morning
From the "Constellation" series
1941 (Palma de Mallorca, January 27)
Gouache and oil wash on paper
46 x 38 cm
Fort Worth, Texas, Kimbell Art
Museum, acquired with the generous
assistance of a grant from
Mr. and Mrs. Perry R. Bass

200 [ill. p. 254]
The Passage of the Divine Bird
From the "Constellation" series
1941 (Montroig, September 12)
Gouache and oil wash on paper
45.7 x 37.8 cm
The Toledo Museum of Art,
purchased with funds from the
Libbey Endowment, gift of
Edward Drummond Libbey

RICHARD MISRACH
201 [ill. p. 316]
Clouds, Fool's Pond, 6.30.96,
11:41-11:56 P.M.
1996
Chromogenic dye-coupler print, 2/3
121.3 x 154.3 cm
The Montreal Museum of Fine Arts,
purchase, Horsley and Annie Townsend
Bequest

202 [ill. p. 316]
Cassiopeia over Unnamed Playa,
7.4.96, 11:29-11:58 P.M.
1996
Chromogenic dye-coupler print, 1/3
121.3 x 154.3 cm
The Montreal Museum of Fine Arts,
purchase, Horsley and Annie Townsend
Bequest

THOMAS MITCHELL
203 [ill. p. 128]
View from Bessels Fiord, Greenland,
Looking Northwest
1875 (August 23-24)
Watercolour over pencil with opaque
white on paper
11.2 x 127.5 cm
Ottawa, National Archives of Canada,
1936-259-12

204 [ill. p. 130]
Arctic Terrain with Cairn
About 1875-1876
Watercolour on paper
23.5 x 32.8 cm
Ottawa, National Archives of Canada,
1936-259-1

205
Aurora Borealis at Lady Franklin Bay,
Ellesmere Island
About 1875-1876
Watercolour over pencil with
scraping-out on paper
24.9 x 35.3 cm
Ottawa, National Archives of Canada,
1936-259-16

206 [ill. p. 128]
Return of the Sun to Discovery
Harbour, Ellesmere Island
1876 (March 1)
Watercolour and opaque white
on paper
25.1 x 47.9 cm
Ottawa, National Archives of Canada,
1936-259-21

207 [ill. p. 130]
Westward Ho! Valley, Ellesmere Island
1876 (May 16)
Watercolour over pencil with opaque
white on paper
22.7 x 30.5 cm
Ottawa, National Archives of Canada,
1936-259-20

208 [ill. p. 130]
From Cape Frazer, Ellesmere Island,
Looking North
1876 (August 22-24)
Watercolour over pencil with opaque
white on paper
25 x 35.2 cm
Ottawa, National Archives of Canada,
1936-259-10

PIET MONDRIAN
209 [ill. p. 35]
Blue Tree
About 1909-1910
Oil on composition board
56.8 x 74.9 cm
Dallas Museum of Art, Foundation
for the Arts Collection, gift of James
H. and Lillian Clark Foundation

In 1908, Mondrian discovered in quick
succession the late works of Van Gogh
and the impact on Dutch painting of Divi-
sionism's broken colour and of Fauvism's
use of pure colour. He then went through
a brief Symbolist period (1908-1911),
which was marked by a spiritual quest
for the universal – a quest no doubt
encouraged by his joining the Dutch
Theosophical Society in 1909. Returning
to the Romantic ideal, he began to focus
on themes that, like this isolated tree,
recall Friedrich.
Mondrian's adaptation of the free poin-
tillist stroke to his personal style and
his use of close framing move him away
from Naturalist space; he seeks instead
to make visible the relationship of the
tree with the space surrounding it. A
bluish light radiates from a stylized
outline, hinting at life's potential. With
its roots plunging into the earth and its
branches reaching up to the sky, the bare
tree standing at the painting's centre
represents an almost universal symbol
of both the rebirth of the cosmos and
the axis of the world.
 C.N.-R.

THOMAS MORAN
210 [ill. p. 75]
Hot Springs of the Yellowstone
1872
Oil on canvas
41 x 76.2 cm
Los Angeles County Museum of Art,
gift of Beverly and Herbert M. Gelfand

211 [ill. p. 78]
The Grand Canyon of the Yellowstone
1872
Watercolour on paper
28.6 x 20.3 cm
Tulsa, Oklahoma,
The Gilcrease Museum

212 [ill. p. 78]
Wyoming Falls, Yellowstone River
1872
Watercolour on paper
33 x 19.1 cm
Tulsa, Oklahoma,
The Gilcrease Museum

213 [ill. p. 78]
Tower Falls
1872
Watercolour on paper
28.6 x 19.7 cm
Tulsa, Oklahoma,
The Gilcrease Museum

214 [ill. p. 78]
The Upper Falls of the Yellowstone
1872
Watercolour on paper
26 x 20.6 cm
Tulsa, Oklahoma,
The Gilcrease Museum

215 [ill. p. 76]
Lower Falls, Yellowstone Park
1893
Oil on canvas
102.9 x 153 cm
Tulsa, Oklahoma,
The Gilcrease Museum

SAMUEL F.B. MORSE
216 [ill. p. 72]
Niagara Falls from Table Rock
1835
Oil on canvas
61 x 76.2 cm
Museum of Fine Arts, Boston, Martha
C. Karolik bequest for the M. and M.
Karolik Collection of American
Paintings, 1815-1865, 48.456

EADWEARD MUYBRIDGE
217 [ill. p. 102]
*Tenaya Canyon, Valley of the
Yosemite from Union Point*
1872
Albumen silver print
42.4 x 54 cm
New York, The Metropolitan Museum
of Art, David Hunter McAlpin Fund,
1966

218 [ill. p. 103]
Mirror Lake, Valley of the Yosemite
1872
Albumen silver print
42.8 x 54.3 cm
New York, The Metropolitan Museum
of Art, David Hunter McAlpin Fund,
1966

219 [ill. p. 102]
Yosemite Studies
1872
Albumen silver prints (stereograph)
8.9 x 17.8 cm
Robert N. Dennis Collection of
Stereoscopic Views, Miriam and
Ira D. Wallach Division of Art, Prints
and Photographs. The New York
Public Library. Astor, Lenox and
Tilden Foundations

NASA, LUNAR SURVEYOR
220 [ill. p. 158]
Day 010, Survey A, Sectors 13 and 14
1966-1968
Photomosaic of gelatin silver prints
91.4 x 30.5 cm
Noelle C. Giddings and Norman
Brosterman collection

221 [ill. p. 159]
Day 262, Survey W-N
1966-1968
Photomosaic of gelatin silver prints
30.5 x 91.4 cm
Noelle C. Giddings and Norman
Brosterman collection

222 [ill. p. 158]
Day 328, Survey EE, Sectors 9 and 10
1966-1968
Photomosaic of gelatin silver prints
91.4 x 30.5 cm
Noelle C. Giddings and Norman
Brosterman collection

NASA, LUNAR ORBITER
223 [ill. p. 161]
*View of the Earth and the Moon
by Orbiter Mission Satellite*
1967
Gelatin silver print
43 x 35 cm
Courtesy of Charles Isaacs
Photographs

224 [ill. p. 157]
*View of the Moon by Orbiter Mission
Satellite*
1967
Adjoining gelatin silver prints
137 x 40 cm
Washington, Gary Edwards Gallery

225 [ill. p. 157]
*View of the Moon by Orbiter Mission
Satellite*
About 1967
Adjoining gelatin silver prints
162 x 46 cm
Washington, Gary Edwards Gallery

**NASA, JET PROPULSION
LABORATORY, VIKING ORBITER**
226 [ill. p. 55]
The Red Planet Mars
1976-1980
Dye-coupler print, digital composite
from Viking Orbiter images
122 x 122 cm
Tucson, Center for Creative
Photography, University of Arizona,
98.064.005

**NASA, SPACE SHUTTLE
MISSION STS 41-B**
227 [ill. p. 57]
*View of Extravehicular Activity
during STS 41-B*
1984
Colour photograph
20.5 x 20.5 cm
Courtesy of NASA

BARNETT NEWMAN
228 [ill. p. 259]
Yellow Edge
About 1968
Acrylic on canvas
238.4 x 198.2 cm
Ottawa, National Gallery of Canada,
gift of Annalee Newman,
New York, 1990

WILLIAM McFARLANE NOTMAN
229 [ill. p. 99]
*Looking down Bow Valley from
CPR Hotel, Banff*
1887
Albumen silver print
42.9 x 52.9 cm
Ottawa, National Gallery of Canada

230 [ill. p. 98]
Mountains at Canmore
1889
Albumen silver print
44.3 x 54.7 cm
Ottawa, National Gallery of Canada

TIMOTHY O'SULLIVAN
231 [ill. p. 100]
*Rock Formations (Tufa Domes),
Pyramid Lake, Nevada*
1867
Albumen silver print
20 x 27 cm
The American Geographical Society
Collection of the University of
Wisconsin-Milwaukee Library

232 [ill. p. 100]
*Steamboat Springs, Ruby Valley,
Nevada*
1867
Albumen silver print
45.6 x 60.8 cm
The American Geographical Society
Collection of the University of
Wisconsin-Milwaukee Library

233 [ill. p. 101]
Tufa: Pyramid Lake
1867
Albumen silver print
20 x 27 cm
The American Geographical Society
Collection of the University of
Wisconsin-Milwaukee Library

CLAUDIO PARMIGGIANI
234 [ill. p. 293]
The Elements
1968
Collage
21.8 x 28.4 cm
Private collection

235 [ill. p. 297]
Scholar Reading
1969
Collage
25.5 x 19.8 cm
Paris, Liliane and Michel
Durand-Dessert collection

236 [ill. p. 300]
Phisiognomoniae coelestis, for Adalgisa
1975
Colour photographs mounted
on plywood
90 x 120 cm (diptych)
Paris, Jean Charles de Castelbajac
collection

237 [ill. p. 280]
Ascent of Memory
1976
Installation: white crayon, canvas,
bread, wood
Frame: 130 cm (diam.);
ladder: 220 x 40 cm;
base (trapezoidal): 125 cm (sides);
20 cm (front edge); 90 cm (back edge)
Collezione "Campiani"

238 [ill. p. 302]
*Untitled (Hand with Moon, Hand
with Butterfly, Hand with Earth)*
1983
3 collages
36 x 26 cm each
Paris, Fondation Cartier pour l'art
contemporain

GIUSEPPE PELLIZZA DA VOLPEDO
239 [ill. p. 175]
The Rising Sun
1904
Oil on canvas
150 x 150 cm
Rome, Galleria Nazionale d'Arte
Moderna

ANTOINE PEVSNER
240 [ill. p. 213]
*Spatial Construction in the Third
and Fourth Dimensions*
1961
Bronze, 3/3
99.5 x 60 x 54 cm (2 sections)
Duisburg, Germany,
Wilhelm Lehmbruck Museum

PABLO PICASSO
241 [ill. p. 254]
Sketchbook
1924 (Juan-les-Pins, summer)
India ink and sanguine crayon
on Arches paper
31.5 x 23.5 cm
Paris, Musée Picasso

In 1924, Picasso began covering the
pages of his precious sketchbooks with
a new kind of drawing, an increasingly
abstract calligraphy of dots and fine
lines; this soon became a maze of curv-
ing lines that culminated in the great
grisaille *Painter and His Model* of 1926,
an illustration for Balzac's *Unknown
Masterpiece*.
These drawings of straight and curved
lines emphasized by dots at the intersec-
tions make up figures at the turning
point of a number of worlds – human,
vegetable, organic, musical (in the shape
of instruments), but also and above all,
cosmic. Whether schematic or skeletal,
they evoke diagrams, structures of
living organisms, even constellations.
They were to reveal their full meaning
in his designs for openwork sculptures,
particularly the Monument to Guillaume
Apollinaire of 1928.
The Surrealists had been attracted by
these stark graphics midway between
anthropomorphism and abstraction, and
published two full-page reproductions
from the sketchbooks in the second
issue of *La révolution surréaliste* in
1925. The influence of these works can
also be seen in Miró's "Constellations"
and later in Calder's filiform construc-
tions punctuated by circles, which also
evoke the movement of constellations.
The disorder of the curvilinear skein in
Painter and His Model is also – purely
by chance? – not unlike the spontaneous,
or automatic, drawing Max Ernst
achieved by anticipating "dripping" in
his painting *The Bewildered Planet*.

J.C.

242 [ill. p. 164]
Horse Lying Down
1930 (Juan-les-Pins, September 5)
India ink over a photograph of
the moon
8.8 x 14 cm
Paris, Musée Picasso

MIKHAIL PLAKSIN
243 [ill. p. 213]
Planetary
1922
Oil on canvas
71.9 x 61 cm
Art Co. Ltd., George Costakis collection

PIERRE PUISEUX
See cats. 170-171.

ROBERT RAUSCHENBERG
244 [ill. p. 296]
Sky Garden
From the series "Stoned Moon"
1969
6-colour lithograph/silkscreen
on Special Arjomari paper
226.1 x 106.7 cm
Courtesy of Gemini G.E.L.,
Los Angeles

ODILON REDON
245 [ill. p. 174]
*Standing Nude Woman Surrounded
with Circles*
About 1870
Pencil on paper
12.9 x 15.8 cm
Paris, Musée du Petit Palais, gift
of Jacques Zoubaloff, 1917

246 [ill. p. 174]
*The Eye, like a Strange Balloon,
Moves towards Infinity*
Plate 1 from the series "To Edgar
Allan Poe"
1882
Lithograph on chine appliqué
26 x 19.6 cm
Cambridge, Massachusetts, Harvard
University Museums, Fogg Art
Museum, gift of Philip Hofer

GERMAINE RICHIER
247 [ill. 261]
The Tendril
1956
Cleaned natural bronze
152 x 33 x 27 cm
Germaine Richier family collection

JEAN-PAUL RIOPELLE
248 [ill. p. 140]
Pangnirtung
1977
Oil on canvas
192.5 x 550 cm (triptych)
Quebec City, Musée du Québec

ALEXANDR RODCHENKO
249 [ill. p. 199]
Points: Composition No. 119
1920
Oil on canvas
47 x 37.5 cm
Cologne, Galerie Gmurzynska

250 [ill. p. 210]
*Spatial Construction No. 9
(The Circle in the Circle)*
1920-1921 (reconstruction by
Alexander Lawretiew, 1993)
Peachtree-plywood, 1/7
90 x 80 x 85 cm
Cologne, Galerie Gmurzynska

251 [ill. p. 210]
*Spatial Construction No. 10
(The Hexagon in the Hexagon)*
1920-1921 (reconstruction 1979)
Aluminum
59 x 68 x 59 cm
Cologne, Galerie Gmurzynska

JOHN ROSS
252 [ill. p. 120]
*Passage through the Ice, June 16, 1818,
Latitude 70°, 44' N.*
1818
Watercolour over pencil on paper
16.2 x 19.5 cm
Ottawa, National Archives of Canada,
1973-9-2

253 [ill. p.120]
*A Remarkable Iceberg,
Latitude 70°, 45' N., June 19, 1818*
1818
Watercolour over pencil on paper
16.3 x 19.6 cm
Ottawa, National Archives of Canada,
1973-9-5

MARK ROTHKO
254 [ill. p. 259]
Untitled (Black and Grey)
1969
Acrylic on canvas
176.9 x 157.9 cm
Washington, National Gallery of Art,
gift of the Mark Rothko Foundation
Inc., 1986.43.163

ROTRAUT
255 [ill. p. 298]
Black Hole
1974
Acrylic on canvas
140 x 130 cm
Private collection

256 [ill. p. 298]
Mother Earth around the World
1993
Acrylic on canvas
121.9 x 96.5 cm
Private collection

THOMAS RUFF
257 [ill. pp. 306-307]
*Stars
1.55 A.M. / -30°, 1989
4.30 P.M. / -55°, 1989
8 P.M. / -50°, 1989
8.52 A.M. / -45°, 1991
4.40 A.M. / -45°, 1992*
1989-1992
5 colour photographs
260 x 188 cm each
Paris, Galerie Nelson

JOHN RUSSELL
258 [ill. p. 151]
Lunar Planisphere
1805-1806
Engraving
40.7 x 40.2 cm
London, Christopher Mendez
collection

MORGAN RUSSELL
259 [ill. p. 236]
Synchromy No. 6
About 1922-1923
Oil on canvas
26 x 33 cm
New York, Whitney Museum of
American Art, Lawrence H. Bloedel
Bequest

LUIGI RUSSOLO
260 [ill. p. 189]
Houses + Lights + Sky
1912-1913
Oil on canvas
100.3 x 100.3 cm
Öffentliche Kunstsammlung Basel,
Kunstmuseum, gift of Sonia Delaunay,
2236

261 [ill. p. 189]
Aurora Borealis
1938
Oil on canvas
60 x 91 cm
Private collection

LEWIS MORRIS RUTHERFURD
262 [ill. p. 152]
The Moon, New York
1865 (March 6)
Albumen silver print
71 x 45 cm
Private collection

ELIEL SAARINEN
263 [ill. p. 273]
Coffee Urn and Tray
Designed about 1933-1934
Produced by Wilcox Silver Plate
Company/International Silver
Company, Meriden, Connecticut
Silverplate
1934-1935
Urn: 36.2 cm (h.); tray: 53.3 cm
(diam.)
Bloomfield Hills, Michigan,
Cranbrook Art Museum,
CAM 1935.8 a-b

NICOLAS SANSON
264 [ill. p. 49]
Planisphere of the Heavens
1658
Hand-coloured copper engraving
44.6 x 58.7 cm
Montreal, Stewart Museum at the Fort,
Île Sainte-Hélène, 1979.529.1

PIETER SCHENK
AND GERARD VALK
See also cats. 345-346.
265 [ill. p. 49]
*Planisphaerium Copernicanum sive
systema universi totius creati ex
hypothesi Copernicana in plano
exhibitum*
(Copernican Planisphere, or A system
of the whole universe based on the
hypothesis of Copernicus, displayed
on a flat surface)
1706
Hand-coloured copper engraving
47.5 x 56.5 cm
Montreal, Stewart Museum at the
Fort, Île Sainte-Hélène, 1979.528.1

ELSA SCHIAPARELLI
266 [ill. p. 274]
Cape from the "Cosmique" Collection
1938-1939
Embroidered by Maison Lesage, Paris
Wool, metallic thread
86 x 45 cm
Musée de la Mode de la Ville de Paris,
Musée Galliera

267 [ill. p. 275]
*Dinner Jacket from the "Cosmique"
collection*
1938-1939
Embroidered by Maison Lesage, Paris
Silk velvet, metallic foil thread, glass
beads, rhinestones
53.3 x 45.7 cm; sleeve: 50.8 cm
Brooklyn Museum of Art, gift of
Mrs. Anthony V. Lynch, 71.67

The midnight blue velvet jacket by Elsa
Schiaparelli was presented in Paris as
part of the designer's "Cosmique" col-
lection for autumn-winter 1938-1939.
The front of the jacket is edged with
signs of the Zodiac embroidered in
gold metallic threads within rectangu-
lar panels outlined in silver threads
and beads. The front of the vest is also
decorated with shooting stars, planets,
spiral galaxies and crescent moons.
The glittering haze of the Milky Way is
suggested by tiny glass beads scattered
in clusters among the constellations.
Small plastic stars are arranged in the
forms of the Big Dipper and Ursa
Minor.
The focus of some of the most spec-
tacular creations by Schiaparelli is
the sumptuous embroidery, which was
created by the Maison Lesage in Paris.
The evening cape from this same astrol-
ogy series is another example of the
sensational effect of embroidery in
Schiaparelli creations. The back of the
cape is decorated with a "shocking
pink" sun; its rays of metallic gold
and silver threads are dazzling, placed
against the background of the striking
pink colour that became a hallmark of
the Schiaparelli look.
The vest and cape were created when
Schiaparelli was at the peak of her
career in Paris. Born in Rome in 1890,
she had grown up in the privileged sur-
roundings of the Royal Academy of
Lincei, where her father was head of the
library. Her uncle, Giovanni Schiaparelli,
was a famous astronomer and director
of the Brera Observatory in Milan. His
discovery of what he called *canali*
("canals" or "channels") on Mars pro-
voked an international debate on the
possibility of human life there. Elsa
Schiaparelli's interest in astronomy
may have been influenced by her uncle,
whom she knew well. Her early years
in Italy, surrounded by books and
scientific objects, inspired some of her
later creations asone of Paris's foremost
couturiers.

R.P.

KATY SCHIMERT
268 [ill. p. 312]
The Moon
1995
Aluminum screen
365.8 x 243.8 x 15.2 cm
Susan and Michael Hort collection

KARL FRIEDRICH SCHINKEL
See also cat. 302.
269 [ill. p. 28]
The Gate of Rock
1818
Oil on canvas
74 x 48 cm
Staatliche Museen zu Berlin,
Nationalgalerie

GEORGE SEGAL
270 [ill. p. 302]
Jacob's Dream
1984-1985
Painted plaster, wood, rock, electric
light, plastic
213.4 x 304.8 x 127 cm
Courtesy of Sidney Janis Gallery,
New York

GINO SEVERINI
271 [ill. p. 234]
Expanding Forms
About 1914
Oil on canvas
49 x 38 cm
Private collection

VLADIMIR SKODA
272 [ill. p. 304]
Untitled
1988
Etching
220 x 125 cm (triptych)
Private collection

273 [ill. p. 313]
Badria
1996
Installation
Stainless steel ball: 25 cm (diam.);
box with projector: 50 x 35 x 16 cm
Collection of the artist

NAUM SLUTZKY
274 [ill. p. 273]
Pendant
About 1927
White gold, hematite, moonstones
7.3 cm (h.); 4.8 cm (diam.)
Museum für Kunst und Gewerbe
Hamburg

275 [ill. p. 273]
Pendant
About 1927
White gold, agate, moonstones,
zirconium, rock crystal
5.3 cm (diam.)
Museum für Kunst und Gewerbe
Hamburg

KIKI SMITH
276 [ill. p. 314]
Stars and Scat
1996
Schott crystal, bronze, blue Nepal paper
19.1 x 777.2 x 360.7 cm
Courtesy of Anthony d'Offay Gallery,
London

NIKOLAI SOUÏETINE (SUETIN)
277 [ill. p. 207]
Suprematism
1920-1921
Oil on canvas
53 x 70.5 cm
Madrid, Fundación
Colección Thyssen-Bornemisza

278 [ill. p. 272]
*Cup and Saucer with Suprematist
Design*
1923
Porcelain, hand-painted enamel
decoration
Cup: 5.7 cm (h.);
saucer: 14.4 cm (diam.)
New York,
Leonard Hutton Galleries

279 [ill. p. 272]
*Cup and Saucer with Suprematist
Design*
1923
Porcelain, hand-painted enamel
decoration
Cup: 6 cm (h.);
saucer: 14.3 cm (diam.)
New York,
Leonard Hutton Galleries

280 [ill. p. 206]
Suprematist City
1931
Pencil on cardboard
49.4 x 50.5 cm
Cologne, Galerie Gmurzynska

EDDIE SQUIRES
281 [ill. p. 296]
"Lunar Rocket" Fabric
1969
Produced by Warner Fabrics Plc
Cotton
122 x 119 cm
London, Warner Fabrics Plc

VLADIMIR STENBERG
282 [ill. p. 211]
Spatial Apparatus KPS 43 N VI
1919 (reconstruction, 1973)
Aluminum
235 x 70 x 215 cm
Cologne, Galerie Gmurzynska

ALFRED STEVENS
283 [ill. p. 166]
The Milky Way
About 1885-1886
Oil on canvas
68 x 53 cm
Brussels, Galerie Patrick Derom

ALFRED STIEGLITZ
284 [ill. p. 38]
A Dirigible
1910-1911
Photogravure on Japan paper
17.7 x 17.9 cm
Ottawa, National Gallery of Canada,
gift of Dorothy Meigs Eidlitz,
St. Andrews, New Brunswick, 1968

AUGUST STRINDBERG
285 [ill. pp. 178-179]
Celestographs
1894 (copy print by Olof Wallgreen,
1995)
5 photographs
9 x 6 cm each
Stockholm, Kungliga Biblioteket,
courtesy of Strindbergsmuseet

As an artist and as a writer, Strindberg
often expressed his confidence in the
images produced by nature and referred
to the tendency of matter to create
images by which, according to a tradi-
tion handed down by the *Naturphi-
losophie* of the Romantics, it reveals
itself to us through signs and symbols.
Thus, all shapes in nature constitute a
kind of secret writing. Strindberg's
ideal as a painter was to imitate this
unconscious way of creating images.
But the photographs dubbed "celesto-
graphs", made without a lens or
darkroom, are perhaps even closer to
what he called in an essay "natural art".

Strindberg carried out these experi-
ments in Austria between the winter of
1893 and the spring of 1894. The plates
were directly exposed to the starry sky,
on a window ledge. The resulting
images were dark, sullen, sprinkled with
white points, "the stars" in Strindberg's
eyes. The following year, he submitted
them to Camille Flammarion and his
Société astronomique de France. Despite
a penchant for occultism and the para-
normal, Flammarion must have found
the artist's methodology too eccentric,
and the Société did not grant Strindberg
the certificate he had expected.

J.C.

NIKOLAI SUETIN
See cats. 277-280.

LÉOPOLD SURVAGE
286 [ill. p. 231]
Coloured Rhythm
1912
Pencil and ink on paper mounted
on cardboard
30.2 x 26 cm
Paris, Musée national d'art moderne/
Centre de création industrielle,
Centre Georges Pompidou

287 [ill. p. 230]
Coloured Rhythm
1913
Pencil and ink on paper
49 x 45 cm
Paris, Musée national d'art moderne/
Centre de création industrielle,
Centre Georges Pompidou

288 [ill. p. 231]
Coloured Rhythm
1913
Pencil and ink on paper
49 x 45 cm
Paris, Musée national d'art moderne/
Centre de création industrielle,
Centre Georges Pompidou

289 [ill. p. 230]
Coloured Rhythm
1913
Coloured ink on paper
48.7 x 44.9 cm
Paris, Musée national d'art moderne/
Centre de création industrielle,
Centre Georges Pompidou

MARK TANSEY
290 [ill. p. 305]
Action Painting II
1984
Oil on canvas
193 x 279.4 cm
The Montreal Museum of Fine Arts,
gift of Nahum Gelber, Q.C.

291 [ill. p. 305]
Clockwork
1993
Oil on canvas
213.4 x 162.6 cm
Los Angeles, Steve Tisch

BRUNO TAUT
292 [ill. p. 238]
Bruno Taut (designer)
Blanche Mahlberg (inventor)
Dandanah, the Fairy Palace
1919
Box of 51 blocks of coloured cast glass
Linear pieces: 2.5 x 5 x 2 cm (max.);
spherical: 2.3 cm (diam.); triangular:
2.7 cm (longest side); cubic: 2 cm
Private collection, on permanent
loan to the Canadian Centre for
Architecture, Montreal

293 [ill. p. 223]
Alpine Architektur
Hagen: Folkwang-Verlag, 1919
40 x 33.8 cm
Montreal, Canadian Centre
for Architecture

294 [ill. p. 223-224]
*Der Weltbaumeister. Architektur-
Schauspiel für symphonische Musik*
Hagen: Folkwang-Verlag, 1920
23.2 x 19.2 cm
Montreal, Canadian Centre
for Architecture

295
Die Auflösung der Städte
Hagen: Folkwang-Verlag, 1920
27.3 x 21.5 cm
Montreal, Canadian Centre
for Architecture

ILIA TCHACHNIK (CHASHNIK)
296 [ill. p. 204]
Suprematist Relief
1922
Painted cardboard
11.3 x 18.5 cm
Private collection, courtesy of Galerie
Gmurzynska, Cologne

297 [ill. p. 272]
Plate
1922-1923
Porcelain, enamelled decoration
18.1 cm (diam.)
New York, Leonard Hutton Galleries

298 [ill. p. 205]
Cosmos – Red Circle on Black
1925
India ink and watercolour on paper
37.2 x 32.8 cm
Private collection

299 [ill. p. 204]
Architecton
1925-1926
Pencil on paper
22 x 17.7 cm
Cologne, Galerie Gmurzynska

300 [ill. p. 204]
Architecton
1925-1926
Pencil on paper
17.6 x 22 cm
Cologne, Galerie Gmurzynska

301 [ill. p. 204]
Architecton
1925-1926
Pencil on paper
22 x 17.7 cm
Cologne, Galerie Gmurzynska

KARL FRIEDRICH THIELE,
AFTER KARL FRIEDRICH SCHINKEL
302 [ill. p. 50]
*Set Design for "The Magic Flute":
The Entrance of the Queen of the
Night (Act I, Scene VI)*
Folio 14 from *Decorationen auf dem
beiden königlichen Theatern in Berlin*
1819
Hand- and plate-coloured aquatint
40.6 x 53.3 cm
New York, The Metropolitan Museum
of Art, The Elisha Whittelsey
Collection, The Elisha Whittelsey
Fund, 1954, 54.602.1

TOM THOMSON
303 [ill. p. 138]
Northern Lights
About 1916
Oil on panel
21.6 x 26.7 cm
The Montreal Museum of Fine Arts,
gift of A. Sidney Dawes

304 [ill. p. 34]
The Jack Pine
1917
Oil on canvas
127.9 x 139.8 cm
Ottawa, National Gallery of Canada,
purchase 1918

ÉTIENNE LÉOPOLD TROUVELOT
305 [ill. p. 52]
The Planet Saturn
1874 (December)
Pastel on paper
88 x 99 cm (framed)
Observatoire de Paris

306 [ill. p. 54]
Total Eclipse of the Sun
About 1874-1875
Pastel on paper
79 x 92 cm (framed)
Observatoire de Paris

307 [ill. p. 53]
Great Orion Nebula
About 1874-1875
Pastel on paper
80 x 100 cm (framed)
Observatoire de Paris

308 [ill. p. 51]
*Part of the Milky Way Visible in
Winter, Observed in 1874-1875*
1874-1875
Pastel on paper
100 x 85 cm (framed)
Observatoire de Paris

J.M.W. TURNER
309 [ill. p. 32]
The Fifth Plague of Egypt
1800
Oil on canvas
124 x 183 cm
Indianapolis Museum of Art, anony-
mous gift in memory of Evan F. Lilly

GERARD VALK
See cats. 265, 345-346.

VINCENT VAN GOGH
310 [ill. p. 227]
Road with Cypress and Star
1889-1890
Oil on canvas
92 x 73 cm
Otterlo, The Netherlands,
Kröller-Müller Museum

In 1889-1890, in one of his last paintings executed in Saint-Rémy and reproducing several elements from his famous *Starry Night*, Van Gogh set forth his definitive formulation of the individual's place – not so much on the earth as within the entire galaxy. The bird's-eye view of the road – itself an allusion to the whitish flow of the Milky Way – "draws" us along with the two labourers to the foot of a cypress, which rises up like a flame towards the heavens, faintly illumined by an orangey crescent moon and a radiating star. For the artist in search of social progress, the humblest of labourers is part and parcel of an unstable and intensely active universe. Entire worlds are born and disappear, and still the sky is resplendent with stars. The unlooked-for ideological vision of this work is reminiscent of one of Flammarion's recurring themes – that astronomy offers the possibility for a renewed religious stance.

C.N.-R.

GEORGES VANTONGERLOO
311 [ill. p. 256]
Masses in the Universe
1946
Painted wood, nickel silver
165 x 110 x 85 cm
Angela Thomas Schmid collection

VICTOR COMPANY OF JAPAN
Yokohama
312 [ill. p. 278]
"JVC Videosphere" Television Set
Designed 1972
Plastic, glass, metal
33 x 27.9 x 29.2 cm (diam.)
Dallas Museum of Art, 20th Century Design Fund

CARLETON WATKINS
313 [ill. p. 95]
From the Best General View, Mariposa Trail
1860s
Albumen silver prints (stereograph)
8.9 x 17.8 cm
Robert N. Dennis Collection of Stereoscopic Views, Miriam and Ira D. Wallach Division of Art, Prints and Photographs. The New York Public Library. Astor, Lenox and Tilden Foundations

314 [ill. p. 36]
Grizzly Giant, 33 Foot Diameter, Mariposa Grove
1860s
Albumen silver prints (stereograph)
8.9 x 17.8 cm
Robert N. Dennis Collection of Stereoscopic Views, Miriam and Ira D. Wallach Division of Art, Prints and Photographs. The New York Public Library. Astor, Lenox and Tilden Foundations

315 [ill. p. 95]
View on the Merced
1860s
Albumen silver prints (stereograph)
8.9 x 17.8 cm
Robert N. Dennis Collection of Stereoscopic Views, Miriam and Ira D. Wallach Division of Art, Prints and Photographs. The New York Public Library. Astor, Lenox and Tilden Foundations

316 [ill. p. 93]
Vernal Falls, 300 Feet, Yosemite, No. 87
1861
Albumen silver print
40.6 x 50.8 cm
Miriam and Ira D. Wallach Division of Art, Prints and Photographs. The New York Public Library. Astor, Lenox and Tilden Foundations. Gift of Albert Boni

317 [ill. p. 58]
Galen Clark before the Grizzly Giant
About 1863
Albumen silver print
51.5 x 38.4 cm
The Art Institute of Chicago, restricted gift of Edward Byron Smith

318 [ill. p. 97]
The Sentinel, 3100 Feet
1865-1866 (printed about 1875)
Albumen silver print
52.6 x 40.7 cm
New York, The Metropolitan Museum of Art, The Elisha Whittelsey Collection, The Elisha Whittelsey Fund 1972

319 [ill. p. 94]
Vernal and Nevada Falls from Glacier Point, Yosemite
About 1866
Albumen silver print
40.6 x 52.1 cm
Miriam and Ira D. Wallach Division of Art, Prints and Photographs. The New York Public Library. Astor, Lenox and Tilden Foundations

CHARLES LEANDER WEED
320 [ill. p. 96]
Cathedral Rocks
About 1864-1865
Albumen silver print
53.3 x 44.5 cm
Miriam and Ira D. Wallach Division of Art, Prints and Photographs. The New York Public Library. Astor, Lenox and Tilden Foundations. Gift of Albert Boni

321 [ill. p. 85]
Yosemite Valley from the Mariposa Trail, Mariposa County, California, No. 1
1865 ?
Albumen silver print
39.9 x 51.6 cm
Ottawa, National Gallery of Canada

JOHN ADAMS WHIPPLE
322 [ill. p. 152]
Moon
1851
Daguerreotype
12 x 9.5 cm
Bradford, England, The National Museum of Photography, Film and Television, courtesy of the Board of Trustees of the Science Museum

JOYCE WIELAND
323 [ill. p. 297]
Man Has Reached Out and Touched the Tranquil Moon
1970
Plastic, cotton, wool, talcum powder
260 x 163.5 x 4 cm
Ottawa, National Gallery of Canada

324 [ill. p. 304]
Crepuscule for Two
1985
Oil on canvas
40.5 x 35.5 cm
Phyllis and Graeme Ferguson collection

ALFRED WORDEN
325 [ill. p. 160]
Crescent Earth over the Lunar Highlands, Apollo 15
1971
Colour coupler print
40.6 x 60.8 cm
Private collection

FRANK LLOYD WRIGHT
326 [ill. p. 260]
Hypothetical Study Model of "Gordon Strong Automobile Objective", Sugarloaf Mountain, Maryland
Created by George Ranalli, with Aaron McDonald and Nathaniel Worden
Produced in collaboration with the Frank Lloyd Wright Foundation, Scottsdale, Arizona, and the Library of Congress, Washington
1995 (project, 1925)
Basswood
122 x 122 x 36 cm
Montreal, Canadian Centre for Architecture

• Artist Unknown

327 [ill. p. 38]
A Bird's-eye View from the Staircase and Upper Part of the Pavilion in the Colosseum, Regent's Park
1829
Aquatint
29.5 x 22 cm
Guildhall Library, Corporation of London

328 [ill. p. 40]
A View of London and the Surrounding Country Taken from the Top of Saint Paul's Cathedral
About 1845
Aquatint
75.5 cm (diam.)
Guildhall Library, Corporation of London

329 [ill. p. 106]
Two Lantern Slides of Arctic Subjects: Iceberg and Igloos
Mid-19th c.
Oil on glass
17.2 x 17.3 cm each
Toronto, Royal Ontario Museum

BAFFIN ISLAND
Pangnirtung area
330 [ill. p.134]
White Whale
1928
Ivory
2.5 x 12.4 cm
Toronto, Royal Ontario Museum, gift of L. A. Learmonth

331 [ill. p. 134]
Walrus
1933-1942
Ivory
6 x 8.5 cm
Toronto, Royal Ontario Museum, Dr. Jon A. and Ms. Muriel Bildfell Collection, purchased through the generosity of Mr. Donald Ross

332 [ill. p. 134]
Narwhal
1933-1942
Ivory
3.5 x 18.7 cm
Toronto, Royal Ontario Museum, Dr. Jon A. and Ms. Muriel Bildfell Collection, purchased through the generosity of Mr. Donald Ross

333 [ill. p. 134]
Polar Bear
1933-1942
Ivory
5 x 12.5 cm
Toronto, Royal Ontario Museum, Dr. Jon A. and Ms. Muriel Bildfell Collection, purchased through the generosity of Mr. Donald Ross

NORTHEASTERN SIBERIA
Chukotka region
334 [ill. p. 135]
Koryak Coat
Before 1901
Fur, hide, hair, sinew, thread
96 x 140 cm
New York, American Museum of Natural History

For the Chukchi and Koryak peoples of Chukotka in northeastern Siberia, the winter sky is a mystical landscape crossed by the luminous band of the Clay River (Milky Way). The Pole Star, Acka'panay, marks the zenith, centre of the four cardinal directions, and home of many mythological beings. Shamans and spirits travel this celestial landscape, slipping into other worlds through holes beneath the Pole Star. The heavens form the inverse of our own world: night is day, summer is winter; when game is scarce on earth, it is plentiful in the heavens. Here, too, the souls of the dead, rising on the smoke of the funeral pyre, join their ancestors.

Throughout northeastern Siberia, shamans' garments embody sacred knowledge and are often empowered with celestial symbols. Pairs of metal disks, representing sun and moon, hang from the coats of Yukaghir shamans; slits and fringes on Chukchi shamans' garments are identified as references to the Milky Way. This shaman's coat was collected among the Koryak in the winter of 1900-1901 by the Russian ethnographer Waldemar Jochelson, a member of the Jesup North Pacific Expedition, organized by the American Museum of Natural History in New York. Its circular disks of bleached hide form a striking design. While Koryak dance coats display similar patches said to cover larvae holes in the reindeer skin, the patterns of circles on this garment were carefully positioned by the shaman, conceivably as a map for celestial travel. The waistbelt of richly stained ochre appears to represent the Clay River. The triangle below the neck, the Pole Star, is considered by the Koryak and Chukchi as the major gateway for shamanistic flight.

Several constellations important in the region may also be identified. Pehittin (Aquila, Eagle), whose appearance at the winter solstice was greeted with sacrificial offerings, is formed by three stars above the Clay River belt. On the left shoulder appears the Wild Reindeer Buck (Ursa Major) with its double star, Mizar and Alcor, in the handle; on the opposite shoulder, the Crooked Archer (Orion), whose distinguishing triad is viewed by the Koryak as the Archer's bow carried crosswise. The Archer's stooped back is said to result from an injury inflicted by his wife, Kilu, who struck him with her tailoring board. This treatment suggests that the Crooked Archer and Orion (punished by Athena for mistreating the seven Pleiades sisters) share certain character traits in addition to being the same constellation. The cluster of the Pleiades appears on the lower left front of the coat, next to a vertical embroidered band, possibly standing for the winter Milky Way. The coexistence of summer and winter constellations reflects the transitory and cyclical nature of seasons.

The orientation of the constellations may also reflect the shaman's inner vision rather than a precise scientific rendering. Such a map would guide the shaman's flight through the skies to negotiate on behalf of the community with the powers of the worlds that lie beyond the Pole Star.

<div align="right">B.D.-E. and V.C.</div>

The authors wish to thank Tom Callen and Cheryl Bauer for their assistance in this research.

BOGORAS, Waldemar. In *The Chukchee. The Jesup North Pacific Expedition 7. Memoirs of the American Museum of Natural History*, 1904-1909.

JOCHELSON, Waldemar. *The Koryak. The Jesup North Pacific Expedition 6. Memoirs of the American Museum of Natural History*, 1908.

1. Crooked Archer (Orion, the Hunter); 2. Tarazed (Aquila, the Eagle); 3. Altair (Aquila, the Eagle); 4. Alshain (Aquila, the Eagle); 5. Vega (Lyra, the Harp); 6. The Clay River (Summer Milky Way); 7. The Clay River (Winter Milky Way); 8. Sirius (Canis Major); 9. Pleiades; 10. Cassiopeia

SOVIET UNION
335 [ill. p. 276]
Sputnik Model Music Box
1957
Plastic
15.2 cm (h.); 12.7 cm (diam.)
Washington, National Air and Space Museum, Smithsonian Institution

336
"USSR" Orb and Rocket
1960s
Porcelain, enamelled and gilt decoration
4.2 x 3.2 cm
New York, Cooper-Hewitt, National Design Museum, Smithsonian Institution

• Scientific Objects

URSIN BARBAY
337 [ill. p. 50]
Terrestrial Globe
Year VII, French Revolutionary calendar (1799)
Wood, glass, paper
32 cm (h.); 21.5 cm (diam.)
Montreal, Stewart Museum at the Fort, Île Sainte-Hélène, 1993.48.1

ROBERT BRETTELL BATE
338 [ill. p. 48]
Orrery
First half of 19th c.
Brass, wood, ivory, velvet, paper, papier-mâché
62 cm (h.); mount: 91 cm (diam.)
Montreal, Stewart Museum at the Fort, Île Sainte-Hélène, 1992.7.1

GIOVANNI DONDI
339 [ill. p. 48]
Astrarium (Astronomical Clock)
About 1364 (reconstruction 1962, Thwaites and Reed, Ltd., London)
Brass
124.5 x 73.7 cm
Washington, National Museum of American History

GALILEO GALILEI
340 Telescope
Early 17th c. (20th-c. replica)
Wood, gold-stamped leather
92 cm (l.)
Florence, Istituto Museo di Storia della Scienza

NATHANIEL HILL
341 [ill. p. 50]
Traveller's Pocket-size Globe and Case
1754
Wood, paper, cardboard, shagreen, brass
6.8 cm (diam.)
Montreal, Stewart Museum at the Fort, Île Sainte-Hélène, 1979.28.2

LITTON INDUSTRIES
342 [ill. p. 142]
Astronaut's Hardsuit: Litton Experimental in Constant Volume
Late 1960s
Helmet: polycarbonate, aluminum, brass
Body: aluminum, plastic, stainless steel, rubber, leather
Gloves: leather, aluminum, nylon
190.5 x 83.8 x 43.2 cm; weight: 35.5 kg
Washington, National Air and Space Museum, Smithsonian Institution

Attributed to
JOHANN GEORG PUSCHNER
343
Celestial Globe
About 1730
Brass, wood
38.7 cm (h.); 18.2 cm (diam.)
Montreal, Stewart Museum at the Fort, Île Sainte-Hélène, 1987.10.1

PAULUS REINMANN
344
Diptych Sundial
1596
Ivory, brass, glass, coloured vellum
10.5 (open) x 7.9 x 10 cm
Montreal, Stewart Museum at the Fort, Île Sainte-Hélène, 1978.53.1

GERARD AND LEONARD VALK
See also cat. 265.
345
Celestial Globe
17[5]0
Brass, wood, papier-mâché
38.3 cm (h.); 23.2 cm (diam.)
Montreal, Stewart Museum at the Fort, Île Sainte-Hélène, 1980.55.2

346
Terrestrial Globe
17[5]0
Brass, wood, papier-mâché
38.3 cm (h.); 23.2 cm (diam.)
Montreal, Stewart Museum at the Fort,
Île Sainte-Hélène, 1980.55.1

FRANCE
347
Celestial Globe
1533
Brass, ormolu
56.3 (h.); 25 cm (diam.)
Montreal, Stewart Museum at the Fort,
Île Sainte-Hélène, 1980.47

348
Armillary Sphere
17th c.
Ormolu
15.7 cm (h); 10.2 cm (diam.)
Montreal, Stewart Museum at the Fort,
Île Sainte-Hélène, 1979.51.6

349
Diptych Sundial
Late 17th c.
Wood, brass, glass
6.2 (open) x 3.4 x 5.9 cm
Montreal, Stewart Museum at the Fort,
Île Sainte-Hélène, 1970.100.43

350
Astronomical Ring Dial
Early 18th c.
Brass, elm bur, ebony
14.3 cm (h.); 10 cm (diam.)
Montreal, Stewart Museum at the Fort,
Île Sainte-Hélène, 1983.58.1

351
Polyhedral Sundial
Early 18th c.
Brass, elm bur, ebony
13.5 cm (h.); 9.5 cm (diam.)
Montreal, Stewart Museum at the Fort,
Île Sainte-Hélène, 1983.59.1

352
Spherical Sundial
Early 18th c.
Brass, elm bur, ebony
12.6 cm (h.); 8.5 cm (diam.)
Montreal, Stewart Museum at the Fort,
Île Sainte-Hélène, 1983.60.1

353
Armillary Sphere
Early 18th c.
Brass, elm bur, ebony
13 cm (h.); 7.6 cm (diam.)
Montreal, Stewart Museum at the Fort,
Île Sainte-Hélène, 1983.57.1

354
Armillary Sphere
Late 18th c.
Brass, wood
54 cm (h.); 32.2 cm (diam.)
Montreal, Stewart Museum at the Fort,
Île Sainte-Hélène, 1973.9.7

355
Polyhedral Sundial
Early 18th c. ?
Brass, wood, glass, paper
19.8 x 17.7 x 17 cm
Montreal, Stewart Museum at the Fort,
Île Sainte-Hélène, 1983.53.1

• Natural Objects

356
Ammonite Fossil
Jurassic of England (about 160 million
years ago)
Limestone
31 x 39 cm
Montreal, Redpath Museum, McGill
University

357
*Two Hexactinellids (Glass sponge)
(Euplectella)*
Modern era
Silica, spongin
29 x 5 cm; 23 x 5 cm
Montreal, Redpath Museum,
McGill University

358
Two Top Shells (Trochus Nyloticus)
Modern era
Calcium carbonate, concholin
12.5 x 11.7 cm (diam.); 6.5 x 7 cm
(diam.)
Montreal, Redpath Museum,
McGill University

359
Meteorite
Found in Madoc, Ontario, in 1854
Iron
53.3 cm (diam.)
Ottawa, Geological Survey of Canada

• Books

SAMUEL COLERIDGE
360
The Rime of the Ancient Mariner,
illustrations by Gustave Doré
New York: Harper & Brothers
Publishing, 1886
47.5 x 37.5 cm
The Montreal Museum of Fine Arts
Library

NIKOLAI FEDOROV
361
Filosofiia obshchego dela (Philosophy
of the Common Task), edited by V. A.
Kojevnikov and N. P. Peterson
Vol. 1: Verny, 1906; vol. 2: Moscow,
1913
28 cm
Céleste Plantureux collection

CAMILLE FLAMMARION
362
L'astronomie populaire
1885 (1st published 1879)
20 x 28 cm
Paris, Société astronomique de
France, Fonds Camille Flammarion

363
Lumen, illustrations by Lucien
Rudaux
Undated (1st published in *L'Artiste,*
1866)
15 x 23 cm
Paris, Société astronomique de
France, Fonds Camille Flammarion

364
Uranie
Undated (1st published 1889)
16.5 x 23.5 cm
Paris, Société astronomique de
France, Fonds Camille Flammarion

GALILEO GALILEI
365
*Dialogo, dove ne i congressi di quattro
giornate si discorre sopra i due mas-
simi sistemi del mondo, Tolmaico e
Copernicano...*
Florence: G.B. Landini, 1632
21.3 x 16 cm
Montreal, McGill University, Osler
Library of the History of Medicine

366

Opere, 2 vols., edited by Carlo
Manolessi
Bologna: HH. del Dozza
22.7 x 17 cm
Montreal, McGill University, Osler
Library of the History of Medicine

**HERGÉ
(pseudonym of Georges Remi)
367**

Les aventures de Tintin: Objectif Lune
Paris and Tournai: Casterman, 1953
30.3 x 23.2 cm
Montreal, Michel Daras collection

368

*Les Aventures de Tintin: On a marché
sur la Lune*
Paris and Tournai: Casterman, 1954
30.3 x 23.2 cm
Montreal, Michel Daras collection

**EDVARD ENGELBERT NEOVIUS
369**

La Plus Haute Mission de notre époque
Warsaw: Jean Noskowski, 1879
15.5 x 24.3 cm
Céleste Plantureux collection

**JOHN ROSS
370**

*A Voyage of Discovery Made under
the Orders of the Admiralty, in
His Majesty's Ships "Isabella"
and "Alexander", for the Purpose
of Exploring Baffin's Bay, and
Enquiring into the Probability
of a North-West Passage*
London: John Murray, 1819
28 x 23 cm
Montreal, Bibliothèque nationale
du Québec

**JONATHAN SWIFT
371**

*Voyages de Gulliver dans des
contrées lointaines*, illustrations
by Grandville (pseudonym of
Jean Ignace Isidore Gérard)
Paris: Hetzel, 1838
21.5 x 14 cm
Université de Montréal, Service
des bibliothèques, livres rares et
collections spéciales

BRUNO TAUT

See cats. 293–295.

**JULES VERNE
372**

*Voyages et aventures du capitaine
Hatteras. Les Anglais au pôle Nord
– Le Désert de glace*, illustrated with
150 vignettes by Riou
Paris: Hetzel, 1873
27.5 x 18.3 cm
Montreal, McGill University Libraries,
Rare Books and Special Collections
Division

373

De la Terre à la Lune
Paris: Hetzel [1910]
27.5 x 18.5 cm
Université de Montréal, Service des
bibliothèques, livres rares et
collections spéciales

374

Une Ville flottante and *Voyage
au centre de la Terre*
Paris: Hetzel, undated
27.5 x 18 cm
Université de Montréal, Service
des bibliothèques, livres rares et
collections spéciales

**ALEXANDRE A. VUILLEMIN
375**

Atlas du Cosmos
Paris: L. Guérin, 1867
50 x 36.5 cm
Montreal, Bibliothèque nationale
du Québec, division des collections
spéciales, secteur des cartes

Fig. 4, p. 172
Lucien Lévy-Dhurmer
Silence
1895, pastel on paper, 54 x 29 cm
Private collection

• **Essay by Giovanni Lista**
Fig. 1, p. 181
Fillia (pseudonym of Luigi Colombo)
Heavier than Air
1933-1934, oil on canvas, 175 x 150 cm
Private collection

Fig. 2, p. 182
Pippo Oriani
The Birth of Simultaneity
1931, oil on canvas, 81 x 65 cm
Private collection

• **Essay by Mary Warner Marien**
Fig. 1, p. 81
Carleton Watkins
Josephine and Pine Tree
1860, salt print, 33.5 x 41.2 cm
Los Angeles, The J. Paul Getty
Museum

Fig. 2, p. 82
Albert Bierdstadt
Rocky Mountains, "Lander's Peak"
1863, oil on linen, 110.8 x 90.2 cm
Cambridge, Massachusetts, Harvard
Art Museums, Fogg Art Museum,
Mrs. William Hayes Fogg

• **Essay by Günter Metken**
Fig. 1, p. 60
Max Ernst
Humboldt Current,
1951-1952, oil on canvas, 36 x 61.5 cm
Basel, Fondation Beyeler

Fig. 2, p. 61
Eduard Ender
*Alexander von Humboldt and Aimé
Bonpland in a Jungle Hut*
Mid-19th c., oil on canvas,
110 x 143 cm
Archiv der Berlin-Brandenburgischen
Akademie der Wissenschaften

Fig. 3, p. 62
Louis Bouquet, after a sketch
by Humboldt
*Tableau physique des Andes
et pays voisins*
1803
Geographie der Pflanzen in den
Tropen-Landen, ein Naturgemälde der
Anden, gegrundet auf Beobachtungen
und Messungen, welche vom 10.ten
Grade nordlicher bis zum 10.ten Grade
sudlicher Breite, angestellt worden
sind in den Jahren 1799 bis 1803
von Alexander von Humboldt und
A. G. Bonpland
(Geography of plants in the tropics: a
nature-painting of the Andes based on
observations and measurements car-
ried out between 10° N. and 10° S. by
Alexander von Humboldt and A. G.
Bonpland in 1799-1803)

Fig. 4, p. 63
Frederic Edwin Church
Heart of the Andes
1859, oil on canvas, 168 x 302.9
New York, The Metropolitan Museum
of Art, bequest of Mrs. David Dows,
1909, inv. 09.95

• **Essay by Constance Naubert-Riser**
Fig. 1, p. 219
Vincent van Gogh
Starry Night
1889, oil on canvas, 73.7 x 92.1 cm
New York, The Museum of Modern Art,
acquired through the Lillie P. Bliss
Bequest

Fig. 2, p. 220
František Kupka
The First Step
1910-1913 ? (dated on painting 1909),
oil on canvas, 83.2 x 129.6 cm
New York, The Museum of Modern Art,
Hillman Periodicals Fund

Fig. 3, p. 223
Bruno Taut
Globes! Circles Wheels!
1919, chromolithograph, 39.4 x 32 cm
Plate 28 from *Alpine Architektur*
(Hagen: Folkwang-Verlag)
Montreal, Canadian Centre for
Architecture

Fig. 4, p. 223
Bruno Taut
*Systems within Systems – Worlds –
Nebulas*
1919, lithograph, 39.4 x 32 cm
Plate 29 from *Alpine Architektur*
(Hagen: Folkwang-Verlag)
Montreal, Canadian Centre
for Architecture

Figs. 5a-f, pp. 223-224
Bruno Taut
Illustrations from *Der Weltbaumeister*
(Hagen: Folkwang-Verlag)
1920, relief half-tone,
22.8 x 18.6 cm (plate)
Montreal, Canadian Centre
for Architecture

• **Essay by Rosalind Pepall**
Fig. 1, p. 115
George Back
Boats in a Swell amongst Ice
1826 (August 24)
Engraved by Edward Finden and
reproduced in John Franklin,
*Narrative of a Second Expedition
to the Shores of the Polar Sea in
the Years 1825, 1826, and 1827*
(London: John Murray, 1828)

Biographies of the artists
were compiled by:

Jean-François Gauvin

Françoise Guiter

Isabelle Nolin

Rosalind Pepall

Christopher Phillips

Mélanie Racette

Lydia Sokoloff

Biographies of the Artists

EERO AARNIO
Helsinki 1932

Finnish interior and furniture designer Eero Aarnio trained at Helsinki's Institute of Industrial Arts (now the University of Art and Design) from 1954 to 1957. In the 1950s, he created wood and wicker furniture of traditional Finnish inspiration, such as the "Jattujakkare" stool and "Appletree" chair. On going to work for furniture manufacturer Asko in 1960, he gradually abandoned wood in favour of plastic. His "Globe", or "Sphere", chair (1963-1965), a spherical shell of coloured fibreglass set on a metallic base, earned him international fame when it was shown in Cologne in 1966. Like a scaled-down private parlour, "Globe" embodied the individualism characteristic of modern society. In 1968, he designed for Asko the wholly fibreglass "Pastilli" chair, for which he received the American Institute of Interior Designers award in 1969. More recently, his interest in the potential of electronics has led him to develop a modular chair with computer-controlled seat, back and armrests.

M.R.

REDHEAD, David, Sue ANDREWS and Hild HAWKINS. "The New Finland". *Blueprint*, no. 93 (December 1992-January 1993), pp. 21-28.

HIS MOST SERENE HIGHNESS PRINCE ALBERT I OF MONACO
Paris 1848 - Paris 1922

Prince Albert I of Monaco abandoned his career as a naval officer around 1873 and, as of 1884, devoted much of his life to oceanography. Sailing aboard the yacht *Hirondelle I* in 1885, he undertook the first of a series of twenty-eight expeditions during which he conducted important scientific research. Upon succeeding his father Charles III in 1889, he set about modernizing the principality's institutions and expanding its economic activity. In 1897, he acquired a Gaumont cinematograph, or movie camera, and produced five films while on a scientific expedition in Morocco and the Azores that year. His

fascination with the Far North and the exploits of explorer Fridtjof Nansen led him to travel four times – in 1898, 1899, 1906 and 1907 – to the Norwegian archipelago of Spitsbergen in the Arctic Ocean. On these voyages, he observed the fauna and physicochemical conditions of the polar region, comparing them with those of tropical and temperate zones. He was a skilled photographer and abundantly documented Spitsbergen's mountainous landscapes. His first colour photos were taken in 1907, using Lumière Autochrome plates. To exhibit the results of his research, he built the Musée océanographique in Monaco; begun in 1899, it was inaugurated in 1910. In 1911, he founded the Institut océanographique in Paris.

M.R.

CARPINE-LANCRE, Jacqueline. *Albert Iᵉʳ, prince de Monaco (1848-1922)*. Monaco: EGC, 1998.

LEFEBVRE, Thierry, ed. "Images du réel: la non-fiction en France (1890-1930)". *1895*, no. 18 (Summer 1995).

HANS (JEAN) ARP
Strasbourg 1886 - Basel 1966

French painter, sculptor, collage-maker and poet Hans Arp attended the Weimar Kunstschule from 1905 to 1907 and studied at the Académie Julian in Paris in 1908. In 1912, he exhibited in the second Blaue Reiter show, where contact with the Munich group revived his interest in German Romanticism. As a war refugee in Switzerland, he showed his first collages at Zurich's Tanner gallery in 1915, seeking to express through art a spirituality that could bring order to the surrounding chaos. It was then that he met Sophie Taeuber, who became his frequent collaborator and, in 1922, his wife. Joining the Dada movement in 1916, he embraced the laws of chance, or random occurrence, in composing his collages and created biomorphic forms reminiscent of microcosmic fragments of nature. Beginning in 1925, Arp took part in Surrealist activities and developed close ties with the Dutch movement De Stijl and the

Parisian Constructivist groups Cercle et Carré and Abstraction-Création. In the late 1920s and early 1930s, he returned to the dominant theme of his Dadaist period – the metamorphosis of natural elements – and transposed his biomorphic forms to a new medium: sculpture. This resulted in a series of "Constellations", evoking the decaying effects of nature's catabolic forces, and his "Concretions", which suggest the reverse natural process of gestation and growth.

M.R.

HANCOCK, Jane, and Stefanie POLEY, eds. *Arp, 1886-1966*, exhib. cat. Minneapolis: Minneapolis Institute of Arts; Cambridge and New York: Cambridge University Press, 1987. Text by Aimée Bleikasten, Jean-Louis Fauré, Patrick Frey, Rainer Hüben, Nadine Lehni, Gabriele Mahn, Greta Stroeh, Aline Vida and Harriett Watts.

RAU, Bernd, ed. *Jean Arp: The Reliefs. Catalogue of Complete Works.* New York: Rizzoli, 1981. Introduction by Michel Seuphor. Text in English, French and German.

SIR GEORGE BACK
Stockport 1796 - London 1878

George Back, an English naval officer, learned the rudiments of topographical drawing in 1808 aboard the British frigate *Arethusa*, which saw battle with the French fleet off Cherbourg and along the coast of northern Spain. Taken prisoner by the French forces in 1809, he was interned for five years at Verdun, where he continued teaching himself to draw. He was freed in 1814 and in 1818 shipped out on the brig *Trent*, crossing the Arctic Ocean from the Spitsbergen archipelago to the Bering Strait. In the course of the voyage, he met Lieutenant John Franklin, who invited him to join an overland expedition along the Coppermine River the following year. During the expedition, Back produced many sketches and watercolours of the Arctic landscape and inhabitants. Returning to the region in 1825, again under Franklin's command, he travelled the banks of the Mackenzie River, making new drawings that served to

illustrate Franklin's published account of the adventure. In 1833, leading a search party for Captain John Ross, he explored the Canadian Northwest and discovered the Thlew-ee-choh (Great Fish) River, later renamed Back River.

M.R.

BACK, George. *Arctic Artist: The Journal and Paintings of George Back, Midshipman with Franklin, 1819-1822.* Ed. C. Stuart Houston, commentary by I. S. MacLaren. Montreal, Kingston, London and Buffalo: McGill-Queen's University Press, 1994.

PEDER ANDERSEN BALKE
Helgøya 1804 - Christiania
(now Oslo) 1887

Norwegian artist Peder Balke went to Christiania in 1827 for training as a painter-decorator. He apprenticed there with Heinrich August Grosch and later worked under the direction of Jacob Munch. From 1829 to 1832, he studied landscape painting at the Academy in Stockholm with Carl Johan Fahlcrantz. In 1835, with the aid of a government scholarship, he went to Dresden to work in Johan Christian Dahl's studio, where he met Caspar David Friedrich. The influence of these two artists is particularly evident in Balke's paintings from the late 1830s: dominated by representations of nature's might, these compositions feature turbulent skies and raging seas. Balke enjoyed independent financial means that allowed him to explore new art forms without regard for the critics or public taste. He transgressed the academic canons of harmony and balance by juxtaposing the geometric circular shape of heavenly bodies with the vaporous forms of clouds and waves. In its evocation of the sublime yet violent aspects of nature, his work informed the development of the Norwegian Romantic landscape tradition.

I.N.

LANGE, Marit. *Peder Balke – Matthias Stoltenberg*, exhib. cat. Oslo: Kunstnerforbnd., 1980.

LOGE, Øystein. *Deformation: Disintegrating the Classical Concept of Nature in Norwegian Landscape Painting*, exhib. cat. Oslo: Bergen Billedgalleri; Dryer, 1991.

GIACOMO BALLA
Turin 1871 - Rome 1958

Self-taught artist Giacomo Balla began painting in Turin. In 1895, he moved to Rome, where he was influenced by the Divisionist technique used by Pellizza da Volpedo, Segantini and Previati. A brief stay in Paris in 1900 kindled his interest in Neo-Impressionism. In 1910, he co-authored the *Manifesto of the Futurist Painters.* Seeking to render the dynamic motion of animals, people and automobiles in his paintings, he approached it through scientific analysis and obtained results similar to Bragaglia's "photodynamic" creations. The influence of the Cubists led him to push the decomposition of movement to the extreme, nearly to the point of abstraction. Balla owned a telescope that enabled him to study the paths of the stars. His desire to portray the cosmos is evident in *Mercury Passing before the Sun* (1914), and in 1915 he co-wrote the manifesto *Futurist Reconstruction of the Universe.* After 1925, he returned to figurative painting, confining his Futurist production to the decorative arts.

L.S.

FAGIOLO DELL'ARCO, Maurizio. *Futur-Balla: la vita e le opere.* Milan: Electa, 1992.

FAGIOLO DELL'ARCO, Maurizio, ed. *Casa Balla: un pittore e le sue figlie tra futurismo e natura*, exhib. cat. Comacchio: Palazzo Bellini; Venice: Marsilio, 1997.

URSIN BARBAY
Active around 1800

Ursin Barbay worked as a royal inspector before becoming a glass master in Montmirail, France. A skilled and creative artisan, he developed a strikingly original globe design, different from all previous models. Barbay is known exclusively for his glass globes; in 1817, he published his only written work, which documents the production process in great detail.

J.-F.G.

ROBERT BRETTELL BATE
About 1793 - 1843

In his day, Robert Bretell Bate was regarded as one of the most important manufacturers of scientific instruments in England. A specialist in metrology, he was commissioned to produce the weights and measures prototypes when the new imperial standards were introduced in the 1820s.

J.-F.G.

FREDERICK WILLIAM BEECHEY
London 1796 - London 1856

Son of noted portraitist Sir William Beechey, Frederick Beechey entered the British Navy at the age of ten and travelled to Spain, Brazil and Africa early in his career. In 1818, he served aboard the *Trent* with John Franklin on David Buchan's expedition to the Arctic; his account of the trip (*A Voyage of Discovery towards the North Pole, Performed in His Majesty's Ships "Dorothea" and "Trent"* ..., 1843), included the drawing *Wreck of the "Trent"'s Boat.* He returned to the Arctic the following year, 1819, under the command of William Edward Parry. In 1825, leading an expedition that would last more than three years, Beechey headed north again by way of Cape Horn to the Bering Strait to reconnoiter with Franklin and Parry, coming from the east. His *Narrative of a Voyage to the Pacific and Bering Strait to Co-operate with the Polar Expeditions in the Years 1825-1828* was published in 1831. He remained closer to home in his later career and retired from sea travel in 1847.

R.P

BERSHAD, Sonia. "The Drawings and Watercolours by F. W. Beechey, 1796-1856, in the Collection of the Arctic Institute of North America". *Arctic*, vol. 33, no. 1 (March 1980), pp. 117-267.

O'BYRNE, William R. *A Naval Biographical Dictionary: Comprising the Life and Services of Every Living Officer in Her Majesty's Navy.* Polstead, England: J.B. Hayward and Son, vol. 1, pp. 66-67.

WILLIAM BELL

Liverpool 1830 - Philadelphia 1910

English-born William Bell was the chief photographer of the Army Medical Museum in Washington during the Civil War (1861-1865). As such, he recorded soldiers' wounds before and after surgery for purposes of medical research. In 1872, he replaced photographer Timothy O'Sullivan on an expedition in Arizona organized as part of Lieutenant George M. Wheeler's Geographical Surveys West of the One Hundredth Meridian. His assignment was to illustrate the theory of geological mechanics propounded by the expedition's specialists, who maintained that the evolution of the earth's crust was the result of movement caused by erosion, volcanic flow and terrestrial uplift and sinking. During this expedition, he took pictures of the Grand Canyon's rocky formations using a dry collodion process that revolutionized photography in the 1880s. His vertical images depicting the desert landscapes of the Kanab Wash canyon, the Colorado River and the Grand Canyon are notable for their dramatic perspectives and striking contrasts of scale and distance, suggesting man's confrontation with the magnificence of nature.

M.R.

NAEF, Weston J., and James N. WOOD. *Era of Exploration: The Rise of Landscape Photography in the American West, 1860-1885.* Buffalo: Albright-Knox Art Gallery; New York: Metropolitan Museum of Art, 1975.

Wheeler's Photographic Survey of the American West, 1871-1873. New York: Dover, 1983 (reprint).

ARIETO (HARRY) BERTOIA

San Lorenzo, Italy, 1915 -
Bally, Pennsylvania, 1978

A proponent of streamlined American design, Harry Bertoia is perhaps best known for his sculptural chair designs in openwork metal wire, created in 1950-1952 for Knoll Associates in Pennsylvania. Bertoia arrived in the United States as a teenager in 1930. He won a scholarship to the Cranbrook Academy of Art in Bloomfield Hills, Michigan, in 1937 and ran the metalworking studio there from 1938 until 1943. Influenced by the school's arts and crafts philosophy, his aim was to design for industrial production. His spherical coffee service, created at Cranbrook, was inspired by the progressive geometric designs of such silversmiths as Puiforcat and Eliel Saarinen, director of the school. In 1943, Bertoia left Michigan to work with Charles and Ray Eames in California; in 1946, he joined Knoll Associates, where he pursued his work in metal furniture design. He began receiving commissions for architectural sculptures in the mid-1950s, at which point he left Knoll to devote the remainder of his career to sculpting.

R.P.

EIDELBERG, Martin, ed. *Design 1935-1965: What Modern Was.* Montreal: Musée des arts décoratifs; New York: Harry N. Abrams, 1991.

NELSON, June Kompass. *Harry Bertoia, Sculptor.* Detroit: Wayne State University Press, 1970.

ALBERT BIERSTADT

Solingen 1830 - New York 1902

Albert Bierstadt, an American painter of German origin, travelled to Germany in 1853 to study at the Kunstakademie in Düsseldorf. In 1859, two years after returning to the United States, he joined a government expedition sent to survey a new route to the Pacific under the command of Captain Frederick W. Lander. He accompanied them as far as western Wyoming, making numerous sketches of the Rocky Mountains and taking stereoscopic photographs of the Native peoples. The following year, he set up a studio in New York's Tenth Street Studio Building and exhibited vast canvases evoking the spiritual power and glories of the Rockies, which he likened to the Alpine peaks of Europe. In 1863, he visited San Francisco, the Yosemite Valley and Oregon with writer Fitz Hugh Ludlow. This trip inspired new works featuring Yosemite's breathtaking panoramas, an idyllic vision that Bierstadt saw as the promise of a new Golden Age. He continued to roam the far reaches of the New World, visiting Yosemite again in 1871, Yellowstone National Park in 1881 and Alaska and the Canadian Rockies in 1889.

M.R.

ANDERSON, Nancy K., and Linda S. FERBER. *Albert Bierstadt: Art and Enterprise,* exhib. cat. New York: Brooklyn Museum; Hudson Hills Press, 1990.

HENDRICKS, Gordon. *Albert Bierstadt: Painter of the American West.* New York: Harrison House; Harry N. Abrams, 1988.

NICOLAS BION

1652 - 1733

Nicolas Bion was among the best-known scientific instrument makers of his time. In addition to producing manifold instruments, including globes, sundials, mathematical instruments and mechanical devices, he published three important books that were translated and repeatedly reissued during the eighteenth century. Bion lived and worked in Paris, at his Soleil d'or atelier on the Quai de l'Horloge.

J.-F.G.

ROSS BLECKNER

New York 1949

In 1972, Ross Bleckner enrolled at the California Institute of Arts, where he produced photographic, video, installation and performance works before turning to painting. Influenced by the Constructivists, his geometric abstractions incorporated organic forms, as in *The First Morning of the Second World* (1980), where celestial bodies stand out against a dark background. To achieve enhanced contrast in his compositions, he added points of light to black-painted surfaces, suggesting the reflection of stars. In 1988, he painted his first "Dot" or "Constellation" pieces, in which sparkling light effects recall both divine radiance and scientific photos of nebulas. Bleckner has pursued the cosmic theme into the1990s, texturing his paintings with impasto and metal pigments to create creviced surfaces like that of the moon. *Architecture of the Sky* (1988-1993) and *Invisible Heaven* (1993-1994) replicate celestial landscapes by means of successive layers of dark and luminous colours, expressing an ambiguous vision of the world, at once mystical and romantic, utopian and pessimistic.

I.N.

Ross Bleckner, exhib. cat. Milwaukee: Milwaukee Art Museum, 1989. Text by Dean Sobel.

Ross Bleckner, exhib. cat. New York: Solomon R. Guggenheim Museum, 1995. Text by Thomas Crow, Lisa Dennison and Simon Watney.

LOUIS BONNIER
Templeuve 1856 - Paris 1946

Architect and urban planner Louis Bonnier entered the École des Beaux-Arts in Paris in 1876. In 1884, he apprenticed as an architect for the City of Paris. He was commissioned to build the town hall of Issy-les-Moulineaux, south of Paris, in 1886, and went on to design a number of private homes. In 1895, he created art dealer Siegfried Bing's gallery, L'Art nouveau. As head of installations for the 1900 Paris Universal Exposition, he worked on a twenty-six-metre-diameter globe for geographer Élisée Reclus, a project that was never carried out. He did, however, build the Schneider Pavilion, graced by a dome forty-five metres in diameter rising majestically above the Seine. In 1910, he directed the City of Paris's architecture, plantings and walkways department and co-founded the École d'art public (later to become the Institut des hautes études urbaines and, in 1919, the Institut d'urbanisme). In 1925, he exhibited at the Exposition internationale des arts décoratifs and industriels modernes in Paris. In the history of French architecture, Bonnier's work spans the period between Viollet-le-Duc and the modernists.

I.N.

MARREY, Bernard. *Louis Bonnier 1856-1946*. Liège: Pierre Mardaga, 1988.

WEISBERG, Gabriel P. "Siegfried Bing, Louis Bonnier et la Maison de l'Art nouveau en 1895". *Bulletin de la Société de l'Histoire de l'Art français*, 1983, pp. 241-249.

PAUL-ÉMILE BORDUAS
Saint-Hilaire, Quebec, 1905 - Paris 1960

Introduced to painting by artist and church decorator Ozias Leduc, Paul-Émile Borduas enrolled at Montreal's École des beaux-arts in 1923. At the urging of his mentor, he went to Paris in 1928 and attended the Ateliers d'art sacré headed by Maurice Denis and Georges Desvallières. Back in Montreal in the Depression-era 1930s, he taught drawing in various elementary schools prior to securing a position at the École du meuble in 1937, where he at last found a stimulating intellectual milieu. In 1941, he abandoned the figurative tradition in favour of an approach derived from Surrealism. Calling on the devices of automatism, his paintings from that period depict objects floating against infinitely receding backgrounds. In 1946-1947, enjoying growing influence among young artists, Borduas founded the Automatiste group, composed of students from the École du meuble and friends Fernand Leduc, Pierre Gauvreau and Jean-Paul Mousseau. In 1948, following publication of the manifesto *Refus global*, in which he denounced the political and religious powers of the day, he was fired from the École du meuble. This left him with only his art to support his family. In 1953, he immigrated to New York, where contact with the Abstract Expressionists wrought a profound change in his work. Despite his success there, he moved to Paris in 1955. His paintings as of 1957 reveal a more cosmic influence, as seen in *The Black Star*, where the inversion of black and white evokes the infinite reaches of a starry night.

M.R.

GAGNON, François-Marc. *Paul-Émile Borduas (1905-1960). Biographie critique et analyse de l'œuvre*. Montreal: Fides, 1978.

GAGNON, François-Marc. *Paul-Émile Borduas*, exhib. cat. Montreal: Montreal Museum of Fine Arts, 1988.

WILLIAM BRADFORD
Fairhaven 1823 - New York 1892

The son of a ship outfitter, William Bradford was raised in Fairhaven, Massachusetts, at the heart of the whaling industry. Impressed by the seascapes of Robert Salmon and Fitz Hugh Lane, he set up a studio in New Bedford in 1855 and began painting port scenes in the manner of English and Dutch marines. That same year, he trained with Dutch painter Albert van Beest, with whom he collaborated on several occasions. He moved to New York in 1860 and, the following year, worked in the Tenth Street Studio Building, where he met Albert Bierstadt. Inspired by the work of explorer Elisha Kent Kane and his book *Arctic Explorations: The Second Grinnell Expedition in Search of Sir John Franklin* (1856), Bradford made ten voyages to the High Arctic between 1854 and 1869, taking pictures and making sketches that he later used in composing his paintings. While his photos constitute a valuable record of the North, his paintings convey the personal vision of an artist arrested by the silence of the vast boreal expanse. In 1869, he undertook his most famous northern voyage, which he documented in *The Arctic Regions*, published in London in 1873 with 125 photographic illustrations. This ambitious venture bears witness to his will to portray the frontier of the New World through images of glacial solitude. Settling in London in 1872, he pursued a fruitful career as a lecturer and was commissioned by Queen Victoria to do a painting that was exhibited at the Royal Academy in 1875.

M.R.

BENAC, Albert F., and Robert DEMANCHE. *William Bradford: Artist at the Water's Edge*. [N.p.]: A.F. Benac, 1996.

WILMERDING, John. *William Bradford, 1823-1892*, exhib. cat. Lincoln, Massachusetts: DeCordova and Dana Museum, 1969.

CONSTANTIN BRANCUSI
Hobitza Gorj (now Tirgu Jiu),
Romania, 1876 - Paris 1957

Trained at the School of Fine Arts in
Bucharest, Constantin Brancusi moved
to Paris in 1904 to study sculpture in
Antonin Mercier's studio at the École
des Beaux-Arts. In 1907, renouncing the
influence of Rodin's aesthetic, which
he had briefly entertained, he returned
to direct carving in a series of pieces of
exotic, primitive inspiration (*The Kiss*,
1907). The sculptural groups he pro-
duced were pure in form, and in them
he sought to evoke the hidden essence
of the carved material. As of 1910, his
interest in the relationship between
the sculpted work and its base led him
to envisage the base as a distinct but
integral part of each piece, relating to
the sculpture in terms of material, form
and colour. That same year, he began
his "Bird" series with *Maiastra*, whose
tapering forms convey the power of
flight. After celebrating the primor-
dial egg shape in *Sleeping Muse*,
Mademoiselle Pogany and *Newborn*,
Brancusi created *The Beginning of
the World* (about 1924); here, an ovoid
volume on a polished metal disk recalls
the origins of the universe. In 1937, he
erected a copper-coated steel version of
Endless Column in the public gardens
of Tirgu Jiu, expressing the cosmogonic
concept of a pillar supporting the
heavenly vault.

M.R.

KLEIN, Ina. *Constantin Brancusi:
Natur, Struktur, Skulptur,
Architektur.* 2 vols. Cologne:
Buchhandlung W. König, 1994.

Constantin Brancusi 1876-1957,
exhib. cat. Paris: Centre Georges
Pompidou, Musée national d'art
moderne; Gallimard, 1995. Text by
Friedrich Teja Bach, Margit Rowell,
Ann Temkin and Germain Viatte.

JAMES LEE BYARS
Detroit 1932 - Cairo 1997

From 1948 to 1956, James Lee Byars
studied art and philosophy at Detroit's
Wayne University and the Meril Palmer
School for Human Development. He
organized his first exhibition in 1955,
rearranging his parents' living room
to display a series of spherical stones.
Three years later, he moved to Japan,
where he explored Japanese literature,
ceramics and the craft of papermaking.
He developed an interest in Oriental
and Occidental spirituality and began
creating his collection of "perfect
thoughts", linking mystical texts of
the East with quotations from great
Western thinkers. Byars spent 1969 at
the Hudson Institute, near New York,
as a member of a committee of experts
taking part in a programme organized
by the Los Angeles County Museum
of Art. The World Question Center, as
the project was known, was aimed at
gathering the world's one hundred
most interesting questions and rapidly
expanded to involve European lumi-
naries. Byars's subsequent work raised
philosophical contemplation and enig-
matic statement to an art form, impart-
ing the mystery of the universe through
these unanswerable queries. In some
of his pieces, the cosmic conundrum is
further suggested by spherical forms
representing the world in perfect plen-
itude. Created with unusual precious
materials, the magical ambiance of
Byars's installations invites viewers to
reflect on the essential and its relation-
ship to language.

M.R.

ELLIOTT, James. *The Perfect Thought:
Works by James Lee Byars*, exhib. cat.
Berkeley: University Art Museum,
1990.

SARTORIUS, Joachim. *James Lee
Byars im Gespräch mit Joachim
Sartorius.* Cologne: Kiepenheuer
und Witsch, 1996.

ALEXANDER CALDER
Lawnton, Pennsylvania, 1898 -
New York 1976

In 1915, American painter, sculptor and
draftsman Alexander Calder enrolled
at the Stevens Institute of Technology
in Hoboken, New Jersey, where he earned
a degree in mechanical engineering.
After a visit to Piet Mondrian's Paris
studio in 1930, he turned to abstraction,
using a palette composed exclusively
of white, black and primary colours. In
1931, he joined the Abstraction-Création
group and exhibited his first abstract
sculptures, in which wooden spheres
on fine stems suggest sidereal motion.
Based on the careful observation of na-
ture and the laws of physics, his cosmic
constructions reflect his engineer's
training and passion for astronomy.
Several pieces, including *A Universe*
(1934), simulate the oscillating move-
ment of the planets, moons and suns
with a motor that powers their various
parts. Recognized as the foremost
exponent of kinetic art, Calder created
mobiles that mirror the universe and
obey its laws of gravity and equilibrium.
In the 1960s, he erected stabiles in busy
urban sites such as airports, train sta-
tions and bank buildings, becoming
the world's leading practitioner of pub-
lic art.

I.N.

MARTER, Joan M. *Alexander Calder.*
Cambridge: Cambridge University
Press, 1991.

PRATHER, Marla. *Alexander Calder,
1898-1976*, exhib. cat. Washington:
National Gallery of Art, 1998. Text by
Arnauld Pierre and Alexander Rower.

JOHN WILSON CARMICHAEL
Newcastle upon Tyne 1799/1800 -
Scarborough 1868

Son of a shipwright, John Wilson
Carmichael came to shipbuilding at an
early age but quit his craft in 1823 to
take up painting. He trained as a pupil
of landscape painter Thomas Miles
Richardson and is said to have worked
on occasion as his collaborator. After
travels in Italy and the Netherlands,
he exhibited in London at the Royal
Academy in 1835, then at the British
Institution and in Suffolk Street. In
1845, he settled in London, where his
work met with striking success, reflecting
the popularity of marine paintings
sparked by England's flourishing
maritime commerce with its overseas
colonies. Carmichael was known for
the vast compositions that attest to his
remarkable draftsmanship and intimate
knowledge of ships. Indeed, the crafts
in his paintings actually appear to move
to the rhythm of the wind and the
waves. In 1855, during the Crimean War,
he sailed with the English fleet on
assignment for the *Illustrated London
News*, sketching the battles against
the Russians in the Baltic Sea. At the
height of his success, Carmichael wrote
two technical books: *The Art of Marine
Painting in Watercolours* (1859) and
*The Art of Marine Paintings in Oil-
colours* (1865).

M.R.

VILLAR, Diana. *John Wilson Carmichael, about 1799-1868.* Portsmouth, England: Carmichael and Sweet, 1995.

EMILY CARR

Victoria, British Columbia, 1871-
Victoria 1945

Canadian painter and writer Emily Carr studied at the California School of Design in San Francisco from 1891 to 1894. In 1899, she went to England to enrol at London's Westminster School of Art. She returned to Canada in 1904 and, three years later, while journeying in Alaska, began portraying Native people. In 1910, she trained briefly at the Académie Colarossi in Paris, where contact with the Fauvists and Post-Impressionists visibly influenced her style. Back in British Columbia the following year, she turned again to depicting Native American heritage, now using an unrestrained style and dazzling colours. Through 1913, she worked on a series of paintings about Amerindians, whose art and crafts she saw as the vestiges of the original glory of the Canadian West. In 1927, after a fifteen-year period during which she virtually ceased to paint, Carr met the Group of Seven; inspired by their unique vision of the Canadian landscape, she took up her brush. Lawren Harris, who became a friend, introduced her to theosophical teachings and urged her to express the concept of a ubiquitous divine spirit in her landscapes. Swirling tree figures began appearing in her work in 1935, their sovereign presence reflecting the pantheistic belief in oneness with God. Following a heart attack in 1937, she gradually gave up painting and turned to writing to convey her faith in the existence of an omnipresent spiritual force.

M.R.

SHADBOLT, Doris. *Emily Carr,* exhib. cat. Ottawa: National Gallery of Canada, 1990.

TIPPETT, Maria. *Emily Carr: A Biography.* Revised edition. Toronto: Stoddard, 1994.

CARL GUSTAV CARUS

Leipzig 1789 - Dresden 1869

Carl Gustav Carus learned to draw in Leipzig, studying first with Julius Diez, then with Johann Veit Schnorr von Carolsfeld at Oeser's drawing academy. This was an amateur pursuit, however, his principal training being in medicine and philosophy, which he studied at the University of Leipzig from 1804 to 1810. In 1814, he was appointed professor of obstetrics and director of the maternity clinic at the Medical-Surgical Academy in Dresden; in 1827, he was named personal physician to the King of Saxony and State Advisor. He began painting in earnest as of 1810 and showed his works publicly for the first time at the 1816 Dresden Kunstakademie exhibition. The following year he met Caspar David Friedrich, who taught him to paint and inspired his profound love of nature. This encounter was to determine the course of his art. His meeting with Goethe the same year was equally crucial, leading him to adopt the observation of nature as an objective basis for understanding the evolution of the living world. In the seventh of his *Nine Letters on Landscape Painting*, written between 1815 and 1824, he defined this concept as *Erdlebenbild* (the representation of life on earth), a term that evokes man's communion with life's ever-changing flow. Carus's predilection for the scientific observation of nature's laws is evident in his paintings of the 1820s, which reflect his interest in geology and the formation of the earth's crust.

M.R.

MEFFERT, Ekkehard. *Carl Gustav Carus. Sein Leben, seine Anschauung von der Erde.* Stuttgart: Freies Geistesleben, 1986.

MÜLLER-TAMM, Jutta. *Kunst als Gipfel der Wissenschaft. Ästhetische und wissenschaftliche Weltaneignung bei Carl Gustav Carus.* Berlin and New York: Walter de Gruyter, 1995.

JEAN-DOMINIQUE CASSINI

Perinaldo 1625 - Paris 1712

Italian-born French astronomer Jean-Dominique Cassini worked in the Modena observatory of a wealthy amateur astronomer under the guidance of two eminent scientists, Jesuit Fathers

Riccioli and Grimaldi. His work soon gained recognition, and in 1650 he was appointed to the chair of astronomy at the University of Bologna; in 1663, he entered the service of Pope Alexander VII. In 1668, Colbert, minister to Louis XIV, offered him corresponding membership in the newly formed Académie des sciences and an invitation to come to Paris to help set up the new observatory. Cassini moved to the French capital the following year. Working with the Académie, he pushed to have Claude Perrault's building plans modified to better meet the astronomers' needs. He began his research in 1671, even before construction was complete, and was named director of the institution by Louis XIV in 1672. Using enormous astronomical lenses, he discovered Saturn's second and third moons in those first two years, and then the fourth and fifth in 1684. From 1671 to 1679, he observed the surface of the moon, tracing its rugged features with the help of draftsmen Sébastien Leclerc and Jean Patigny. Their drawings later served to develop a large map of the moon, which Cassini presented to the Académie in 1679. He died in 1712, leaving a legacy of three generations of eminent astronomers who would head the Paris Observatory until the Revolution.

M.R.

DÉBARBAT, S., S. GRILLOT and J. LÉVY. *L'Observatoire de Paris : son histoire 1667-1963.* Paris: Observatoire de Paris, 1990.

WOLF, Charles. *Histoire de l'Observatoire de Paris, de sa fondation à 1793.* Paris: Gauthier-Villars, 1902.

ANDREAS CELLARIUS

Active around 1660

Andreas Cellarius's foremost accomplishment is without doubt his *Atlas coelestis* or *Harmonia macrocosmica*, published in Amsterdam in 1660 and reissued in 1661 and 1708. Containing twenty-nine maps of the heavens, among the most beautiful ever made, this atlas perfectly illustrates the dominant astronomical theories of the seventeenth century.

J.-F.G.

VIJA CELMINS
Riga 1939

Forced to flee their native Latvia during World War II, Vija Celmins and her family sought refuge in Germany, then in the United States, where they settled in Indianapolis in 1949. In the early 1960s, Celmins concentrated on depicting everyday objects, rendering them as individual, carefully centred painting subjects or exaggeratedly large sculptures of Pop Art inspiration. War and urban crisis themes marked her work in 1965, with imagery drawn from childhood memories and newspaper photos. Joining the faculty of the University of California at Irvine in 1967, she continued to develop her projects, working from photos to produce drawings of the rugged lunar crust, the ocean's movements and barren landscapes. In the early 1970s, her production focussed mainly on images of galaxies and constellations. Celmins's concern for realism is satisfied by information gleaned from astronomy magazines and frequent visits to California observatories. Ever defying the spatial limits of her paintings, she seeks to render infinity from the many faces of the cosmos.

I.N.

STORR, Robert. *Vija Celmins*, exhib. cat. Paris: Fondation Cartier pour l'art contemporain, 1995.

Vija Celmins, exhib. cat. London: Institute of Contemporary Arts; New York: D.A.P., 1996. Text by James Lingwood, Stuart Morgan, Richard Rhodes and Neville Wakefield.

EUGENE ANDREW CERNAN
Chicago 1934

Eugene Cernan was the lunar module commander during the Apollo 17 flight of 1972, the final manned mission of the Apollo programme. He attended Purdue University, graduating in 1956 with a B.S. degree in electrical engineering. That same year, he went on active Navy duty and served as a fighter pilot. In 1963, he received an M.S. in aeronautical engineering from the U.S. Naval Postgraduate School; at this time, he was chosen by NASA to train as an astronaut. Cernan made three space flights. In 1966, he was the pilot of Gemini 9 and made a two-and-a-half-hour space walk. Three years later, he

was the lunar module pilot of Apollo 10, a dress rehearsal flight for the first lunar landing later that year. In 1972, as part of the Apollo 17 mission, he and geologist Harrison Schmitt landed on the moon near the Sea of Tranquillity. During a three-day period, they spent twenty-two hours exploring the lunar surface, travelling in a motorized lunar rover to examine the geographical features and collect rock and soil samples. Cernan subsequently took part in the astronaut training programme for the Apollo-Soyuz project. Following his retirement from the Navy in 1976, he founded his own aerospace consulting firm.

C.P.

CORTWRIGHT, Edgar M. *Apollo Missions to the Moon*. Washington: NASA, 1975.

SCHICK, Ron, and Julia VAN HAAFTEN. *The View from Space: American Astronaut Photography, 1962-1972*. New York: Clarkson N. Potter, 1988.

ILIA GRIGORIEVICH CHASHNIK
Lyucite, Latvia, 1902 -
Leningrad 1929

In 1919, after a brief stint as an architecture student in Moscow, Ilia Chashnik enrolled at the Vitebsk Art Institute to study with Malevich and joined the Unovis group. The following year, he designed projects for airborne cities based on theories of free-floating forms and the assumption of a dynamic space with zero gravity. After graduating in 1922, Chashnik followed his teacher to the Ginkhuk (State Institute of Painterly Culture) to help set up the formal-theoretical section. In 1923, Malevich assigned him to design ceramics with Suprematist motifs at the Lomonosov State Porcelain factory. He went on to produce compositions in which rectangular Suprematist elements arranged on a cross-shaped structure radiate from a central circular motif. Inspired by Malevich's cosmic approach, his forms were off-centred and set in parallel fashion to suggest the uninterrupted movement of the particles that make up the microscopic universe. He applied Suprematist principles in design and decorative work, as well, then in 1926 began creating his own architectons, which differed from Malevich's maquettes in their larger dimensions and internal symmetry.

I.N.

RAKITIN, Wassili. *Malewitsch, Suetin, Tschaschnik*, exhib. cat. Cologne: Galerie Gmurzynska, 1992. Text by Krystyna Gmurzynska-Bescher, Evgeniya Petrova and Nina Suetina.

Ilya Chashnik and the Russian Avant-garde: Abstraction and Beyond, exhib. cat. Austin: Archer M. Huntington Art Gallery, University of Texas, 1981. Text by J. E. Bowlt, M. Frost and E. S. McCready.

FREDERIC EDWIN CHURCH
Hartford 1826 - New York 1900

A foremost figure of the Hudson River School, Frederic Edwin Church learned to paint with Thomas Cole and embraced his heroic, spiritual vision of the American landscape. After Church moved to New York in 1847, his work was marked by the aesthetic of John Ruskin; the careful study of nature, he believed, could reveal the world's underlying truths. The influence of Alexander von Humboldt's treatise *Cosmos* led him to depict the harmonious oneness of the universe described by the German naturalist as vast panoramic expanses enhanced with scientific detail. Drawn by the description of botanical and geological wonders, he travelled in South America in the spring of 1853, retracing Humboldt's 1802 itinerary. In 1857, the stunning success of *Niagara Falls*, inspired by a trip to the falls the previous year, brought him acclaim as America's greatest painter. On a return voyage to South America, he made numerous sketches of the Chimborazo, Cotopaxi, Pichincha, Cayambe and Sangay volcanos. In 1859, forsaking the Andean wilds for the virgin regions of the North, he journeyed to Newfoundland and Labrador to paint the sublime but terrifying glacial landscape. His travelling companion was Thomas Cole's biographer, the Reverend Louis L. Noble, whose *After Icebergs with a Painter* (1861) offers a journalistic account of the expedition. In 1860, Church married Isabel Carnes and purchased a home-site overlooking the Hudson River, on which he built Olana, a Persian-inspired villa. There, he spent the last years of his life, producing small oil studies of the sky and lands surrounding his home.

M.R.

CARR, Gerald L. *Frederick Edwin Church: Catalogue Raisonné of Works of Art at Olana State Historic Site*. Cambridge and New York: Cambridge University Press, 1994.

357

KELLY, Franklin, ed. *Frederic Edwin Church*, exhib. cat. Washington: National Gallery of Art; Washington and London: Smithsonian Institution Press, 1989. Text by Stephen Jay Gould, Debora Rindge and James Anthony Ryan.

MIKALOJUS KONSTANTINAS ČIURLIONIS

Varena, Lithuania, 1875 - Pustelnik (now in Poland) 1911

Lithuanian painter and composer Mikalojus Čiurlionis was destined for a brilliant musical career. In 1904, however, his interest turned to painting and he began training at Warsaw's School of Fine Arts with Kazimierz Stabrowski, a painter recognized for his mystical, Symbolist allegiances. Inspired by Stabrowski's theosophical views, Čiurlionis's early works revived the biblical and philosophical themes then in vogue among the Symbolists. But his fascination with the mysteries of the universe originated in 1894, when he entered the Warsaw Conservatory and delved into the astronomical theories of Kant, Laplace and Flammarion. Flammarion's writings led him to adopt a pantheistic vision that advocated communion with nature. In 1905, while travelling the Black Sea coast and in the Caucasus, he began *The Creation of the World* (1906), a cycle of thirteen paintings depicting the origins of life. In 1908 and 1909, he created ambitious pictorial cycles with musical structures and titles, representing man's ancient union with the cosmos, which only the "music of the spheres" can restore. Seeking wider recognition during that period, he spent time in Saint Petersburg, where his work met with great acclaim. His monumental triptych *Rex*, shown at the Union of Russian Artists exhibition in 1906, intimates the existence of an omnipresent force governing the universe.

M.R.

BUDDE, Rainer, ed. *Die Welt als große Sinfonie. Mikalojus Konstantinas Čiurlionis (1875-1911)*. Cologne: Wallraf-Richartz-Museum; Oktagon, 1998.

GOŠTAUTAS, Stasys et Birute VAIČJURGIS-ŠLEŽAS, eds. *Čiurlionis, Painter and Composer: Collected Essays and Notes, 1906-1989*. Vilnius: Vaga; Chicago: Institute of Lithuanian Studies, 1994.

THOMAS COLE

Bolton-le-Moors, England, 1801 - Catskill, New York, 1848

Founder of the Hudson River School, Thomas Cole immigrated to the United States in 1818, settling first in Philadelphia, then joining his family in Steubenville, Ohio. While an assistant engraver in his father's wallpaper factory, he learned the rudiments of oil painting from an itinerant portraitist and, soon after, began producing landscapes. From 1823 to 1825, he studied the work of landscape artists Thomas Doughty and Thomas Birch, sketching from nature and developing the meticulously detailed drawing technique that would characterize his work. In 1825, following a sketching trip along the Hudson, he completed a series of paintings that caught the attention of artists John Trumbull, William Dunlap and Asher B. Durand when they were shown later that year in an exhibition at the American Academy in New York. Beginning in 1827, he secured commissions from such influential clients as Robert Gilmor, Jr., Daniel Wadsworth and Lumen Reed. In 1829, with his reputation established as America's foremost landscape painter, he sailed for Europe, where the noble themes he sensed in the works of the great masters aroused his Romantic spirit. Deeply influenced by Turner, Constable and Lorrain, he returned home and sought to elevate the landscape genre by infusing his compositions with moral value. During a second European voyage in 1841-1842, he perfected the technical skills evident in his remarkable use of colour and evocative atmospheres. In both his paintings and writings, Thomas Cole interpreted the American landscape as a metaphor for a superior moral quest, seeing there the promise of mankind's rebirth.

M.R.

NOBLE, Louis Legrand. *The Life and Works of Thomas Cole* [1853]. Hensonville, New York: Black Dome Press, 1997.

TRUETTNER, William H., and Alan WALLACH, eds. *Thomas Cole: Landscape into History*, exhib. cat. Washington: National Museum of American Art, Smithsonian Institution; New Haven and London: Yale University Press, 1994. Text by Christine Stansell, J. Gray Sweeney and Sean Wilentz.

JOSEPH CORNELL

Nyack, New York, 1903 - New York 1972

American painter, sculptor and experimental filmmaker Joseph Cornell came onto the New York art scene in 1932 with a series of collages, informed by those of Max Ernst, shown at the exhibition *Surrealism* organized by Julien Levy. Later in the 1930s, he began producing shadow boxes housing assemblages of small, disparate objects. The first of his *Soap Bubble Set* boxes appeared in the 1936 exhibition *Fantastic Art, Dada, Surrealism* at New York's Museum of Modern Art. This composition includes four small cylinders, a clay pipe, a doll's head, an egg in a wineglass and an antique map of the moon, inviting contemplation of the cosmos, here evoked by the rounded forms of the assembled objects. Cornell paid frequent visits to the Hayden Planetarium and collected books and magazines on astronomy. He translated his passion for the wonders of the universe through representation of the mysterious, poetic aspects of outer space. This fascination with the cosmos is especially evident in his 1950s production, such as the series of assemblages devoted to constellations shown in the 1955 exhibition *Winter Night Skies* and *Untitled (Space Object Box)* (about 1958), where a cork ball represents the sun, and planetary orbits are symbolized by a ring.

I.N.

McSHINE, Kynaston, ed. *Joseph Cornell*, exhib. cat. New York: Museum of Modern Art; Munich: Prestel, 1980. Text by Dawn Ades, Lynda Roscoe Hartigan, Carter Ratcliff and P. Adam Sitney.

SOLOMON, Deborah. *Utopia Parkway: The Life and Work of Joseph Cornell*. New York: Farrar, Straus and Giroux, 1997.

TULLIO CRALI

Igalo, Croatia, 1910

Tullio Crali taught himself to paint in the Italian city of Gorizia. Following in the footsteps of Balla, Boccioni and Prampolini, he joined the Futurists in 1929 and showed in their aero-painting exhibitions as of 1931. His interests extended to stage and set design, as well as architecture, and in 1933 he

participated in the *Mostra futurista di scenotecnica cinematografica* (Futurist Exhibition of Cinematic Set Design) held in Rome. From 1934 to 1942, he exhibited with the Futurists at the Venice Biennale. Crali's interest in the new aerial views of the earth is apparent in his work, as is his particular fascination with the aircraft he so often depicted. In 1942, at Futurist gatherings in Gorizia and Venice, he gave public readings of the manifesto he wrote in collaboration with Marinetti, *Illusionismo plastico di guerra e perfezionamento della terra*. From 1950 to 1958, he lived in Paris, furthering his investigation of aeropainting and experimenting with new materials.

L.S.

ASTORI, Amedeo, ed. *Mostra antologica di Tullio Crali*, exhib. cat. Trieste: Sala comunale d'arte di Palazzo Costanzi; La Editoriale Libraria, 1976.

REBESCHINI, Claudio, ed. *Crali futurista; Crali aeropittore*, exhib. cat. Trento and Rovereto: Museo di arte moderna e contemporanea; Rovereto: Archivio del' 900; Milan: Electa, 1994.

HENRY SAMUEL DAVIS
London 1809 - England 1851/52

Topographer and British army officer Henry Samuel Davis was the regiment standard bearer of the 13th Light Infantry in 1827. In 1828, he sailed aboard the *Amity* to Nova Scotia, where he was stationed until 1831. Promoted to captain in 1835, then major in 1839, he was posted to the Antilles – Saint Vincent, Demerara and Barbados – during the 1840s. While on a second Canadian expedition, in 1845, he produced topographical watercolour views of the Niagara region and the Thousand Islands archipelago in the Saint Lawrence River. During a stay in England later that year, he exhibited sketches of Amerindians at the Society of Irish Artists. In 1847, he showed his watercolours in Canada at the inaugural exhibition of the Montreal Society of Artists, of which he was an honorary member. The following year, back in London, he published four of his Niagara Falls drawings as chromolithographs engraved by artist Thomas McLean. He was made lieutenant colonel in 1850 and headed the 52nd Light Infantry until his retirement in 1851.

M.R.

GIORGIO DE CHIRICO
Vólos, Greece, 1888 - Rome 1978

Giorgio De Chirico studied in Athens at the Higher School of Fine Arts prior to enrolling at the Akademie der Bildenden Künste in Munich, where he was struck by the mythological paintings of Symbolists Arnold Böcklin and Max Klinger. Under the additional influence of Nietzsche, he developed a new perception of reality by observing familiar places and things as if for the first time. De Chirico was a forerunner of Surrealism. In 1910, he began producing strange, enigmatic canvases in which dreams and reality commingle; Guillaume Apollinaire, whom he met while living in Paris between 1911 and 1914, dubbed his work "metaphysical". Pursuing this theme, he painted oddly juxtaposed objects in deserted architectural complexes that cast sharp shadows, creating a mysterious, disquieting impression of terra incognita. He peopled these dreamscapes with faceless mannequins. In 1917, he began work on the "Metaphysical Interior" series and, with Carlo Carrà, established the style known as *pittura metafisica*. He reverted to the classical manner of the Italian masters in 1919, but his late production is infused with mythological references and Surrealist symbols, marking a return to the metaphysical motif.

L.S.

BALCACCI, Paolo. *De Chirico, 1888-1919 – la metafisica*. Milan: Leonardo Arte, 1997.

FAGIOLO DELL'ARCO, Maurizio. *Vita silente: Giorgio De Chirico dalla metafisica al barocco*, exhib. cat. Acqui Terme: Palazzo Liceo Saracco; Milan: Skira, 1997.

WARREN DE LA RUE
Guernsey 1815 - London 1889

Warren De la Rue was two when he moved with his family to England, where his father, Thomas De la Rue, established the family fortune as proprietor of an acclaimed stationery firm. De la Rue was educated in Paris at the Collège Sainte-Barbe, where he showed a special aptitude for science. He returned to England in 1830 and at age sixteen entered the family business, in which he remained active for the rest of

his life. He nevertheless maintained an intense lifelong involvement in scientific experimentation, notably in chemistry and astronomy; he was elected to the Royal Society, the Royal Astronomical Society and the French Académie des sciences. In the early 1850s, inspired by Bond and Whipple's daguerreotypes of the moon, De la Rue took up astronomical photography, which he carried out at private observatories equipped with telescopes of his own design. By the end of the decade, he was recognized as one of the most skilled astronomical photographers of the era. In 1860, he led the British expedition to Spain that observed the solar eclipse of that year; his findings helped to clarify the nature of the solar prominences visible during eclipses.

C.P.

DE LA RUE, Warren. *Report of Celestial Photography in England*. London: Taylor and Francis, 1860.

ROTHERMEL, Holly. "Images of the Sun: Warren De la Rue, George Biddell Airy and Celestial Photography". *British Journal for the History of Science*, no. 26 (1993), pp. 137-169.

ROBERT DELAUNAY
Paris 1885 - Montpellier 1941

Painter and art theorist Robert Delaunay entered Ronsin's Belleville stage set workshop in 1902 and apprenticed there for two years. In 1907-1908, deeply influenced by Eugène Chevreul's 1839 theory of simultaneous colour contrast, he merged the Impressionists' investigation of the effect of colour on form with Neo-Impressionist experimentation on the interrelationship of colours. He painted his first abstract works in 1912, among them *Simultaneous Disk*, in which the alternating colours lend impetus to the form. His study of light sources, based on solar and lunar observations, led him to vest the circular motif with cosmic power. In its formal perfection, he believed, the circle represents the entire universe – from the least atom to the planets themselves – as a well-ordered whole. Seeking to portray the essence of the cosmos, Delaunay painted colour contrasts in which the key element is light. In 1921, after living for seven years in Spain and Portugal, he returned to Paris, where he became friendly with Tristan Tzara

and the Dadaists. As artistic director of two pavilions for the 1937 World's Fair, he realized his dream of producing monumental artworks integrated into architectural environments.

I.N.

KUTHY, Sandor. *Sonia and Robert Delaunay*, exhib. cat. Bern: Kunstmuseum Bern, 1991. Text by Kuniko Satonobu.

Robert et Sonia Delaunay, exhib. cat. Paris: Musée d'art moderne de la ville de Paris, 1985. Text by Bernadette Contensou, Charles Delaunay and Danielle Molinari.

MINO (DOMENICO) DELLE SITE
Lecce, Italy, 1914 - Rome 1996

Mino Delle Site began as a pupil of Geremia Re at the Scuola Artistica Statale in Lecce, studying engraving and drawing. In 1930, he moved to Rome, where he trained at the Liceo Artistica, on Via Ripetta. The following year he met Marinetti, Balla, Prampolini, Benedetta, Diulgheroff and Dottori at the *Mostra di aeropittura – Omaggio futurista ai trasvolatori* (Aero-painting Exhibition – Futurist Tribute to the Flyers); in 1932, he took part in the *Omaggio futurista a Umberto Boccioni* at the Pesaro gallery in Milan. He became an official member of the Futurist movement in 1933, showing regularly in the group's exhibitions. His 1932 *Le pilote Aliluce* (Pilots with Wings of Light) renders aero-painting with a schematized aircraft motif and conic forms depicting its luminous trajectory through space. Delle Site exhibited at the 1938 Venice Biennale with the Futurists. He began experimenting with abstract Symbolism in 1948; in 1956, he turned to "Structural Automatism" and "rhythm visions". Between 1968 and 1973, he taught graphic arts, first at the Accademia del Costume e della Moda in Rome, then at the University of Bologna.

L.S.

CRISPOLTI, Enrico. *Mino Delle Site: aeropittura e oltre, dal 1930*, exhib. cat. Lecce: Museo provinciale; Milan: Electa, 1989.

VENTUROLI, Marcello. *Mino Delle Site*. Rome: Astrolabio galleria d'arte, 1973.

MICHELE DE LUCCHI
Ferrara 1951

Michele De Lucchi trained at the architecture school of the Accademia di Belle Arti in Florence from 1969 to 1975. The following year, he worked as an assistant to Professor Adolfo Natalini, a charismatic figure of the "radical architecture" school, and taught an industrial design seminar. After a period with the Alchymia studio in 1978, he joined Olivetti as a consultant in 1979; as of 1994, he headed the company's office furniture and accessory design. After co-founding the Memphis group with Ettore Sottsass in 1981, he conceived commercial product designs of 1950s kitsch inspiration. Dedicated to making their creations widely accessible, the Memphis designers produced utilitarian objects, such as lamps, toasters and irons, employing geometric shapes and bright colours to give them a playful quality. De Lucchi created some of his most famous pieces during this period, including the "First" chair (1983), composed of a stool haloed by a tubular metal arc bearing a circular backrest and two spherical armrests. This piece, which resembles a model of the solar system, underscores the extent to which appearance outweighs functionality in his work. In 1984, he opened his own studio in Milan and now exports his creations throughout the world.

I.N.

BUCK, Alex, and Matthias VOGT, eds. *Michele de Lucchi*. Berlin: Ernst und Sohn; New York: St. Martin's Press, 1993. Text by Volker Fischer, Klaus Stefan Leuschel, Ettore Sottsass, Penny Sparke, Deyan Sudjic and Isa Tutino Vercelloni.

KICHERER, Sibylle, and Silvio SAN PIETRO, eds. *Michele de Lucchi*. Milan: Edizioni L'Archivolto, 1992.

OTTO WILHELM HEINRICH DIX
Untermhaus, Germany, 1891 - Singen 1969

German painter and engraver Otto Dix studied at the Kunstgewerbeschule in Dresden from 1909 to 1914. After serving in World War I, he trained at Dresden's Kunstakademie (1919-1922) and founded the Dresden Secession group, which included both artists and writers. Marked by the influence of Expressionism and Futurism, his work dealt with the complexity of life and human suffering. In 1918, he began a small series of compositions in which masculine, warlike, destructiveness contrasts with the feminine ideal of fertility and fecundity. With an eye to the microscopic and the macroscopic alike, he painted rounded female bodies against dark backgrounds strewn with such cosmic motifs as stars, moons and luminous crystals, linking the birth of mankind with the creation of the universe. After a brief foray into Dadaism, he joined the Neue Sachlichkeit movement. In the early 1920s, his style was closer to Realism, as were his themes: war, prostitution, the bourgeoisie and social evils. Dix was profoundly troubled by his wartime experience and is known for his depiction of the horrors of war. In his final paintings, he sought inspiration in biblical subjects.

I.N.

SABARSKY, Serge. *Otto Dix*. Paris: Herscher, 1992.

Otto Dix, 1891-1969, exhib. cat. London: Tate Gallery, 1992. Text by Keith Hartley, Sarah O'Brien Twohig, Iain Boyd Whyte, Frank Whitford and Ursula Zeller.

GIOVANNI DONDI
Chioggia 1318 - Genoa 1389

The son of physician and astronomer Jacopo de' Dondi dall'Orologio, Giovanni Dondi left Chioggia in 1349 for Padua, where he served as personal physician to Emperor Charles IV. Around 1350, he was named to the faculty of astronomy at the University of Padua, where he also lectured in medicine, astrology, philosophy and logic. In 1364, he completed the construction (begun in 1348) of his astrarium, an astronomical clock of bronze, copper and brass that brought him fame throughout Europe. In an accompanying treatise entitled *Tractatus astrarii* or *Tractatus planetarii*, he provided a detailed account of the instrument's workings. The astrarium, driven by a series of gears, was a heptagonal equatorium faced with seven dials representing the sun, moon and planets Mercury, Venus, Mars, Jupiter and Saturn. Additional dials indicated the current time, the rising and setting of the sun, the moon's orbital speed

and religious holidays. Dondi taught medicine in Florence between 1367 and 1370. In 1381, his astrarium was purchased by Gian Galeazzo Visconti, Duke of Milan, who placed it in the library at the Castello Visconteo in Pavia. All trace of the clock was lost in 1530.

<div align="right">M.R.</div>

BEDINI, Sylvio A., and Francis R. MADDISON. *Mechanical Universe: The Astrarium of Giovanni de' Dondi.* Philadelphia: American Philosophical Society, 1966.

Padua sidus preclarum: I Dondi dall'Orologio e la Padova dei Carraresi, exhib. cat. Padua: Edizioni 1 + 1, 1989. Text by Giovanni Lorenzoni.

JOHANN GABRIEL DOPPELMAYR
About 1671 - 1750

Of all of the globe makers in Nuremberg, Doppelmayr was the most prolific. An astronomer and cartographer by profession, he devoted his life to promoting Copernicus's heliocentric system. His most famous cartographic achievement, the 1742 *Atlas novus coelestis,* defines the basic principles of astronomy and traces the history of the solar system in the manner of Andreas Cellarius, who worked around 1660.

<div align="right">J.-F.G.</div>

GUSTAVE DORÉ
Strasbourg 1832 - Paris 1883

At the age of fifteen, French painter, illustrator and sculptor Gustave Doré was already working for Charles Philippon's satirical *Journal pour Rire* and continued to turn out weekly caricatures until 1850. In 1851, he began producing illustrations for literary classics, which became a lifelong pursuit. His drawings – part lyricism, part buffoonery – added a romantic dimension to such works as Balzac's *Droll Stories,* Ariosto's *Orlando furioso* and Dante's *Inferno.* He was uncommonly prolific and used craftsmen to engrave his illustrations, which he roughly outlined in wash drawings and gouache. Parallel to his career as an illustrator, he executed numerous paintings and exhibited with great success at the Doré Gallery in London, beginning in 1868. Between 1855 and 1879, he travelled in the Swiss Alps and the Pyrenees on several occasions. In 1873, while touring Scotland with an English friend, Colonel Teesdale, he experimented with watercolours and painted many landscapes inspired by the work of English watercolourists seen in London. Abandoning the picturesque style of his earlier scenes, he adopted a cosmic vision, endowing the grandiose and at times hostile landscape with a divine spirit.

<div align="right">M.R.</div>

FAVIÈRE, Jean, ed. *Gustave Doré 1832-1883,* exhib. cat. Strasbourg: Musée d'art moderne, Cabinet des estampes, 1983. Text by Claude Bouret, Samuel F. Clapp, Gabrielle Feyler, Marie-Jeanne Geyer, Christine Hamm, Jean Lacambre, Michèle Lavallée, Nadine Lehni and Ségolène de Men-Samson.

MALAN, Dan. *Gustave Doré: Adrift on Dreams of Splendor.* Saint Louis: Malan Classical Enterprises, 1995.

GEORG CHRISTOPHE EIMMART
1638 - 1705

Georg Eimmart, a distinguished mathematician, took up soft cut copper engraving around 1658 and opened his Nuremberg studio in 1660. Turning from mathematics to astronomy, his particular interest was in the manufacture of specialized instruments such as quadrants, sextants, telescopes and astronomical clocks. He set up a small observatory in the city's fortified walls, where he made his observations and shared his science with young would-be astronomers.

<div align="right">J.-F.G.</div>

EMES & BARNARD
Operated in London 1808-1829

Introduced to silversmithing by Thomas Chawner in 1773, Edward Barnard worked as a foreman in Henry Chawner's studio around 1786. In 1796, engraver John Emes joined the firm as an associate, bringing the capital necessary for its expansion. When Chawner retired in 1798, Emes took over the company with Edward Barnard as his manager. Emes's death in 1808 led to a new partnership, formed by Rebecca Emes, his widow, and Edward Barnard. As commercial silversmiths, Emes & Barnard specialized in the manufacture of commissioned articles for British and foreign private customers, retailers and manufacturers. In 1811-1812, at the request of William Frend, a future member of the Royal Astronomical Society, they created a cylindrical silver tankard adorned with a comet, three planets and a multitude of engraved stars, and topped with a star in a mass of clouds. In 1829, Rebecca Emes retired from the firm, which was taken over by Barnard and his sons Edward, John and William. Operating under the name Edward Barnard & Sons, the company is now a subsidiary of Padgett and Braham Ltd.

<div align="right">M.R.</div>

WEES, Beth Carver. *English, Irish and Scottish Silver at the Sterling and Francine Clark Art Institute.* New York: Hudson Hills Press, 1997.

MAX ERNST
Brühl 1891 - Paris 1976

Further to schooling in philosophy, psychology and art history, which sparked his interest in German Romantic literature, Max Ernst turned to painting as a self-taught artist. In 1919, he formed a Dada group in Cologne, which Arp joined later that year. In 1924, then living in Paris, he became a member of the Surrealist movement. In seeking ways to unleash the power of the unconscious, he developed frottage, an automatism-derived technique that consists of rubbing pencil lead over paper laid on the textured surface of an object, so as to unveil its hidden structure. The discovery of this process led to "Histoire naturelle", a series of thirty-four frottage drawings executed in 1925-1926, in which Ernst depicts a fantastical cosmogony. He later adapted this technique to painting, causing the luxuriant vegetation of his "Forest" series to surge from forms scratched into the colours. Interned in a French camp at the outset of the War, he fled to the United States in 1941, where he produced images of a crumbling world using the transfer process known as decalcomania. During the 1960s and 1970s, he revived the cosmic imagery developed in "Histoire naturelle" for another series, "Tableaux-planètes", in which the circle symbolizes the elements of the universe. In 1963, he executed

Earth Seen from Maximiliana, a painting on glass portraying the earth as seen from space by the first astronauts. His interest in astronomy led to the 1954 publication of *Maximiliana, or The Illegal Practice of Astronomy*, for which he made thirty-four engravings to illustrate the writings of astronomer Ernst Wilhelm Leberecht Tempel.

<div align="right">M.R.</div>

CAMFIELD, William A., ed. *Max Ernst: Dada and the Dawn of Surrealism*, exhib. cat. New York: Museum of Modern Art; Houston: Menil Collection; Munich: Prestel, 1993.

SPIES, Werner, Sigrid METKEN and Günter METKEN, eds. *Max Ernst: Œuvre-Katalog*. Houston: Menil Foundation; Cologne: DuMont Schauberg, 1975.

SPIES, Werner, ed. *Max Ernst: A Retrospective*, exhib. cat. London: Tate Gallery; Munich: Prestel, 1991. Text by Karin von Maur, Sigrid Metken, Uwe M. Schneede and Sarah Wilson.

PATERSON EWEN
Montreal 1925

From 1947 to 1950, Paterson Ewen studied with Goodridge Roberts, Arthur Lismer and Marian Scott at the Montreal Museum of Fine Arts' School of Art and Design, where he was influenced by Post-Impressionist painting. He became acquainted with the Automatiste movement through the writings of Françoise Sullivan, whom he married in 1949, and showed in the group's *Exposition des Rebelles* in 1950. Contact with the Automatistes led him to explore abstraction in the 1950s and 1960s, although he retained the references to nature that remain central to his work. In 1968, having settled in London, Ontario, he made a radical departure from his earlier production: in an attempt to ally gestural abstraction and hard-edge technique, he turned to diagrammatic compositions to evoke the power of natural phenomena. His defining move from traditional painting came late in 1971, when he began using an electric router to gouge sheets of plywood. Since then, he has used large, gouged-out boards, enhanced with paint and diverse materials such as metal and linoleum, to portray the internal dynamics of

natural phenomena. Through their imposing dimensions and the intense process from which they derive, these "Phenomenascapes" – evidence of Ewen's lifelong interest in the natural sciences and astronomy – suggest the often terrifying grandeur of the systems and occurrences of the cosmos.

<div align="right">M.R.</div>

MONK, Philip. *Paterson Ewen: Phenomena: Paintings 1971-1987*, exhib. cat. Toronto: Art Gallery of Ontario, 1987.

TEITELBAUM, Matthew, ed. *Paterson Ewen*, exhib. cat. Toronto: Art Gallery of Ontario; Vancouver and Toronto: Douglas and McIntyre, 1996. Text by Eric Fischl, Ron Graham and Michael Ondaatje.

ARMAND HIPPOLYTE LOUIS FIZEAU
Paris 1819 - Venteuil 1896

After poor health brought a halt to his medical studies, Hippolyte Fizeau enrolled at the Collège de France, where he studied optics under H.-V. Regnault; he also studied under François Arago at the Paris Observatory. Following Arago's announcement of the daguerreotype process in August 1839, Fizeau began his first research work, seeking ways to improve the process. It was because of this familiarity with the daguerreotype that he and his collaborator at that time, Léon Foucault, were commissioned by Arago in 1845 to make one of the first successful photographs of the sun's surface. Fizeau went on to develop special instruments with which he was able to measure the approximate speed of light. In addition, he made important contributions to the understanding of the Doppler effect. Independently wealthy, he pursued his interest in science largely for his own pleasure. He was awarded the triennial prize of the Institut de France in 1856 and elected to the Académie des sciences in 1860; he received the British Royal Society's Rumford Award in 1866.

<div align="right">C.P.</div>

CORNU, Alfred. "Notice sur l'œuvre d'Hippolyte Fizeau", in *Annuaire pour l'an 1898*. Paris: Bureau de Longitudes, 1898.

LUCIO FONTANA
Rosario, Argentina, 1899 - Comabbio, Italy, 1968

Born of an Italian father and an Argentine mother, painter and sculptor Lucio Fontana divided his time between the two countries until settling in Italy in 1947, having found greater opportunity there. He enrolled at the Istituto tecnico Carlo Cattaneo in 1914, then studied at Milan's Accademia di Brera in the late 1920s. His interest in the work of the Russian Constructivists led him to abandon representation, and in 1935 he presented Italy's first abstract sculpture exhibition at the Galleria del Milione in Milan. From 1940 to 1947, he lived in Buenos Aires, where he wrote the *Manifesto Blanco*, repudiating the borders between painting and sculpture, and developed the theoretical principles of Spatialism. In the late 1940s, Fontana began creating pierced canvases under the generic title "Spatial Concepts": first *bucchi*, with spiral-shaped perforations or fissures, then in the late 1950s *tagli*, or lacerations, suggesting the universe born of splitting matter. The slits that allow light to penetrate the paintings' surface evoke celestial landscapes. At about the same time, he was creating sculptural works in fired clay, their forms suggestive of lunar craters and cosmic spatiality. He went on to produce architectural installations representing constellations, using modern materials such as Wood's lamps and the neons that inspired many artists in the 1960s.

<div align="right">I.N.</div>

JOPPOLO, Giovanni. *Lucio Fontana*. Milan: Image en manœuvre, 1992.

MESSER, Thomas M., ed. *Lucio Fontana: Retrospektive*, exhib. cat. Frankfurt: Schirn Kunsthalle; Gerd Hatje, 1996. Text by Bernard Ceysson, Lucio Fontana, Lóránd Hegyi and Ethel Martínez Sobrado.

PIERO FORNASETTI
Milan 1913 - Milan 1988

Italian artist and designer Piero Fornasetti studied drawing at Milan's Accademia di Brera from 1930 to 1932, when he was expelled for lack of discipline. His career as a designer began in earnest with the 1933 showing of a series of silk scarves at the fifth

Triennale in Milan. The seventh Triennale, in 1940, led to his decisive encounter and ensuing collaboration with designer Gio Ponti. At Ponti's request, he undertook a series of sun-inspired *lunari*, or almanacs, which he continued to produce into the 1960s. During their collaboration, he decorated objects designed by Ponti with his favourite motifs: hot air balloons, butterflies, flowers, fish and musical instruments. He was intensely active in the 1950s and contributed to the decoration of the liners *Conte Grande* (1949) and *Andrea Doria* (1952). He also began a vast series of objects inspired by astronomy and space exploration, among them a set of twelve "Astronomical Plates" (1955), the "Western Hemisphere" tabletop and the "Man in Space" plate collection (1966).

M.R.

FORNASETTI, Piero. *Ritratti di ignoti e non*. Milan: All'insegna del pesce d'oro, 1974.

MAURIÈS, Patrick. *Fornasetti, Designer of Dreams*. Boston and Toronto: Little, Brown and Co., 1991. Text by Ettore Sottsass.

JEAN BERNARD LÉON FOUCAULT
Paris 1819 - Paris 1868

Léon Foucault was the son of a well-to-do publisher and bookseller. He attended Collège Stanislas, a highly regarded secondary school; there, one of his classmates was Hippolyte Fizeau. After briefly pursuing medical studies, the two became involved with daguerreotypy when it was made public in 1839 and, in the early 1840s, contributed to technically perfecting the process. At the request of François Arago, secretary of the Académie des sciences and director of the Paris Observatory, Foucault and Fizeau carried out the first successful daguerreotypes of the sun. Foucault also produced photomicroscopic daguerreotypes for Alfred Donné, a professor of clinical microscopy, which resulted in an atlas of eighty microscopic views published in 1845. In 1854, he became one of the founding members of the Société française de photographie. He made his scientific reputation by inventing precision instruments designed to solve two fundamental problems: the speed of light and the mechanics of the earth's rotation.

He is best remembered for his use of a large pendulum to demonstrate that the rotation of the earth will slowly cause a pendulum's swing plane to veer. In 1853, Foucault won an appointment as a physicist at the Paris Observatory, where he devoted himself to technical improvements of reflecting telescope optics. He also investigated questions related to the optics of the human eye, spectral analysis, the conductivity of liquids and the conversion of motion into heat.

C.P.

BUERGER, Janet E. *French Daguerreotypes*. Chicago: University of Chicago Press, 1989.

GILBERT, P. "Léon Foucault, sa vie et son œuvre scientifique". *Revue des questions scientifiques*, vol. 5 (1879), pp. 108-154, 516-563.

CASPAR DAVID FRIEDRICH
Greifswald 1774 - Dresden 1840

Caspar David Friedrich, the foremost German Romantic, studied drawing and engraving with Johann Gottfried Quistorp prior to enrolling in 1794 at Copenhagen's Akademi for de Skønne Kunster to train with Nicolai Abildgaard, Jens Juel, Christian August Lorentzen and Johannes Wiedewelt. In 1798, he moved to Dresden, where he was to spend the rest of his life, save travels in central Germany and Bohemia. Dresden was then a lively cultural centre, and Friedrich was soon imbued with the spirit of Romanticism through contact with its principal proponents. In 1801, he met painter-poet Philipp Otto Runge and embraced his plan to portray the glory of the German countryside. Like Runge, he saw the representation of nature as a means of attaining the universal and strove to depict the landscape with the precision that comes only through exacting observation. After initial trials with oil in 1807, he composed the *Tetschen Altar* (or *Cross in the Mountains*), breaking down the barriers between art and religion to propose the contemplation of nature as an act of devotion. From his faith in nature's divinity came *Monk by the Sea* (1808-1810), which evokes the dizzying reaches of infinity that mere humans, in their insignificance, can face only through meditation. In the 1820s, he executed vast polar landscapes in which

man's ephemeral aspirations collide with the immutable natural world.

M.R.

BÖRSCH-SUPAN, Helmut. *Caspar David Friedrich*. Munich: Prestel, 1990.

BÖRSCH-SUPAN, Helmut, and Karl Wilhelm JÄHNIG. *Caspar David Friedrich. Gemälde, Druckgraphik und bildmäßige Zeichnungen*. Munich: Prestel, 1973.

RICHARD BUCKMINSTER FULLER
Milton, Massachusetts, 1895 - Los Angeles 1983

American architect, engineer, mathematician and philosopher Buckminster Fuller first came to public notice in 1927 with his Dymaxion house, equipped with devices for transforming solar energy and wind power into heat and light. Around 1932, he took the experiment a step further with the three-wheeled Dymaxion car. In the late 1940s, he invented the Geodesic Dome, a complex spherical network of triangles made of lightweight materials framed by metal tubes. Of the many he built, the most famous remains the United States Pavilion at the 1967 Montreal World's Fair. Lightweight, resistant and easily assembled in a matter of days, these domes can be adapted to an endless variety of functions and climates. Fuller's interests lay more with the mechanical aspects of a structure than with its aesthetics, and his hope was for technical and scientific progress that would benefit all mankind. Seeking to make decent, ecologically sound housing universally accessible, he designed airborne structures meant to hold entire cities. These autonomous, spherical creations, called "Cloud Nine", resembled planets floating in space. His vast 1967 project "Triton City" featured equally large spheres designed to float on water. A controversial figure among his professional peers, "Bucky" Fuller was well loved by the younger generation of architects, who were drawn to his visionary scientific theories.

I.N.

BALDWIN, J. *BuckyWorks: Buckminster Fuller's Ideas for Today*. New York: John Wiley and Sons, 1996.

PAWLEY, Martin. *Buckminster Fuller*. London: Grafton, 1992.

GALILEO GALILEI
Pisa 1564 - Arcetri 1642

Renowned Italian mathematician, as-
tronomer and physicist Galileo studied
mathematics at the University of Pisa
from 1581 to 1585, while at the same
time acquiring vast learning in the
humanities. He held the chair of mathe-
matics at the University of Padua from
1592 until 1610, when he was named
mathematician to the Grand Duke of
Tuscany, Cosimo II de' Medici, and
returned to Pisa. In 1609, he learned
of a device invented in the Netherlands
for "seeing faraway things as though
nearby" and proceeded to construct his
own version. Obtaining results that
surpassed those of the Dutch, he used
the resulting telescope to make a series
of discoveries that would revolutionize
astronomy. In addition to discovering
Jupiter's four satellites and observing
the moon's surface, Saturn's ring, sun-
spots, the light of the sun reflected by
the earth, and the stars and nebulas of
the Milky Way, he verified the phases
of Venus. Published in 1610 in *Sidereus
nuncius* (The Starry Messenger), these
findings attested to the rotation of the
earth around the sun, corroborating
the Copernican system opposed by
theologians and scholars who clung to
the Aristotelian vision of a geocentric
universe. Despite the protection afforded
by his position as philosopher and
mathematician to the Grand Duke, he
was soon embroiled in a polemic with
the orthodox Roman Catholic Church.
Following publication of his *Dialogo
sopra i due massimi sistemi del mondo...*
(Dialogue Concerning the Two Chief
World Systems) in 1632, he was tried
and sentenced to confinement in his
Arcetri villa by the Roman Inquisition.

M.R.

DRAKE, Stillman. *Galileo: Pioneer
Scientist.* Toronto: University of
Toronto Press, 1990.

GEYMONAT, Ludovico. *Galilée.*
Paris: Seuil, 1992.

SHEA, William R. *Galileo's Intellectual
Revolution.* London: Macmillan, 1972.

EDWARD G. GIBSON
New York 1936

Edward G. Gibson was among the four
American astronauts who spent eighty-
four days in the Skylab 4 orbital station
in 1973-1974. During his stay in
space, he studied and made sketches of
the Kohoutek comet, which he developed
into more finished drawings upon his
return to earth. Gibson left NASA in 1980
and currently heads his own technical
and management consulting firm.

R.P.

ALFRED CLAUDE AIMÉ GIRARD
Paris 1830 - Paris 1898

A chemist by training, Aimé Girard
was a pioneer in the application of
chemistry to industrial processes and
to such fields as glassware, ceramics,
photography and agriculture. After
completing his studies at the Lycée
Louis-le-Grand and the university, he
was prevented by poor health from
pursuing his studies at the Polytechnic.
He worked initially as a teacher in
private chemical laboratories, preparing
students for work in the industrial
sector, then as a laboratory director at
the Sorbonne. In 1858, he was appointed
conservator of the chemistry collection
and director of student laboratory
exercises at the Polytechnic. Girard was
named to the chair of industrial
chemistry at the Conservatoire des
Arts et Métiers in 1871; five years
later, he assumed the additional position
of professor of agricultural technology
at the Institut agronomique de Versailles,
where he pioneered in the application
of chemistry to agriculture. Girard took
a special interest in photography. From
1855 to 1871, he was involved in editing
the bulletin of the Société française de
photographie, and in 1864 he published
a technical book on the permanence of
photographic prints in collaboration
with Alphonse Davanne. In July 1860,
he produced a series of photos of the
phases of a solar eclipse as seen from
the observatory in Algiers.

C.P.

CONSERVATOIRE DES ARTS ET
MÉTIERS. "La vie et les travaux
d'Aimé Girard". *Annales*, 3rd series,
vol. 1 (1899), pp. 116-144.

BETTY GOODWIN
Montreal 1923

Introduced to printmaking by Yves
Gaucher at Montreal's Sir George
Willams University (now Concordia),
Betty Goodwin began her career with
etchings and assemblages of common-
place objects (the series "Vests" and
"Tarpaulins"). From 1977 to 1979, she
worked with installations. In 1982,
she undertook "Swimmers", the famous
series of large pastels in which distorted
human figures float in watery space,
evoking the fragility of the human
condition. In 1985, she designed a set
for the Grands Ballets Canadiens
production of James Kudelka's chore-
ography *Collisions*, reproducing a
cosmography from Nigel Calder's
1980 book *The Comet Is Coming! The
Feverish Legacy of Mr. Halley.* Inspired
by the sky charts that appear in the
weekend edition of the *New York
Times*, she began a series of paintings
depicting the constellations as infinites-
imal specks dotting the heavens. Her
1992-1993 series "Nerves" associates
plant roots, a symbol of vital energy,
with human nerve tissue. In 1996, she
further explored the notion of passage
in the series "Pieces of Time", where
figures wander in narrow, spiralling
labyrinths. Cosmic themes are increas-
ingly present in her recent work, as
in the series "Beyond Chaos" (1998),
peopled with figures afloat in a vast
interstellar cloud.

M.R.

The Art of Betty Goodwin, exhib. cat.
Toronto: Art Gallery of Ontario;
Vancouver and Toronto: Douglas
and McIntyre, 1998. Text by
Jessica Bradley, Anne Michaels,
Anne-Marie Niniacs, Rober Racine
and Matthew Teitelbaum.

*Betty Goodwin: Signs of Life/Signes
de vie*, exhib. cat. Windsor: Art Gallery
of Windsor, 1995-1996. Text by Jessica
Bradley.

FRANCISCO DE GOYA
Fuendetodos, Spain, 1746 -
Bordeaux 1828

Having enjoyed growing success as
a society portrait painter since 1780,
Francisco de Goya was appointed deputy
director of painting at Madrid's Aca-
demia de Bellas Artes de San Fernando

in 1785, then court painter to King Charles III in 1786. In 1789, he was named *pintor de cámara* by Charles IV, for whom he executed numerous official portraits. His fame was on the rise when a devastating illness left him incurably deaf in 1792. He regained his health, but his subsequent work was marked by the pessimism manifest in "Los Caprichos", a print series published in 1799 in which he bitingly satirized the social ills and mores of the time. That same year, he became first court painter and in 1800-1801 executed the severe portrait *Family of Charles IV*. Between 1800 and 1808, while pursuing portraiture, he took an interest in various attempts to conquer space and depicted a historic event: the Montgolfier brothers' maiden hot air balloon voyage in Spain. Beginning in 1810, the Napoleonic War in Spain spurred him to create the print series "Disasters of War" and the renowned paintings *Second of May* and *Third of May*, commemorating the executions of May 2 and 3, 1808. Despite his Spaniard's resentment of the French invasion, he saw France as a haven of tolerance and, in 1824, fled the autocratic rule of Ferdinand VII to settle there.

M.R.

GUDIOL, José. *Goya, 1746-1828: Biography, Analytical Study and Catalogue of His Paintings*. 4 vols. New York: Tudor, 1971.

TOMLINSON, Janis A. *Goya: In the Twilight of Enlightenment*. New Haven and London: Yale University Press, 1992.

WENZEL HABLIK
Brüx 1881 - Itzehoe 1934

German painter and architect Wenzel Hablik enrolled at the Kunstgewerbeschule in Vienna in 1902; in 1905, he trained at the Academy of Fine Arts in Prague. Joining the Expressionist movement, he drew his first imaginary architecture around 1908. He spent the year 1911 renovating the interior of Robert Biel's villa and Itzehoe's principal hotel and designing furniture for both. The following year, he exhibited the series "Schaffende Kräfte" (Creative Forces) at Berlin's Sturm gallery. In 1919, Bruno Taut invited him to join the Gläserne Kette, whose members exchanged their thoughts on experimental building projects and imaginary architecture through correspondence. Inspired by Paul Scheerbart's theoretical writings on the use of glass in architecture, Hablik proposed his own concept of Alpine architecture in visionary drawings featuring transparent castles on mighty mountain peaks. These plans present utopian constructions composed of crystal-like forms, vast sheltering domes and airborne structures. His fascination with natural phenomena – especially crystal, symbolizing the spiritual forces of the universe – led him to design entire housing projects made of glass. Created to encourage harmony between mortal man and the cosmos, his works connote pureness and freedom and promote respect for the environment.

I.N.

BREUER, Gerda, ed. *Wenzel Hablik. Architekturvisionen, 1903-1920*, exhib. cat. Itzehoe: Wenzel Hablik Stiftung; Darmstadt: Häusser, 1995.

Hablik: Designer, Utopian Architect, Expressionist Artist, 1881-1934, exhib. cat. London: Architectural Association, 1980. Text by Eugene A. Santomasso, Dennis Sharp and Anthony Tischhausser.

JAMES HAMILTON
Entrien, Ireland, 1819 - San Francisco 1878

On immigrating to the United States in 1834, James Hamilton settled in Philadelphia and began studying drawing with various local teachers. In the drawing and engraving handbooks he used to further his training, he discovered the work of English painters Samuel Prout and J.M.W. Turner. He was one of the first American artists to use the English watercolour technique, painting the freestyle landscapes and seascapes that earned him the title "the American Turner". During the 1840s and 1850s, he concentrated on illustrations, turning out numerous watercolour compositions to be used for engravings and lithographs. His most important project was illustrating Elisha Kent Kane's account of the expedition sent to scour the Arctic for Captain John Franklin. Working from Kane's sketches, he produced a series of watercolours depicting the majestic glaciers, fiords and silent expanses of the polar region. Following Kane's second voyage to the North in 1853-1855 Hamilton again celebrated the splendour of the Arctic in watercolour illustrations for the explorer's second book, *Arctic Explorations* (1856).

M.R.

MARTIN, Constance. *James Hamilton: Arctic Watercolours*, exhib. cat. Calgary: Glenbow Museum, 1983.

James Hamilton, 1819-1878: American Marine Painter, exhib. cat. New York: Brooklyn Museum, 1966. Text by Arlene Jacobowitz.

LAWREN STEWART HARRIS
Brantford, Ontario, 1885 - Vancouver 1970

After a brief stint at university in 1903, Lawren Harris travelled to Berlin, where he spent four years studying art. Returning to Canada in 1908, he became a charter member of Toronto's influential Arts and Letters Club, which was formed as a haven in the prevailing conservative climate. In 1913, he and J.E.H. MacDonald visited an exhibition of contemporary Scandinavian art in Buffalo, and the Northern European landscapes he saw there prompted him to depict the Canadian wilds. Beginning in 1918, he and other artists made repeated trips to the Algoma region, on the shores of Lake Superior. This soon resulted in the formation of the Group of Seven, led by Harris and composed of Toronto artists who shared a vision of Canadian landscape painting as the expression of their young country's soul. In the early 1920s, after roaming the northern shore of Lake Superior, he began embodying his spiritual convictions, founded on long-held theosophical beliefs, in his landscapes. From 1926 to 1929, he travelled each summer to the Rocky Mountains, seeing them as the ideal motif for his inner quest. This quest culminated in a 1930 voyage with A. Y. Jackson to the unexplored reaches of the Arctic. He later portrayed these lands in stark, highly structured compositions intimating a transcendental vision of the cosmic force that quickens the universe.

M.R.

JACKSON, Christopher. *Lawren Harris.*
North by West: The Arctic and Rocky
Mountain Paintings of Lawren Harris,
1924-1931/Le Grand Nord via l'Ouest :
les tableaux de l'Arctique et des
Rocheuses peints par Lawren Harris
de 1924 à 1931, exhib. cat. Calgary:
Glenbow Museum, 1991.

LARISEY, Peter. *Light for a Cold*
Land: Lawren Harris's Work and Life –
An Interpretation. Toronto: Dundurn
Press, 1993.

MARSDEN HARTLEY
Lewiston, Maine, 1877 -
Ellsworth, Maine, 1943

American painter and writer Marsden
Hartley studied at the Cleveland School
of Art in 1898, then in New York at the
Chase School and the National Academy
of Design (1900-1904). During trips to
France and Germany in 1912 and 1913,
he developed ties with such avant-garde
groups as Der Blaue Reiter, with whom
he exhibited at the invitation of Franz
Marc. Much influenced by Cézanne's
work and Kandinsky's spiritual theo-
ries, he developed a semi-abstract
formal vocabulary dominated by land-
scape representation. This he used
in painting the Bavarian Alps, which
symbolize nature's ascendancy over
mortal man. Hartley was humbled by
the immensity and power of nature and
viewed the act of painting as a means
of re-creating the universe. The earth-
bound mountains stretching towards
the sky suggest mankind's union
with the cosmos. On his return to the
U.S. during World War I, he painted
"Movement", a series of geometric ab-
stractions characterized by primary
colours applied on a dark background.
After travel in New Mexico, France,
Germany and Nova Scotia, he at last
settled in Maine, in 1937, where he
continued to portray the landscape.
 I.N.

LUDINGTON, Townsend. *Seeking the*
Spiritual: The Paintings of Marsden
Hartley, exhib. cat. New York: Ackland
Art Museum; Ithaca and London:
Cornell University Press, 1998.

Somehow a Past: The Autobiography of
Marsden Hartley. Ed. Susan Elizabeth
Ryan. Cambridge, Massachusetts, and
London: MIT Press, 1997.

MONA HATOUM
Beirut 1952

Born of Palestinian parents forced to
leave their homeland when Israel
achieved statehood in 1948, Mona
Hatoum was raised in Beirut. Exiled in
London, she attended the Byam Shaw
School of Art from 1975 to 1979 and
graduated from the Slade School of
Fine Art in 1981. In her early work, she
developed an art form that combines
the commonplace with technological
experimentation, depicting, for example,
kitchen utensils conveying electric
current to a light bulb. In 1983, re-
sponding to the atrocities suffered by
the Palestinians during the Israeli
invasion of Lebanon, she came to
Canada to stage *The Negotiating Table*,
a performance work intended as a
metaphor for oppression everywhere.
In 1988, she produced videos and in-
stallations evoking torture and the
penitentiary environment. Hatoum uses
subtly contrasting material to raise the
viewer's awareness of "difference". *Socle*
du monde (1992-1993), an immense
metal cube covered with wire affixed
by magnets, is a work of contradictions
(heaviness-lightness, bitterness-gentle-
ness), illustrating the diversity of the
elements that make up our world. Fly-
ing in the face of popular beliefs and
traditional power-based relationships,
Hatoum's Minimalist art questions our
certainties about outward appearances.
 I.N.

ARCHER, Michael, Guy BRETT
and Catherine DE ZEGHER. *Mona*
Hatoum, exhib. cat. London:
Phaidon Press, 1997.

Mona Hatoum, exhib. cat. Bristol:
Arnolfini, 1993. Text by Guy Brett,
Tessa Jackson and Desa Philippi.

PAUL PIERRE HENRY
Nancy 1848 - Montrouge 1905

PROSPER MATHIEU HENRY
Nancy 1849 - Massif de la Vanoise
1903

Born to a family of humble means, Paul
and Prosper Henry were largely self-
educated. While still adolescents, both
brothers joined the meteorological ser-
vice of the Paris Observatory. The two
young men developed a passion for
astronomy and on their own initiative

began to construct an ecliptic sky
chart, employing a telescope designed
in their home workshop. The director
of the Observatory encouraged their
efforts, and in 1871 the brothers were
named to positions at the Observatory.
They were given the task of continuing
the ecliptic chart begun by the astron-
omer Jean Chacornacat. In order to
complete this task, the Henrys turned
to photography. They designed a special
achromatic telescope that, by 1885,
allowed them to obtain celestial pho-
tographs of previously unattainable
sharpness and clarity. Because of their
success in photographing the moon,
sun, stars and comets, the Observatory
in 1887 launched the Carte du Ciel
project, aimed at photographically
charting the magnitudes of about two
million stars. The task was divided
among eighteen observatories around
the world, each using identical tele-
scopes and standardized photographic
methods. The ultimate efficacy of this
enormous international project, which
dragged on for seventy-five years,
remains a subject of debate.
 C.P.

CALLANDREAU, Octave, *et al.*
"Discours prononcés aux obsèques
de Prosper Henry". *Bulletin*
astronomique, vol. 21 (1904), pp. 49-58.

PUISEUX, Pierre, *et al.* "Discours
prononcés aux obsèques de M. Paul
Henry". *Bulletin astronomique*, vol. 22
(1905), pp. 97-102.

NATHANIEL HILL
Active 1746 - 1764

Working from his Sun and Globe
studio in London's Chancery Lane,
Nathaniel Hill began as an engraver
before turning to the manufacture of
globes. Almost all of Hill's globes
currently in collections worldwide are
small in size (7 and 14 cm) and date
from the 1750s.
 J.-F.G.

SARA HOLT

Los Angeles 1946

American photographer and sculptor Sara Holt studied painting and sculpture at the University of Colorado at Boulder from 1964 to 1968. In 1966, she created a series of transparent polyester resin sculptures that served to decompose and reconstitute the light spectrum; the diffraction produced by these prisms causes colour to vary according to the ambient light. Holt moved to Paris in 1968 and there took her first photographs of trees, their bark and the movement of their branches. In 1969 and 1970, she experimented with space, light and transparency in images of her own crystalline sculptures. She began working with time-lapse exposure in 1973, capturing the movement of the stars through nighttime skies as luminous traces on film. Her production expanded in 1976 to include numerous outdoor installations and sculptures, among them *Arc-en-ciel* (1976) and *Double Rainbow* (1977). Further experiments with time-lapse photography led her to turn her camera to the sky during a 1978 stay on the island of Stromboli in the Tyrrhenian Sea. Later that year, back in Paris, she produced a series of photos of a lunar eclipse.

M.R.

BAATSCH, Henri-Alexis, and Jean-Christophe BAILLY. *Sara Holt: Sculptures and Photos*. Bergamo: Grafica Gutenberg, 1980.

NAGGAR, Carole. *Night Light*, exhib. cat. Paris: Pierre Bordas et Fils, 1979.

MARTIN HONERT

Bottrop 1953

After studies at Düsseldorf's Staatliche Kunstakademie from 1981 to 1985, German sculptor Martin Honert trained with Fritz Schwegler. It was then that he began re-creating images familiar to children in the 1950s and now firmly entrenched in the collective memory. In 1986, he produced *Frei-, Fahren-, und Jugendschwimmabzeichen*, a ceramic replica of three sports badges awarded to children having passed their swimming tests. *Children's Crusade* (1985-1987) uses human-sized reproductions of toy figures to evoke a childhood memory of history class. In 1990, Honert began working with a tree motif derived from the Germanic pictorial tradition and produced *Linden*, made of wire, insulating board, polyurethane, polyester, silk paper and enamel paint. In 1992, he conceived *Tree*, based on a tree image drawn from childhood recollections. That same year, he completed *Fire,* a sculpture of synthetic resin shaped in a silicone cast, in which he interprets fire not as a destructive element but as a gathering place for popular, rather than mythical, culture.

M.R.

GROYS, Boris. *Martin Honert: Ein szenisches Modell des fliegenden Klassenzimmers nach der Erzählung von Erich Kästner*, exhib. cat. Ostfildern: Cantz, 1995.

Martin Honert, exhib. cat. Frankfurt: Museum für Moderne Kunst, 1994. Text by Jean-Christophe Ammann

WILLIAM HENRY JACKSON

Keesville, New York, 1843 -
New York 1942

In 1867, American photographer William Henry Jackson opened a commercial portrait studio in Omaha with his brother Edward. In the summer of 1869, he and A. C. Hull took a series of photographs along the Union Pacific Railroad line. From 1870 to 1878, he was the official photographer of the U.S. Geological and Geographical Survey of the Territories, headed by Ferdinand V. Hayden. In that capacity, he produced a vast collection of wet collodion negatives featuring the rock formations, geysers, mountain chains and ancient tribal vestiges of the American West. In 1871, he roamed the uncharted Yellowstone region with painter Thomas Moran. Moran helped him select vantage points for his photos and, in turn, later used them in composing his paintings. In 1873, Hayden's team explored the Colorado Rockies; Jackson was fascinated by their hierarchic formations and captured spectacular views of the Mountain of the Holy Cross. He founded the Jackson Photo Company in Denver in 1879 and, in 1881, was awarded important publicity photo commissions for the Denver and Rio Grande, Colorado Central and Pacific railroads.

M.R.

HALES, Peter B. *William Henry Jackson and the Transformation of the American Landscape*. Philadelphia: Temple University Press, 1988.

NEWHALL, Beaumont, and Diane E. EDKINS. *William H. Jackson*, exhib. cat. Fort Worth: Amon Carter Museum of Western Art; New York: Morgan and Morgan, 1974. Text by William L. Broecker.

PIERRE JULES CÉSAR JANSSEN

Paris 1824 - Meudon 1907

Jules Janssen showed an early interest in drawing and as an adolescent seemed inclined to study painting. After pursuing further studies in mathematics and physics, he qualified for his doctorate in 1860 with a study of thermal radiation. Soon, he began to investigate solar radiation, and his subsequent career was devoted largely to questions of physical astronomy. He constructed a small observatory on the roof of a house north of Montmartre and began work in spectral analysis of the sun and the planets. In 1874, the French government chose him to establish a new observatory at Meudon devoted principally to physical astronomy. It was here that he carried out his celebrated series of solar photographs from 1876 to 1903, employing a special telescope of his own design. Adept at technical invention, he devised a photographic "revolver" to record the 1874 transit of Venus; this camera made forty-eight small exposures on a daguerreotype disk in seventy seconds. Janssen was deeply involved in photography, whose value as an aid to science he repeatedly emphasized. He became a member of the Société française de photographie in 1876 and served as its president from 1891 to 1893 and from 1900 to 1902.

C.P.

DEHERAIN, H., ed. *Œuvres scientifiques de Jules Janssen*. 2 vols. Paris: Société d'éditions géographiques, maritimes et coloniales, 1929-1930.

SICARD, Monique. "Passage de Vénus. Le revolver photographique de Jules Janssen". *Études photographiques*, no. 4 (1998), pp. 44-63.

FRANZ (FRANK) JOHNSTON
Toronto 1888 - Toronto 1949

Canadian painter Franz Johnston joined Toronto's Grip Ltd. as a graphic artist in 1908, then in 1910 moved to New York, where he produced commercial design for Carlton Studios. He returned to Toronto in 1915 and in 1918 travelled in a boxcar with J.E.H. MacDonald, Lawren Harris and Dr. MacCallum on his first visit to the Algoma region, north of Lake Superior. During the excursion, he sketched the beautiful untamed landscape, portraying the changing fall scenery in a decorative style. An original member of the Group of Seven, he took part in the Group's inaugural exhibition in 1920. He was principal of the Winnipeg School of Art from 1921 to 1924 and, on his return to Toronto, officially resigned from the Group. During the 1930s, he made a series of trips to the Far North to paint the pure air, northern lights and virgin expanses. In 1939, he travelled to the Canadian Arctic to execute a commission for the Eldorado Gold Mines consisting of some hundred sketches representing the arid land and the natives and miners of the region.

M.R.

HILL, Charles C. *The Group of Seven: Art for a Nation*, exhib. cat. Ottawa: National Gallery of Canada; Toronto: McClelland and Stewart, 1995.

MASON, Roger Burford. *A Grand Eye for Glory: A Life of Franz Johnston*. Toronto: Dundurn Press, 1998.

ILYA KABAKOV
Dniepropetrovsk 1933

Ukrainian-born painter, graphic artist and illustrator Ilya Kabakov studied graphic art at Moscow's Sourikov Art Institute, graduating in 1957 with a degree in illustration. In the 1960s, he began incorporating dialogue into his images. His 1970s *Albums* feature characters with extravagant dreams crushed by the mediocrity of their lives, illustrating the dead-end reality of the 1920s Soviet socialist utopia. He executed more than fifty paintings in the Sots Art style, which derided Russian cultural icons by depicting them in conjunction with avant-garde, Abstract Expressionist and Surrealist references. In the 1980s, he turned to installations to recount the everyday life and desperate poverty of the Soviet Union; these led to his first New York and London shows, at the end of the decade. Kabakov's art is closer to flight than to confrontation, hence the theme of space flight ending mankind's mindless existence on earth, as in *The Man Who Flew into Space from His Apartment* (1981-1988). A nomad, Kabakov roams the world from his New York base, creating installations for galleries and museums.

I.N.

POUILLON, Nadine, ed. *Ilya Kabakov: installations 1983-1995*, exhib. cat. Paris: Centre Georges Pompidou, Musée national d'art moderne, 1995. Text by Boris Groys, Jean-Hubert Martin and Robert Storr.

WALLACH, Amei. *Ilya Kabakov: The Man Who Never Threw Anything Away*. New York: Harry N. Abrams, 1996.

VASSILY KANDINSKY
Moscow 1866 - Neuilly-sur-Seine 1944

Painter and art theorist Vassily Kandinsky studied law and economics at the University of Moscow prior to settling in Munich in 1896 to take up painting. He trained first at Anton Azbe's art school, then at the Akademie der Bildenden Künste in Munich. In 1911, he met Franz Marc, with whom he founded Der Blaue Reiter. The influence of the theosophical writings of Annie Wood Besant, Charles W. Leadbeater and Rudolph Steiner is evident in his paintings, which represent utopian worlds in the form of spiritual vibrations illustrated by irregular curves suggesting chaotic, apocalyptic landscapes. During World War I, Kandinsky was forced to return to Russia, where he joined the visual arts section (IZO) of the People's Commissariat for Enlightenment (Narkompros) and later taught at the Free State Art Studios (Svomas) in Moscow. Back in Germany, he joined the Bauhaus in 1922 to head the mural painting studio, where he developed his colour theories. Abandoning figuration for geometric forms, he painted compositions in which precise form is balanced with a brilliant palette. In 1933, the Bauhaus closed its doors under threat from the Gestapo, and Kandinsky moved to France, where, with the support of the Surrealists, he continued to paint.

I.N.

BARNETT, Vivian Endicott, and Armin ZWEITE. *Kandinsky: dessins et aquarelles*, exhib. cat. Paris: Flammarion, 1992.

DABROWSKI, Magdalena, ed. *Kandinsky Compositions*, exhib. cat. New York: Museum of Modern Art; Harry N. Abrams, 1995.

ELISHA KENT KANE
Philadelphia 1820 - Havana 1857

American explorer, surgeon and author Elisha Kent Kane studied medicine at the University of Pennsylvania from 1839 to 1842. Having enlisted as an assistant surgeon in the U.S. Marine Infantry in 1843, he established a brief but distinguished service record during the 1846-1848 Mexican-American War. In 1850, he signed on as a surgeon with the expedition searching for Captain John Franklin, missing in the Arctic since 1847. Aboard the brig *Advance*, he sailed the Lancaster Sound all the way to Port Leopold, where he made minutely detailed pencil and watercolour sketches of the magnificent glacial landscape. Returning to New York in 1851, he related the main events of the expedition in *The U.S. Grinnell Expedition in Search of Sir John Franklin, 1850-51*, published in 1853. Bent on proving the existence of an ice-free polar sea, Kane organized and led a second expedition in 1853 to search for Franklin in Smith Sound, between Greenland and Ellesmere Island. Trapped by pack ice until May 1855, he and his men finally abandoned ship and trekked twenty-five hundred kilometres to safety. Returning to the U.S., he published his account of the voyage in *Arctic Explorations* (1856).

M.R.

CORNER, George Washington. *Doctor Kane of the Arctic Seas*. Philadelphia: Temple University Press, 1972.

HANDLIN, Oscar, ed. *Elisha Kent Kane and the Seafaring Frontier*. Westport, Connecticut: Greenwood Press, 1971.

JOHN FREDERICK KENSETT
Cheshire, Connecticut, 1816 -
New York 1872

After training as an engraver in the New Haven workshop of his father, Thomas Kensett, John Kensett perfected his craft with his uncle, Alfred Daggett. In 1840, he travelled to Europe with Asher B. Durand, John Casilear and Thomas Rossiter to study the works of the great masters. In 1847, he returned to New York, where he was named associate (1848), then full member (1849) of the National Academy of Design. Again with Casilear and Durand, he went up the Hudson River in 1849 to the village of Catskill, where painter Thomas Cole had lived, to sketch the landscapes depicted in Cole's work. Following an 1850 expedition in the White Mountains, he executed the ambitious canvas *The White Mountains, from North Conway* (1851), which evokes the serene rapport between mankind and nature in the manner of French landscape painter Claude Lorrain and the Hudson River School artists. As of 1855, he abandoned the panoramas inspired by Cole and Durand to portray the coastal landscapes of New England, representing nature's peaceful harmony in the shimmering, luminous reflections of the sky and sea.

M.R.

DRISCOLL, John Paul, ed. *John F. Kensett: Drawings*, exhib. cat. University Park, Pennsylvania: Pennsylvania State University Museum of Art, 1978.

DRISCOLL, John, and John K. HOWAT. *John Frederick Kensett: An American Master*, exhib. cat. Worcester, Massachusetts: Worcester Art Museum; New York and London: Norton, 1985. Text by Dianne Dwyer and Oswaldo Rodriguez Roque.

ANSELM KIEFER
Donaueschingen, Germany, 1945

Anselm Kiefer studied law at Albert-Ludwig University in Freiburg in 1965 but gave it up the following year to study painting. He trained with Horst Antes at the Staatlichen Akademie der Bildenden Künste in Karlsruhe in 1969 and that year exhibited *Occupations*, one of his earliest works. *Occupations* comprises a series of photos taken in Switzerland, Italy and France showing the artist giving the Nazi salute in front of various landscapes and historical monuments in places once occupied by Hitler's armies. Beginning in 1970, Kiefer made several visits to artist Joseph Beuys in Düsseldorf. This led him to explore the symbolic dimension of mythology in his paintings, using Norse myths to lay open the collective memory of the German people (*Germany's Spiritual Heroes*, 1973). Following a trip to Israel in 1984, he produced vast images marked by the universal themes of metamorphosis, divinity and the cosmos (*Osiris and Isis*, 1985-1987). In a 1996 solo exhibition held in Paris, *This Dark Light Falling from the Stars*, he presented works inspired by the vastness of the star-strewn firmament, among them *Sol invictus* (1995) and *Man under a Pyramid* (1996).

M.R.

CACCIARI, Massimo, and Germano CELANT. *Anselm Kiefer*. Venice: Museo Correr; Milan: Charta, 1997.

ROSENTHAL, Mark, and Angela SCHNEIDER, eds. *Anselm Kiefer*, exhib. cat. Berlin: Staatliche Museen Preußischer Kulturbesitz, 1991.

PAUL KLEE
Münchenbuchsee, Germany, 1879 -
Muralto-Locarno 1940

Swiss painter and art theorist Paul Klee studied under Franz von Stuck at the Akademie der Bildenden Künste in Munich. Much taken with the work of Kandinsky, he joined Der Blaue Reiter in 1911 and exhibited with the group the following year. In 1913, he began incorporating cosmic motifs into his paintings, as evidenced in *Celestial Message of Disaster* (1913), where stars, moons, suns and crystals border the upper section of the canvas. Seeking to express the dynamics of the laws that govern the universe, rather than simply reproducing outward appearances, he composed several works in which empty spaces and volumes interact in a weightless environment. To illustrate the forces at play in the cosmos, he developed a formal vocabulary of symbols and signs, such as arrows, lines and clocks. In 1920, Klee joined the faculty of the Bauhaus at the invitation of Walter Gropius and there headed the bookbinding and glass-painting workshops. In 1925, he followed the Bauhaus to Dessau, and the Vavin-Raspail gallery organized his first Paris showing. When the Nazis came to power in 1933, he was fired from the Düsseldorf Kunstakademie, where he had been teaching for two years. After settling in Bern, he came down with the crippling scleroderma that hindered the production of his final works.

I.N.

GLAESEMER, Jürgen. *Paul Klee: The Colored Works in the Kunstmuseum Bern*. Bern: Kornfeld, 1979.

KERSTEN, Wolfgang, and Osamu OKUDA. *Paul Klee. Im Zeichen der Teilung*. Stuttgart: Hatje, 1995.

YVES KLEIN
Nice 1928 - Paris 1962

Yves Klein began working as a self-taught painter in 1946 and that same year formulated his first theories on monochromy. Not long after, having come by a copy of Max Heindel's *Rosicrucian Cosmo-conception*, he studied and practised the teachings of the Rosicrucian Brotherhood until 1953. His first monochromic paintings, done around 1950, represented the vastness of space and unveiled the cosmic energy of colour. Late in 1956, with the help of the Parisian colourman Adam, he developed a deep ultramarine blue known as IKB (International Klein Blue). He went on to paint a series of blue monochromes that allude to the infinite reaches of the universe. His 1958 exhibition *Le Vide*, held at the Iris Clert gallery, was followed by performances on the theme of emptiness, or boundlessness, in which he sought to reveal the immaterial. In 1960, he produced "Anthropometries", a series of imprints on paper of the bodies of naked models coated in blue paint. In "Cosmogonies", another series done that year, he captured the effects of rain, wind, lightning and other natural phenomena directly on canvas. In 1961, inspired by the Russian and American astronauts' ventures into space, he executed "Planetary Reliefs", a series of imaginary topographical maps of the moon, Mars and the earth as seen from space.

M.R.

MOCK, Jean-Yves, ed. *Yves Klein*, exhib. cat. Paris: Centre Georges Pompidou, Musée national d'art moderne, 1983.

VUORIKOSKI, Timo, and Karin HELLANDSJØ, eds. *Yves Klein*, exhib. cat. Oslo: National Museum of Contemporary Art, 1997. Text by Pierre Descargues, Yves Klein, Yongwoo Lee, Héléna Palumbo-Mosca and Pierre Restany.

IVAN VASILIEVICH KLIUN
Bolshie Gorki 1873 - Moscow 1943

Prior to meeting Malevich in 1907 and turning to abstraction, painter, sculptor and art theorist Ivan Kliun produced Symbolist paintings. He joined the avant-garde Union of Youth and Jack of Diamonds groups and participated in their respective 1913-1914 and 1916 shows. He was a signatory to Malevich's *Suprematist Manifesto* in 1915 and the same year began a series of compositions featuring coloured geometric forms applied on a white background. After the Revolution, he taught at Moscow's Free State Art Studios (Svomas) and Higher State Art-Technical Studios (Vkhutemas) until 1921, while continuing to head the Department of Visual Arts at the Narkompros. Kliun was fascinated by the energy of colour and painted chromatic volumes suspended in space, which convey his perception of the cosmos. In *Red Circle* (about 1921) and *Red Light, Spherical Composition* (about 1923), disks of red stand out against a black background, attesting to his fondness for the circular form, which recalls that of the heavenly bodies. Indeed, their hazy outlines, rendered by a luminous aura, allude to the radiance of the sun. In the 1930s, drawn to the theories and work of Ozenfant, he embraced Purism and adopted a simplified figurative style.

I.N.

Russian Constructivism and Suprematism, 1914-1930, exhib. cat. London: Annely Juda Fine Arts, 1991.

Culture of Materials: The Russian Avant-garde Counter Cubism, exhib. cat. New York: Stux Modern, 1991. Text by Kimberly Paice.

JOHN KNOX
Paisley 1778 - Keswich 1845

John Knox was a student of Alexander Nasmyth in Edinburgh prior to moving to Glasgow sometime before 1800, where he began working as a portraitist in 1809. In the 1820s, his panoramic views of Glasgow, Dublin and Ben Lomond earned him considerable esteem. Executed using a camera obscura, these vast scenes are notable for their elevated perspective and precise topographic details (*Panoramic View from the Top of Ben Lomond*). Knox was also recognized for his compositions – marked by the influence of Claude Lorrain – depicting urban activity along the Clyde River (*The First Steamboat on the Clyde*). From 1829 to 1849, he exhibited at the Royal Academy, the British Institution and in London's Suffolk Street. As a drawing instructor in Glasgow, he conveyed his poetic vision of the landscapes to students Horatio McCulloch, William Leighton Leitch and Daniel Macnee. Around 1840, he retired to the Lake District, in the Northwest of England, where he continued to portray picturesque British scenery.

M.R.

John Knox, Landscape Painter: An Exhibition of the Work of the Artist John Knox (1778-1845) and the Glasgow of His Day, exhib. cat. Glasgow: Glasgow Art Gallery and Museum, 1974.

Hidden Assets: Scottish Paintings from the Flemings Collection, exhib. cat. Edinburgh: National Galleries of Scotland, 1995. Text by Mungo Campbell, Helen Smailes and Bill Smith.

GEORGY TIKHONOVICH KRUTIKOV
Voronezh 1899 - Moscow 1958

Georgy Krutikov studied at the Vkhutemas from 1922 to 1928 under Nikolai Ladovsky, an architectural theorist whose work was closely akin to that of Lissitzky. For his graduation project in 1928, he presented a design for an airborne, floating city, consistent with the utopian projects so popular in the 1920s. Borrowing from Suprematist theories on weightless flight, he conceived an audacious architecture based on the assumption of an existing space free from the pull of gravity. In response

to the unwholesome environment of working neighbourhoods, urban traffic problems and unsightly public buildings, he proposed a Constructivist, Productivist architectural programme in which simple geometric volumes form a homogenous whole. In keeping with the Communist ideal, his constructions were laid out in clear patterns established as a function of human activity (home, leisure and work). His floating city, composed of residential and industrial areas, included shared space for accommodating vehicles that were to serve as "flying cabins". This new form of transportation would free people from the constraints of urban transport and open up the possibility of flight. During the 1930s, Krutikov took part in several competitions for various architectural projects, including the Soviet Palace in 1931.

I.N.

Architectural Drawings of the Russian Avant-garde, exhib. cat. New York: Museum of Modern Art, 1990. Text by Catherine Cooke, I. A. Kazus and Stuart Wrede.

The Great Utopia: The Russian and Soviet Avant-garde, 1915-1932, exhib. cat. New York: Solomon R. Guggenheim Museum, 1992.

FRANTIŠEK (FRANZ) KUPKA
Opocno, Bohemia, 1871 - Puteaux, France, 1957

In 1892, after graduating from the Academy of Fine Arts in Prague, Czech painter František Kupka sought training in Vienna, where the work of philosophers and poets furthered his interest in theosophy. He settled in Paris in 1896, with a job supervising Czech scholarship students. He began his artistic career in the French capital as a traditional social caricaturist and then turned to Symbolist painting. His passion for astronomy drew him to all manner of things dealing with cosmic manifestations. *The First Step* (dated 1909), in which striae and canals stand out against a circular background, is strongly inspired by lunar photographs dating from the late nineteenth century. In 1910, Kupka undertook true avant-garde experimentation in a nonfigurative art characterized by autonomous forms and colours. While still adhering to the esoteric teachings of his Viennese

period, he drew inspiration from scientific theories and sought to depict the entire body of phenomena governing the world, so as to reveal their invisible structures. He invented a catalogue of forms and colours apt to reproduce the manifold elements that make up the universe.

I.N.

KOSINSKI, Dorothy, and Jaroslav ANDĚL, eds. *Painting the Universe, František Kupka, Pioneer in Abstraction*, exhib. cat. Dallas: Dallas Museum of Art; Bonn: Vgbild-Kunst, 1997. Text by Franziska Baetcke, Laurence Lyon Blum, Pierre Brullé, Benoit Mandelbrot and Marketa Theinhardt.

KOTALÍK, Jiří, and Suzanne PAGÉ, eds. *František Kupka 1871-1957 ou L'invention d'une abstraction*, exhib. cat. Paris: Musée d'art moderne de la Ville de Paris, 1990. Text by Gladys Fabre, Linda Dalrymple Henderson, Miroslav Lamač, Jean-Hubert Martin, Meda Mladek, Krisztina Passuth, Margit Rowell, Virginia Spate and Ludmila Vachtova.

WILLIAM LANGENHEIM

Braunschweig, Germany, 1807 - Philadelphia ? 1874

FREDERICK LANGENHEIM

Braunschweig, Germany, 1809 - Philadelphia ? 1879

Brothers William and Frederick Langenheim showed an early fascination with optical instruments; this interest was spurred by their acquaintance with Peter Voigtländer, of the celebrated German optical firm, who married a Langenheim sister. William Langenheim immigrated to Texas in 1834 and served with the Texan forces in a conflict with Mexico. In 1840, he settled in Philadelphia, where he and Frederick began to work as reporters for a German-language newspaper. In 1842, having learned of the daguerreotype process through Voigtländer, they became American agents for his high-quality cameras and lenses and opened what became a thriving portrait studio. The Langenheims established an international reputation in 1845 with a stunning eight-plate panorama of Niagara Falls, copies of which were presented as gifts to the reigning sovereigns of Europe. In 1854, they were among the many American photographers who sought to record the solar eclipse of that year. Their set of seven small daguerreotypes showing the passage of the moon before the sun was an extraordinary technical accomplishment for its day.

C.P.

LAYNE, George S. "The Langenheims of Philadelphia". *History of Photography*, vol. 11, no. 1 (January-March 1987), pp. 39-52.

NEWHALL, Beaumont. *The Daguerreotype in America*. New York: Duell, Sloan and Pierce, 1961.

EL LISSITZKY
(LAZAR MARKOVICH LISITSKY)

Potchinok, Russia, 1890 - Moscow 1941

El Lissitzky studied engineering and architecture in 1909 at the Technische Hochschule in Darmstadt, Germany. He returned to Russia in 1914 and graduated from the Riga Technological University in 1915. In 1919, Chagall invited him to teach architecture and graphic design at the Vitebsk Art Institute, where he met Malevich and joined the Unovis (Affirmers of the New Art) group. Imbued with the ideology of Suprematism, he developed a form of abstract art called Proun (Project for the affirmation of the new), in which space is conceived as an "interchange station between painting and architecture". He introduced an imaginary rotation of elements propelled into space, similar to the movement of the stars and planets. Inspired by the commanding forces of the cosmos, he painted geometric, three-dimensional forms linked by the extension of their outlines, suggesting the entire universe. In line with the myriad utopian projects of the 1920s, his paintings referred to a world yet to come, where earth's gravity would be vanquished to permit the construction of floating cities. He published his *Suprematist Tale of Two Squares* in 1922 and, in 1924, worked with Kurt Schwitters in Germany on the famous issue no. 8-9 of *Merz* magazine. Returning to Russia in 1925, he settled in Moscow and worked on the design and installation of Soviet pavilions at international exhibitions.

I.N.

LISSITZKY-KÜPPERS, Sophie. *El Lissitzky: Life, Letters, Texts*. London: Thames and Hudson, 1980.

El Lissitzky (1890-1941): Architect, Painter, Photographer, Typographer, exhib. cat. Eindhoven: Municipal Van Abbemuseum, 1990. Text by Yve-Alain Bois, S. O. Chan-Magomedov, Kai-Uwe Hemken, Jean Leering, M. A. Nemirovskaya, Peter Nisbet and Henk Puts.

MAURICE LŒWY

Vienna 1833 - Paris 1907

Born and educated in Vienna, Maurice Lœwy made his first astronomical observations and published his first scientific papers on the orbits of comets and asteroids. His work attracted the attention of Urbain Le Verrier, the director of the Paris Observatory, who in 1860 persuaded the young Austrian to move to France and join his staff. (He was naturalized a French citizen in 1869.) Lœwy was named assistant director of the Observatory in 1878; he took over as director in 1896. He spent the final decade of his life engaged almost exclusively in carrying out the *Atlas photographique de la Lune* with Pierre Puiseux and helped to design the special telescope that was used to make the photographs.

C.P.

LŒWY, Maurice, and Pierre PUISEUX. *Atlas photographique de la Lune*. Paris: Observatoire de Paris, 1896-1909. "Maurice Lœwy". *Bulletin astronomique*, vol. 24 (November 1907), pp. 385-395.

JAMES EDWARD HERVEY MACDONALD

Durham, England, 1873 - Toronto 1932

J.E.H. MacDonald worked as a graphic designer for Grip Ltd. in Toronto between 1894 and 1911, with time off from 1903 to 1907 to create layouts for Carlton Studios in London. As of 1911, he devoted his full efforts to painting, depicting the Canadian wilds discovered during excursions in the Georgian Bay area (1909), the Laurentians (1913) and Algonquin Park (1914). In 1913, a visit to an exhibition of Scandinavian

art in Buffalo with Lawren Harris prompted him to concentrate on representing the Canadian North. Each fall, from 1918 to 1920, he and Harris travelled in the Algoma region, north of Lake Superior. His paintings from this period reflect the influence of transcendental writers Walt Whitman and Henry David Thoreau, exalting the spiritual force of the rugged landscape. MacDonald exhibited with the Group of Seven in their 1920 inaugural show and for the following ten years. He was fascinated by mountainous formations and summered in the Rockies from 1924 to 1930, painting the mighty Canadian peaks.

M.R.

STACEY, Robert. *J.E.H. MacDonald, Designer: An Anthology of Graphic Design, Illustration and Lettering.* Ottawa: Carleton University Press, 1996.

WHITEMAN, Bruce. *J.E.H. MacDonald.* Kingston: Quarry Press, 1995.

STANTON MACDONALD-WRIGHT

Charlottesville 1890 -
Pacific Palisades 1973

Following studies at the Art Students League in New York in 1904-1905, Stanton Macdonald-Wright travelled to Paris in 1907 to attend the École des Beaux-Arts, the Académie Colarossi and the Sorbonne. In 1910, he exhibited at the Salon d'Automne and the following year met Morgan Russell. Their common interest in Neo-Impressionist colour theory induced them to explore the principles discovered by scientists Chevreul, Helmholtz and Rood, which, in turn, led them to develop Synchromism, a colour theory based on dynamic contrasts. Macdonald-Wright was intrigued by the orbit of the planets around the sun and painted circles arranged according to the law of complementary colours, reproducing the rotation of the spheres on their axes. His first solo exhibition took place at Alfred Stieglitz's New York gallery in 1917. In 1919, he moved to California, where he headed the Art Students League in Los Angeles and taught art history and Eastern philosophy at UCLA. During the 1930s, he found inspiration in Oriental art and the work of the Cubists. In the 1950s, after the death of Russell, he returned to Synchromism.

I.N.

SOUTH, Will. "Stanton Macdonald-Wright, 1890-1973: From Synchromism to the Federal Art Projects", Ph.D. dissertation. City University of New York, 1994.

MACDONALD-WRIGHT, Stanton. *The Art of Stanton Macdonald-Wright*, exhib. cat. Washington: National Collection of Fine Arts; Smithsonian Press, 1967. Introduction by David W. Scott.

JOHN MACWHIRTER

Slateford, Scotland, 1839 -
London 1911

After apprenticing at the Oliver & Boyd bookshop in Edinburgh, John MacWhirter studied under Robert Scott Lauder and John Ballantyne at the Trustees' Academy in 1851. He began his painting career with a series of naturalist watercolours, representing trees, bushes, wild flowers and rocks with great precision. Named an associate of the Royal Scottish Academy in 1867, he became an honorary member in 1880. He settled in London in 1869. There, his watercolours were admired by English art critic and theoretician John Ruskin, who purchased twenty-five of them the following year for his courses at the Oxford Art School. MacWhirter was made an associate of the Royal Academy in 1879, then a full member in 1893. Marked by the influence of Turner, Millais and Horatio McCulloch, his oils and watercolours represent the serene beauty of landscapes admired during his travels in France, Switzerland, Italy, Austria, Norway, Turkey and North America. In 1900, he published *Landscape Painting in Water-colour*, a technical handbook advocating the careful observation of nature; a second work, *The MacWhirter Sketch Book*, appeared in 1906.

M.R.

IRWIN, David, and Francina IRWIN. *Scottish Painters: At Home and Abroad, 1700-1900.* London: Faber and Faber, 1975.

SINCLAIR, William Macdonald. *John MacWhirter (Royal Academician): His Life and Work.* London: Virtue and Co., 1903.

RENÉ MAGRITTE

Lessines 1898 - Schaerbeek 1967

Belgian painter and draftsman René Magritte studied at the Académie Royale des Beaux-Arts in Brussels from 1916 to 1918. In the early 1920s, he worked as a graphic artist in a wallpaper factory and devoted his spare time to painting. His first influences were Cubism, Futurism and abstraction, but the discovery of the work of Giorgio De Chirico in 1923 moved him to re-create the mystery, or magic, of reality in his paintings. In 1927, he settled in Perreux-sur-Marne, near Paris, and was active with the Parisian Surrealist group until 1930. Between 1927 and 1931, seeking to thwart the conventions governing the depiction of reality, he formed a series of poetic concepts, which he developed during the 1930s. Exploring the landscape motif, in flames or surrounded by nothingness, he questioned the substance of the visible world. From 1943 to 1947, he painted "sunny" canvases, which challenged the pessimism of the Surrealist aesthetic and its aspiration for the sublime. When these paintings failed to win favour, he began producing the crisp, mordantly witty works shown in 1948 that provoked the consternation and anger of the Parisian Surrealists. His Paris days were over, but that same year, he successfully exhibited variations on his earlier works in New York and explored the notions of space and gravity in compositions featuring stone, bird and azure motifs.

M.R.

OLLINGER-ZINQUE, Gisèle, and Frederick LEEN, eds. *René Magritte 1898-1967*, exhib. cat. Brussels: Musées Royaux des Beaux-Arts de Belgique; Ghent: Ludion, 1998.

SYLVESTER, David, ed. *René Magritte: Catalogue Raisonné.* 5 vols. Antwerp: Fonds Mercator, Menil Foundation; London: Philip Wilson, 1992-1997.

KAZIMIR SEVERINOVICH MALEVICH
Kiev 1878 - Leningrad 1935

In 1896, Kazimir Malevich hired on as a draftsman with the railroad company in Koursk. He attended the Moscow Institute of Painting, Sculpture and Architecture in 1904 and in 1910 was invited by Larionov and Goncharova to show in the first exhibition of the avant-garde group Jack of Diamonds, which contested social conformity. In 1915, he delved further into the formal research that led him to Suprematism, a new form of abstract art. Like constellations crisscrossing the cosmos, his coloured geometric forms appear to float in the pictorial space, reproducing the mass, speed and path of the elements that compose the universe. In 1919, he began teaching at the Vitebsk Art Institute and with his students founded Unovis (Affirmers of the New Art). Seeking to expand the social impact of Suprematism, he turned to experimental work in architecture and urbanism and, in 1923-1924, rendered his drawings in three-dimensional prototypes. These included "planits", white cardboard maquettes of floating constructions designed to move around in space, and "architectons", plaster models of ideal dwellings. Based on cubic and rectangular volumes, these simple homogeneous structures were utopian concepts meant to inspire future builders. Following a 1927 retrospective in Berlin, the Soviet authorities, who found his work suspect, forced him to abandon his research. About 1930, he returned to figurative art.

I.N.

MALEVITCH, K. S. *Écrits*. 4 vols.:
De Cézanne au suprématisme;
Le miroir du suprématisme;
Les arts de la représentation;
La lumière et la couleur.
Ed. Jean-Claude Marcadé.
Lausanne: L'Âge d'homme,
"Écrits sur l'art" series, 1974-1981.

Kasimir Malevich, 1878-1935,
exhib. cat. Washington: National Gallery of Art, 1990. Text by Natalia Avtonomova, W.A.L. Beeren, John E. Bowlt, Joop M. Joosten, Alla Lukanova, Dmitrii Sarabianov and Milda Vikturina.

DAVID MALIN
Summerseat, England, 1942

As a young man, David Malin was employed as an apprentice by the Manchester branch of the Geigy company. There, he began to carry out photography and photomicroscopy, becoming an expert chemical microscopist. In 1975, he joined the staff of the Anglo-Australian Observatory in New South Wales, Australia, where he established the photographic service. In the years that followed, Malin won international recognition as one of the world's leading astronomical photographers, specializing in true-colour images of stars and galaxies. His invention of new ways of extracting information from astronomical photographs via image-enhancement techniques has led to the discovery of two new types of galaxies. A fellow of England's Royal Photographic Society, he has also worked with Australian composer Martin Wesley-Smith on audiovisual productions that combine astronomical images with modern music.

C.P.

ALLEN, David, David MALIN and Paul MURDIN. *Catalogue of the Universe*. Cambridge: Cambridge University Press, 1979.

MALIN, David. *A View of the Universe*. Cambridge: Cambridge University Press, 1993.

JOHN MARTIN
Haydon Bridge, England, 1789 - Douglas, Isle of Man, 1854

After studying painting and drawing with Italian artist Boniface Musso, John Martin settled in London in 1806, where he found work decorating ceramics. John Martin rose to fame in 1816, when his *Joshua Commanding the Sun to Stand Still upon Gibeon*, a dramatic landscape composed of a vast architectural perspective peopled with tiny figures, was shown at London's Royal Academy. In the years that followed, he produced a series of paintings notable for their cataclysmic atmosphere inspired by the tormented landscapes of J.M.W. Turner. His most famous work, dating from 1821, is *Belshazzar's Feast*, which portrays the splendour of a Babylonian palace under a livid sky lit by the moon and stars. About 1824, looking to build on the success of his paintings, he turned to printmaking, especially mezzotints after his own work. As illustrations for Milton's *Paradise Lost*, he produced a series of engravings in which Eden's pastoral harmony opposes the chaotic depths of Hell. As of 1827, Martin devoted most of his time to developing utopian projects, such as the renovation of London's sewer system, yet he continued to produce visionary works on the cosmic theme (*The Last Man*, 1849).

M.R.

CAMPBELL, Michael J. *"Darkness Visible": The Prints of John Martin*, exhib. cat. Williamstown, Massachusetts: Sterling and Francine Clark Art Institute, 1986. Text by Richard A. Burnett and J. Dustin Wees.

CAMPBELL, Michael J. *John Martin: Visionary Printmaker*, exhib. cat. York: York City Art Gallery, 1992. Text by Richard A. Burnett and J. Dustin Wees.

ANDRÉ MASSON
Balagny-sur-Thérain 1896 - Paris 1987

André Masson painted his first works of cosmic inspiration during the 1920s. *Meteors* (1925) and *Comet* (1926) belong to the series that marks the formal evolution of his art from Cubist-derived plasticity to the linear automatism of Surrealist compositions. *The Constellations* (1925) was purchased by Antonin Artaud and inspired him to write these lines: "The fire woven in coils of tongues, in the shimmering of the earth that opens like a belly in labour to entrails of honey and sugar." This description conveys the passage or morphogenesis that links these cosmic works to those which, at the same time, exalt the spirit of metamorphosis. For Michel Leiris, Masson's painting was "an uninterrupted quest for the origins of life". In his oeuvre, a like movement animates cellular life and galactic immensity, ceaselessly impelling them to evolve, to open up to endless possibilities. One work from 1942 is eloquently entitled *The Seed and the Star*. That same year, the vast skies of America inspired Masson to paint a new series in tempera on the theme of constellations. Fifteen years later, in *Sky, Milky Way, Beyond ...*, he again evinced his fervent

wish to reconcile the microscopic and the macroscopic, quickening and merging them with the same vital energy.

D.O.

ADES, Dawn. *André Masson.* New York: Rizzoli, 1994.

RUBIN, William, and Caroly LANCHNER. *André Masson*, exhib.cat. New York: Museum of Modern Art, 1976.

de TURENNE, Solange A., Michel LEIRIS and Françoise WILL-LEVAILLANT. *André Masson*, exhib. cat. Nîmes: Musée des beaux-arts, 1985.

GEORGES MÉLIÈS

Paris 1861 - Paris 1938

Son of a Parisian shoe manufacturer, Georges Méliès went to London in 1885, where he learned the art of conjuring and how to make automatons. On returning to Paris the following year, he worked as a caricaturist for *La Griffe*, publishing numerous satiric drawings under the pseudonym Géo Smile. In 1888, he acquired the Théâtre Robert-Houdin, where he put on magic shows, acting as director, set builder, technician and performer. In 1895, the famous public screening of a Lumière brothers' film at the Grand Café in Paris inspired him to design his own camera, the "kinétographe". Following an incident in 1898 when the camera accidentally jammed, he chanced upon the process of double exposure, which led him to develop the spectacular theatrical potential of the cinema. He shot some five hundred films between 1896 and 1913, re-creating adventures inspired by current events (*The Dreyfus Affair*), fairy tales (*Cinderella*) and scientific fiction (*Le rêve de l'astronome*). The writings of Jules Verne and H. G. Wells led him to produce the celebrated 1902 *Trip to the Moon*, which recounts the fantastical lunar voyage of six scientists.

M.R.

MALTHÊTE, Jacques. *Méliès. Images et illusions.* Paris: Exporégie, 1996.

MALTHÊTE-MÉLIÈS, Madeleine, ed. *Méliès et la naissance du spectacle cinématographique*, exhib. cat. Cerisy: Centre culturel international de Cerisy la Salle; Paris: Klincksieck, 1984.

CLAUDE MELLAN

Abbeville 1598 - Paris 1688

French engraver and painter Claude Mellan trained in Paris. He went to Rome in 1624 and apprenticed briefly in the studio of engraver Francesco Villamena; after Villamena's death that same year, he studied drawing with Simon Vouet. Over the following three years, he produced small black and red chalk portraits in the manner of the Italian masters. He also developed a new burin engraving technique called "single continuous line" etching, which earned him great success after his return to Paris (*Face of Christ*, 1649). In 1636, he spent time at the home of humanist Nicolas-Claude Fabri de Peiresc in Aix-en-Provence, where he made large engraved maps of the moon in its first and last quarters. Returning to Paris, he pursued this undertaking with a large view of the full moon. Mellan was appointed engraver to Louis XIV but continued to work as a portraitist, producing numerous black chalk likenesses of influential members of Parisian society, among them the intellectuals Fabri de Peiresc and Gassendi, as well as Cardinal Richelieu and Henry II of Savoy, Duke of Nemours.

M.R.

FICACCI, Luigi, ed. *Claude Mellan, gli anni romani – un incisore tra Vouet e Bernini*, exhib. cat. Rome: Palazzo Barberini, 1989.

L'œil d'or. Claude Mellan 1598-1688, exhib. cat. Paris: Bibliothèque nationale, 1988. Text by Barbara Brejon de Lavergnée and Maxime Préaud.

ERICH MENDELSOHN

Allenstein, Eastern Prussia (now Olsztyn, Poland), 1887 - San Francisco 1953

Further to architecture studies at Berlin's Technische Hochschule in 1908, Erich Mendelsohn went to Munich in 1910 to complete his training with Theodor Fischer. In 1916, at the worst of World War I, he was sent to the Russian front, where he continued to produce architectural sketches. On his return to Berlin in 1918, he opened an architecture firm and organized an exhibition of his drawings at the Paul Cassirer gallery. These included a series of projects for imaginary observatories, which were commissioned by the Prussian government in 1920 and resulted in the Einstein Tower (1920-1924). A combined observatory and astrophysics laboratory built in Potsdam for the purpose of exploring certain aspects of Einstein's theory of relativity, the tower was an organic arrangement of curvilinear forms and embrasures that embodied the newborn world of modern science. In his final German period, begun in 1928, Mendelsohn designed department stores in Stuttgart and Chemnitz, the Universum movie theatre in Berlin and the Mendelsohn villa in Rupenhorn. Fleeing the Nazi regime, he sought refuge in England in 1933, then in Palestine in 1939, finally settling in the United States in 1941.

M.R.

MENDELSOHN, Erich. *Erich Mendelsohn: Complete Works of the Architect – Sketches, Designs, Buildings.* New York: Princeton Architectural Press, 1992.

ZEVI, Bruno. *Erich Mendelsohn.* Paris: Philippe Sers, 1984.

DUANE MICHALS

McKeesport, Pennsylvania, 1932

Duane Michals studied art at the University of Denver from 1949 to 1953, prior to serving in Germany as a second lieutenant in the U.S. Army. On returning to the United States in 1956, he briefly studied graphic arts at the Parsons School of Design in New York. His decision to be a photographer came after taking his first snapshots with an Argus C3 while travelling in the Soviet Union in 1958; by 1960, he was working for several magazines. In 1964, inspired by Eugène Atget's photos of deserted Paris streets, he shot "Empty New York", a series featuring deserted laundromats, subway stations and coffee shops. Michals began producing photo sequences in 1966; these narratives, developed from a succession of images, explore death, spirituality and the universe. His photo sequence *The Human Condition* depicts a man progressively disappearing into the blinding light of the cosmos. He further expanded the photographic medium in the 1970s, first by adding short, handwritten texts to his images, then by writing directly on photographic paper with no image at all.

M.R.

KOZLOFF, Max. *Duane Michals: Now Becoming Then*, exhib. cat. Altadena, California: Twin Palms Publishers, 1990.

LIVINGSTONE, Marco. *The Essential Duane Michals*. London: Thames and Hudson, 1997.

JOAN MIRÓ
Barcelona 1893 -
Palma de Mallorca 1983

Joan Miró began his artistic training at the Escuela de Artes y Oficios de la Lonja in Barcelona in 1907. Five years later, he enrolled at the art school headed by architect Francesc Gali. After a Fauvist period, lasting from 1915 to 1918, he adopted the precise, detailed drawing style that marked his work until 1921. He moved to Paris in 1920 but returned each summer to Montroig, in the Catalan countryside, where the Mediterranean landscape inspired many of his paintings, among them *The Farm* (1921-1922). In 1924, he struck up a friendship with Surrealists Louis Aragon, André Breton and Paul Eluard and, under the influence of their automatic writing technique, began producing works of a dreamlike nature. *Harlequin's Carnival* (1924-1925) is emblematic of this period, during which Miró developed a fantasy world swarming with embryonic, biomorphic forms. Seeking freedom from the constraints of pictorial convention, he turned to collages between 1929 and 1931, using crude materials, such as sandpaper and rope, and experimenting with a wide variety of techniques. In 1939, he took up residence in the Normandy town of Varengeville. The following year, he began the "Constellation" series, completed in Majorca in 1941, in which his familiar elemental forms appear as ethereal signs hovering in space. Miró was fascinated by the azure expanses of the the Majorcan sky and sea; between 1960 and 1968, he painted canvases exalting the spiritual radiance of the colour blue, with which he had worked in his Parisian period.

M.R.

LANCHNER, Carolyn. *Joan Miró*, exhib. cat. New York: Museum of Modern Art, 1993.

Joan Miró: La Colección del Centro Georges Pompidou, Musée national d'art moderne, y otras colecciones, exhib. cat. Mexico City: Centro Cultural Arte Contemporáneo; Paris: Centre Georges Pompidou, 1998. Text by Agnès de la Beaumelle, Jacques Dupin, Octavio Paz, Pierre Schneider and Yvon Taillandier.

RICHARD MISRACH
Los Angeles 1949

A psychology graduate of the University of California, Berkeley, Richard Misrach taught himself the rudiments of photography and went on to teach it at the Berkeley student association from 1971 to 1977. His career as a photographer began in 1974 with the publication of *Telegraph 3 A.M.*, a book of black-and-white photos of nocturnal wanderers on Berkeley's Telegraph Avenue. When the social and political commentary of these images met with indifference, he abandoned the street theme in favour of idealized landscapes. In 1975, the visionary writings of William Butler Yeats, William Blake and Carlos Castaneda induced him to visit the deserts of the American West, where he depicted the nighttime silence in tones of black and white. Other of his photos from that period express the mystic energy of the Stonehenge monoliths and Hawaii's tropical vegetation. In the early 1980s, he travelled the uninhabited deserts of southeastern California, Nevada and northwestern Utah, the site of devastating secret experiments carried out by the U.S. Army. Re-embracing his former socio-political concerns, he created vast panoramic images that invite reflection on the mindless destruction of a seemingly idyllic landscape. They are grouped in thematic cantos that explore the thorny relationship between civilization and nature.

M.R.

WILKESTUCKER, Anne. *Crimes and Splendors: The Desert Cantos of Richard Misrach*, exhib. cat. Houston: Museum of Fine Arts; Boston and Toronto: Bulfinch Press, 1996. Text by Rebecca Solnit.

WILLIAMS, Terry Tempest. *Richard Misrach's Bravo 20: The Bombing of the American West*, exhib. cat. New York: Whitney Museum of American Art; Harry N. Abrams, 1996.

THOMAS MITCHELL
1833 ? - Westgate-on-Sea,
England, 1924

As a member of the British Navy, Thomas Mitchell spent his life at sea and travelled all over the world. On the George Nares expedition to the polar sea in 1875-1876, he is listed among the officers as the Assistant Paymaster of the ship *Discovery*. Nares also mentions his name among those responsible for the photographs of the trip and for the illustrations executed on the spot. Mitchell clearly had some training in watercolour technique, and his works range from topographical renderings of the sea-coast to more expressive depictions of the colour and sublime effects of the Arctic landscape. His documentary record consisted of photographs that were photomechanically reproduced in the published accounts of the voyage. After this trip, he continued to travel with the Navy and rose up through the ranks, finally retiring as Paymaster-in-chief in 1898.

R.P.

BELL, Michael. "Thomas Mitchell, Photographer and Artist in the High Arctic, 1875-1876", *Image*, George Eastman House, vol. 15, no. 3 (September 1972), pp. 12-21.

"Thomas Mitchell". *Archives Canada Microfiches*, series 5. Ottawa: Public Archives, 1975-1976.

PIET MONDRIAN
Amersfoort 1872 - New York 1944

Dutch painter and art theorist Piet Mondrian studied drawing at the Rijksakademie in Amsterdam from 1892 to 1897. While there, he painted the surrounding countryside in a style influenced by the Hague school and the Dutch Impressionist and Symbolist movements. Around 1908, however, the dusky light and subdued palette of his first efforts gave way to vividly coloured compositions dominated by tones of purple. This change is attributable to Mondrian's stay on the island of Walcheren, where he discovered the work of the Divisionists, the Fauvists and Van Gogh through their Dutch followers. In 1909, under the influence of Cornelius Spoor, with whom he exhibited at the Stedelijk Museum, he joined the Theosophical Society and

committed himself to fathoming the nature of the universe through painting. His quest for transcendence led to myriad representations of trees, which, although present in his work since 1900, culminated with the Cubist-inspired series done in Paris. The tree theme served to evoke the intense, organic vitality of nature, whose every element is a microcosm, and after settling in Paris in 1911, he used this motif to explore the issue of harmony in lines and colours. In 1914, unable to leave his homeland, he took to the beaches of Domburg to capture the waves crashing against the wharves in drawings that heralded the Neoplasticist innovations to come.

M.R.

JOOSTEN, Joop M., and Robert P. WELSH. *Piet Mondrian: Catalogue Raisonné*. 2 vols. New York: Harry N. Abrams, 1997.

Piet Mondrian, 1872-1944, exhib. cat. The Hague: Haags Gemeentemuseum; Boston, New York, Toronto and London: Little, Brown and Company, 1995. Text by Yve-Alain Bois, Hans Janssen, Joop M. Joosten and Angelica Zander Rudenstine.

THOMAS MORAN

Bolton, England, 1837 -
Santa Barbara 1926

An immigrant to the United States since 1844, Thomas Moran's first job was as an apprentice in an engraver's shop. His official career as an artist began in 1856, when six of his watercolours were shown at the Pennsylvania Academy of Fine Art. In 1860, he visited the Lake Superior region with artist Isaac L. Williams. At the urging of seascape painter James Hamilton, he sailed to London the following year to study the paintings of Turner, whose atmospheric effects, vibrant colours and sublime vision of the landscape would have a lasting influence on his work. Returning to Philadelphia in 1862, he married artist Mary Nimmo, with whom he worked to revive the art of etching. In 1871, he joined the U.S. Government Geological Survey headed by Ferdinand V. Hayden, the first of the expeditions he was to accompany to the American West. Travelling with photographer William Henry Jackson, he recorded the breathtaking vistas of Yellowstone in delicate drawings that

brought him fame and fortune as illustrations for several New York magazines. He continued to journey in the West until 1892, visiting the Yosemite Valley, the Rockies, Utah, the Grand Canyon, the Tetons, Arizona, New Mexico and Mexico. These trips were to inspire the large-scale canvases in which he portrayed the splendours of the New World.

M.R.

ANDERSON, Nancy K. *Thomas Moran*, exhib. cat. Washington: National Gallery of Art; New Haven and London: Yale University Press, 1997. Text by Thomas P. Bruhn, Joni Louise Kinsey and Anne Morand.

WILKINS, Thurman. *Thomas Moran: Artist of the Mountains.* Norman, Oklahoma: University of Oklahoma Press, 1998. Text by William H. Goetzmann and Caroline Lawson Kinckley.

SAMUEL FINLEY BREESE MORSE

Charlestown, Massachusetts, 1791 -
New York 1872

Painter and inventor Samuel Morse went to London in 1811 to study academic painting at the Royal Academy and work with American artists Benjamin West and Washington Allston. The canvases he brought back to Boston in 1815 met with scant success, forcing him to work as a travelling portraitist. In 1823-1824, after years spent scouring the New England states and Charleston, South Carolina, for commissions, he executed *The House of Representatives*, a historical painting depicting the members in their congressional chamber. He moved to New York in 1824 and in 1826 founded the National Academy of Design with architect Ithiel Town and painter Thomas Cole. In 1828-1829, he painted the classical landscape *The View from Apple Hill*, representing the bucolic charm of the land at the mouth of the Susquehanna River. He travelled to Europe a second time in 1829 and in 1832 began developing the electromagnetic telegraph, for which he obtained a patent in 1840. Abandoning painting for politics and science, Morse introduced the daguerreotype to the United States in 1839 and used the process in his photographic portrait studio, established in 1840.

M.R.

STAITI, Paul J. *Samuel F.B. Morse.* Cambridge: Cambridge University Press, 1989.

Samuel F.B. Morse: Educator and Champion of the Arts in America, exhib. cat. New York: National Academy of Design, 1982. Text by Nicolai Cikovsky, Jr., and Paul J. Staiti.

EADWEARD MUYBRIDGE

Kingston upon Thames 1830 -
Kingston upon Thames 1904

Eadweard Muybridge, baptized Edward James Muggeridge, established himself as a professional photographer in 1867 with a series of skyline panoramas of San Francisco. That same year, he made a trip to the area that would become Yosemite National Park, recording its striking features in photographs he published in 1868 under the trade name "Helios". Using a homemade shutter, he captured the clouds above the Yosemite peaks, producing atmospheric effects that were later imitated by Carleton Watkins. While on a survey led by General William Halleck in the summer of 1868, he documented the Alaskan landscape near Indian villages in Sitka, Fort Wrangle and Fort Tongass. In 1872, he returned to Yosemite to produce the ambitious series of fifty-one mammoth plates that caused his reputation to surpass that of Watkins. Inspired by his travelling companions, painter Albert Bierstadt and geologist Clarence King, Muybridge grew increasingly fascinated by the boundless spaces and mysterious beauty of the valley's craggy planes. The same year, he was commissioned to verify the conclusions of French physiologist Étienne Jules Marey and undertook a series of photographic studies that served to analyze human and animal locomotion.

M.R.

HENDRICKS, Gordon. *Eadweard Muybridge: The Father of the Motion Picture.* New York: Grossman Publishers, 1975.

MUYBRIDGE, Eadweard. *Muybridge's Complete Human and Animal Locomotion.* 3 vols. New York: Dover, 1979. Introduction by Anita Ventura Mozley.

BARNETT NEWMAN

New York 1905 - New York 1970

Foremost colour-field painter Barnett Newman took natural science classes at the Brooklyn Botanic Garden in 1939 and studied botany and ornithology at Cornell University in 1941. In 1946, inspired by native art from the Canadian Northwest, he began painting abstract works featuring biomorphic forms symbolic of the birth of the universe. These include *The Command* (1946), *Death of Euclid* (1947) and *Genetic Moment* (1947), in which he developed an elementary cosmogony drawn from cabalistic texts on the Creation. In 1948, his work underwent a profound change, as he began using masking tape to divide the colour field of his canvases. From this came *Onement I,* a cadmium red surface bisected by a vertical orange band intimating the divine primal gesture. Beginning in 1949, he produced large-scale, horizontal compositions designed to give viewers a terrifying and exalting sense of the cosmos (*Vir heroicus sublimis*, 1950-1951). Between 1963 and 1969, he created *Broken Obelisk*, one of his rare sculptures, composed of an obelisk balanced on the apex of a pyramid, suggesting the cosmic concept of levitation.

M.R.

ROSENBERG, Harold. *Barnett Newman*. New York: Harry N. Abrams, 1978.

STRICK, Jeremy. *The Sublime Is Now: The Early Works of Barnett Newman – Paintings and Drawings, 1944-49*, exhib. cat. Minneapolis: Walker Art Center; New York: PaceWildenstein, 1994.

WILLIAM McFARLANE NOTMAN

Montreal 1857 - Montreal 1913

William McFarlane Notman learned photography from his father, the Scots-born Canadian photographer William Notman, with whom he worked beginning in 1882. In 1884, as a result of a commission obtained by William Notman and Son from the director of the Canadian Pacific Railroad, he made his first trip to the West. To carry out his task of documenting Canada's attractions for publicity purposes, he travelled the transcontinental line from east to west, taking photographs of railway construction, prosperous farms and rapidly growing Western villages, all signs of the country's expanding settlement. In 1887, on a new expedition along the CP line, he produced large-format pictures of British Columbia's Native peoples. In 1889, he journeyed to the Lake Louise region to take the first photos of the lake and the Victoria glacier ever to be put on public exhibition. Following the death of his father in 1891, he assumed management of what, at its peak, was North America's biggest photographic firm, comprising seven studios in Canada and nineteen in the United States.

M.R.

TRIGGS, Stanley G. *William Notman: The Stamp of a Studio*, exhib. cat. Toronto: Art Gallery of Ontario, 1985.

TRIGGS, Stanley G. *William Notman's Studio: The Canadian Picture/Le studio de William Notman. Objectif Canada*, exhib. cat. Montreal: McCord Museum of Canadian History, 1992.

TIMOTHY O'SULLIVAN

Ireland ? 1840 -
Staten Island 1882

Timothy O'Sullivan served as a photographer on the battlefields of the Civil War (1861-1865). From 1867 to 1870, he worked with the U.S. Geological Exploration of the Fortieth Parallel headed by geologist and transcendentalist Clarence King, whose mission was to survey the territory west of the Mississippi. O'Sullivan documented the region's arid expanses and rock formations, which, like King, he saw as the result of antediluvian forces. Also on this trip, he became the first photographer to take pictures of underground mine galleries, using a magnesium torch at the Comstock Lode site in Virginia City. After an assignment with the Darien Survey in Panama in 1870, he joined Lieutenant George M. Wheeler's Geographical Surveys West of the One Hundredth Meridian. On these expeditions he produced stark images of the Colorado River canyons (1871), the Chelly Canyon (1873), Pueblo Indian sites (1873) and Apache and Navajo tribes (1873-1874).

M.R.

DINGUS, Rick. *The Photographic Artifacts of Timothy O'Sullivan.* Albuquerque: University of New Mexico Press, 1982.

SNYDER, Joel. *American Frontiers: The Photographs of Timothy H. O'Sullivan, 1867-1874*, exhib. cat. Millerton, New York: Aperture, 1981.

CLAUDIO PARMIGGIANI

Luzzara 1943

Claudio Parmiggiani graduated from the Istituto d'Arte in Modena in 1960 and had his first solo exhibition in Bologna in 1965. Reflecting his fascination with the relationship between mankind and the cosmos, his early drawings were fantastical, peopled with philosophers and magi conversing with celestial spheres. In the 1970s, he created montages of objects selected for their meaning and poetic impact: casts of antique sculpture, musical scores, maps, mirrors and other such. His compositions, which often allude to art history and the classical ideal, seek to reveal the spiritual content of our earthly, material environment. Preoccupied by the theme of identity, macroscopic and microscopic alike, he produced photographic diptychs illustrating the analogy between human bodies and those of the firmament, as in *Phisiognomoniae coelestis* (1975), where beauty spots on a woman's back form a constellation. In the 1980s and 1990s, his predilection for monochromatic canvases and exclusive use of pure colours resulted in lithographs, installations and architectural works that, with great economy of means, evoke the cosmos through combinations of symbolic objects.

I.N.

RECHT, Roland. *Claudio Parmiggiani*, exhib. cat. Strasbourg: Ancienne Douane, Musées de la ville de Strasbourg, 1987.

Claudio Parmiggiani, exhib. cat. Nantes: Musée des beaux-Aarts de Nantes, 1997. Text by Arielle Pelenc.

GIUSEPPE PELLIZZA DA VOLPEDO
Volpedo, Italy, 1868 - Volpedo 1907

Giuseppe Pellizza da Volpedo acquired drawing skills at Milan's Accademia di Brera in 1884 prior to studying painting, first with Giuseppe Puricelli, then with Pio Sanquirico. In 1887, he enrolled at the Accademia di San Luca in Rome but was unhappy with the teaching there and left the following year to attend the Accademia di belle arti in Florence. Between 1888 and 1890, he studied in Bergamo and Genoa and visited Paris. As of 1891, he made his home in Volpedo. A Realist by training, he adopted the techniques of the Lombardy artists to perfect his rendering of facial structures and took pains with the geometrical arrangement of space. In 1892, he began experimenting with the Divisionist technique of Segantini and Angelo Morbelli, which allowed him to achieve near-geometric simplification in depicting reality and rendered his work more intensely luminous. In the 1890s, he dealt chiefly with social themes, then began exploring symbolic subjects such as love, life, death and work. After the turn of the century, he sought to convey the emotions and moods aroused by certain seasons and times of the day, as seen in *The Rising Sun* (1904).

L.S.

SCOTTI, Aurora. *Pellizza da Volpedo. Catalogo generale.* Milan: Electa, 1986.

SCOTTI-TOSINI, Aurora, ed. *Giuseppe Pellizza da Volpedo: disegni: "Lo studio dell'uomo mi condusse alla natura"*, exhib. cat. Garbagnate Milanese: Corte Valenti; Milan: Mazzotta, 1996.

ANTOINE PEVSNER
Orel 1886 - Paris 1962

Russian-born French painter and sculptor Antoine Pevsner attended art school in Kiev from 1902 to 1909 and the Academy of Arts in Saint Petersburg in 1911. He developed ties with the Parisian avant-garde through Archipenko and Modigliani and signed his first abstract painting in 1913. In 1917, he was named to the teaching staff of the Svomas, where he met Malevich, who introduced him to the theories of Suprematism. In 1920, he and his brother Naum Gabo issued their *Realist Manifesto*, and Pevsner began work on his first constructions made of various industrial materials such as glass, metal, acrylic and other plastics. He was a founding member of Cercle et Carré and joined the Abstraction-Création group in 1931. Subsequently, he gave up working with spatial volumes and rectangular planes in favour of vast spatial curves shaped like rounded vaults. To these he added grids of tight lines, creating movement that stretches heavenward to compose a cosmic architecture. Pevsner was less concerned with science than his brother was, and his art imitates the rhythms of nature, producing an almost musical effect. In 1946, he joined Auguste Herbin and Albert Gleizes in founding the Réalités Nouvelles group. A retrospective of Pevsner's work was shown at the Musée d'art moderne in Paris in 1956.

I.N.

PEISSI, Pierre, and Carola GIEDION-WELCKER. *Antoine Pevsner: Tribute by a Friend.* Neuchâtel: Éditions du Griffon, 1961.

Naum Gabo, Antoine Pevsner, exhib. cat. New York: Museum of Modern Art, 1948. Text by Abraham Chanin, Ruth Olson and Herbert Read.

MIKHAIL MATVEEVICH PLAKSIN
Shlisselburg 1898 - Moscow 1965

Painter, graphic artist and draftsman Mikhail Plaksin studied lithography prior to training with Nikolai Roerich and Alexandr Iakolev at the Society for the Encouragement of the Arts in Saint Petersburg. During the War, he served in the Russian Navy. After the Revolution, he worked with an amateur theatre group and designed propaganda material. The influence of Alexandr Labas led him to abstract art, and in 1920 he enrolled at the Vkhutemas to study in Robert Falk's studio. In 1921, he became a founding member of the Electroorganism group, with whom he exhibited in Moscow in 1922. That year, he painted *Planetary*, a composition of cosmic inspiration in which geometrically disposed features are enclosed in a luminous circle against a dark background. In 1924, he took part in the First Discussional Exhibition of the Associations of Active Revolutionary Art and signed the declaration of the Projectionists' group, published in the catalogue. Plaksin gradually gave up painting to work in publishing and the theatre; he also organized printing and agricultural exhibitions. Beginning in 1920, he devoted part of his time to inventions that included a stereo projector and a colour movie camera.

I.N.

BOWLT, John E. *Russian Art of the Avant-garde: Theory and Criticism, 1902-1934.* London: Thames and Hudson, 1988.

The Russian and Soviet Avant-garde: Works from the Collection of George Costakis, exhib. cat. Montreal: Montreal Museum of Fine Arts, 1989. Text by George Costakis.

PIERRE HENRI PUISEUX
Paris 1855 - Paris 1928

Pierre Puiseux was born in Paris, the son of the noted mathematician and astronomer Victor Puiseux. He determined to follow in his father's footsteps, entering the École Normale supérieure and specializing in mathematics and celestial mechanics; his doctoral thesis examined certain peculiarities of the moon's orbital movement. In 1879, he took a post at the Paris Observatory, where he demonstrated a gift for astronomical observation and devoted considerable time to the improvement of astronomical instruments; he remained there until his retirement thirty-eight years later. In the mid-1890s, Puiseux began his collaboration with Maurice Lœwy on the *Atlas photographique de la Lune*, which appeared in successive fascicules from 1896 to 1909. A professor of astronomy at the Faculté des sciences and a member of the Académie des sciences, he was one of his era's leading experts on lunar geology. At the time of his death, it was written, "One can say that thanks to him, the visible surface of the moon is better known today than that of the earth."

C.P.

LŒWY, Maurice, and Pierre PUISEUX. *Atlas photographique de la Lune.* Paris: Observatoire de Paris, 1896-1909.

PUISEUX, Pierre. *La terre et la lune : forme extérieure et structure intérieure.* Paris: Gauthier-Villars, 1908.

JOHANN GEORG PUSCHNER
1680 - 1749

Engraver Johann Puschner, born in Nuremberg, is recognized above all for his work as globe maker for Nuremberg cartographer and astronomer Johann Gabriel Doppelmayr (about 1671-1750). His son, Johann Georg II, manufactured scientific instruments and took over production of Doppelmayr's globes after his father's death.

J.-F.G.

ROBERT RAUSCHENBERG
Port Arthur, Texas, 1925

Robert Rauschenberg studied under Josef Albers from 1949 to 1954 at Black Mountain College in North Carolina, where he met and worked with composer John Cage and choreographer Merce Cunningham. Under their influence, his work grew increasingly spontaneous, incorporating collage techniques and an eclectic assortment of everyday materials. In 1953, after a period of white, black and red monochromes, he began producing "combine" paintings. Harbingers of Pop art, these assemblages juxtaposed found objects on canvas covered with appropriated media images and paint (*Bed*, 1955). Rauschenberg gave up combines in 1962 to experiment with silkscreening, which he used to print images of contemporary America on canvas. He was fascinated by space exploration and attended the 1969 launch of the Apollo 11 space shuttle at Cape Canaveral. Using photographs obtained from NASA, he produced "Stoned Moon", a series of thirty-three prints commemorating the different phases of the space mission. These images present man's first steps on the moon as the result of man's fruitful partnership with technology.

M.R.

KOTZ, Mary Lynn. *Rauschenberg: Art and Life*. New York: Harry N. Abrams, 1990.

Robert Rauschenberg, exhib. cat. Düsseldorf: Kunstsammlung Nordrhein-Westfalen; Cologne: DuMont, 1994. Text by Armin Zweite and Hiltrud Reinhold.

ODILON REDON
Bordeaux 1840 - Paris 1916

From 1855 to 1857, Odilon Redon studied drawing with Romantic landscape artist Stanislas Gorin, who introduced him to the work of Delacroix, Corot and Moreau. Following a brief, unhappy stint in Gérôme's studio in 1864, Redon returned to Bordeaux, where he learned engraving and lithography techniques with Rodolphe Bresdin. At about the same time, he struck up a friendship with botanist Armand Clavaud, through whom he discovered the world of natural science. Shortly after the Franco-Prussian War, he began "Noir", a series of visionary charcoal drawings and lithographs. He published thirteen lithographic albums between 1879 and 1899, including *In Dreams* (1879), *The Origins* (1883) and *Drawing à la Goya* (1885), in which fantastical visions peopled with strange figures are evoked with naturalistic precision. In his 1882 *The Eye, like a Strange Balloon, Moves towards Infinity*, the first of a lithographic series entitled "To Edgar Allan Poe", Redon used the image of an eye-shaped balloon to represent the soul's ascension into the vast cosmos. In 1890, he abandoned the "Noir" series to concentrate on oil and pastel portraits, illustrations of famous myths and still lifes of flowers in dazzling tones.

M.R.

WILDENSTEIN, Alec. *Odilon Redon. Catalogue raisonné de l'œuvre peint et dessiné*. 2 vols.: *Portraits et figures; Mythes et légendes*. Paris: Wildenstein Institute, "Bibliothèque des arts" series, 1992.

Redon: Prince of Dreams, 1840-1916, exhib. cat. Chicago: Art Institute of Chicago; New York: Harry N. Abrams, 1994. Text by Douglas W. Druick, Gloria Groom, Fred Leeman, Kevin Sharp, Maryanne Stevens, Harriet K. Stratis and Peter Kort Zegers.

PAULUS REINMANN
About 1557 - 1609

Born to a family of Nuremberg sundial makers who specialized in two-faced ivory designs, Paulus brought fame to the Reinmann name. Nuremberg was the centre of European ivory sundial production from 1500 to 1700, and in the early seventeenth century, the Reinmanns were foremost in the field.

J.-F.G.

GERMAINE RICHIER
Grans, France, 1904 - Montpellier 1959

Germaine Richier studied at the École des Beaux-Arts in Montpellier from 1920 to 1926, focussing primarily on sculpture with Louis-Jacques Guigues, a former collaborator of Rodin. Settling in Paris in 1926, she executed a number of nudes in addition to the classical busts that earned her the Blumenthal sculpture award in 1936. When war was declared in 1939, she moved to Zurich. There she created hybrid figures – half-human, half-insect (*Sauterelle, petite*) or half-human, half-plant (*Homme-forêt, petit*) – no doubt inspired by childhood memories of southern France. Returning to France in 1946, she produced *The Spider I*, also a hybrid but in front of which she introduced taut wires for the first time. New figures also appeared, including *The Storm* (1947-1948) and *The Hurricane* (1948-1949). Speaking of her sculptures, Richier said, "Their mangled forms were all conceived full and whole. Only later did I dig into and tear them, to make them different on all sides, to make them appear changing, alive. I love life. I love moving things." In 1952, she cast several figures in lead and placed them in front of square canvases by such artists as Maria Elena Vieira da Silva, Hans Hartung and Zao Wou-ki. In 1956, Richier created *The Tendril*, rising from a reworked shell form. This was to be her only wholly abstract work, designed to symbolize the midpoint of her oeuvre at her 1956 exhibition at the Musée national d'art moderne in Paris. She enlarged this work in 1957, calling it *The Spiral*.

F.G.

PRAT, Jean-Louis, ed. *Germaine Richier : rétrospective*, exhib. cat. Saint-Paul: Fondation Maeght, 1996. Text by Françoise Guiter.

Germaine Richier, exhib. cat. Berlin: Akademie der Künste; Cologne: Wienand, 1997. Text by Angela Lammert, Christa Lichtenstern and Jörn Merkert.

JEAN-PAUL RIOPELLE
Montreal 1923

Born and trained in Montreal, Jean-Paul Riopelle was drawn to the group of artists who, under the leadership of Paul-Émile Borduas, became known as the Automatistes, their nonfigurative works being inspired by the Surrealist concept of automatic writing. These artists defended the notion of absolute political and social freedom and in 1948 produced the manifesto *Refus global*. Riopelle was a signatory, although he had moved to Paris the previous year and was associating with various Surrealist groups. His first one-man show took place in Paris in 1949, at the Galerie Nina Dausset. From then on, he met with increasing success, and his reputation spread to New York, where he began exhibiting at the Pierre Matisse Gallery in 1954. In the late 1960s, he executed a series of figurative cycles focussing on themes bespeaking his strong attachment to wilderness landscapes and wild animals, especially birds. Frequent visits to Quebec prompted him to build a studio at Sainte-Marguerite in the Laurentian Mountains in 1974. In 1977, after a trip to Baffin Island in Canada's Eastern Arctic, he created a series of "iceberg" paintings in black and white. He was impressed by the inky midnight sky and shifting glacial masses: "The icebergs are fantastic to see, they are like white mushrooms that melt, alter, shift until they find a new equilibrium."
In 1981 and 1982, a major Riopelle exhibition was presented at the Musée national d'art moderne, Centre Georges Pompidou, in Paris; the Musée du Québec, in Quebec City; and the Musée d'art contemporain de Montréal. More recently, in 1992, a large exhibition of his work was shown at the Montreal Museum of Fine Arts.

R.P.

Jean-Paul Riopelle, exhib. cat. Montreal: Montreal Museum of Fine Arts, 1992.

GAGNON, Daniel. *Riopelle, grandeur nature*. Montreal: Fides, 1988.

SCHNEIDER, Pierre, *et al. Jean-Paul Riopelle : peinture 1946-1977*. Paris: Centre Georges Pompidou, 1981.

ALEXANDR MIKHAILOVICH RODCHENKO
Saint Petersburg 1891 - Moscow 1956

Alexandr Rodchenko attended the Kazan School of Fine Arts from 1910 to 1914, then moved to Moscow in 1915 to enrol in the Graphic Section of the Stroganov Institute of Applied Arts. In 1916, he exhibited in *The Store*, organized by Tatlin, with compass-and-ruler drawings, his first abstract work. Active in the post-Revolution avant-garde movement, he also held important positions in education reform and played a highly visible role in various artistic activities, working simultaneously in painting, sculpture and architectural projects. At the exhibition *Nonobjective Creation and Suprematism*, he presented the series "Black on Black", his polemical response to Malevich's "White on White". In 1921, he presented hanging spatial constructions at the second Obmokhu show and, at the *5 x 5 = 25* exhibition, the three primary-colour monochromatic canvases that marked the end of his painting career. In 1923, he began producing innovative posters and book covers, using photomontages as a basis for his compositions. He also illustrated Vladimir Mayakovsky's collection of poems *Pro Eto* in this manner. His workers' club, an exemplary Constructivist design, was an important feature of the Soviet presence at the 1925 Exposition internationale des arts décoratifs et industriels in Paris, which he attended. He developed an interest in photography in 1924 and, in the 1930s, produced photographic albums on Russian film, literature and architecture.

I.N.

KHAN-MAGOMEDOV, Selim O. *Rodchenko: The Complete Work*. Cambridge, Massachusetts: MIT Press, 1987.

Aleksandr Rodchenko, exhib. cat. New York: Museum of Modern Art; Harry N. Abrams, 1998. Text by Magdalena Dabrowski, Leah Dickerman and Peter Galassi.

SIR JOHN ROSS
Stranraer, Scotland, 1777 - London 1856

By the time John Ross was appointed commander of his first Arctic expedition in 1818, he had over thirty years of experience with the British Navy. Apprenticed at age nine, he had travelled the seas of the Mediterranean, West Indies and the Baltic and distinguished himself in the Napoleonic Wars with gallant exploits in both Spain and Sweden. His reputation with the British Admiralty was badly tarnished when, on his first polar voyage, he mistakenly believed a range of mountains to be blocking an inlet that turned out to be a crucial passage through to the West. Despite this setback, he made two more trips to the North, under private patronage. His second voyage, carried out by steamship, lasted four gruelling years, during which he discovered the North Magnetic Pole and surveyed areas never before charted. Returning home a hero, he was knighted for his efforts and served as Her Majesty's Consul to Sweden from 1839 to 1846. In 1850, he set out on a final expedition in search of his old friend John Franklin. Ross had no professional art training, but throughout his career, he sketched landscapes and Native people and is known to have done portraits of his fellow seamen.

R.P.

DODGE, Ernest. *The Polar Rosses*. London: Faber and Faber, 1973.

ROSS, Maurice James. *Polar Pioneers: A Biography of John and James Clark Ross*. Montreal and Kingston: McGill-Queen's University Press, 1994.

MARK ROTHKO (MARCUS ROTHKOWITZ)
Dvinsk, Russia (now Daugavpils, Latvia), 1903 – New York 1970

Mark Rothko arrived in the United States in 1913. He studied science at Yale University from 1921 to 1923, then settled in New York, where he trained in 1925 with Max Weber at the Art Students League. In the early 1940s, after an initial Expressionist period, he produced works that were visibly influenced by the Surrealists and the writings of Carl Jung, evoking embryonic, microscopic life-forms (*Hierarchical*

Birds, 1944). In 1947, striving to express the human condition, he eliminated all figuative imagery from his painting in favour of large diffuse colour planes (*Number 18*, 1947). He simplified his abstract compositions to the extreme in 1949-1950 with luminous, ethereal volumes, chiefly rectangles, floating against grounds of paler colour (*Untitled*, 1949). His canvases reached spectacular size in 1950, giving the viewer a sublime sensation of nearness to the void. In the 1960s, Rothko executed dark-toned works suggestive of the silent stillness of outer space (*Untitled*, 1969). These works gave rise to a 1967-1970 series of fourteen meditative paintings commissioned by collectors John and Dominique de Ménil for the decoration of a chapel in Houston.

M.R.

SELDES, Lee. *The Legacy of Mark Rothko*. New York: Da Capo Press, 1996.

Mark Rothko, exhib. cat. Washington: National Gallery of Art; New Haven and London: Yale University Press, 1998. Text by John Gage, Carol Mancusi-Ungaro, Barbara Novak, Brian O'Doherty, Mark Rosenthal, Jessica Steward and Jeffrey Weiss.

ROTRAUT
Rerik, Germany, 1938

Born Rotraut Uecker, Rotraut studied art around 1956 at the Düsseldorf Kunstakademie, where she took part in the discussions of the future members of the Zero Group. The following year, she went to Nice, where she met painters Arman and Yves Klein. She then began her series of "relief paintings", surfaces coated with a thick, grainy white paste, which, once covered in black paint and lightly polished, suggested galaxies. Covered with ink and pressed against another surface, these reliefs produced prints that, like X rays, appeared to reveal a form of molecular life. In 1960, Rotraut undertook *Vols de sensibilité*, a series of paintings in which she sought to capture the pictorial sensitivity of the masters by projecting famous artworks onto canvas and copying their force lines. In 1962, she married Yves Klein. The following year, she began a series of works in which she used thin coats of powdered paint to depict the solitary orbit of celestial bodies in space. In the early 1970s, she pursued her work with stars in vibrant-toned images representing the luminous expansion of the sun. She settled in the United States in 1982 and, in the late 1980s, turned to monochromes to evoke the immensity of Creation.

M.R.

Rotraut, exhib. cat. Kaarst: Gallery 44; La Colle-sur-Loup: Graph 2000, 1989. Text by Peter Clothier.

GIRAUDY, Danielle. "Rotraut. Indigo Mood". *Cimaise*, vol. 36, no. 198 (January-February 1989), pp. 37-56.

THOMAS RUFF
Zell am Harmersbach, Germany, 1958

Thomas Ruff studied photography at the Düsseldorf Kunstakademie with Bernd Becher, espousing his objective, scientific approach to art. Between 1981 and 1985, he produced a series of small portraits of his contemporaries in full-face, profile and three-quarter poses against coloured backgrounds. In 1986, he adopted a larger format for his "Portraits", shooting his subjects in frontal, bust-length poses against monochromatic fields. Eliminating all notion of subjectivity from his work, Ruff stressed the documentary function of photography, believing that it can reproduce only the surface of things. Concurrent with his portrait work, he began photographing buildings in the mid-1980s, producing a clinical view of postindustrial urban reality. In 1989, he undertook a series of black-and-white photos of stars, based on observatory photos that he enlarges and reframes to embrace tiny fragments of the heavenly vault. These views of space reveal the infinite grandeur of the universe. Manifest in Ruff's unromanticized vision of the cosmos is the inability of science and technology to circumscribe reality, whose mystery thus remains intact.

M.R.

Thomas Ruff: Portretten Huizen Sterren/Des portraits, des maisons, des étoiles/Porträts Häuser Sterne, exhib. cat. Amsterdam: Stedelijk Museum, 1989. Text by Els Barents.

Thomas Ruff, exhib. cat. Paris: Centre national de la photographie; Arles: Actes Sud, 1997. Text by Régis Durand.

JOHN RUSSELL
Guilford 1745 - Hull 1806

English pastellist, painter, writer and astronomer John Russell learned pastel techniques with Francis Cotes, a founding member of the Royal Academy in London. He left his mastér in 1767 to establish his own studio and in 1770 pursued further training at the Royal Academy, where his portraits earned him notice. He was admitted to the Academy as an associate in 1772 and soon became known as a leading portraitist; he was made a full member in 1788, while holding the position of pastellist to King George III and the Prince of Wales. In *Elements of Painting with Crayons*, a handbook published in 1772, Russell set out his pastel technique, which, with its remarkable use of reds, blues and yellows, surpassed Cotes's teachings. He was a great enthusiast of astronomy and, after meeting celebrated astronomer Sir William Herschel in 1784, devoted his free time to observing the moon's surface. In 1785, using a large telescope, he undertook to map the moon, an endeavour at which he worked diligently for many years. This resulted in two circular drawings that served to produce engravings of lunar segments, which, once assembled, depicted the area of the moon visible from earth. His contribution was crowned in 1797 with a patent for the moon-charting device he called a "selenograph".

M.R.

WILLIAMSON, George C. *John Russell R.A.* London: George Bell and Sons, 1909.

MORGAN RUSSELL
New York 1886 - Broomall, Pennsylvania, 1953

After formative travels in France and Italy, Morgan Russell returned in 1906 to New York, where he studied sculpture at the Art Students League and later took painting classes with Robert Henri. He went back to Paris in 1908. In 1911, he studied colour theory under Canadian painter Ernest Percyval Tudor-Hart and gave up landscape painting for abstract compositions marked by intense, harmonious colours. That same year Russell met Stanton Macdonald-Wright, with whom he developed Synchromism, a theory based on dynamic colour contrasts inspired by

the scientific research of Chevreul, Rood and Helmholtz. Endeavouring to produce through painting an effect similar to that of music, Russell organized abstract forms and complementary colours so as to suggest tonal rhythms, as in his "Synchromy" series. His fascination with sidereal motion led him to paint the 1913-1914 *Cosmic Synchromy*, which portrays the dynamic structure of the cosmos in spirals, circles and large, luminous lines. He and Macdonald-Wright exhibited their synchromic works at the Bernheim-Jeune gallery in 1913, where they drew the attention of art critics Guillaume Apollinaire and Louis Vauxcelles.

I.N.

KUSHNER, Marilyn S. *Morgan Russell*. New York: Hudson Hills Press; Montclair: Montclair Art Museum, 1990. Introduction by William C. Agee.

KUSHNER, Marilyn Satin. "Morgan Russell (1886-1953): An Expatriate American Modernist", Ph.D. dissertation. Northwestern University, 1991.

LUIGI RUSSOLO

Portogruaro, Italy 1885 -
Cerro di Laveno, Italy 1947

Born to a family of musicians, Luigi Russolo moved to Milan in 1901 and enrolled at the Accademia di Brera. He produced a series of Symbolist-inspired etchings, which he showed at the 1909 exhibition *Bianco e nero* at the Famiglia Artistica in Milan. The same year, he met Boccioni and embraced the Futurist ideology; while still adhering to the spirit of Symbolism, he began dealing with contemporary subjects and opposed all forms of attachment to the past. He experimented with the Divisionist technique and explored various ways of representing motion and light. In *Lightning* (1910), he successfully created an intensely luminous atmosphere, not only through the juxtaposition of bright, complementary colours but also by suggesting the immaterial nature of the lightning rending the sky. He next sought to convey musical rhythms in his paintings, then later adopted the Cubist vocabulary. Russolo spent the year 1913 experimenting with music and writing the manifesto *L'arte dei rumori* (The Art of Noises). He became interested in Oriental philosophies and the occult and did not take up painting again until 1929.

L.S.

COLLOVINI, Diego. *Luigi Russolo: un' appendice al futurismo*. Venice: Supernova, 1997.

MAFFINA, G. F. *Luigi Russolo e l'arte dei rumori, con tutti gli scritti musicali*. Turin: Martano, "Nadar" series, vol. 15, 1978.

LEWIS MORRIS RUTHERFURD

Morissania, New York, 1816 -
Tranquillity, New Jersey, 1892

Born to a distinguished New York family, Lewis Rutherfurd attended Williams College and then studied law, gaining admission to the bar in 1837. Because of his wife's poor health, he gave up his practice in 1849. In the following years, the couple resided in France, Germany and Italy, and Rutherfurd devoted much of his time to studying chemistry and astronomy. Upon returning to New York City in 1856, he installed a small observatory in the garden of his house and began his pioneering work in astronomical photography and spectrography. He was among the first to construct telescopes equipped with achromatic lenses; this allowed astronomers to focus on the part of the spectrum that most strongly affects the photographic negative. With such instruments, he carried out photographs of the sun and moon whose clarity and beauty were widely praised in the U.S. and Europe. For many years a trustee of Columbia College, Rutherfurd played a leading role in establishing a department of geodesy and astronomy there in 1881. He donated his astronomical equipment, his astronomical negatives and his twenty volumes of plate measures to the school. He was one of the original members of the U.S. National Academy of Science and an associate of the Royal Academy of Astronomy. In 1887, he was invited by the French Académie des sciences to participate in that year's international conference on astronomical photography, but failing health prevented him from attending.

C.P.

RUTHERFURD, Lewis Morris. "Astronomical Photography". *American Journal of Science*, vol. 39 (May 1865).

GOULD, Benjamin Apthorp. "Memoir of Lewis Morris Rutherfurd". *National Academy of Science Biographical Memoirs*, vol. 3 (1895), pp. 415-441.

ELIEL SAARINEN

Rantasalmi, Finland, 1873 -
Bloomfield Hills, Michigan, 1950

From 1893 to 1897, Eliel Saarinen studied architecture at the Helsinki Polytechnic Institute and painting at the Imperial Alexander University. In 1896, he formed a partnership with fellow students Herman Gesellius and Armas Lindgren, who shared his comprehensive approach to design, which merges architecture and the creation of objects. This concept was clearly apparent in the Finnish Pavilion conceived by the three colleagues for the 1900 Paris Universal Exposition, where the architecture, decoration and furniture all reflected Finland's "Romantic National" style. In 1904, working alone, Saarinen won the competition for Helsinki's central station (1904-1914). Lindgren and Gesellius judged the building style to be too personal, and the trio's partnership was dissolved in 1907. In 1923, after his project for the Chicago Tribune building was favourably received in American architectural circles, Saarinen immigrated to the United States. During his American period, he designed lighting fixtures, textiles and metal objects marked by the Art Deco style he admired in 1925 at the Paris Exposition internationale des arts décoratifs et industriels modernes. From his interest in the sphere as a pure form came a metal coffee urn designed as part of the tableware for his Cranbrook, Michigan, home.

M.R.

HAUSEN, Marika, Kirmo MIKKOLA, Anna-Lisa AMBERG and Tytti VALTO. *Eliel Saarinen: Projects, 1896-1923*. Cambridge, Massachusetts: MIT Press, 1990.

WITTKOPP, Gregory, ed. *Saarinen House and Garden: A Total Work of Art*. Cranbrook, Michigan: Cranbrook Academy of Art Museum; New York: Harry N. Abrams, 1995. Text by Diana Balmori and Roy Slade.

NICOLAS SANSON
1600 - 1667

Nicolas Sanson, who published some three hundred maps, was largely responsible for establishing the French school of cartography. This caused Europe's mapmaking hub to shift from the Netherlands in the mid-seventeenth century to France, where it remained until the early 1900s. After Sanson's death, the family business was carried on by his three sons and a grandson.

J.-F.G.

PIETER SCHENK
1661 - 1711

German-born engraver and book merchant Pieter Schenk went into business with his brother-in-law Gerard Valk (1652-1726) in Amsterdam around 1680. They obtained an initial licence to publish reproductions of maps by Nicolas Sanson (1600-1667) in 1695 and later issued works by several other French geographers. Schenk did not join Valk in his globe-making venture, undertaken around 1700.

J.-F.G.

ELSA SCHIAPARELLI
Rome 1890 - Paris 1973

Elsa Schiaparelli, one of the foremost couturiers working in Paris in the 1930s and early 1940s, was born to a distinguished family in Rome, where her father headed the Library of the Royal Academy of Lincei (today the Italian Academy of Sciences). She had a privileged upbringing, living in the eighteenth-century Palazzo Corsini, surrounded by books, manuscripts and historical objects that provided inspiration for her future designs. Her uncle, a famous astronomer, was the director of the Brera Observatory in Milan. Not until the 1920s, when she settled in Paris, did she begin designing clothes. With the support of Paul Poiret, she gradually gained a reputation for originality and daring, and her career prospered, even during the Depression. She adapted features of men's styles to her day clothes and created sensational evening wear with bold colours and cuts. During her heyday, the collections she launched from her Place Vendôme headquarters were often based on themes such as music, the circus, the commedia dell'arte and astrology. Artists like Dalí, Cocteau, Van Dongen and Christian Bérard collaborated with Schiaparelli on her designs, which were sought after by movie stars, heiresses and royalty.

R.P.

Hommage à Elsa Schiaparelli, exhib. cat. Paris: Musée de la Mode et du Costume, Palais Galliera, 1984.

WHITE, Palmer. *Elsa Schiaparelli: Empress of Paris Fashion*. New York: Rizzoli, 1986.

BAUDOT, Francius. *Elsa Schiaparelli*, Paris: Assouline, 1997.

KATHLEEN (KATY) SCHIMERT
Grand Island, New York, 1963

Katy Schimert is an artist of the Postmodern generation. Throughout her work runs the theme of tragic love inspired by the likes of Ophelia, Lancelot and Guinevere. She began her career as an artist in the late 1980s with sculptures, installations and short films linking cosmic allusions and a fantasy world of mystery and romance. In *Dear Mr. Armstrong*, an installation shown in New York in 1995, sculpted ceramic moon rocks sit side-by-side with women's letters written in the manner of automatic writing. The rocks, with their uneven surface glazed in gleaming platinum, offer the viewer a tactile and visual experience. The accompanying letters reflect the mood of the writers and serve to draw a parallel between our inner life and the life of the universe, both being subject to upheaval. Drawing on the structure of conventional love stories in her texts and videos, Schimert sometimes locates her characters in space or on the moon to create a pure environment favourable to the expression of emotion. In 1996, she exhibited in the Universalis section at the twenty-third São Paulo Biennial and presented the installation *Love on Lake Erie* in New York.

I.N.

AVGIKOV, Jan. "Kathleen Schimert". *Art Forum*, vol. 34 (September 1995), pp. 84-85.

REES, Michael. "Yale Sculpture: A Recent Breed of Critically Trained Artists from the Noted School of Art". *Flash Art*, vol. 26, no. 170 (May-June 1993), pp. 65-67.

KARL FRIEDRICH SCHINKEL
Neuruppin 1781 - Berlin 1841

German architect, painter and stage designer Karl Friedrich Schinkel studied architecture under David Gilly in 1798 and the following year enrolled at the Bauakademie in Berlin, where both Gilly and his son Friedrich were teaching. Friedrich died an untimely death, leaving behind projects that Schinkel completed prior to a study trip to Italy in 1803-1804. Facing financial difficulties occasioned by the French occupation of Prussia, he began working as a landscape painter in 1805. Through 1815, he painted what he called "historical landscapes", which evoked the traces of human presence in so-called civilized nature, seen as an ideal of aesthetic harmony and political order. He also produced a series of transparencies, much inspired by the panoramas and dioramas so popular at the time, and created musical backgrounds and theatrical lighting to accompany his architectural constructions, historical scenes and shadowed landscapes. Using these "optical perspective pictures", he depicted majestic Gothic cathedrals of crystalline transparency symbolizing the interpenetration of architecture and nature. Between 1815 and 1832, he designed numerous stage sets, the most accomplished of them for Mozart's *Magic Flute* (1815-1816). Here, he sacrificed the easygoing grace of Papageno's world for the Romantic contrast between day and night, suggested by opposing the infinite harmony of a sun-filled city to the darkness of grottoes and forests.

M.R.

BÖRSCH-SUPAN, Helmut. *Karl Friedrich Schinkel. Bühnenentwürfe/Stage Designs*. 2 vols. Berlin: Ernst und Sohn, 1990.

ZUKOWSKY, John, ed. *Karl Friedrich Schinkel, 1781-1841: The Drama of Architecture*, exhib. cat. Chicago: Art Institute of Chicago; Tübingen: Ernst Wasmuth, 1994. Text by Kurt W. Foster, Wolfgang Pehnt, Mitchell Schwarzer, Birgit Verwiebe, Christoph Martin Vogtherr and David van Zanten.

GEORGE SEGAL
New York 1924

Further to studies in art and architecture between 1941 and 1949, George Segal earned his living raising chickens in New Jersey and painted in his spare time. In 1958, he gave up farming to devote himself to sculpting, using crude farm materials such as chicken wire, burlap and plaster. In 1961, he began fashioning human figures directly from life by wrapping live models in strips of plaster-soaked gauze and then reassembling the resulting casts of the various body parts. Frozen in stereotypical poses and placed in contemporary urban settings suggested by found objects, these ghostly figures recall the fleeting nature of everyday life. In the early 1970s, he altered his technique to produce more detailed figures, obtained by pouring Hydrostone, a durable industrial plaster, into the gauze-strip moulds. After completing his first bronze for a public space in 1976, he was commissioned to execute a number of pieces on controversial themes, among them *Gay Liberation* (1980) and *The Holocaust* (1982). Over the past four decades, Segal has also created five scenes from Genesis in an exploration of the universal questions of mortality, faith and family. In his depiction of Jacob's dream, a starry firmament intimates the patriarch's desire for a spiritual life.

M.R.

LIVINGSTONE, Marco. *George Segal, a Retrospective: Sculptures, Paintings, Drawings*, exhib. cat. Montreal: Montreal Museum of Fine Arts, 1997.

George Segal: Works from the Bible, exhib. cat. Los Angeles: Skirball Cultural Center, 1997. Text by Nancy M. Berman.

GINO SEVERINI
Cortona 1883 - Paris 1966

Gino Severini studied in Rome at the Scuola libera del nudo and took night courses at the Villa Medici. In 1901, he met Boccioni, with whom he trained in Balla's studio. Balla introduced him to the Divisionist technique, which he further explored after settling in Paris in 1906. There, he met the artists of the Parisian avant-garde and produced works that borrowed heavily from Cubism. He co-authored the *Manifesto of the Futurist Painters* in 1910 and promoted the Futurist movement in France. Unlike his Italian confreres, however, he preferred to represent dynamism through such subjects as café scenes, boulevards and dancing figures. By juxtaposing coloured geometric forms, he succeeded in fragmenting light and decomposing motifs in motion. Turning to Orphism for inspiration, he produced "Expansion of Light" (1914), a series of abstract paintings in which interpenetrating luminous prisms move to the cosmic rhythm generated by the light. Severini's compositions after 1916 reflected a return to synthetic Cubism; later, in keeping with the "call to order" then sweeping Europe, he took up classical painting in the Italian Renaissance manner.

L.S.

HANSON, Anne Coffin. *Severini futurista: 1912-1917*, exhib. cat. New Haven: Yale University Art Gallery, 1995.

SEVERINI, Gino. *The Life of a Painter: The Autobiography of Gino Severini*. Princeton: Princeton University Press, 1995. Trans. Jennifer Franchina.

VLADIMIR SKODA
Prague 1942

Czech-born French sculptor Vladimir Skoda focussed on painting until 1968, when he left Prague. Settling in Paris, he began working with wire in a series of pieces evoking the themes of absence and disarray dear to the Czech Romantics. After a stay in Rome in 1973-1974, he gave up wire to design a set of serial games that questioned the sculptural process. He began forging his own pieces in 1975, abandoning his previously rigorous conceptual research for an approach based on chance: the basic idea for each piece was determined by the virtual shape of the incandescent material. Early in the 1980s, he began his "meteorite" period, marked by spherical, spiral and conical pieces arranged directly on the ground. Exhibiting geometric forms shaped by the heat of the forge, he revealed the potential energy of fusing matter caused by the continuous movement between expansion and contraction, the infinite and the infinitesimal. This later led him to favour the sphere in his experiments, attesting to his growing interest in cosmology.

M.R.

Vladimir Skoda : œuvres 1975-1986, exhib. cat. Ivry-sur-Seine: CREDAC; Paris: Galerie Montenay-Delsol, 1986. Text by Philippe Cyroulnik and Olivier Kaeppelin.

Vladimir Skoda: Skulpturen. Berlin: Galerie Springer, 1990. Text by Ljuba Berankova.

NAUM SLUTZKY
Kiev 1894 - Birmingham 1965

Russian goldsmith and designer Naum Slutzky began his career at the Wiener Werkstätte under the direction of Austrian architect and decorator Joseph Hoffman. In 1919, having moved to Germany, he opened his own jewellery studio, which was affiliated with Weimar's Bauhaus studio. Using a variety of metals and precious stones, he created functional jewellery based on the circle and other simple geometric forms. His circular pieces were of cosmic inspiration, evoking the immutable perfection of the universe and its microcosmic replica, the earth. In 1924, following Moholy-Nagy's appointment as head of the Bauhaus metal workshop the year before, the Weimar jewellery studio closed its doors. Slutzky then worked as an independent goldsmith and designer in Vienna, Berlin and Hamburg. In 1933, he settled in England, where he taught goldworking, jewellery making and industrial design at the Royal College of Art from 1950 to 1957 and held a teaching position at Birmingham's College of Arts and Crafts in 1964-1965. Because of their utilitarian nature, his pieces had a marked influence on Scandinavian jewellery in the years following World War II.

M.R.

RUDOLPH, Monika. *Naum Slutzky: Meister am Bauhaus, Goldschmied und Designer*. Stuttgart: Arnoldsche, 1990.

Naum Slutzky, 1894-1965: Ein Bauhaus-Künstler in Hamburg, exhib. cat. Hamburg: Museum für Kunst und Gewerbe Hamburg, 1995. Text by Rüdiger Joppien.

KIKI SMITH
Nuremberg 1954

German-born Kiki Smith moved to New York in 1976 and was active in COLAB (Collective Projects Inc.), an art group working outside the gallery system. In 1979, working from *Gray's Anatomy*, she began a series of drawings of the body, reproducing microscopic images, histological sections and nerve endings. The following year, she produced her first body-part work, *Severed Limbs*. To perfect her knowledge of the human body, both the outer envelope and the inner organs, she took an emergency medical training course at a Brooklyn hospital in 1985. Working with glass, bronze, tin, clay, paper and beeswax, she focussed on representing human body parts, exhibiting her work as an abject collection of flesh, fluid and inner organs. In the early 1990s, she began restoring the link between mankind and nature in drawings, sculptures, engravings and video installations showing human figures surrounded by animals, birds, flowers and celestial bodies. By reintegrating the human body into the natural world, she reveals the unity of Creation, which embraces the cosmic universe.

M.R.

Kiki Smith, exhib. cat. Montreal: Montreal Museum of Fine Arts, 1996. Text by Christine Ross and Mayo Graham.

Kiki Smith: Night, exhib. cat. Washington: Hirshhorn Museum and Sculpture Garden, Smithsonian Institution, 1998. Text by Phyllis Rosenzweig.

EDDIE SQUIRES
Anlaby Hull, England, 1940 - London 1995

Eddie Squires worked as a freelance textile and interior designer prior to joining Warner and Sons in London in 1964. He became their chief designer of printed fabrics and created the "Lunar Rocket" design to commemorate man's first landing on the moon in 1969.

R.P.

VLADIMIR AVGUSTOVICH STENBERG
Moscow 1899 - Moscow 1982

Russian painter and sculptor Vladimir Stenberg entered the Stronganov Institute in 1912 and went on to study at the Svomas (Free State Art Studios) in 1917. He was a member of the Obmokhu (Society of Young Artists) and, between 1919 and 1923, showed in the second of the group's four exhibitions, which featured posters, urban projects and theatre decors designed to meet the propaganda needs of the new regime. He joined the Inkhuk (Institute of Painterly Culture) in 1920 and the following year, with Konstantin Medunetsky, exhibited constructions called *Spatial Apparatus* at the Poets' Café. Reflecting the difficulty of nonobjective art, these works were linear structures, vertically aligned to project their dynamic energy into space. During the 1920s, he and his brother Georgy produced numerous film posters signed "2 Stenberg 2". In 1922, they designed the costumes for Alexandr Tairov's production of *The Yellow Blouse* at the Kamernyi (Chamber) Theatre in Moscow. Both designed magazine covers as well, and in 1928 they were commissioned to decorate Red Square for the anniversary of the October Revolution. After the death of his brother in 1933, Vladimir continued to work as a decorator for state ceremonies.

I.N.

BOWLT, John E. *Russian Art of the Avant-garde: Theory and Criticism, 1902-1934*. London: Thames and Hudson, 1988.

NAKOV, Andréi B. *2 Stenberg 2: The "Laboratory" Period (1919-1921) of Russian Constructivism*, exhib. cat. Paris: Galerie Jean Chauvelin, 1975.

ALFRED STEVENS
Brussels 1823 - Paris 1906

After studying painting at the Académie des Beaux-Arts in Brussels from 1840 to 1844, Alfred Stevens went to Paris, where he attended classes given by Jean Dominique Ingres. On his return to Brussels in 1849, he produced works of a Realist-historical nature, which he exhibited for the first time at the 1851 Brussels Salon. Settling in Paris the following year, he became a leading light in social, artistic and literary circles. He abandoned historical

themes in 1854 to concentrate on depicting the belles of Second Empire Paris. His fascination at the time with things Japanese is evident in the Oriental decors and accessories that he was prone to render in great detail. In 1880, at the urging of his doctor, he began taking regular vacations, first on the Normandy coast, then in the South of France. Inspired by the beauty of the coastal landscapes, he produced a series of marines, which met with great success in Paris. He occasionally included figures in his compositions, as in *The Milky Way*, where a young woman is lost in contemplation of the star-studded sky.

M.R.

COLES, William A. *Alfred Stevens*, exhib. cat. Ann Arbor, Michigan: University of Michigan Museum of Art, 1977.

GRENEZ, Annie. *Rétrospective Alfred Stevens*, exhib. cat. Charleroi: Palais des beaux-arts, 1975.

ALFRED STIEGLITZ
Hoboken 1864 - New York 1946

While studying at the Technische Hochschule in Berlin between 1882 and 1890, Alfred Stieglitz trained in photography and photochemistry under research scientist Hermann Wilhelm Vogel. Returning to the United States in 1890, he worked as a partner in a New York photoengraving firm and, in his free time, took pictures of the busy city streets. He gave up commercial photoengraving in 1895 and, two years later, launched *Camera Notes*, the New York Camera Club magazine, which he headed. In 1902, he left *Camera Notes* to form the pictorialist group Photo-Secession and, in 1903, founded the group's house organ *Camera Work*. In 1905, he and Edward Steichen opened the Little Galleries of the Photo-Secession – which came to be known simply as "291" – where he introduced the American public to the work of the European avant-garde. During this period, he produced remarkable portraits of New York artistic and literary luminaries and technically accomplished city scenes. After the "291" gallery closed in 1917, he spent his summers on Lake George, in upstate New York, where he recorded the clouds, intimating his own moods in the changing stratosphere.

M.R.

SZARKOWSKI, John. *Alfred Stieglitz at Lake George*, exhib. cat. New York: Museum of Modern Art, 1995.

AUGUST JOHAN STRINDBERG
Stockholm 1849 - Stockholm 1912

In 1886, Swedish painter, sculptor and playwright August Strindberg took the first of the many train trips during which he photographed the passing landscape from the window, thus associating photographic instantaneity with the speed of train travel. In 1890, he produced "plant photograms" and "crystallograms"; the following year, he undertook chromatic experiments, attempting to photograph the colours of the solar spectrum by replacing the lens with a simple pinhole serving to filter the light. He took a passionate interest in astronomy and was bent on mapping the sky and locating stars invisible to the naked eye by directing a Lumière plate – without benefit of a camera or lens – towards the moon, stars and sun. Convinced that he had discovered a revolutionary means of photographing the heavens, he sent his first pictures to Camille Flammarion, director of the magazine *L'Astronomie*, hoping to obtain expert backing. Although Flammarion could discern nothing more than an unevenly visible surface covered with fortuitous silvery microoxidation deposits, Strindberg was elected to the Société astronomique de France in December 1894. Later, realizing how little credit the scientists afforded his "celestographs", he turned to the occult and, like Baraduc, attempted to photograph the human soul.

I.N.

CHÉROUX, Clément. *L'expérience photographique d'August Strindberg : du naturalisme au sur-naturalisme.* Arles: Actes Sud, 1994.

HEMMINGSSON, Per. *August Strindberg, som fotograf.* Ahus, Sweden: Kalejdoskop, 1989.

NIKOLAI SUETIN
Province of Kaluga 1897 - Leningrad 1954

From 1918 to 1922, Nikolai Suetin was a student at the Vitebsk Art Institute, where he took courses with Malevich. He was an active member of Unovis (Affirmers of the New Art) and exhibited regularly with the group in the 1920s. In 1922, he followed his teacher to the Ginkhuk (State Institute of Painterly Culture) in Petrograd, where he helped establish the formal-theoretical section (FTO). In 1923, he began working at the Lomonosov ceramics factory, where he held the position of artistic director from 1932 to 1952. In 1923 and 1924, he assisted Malevich in his work on "planits" and "architectons". Suetin's preoccupation with the square – an elementary nonobjective form – and with tonal relationships led him to seek stronger sensations in his painting through the use of intense colours. His works, which brought a lyrical dimension to the formal Suprematist vocabulary, reflect a cosmic sensibility, something that was fundamental to the Malevichian theory. Suetin worked mainly as an exhibition decorator in the 1930s. His work was recognized at the Paris World's Fair in 1937, and he received a commission for the 1939 Soviet Pavilion in New York. Malevich regarded Suetin as his spiritual heir and, in his last wishes, asked that Suetin decorate his casket.

I.N.

RAKITIN, Wassili. *Malewitsch, Suetin, Tschaschnik*, exhib. cat. Cologne: Gmurzynska Gallery, 1992. Text by Krystyna Gmurzynska-Bescher, Evgeniya Petrova and Nina Suetina.

SCHLÉGL, István, ed. *Suprematismus: Werke von Kasimir S. Malewitsch, Nikolaj M. Suetin, Ilja G. Tschaschnik*, exhib. cat. Zurich: Galerie Schlégl, 1989. Text by Wassilj Rakitin.

LÉOPOLD SURVAGE (STÜRZWAGE)
Moscow 1879 - Paris 1968

Léopold Survage entered Moscow's Institute of Painting, Sculpture and Architecture in 1899. He immigrated to Paris in 1909 and enrolled at Matisse's studio. In 1914, under the influence of Cézanne and the Cubists, he produced works whose rhythmic

surface distribution tends to stir emotions in the viewer similar to those aroused by listening to a symphony. Pursuing his exploration of dynamic, kinetic movement, he developed a film project for which he made a set of *Coloured Rhythms*, featuring geometric forms and colour groups that suggest the full array of cosmic phenomena. Fascinated by the theme of harmony between mankind and the universe, he grouped organic motifs and figures along an axis to represent the links uniting the earthly world and outer space. In 1920, he, Archipenko and Gleizes reorganized the Section d'Or salon, which was responsible for exhibiting the work of avant-garde artists. In 1937, Robert and Sonia Delaunay commissioned him to decorate the National Railway Pavilion at the Paris World's Fair. Stimulated by the writings of theosophists Steiner and Swedenborg, he developed a passion for mysticism in 1939, and his work became highly symbolic. In 1959, he painted a fresco on the theme of peace for the Palais des Congrès in Liège.

I.N.

ABADIE, Daniel. *Survage : les années héroïques*, exhib. cat. Paris: Anthèse, 1993.

SURVAGE, Léopold. *Écrits sur la peinture*. Ed. Hélène Seyres. Paris: L'Archipel, 1992.

MARK TANSEY
San Jose 1949

Mark Tansey studied at the Art Center College of Design in Los Angeles from 1969 to 1972, then moved to New York in 1973 to do a Master's degree in visual arts at Hunter College (1974-1978). In 1979, he began a series of monochromatic paintings in which he rethought the limits of representation. Working from myriad references – reproductions, photographs and photo-copies – he produced compositions that question the nature of figurative art, the Modernist heritage, the notion of truth in painting and the relationship between representation and its subject. These questions are contained in *Action Painting II* (1984), which represents an open-air painting session where students face the impossible task of reproducing a space launch. Around the same time, Tansey began

creating pieces in which confrontation with the unknown serves as a metaphor for the eternal search for learning. Beginning in 1987, he rendered this aspiration by integrating portraits of such famous theorists as Roland Barthes and Jacques Derrida into his compositions. In *Constructing the Grand Canyon*, completed in 1990, he compares their ambitious quest for knowledge to the gigantic enterprise of "building" the Grand Canyon.

M.R.

DANTO, Arthur C. *Mark Tansey: Visions and Revisions*. New York: Harry N. Abrams, 1992.

FREEMAN, Judi. *Tansey*, exhib. cat. Los Angeles: Los Angeles County Museum of Art; San Francisco: Chronicle Books, 1993. Text by Alain Robbe-Grillet and Mark Tansey.

BRUNO TAUT

Königsberg 1880 - Istanbul 1938

Bruno Taut began his architectural career in Bruno Möhring's Berlin firm in 1903. The following year, he and Theodor Fischer designed workers' housing in Stuttgart. In 1909, he opened an architectural firm in Berlin in partnership with his brother Max and Franz Hoffmann. Taut designed a number of buildings, notably the combined residential and commercial complex in Neukölln (1910-1911), but his fame came with Monument to Steel, a work of iron and glass built for the Leipzig Exposition in 1913. A charter member of the Arbeitsrat für Kunst (Work Council for Art), president of the November Group and founder of the review *Frühlicht*, he expressed his utopian views on society in a variety of works published after World War I, among them *Alpine Architektur* (1919), *Die Stadtkrone* (The City-Crown, 1919) and *Die Auflösung der Städte* (The Dissolution of the Cities, 1920). Believing that modern technology and mechanics must serve to build a harmonious society, he drew plans for glass cathedrals atop Alpine peaks and coloured-glass satellites for space travel. His architecture projects, designed to reflect the light of the sun, moon and stars, bear witness to his desire to bring mankind closer to the cosmos through contemplation of the firmament. As the Nazi movement emerged, Taut left Germany;

he went first to Moscow, then to Japan and finally settled in Istanbul, where he was named to the faculty of the Art Academy.

I.N.

SPEIDEL, Manfred. *Bruno Taut Retrospective: Nature and Fantasy*, exhib. cat. Tokyo: Treville; Sezon Museum of Art, 1994.

THIEKÖTTER, Angelika. *Kristallisationen, Splitterrungen, Bruno Tauts Glashaus*, exhib. cat. Berlin: Birkhäuser; Martin-Gropius-Bau, 1993.

THOMAS JOHN THOMSON

Claremont, Ontario, 1877 - Canoe Lake, Algonquin Provincial Park, Ontario, 1917

Tom Thomson came late to painting. He worked as a graphic artist for ten years at Grip Ltd., a large commercial design firm in Toronto, where he met the artists who later founded the Group of Seven. They encouraged him to paint, and in 1912 he made a first trip to Algonquin Park, where he discovered the wild beauty of the northern forests that would be his main source of inspiration. During this trip, he made small oil sketches, which he later used in composing his first large painting, *Northern Lake*. He spent most of the next four years painting in the park while working as a guide and forest ranger to earn his keep. But it was not until 1914 that he assumed his status as a professional artist and decided to share a studio with A. Y. Jackson. He returned to the park that year, accompanied by Jackson, and experimented with the bright colours that are reflected in *Northern River*. Here Thomson evokes the mystery of the Canadian landscape that the Group of Seven painters later sought to portray. Shortly before his tragic death in 1917, he painted the famous *Jack Pine*, a majestic expression of nature's vitality.

M.R.

MURRAY, Joan. *Tom Thomson: The Last Spring*. Toronto and Oxford: Dundurn Press, 1994.

REID, Dennis. *Tom Thomson: "The Jack Pine"/Tom Thomson: « Le pin »*, exhib. cat. Ottawa: National Gallery of Canada, 1975.

ÉTIENNE LÉOPOLD TROUVELOT

Aisne 1827 - Meudon 1895

French-born draftsman and astronomer Étienne Trouvelot immigrated in 1855 to the United States, where he worked as an artist in Massachusetts, finally settling in a suburb of Boston in 1860. Recognized for the quality of his representations of the aurora borealis, he was invited to join the Harvard College Observatory team in 1872. Using Harvard's famed astronomical telescope, he observed celestial bodies and depicted them in a series of images entitled "Astronomical Engravings from the Observatory of Harvard College". In 1875, he discovered veiled spots in the sky, which he related to sunspots, and studied Mars, Jupiter and Saturn with the intention of faithfully reproducing the heavenly vault. That same year, the U.S. Naval Observatory in Washington offered him the use of the world's largest existing lens, with which he improved his illustration of Saturn and produced an image of the Orion nebula. In the years following, he produced some seven thousand pastels, fifteen of which he chose to serve as the basis for chromolithographic prints published in 1881 along with a descriptive guide written by the artist. Trouvelot was intrigued by the sun. In 1878, he travelled to Wyoming to observe an eclipse, in order to depict the phenomenon in detail and analyze the sun's chromosphere by means of a spectroscope. In 1882, he returned to France, where Jules Janssen, an eminent astronomer specializing in solar research, invited him to the Meudon Observatory to study and map the sun.

M.R.

HERMAN, Jan K., and Brenda G. CORBIN. "Trouvelot: From Moths to Mars", *Sky and Telescope*, December 1986, pp. 566-568.

JOSEPH MALLORD WILLIAM TURNER

London 1775 - Chelsea 1851

Early in his career, painter, engraver and watercolourist J.M.W. Turner made topographical renderings, which he soon abandoned in favour of picturesque architectural and landscape scenes. A student at London's Royal Academy from 1789 to 1793, he exhibited a painting there for the first time in

1796, became a member in 1802 and a teacher of perspective in 1807. After travels in England and Scotland, he made frequent trips to the Continent, touring Switzerland, France, the Netherlands and Germany. An initial visit to Italy in 1819 resulted in his renowned scenes of Venice. His travels along the English coast in 1824 and on the Isle of Wight in 1827 fostered the emergence of seascapes in his work. Little by little, he infused his canvases and watercolours of landscapes of every kind (historical, architectural, mountainous and pastoral) with an incomparable Romantic dimension drawn from a profound sense of the sublime inspired by nature. After 1840, rendering palpable atmospheric effects and climatic variations with colour, he conceived technically daring compositions that occasionally leaned towards the abstract.

M.R.

BUTLIN, Martin, and Evelyn JOLL. *The Paintings of J.M.W. Turner.* 2 vols. New Haven and London: Yale University Press, 1977; revised 1984.

Joseph Mallord William Turner, exhib. cat. Vienna: Bank Austria Kunstforum; Munich and New York: Prestel, 1997. Text by David B. Brown.

GERARD VALK
1652 - 1726

LEONARD VALK
1675 - 1746

The Amsterdam Valks, father and son, were the last of the great Dutch cartographers and globe makers. In the purest tradition of their illustrious predecessors (Mercator, Hondius, Blaeu, etc.), they combined the sure hand of the artist with a geographer's erudition. In their time, their works were sold throughout Europe.

J.-F.G.

VINCENT VAN GOGH
Groot-Zundert, The Netherlands, 1853 - Auvers-sur-Oise, France, 1890

The son of a Calvinist pastor, Vincent van Gogh served between 1878 and 1880 as a lay preacher in the Borinage mining district of Belgium, where, under the evident influence of Millet, he made his first drawings from nature. In 1880, intent on depicting the misery of the rural poor, he enrolled at the Académie Royale des Beaux-Arts in Brussels to study drawing; due to financial difficulties, he left the following year. In 1886, he joined his brother Theo in Paris, where he encountered the work of the Impressionists and several Japanese printmakers. Pursuing his training at Fernand Cormon's studio, he met Émile Bernard, who introduced him to Paul Gauguin; contact with these two artists led him to simplify his forms and free colour from its descriptive function. He moved in 1888 to Arles, where the Mediterranean landscape inspired him to paint numerous landscapes celebrating the awesome energy of the sun in intensely brilliant hues. Gauguin came to stay and paint with him that year, but their collaboration was interrupted by the dramatic incident that led to Van Gogh's internment in an asylum at Saint-Rémy-de-Provence. He found inspiration in the writings of American poet Walt Whitman and French astronomer Camille Flammarion and, in 1889, painted *Starry Night*, in which he exalts the divinity of nature by representing the cosmos as the source of primordial life. In 1890, he settled in Auvers-sur-Oise, where he spent the last year of his life under the care of Dr. Paul Gachet.

M.R.

HULSKER, Jan. *The New Complete Van Gogh: Paintings, Drawings, Sketches.* Amsterdam: J.M. Meulenhoff; Philadelphia: John Benjamins, 1996.

KENDALL, Richard. *Van Gogh's Van Goghs: Masterpieces from the Van Gogh Museum, Amsterdam,* exhib. cat. Washington: National Gallery of Art; New York: Harry N. Abrams, 1998. Text by Sjraar van Heugten and John Leighton.

GEORGES VANTONGERLOO
Antwerp 1886 - Paris 1965

Belgian painter and sculptor Georges Vantongerloo received training at the Fine Arts Academy in Antwerp (1900-1904) and at the Académie Royale des Beaux-Arts in Brussels (1906-1909). From 1918 to 1920, in a series of articles entitled "Reflections", published in *De Stijl*, he spelled out his spatial formula (volume + void = space) in pseudo-scientific terms inspired by the theosophical writings of M.H.J. Schoenmakers. After meeting Theo Van Doesburg, he turned to geometric abstraction. He settled in the French village of Menton in 1920 and devoted his efforts to interior decoration until moving to Paris in 1928. There he developed utopian architectural projects in designs for villas, bridges and airports. He joined the Cercle et Carré group in 1930 and Abstraction-Création the following year. From 1937 to 1945, the rectangular forms that marked his early works gave way to curves and ellipses. Taking up sculpture again in the late 1940s, he used plexiglass and other plastics to create playful representations of celestial bodies, comets and atomic particles, attesting to his interest in cosmic phenomena.

I.N.

Georges Vantongerloo: A Traveling Retrospective Exhibition, exhib. cat. Washington: Corcoran Gallery of Art; Brussels: Loiseau, 1980. Text by R. De Backer-Van Ocken, Jane Livingston, Peter C. Marzio, Phil Mertens and Angela Thomas-Jankowski.

Georges Vantongerloo, 1886-1965. Brussels: Musées Royaux des Beaux-Arts de Belgique, 1981. Text by Phil Mertens and Philippe Roberts-Jones.

CARLETON WATKINS
Oneonta, New York, 1829 - Imola, California, 1916

After opening his own studio in 1858, Carleton Watkins began photographically documenting the American West for projects involving topographical, geological, industrial, architectural and legal matters. In 1861, vying with fellow photographer Charles Leander Weed, he made the first of eight trips to Yosemite Valley, where he captured some of the earliest images of its striking sites taken with mammoth plates. His photos from this expedition represent the breathtaking features of the valley as a newfound earthly paradise. He also recorded the valley's giant sequoias, symbolizing with their loftiness the nation's glory and the riches afforded the American people through divine magnanimity. In 1866, he returned to Yosemite with the government geological survey led by

Josiah D. Whitney, whose *Yosemite Book* (1868) he subsequently illustrated. In 1870, he joined the U.S. Geological Survey of the Fortieth Parallel headed by geologist and transcendentalist Clarence King, with whom he climbed Mount Shasta and Mount Lassen to photograph their rock formations. Obtaining various government commissions, he continued to travel the West throughout the 1880s.

<div align="right">M.R.</div>

RULE, Amy, ed. *Carleton Watkins: Selected Texts and Bibliography.* Boston: G.K. Hall, 1993.

Carleton Watkins: Photographs from the J. Paul Getty Museum. Los Angeles: The Museum, "In Focus" series, 1997.

CHARLES LEANDER WEED
New York 1824 - Oakland 1903

American photographer Charles Leander Weed went to work with noted San Francisco daguerreotypist Robert H. Vance in 1858. Through Vance, he obtained specialized equipment for the wet collodion process, which he used on his expedition along the American River that same year. In 1859, accompanied by entrepreneur James M. Hutchings, he travelled to the recently discovered Yosemite Valley to take the first-ever stereoscopic photographs of its wonders. Following a stay in Hong Kong, he returned to Yosemite in 1865 and there, with the help of Eadweard Muybridge, produced mammoth plate views that rivalled those taken by Carleton Watkins in 1861. While Watkins's photographs portrayed the primitive, virgin land of the West, Weed's evoked mankind's rapture before the beauty of the scenery. On his return to San Francisco in 1869, Weed went back to his previous job as a photographer for the Houseworth firm, which published most of his photos under its name. He began working as a photoengraver in the 1880s and continued to do so until his retirement in the 1890s.

<div align="right">M.R.</div>

NAEF, Weston J., and James N. WOOD. *Era of Exploration: The Rise of Landscape Photography in the American West, 1860-1885.* Buffalo: Albright-Knox Art Gallery; New York: Metropolitan Museum of Art, 1975.

JOHN ADAMS WHIPPLE
Grafton, Massachusetts, 1823 - Boston 1891

Having first worked in the sale and manufacture of chemicals used in the daguerreotype process, John Whipple opened his own photography studio in 1846. He specialized in likenesses made using the Crayon Portraiture technique, which consisted of interposing a circular mask between the camera and the subject to produce a vignette effect. Beginning in 1848, he took pictures of the sky using the large telescope at the Harvard College Observatory. After two years of experimenting, he successfully obtained a clear silver print of the star Alpha Lyrae. In March 1851, he produced a remarkable daguerreotype of the moon, which earned him one of the five medals awarded at the Crystal Palace exhibition in London that year. His continued interest in the representation of celestial bodies led him to photograph a solar eclipse in 1867. Parallel to these activities, he contributed to the development of scientific photography with photomicrographs and images lit by electric light. Whipple's most important invention was the "crystalotype", a paper print produced using the albumen process, developed in 1850.

<div align="right">M.R.</div>

PIERCE, Sally. *Whipple and Black: Commercial Photographers in Boston.* Boston: Boston Athenaeum, 1987.

JOYCE WIELAND
Toronto 1931 - Toronto 1998

Canadian painter and filmmaker Joyce Wieland trained in dressmaking and fashion design at Toronto's Central Technical School, where her talent was quickly noted by Doris McCarthy, a protegé of the Group of Seven. She learned the basics of animation and screenwriting during her years at Graphic Films, where she met artist Michael Snow, whom she married in 1956. From 1962 to 1970, the couple lived in New York, where Wieland gained recognition for her experimental films. Taking an interest in Canada's political situation, she travelled the country from coast to coast in 1967 and 1968 making *Reason over Passion* (1969), a film that celebrates the majesty of the Canadian landscape. In 1970,

inspired by the words of Canadian Prime Minister Pierre Elliott Trudeau, she created *Man Has Reached Out and Touched the Tranquil Moon.* This work commemorates mankind's first step on the moon, evoking the cold lunar light in letters of white cotton and transparent plastic surrounded by coloured shapes. In 1971, the National Gallery of Canada presented her *True Patriot Love*, an exhibition of pieces pertaining to the threatened Canadian environment. Following a trip to Cape Dorset, in the Arctic, where she discovered the spiritual power of northern light, she began painting again, creating landscapes alive with an intense organic vitality.

<div align="right">M.R.</div>

Joyce Wieland, exhib. cat. Toronto: Art Gallery of Ontario; Key Porter Books, 1987. Text by Marie Flemming, Lucy Lippard and Lauren Rabinovitz.

Joyce Wieland: Twilit Record of Romantic Love, exhib. cat. Kingston: Queen's University, Agnes Etherington Art Centre, 1995. Text by Jan Allen.

ALFRED WORDEN
Jackson, Michigan, 1932

A U.S. Air Force pilot who became an astronaut in 1966, Alfred Worden took part in the Apollo 15 mission of July 1971. While his two crewmates landed on the lunar surface, Worden spent three days orbiting the moon in the command module. During that time, he made a number of spectacular colour photographs of the earth and moon.

<div align="right">C.P.</div>

SCHICK, Ron, and Julia VAN HAAFTEN. *The View from Space: American Astronaut Photography, 1962-1972.* New York: Clarkson N. Potter, 1988.

FRANK LLOYD WRIGHT
Richland Center, Wisconsin, 1867 -
Phoenix 1959

Frank Lloyd Wright worked from
1888 to 1893 as senior draftsman for
Louis Sullivan and Dankmar Adler
prior to opening his own practice in
the Chicago suburb of Oak Park.
Following publication of his "House
for a Prairie Town" project in 1901, he
developed his Prairie style in a series
of houses marked by flared eaves,
asymmetrical design and horizontal
lines reflecting the open spaces of the
Midwest. In 1936, he built Fallingwater
in Bear Run, Pennsylvania; rising
over a waterfall, this house embodies
the perfect union of man and nature.
Also built in the mid-1930s were his
Usonian houses, which blended organ-
ically into their settings. The spiral
motif first appeared in Wright's work
in 1925, with his concept for the
"Gordon Strong Automobile Objective",
a roadway and series of automobile
ramps circling Sugarloaf Mountain
upwards to a planetarium, also of spiral
design. This motif is apparent again
in his 1946 design for New York's
Guggenheim Museum, whose main
building gently expands in a continuous
upward curve.

M.R.

LEVINE, Neil. *The Architecture
of Frank Lloyd Wright*. Princeton:
Princeton University Press, 1996.

RILEY, Terence, ed. *Frank Lloyd
Wright: Architect*, exhib. cat.
New York: Museum of Modern Art;
Harry N. Abrams, 1994. Text by
Anthony Alofsin, William Cronon,
Kenneth Frampton and Gwendolyn
Wright.

Select Bibliography

Note: Bibliographical references for individual artists in the exhibition are given with their biographies, pp. 351-390.

• **Monographs**

BARROW, John D. *The Origin of the Universe.* New York: Basic Books, 1994.

BEGUET, Bruno, ed. *La science pour tous. Sur la vulgarisation scientifique en France de 1850 à 1914.* Paris: Bibliothèque du Conservatoire national des arts et métiers, 1990.

BELL, Michael, ed. *Painters in a New Land.* Toronto: McClelland and Stewart, 1973.

BERRY, Arthur. *A Short History of Astronomy from Earliest Times through the Nineteenth Century* [1898]. New York: Dover, 1961.

BERTON, Pierre. *The Arctic Grail: The Quest for the North West Passage and the North Pole, 1818-1909.* Toronto: McClelland and Stewart; New York: Viking, 1988.

BOATTO, Alberto. *Lo sguardo dal di fuori.* Bologna: Cappelli, 1981.

BOIA, Lucian. *L'exploration imaginaire de l'espace.* Paris: La Découverte, 1987.

CHAPERON, Danielle. *Camille Flammarion. Entre astronomie et littérature.* Paris: Imago, 1998.

CORTWRIGHT, Edgar M., ed. *Apollo Expeditions to the Moon.* Washington: NASA, 1975.

CROWE, Michael J. *The Extraterrestrial Life Debate, 1750-1900: The Idea of a Plurality of Worlds from Kant to Lowell.* Cambridge and New York: Cambridge University Press, 1986.

DAVIS, Ann. *The Logic of Ecstasy: Canadian Mystical Painting, 1920-1940.* Toronto and Buffalo: University of Toronto Press, 1992.

DICK, Steven J. *Plurality of Worlds: The Origins of the Extraterrestrial Life Debate from Democritus to Kant.* Cambridge and New York: Cambridge University Press, 1982.

DOLLFUS, Charles, and Henri BOUCHÉ. *Histoire de l'aéronautique.* Paris: L'Illustration, 1932.

ELIADE, Mircea. *The Quest: History and Meaning in Religion.* Chicago: University of Chicago Press, 1969.

FEHRENBACH, Charles. *Des hommes, des télescopes, des étoiles.* Paris: CNRS, 1990.

FERRIS, Timothy. *Coming of Age in the Milky Way.* New York: Morrow, 1988; Anchor Books, 1989.

GINGERINCH, Owen, ed. *The General History of Astronomy.* Vol. 4: *Astrophysics and Twentieth-century Astronomy to 1950.* Cambridge and New York: Cambridge University Press, 1984.

GOETZMANN, William H. *Exploration and Empire: The Explorer and the Scientist in the Winning of the American West.* New York: Knopf, 1966.

GOETZMANN, William H., and William N. GOETZMANN. *The West of the Imagination.* New York: Norton, 1986.

GUILLEMIN, Amédée Victor. *Le ciel. Notions d'astronomie à l'usage des gens du monde et de la jeunesse.* Paris: Librairie L. Hachette, 1865. Published in English as *The Heavens: An Illustrated Handbook of Popular Astronomy.* London: R. Bentley, 1867.

HALLYN, Fernand. *La structure poétique du monde : Copernic, Kepler.* Paris: Seuil, 1987. Published in English as *The Poetic Structure of the World: Copernicus and Kepler.* Trans. Donald M. Leslie. New York: Zone Books, 1990. Distributed by MIT Press.

HAVELANGE, Carl. *De l'œil et du monde. Une histoire du regard au seuil de la modernité.* Paris: Fayard, 1998.

HAYES, Dr. Isaac. *An Open Polar Sea: A Narrative of a Voyage of Discovery towards the North Pole.* London: Sampson, Low, Son and Marston; New York: Hurd and Houghton, 1867.

HERRMANN, Dieter B. *The History of Astronomy from Herschel to Hertzsprung.* Trans. and rev. Kevin Krisciunas. Cambridge and New York: Cambridge University Press, 1984.

HOSKIN, Michael, ed. *The Cambridge Illustrated History of Astronomy.* Cambridge and New York: Cambridge University Press, 1997.

KOYRÉ, Alexandre. *Du monde clos à l'univers infini.* Paris: Gallimard, 1973.

LA COTARDIÈRE, Philippe de, and Patrick FUENTÈS. *Camille Flammarion.* Paris: Flammarion, 1994.

LÉNA, Pierre, ed. *Les sciences du ciel (Bilan et perspectives, concepts et vocabulaire).* Paris: Flammarion, 1996.

LOOMIS, Chauncey C. *Weird and Tragic Shores: The Story of Charles Francis Hall, Explorer.* New York: Knopf, 1971; reprinted Lincoln: University of Nebraska Press, 1991.

MACDONALD, John. *The Arctic Sky: Inuit Astronomy, Star Lore, and Legend.* Toronto: Royal Ontario Museum; Iqaluit: Nunavut Research Institute, 1998.

MARIENSTRAS, Élise. *Les mythes fondateurs de la nation américaine. Essai sur le discours idéologique aux États-Unis à l'époque de l'Indépendance, 1763-1800.* Brussels: Complexe, 1992.

MAXTONE-GRAHAM, John. *Safe Return Doubtful: The Heroic Age of Polar Exploration.* New York: Scribner, 1988.

McKINSEY, Elizabeth R. *Niagara Falls: Icon of the American Sublime.* Cambridge and New York: Cambridge University Press, 1985.

MIRABITO, Michael M. *The Exploration of Outer Space with Cameras: A History of the NASA Unmanned Spacecraft Missions.* Jefferson, North Carolina, and London: McFarland, 1983.

NAEF, Weston J., and James N. WOOD. *Era of Exploration: The Rise of Landscape Photography in the American West, 1860-1885.* Buffalo: Albright-Knox Art Gallery; New York: Metropolitan Museum, 1975.

NOBLE, Louis Legrand. *After Icebergs with a Painter* [1861]. London: Sampson, Low; New York: D. Appleton, 1985.

NOVAK, Barbara. *Nature and Culture: American Landscape and Painting, 1825-1875.* New York: Oxford University Press, 1995.

OETTERMANN, Stephan. *The Panorama: History of a Mass Medium.* Trans. Deborah Lucas Schneider. New York: Zone Books, 1997.

OLSON, Roberta J.M., and Jay M. PASACHOFF. *Fire in the Sky: Comets and Meteors, the Decisive Centuries in British Art and Science.* Cambridge and New York: Cambridge University Press, 1998.

OSTROFF, Eugene. *Western Views and Eastern Visions.* Washington: Smithsonian Institution Traveling Exhibition Service; U.S. Geological Survey, 1981.

PORTER, Roy, ed. *The Norton History of Astronomy and Cosmology.* New York: Norton, 1994.

RAYET, Georges. *Notes sur l'histoire de la photographie astronomique.* Paris: Gauthier-Villars, 1887.

RITCHEY, G. W. *L'évolution de l'astrophotographie et les grands télescopes de l'avenir.* Paris: Société astronomique de France, 1929.

ROBERTSON, David. *West of Eden: A History of the Art and Literature of Yosemite.* Yosemite National Park, California: Yosemite Natural History Association; Berkeley, California: Wilderness Press, 1984.

ROSENBLUM, Robert. *Modern Painting and the Northern Romantic Tradition: Friedrich to Rothko.* New York, Evanston, San Francisco and London: Harper and Row, 1975.

SANFORD, Charles L. *The Quest for Paradise: Europe and the American Moral Imagination.* Urbana: University of Illinois Press, 1961; reprinted New York: AMS Press, 1979.

SCHAMA, Simon. *Landscape and Memory.* New York: Knopf, 1995.

SCHICK, Ron, and Julia VAN HAAFTEN. *The View from Space: American Astronaut Photography, 1962-1972.* New York: Clarkson N. Potter, 1988.

SILK, Joseph. *The Big Bang.* New York: W.H. Freeman, 1989.

SMITH, Henry Nash. *Virgin Land: The American West as Symbol and Myth.* Cambridge, Massachusetts: Harvard University Press, 1950.

SUTHERLAND, Patricia D., ed. *The Franklin Era in Canadian Arctic History, 1845-1859.* Ottawa: National Museums of Canada, 1985.

TRACHTENBERG, Alan. *Reading American Photographs: Images as History, Matthew Brady to Walker Evans.* New York: Hill and Wang, 1989.

TRENTON, Patricia, and Peter H. HASSRICK. *The Rocky Mountains: A Vision for Artists in the Nineteenth Century.* Norman, Oklahoma: University of Oklahoma Press, 1983.

VAUCOULEURS, Gérard de. *Astronomical Photography from the Daguerreotype to the Electron Camera.* New York: Macmillan, 1961.

VERDET, Jean-Pierre. *Une histoire de l'astronomie.* Paris: Seuil, 1990.

VERDET, Jean-Pierre. *Astronomie et astrophysique.* Paris: Larousse, 1993. "Textes essentiels" series.

VIOLA, Herman J. *Exploring the West.* Washington: Smithsonian Books; New York: Harry N. Abrams, 1987.

WAT, Pierre. *Naissance de l'art romantique : peinture et théorie de l'imitation en Allemagne et en Angleterre.* Paris: Flammarion, 1998.

WILLIAMS, George Huntston. *Wilderness and Paradise in Christian Thought: The Biblical Experience of the Desert in the History of Christianity and the Paradise Theme in the Theological Idea of the University.* New York: Harper, 1962.

WORSTER, Donald. *The Wealth of Nature: Environmental History and the Ecological Imagination.* New York: Oxford University Press, 1993.

• **Exhibition Catalogues**

ADAMSON, Jeremy Elwell. *Niagara: Two Centuries of Changing Attitudes, 1697-1901.* Washington: Corcoran Gallery of Art, 1985. Text by Elizabeth McKinsey, Alfred Runte and John F. Sears

American Paradise: The World of the Hudson River School. New York: Metropolitan Museum; Harry N. Abrams, 1987. Text by John K. Howat.

Architectural Drawings of the Russian Avant-garde. New York: Museum of Modern Art; Harry N. Abrams, 1990. Text by Catherine Cooke, I. A. Kazus and Stuart Wrede.

Arktis – Antarktis. Bonn: Kunst- und Ausstellungshalle der Bundesrepublik Deutschland, 1997-1998. Text by Stephen Andreae, Klaus Bachmann, Annagreta Dyring, Eric Dyring, Stanislav Fischer and Johanna Roos.

L'art du rêve. De la montgolfière au satellite. Paris: Grand Palais, 1983.

BEGUET, Bruno, ed. *La science pour tous.* Paris: Musée d'Orsay, 1994.

BICE, Megan, and Sharyn UDALL. *The Informing Spirit: Art of the American Southwest and West Coast Canada, 1925-1945.* Kleinburg, Ontario: McMichael Canadian Art Collection; Colorado Springs: Taylor Museum for Southwestern Studies, Colorado Fine Art Center, 1994. Text by Ann Davis and Charles Eldredge.

CARTER, David G. *The Painter and the New World.* Montreal: Montreal Museum of Fine Arts, 1967.

CASTLEBERRY, May, ed. *Perpetual Mirage: Photographic Narratives of the Desert West*. New York: Whitney Museum of American Art; Harry N. Abrams, 1996. Text by Martha A. Sandweiss, John Chavez *et al*.

CRISPOLTI, Enrico, and Franco SBORGI, eds. *Futurismo. I grandi temi, 1909-1944*. Milan: Fondazione Antonio Mazzota, 1998.

Crossing the Frontier: Photographs of the Developing West, 1849 to the Present. San Francisco: San Francisco Museum of Modern Art; Chronicle Books, 1996. Text by Aaron Betsky, Eldridge M. Moores, Sandra S. Phillips and Richard Rodrigues.

DAVIS, Ann. *A Distant Harmony: Comparisons in the Painting of Canada and the United States of America*. Winnipeg: Winnipeg Art Gallery, 1982.

The Expressionist Landscape: North American Modernist Painting, 1920-1947. Birmingham, Alabama: Birmingham Museum of Art; Seattle and London: University of Washington Press, 1988. Text by Ruth Stevens Appelhof, Barbara Haskell and Jeffrey R. Hayes.

Figures du ciel, de l'harmonie des sphères à la conquête spatiale. Paris: Galerie de Tolbiac; Bibliothèque nationale de France, 1998-1999. Text by Marc Lachieze-Rey and Jean-Pierre Luminet.

FLETCHER, Valerie J. *Dreams and Nightmares: Utopian Visions in Modern Art*. Washington: Hirshhorn Museum and Sculpture Garden; Smithsonian Institution Press, 1983.

The Frontier in American Culture. Chicago: Newberry Library; Berkeley: University of California Press, 1994. Text by Richard White and Patricia Nelson Limerick, ed. James R. Grossman.

The Great Utopia: The Russian and Soviet Avant-garde, 1915-1932. New York: Solomon R. Guggenheim Museum; Rizzoli, 1992.

HULTEN, Karl Gunnar Pontus, ed. *Futurismo e Futurismi*. Venice: Palazzo Grassi; Milan: Bompiani, 1986.

ISHI-KAWA, L., ed. *Sputnik*. Madrid: Fundación Arte y Tecnologia, 1997.

Kosmische Bilder in der Kunst des 20. Jahrhunderts. Baden-Baden: Die Kunsthalle, 1983. Text by Siegmar Holsten.

Die Kunst des Fliegens. Friedrichshafen: Zeppelin Museum Friedrichshafen, 1996.

LOERS, Veit, ed. *Okkultismus und Avantgarde, von Munch bis Mondrian, 1900-1915*. Ostfildern: Tertium; Frankfurt: Schirn Kunsthalle, 1995.

McSHINE, Kynaston, ed. *The Natural Paradise: Painting in America, 1800-1950*. New York: Museum of Modern Art; Boston: New York Graphic Society, 1976. Text by Barbara Novak, Robert Rosenblum and John Wilmerding.

MINOTTO, Claude, ed. *Arctic Images: The Frontier Photographed, 1860-1911*. Ottawa: Public Archives of Canada, Supply and Services Canada, 1977.

Myth of the West. Seattle: Henry Art Gallery, University of Washington; New York: Rizzoli, 1990. Text by Chris Bruce *et al*.

NYGREN, Edward J. *Views and Visions: American Landscape before 1830*. Washington: Corcoran Gallery of Art, 1986.

PROWN, Jules David, *et al*. *Discovered Lands, Invented Pasts: Transforming Visions of the American West*. New Haven: Yale University Art Gallery; Yale University Press, 1992.

SEIPEL, Wilfried, ed. *Mensch und Kosmos. Die Heraufkunft des modernen naturwissenschaftlichen Weltbildes*. 2 vols. Linz: Schloß-museum; Neue Folge, 1990.

SHEPARD, Lewis. *American Painters of the Arctic*. Amherst, Massachu-setts: Mead Art Gallery, 1975.

The Spiritual in Art: Abstract Painting, 1890-1985. Los Angeles: Los Angeles County Museum of Art; New York: Abbeville Press, 1986. Organized by Maurice Tuchman and Judi Freeman.

STEBBINS, Theodore E. Jr., Carol TROYEN and Trevor J. FAIRBROTHER. *A New World: Masterpieces of American Painting, 1760-1910*. Boston: Museum of Fine Arts, 1983. Text by Pierre Rosenberg and H. Barbara Weinberg.

TRUETTNER, William H., ed. *The West as America: Reinterpreting Images of the Frontier, 1820-1920*. Washington: National Museum of American Art; Smithsonian Institution Press, 1991.

VIATTE, Germain, ed. *La planète affolée. Surréalisme, dispersion et influences 1938-1947*. Marseilles: Centre de la Vieille Charité, Musées de Marseille; Paris: Flammarion, 1986.

WILSON, Richard Guy, Dianne H. PILGRIM and Dickran TASHJIAN. *The Machine Age in America, 1918-1941*. New York: Brooklyn Museum; Harry N. Abrams, 1986.

Photographic Credits

National Gallery of Canada, Ottawa
Cats. 17, 103, 104, 228-230, 284, 304, 321, 323

National Maritime Museum, London
Cat. 44

Otto E. Nelson
Cats. 278, 279

Observatoire de Paris
Cats. 48, 305-308

Öffentliche Kunstsammlung Basel
Martin Bühler, cat. 260

Gene Ogami
Cat. 50

Old Dartmouth Historical Society –
New Bedford Whaling Museum
Tim Sylvia, cat. 30

Margareth Olsen
Cat. 148

Dr. Parisini
Cat. 12

© Photothèque des Musées de la Ville de Paris
P. Pierrain, cat. 245

RMN – Picasso
J. G. Berizzi, cat. 242
B. Hatala, cat. 241

© 1969 Robert Rauschenberg/
Gemini G.E.L./Licensed by VAGA, New York, NY
Cat. 244

© Reading Public Museum
Cat. 68

Rheinisches Bildarchiv, Cologne
Cat. 157

Adam Rzepka
Cat. 25

© Foto G. Schiavinotto
Cats. 106, 107

John T. Seyfried (8/96)
Cats. 198, 200

Courtesy Sidney Janis Gallery, New York
Duane Michals, cat. 196

Courtesy of the Sir Sam Steele Art Gallery,
© Jack McQuarry, cat. 139

© Société française de photographie
Cats. 113, 133, 134, 138

© The Solomon R. Guggenheim Foundation, New York
David Heald, cat. 42 (FN 54.1393), cat. 142 (FN 41.283)

Staatliche Museen zu Berlin –
Preußischer Kulturbesitz Nationalgalerie
Jörg P. Anders, Berlin, 1990 90/30-1, cat. 110, 90/28-2, cat. 269

Lee Stalsworth
Cat. 36

© The State Russian Museum
Cat. 177

Stewart Museum at the Fort, Île Sainte-Hélène
Cats. 49, 93, 343-355
Giles Rivest, cats. 20, 96, 264, 265, 337, 338, 341

Strindbergsmuseet, Stockholm
Olof Wallgren, cat. 285

Joseph Szaszfai
Cat. 146

© Tate Gallery
John Webb, cat. 188

© Tel Aviv Museum of Art
Cat. 99

Thomas Gilcrease Institute, Tulsa, Oklahoma
Cats. 210, 212-215

© Angela Thomas Schmid, Pro Litteris, Zurich
Peter Schälchli, Zurich, cat. 311

Tyne and Wear Museums
Cat. 187

UWM Photographic Services
Cats. 231, 232, 328

Courtesy Vancouver Art Gallery
Trevor Mills, cats. 45, 46

© Virginia Museum of Fine Arts
Katherine Wetzel, cat. 76

© Siegfried Wameser
Cat. 272

© 1998 Whitney Museum of American Art, New York
Geoffrey Clements, cats. 174, 259

Geoff Wilkinson
Cat. 258

© Jens Willebrand, Foto-Design
Cat. 282

• Figures

Essay by François Brunet
Figs. 2a-c
Bibliothèque nationale du Québec

Fig. 3
Société de géographie, Paris

Fig. 4
Courtesy of The Bancroft Library, University of California, Berkeley

Essay by Mayo Graham
Fig. 1
© 1998, The Art Institute of Chicago. All rights reserved.

Essay by Eleanor Jones Harvey
Fig. 1
Jörg P. Anders, Berlin

Fig. 2
© Elke Walford, Hamburg

Fig. 6
Diane McConnell, Art Gallery of Ontario

Essay by Barbara Larson
Fig. 1
Observatoire de Paris

Fig. 2
Tom Haarsten, © Stichting Kröller-Müller Museum (negative no. E-221.4)

Fig. 3
© 1998, The Art Institute of Chicago. All rights reserved.

Fig. 4
© RMN – F. Vizzanova / M. El Garby

Essay by Giovanni Lista
Fig. 1
© Il Vicolo

Essay by Mary Warner Marien
Fig. 2
Rick Stafford, © President and Fellows of Harvard College, Harvard University

Essay by Constance Naubert-Riser
Figs. 1-2
© 1998 The Museum of Modern Art, New York

Essay by Rosalind Pepall
Fig. 1
National Library of Canada, Ottawa (negative no. C-094116)

Copyrights

The catalogue of the exhibition

Cosmos
From Romanticism to the Avant-garde

is a production of the Publications Service of
The Montreal Museum of Fine Arts.

Production co-ordinator
Francine Lavoie

Revision
Donald Pistolesi

Translation
Jill Corner
Marcia Couëlle
Elaine Kennedy and Marcia L. Barr
Bernard McGrade
Donald McGrath
Amerussia

Research
Maryse Ménard
Caroline Ohrt

Copyright and photo research
Marie-Claude Saia
Majella Beauregard

Technical assistance
Pierrette Couture
Marthe Lacroix
Jasmine Landry
Micheline Poulin
Danielle Sarault

Graphic design

Philippe Ducat

Photoengraving
Euronumérique

Printing
Aubin Imprimeurs

Printed April 1999
by Aubin Imprimeurs
Poitiers, France
90599